TRADITIONAL ENGLISH COUNTRY CRAFTS
and How to Enjoy Them Today

by Andy Pittaway and
Bernard Scofield

PANTHEON BOOKS
A Division of Random House, New York

Library of Congress Cataloging in Publication Data

Pittaway, Andy.
Traditional English Country Crafts and How To Enjoy Them Today.
Published in 1974 under title: Country Bizarre's Country Bazaar.
 Includes bibliographies.
 1. Handicraft. 2. Agriculture—Handbooks, manuals, etc. 3. Handicraft—
England. I. Scofield, Bernard, joint author. II. Title.
TT157.P535 1975 630'.942 73-18719
ISBN 0-394-49161-0
ISBN 0-394-70643-9 pbk.

Contents

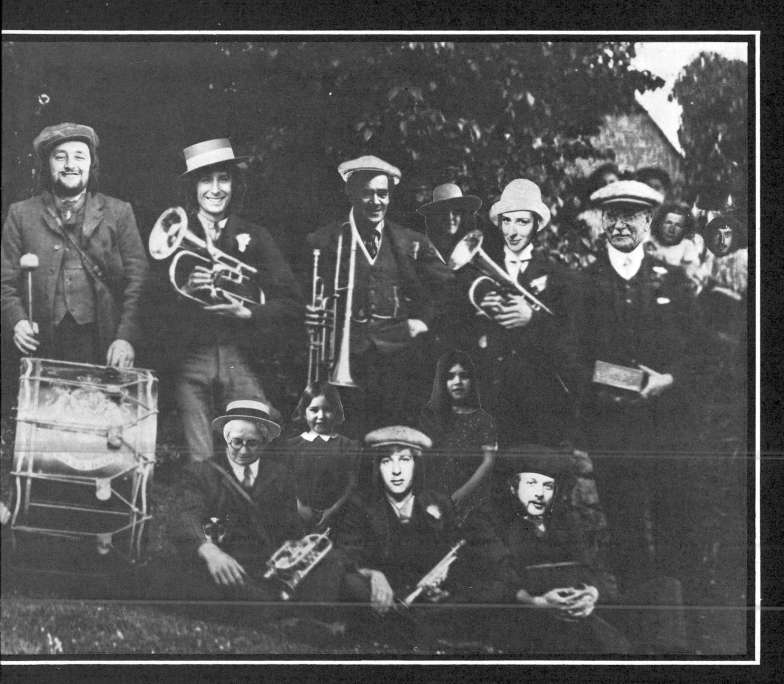

THE COUNTRY BAZAAR BRASS BAND

Acknowledgements

Our warm thanks and appreciation go to the following people who have contributed in one way or another to the creation of this book: to Irene; to Edwin (Neddy) Cooke for his illustrations which appear on pp. 36, 92, 150 and for other services rendered!; to Lisa and Lara for their drawings on pp. 62, 192–194, 197 and to their parents Jethro and Jackie Large for all their kindness; to Liz and Gavin Gault for providing the illustrations and photographs on pp. 76, 81–84, and especially for their help and support; to Malcolm (Tiny) Chile who provided the photograph of his self-made silver brooch 'The Cottage' which appears on p. 127; to Mr and Mrs E. Frost for all their help and encouragement and in particular to Mr Frost who took the photographs which appear on pp. 50, 112, 208; to Marie and Alan Jenkins for lending us a number of their books and for providing the illustration which appears on p. 78; to Stephen Jenner for lending us his engravings by Stanley Anderson which appear on pp. 100, 105, 152; to Betty Swanwick A.R.A. for her continued support and in particular for providing the photograph of her watercolour 'The Approach' on p. 179 and to Joan Gibson for permission to reproduce this painting which she owns; to Christopher Walker for his pen and watercolour picture 'The Children of Albion' which is on pp. 230–231; to John Shelley for supplying the photograph of his oil painting 'The Old Mill' which appears on p. 117; to Dr. Richard St. Barbe Baker for supplying the photographs of trees on pp. 140, 143; to Lawrence Whistler for supplying the photograph of his engraved goblet 'And Summer And Winter' on p. 182; to Ron Wilson for his article 'The Living Hedge' on pp. 151–153; to Peter Brown for his article 'Starting a Pottery' which appears on pp. 29–34; to Ray Moller for photographs which are featured on pp. 15, 246; to Gordon for lending us his engravings by Gustav Doré which are reproduced on pp. 22, 122; to Linda Wheeler of the Smile Design Group for her pen and ink illustration; to Tim and Sally Rodwell for supplying the information in 'Wayside Wines and Other Delights' pp. 183–190; to Bridget St. John for her poems which appear on pp. 61, 135; to Owen Stanier for the pottery photographs pp. 28–35; to John Allen for his information on tree tapping pp. 144–145; to Frank W. Lane for his Agfa-colorfilm photograph of lightning on p. 138; to *International Times* for the illustration on p. 166; to Michael Wills for his photograph from the Wills Family Album featured on p. 23; to Janet Bord for her tree photograph on p. 146; to Tin Pan Alley Music Ltd. for the poem on p. 156; to the Royal Society for the Protection of Birds for giving us permission to reprint extracts from their booklet *The Birds in Your Garden*; to the Council for the Protection of Rural England for granting us permission to reproduce extracts from their leaflets *Making a Hedge Survey* and *Making a Tree Survey*; to J. M. Dent & Sons Ltd. for permission to reproduce the photograph 'Thank you for the Clouds Above' from *A Child's Grace* which appears on p. 168; to the Ramblers' Association for permission to reproduce several of their Fact Sheets; to the Shirley Institute, Manchester for kindly supplying the photograph of the silk moth's life-cycle on p. 58; to Collins Sons & Co. Ltd. for permission to reproduce the illustration by J. Yunge-Bateman on p. 205 from their book *Shining Hours*; to Bob Hall for his work in correlating design and for his photographs on pp. 48, 52, 53, 54, 55, 94, 99, 202.

Our gratitude must also be extended to the following organisations from which we obtained help and information:
Banbury School of Art; Goldsmiths School of Art; Crafts Advisory Committee; Design Centre; Silk Education service; Irish Linen Guild; West Dean College; Cranks Vegetarian Restaurant; Burfield House School; CoSIRA; the Forestry Commission; Nature Conservancy; Frendz Magazine.

THE COUNTRY BAZAAR BRASS BAND

Back row, left to right: **Ray Moller** euphonium and photographs; **Mr E. Frost** tuba and photographs; **Malcolm (Tiny) Chile** slide trombone and illustrations; **Edwin (Neddy) Cooke** cornet and drawings; **Andy Pittaway** clarinet and co-author; **Bob Hall** bass drum and production; **Bernard Scofield** horn and co-author; **Godfrey Golzen** valve trombone and management; **Gavin Gault** tea urn, spoons and illustrations; **Sally Rodwell** second horn and wine know-how; **Richard St Barbe Baker** collecting box and tree photographs; **Christopher Walker** painting; **John Allen** tree-tapping notes.
Front row, left to right: **Bridget St John** bugle and poems; **Liz Gault** trumpet and illustrations; **Alexandra Artley** trumpet and editorial; **Betty Swanwick A.R.A.** trumpet and painting; **Lara Large** triangle and drawings; **Stephen Jenner** trumpet and engravings; **Lisa Large** penny whistle and drawings; **Tim Rodwell** collecting box and information.

Where should a man live? In solitude, or in society? In the green stillness of the country where he can hear the heart of nature beat; or in the dark, grey town where he can hear and feel the throbbing heart of man?

I fear, however, that in towns the soul of man grows proud. He needs at times to be sent forth, like the Assyrian monarch into green fields, a wondrous wretch and weedless, to eat green herbs and be awakened and chastised by the rain shower and winter's bitter weather.

LONGFELLOW

Introduction

About three years ago, a small magazine appeared in some London bookshops for the first time. The magazine was called *The Country Bizarre* and appeared seasonally, filled with a peculiar patchwork of country matters ranging from conservation, folklore and craftwork, to nature, poetry, stories and pictures. From its humble beginnings, *The Country Bizarre* grew into a well-loved publication and so it was only a matter of time before a book based on the magazine and preserving its unique atmosphere should appear.

Although the book contains a number of articles taken from the magazine, the majority of what lies within is quite new. Craftwork had always been an integral part of *The Country Bizarre* and so there are many articles in the book on country crafts: crafts that can be pursued without an expensive outlay in equipment and materials, and where the countryside itself provides the basics of the craft. There is a vast amount of information on sources of materials, making one's own equipment, crafts workshops and museums to visit in England, and further reading. We hope in this way to draw American readers not only to our crafts but also to our countryside.

When setting out initially on the production of *The Country Bizarre's Country Bazaar, Traditional English Country Crafts in America*, we were haunted by the hundreds of other publications already on the market. Most of them, we felt, were stereotyped, uninspiring and in general, divorced from the world of creative art and design. In trying to avoid these faults, we have compiled a book which we hope not only overflows with information, but will delight and inspire the reader with beautiful drawings, engravings, illustrations and photographs by many artists, not just from our own times, but from historical periods long before our own. Only by studying and appreciating all kinds of art can the quality of design in craft work be raised from the generally low standard it has fallen to today.

Finally, we must express warm thanks to our friends at the Architectural Press for having taken such an interest in the magazine and for giving us help and advice whenever needed. In particular, our thanks must go to Ted Cooke, who got the whole idea going, for without him this book would never have happened. There are many others who must be equally thanked for their help, information and contribution and a fitting tribute to their collective effort appears on pages 4 and 5.

So here is *The Country Bizarre's Country Bazaar* and we sincerely hope you all get as much pleasure out of owning it as we did in creating it.

Love and best wishes

Andy Pittaway

Bernard Scofield

Note: At the end of each chapter is an "In the USA" section which lists American sources of materials, societies, and books. The sources of materials come from the American Crafts Council suppliers lists and others, described under "Further Useful Information," and are listed alphabetically by state. They were selected for their range of offerings, willingness to mail order, and, where possible, geographic variety. Some of the books are American editions of British books we chose; others come from specialized catalogs, also described in the last section.

On page 224 is a glossary with explanations of British words you will encounter in the text and American equivalents for British products.

Of all the many monuments to be found in our churches and cathedrals, beautifully engraved brasses are frequently the most overlooked. Not only are they fine examples of the metal-worker's craft from the 13th to the 17th centuries, but they also serve as a pictorial guide to the development of fashions in armour and ecclesiastical gowns. They are also a commentary on the way of life in medieval England with such characters as monks, ladies, bishops, servants and knights all rigidly portrayed in brass as their contemporaries saw them.

Even today their value as a source of historical information has been increased by the simple techniques available to reproduce their exact designs, capturing the different textures and qualities in wax on paper.

Although one normally thinks of a church as belonging to the people, permission must in fact be sought from the priest of the church concerned, stating the time and date that you wish to make your rubbing. You must also contact the people responsible for the church's ornaments as sometimes a brass may be located under a pew or, in one case, behind an organ. CROCKFORD'S CLERICAL DIRECTORY (available in most public libraries) lists hundreds of names and addresses of these people. A small fee of probably no more than 25p may also be required to help with the up-keep of the church.

EQUIPMENT

The basic materials needed for brass rubbing consist of detail or lining paper, heelball wax or crayons, black ink, strong adhesive tape, a soft brush and rags. Before starting on your rubbing, dust and brush the brass carefully to remove any grit that might be wedged between the grooves and roll out the paper onto the brass, securing it firmly with the tape.

A Guide to Brass Rubbing

So that you know the area of the paper for rubbing, gently bring out the outline of the plate by rubbing the paper with a clean piece of cloth.

METHOD

There are three recognized rubbing methods which produce differing results. The first is with either sticks or cakes of black heelball which is a mixture of beeswax, tallow and lamp black. This method needs hard rubbing to produce an even black image and for good results a dull point should be kept on the sticks. When a brass is too detailed for the heelball to define it, a second method will have to be used: this is the dabbing technique.

Make a pad from a piece of chamois leather wrapped round some cotton wool and dip it into a paste of graphite mixed with linseed oil. Wipe off the surplus paste from the pad and dab it with medium pressure onto the surface of the paper. As very little friction is caused, thin paper, like tissue paper can be used. This process is ideal if you also want a fine impression of the stone surrounding the brass.

The third technique is based on the heelball process and is used solely for decoration. Instead of using a black heelball, a brown or yellow one could be used. The rubbing is made in the same way as before but after completion, wipe the paper with waterproof black ink. The ink will stain only the parts not touched by the wax and will give a white-on-black image. The rubbing is then cut out and mounted on coloured board.

Altogether there are some 2,000 brasses scattered throughout Great Britain, the most numerous being in the counties of East Anglia, the Home Counties and the Thames Valley, Kent, Essex, Norfolk and Suffolk contain a large amount followed closely by Buckinghamshire, Oxfordshire, Berkshire, Surrey and Hertfordshire.

Instead of listing every location, we think it best to mention only those brasses of high interest and good quality:

Bedfordshire:

BROMHAM: A Man in armour (1435) plus 2 Wives.

WYMINGTON: A Man in civilian dress with Wife (1391); Sir Thomas Brounflet in armour (1430); a Priest with chalice (1520); a Lady (1407).

Berkshire:

BLEWBURY: John Balam: priest (1496); a Man in armour plus 2 Wives (1515); Sir John Daunce in armour and tabard of arms with Wife (1523).

BRAY: Foxley in armour with 2 Wives (1378); a Judge (1475); a Man in civilian dress plus 2 Wives (1490).

CHILDREY: A Priest with chalice (1490); a Lady in a shroud (1507); a Man in civilian dress with Wife in shroud (1516); a Priest in academical dress (1529).

SHOTTESBROOKE: A Priest with civilian (1370); a Lady (1401); a man in armour (1511); a Man in civilian dress with 3 Wives (1567).

SPARSHOLT: A Priest (1353); a Civilian (1495); a Lady (1510).

WINDSOR: *(St Georges' Chapel)* A Child in a cradle (1630).

Buckinghamshire:

DENHAM: A Man in armour with 2 Wives (1494); a Lady (1545); a Priest (1560).

DRAYTON BEAUCHAMP: A Man in armour (1368); a Priest with a small chalice (1531).

ETON COLLEGE: *Chapel:* A Fellow with a small chalice (1509); a Fellow kneeling with 11 inscriptions (1636).

STOKE POGES: Sir William Molyns with Wife (1425).

TAPLOW: A Cross and Man in civilian dress (1350); a Man in armour with 2 Wives (1540).

THORNTON: Robert Ingylton dressed in armour with 3 Wives (1472); a Lady (1557).

Cambridgeshire:

BALSHAM: A Priest (1401).

ELY CATHEDRAL: Bishop Goodrick (1554); Dean Tyndall (1614).

HILDERSHAM: Robert de Paris; a Man in civilian dress with Wife kneeling (1379).

TRUMPINGTON: Sir Roger de Trumpington (1289).

WESTLEY WATERLESS: Sir John de Creke with Wife (1325).

Cheshire:

MACCLESFIELD: Roger Legh in civilian dress (1506).

WILMSLOW: Sir Robert del Bothe dressed in armour with Wife (1460).

Cornwall:

CALLINGTON: Nicholous Assheton (1465).

MAWGAN-IN-PYDER: A Lady (1578); a Man in civilian dress (1580).

Cumberland:

CARLISLE CATHEDRAL: Bishop Bell (1496); Bishop Robinson (1616).

Derbyshire:

MORLEY: Sacheverell dressed in armour with Wife (1525).

TIDESWELL: Holy Trinity for Sir Sampson Meverell (1462); A Man in civilian dress with Wife (1483).

Devonshire:

DARTMOUTH: *(St Saviour)* John Hauley dressed in armour with 2 Wives (1408); a Lady (1470).

STOKE FLEMING: John Corp dressed in civilian clothes (1391).

Durham:

SEDGEFIELD: Two skeletons in shrouds (1470).

Essex:

BOWERS GIFFORD: Sir John Gifford dressed in armour (1348) (mutilated).

CHIGWELL: Archbishop Harsnett (1631).

DAGENHAM: Sir Thomas Urswyk (1479).

OCKENDON: Sir Ingelram Bruyn (1400); a Lady (1602).

PEBMARSH: Sir William Fitzralph sitting cross-legged (1320).

WYVENHOE: Elizabeth, Countess of Oxford (1537).

Gloucestershire

CHIPPING CAMPDEN: Wool-merchant with Wife (1401).

CIRENCESTER: 12 brasses of Wool Merchants with Wives (1400–1626).

DRYHAM: Sir Morys Russel and Wife (1401).

NORTHLEACH: 7 brasses of Wool Merchants with Wives (1400–1526).

Hampshire:

CRONDALL: A Skeleton (1641).

RINGWOOD: A Priest with Saints (1416).

THRUXTON: Sir John Lysle (1425).

Herefordshire:

HEREFORD CATHEDRAL: Bishop Trilleck (1360); a Priest in head of cross (1360).

Hertfordshire:

BERKHAMSTEAD: Lady in a small shroud (1520).

CLOTHALL: John Wynter (1404); Priest with chalice (1519); a Lady (1572).

ST ALBANS ABBEY: Abbot Delamere (1360); 4 Monks (1450).

Kent:

CHARTHAM: Sir Robert de Setvans (1306); a Small Lady (1530).

COBHAM: A Lady (1320); a Man dressed in armour (1354).

HORSMONDEN: A Priest (1340); a Lady (1604).

MARGATE: Heart and scrolls (1433); a Skeleton (1446).

SEAL: Lord William de Bryene dressed in armour (1395).

STONE: A Priest in head of cross (1408)

WICKHAM: A Yeoman of the Guard with 3 Wives (1568).

Leicestershire:

BOTTESFORD: Henry de Codyngtoun with Saints (1404).

DONINGTON CASTLE: Robert Staunton dressed in armour (1458).

Lincolnshire:

BOSTON: A Man in civilian dress (1398).

CROFT: A Man dressed in armour (1300).

LINWOOD: John Lyndewode with Woolman and Wife (1419); a Woolman (1421).
STAMFORD: *(All Saints)* : Woolman with Wife (1475).

Middlesex:
HARROW: A Man in civilian dress with 3 Wives (1488).
HILLINGDON: Lord Le Strange with Wife (1509).
LONDON *(All Hallows Barking, Tower Hill)* : A Woolman with Wife (1437); The Resurrection (1510). Westminster Abbey: Bishop John de Waltham (1395); Archbishop Robert de Waldeby (1397).

Norfolk:
BURNHAM THORPE: Sir William Calthorpe dressed in armour (1420).
ROUGHAM: Judge with Wife (1470).
SHERNBOURNE: Sir Thomas Shernborne (1458).
UPWELL: Henry Martyn (1435); a Lady (1631).

Northamptonshire:
NEWTON-BY-GEDDINGTON: John Mulsho dressed in civilian clothes with Wife kneeling to cross (1400); a Lady (1604).

Northumberland:
NEWCASTLE-UPON-TYNE *(All Saints)* : Merchant with Wife (1429) (foreign).

Oxfordshire:
BRIGHTWELL BALDWIN: English inscription to John the Smith (1370).
DORCHESTER: Abbot Bewfforeste (1510); a Lady (1490).

Rutland:
LITTLE CASTERTON: Sir Thomas Burton (1410).

Staffordshire:
OKEOVER: Zouch and 2 Wives (1447) altered to Oker and Wife (1538).

Suffolk:
GORLESTON: Man dressed in armour, of Bacon family (1320).
PLAYFORD: Sir George Felbrigg dressed in armour (1400).

Surrey:
HORSLEY: Man in civilian dress (1400); Bishop Bowthe kneeling (1478).
LINGFIELD: Lady Cobham (1374).

Worcestershire:
FLADBURY: Man dressed in armour with Wife (1445).
KIDDERMINSTER: Sir John Phelip (1415).

Yorkshire:
TOPCLIFFE: Thomas de Topclyff dressed in civilian clothes with Wife (foreign) (1391).
WENSLEY: Simon de Wensley (1360).

There are no outstanding brasses in Ireland, Scotland, or Wales. The Channel Islands and the Isle of Man possess no known brasses at all.

12

SOURCES OF MATERIALS

Detail paper can be obtained from stationers, artshops or from:
WINDSOR & NEWTON LTD, Wealdstone, Harrow, Middlesex.
Shelf paper from:
BOOTS CHEMISTS, WOOLWORTHS, W. H. SMITH & SON.
Heelball, cobbler's wax, astral wax, available from:
PHILIPS & PAGE & SONS, Ltd, 50 Kensington Church Street, Kensington, London W8.

SOCIETIES

MONUMENTAL BRASS SOCIETY, c/o The Society of Antiquarians, Burlington House, Piccadilly, London W1. *For the study and preservation of brasses and their care and repair. Gives free advice to churches.*

SERVICES

THE CHURCH OF ENGLAND ENQUIRY CENTRE, Church House, Dean's Yard, London SW1P 3NZ. *Has a directory of brasses to be found in churches in London.*

BIBLIOGRAPHY

BEGINNERS GUIDE TO BRASS RUBBING, by Richard J. Busby/Pelham Books, London; Transatlantic Arts, Levittown, N.Y.
COMPLETE DESCRIPTIVE GUIDE TO BRITISH MONUMENTAL BRASSES, by Richard Le Strange/Thames & Hudson, London; Transatlantic Arts, Levittown, N.Y.
THE CRAFT AND DESIGN OF MONUMENTAL BRASSES, by Henry Trivick/John Baker, London; Humanities, New York.
CREATIVE RUBBINGS, by Laye Andrew/B. T. Batsford, London; Watson-Guptill, New York.
CROCKFORDS CLERICAL DIRECTORY/Oxford University Press, London. *(Consult this in a reference library for the names and addresses of clergymen whose permission you will have to ask.)*
MACKLIN'S MONUMENTAL BRASSES, edited by

John Page-Phillips/Allen & Unwin, London; Praeger, New York.

MONUMENTAL BRASSES, by Herbert W. Macklin (revised by Charles Oman)/Allen & Unwin, London; Lawrence Verry, Mystic, Conn.

MONUMENTAL BRASSES IN SOMERSET, by A. B. Connor/Kingsmead Reprints, Bath, Somerset; Albert Saifer, W. Orange, N.J.

MONUMENTAL BRASSES OF CORNWALL, by Edwin H. Dunkin/Kingsmead Reprints, Bath, Somerset; Albert Saifer, W. Orange, N.J.

THE PICTURE BOOK OF BRASSES, by H. Trivick/John Baker, London; Scribner's, New York.

IN THE USA

Possible subjects for rubbing in the United States include manhole covers, company plaques, and grillwork. But the most elegant American rubbings come from gravestones, especially in New England. Three active cemetery associations will provide information on their states' cemeteries and will also help you to locate the gravestone of a relative.

MAINE OLD CEMETERY ASSOCIATION, c/o Dr. Hilda Fife, Eliot, Maine.

VERMONT OLD CEMETERY ASSOCIATION, c/o Mrs. Donald C. Billings, RFD 3, Middlebury, Vt. 05753.

WISCONSIN OLD CEMETERY ASSOCIATION, c/o Gloria A. Steber, 9957 N. River Rd., 41 W, Mequon, Wisc. 53902.

SOURCES OF MATERIALS

OLDSTONE ENTERPRISES, 77 Summer St., Boston, Mass. 02110. *Free Leaflet. You can buy supplies individually or a beginner's kit for $7.50, which includes an instruction booklet, five sheets of the right kind of paper, two cakes of wax, masking tape, and a brush.*

BIBLIOGRAPHY

EARLY NEW ENGLAND GRAVESTONE RUBBINGS, by Edmund Vincent Gillon, Jr./Dover, New York.

GRAVESTONE DESIGNS: RUBBINGS AND PHOTO-GRAPHS FROM EARLY NEW YORK AND NEW JERSEY, by Emily Wasserman/Dover, New York.

GRAVESTONES OF EARLY NEW ENGLAND AND THE MEN WHO MADE THEM, 1653–1800, by Harriette M. Forbes/Pyne Press, Princeton, N.J.

THE LAST WORD, by Dr. Melvin Williams/available from Oldstone (see above).

RUBBINGS AND TEXTURES, by John Bodor/Van Nostrand Reinhold, New York.

STRANGER STOP AND CAST AN EYE, by G. Walker Jacobs/Stephen Greene, Brattleboro, Vt.

Natural Cosmetics

Many people may suffer discomfort from using brand-name soaps which contain harmful chemicals and perfumes. Rashes and unhealthy complexions can occur with the use of modern cosmetics so that alternative types composed of natural ingredients are the only answer. We have therefore compiled a list of the more important herbs which have been used traditionally in cosmetics, followed by a collection of recipes for simple soap, shampoo and face cream etc. which are completely harmless to delicate skins and will help to naturally enhance the beauty of face, skin, hair and scalp.

CHAMOMILE (Matricaria chamomilla)
Keeps blonde hair healthy. Good for ageing skin and helps soothe and heal inflammatory areas. Infuse in water and apply hot.

COLTSFOOT (Tussilago fartara)
Helps relieve the effects of dilated facial veins (sometimes known as thread veins). Infuse in water and apply cold only.

ELDER FLOWERS (Sambucus nigra)
One of the finest cures for sunburn, wrinkles and freckles. Also good for cleansing, softening and whitening the skin. Use infused in water, applied cold or in a cream.

EYEBRIGHT (Euphrasia officinalis)
Has been used for centuries in relieving tired eyes and inflamed eye-lids. Use infused in water and apply cold.

FENNEL (Foeniculum vulgare)
Good for smoothing out wrinkles and relieving tired eyes. Use infused in water and apply cold.

HORSE TAIL (Equisetum arvense)
An excellent herb for improving the condition of both hair and nails. Use infused in water and either take internally as a tea or applied warm as a hair rinse.

LIME FLOWERS (Tilia europaea)
Very good for eliminating wrinkles, whitening the skin, bleaching out freckles and stimulating the growth of hair. Use infused in water and apply hot or cold.

LOVAGE (Levisticum officinalis)
A herb best known for its deodorant qualities when taken internally, infused in water as a tea.

MARIGOLD PETALS (Calendula officinalis)
Helpful in reducing inflammation, smoothing rough skin and reducing acne and other skin complaints. Use infused in water and apply hot or cold.

NETTLE (Urtica dioica)
An excellent tonic for hair and equally good as a skin conditioner. Use infused in water and take internally hot or cold, or apply externally the same.

PEPPERMINT (Mentha piperita)
A skin conditioner and tonic, as well as having disinfectant qualities. Use infused in water and take internally hot or cold.

ROSEMARY (Rosmarinus officinalis)
Perhaps the finest herb for strengthening and beautifying the hair. Use infused in water and apply as a warm hair rinse.

SAGE (Salvia officinalis)
A good herb for improving the quality of hair. Use the same as rosemary.

SALAD BURNET (Sanguisorba minor)
For cleansing and beautifying the skin. Use infused in water and apply hot or cold.

VERBENA (Lippia citriodora) *Lemon Verbena*
A herb which has soothing qualities and is best used in relieving inflamed eyelids and tired eyes. Use infused in water and apply cold.

RECIPES

Simple Soap: 1 lb caustic soda, 35 oz olive oil (or any other vegetable oil) and 3 pints of water. Put the soda and water into a large cooking pot and heat slowly, dissolving the soda by stirring gently. Allow the solution to cool until lukewarm and then add the oil. Stir for a couple of minutes and then pour the mixture into shallow metal trays lined with cotton or muslin. Keep the trays in a warm place for one day and after cutting the soap into bars, leave them to solidify in a cool place for *at least* six weeks. (Oil for simple soap can be obtained from grape seed and sunflower seed etc, simply by crushing with a mortar and pestle.) If desired, a little natural oil of geranium, rose or lavender etc., may be added during the mixing stage.

Irish Moss Cream: 1 oz Irish moss, 2 oz glycerine, 1 dram boracic acid; 1 oz eau de cologne and 10 oz of distilled water.
After washing the moss in water, gently boil it in the distilled water in a saucepan or some other pot with a lid. When cool, strain the mixture and add the glycerine and boracic acid (borax). Mix thoroughly and finally add the eau de cologne. Put the cream in little pots and cover them.

Witch Hazel Cream: ½ oz sodium carbonate, 4 fluid oz glycerine, 20 fluid oz distilled extract of witch hazel, 4 oz stearic acid and 16 fluid oz of water.

Using only an enamel or stainless steel pot, add the sodium carbonate and the glycerine to the water and thoroughly stir. Add the stearic acid and gently heat the solution until all the effervescence has disappeared, leaving a clear liquid. Keep the solution on the heat and near to boiling point for an hour, continually stirring. Take off the heat, add the witch hazel and stir until a good cream has been made. Store in small pots.

Skin Softeners: Rub potato slices over the skin first thing in the morning and last thing at night. Equally as good is to fill a small bowl with half a cup of hot milk. Drop a slice of lemon in and let the mixture stand for a few minutes. Strain and throw away the curd. Wash your skin first with ordinary warm water and then apply the liquid gently massaging into the skin. Wipe off the surplus and allow the rest to soak into the skin.

For Large Pores: To close large pores and liven up the skin do the following: put four tablespoonfuls of bran and the shredded rind of two lemons into a flannel bag. Place in a pot of boiling water for a few seconds and then apply to the face, as hot as can be tolerated, gently squeezing the bag as you go.

Rough Skin Lotion: Put $\frac{1}{2}$ pint of milk into a pan and add $\frac{1}{2}$ oz of bicarbonate of soda, $\frac{1}{2}$ oz of glycerine, $\frac{1}{2}$ teaspoonful of powdered borax just before boiling. Remove immediately from the heat and when cold, apply freely to the skin.

Sunburn Protection: Firstly let it be said that sunbathing in large amounts has a severe and detrimental effect on the skin. It ages the skin like nothing else and stops the skin absorbing the sun's vital vitamin A content that is essential for a healthy complexion. If you are out in the hot sun for any length of time it is advisable to rub one or two slices of cucumber over the face, arms and neck and allow the juice to dry. Not only will this protect you from sunburn but it is a very good skin conditioner. A good sun oil can be made from olive oil with the addition of a little vinegar. Use liberally over exposed parts.

Freckle Cure: Freckles are not shaming in the least, but if you want to clear them, the following should be done. Pour $\frac{1}{2}$ pint of boiling milk over 2 tablespoons of freshly-scraped horse-radish root. When cold, apply all the mixture to the face as thickly as possible and leave it to dry for half an hour. Wash off with rainwater if possible and repeat each day until the freckles disappear. Another way is to rub the leaves of an elm tree over the face just after a heavy dew or rain. It will clear freckles and make the skin beautiful.

Skin Fresheners and Other Advice: To revitalize the skin, take two handfuls of scented rose petals and put them into an earthen pot. Pour two pints of hot or cold water and $\frac{1}{2}$ lb sugar over them, leaving the mixture for an hour. Take an empty jug and pour the mixture back and forth until the scent is abundant in the water. Strain and apply freely to the skin.

To clear pimples more effectively than with any shop preparation, pick a dandelion flower and squeeze the stem until a milky juice appears. Apply the juice to the pimples and they will soon dry up and disappear. This remedy is unfortunately limited to Spring and Summer as the dandelion loses its cunning qualities in the Autumn and Winter.

Complexion Lotion: Into a large bowl put 1 oz of spirits of camphor, 2 oz sea salt, 1 oz spirits of ammonia and $\frac{1}{4}$ pint of unsweetened gin. Add boiling water to make 1 quart of liquid. Stir until the salt has dissolved and bottle, corking well. Shake the bottle before use and apply to the skin freely. This lotion has an amazing effect on the feel of the skin and its appearance.

Eye Preparations: The latter-day medical profession has scorned the use of the herb eye-bright as having no positive effect on eye care, but you never see a gypsy with glasses and eye bright was their herb. Put a teaspoonful of the dried herb in a teacup and infuse with boiling water. After allowing the solution to cool, strain and bathe the eyes with it. This preparation reduces tension in the eyes and makes them sparkle.

Nail Care: Never cut nails to shorten them as this makes them brittle. Instead use an emery board or file. If your nails are brittle rub them with slightly warm Lucca Oil (from any chemist).

Hair Tonics and Preparations: Add cat-mint to your rinsing water after washing your hair as this promotes bright shiny hair. Chamomile is equally good and keeps fair hair light and golden. To keep naturally blonde hair its natural colour, and to prevent it darkening, boil half an oz of chamomile flowers in a pint of water for 20 minutes. When cool, use it as a hair rinse after washing the hair with the following shampoo.

Chamomile Shampoo: Into a basin put 1 tablespoonful of pure soapflakes, 1 teaspoonful of borax and 1 oz of powdered chamomile flowers. Add $\frac{1}{2}$ pint of hot water and beat till a thick later appears. After wetting the hair with warm water, add the lather and massage well into the scalp. Rinse thoroughly and repeat.

Healthy Teeth: For sparkling, healthy teeth, rub them with fresh sage leaves. This freshens the teeth, hardens the gums and improves the state of your mouth immensely.

Rosemary Hair Rinse: Infuse a teacupful of boiling water with 1 desertspoonful of dried or fresh rosemary leaves. When cool add to your rinsing water and you can expect to have lovely hair if used continually. Verbena, columbine and lad's love are other good rinses which perfume and condition the hair in a wonderful way.

To Help Stop Hair Falling Out: This condition is generally caused by stress, worry or by such deficiencies as anaemia. A tonic of Peruvian bark will help to cure this malady. Into 1 pint of cold water place $\frac{1}{2}$ oz Peruvian Bark (from a good herbalist) and after bringing to the boil, simmer for 10 minutes. Strain when cold and take half a cupful every day before going to bed and first thing in the morning. For hair that is in a serious condition, take a handful of green artichoke leaves and cook them (as with spinach) in their own juice

mixed only with a little water. Cook gently for three hours, do not strain, then rub well into the hair two or three times a week.

Dandruff Cure: In a cupful of warm water dissolve a thimbleful of powdered borax. Wet the hair first and then brush in this solution, rubbing well into the scalp. Repeat daily.

Woodland Hair Tonic: Obtain from a good herbalist the following extracts: ½ fluid oz of skullcap, ½ fluid oz mistletoe, ½ fluid oz valerian root, ½ fluid oz wahoo bark, 1 fluid oz of hollyhock root, ½ fluid oz gentian root, 2 fluid drachms of golden seal root and 8 oz distilled water. Mix together and take 1 teaspoonful three times a day.

IN THE USA

SERVICES

If you have any questions relating to the material presented in this chapter, send them to Gardens Department, THE NEW YORK TIMES, *229 W. 43 St. New York, N. Y. 10036. Include a stamped, addressed return envelope with your inquiry.*

SOURCES OF MATERIALS

To find sources for many of the ingredients mentioned in this chapter look in the back of a book on herbs for a list of Herb Nurseries or Garden Centers. To locate herbal outlets near you, consult the yellow pages. Here is a list of herbal outlets from which you can mail order. (If no catalog price is listed, write for information.)
NATURE'S HERB COMPANY, 281 Ellis St., San Francisco, Calif. 94102.
Unusual botanicals. Catalog 25¢.
PINE HILLS HERB FARMS, P.O. Box 144, Roswell, Ga. 30075.
HAHN AND HAHN, Homeopathic Pharmacy, 324 W. Saratoga St., Baltimore, Md. 21201.
BORCHELT HERB GARDENS, 474 Carriage Shop Rd., E. Falmouth, Mass. 02536. *Catalog 10¢.*

WELL SWEEP HERB FARM, 451 Mount Bethel Rd., Port Murray, N.J. 07865. *Price list available for seeds, plants, and products.*
APHRODISIA, 28 Carmine St., New York, N.Y. 10014. *Unusual botanicals. Catalog 25¢.*
GARDENS OF THE BLUE RIDGE, Ashford, N.C. 28603. *Native live herbs.*
NICHOLS GARDEN NURSERY, Pacific North, Albany, Oreg. 97321. *Herbs, vegetables, flowers, and other plants, seeds, botanical products. Catalog 15¢.*
HUSSMANN'S PHARMACY, 534–536 W. Girard Ave., Philadelphia, Pa. 19123. *Unusual botanicals. Catalog.*
GREENE HERB GARDENS, Greene, R. I. 02872. *Herbs, herb plants, seeds.*
MEADOWBROOK HERB GARDEN, Wyoming, R.I. 02898. *Seeds, plants, herbal products. Catalog 50¢.*
HILLTOP HERB FARM, Box 866, Cleveland, Tex. 77327. *Herbs, herb plants, seeds, unusual botanicals. Catalog 30¢.*
BLACK FOREST BOTANICALS, Route 1, Box 34, Yuba, Wisc. 54672. *Catalog 10¢.*

BIBLIOGRAPHY

HERB GARDENING, by Claire Loewenfeld (illus.)/Branford, Newton Centre, Mass.
HERB MAGIC AND GARDEN CRAFT, by Louise Evans Doole/Sterling, New York.
HERBAL HANDBOOK FOR EVERYONE, by Juliette de Bairacli Levy/Branford, Newton Centre, Mass.
THE HERBALIST, by Joseph E. Meyer, (rev. ed. with illus.)/Sterling, New York.
HERBCRAFT, by Violet Schaffer/Yerba Buena, San Francisco, Calif.
HERBS, HEALTH & COOKERY, by Claire Loewenfeld and Phillppa Back/Universal Publishing and Distributing Corp., New York.
HERBS: HOW TO GROW THEM AND HOW TO USE THEM, by Helen Noyes Webster/Branford, Newton Centre, Mass.
ORGANIC MAKE-UP: THE ABC'S OF NATURAL BEAUTY, by Dian Buchman/Ace Books, New York.
THE ROOTS OF HEALTH, by Leon Petulengro/New American Library, New York.
26 EASY-TO-GROW HERBS AND HOW TO USE THEM, edited by Ed and Carolyn Robinson/Garden Way, Charlotte, Vt. *Bulletin, 50¢.*

Come, let us daub, my crazys,
Surrealize the thrill.
Of soapsuds on the daisies
And skylarks in the swill.

LEONARD FEENEY

Three Corn Dollies

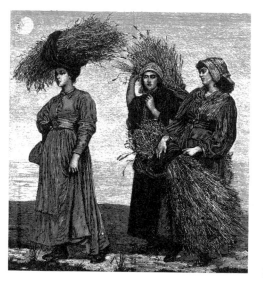

The art of making corn dollies is very old indeed and is almost untraceable in its origins. It has always been centred around the need to express hope for a good harvest and to give thanks at that time of year to goddesses of the earth and fertility, such as Ceres and Demeter. One of the most common symbols in harvest rituals is that of the cornucopia on the Horn of Plenty which is thought to have strongly inspired the traditional English corn dolly. As to the name 'dolly', this is subject to much discussion, but seems to be more akin to an idol or female deity to be worshipped, than a child's doll.

When the harvest was over, dollies were always carried round the fields to celebrate the year's sowing and reaping and there was much joy and thanksgiving. It is a sad tribute to our times that the harvest festivals which were once an accepted ceremony are now slowly disappearing.

Before the days of the combine harvester, which has virtually killed off the craft, there were rituals involving corn dollies all over the country, varying from region to region, though all having much the same things in common. A man was selected from the farm labourers and was elected 'Lord of the Harvest'. The 'Lord' was then to be respected above all the other men and it was he who would lead the pace in the harvest. Usually he was a man with much experience and the fastest worker, for the other men could then try to match his ability. His job also, was to see that each man was fairly paid for his work. At the end of the harvest, a procession of all the farm wagons, gaily decorated with flowers and ornaments, made a tour of the fields. The horses were at their best: groomed and wearing bells and trinkets, and the men and women were none the less gaily dressed. As they moved round the field, ancient songs were sung, bells rung and there was much fun and laughter. More often than not, the prettiest girl of the village was chosen to ride the leading horse and she was a frequent excuse for the young men to partake in kissing and horseplay. After the procession came the feast—an enormous affair of the like that our ancestors were famous for. No doubt the old songs were sung year after year, such as:

Harvest home, Harvest home,
We have ploughed, we have sowed,
We have reaped, we have mowed,
We have brought home every load.
Hip! Hip! Hip! Harvest home.

There is a wide variety of corn dollies, one or two being peculiar to a county and each type usually had a beautiful name. We have listed a few for you: 'The Suffolk Horn', 'The Cornucopia', 'The Norfolk Lantern', 'The Durnham Chandelier', 'The Corn Neck', 'The Vale of Pickering Chalice', 'The Cambridgeshire Bell', 'The Mother Earth', 'The Horn and Whip', 'The Essex Teret', and 'The Five Straw Plait'.

When mechanisation came in, there was coupled with it the introduction of wheats that had a pithy-centred straw which unfortunately led to a general decline in the craft. Today, however, new wheats are being grown with a hollow straw such as Maris Widgeon and Elite Lepeuple and these are excellent for corn-dolly making. Should you be unable to get hold of these wheats, rye and oats will do, but barley is unsuitable.

COLLECTING

First find a farmer who is growing the type of grain you require and get permission from him to cut some of the straw when it is nearly ripe and the first joint below the ear is still green. If the straw is used within a week of collecting, dampening will not be required.

STORING

Straw tends to mildew rather easily so your first job must be to dry it, either in the sun, an airing cupboard, or in a slow oven with the doors open. It is then advisable to store the straw loosely packed in boxes until needed and this way will enable you to keep it for years.

TRIMMING

You will notice, on observing an individual straw, that it is made up of a number of joints at varying lengths up the stem. Each straw should be cut off above the top joint, just below the ear, and also just above the bottom joint nearest the base of the straw. The sheath should also be removed, i.e. the leaf that grows up and out of either the bottom or the second joint.

SELECTION

Your straw will probably be of varying shapes and sizes and you should grade them into bundles of fine, medium and thick straw.

MAKING THE CORN DOLLIES

Three types of corn dollies will be explained, and one finishing plait. These are:
THE FIVE STRAW PLAIT, THE CORN NECK, THE CORNUCOPIA, AND THE FOUR-STRAW PLAIT.
These are all basic types and are the basis of more complicated dollies. If, on mastering these techniques, you feel that you would like to progress to the more advanced aspects of the craft, we suggest that you get hold of the books listed at the end of this chapter.

The Five-straw plait *(the basis of most dollies)*
Take a bundle of graded straws and secure a rubber band round the thick ends. Pull up one straw and hold it so that you can hold the straws, five ends downwards into a bowl (fig 1) and pour boiling water over them. Roll the straws up in a damp cloth and always remember to keep those straws not being used immediately covered during working operations to keep them damp. This damping operation is necessary for all types of dollies being made as it renders them pliable for use.

METHOD

(a) Take five dampened straws and tie together tightly with a strong linen thread at the five ends using a clove-hitch knot for preference *(fig 2)*.
(b) With the short ends held between the left hand thumb and middle fingers, bend four of the straws down at right angles and bend the fifth straw right so that it is on top of straw 1 *(fig 3)*.
(c) Taking straw 1, move it under straw 5 and towards straw 4 *(fig 4)*.
(d) Bend straw 1 up and over straw 5 very closely so that it now lies beside straw 2 *(fig 5)*.
(e) Whilst holding these two straws together with the right hand, release the grip with your left and turn the whole thing clockwise so that you are back at the beginning again—*(as in fig 3 when straw 5 was lying over straw 1—the starting position)*.
(f) Repeat the operations using straw 2 this time, and then straw 3, etc., etc., using each straw in turn.

You will see that a definite shape begins to arise *(fig 6)*, which is a spiral consisting of a square section. The size of the square section will be seen to determine the size of the whole work and can be increased or decreased to the fancy of the craftsman and it is this variance that gives this particular dolly its character. To increase the diameter of the spiral (i.e. by increasing the square section) you simply place the moving straw at the right of the straw it kinks over *(figs 7 and 8)*. However, should you wish to keep the work of a uniform size, it is advisable to work around a round object such as a pencil.
ADDING STRAWS: If you are re-working a dolly of some size, or if one or more of your straws snaps or fractures, you just simply cut off that particular straw at the corner of the square section and insert the new straw into the old one, pushing it in as far as it will go—then simply carry on working.

The corn neck
This is basically the five-straw plait worked round a bundle of straws with the ears still intact (fig 9) or round a core and a head of ears inserted afterwards. You will need for this some Sellotape and florist wire 12 inches long as well as your straw.

METHOD

(a) Insert one piece of wire down a straw and around this, bind another six straws about ½-inch further along the wired straw, each in turn so that you form a taper, using the cellotape as a binder. Insert more straws down the centre of the taper until you have a nice firm taper as a mould *(fig 10)*. Finally wedge a fat pencil down the centre—this is to create a hole for the head to be inserted into later.
(b) Make another taper, only this time it should be about 6 inches long. This is known as the false 'tail' and is made simply to make the starting off of the plaiting easier.
(c) Now we begin the plaiting. Grade your straws into fine, medium and thick, and taking the finest first, use five straws and begin plaiting around the false tail. Do this for about 3 or 4 inches and then remove it and insert the real tail *(fig 11)*. As you work up to it (as close as you can) gradually work in the medium straws and then the thick nearest the top.
(d) When the top is reached, aim to have a good 6 inches of each straw left as there must be no joins at this stage. You can judge this when you are about 2 inches from the top. Remove the pencil, and poke down the hole, all that remains of your plaiting straw.
(e) To make the head *(fig 12)* take a bunch of the best ears you can find, tie them firmly together (boot to hind with Sellotape) and then insert in the hole left by the pencil.
(f) To finish off, you can tie ribbon just below the neck to hang up the dolly. Also the thin end can be bent round into a hook which is the traditional shape for this dolly.

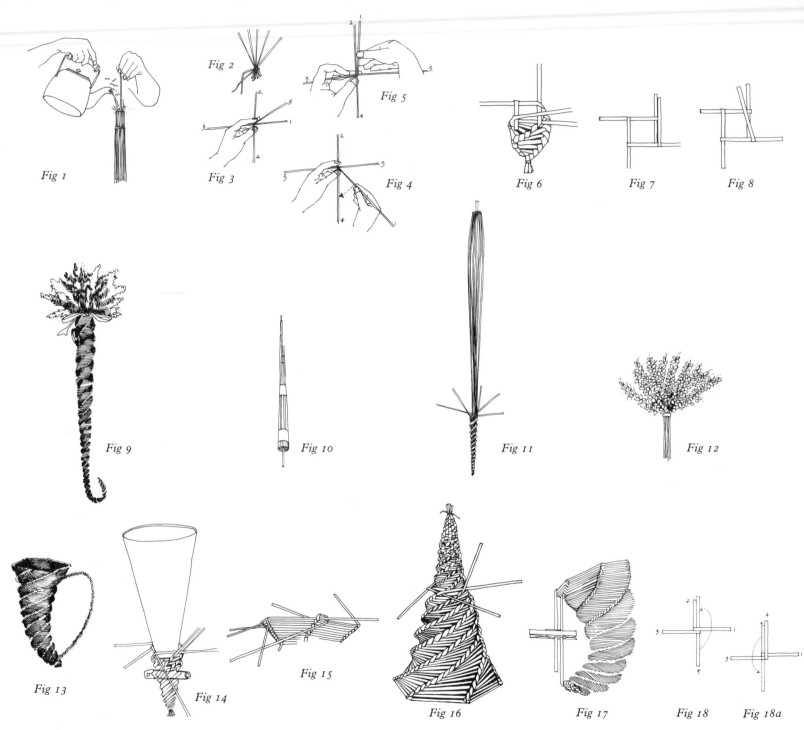

Fig 1

Fig 2

Fig 3

Fig 4

Fig 5

Fig 6

Fig 7

Fig 8

Fig 9

Fig 10

Fig 11

Fig 12

Fig 13

Fig 14

Fig 15

Fig 16

Fig 17

Fig 18

Fig 18a

The cornucopia

This again is plaiting round a cone but this time you use seven straws instead of five and you double plait; that is you work from the point of the cone to the open top and then double back again to the point. It is a more difficult dolly to make well, so take your time and don't worry if you can't do it properly at first *(fig 13)*.

METHOD

(a) Using thin cardboard, make a cone 6 inches deep with a hole 3 inches wide.

(b) Tie seven straws very tightly together and spread six of them out in an even circle with the seventh straw on top and to the right of the first straw.

(c) Using exactly the same principle as the five straw plait, work each straw in turn, the only difference being that you end up with a six-sided figure instead of four. When you have done a few turns, insert the cone and hold it in turn with a safety pin *(fig 14)*.

(d) When you reach the top, make sure you don't end up with any joins but have ample straw length to begin doubling back.

(e) Tend to work out at the top of the cone which will form the rim.

(f) To double back, simply take your working straw and bend it right round the adjacent straw instead of over it *(fig 15)* and back to the left to be beside this straw.

(g) Turn the whole thing upside down and plait back to the start, tying the ends very tightly on finishing and removing the cone *(fig 16)*.

(h) Insert six of the seven straws (now at the point and tied through the dolly) through the bottom of the cone and into the centre which forms a neat finish. If you have a lot of straw length left, shorten each one to about 3–4 inches.

(i) Dampen the dolly and bend it to a bow shape very slightly and then, using the seventh straw, insert it through the bottom of the cone and back up, fixing it with a peg *(fig 17)*. At the same time, pull the straw into a tighter bow shape. Allow to dry.

(j) After drying, cut off the seventh straw and make a length of four straw plaiting and tie at both ends to hang up your dolly. The method of the four straw plait is as follows.

The four straw plait

This is a finishing plait and can be used for hanging your dollies up as loops or ends.

METHOD

(a) You must have long straws for this and fine straws at that. Tie them up at the fine end and spread them out at right angles in an even circle.

(b) As in *fig 3*, bend straw 4 over straw 1 to lie beside straw 2.

(c) Bend straw 2 down over straw 3 to take the empty place left by straw 4 *(fig 18 and 18a)*.

(d) Turning the whole thing round one quarter of a circle clockwise, repeat the procedure.

(e) Carry on working until you reach the required length.

BIBLIOGRAPHY

CORN DOLLIES AND HOW TO MAKE THEM, by L. Sandford and P. Davis/Herefordshire Federation of Women's Institutes, Hereford FWI.

DECORATIVE STRAW WORK, by L. Sandford and P. Davis/B. T. Batsford, London.

A GOLDEN DOLLY: THE ART, HISTORY AND MYSTERY OF CORN DOLLIES, by M. L. Lambert/John Baker, London.

MAKING CORN DOLLIES, by Emmie White/ available from the author at High Willows, Vineyards Road, Northaw, Potters Bar, London EN6 4PE.

CORN-DOLLY CRAFT STUDIOS TO VISIT

MRS P. ELAM, 'Gleanings', Rectory Lane, Ashdon, Saffron Walden. Tel Ashdon 344
Maker of traditional and modern corn dollies.
Living on the premises. Visitors welcome at any reasonable hour.

ANGELA GIBSON, 9 Park Street (rear entrance), Stow-on-the-Wold GL54 1AQ. Tel. Stow 30259
Corn dollies. Modern and traditional, from small favours to large Corn Maidens. Member of the Craftsmen of Gloucestershire.
Please write or telephone for appointment.

WINIFRED NEWTON-SEALEY, NDD, Straw Plaiter, Perton Croft, Stoke Edith, Hereford
Traditional corn dollies and cut straw work.
Most times.

JAQUIE BAKER, 54 The Avenue, Yeovil. Tel. Yeovil 22751
Traditional and modern corn dollies—special designs to order.
Any time by appointment, just off dual carriageway, behind hospital.

JAN WILKINS, Mullions, South Street, Walton Street
Corn dollies and straw work. Variety of traditional and modern designs, including: Cornucopia, Corn Maiden, Welsh Fan, Yorkshire Spiral, Staffordshire Knot, Horseshoes, earrings and lavender dollies. Any particular design, large or small made to order. Member of the Somerset Guild of Craftsmen.
Resident. Visitors welcome.

TINA PEACOCK, The Willows, Earl Soham, Woodbridge IP13 7SA (3 miles from Bramlingham). Tel. Earl Soham 418
Traditional and modern corn dollies including Suffolk Horseshoe and Whip, Norfolk Lantern, Essex Terret, Cambridge Umbrella, Shepherd's Crook, Cornucopia, bells, rattles, fans, stars and angels.
Visitors welcome but telephone first please!

IN THE USA

SOURCES OF MATERIALS

For those of you who have difficulty finding the right sort of straw, you can practice the techniques on Sweetheart paper straws, which are long, thin drinking straws available in many grocery stores.

BIBLIOGRAPHY

THE CRAFT OF STRAW DECORATION, by Alec Coker/Dryad, Northgates, Leicester; available from Craftool Co., 1421 240 St., Harbor City, Calif. 90710.

STRAW WORK AND CORN DOLLIES, by Lettice Sandford/ Viking, New York.

21

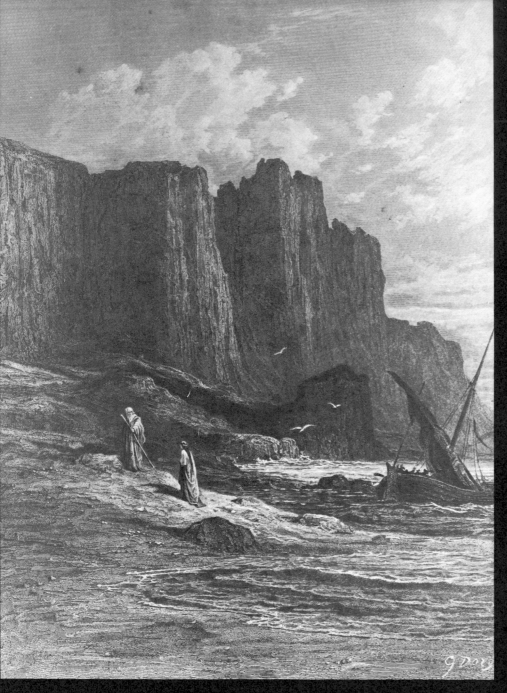

Collecting Shells & How To Use Them

Within the British Isles alone there are about 350 different types of shells to be found, the colour, pattern and shape of each varying immensely. Every venture into the countryside or to the seashore may yield new specimens or exciting variations within each variety.

The inland shell most likely to be found will belong to the snail family and there are about 40 different types of these. Although most of them will be found between April and December, it is not unusual to pick up specimens at most times of the year. Unless you enjoy killing creatures (which we hope sincerely you don't) your collection will rely on empty shells which are mostly to be found amongst rubbish heaps, tree roots and under leaves and logs etc.

With regard to salt-water shells, there will invariably be a dozen or more types to be found on any stretch of coastline. Rockpools are often a veritable treasure trove, as well as high-tide lines on the beach and underneath seaweed patches.

You may feel that the shells you have

collected arc beautiful as they are, kept perhaps in a nice box or jar, in which case read no further. But for those who may like to make something out of the shells, there are lots of ways to incorporate them, whether it be for jewellery, trinkets or purely decorative purposes. Most examples of shell craft tend to be found in trashy souvenir shops in Margate or Blackpool, but there are superb examples of shell craft in many of our museums such as the Victoria & Albert and the British Museum, as well as the odd folk museum around the country. The thing is to get around and have a look at as many examples as possible, for in this way, you will collect ideas for your own work.

USING THE SHELLS

Never use damaged shells but select only complete unbroken specimens. It is also advisable to sort them out into types and sizes, keeping them separately in bags or, preferably, boxes. When actually using the shells in a design, for example, a jewel box, it will be better to use groups of shells of the same type and size together, as they tend to look more effective this way. If all the shells are mixed up higgledy-piggledy and stuck on ad-hoc, the results are not so good. Another good point to remember is that the shells must be stuck closely together when using the embedding technique, i.e. embedding the shells in a layer of plaster or 'Polyfiller'. With this method, boxes, flowerpots, candle holders, vases, lamp-stands and mirror surrounds etc., can be decorated. The shells can also be stuck on with a glue, such as 'Bostik'.

Whatever the object to be decorated, it must be cleaned so that the 'Polyfiller' will take to the surface. Mix up a good quantity of 'Poly-filler' and cover the surfaces to be decorated with a layer about ½-inch thick. With boxes, or large objects it will be easy to do one side or one part at a time as the 'Polyfiller' may begin to go hard. The shells can now be embedded gently into the surface according to your own design. (It is a good idea to have the shells laid out ready in the design intended so that sticking them on correctly is made easier.) With very tiny shells, tweezers can be used to embed them in the surface.

When the filler is dry, a coat of clear varnish over the surface will greatly enhance the beauty of the finished object. Water-colour paint can be brushed on to add interest to the design if needs be, but this must be done before varnishing.

Other uses of shells include the making of jewellery such as necklaces, bracelets or individual shell brooches. With necklaces and bracelets, a tiny hole should be drilled in each shell so that a strong linen or wax thread can be passed through to string them together. For this purpose, there are a number of small drills available on the market. Great care must be taken when drilling as the shells will crack very easily. It will be found advantageous to hold them gently in a vice whilst drilling.

Clasps can be bought to finish off the necklace or bracelet, or they can be attached to a choker or strap.

SOURCES OF MATERIALS

Beaches:

A shingle beach will produce a good quantity of shells but only the sandy patches may have perfect specimens as shells easily become broken when lying amongst pebbles. Some suitable specimens to look out for are as follows:

THE AUGER SHELL (Turritella communis).

THE BLUE-RAYED LIMPET (Patina pellucida): a greenish-grey shell with vibrant blue spots, usually found amongst seaweed off-shore.

THE ELEPHANTS' TUSK SHELL (Dentalium entalis): a lovely long tusk-shaped shell, usually white and about 30 mm long.

THE EUROPEAN COWRIE (Trivia monacha): a lovely spotted shell up to 10 mm across in size.

THE FLAT TOP (Gibbula umbilicalis): a dark red shell, striped with grey.

THE ROUGH WINKLE (Littorina saxatilis): a common shell, usually brown, white or yellow and occasionally marked with darker bands.

THE SLIPPER LIMPET (Crepidula fornicata): a mottled pink and brown shell, white inside.

THE THIN TELLIN (Tellina tenuis): an orange, white and pink shell.

THE TROUGH SHELL (Mactra corallina).

THE WEDGE SHELL (Donax vittatus).

THE WENTLETRAP (Clathrus clathrus).

The following list gives stretches of seashore where a good variety of marine shells can be found:

ALLONBY BAY, Cumberland.
ABERDEEN BAY, East Lothian.
ABERLADY BAY, East Lothian.
BANGOR, Caenarvon.
BLACKWATER ESTUARY, Essex.
BLYTH, Northumberland.
BORTH, Cardigan.
CAMBER SANDS, Sussex.
CREAGORRY, Hebrides.
CROMER, Norfolk.
CRACKINGTON HAVEN, Cornwall.
DRIGG, Cumberland.
EASTBOURNE, Sussex.
GAIRLOCH, Ross and Cromarty.
HARLECH, Merioneth.
KISHORN, Ross and Cromarty.
MARLOES SANDS, Pembrokeshire.
NEWPORT, Pembrokeshire.
NEWQUAY, Cornwall.
PORT ST MARY, Isle of Man.
PORT ERIN, Isle of Man.
PETERHEAD, Aberdeenshire.
SALCOMBE, Devon.
SANDEND BAY, Banff.
SCILLY ISLES (St Martins Flats, St Mary's Rocks, Tresco Sands).
SCARBOROUGH, Yorkshire.
SENNEN COVE, Cornwall.
ST ANTHONY, Cornwall.
SHELL BAY, Dorset.
STUDLAND BAY, Dorset.
TONGUE, Sutherland.
TOR BAY, Devon.
WEYMOUTH, Devon.
WHITBY, Yorkshire.
WHITSTABLE, Kent.
ROBIN HOOD BAY, Yorkshire.
PORTHCURNO, Cornwall.
ALNMOUTH, Northumberland.

Inland Water Areas:

Apart from the seashore and estuaries, other sources of shells are rivers, lakes and canals. Areas of water such as reservoirs, gravel pits and the Norfolk Broads are perfect for searching out freshwater species. Look out for the following:

THE BLADDER SNAIL (Physa fontinalis).

THE COMMON BITHYNIA (Bithynia tentaculata).

THE DWARF POND SNAIL (Lymnaea truncatula).

THE EAR POND SNAIL (Lymnaea auricularia).

THE FRESHWATER NERITE (Theoduxus fluviatilis).

THE HORNY ORB SHELL (Sphaerium corneum).

THE LAKE LIMPET (Acroloxus lacustris).

LEACH'S BITHYNIA (Bithynia leachii).

THE MARSH SNAIL (Lymnaea palustris).

THE RIVER LIMPET (Ancylus fluviatilis).

THE WANDERING POND SNAIL (Lymnaea peregra).

Inland Habitats:

There are five main areas of habitat where land snails are best sought:

(a) HEDGEROWS Old tree stumps and beneath shrubs and leaves will always produce one or two species.

(b) WOODS Mixed woods will provide a greater variety of snails than other types of woods, such as those featuring only one species of tree, i.e. pine wood, birch wood.

(c) DOWNS Found living amongst the grass and low growing perennials.

(d) GARDENS A number of 'wild' snails can often be found in the garden, some of which live mainly underground while others live beneath low growing perennials such as the plants featured in rockeries.

(e) ROCKS AND WALLS.

Look out for the following species:

THE COMMON SNAIL (Helix aspersa).

THE DOOR SNAIL (Clausilium): cigar-shaped shells varying from fawn-grey to brown in colour.

THE GARDEN SNAIL (Helix hortensis): a pale yellow shell with darker coloured bands.

THE KENTISH SNAIL (Monacha cantiana): a whitish shell often tinged with red.

THE GLASS SNAIL (Retinella and Oxychilus): whitish almost transparent shells.

THE GROVE SNAIL (Helix nemoralis): varies between fawn, pink and yellow with darker bands.

THE ROCK SNAIL (Pyramidula rupestris): a deep brown to dark grey, tiny shell.

THE ROUNDED SNAIL (Discus rotundatus): a brown shell with red patches.

THE STRAWBERRY SNAIL (Hygromia striolata): a reddish brown shell sometimes varying to white.

THE TREE SNAIL (Balea perversa): a fawn grey shell.

SOCIETIES

CONCHOLOGICAL SOCIETY, c/o Hon. Sec., Mrs E. B. Rands, 51 Wychwood Avenue, Luton, Bedfordshire LU2 7HT.
CONCHOLOGY SOCIETY OF GREAT BRITAIN & IRELAND, 58 Teignmouth Road, London NW2.

BIBLIOGRAPHY

BRITISH BIVALVE SHELLS, by N. Tebble/British Museum, London.
BRITISH FRESHWATER BIVALVE MOLLUSCS, by A. E. Ellis/The Linnean Society, London.
BRITISH SHELLS, by Nora McMillan/Frederick Warne & Co., London.
COLLECTING SEA SHELLS, by F. D. Ommaney/Arco Publications, London.
COLLECTING SHELLS, by Stella Turk/W. & G. Foyle, London.
COMMON BRITISH SEA SHELLS, by W. S. Forsyth/A. & C. Black, London.
DISCOVERING SEA SHELLS, by Barry Charles/Shire Publications Ltd, 12B Temple Square, Aylesbury, Buckinghamshire; International Publications Service, New York.
HOW TO MAKE THINGS FROM THE BEACH, by John Portchmouth/Studio Vista, London.
KEY TO THE BRITISH FRESH AND BRACKISH WATER GASTROPODS, by T. T. Macan/The Freshwater Biological Association, Ferry House, Far Sawrey, Ambleside, Westmorland.
LIFE ON THE SEASHORE, by A. J. Southward/Heinemann, London; Harvard University, Cambridge, Mass.
MOLLUSCS, by H. Janus/Burke, London.
POCKET GUIDE TO THE SEASHORE, by J. Barret and C. M. Yonge/Collins, Sons, London and New York.
THE SEA SHORE, by C. M. Yonge/Collins, Sons, London; Atheneum, New York.
THE SHELL BOOK OF BEACHCOMBING, by Tony Soper/David & Charles, Newton Abbot, Devon; Taplinger, New York.
SHELL COLLECTING, AN ILLUSTRATED HISTORY, by S. Peter Dance/Faber & Faber, London.
SHELL LIFE, by Edward Step/Warne & Co., London.
SHELL-LIFE AND SHELL COLLECTING, by S. B. Murray/Sterling, New York.
YOUR BOOK OF SHELL COLLECTING, by L. W. Stratton/Faber & Faber, London; Transatlantic Arts, Levittown, New York.

Journal

JOURNAL OF CONCHOLOGY, Conchological Society, c/o 51 Wychwood Avenue, Luton, Bedfordshire Lu2 7HT.

SHELLCRAFT STUDIOS TO VISIT

'SHELLCRAFT by Kay Wilson', 'DRIFTWOOD SCULPTURE by Karen Wilson'. Mary's Cottage, Vicarage Lane, Frodsham, Cheshire. Tel. Frodsham 33375
Wide selection of animals made from British shells. Abalone shell jewellery. Tropical shells for collectors. Driftwood collection includes bracelets, pendants, cuff-links and rings, etc.
Open 11 am–5 pm except Thursday, advisable to phone first. Enquiries by letter (enclose S.A.E.).
SEA CREATURES (John Aitchison), 'West Winds', Burnmouth, Eyemouth, 200 yards off A1 at Burnmouth, road no. 1107, Berwickshire, Scotland. Tel. Ayton 283
Real shellfish preserved for ornaments and displays, lobster, hermit, spider, green crabs, etc., world-wide shells, mother-of-pearl, tropical shell and gemstone jewellery.

MUSEUMS TO VISIT

The following list gives museums which contain important and interesting collections of shells, as well as specimens of shellcraft and curios. You may have to enquire to view any specific collection which isn't on public display:
BATH, Victoria Art Gallery and Municipal Galleries, 18 Queen Square.
BIRMINGHAM: University Museum and City Museum.
BRIGHTON: Art Gallery and Museum, The Royal Pavilion, Church Street.
BRISTOL: City Museum, Queens Road.
BRITISH MUSEUM (Natural History): Cromwell Road, SW7.
CAMBRIDGE: University Museum of Zoology, Downing Street.
CARDIFF: National Museum of Wales.
DEVIZES: Devizes Museum, Long Street.
DUBLIN: National Museum of Ireland, Kildare Street.
EDINBURGH: Royal Scottish Museum.
EXETER: Exeter Museum.
GLASGOW: Department of Zoology, The University.
LEEDS: City Museum, Municipal Buildings.
LEWES: Lewes Museum.
LINCOLN: City Library, Free School Lane.
LIVERPOOL: City Museum, William Brown Street.
MANCHESTER: The Museum, The University.
NEWCASTLE-UPON-TYNE: Hancock Museum, Claremont Road.
NOTTINGHAM: University Museum.
OXFORD: University Museum.
PAISLEY: Paisley Museum and Art Gallery.
PLYMOUTH: City Museum and Art Gallery.
PORTSMOUTH: Natural History Department, Cumberland House, Eastern Parade, Southsea.
RYDE, ISLE OF WIGHT: Shell Museum, Binstead Hill.
SALFORD: Science Museum, Buile Hill Park, Pendleton.
SCARBOROUGH: Museum of Natural History, Wood End, The Crescent.
TENBY: The Museum, Castle Hill.
WARRINGTON, Warrington Museum.

IN THE USA

SOURCES OF MATERIALS

Apart from finding them yourself, shells may be bought from local dealers listed in the yellow pages or mail ordered from the following places.
FERGUSON'S MARINE SPECIALTIES, 617 N. Fries Ave., Wilmington, Calif. 90744. *Free catalog.*
BENJANE ARTS, 320 Hempstead Ave., W. Hempstead, L.I., N.Y. 11552. *Catalog $1.50.*
FLORIDA SUPPLY HOUSE, P.O. Box 847, Bradenton, Fla. 33506. *Free catalog.*

SOCIETIES

AMERICAN MALACOLOGICAL UNION, c/o Paul R. Jennewein, P.O. Box 394, Wrightsville Beach, N.C. 28480. *"Dedicated to the study and appreciation of mollusks and their shells." Membership is divided equally between amateurs and professionals. Dues of $4 a year entitle you to the* AMU BULLETIN, *with abstracts of papers delivered at the annual meeting and a list of other members and their special interests, and newsletters during the year. The AMU has also published* HOW TO COLLECT AND STUDY SHELLS *($2.50), which includes articles on shore, reef, land, and freshwater collecting, dredging, a list of local shell clubs, a bibliography, and a list of outstanding shell collections in the U.S.*

CONCHOLOGISTS OF AMERICA, 946 Ralph Ave., Brooklyn, N.Y. 11236. *Membership of $2 includes newsletter. A group of amateurs interested in collecting shells.*

WESTERN SOCIETY OF MALACOLOGISTS, c/o Dr. James H. McLean, Los Angeles County Museum, 900 Exposition Blvd., Los Angeles, Calif. 90007. *Membership $5 a year, includes bulletin with abstracts of papers delivered at the annual meeting, held on the West Coast. Amateurs and professionals.*

BIBLIOGRAPHY

The following books about shells are recommended by the American Malacological Union. Encyclopedias are another source of information or articles in NATIONAL GEOGRAPHIC *or* NATURAL HISTORY *magazines.*

AMERICAN SEASHELLS *(second .ed.),* by R. Tucker Abbott/ Van Nostrand Reinhold, New York. *The largest and most detailed coverage of marine mollusks of both sides of North America and the West Indies. Many plates, 24 in color.*

COLLECTING SEASHELLS, by Kathleen Y. Johnstone/Grosset & Dunlap, New York. *Introduction to shell collecting with personal anecdotes.*

A FIELD GUIDE TO SHELLS OF THE ATLANTIC AND GULF COASTS AND THE WEST INDIES, by Percy A. Morris/Houghton Mifflin, Boston, Mass. *76 plates, 8 in color, illustrating all but 2 of 1035 species and subspecies of shells. De-scriptions of range, habitat, and physical characteristics. Part of Peterson Field Guide Series. Paperback, for use in field.*

A FIELD GUIDE TO PACIFIC COAST SHELLS, by Percy A. Morris/Houghton Mifflin, Boston, Mass. *72 plates, 2 in color, illustrating all 945 species and subspecies discussed. Companion to preceding book.*

HOW TO KNOW THE EASTERN LAND SNAILS, by John B. Burch/William C. Brown, Dubuque, Iowa. *Pictured keys of 377 land species. Paperback.*

KINGDOM OF THE SEASHELL, by R. Tucker Abbott/Crown, New York. *A vividly illustrated, comprehensive survey of seashells, giving their biology and influence on art, medicine, religion, and commerce. Color plates of living snails, nudibranchs, and squid.*

SEA SHELLS OF THE WORLD, by R. Tucker Abbott/Western, New York. *Paperback guide, showing about 600 kinds of worldwide shells in color.*

SEA TREASURE, by Kathleen Y. Johnstone/ Houghton Mifflin, Boston, Mass. *Excellent illustrated introduction to the study, hobby, and collecting of shells.*

SEASHELLS OF NORTH AMERICA, by R. Tucker Abbott/Western, New York. *Common U.S. shells; how to collect and arrange a collection; biology of the Mollusca. 130 colored plates.*

A SHELLER'S DIRECTORY OF CLUBS, BOOKS, PERIODICALS, AND DEALERS, by Tom Rice/ P.O. Box 33, Port Gamble, Wash. 98364. *Mimeo, $1.*

SHELLS IN COLOR, by Kjell Sandved and R. Tucker Abbott/Viking, New York. *Photographic essay on shells and their growth.*

WONDERS OF THE WORLD OF SHELLS: SEA, LAND, AND FRESH-WATER, by Morris K. Jacobson and William K. Emerson/Dodd, Mead, New York. *Many illustrations. An excellent introduction for adolescent or adult.*

These are books with ideas for shell craft.

ART FROM SHELLS, by Stuart and Leni Goodman/Crown, New York.

SHELLCRAFT, by Anthony Parker/Branford, Newton Centre, Mass.

CREATIVE SHELLCRAFT, by Katherine N. Cut-ler/Lothrop, Lee & Shepard, New York.

MAKING SHELL FLOWERS, by Norma M. Conroy/Sterling, New York.

Journals

HAWAIIAN SHELL NEWS, P.O. Box 10391, Honolulu, Hawaii 96816. *Monthly, $8. 8-page magazine with pictures, stories, and news about marine shells, mainly about the tropical Pacific.*

THE NAUTILUS, c/o Mrs. H. B. Baker, 11 Chelten Rd., Havertown, Pa. 19083. *Quarterly, $7. Scientific research articles on land, freshwater, and marine mollusks. Not for beginners.*

OF SEA AND SHORE, P.O. Box 33, Port Gamble, Wash. 98364. *Quarterly, $5. Best popular magazine on shells. Excellent articles and illustrations for amateurs and serious students.*

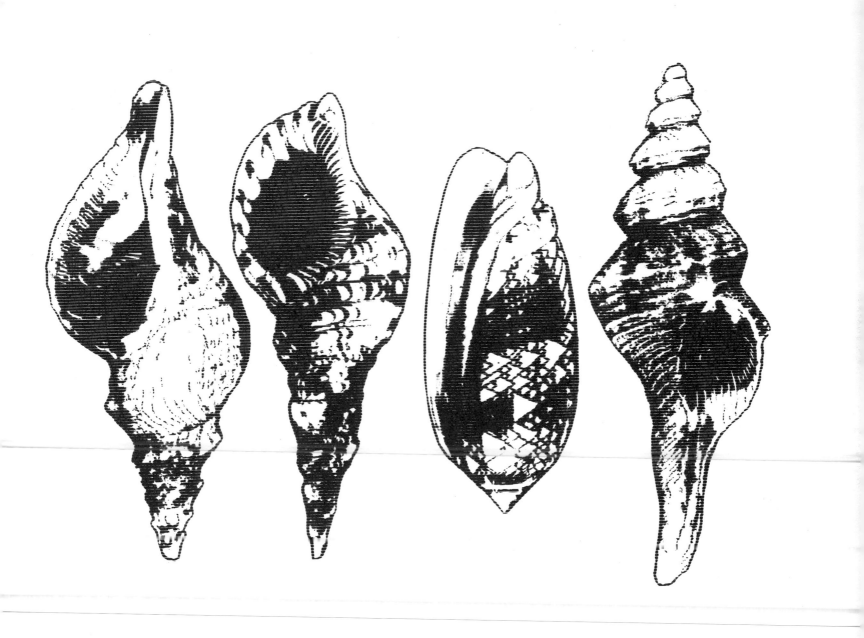

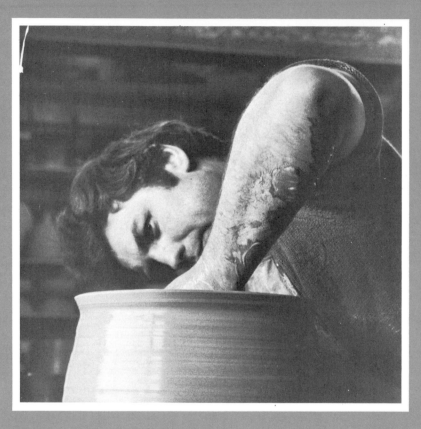

Starting a Pottery

It isn't difficult to set up a full-time pottery using local materials and improvised equipment.[1] After all, the pre-industrial potters did just that, and in many ways it's easier now than it was then. Appreciation of hand-made ware is high in this country, and centralized industry is now so inefficient that your prices may compare surprisingly well with the mass-produced (and lifeless) article. Some of the wasted material of industry can be put to good use in your workshop.

A large workshop is pleasant but not essential: it is not impossible to make a living in a shed 10 feet by 15 feet (I do). If you want to make large pots you need a larger workshop, but it must be frost-proof in winter. Medieval potters only made and fired pots in the summer months: the Winter was spent digging and weathering clay. In Winter, the wet pots would be frosted or else they would not dry out quickly enough. Also, kiln sites became waterlogged and fuel, which needed to be tinder-dry, would only be in that condition in the summer months.

CLAY The arguments for using a local clay are overwhelming: two to five hard days digging with a friend will yield a year's supply of clay. Every clay is unique, and a new pottery started on a new clay will produce a distinctive local ware, unique without gimmickery. Also, local diggers do not despoil the countryside, as do the big firms which sell clay; so there are spiritual reasons for digging it, too.

PROSPECTING Useable potting clay is to be found on the surface in almost every county in Britain, and is to be had for nothing. To find it, consult local people such as farmers, ditch-diggers, and builders, etc. Brickyards indicate the presence of clay and will often give, or sell large quantities very cheaply. Consult local libraries, archaeological societies (for kiln sites are always on clay) and geologists. There are also geological maps and surveys of your area. Explore fast-running streams, quarry floors, cuttings, post-holes and toppled tree roots for clay is as likely on hillsides as in valleys.

TESTING Clay is not always soft when dug. Any material which becomes sticky when wetted, and can be kneaded with a little water into a plastic mass, should be test fired. For this, charm a local art teacher or headmaster. Fire thin bars of the material, supported at each end, until they bend from the heat and record the temperature. This may be your eventual glazing temperature. Failing a school kiln, try a blowlamp, but gently at first.[2]

Explosions of the sample indicate too fast heating, not bad clay. Record temperatures with miniature cones.[3] When cool, the clay should be dense and hard; if it is porous and easily scratched, fire it higher. If it is hard but blistered, fire it to a lower temperature. As a last resort, send me a small sample with an exact map reference.

Always aim to fire your finished pottery as high as it will go, in order to develop its maximum strength. Surface clays mature at 1,000°C to 1,100°C, to make 'earthenware', but you may be lucky enough to find one which will go much higher: 1,200°C or more, to give you 'stoneware'. Such clays are usually found in or around coalfields (N.B. a coalfield does not necessarily contain any coalmines), and if you are near one it is worth a thorough search.

Clay is often thrown out on the spoil heaps of coal mines, however, or perhaps you can persuade the local mining authorities to get you some. Clays which seem very slimy and crack or warp badly when drying, may be improved by adding up to 20% of local lime-free sand. Clays which are 'short', i.e. crumbly and non-plastic, can often be made workable by additions of bentonite (up to 7%) or 'ball clay' (up to 30%) and long ageing or 'souring'.

DIGGING Wherever you get your clay, be sure you can get more later. Take off the turf, topsoil and subsoil and put them aside separately. Take the clay as soon as it looks clean, and reject any material which looks different from the rest. When finished, refill the hole immediately with local rubbish, replace the soils and turf in their correct order leaving a 'tump' to settle. Plant a tree as a marker and never leave open holes. A hole about 10 feet by 6 feet deep, excavated and refilled in 2 days by 2 men, will yield several tons of clay.

TREATMENT OF CLAY Ideally, clay-making has a yearly cycle: dig at Christmas, weather 3 months, paddle and seive, settle 3 months, sour

[1] *This chapter was written for us by a potter, Peter Brown, of The Snake Pottery, Green Street Cottage, Cam Green, Dursley, Gloucestershire GL11 5HW, and we are extremely grateful to him for all the work he has put in on our behalf.*

[2] See: *A Potter's Book*, by Bernard Leach/Faber & Faber, p. 245, for a description of a simple blowlamp test kiln.

[3] Ibid.

for 6 months. (The paddle used should have several 5 inch long lines of $\frac{1}{4}$ inch diameter mild steel projecting out of the bottom for maximum efficiency.) But to begin with you will have to shorten this process to get some useable clay quickly. Few clays are clean enough to use when dug, so you will probably have to puddle-and-sieve to remove grit and lime particles, as follows. First weather your clay (artificially if you are in a hurry by alternately drenching and drying it), turning it with a shovel after each frost. Next, soak in a tub of water (for small quantities in a hurry, hot water), stirring with a paddle to a creamy 'slip'. Pour from a height through a 40-mesh potters' sieve, then leave it to settle for as long as possible. This process may seem laborious at first but with practice it takes up only a few hours a month. For those clays that are clean, tread them with a little water on a firm floor until they are plastic.

The next job is drying the slip, and this is often a bottleneck. Syphon off the water and dump the slurry into large earthenware flower-pots, or boxes made from porous tiles, to dry in the wind. For larger quantities of stiffer slurry, the job is best done in a box built of unmortared common bricks, standing on legs in an exposed place. Any leaks can be stopped with clay from the inside. (Frost will help this device to work, whereas it cracks flowerpots.) In Winter the slip can be alternately frozen and thawed in metal containers and this method is very efficient.

Finish it off on large plaster slabs and store it in bins away from the frost. (For small quantities in a hurry, pour the slip on to newspaper, then plaster.)

POT-MAKING Knead your clay thoroughly

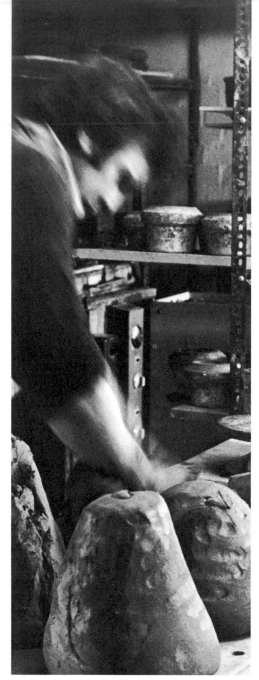

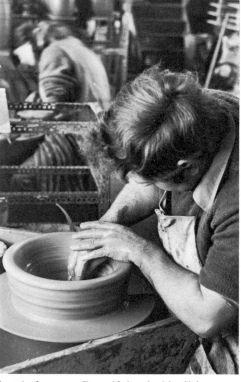

just before use. Beautiful, saleable dishes may be made by rolling out or slicing clay $\frac{1}{4}$ inch to $\frac{1}{2}$ inch thick on hessian or plaster, and laying it into 'depression' moulds or over hump moulds. Allow it to stiffen and then decorate with contrasting slips.

Many other pots can be made without a potters' wheel, but for sheer productive power the wheel beats even modern automation. If you lack the skill, enrol at an evening institute and behave like a fanatic. Refuse anything but

an electric (that's important) wheel; squash up everything you make; eat and sleep and think 'throwing' for about two months and you may then have enough skill to continue on your own.

MAKING A WHEEL This is easy. Although you will learn quickest on an electric wheel, the crudest kickwheel will start you off in your own workshop, but avoid the crack-and-treadle type (unless you are given one). Good designs for a crude wheel running on a single post are given in David Green's book (listed in the bibliography, p. 35.), and here is a description of a solid wheel I have used. Take any fairly straight, sound stick 2 inches or more thick and about 3 feet long, and sharpen the bottom to a rounded point. Fill a recessed wine-bottle with cement, up-end it firmly in the ground and fill the recess with grease. This forms the bottom bearing.

Next, fix a heavy flywheel about 2½ to 3 feet in diameter to the stick, about 6 inches from the pointed end. Any wheel with a centre hole larger than the stick may be secured true-running with wedges all around. Wedge it from above and below, and nail wedges to the stick. Best of all, a reinforced concrete fly-wheel can easily be cast onto the stick, by driving it into the ground plumb upright, and carefully excavating a 'mould' around it about 2½ feet in diameter, the floor of which should be dead level. Drive some large nails halfway into the stick in the area of the casting, check for uprightness, put some reinforcing (wire netting, fencing wire etc.) in place and pour in concrete to a depth of 5 or 6 inches. Leave this for at least a week, protected from frost if necessary. Then, raising it with great care, ease it into place over the bottle. Next, rough

carve or file a top bearing area on the stick as true as you can, just below the top. Now drive in four strong stakes around the wheel and fix rigid cross-pieces, with carved 'clamps' to accommodate the top bearing. Face these with hard leather, anoint them with grease and tighten until the assembly just turns freely.

Make a wheel-head from two pieces of 1-inch plank clinch-nailed together with the grain crossed, or from two discs of thick plywood. Attach this securely to top of the stick with brackets, taking care that it runs true.

Make your pots on removable asbestos tiles (bats) which attach to this wheelhead. This way you will have no trouble removing your pots after throwing.

This type of wheel is turned by kicking the top surface of the flywheel while sitting with your behind at wheelhead level.

More sophisticated bearings are better if you can get them—I'm told a car axle with wheel is very good. A 1-inch diameter steel shaft through a greased hardwood hole, with the bottom point resting on a dented (old) penny, will never wear out.

Electric wheels are expensive to buy. A simple but first-class electric wheel can be made easily from standard industrial parts at a cost of about £35 including the motor. I will send a copy of the plans (free) to anyone who sends me a stamped addressed envelope.

FIRING YOUR POTS The potter's worst problem is the large amount of energy needed for firing, and in the past they have been guilty of deforestation. The ideal solution is a water-wheel driving a dynamo, but until you are given a watermill you will have to make do with something less perfect. (At a rough estimate, an average waterwheel generating continuously for, say, 3 small kilns heated in rotation, could fire the output of 2 or more potters, with power left over for machinery. Workshops would be heated by the cooling kilns. In time, such local sources of energy may become a necessity for small workshops.) If your conscience allows you to make use of waste wood, then vast amounts of off-cuts may be had for nothing from local sawmills, where they are otherwise burnt as rubbish. Get as much coniferous wood as you can. You will

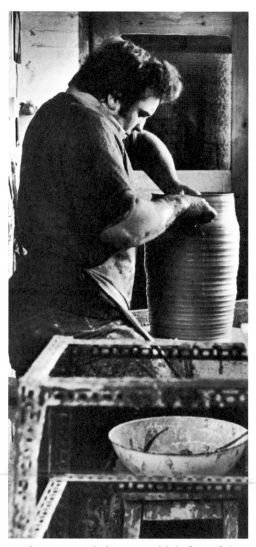

need more wood than you think for a firing, and you must dry it thoroughly before use. It is the traditional potters' fuel, it gives wonderful results and great satisfaction, but is very laborious. There are, however, good alternatives to wood which are as follows:

OIL involves very much less labour in use. It costs much less than electricity, and lends itself to improvisation more than gas.

GAS, both piped and bottled, is economical for potters.

31

ELECTRICITY is expensive, convenient, trouble-free and quite, quite soulless. (I use it, but many potters despise it.)

PEAT is a possible fuel if you can dig it, and if you can invent a burner which will cope with sawdust you'll fire cheaply.

KILNS You will have to decide which fuel you are using before building the kiln.

Although it is possible to fire pottery in holes in the ground or even in bonfires, to make a saleable ware it is necessary to make a fairly respectable kiln, lined with firebricks and built to a plan. The down-draught type is by far the best.

Vast quantities of used firebricks are thrown on industrial tips ($1\frac{1}{2}$ million tons a year in Britain) and large amounts can be had for nothing if you know where to go. Try foundries, demolished brickworks and scrapyards in industrial towns where they are just regarded as rubbish. Learn to recognise a firebrick and distinguish the various types: all firebricks are light in colour, yellow or pinkish, though some have dark spots all over them. They never have a 'frog' like building bricks do. The solid ones are very heavy, but you may be lucky enough to find 'insulating' firebricks, which are porous and light in weight and quite soft. These are particularly valuable to the potter, as a kiln lined with insulating bricks may cut down the use of fuel by half.

It is possible to make fairly good insulating firebricks if you have time. Take five parts (by volume) of sawdust, and mix it *very thoroughly* with four parts of 'N6 fireclay, ground 16's down', and one part of 'crude grog $\frac{1}{8}$ inch to dust'. (The last two items are available from all of the sources on pp. 34–5.) Mix in enough water to make a dryish dough, and press it into a frame measuring about $6 \times 6 \times 4$ inches deep. To help drying, make nine equally-spaced holes $\frac{1}{2}$ inch in diameter going about two-thirds of the way down, before pressing or shaking each brick out of the frame on to a board. Turn them frequently when drying. When thoroughly dry, stack the bricks in a loose 'chequer' and build a simple, temporary kiln around them with bricks, carefully sealed with a sand and mud mixture. Seal over the top but leave a hole for some sort of chimney. (This

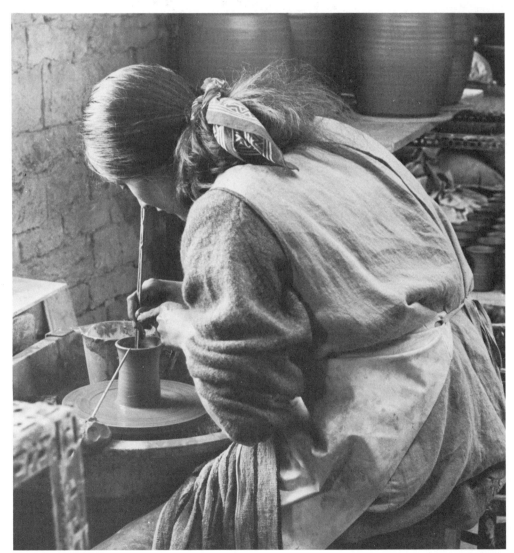

can be supported by angle-irons across the top, provided you arrange for them not to get too hot.) Leave two fireholes at the bottom (if you use solid fuel remember to dig a large fire pit for the embers) and fire the stack slowly and thoroughly, *getting it as hot as you can*. Nothing less than bright red heat (1,000°C) is any good. You may have to re-shuffle and re-fire when the stack has cooled, as up-draught kilns are notorious for uneven heating. (Oil is probably

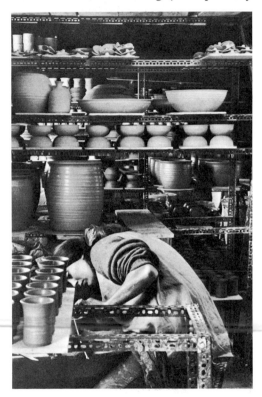

the best fuel for this job.)

For really first-class insulation, build your actual potting kiln as follows:

The outside skin should consist of 9 inches of common brick; then a 5-inch cavity, then your home made firebricks. A mortar of 4 parts sawdust, 2 parts grog, 3 parts N6 is used to set the bricks. The firebricks are laid *on edge*, with the perforated side facing the cavity. Fix 'bridge' bricks across the cavity at intervals to stabilise the structure, and fill the cavity as follows. Put some vermiculite into a tub and mix with it a small quantity of N6 fireclay, then a small quantity of water, until the vermiculite will just bind if compressed in the hand. Fill the cavity with this mixture, lightly pressing it down. At the top of the wall you must bridge the cavity solidly all round to support the roof arch or dome. Make the roof arch from cones of insulating firebrick about 4 inches long, 2 inches in diameter at one end and $2\frac{1}{4}$ inches at the other, or square if you wish. Cover the arch with 6 inches or more of the vermiculite mixture, then asbestos (no bricks) and protect it from the weather. The outside of this structure will remain stone cold throughout a firing and I bring my own kiln to 1,150°C with only 2 cwt of wood.

Temporary small kilns may be built from common house bricks bonded with fireclay and this is adequate for an uncertain number of earthenware firings.

Electric kilns are best bought ready-made unless you are an electrician.

Begin with a small kiln, of say 1–2 cubic feet, which will allow you to experiment frequently without loosing too much ware. A small kiln in the workshop will keep you warm, and dry pots as it cools.

GLAZES The appeal of your pottery depends more than anything else on the quality of your glazes. When beginning, or passing through a bad patch, it is excusable, but expensive, to buy ready-made glazes. As soon as possible, progress to mixing your own recipes from ready-ground bought minerals, i.e. flint, feldspar and whiting, and thence to using the highest possible proportion of local materials in the glazes. But this process is an uphill job, *and must not be hurried on at the expense of glaze quality*.

If you fire to stoneware temperatures you may soon be able to use 100% local materials (cost nil!), but earthenware potters will be lucky to use 70%, the addition being a soft borax 'frit' to flux the glaze. Below 1,120°C you may also have to add increasing proportions of lead frit, but keep the proportion of this as low as you possibly can. (N.B. *on no account* use lead ore, 'galena', from local lead mines.)

LOCAL MATERIALS Wood ash of any kind is particularly good for stoneware glazes, and needs little preparation. Whether you make earthenware or stoneware, try quarry stone of any kind except slate. If the quarry has a crusher, ask to take away a few hundred-weight of the very fine powder (it must be fine) which accumulates under the machine. Find out what sort of rock it is and look up its chemistry. Gromite and other igneous rocks are useful, but tend to contain iron, giving only dark glazes. Igneous rocks will replace flint and feldspar in conventional recipes. Sandstones will replace flint (quarty), and limestones will replace whiting. Some limestones contain magnesium ('dolomite') which is good for stoneware.

Any very fine natural deposit may be usable, including fine sand or silt, marl (crumbly material), river mud (Severn River mud is very good), some impure fusable clays, and a few crystaline minerals (in particular feldspar if you can find it) but *not* galena or barytes. Useful small pockets of volcanic ash, lava or pumice occur in many counties.

At the lower temperatures, say below 1,050°C, the proportion of local material which can be melted falls away sharply. The best plan then is to raise the maturing temperature of your local clay by adding fireclay, or not more than 20% of china clay.

NOTE: Always 'biscuit low, glaze high', as the old potters did. Fire your ware standing upright on the shelf, on sand. Fire as high as your clay will go, and counter any distortion by heavy ribbing and curving shapes. If you can use the 3-pointed stilts beloved of art-schools, then you are not firing high enough.

PIGMENTS Iron (brown, reds, yellows),

copper (blues, greens) and cobalt (blue) are the potter's main pigments. Stoneware potters get a whole range of colours from iron alone. Iron-rich rocks are fairly common. Copper oxide can be got by burning scrap copper wire in the kiln. Cobalt will have to be bought.

BALL MILL This is vital for the final grinding of glaze materials. It can be made fairly easily from two rubber-coated wringer rollers, mounted 6 inches apart and running freely in wood or brass bearing-holes. Attach a bicycle wheel to the end of one and drive it with a 'belt' of cord from a ¼ h.p. motor. The jar, which can be a glass wine jar, a small hooped wooden barrel or a polythene or stoneware jar, etc., is filled with water, any hard pebbles from the beach (but not slate stones), and the material to be ground. The jar turns on the rollers for 12 hours.

BLUNGER A rotary paddle driven *slowly* by a ¼ h.p. motor mounted on the lid of a large waterbutt can do your clay puddling for you.

ROCK CRUSHER This is immensely useful, but difficult to scrounge. Invent one (an eccentric and jaws housed inside a slotted oak log, powered by hand via heavy cast flywheel?).

MACHINERY The potter is able to salvage a great deal from the scrapheaps of the throwaway society. Cars, washing-machines and so on yield many useful parts. In particular collect bearings, belts, pulleys and quiet electric motors of all sizes.

DOUGH MIXER This large machine is often thrown out by bakeries. It will mix and knead large quantities of clay.

WASHING MACHINES Old ones make excellent blungers and slip mixers.

CORN MILL Old hand-powered corn mills, once used by farmers, must be rusting in many barns. They are good for powdering clays, marls, and rock already small in preparation for the ball mill.

SELLING YOUR POTS This is some-thing the books never mention! Price your pots to give yourself a living wage, plus expenses, plus a margin for trouble. You will need to work hard to offer reasonable prices. One golden rule is to keep your work out of conventional shops, although this may be difficult at first. A lively and individual ware of good quality will sell itself, and direct contact with the customer can be a very valuable asset.

For further information, see SELLING YOUR CRAFT, *by N. Nelson, and* SELLING WHAT YOU MAKE, *by Jane Wood, in the bibliography. Every month the magazine* CRAFT HORIZONS *(see p.222) has a "Where to Show" section, which lists shops and festivals.*

IN THE USA

Do not be discouraged from potting if you do not own a kiln. Many potters rent space in their kilns, and a studio may be in your vicinity. Look in the yellow pages under "Ceramics."

SOURCES OF MATERIALS

The following suppliers will mail order ball mills, wheels, batts, brushes, bricks, and other essential tools, several varieties of clay, and clay components. Most supply kilns and kiln paraphrenalia as well. (Free catalogs are listed; otherwise write for information.)

LESLIE CERAMIC SUPPLY CO., 1212 San Pablo Ave., Berkeley, Calif. 94706. *Free catalog.*

NASCO ARTS AND CRAFTS, P.O. Box 3837, Modesto, Calif. 95352. *Free catalog.*

VAN HOWE CERAMICS SUPPLY, 11975 E. 40 Ave., Denver, Colo. 80239.

COLE CERAMICS LABORATORIES, Gay St., Sharon, Conn. 06009. *Free catalog.*

DICK BLICK, P.O. Box 1267, Galesburg, Ill. 61401. *Free catalog.*

NEWTON POTTERS SUPPLY, INC., 96 Rumford Ave., P.O. Box 96, West Newton, Mass. 02165. *Free catalog.*

MINNESOTA CLAY CO., 2410 E. 38 St., Minneapolis, Minn. 55406.

BONA VENTURE, 17 Village Sq., Hazelwood, Mo. 63042.

VAN HOWE CERAMICS SUPPLY, 4860 Pan American Freeway, N.E., Albuquerque, N.M. 87107.

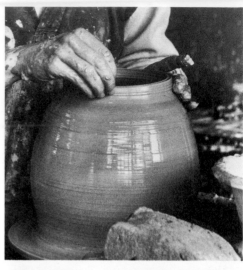

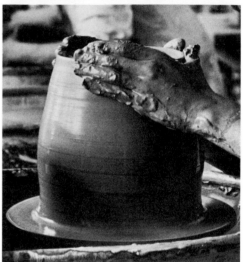

ART CONSULTANTS, 100 E. 7 St., New York, N.Y. 10009. *Free catalog.*

STEWART CLAY CO., 133 Mulberry St., New York, N.Y. 10013. *Free catalog.*

JACK D. WOLFE CO., 724 Meeker Ave., Brooklyn, N.Y. 11222.

TEPPING STUDIO SUPPLY CO., 3003 Salem Ave., Dayton, Ohio 45406.

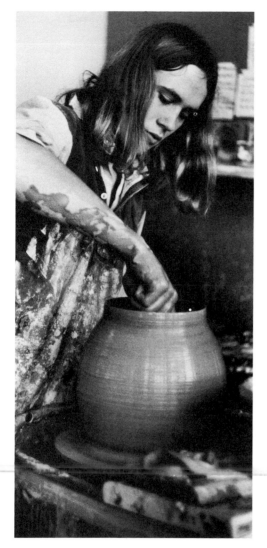

NASCO ARTS AND CRAFTS, Fort Atkinson, Wisc. 53538. *Free catalog.*

BIBLIOGRAPHY

BEGINNERS' BOOK OF POTTERY, by H. Powell/Emerson, New York.

CERAMIC SCIENCE FOR THE POTTER, by W. G. Lawrence/Chilton, Radnor, Pa. *Explains to those with no scientific background why some materials work and others do not.*

CERAMICS: A POTTER'S HANDBOOK, by G. C. Nelson/Holt, Rinehart and Winston, New York.

CLAY & GLAZES FOR THE POTTER, by Daniel Rhodes/Chilton, Radnor, Pa.

COMPLETE BOOK OF POTTERY MAKING, by John B. Kenny/Chilton, Radnor, Pa. *A basic handbook for beginners.*

THE ENGLISH COUNTRY POTTERY, by P.C.D. Brears/C. E. Tuttle, Rutland, Vt.

EXPERIMENTING WITH POTTERY, by David Green/Faber & Faber, London.

FURTHER STEPS IN POTTERY, by H. Powell/Branford, Newton Centre, Mass.

THE HOME POTTER, by Ian Lauder/Universe, New York. Includes information on how to *refine clay from one's own garden.*

AN ILLUSTRATED DICTIONARY OF PRACTICAL POTTERY, by R. Fournier/Van Nostrand Reinhold, New York.

KILNS: DESIGN CONSTRUCTION AND OPERATION, by Daniel Rhodes/Chilton, Radnor, Pa.

MAKING POTTERY, by Judith and Roy Christie/Penguin, Baltimore, Md.

MAKING POTTERY WITHOUT A WHEEL, by F. Ball & J. Lovoos/Van Nostrand Reinhold, New York.

PIONEER POTTERY, by Michael Cardew/St. Martin's, New York.

A POTTER'S BOOK, by Bernard Leach/Transatlantic Arts, Levittown, N.Y. *A classic by one of Britain's greatest living potters.*

THE POTTERY HANDBOOK OF CLAY, GLAZE & COLOR, by Harold Powell/Branford, Newton Centre, Mass.

POTTERY: THE TECHNIQUE OF THROWING, by John Colbeck/Watson - Guptill, New York.

PRACTICAL POTTERY AND CERAMICS, by Kenneth Drake/Viking, New York.

PRIMITIVE POTTERY, by Hal Riegger/Van Nostrand Reinhold, New York. *Guide to methods used by earliest potters.*

SELLING WHAT YOU MAKE, by Jane Wood/Penguin, Baltimore, Md.

SELLING YOUR CRAFT, by N. Nelson/Van Nostrand Reinhold, New York.

Journals

CERAMIC MONTHLY/BOX 4548, Columbus, Ohio 43212. *Subscription $8. Articles by craftsmen about ceramic techniques. For the more advanced potter.*

STUDIO POTTER/BOX 172, Warner, New Hampshire 03278. *Biannual, subscription $5. Highly recommended for both the student and practicing potter. Contains valuable technical information related to kilns, glazes, and new techniques, and carries profiles of practicing studio potters in each issue.*

TACTILE/published bi-monthly by the Canadian Guild of Potters, Inc., 100 Avenue Road, Toronto, Ontario M5R 2II3. *Subscription and membership $10. Provides general and technical information on Canadian ceramic activities and has articles on people, places, and events in the field.*

THE FORMING COMPANY, 2764 N.W. Thurman St.,Portland, Oreg. 97210. *Free catalog.*

HOUSE OF CERAMICS, 1011 N. Hollywood St. Memphis, Tenn. 38108.

EARTHWORKS, INC., 2309 W. Main St., Richmond, Va. 23220. *Free catalog.*

SPENCERS POTTERY, INC., 5021 S. 144 St., Seattle, Wash. 98168. *Free catalog.*

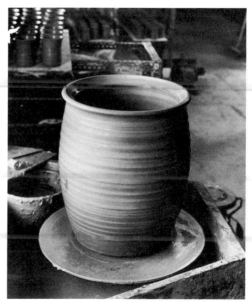

Berkshire

ALDERMASTON POTTERY, Aldermaston. Tel. Woolhampton 3359

Tin-glazed decorated earthenware and lustre-ware, tableware, ovenware, tiles and individual pots.

9 am–6 pm week-days except Tuesday.

PAULINE THOMPSON, Ginge Brook Pottery, East Hendred. Tel. East Hendred 484

Hand-made pottery to fill any need—domestic or decorative.

Open to visitors by appointment. Please write or phone.

TOUCHEN END POTTERY (Bill & Laddie Akroyd), Touchen End, nr Maidenhead (3½ miles from Maidenhead on A330 to Ascot). Tel. Maidenhead 27680

Hand-made earthenware with coloured glazes—dinner-sets, coffee-sets, ramekins, jugs, bowls, vases, lamps, etc.

Open daily 10.30 am–6 pm except Mondays.

ANN WRIGHTSON, THE POTTERY, 11a Washington Road, Caversham, Reading. Tel. Reading 479344

Stoneware, slipware and majolica tableware, ovenware and individual pieces.

10 am–6 pm Monday to Friday.

MICHAEL & SHEILA CASSON, Pottery Workshop, High Street, Prestwood, Great Missenden. Tel. Great Missenden 2134

Stoneware, some porcelain, individual pieces, table and ovenware.

Shop open for sales: Saturday only (except by appointment). Every day during the month of December.

CLAYCUTTERS STUDIO (BILL & VICKI READ), Sheep Street, Winslow. Tel. Winslow 2663 (main A413 road)

Hand-made reduction fired stoneware. Domestic and individual pieces.

Showroom. Resident.

DANNY KILLICK, School House, Mentmore, nr Leighton Buzzard. Tel. Cheddington 668436

Hand-made pottery, stoneware, domestic ware and individual pieces.

Visitors welcome any time. Advisable to telephone first.

Cambridgeshire

ABINGTON POTTERY, 26 High Street, Little Abington (on road A604). Tel. Cambridge 891-723

Stoneware pottery by David Lane. Also a large selection of work by other East Anglian potters. Resident showroom open every day except Thursday. Abington pottery is available from their stall at Cambridge Market on Wednesdays and Thursdays.

'THE CRAFTSMAN', 15 Magdalene Street, Cambridge CB3 0AF. Tel. Cambridge 62515

Stoneware pottery made on premises adjacent to Craft Shop, on sale, together with varied and interesting crafts.

Visitors welcome. Open 6 days a week, 9 am–5.30 pm.

Cheshire

M.B. POTTERY (Margaret Beaumont), 11a Heathfield Park, Grappenhall, nr Warrington. Tel. Warrington 65678

Hand-painted and decorated china and porcelain, including wall-plates, tea- and coffee-sets, fruit- and salad-bowls, children's named mugs, ceramic tiles, etc. Items styled to individual customers' requirements.

Open 10 am–5.30 pm except Monday. Please telephone first if possible.

Cornwall

AVALON POTTERY (S. J. & V. R. Boundy), Tintagel (showrooms at Bossinney Road, Tintagel). Tel. Tintagel 415

Genuine hand-made pottery, including coffee-sets, condiment-sets, vases, jugs, egg-cups, etc. A wide variety of shapes and colours. Special orders taken.

Open all day, every day.

CLIVE BLACKMORE, The Cottage, Old Hill, St John's, Helston.

Hand-made earthenware, stoneware and majolica. Range includes; mugs, wine-sets, vases, coffee-sets, jugs, etc.

Workshop is situated close to Old Mills Pottery where work is on show but some individual pots are available from the workshop itself.

BOSCEAN POTTERY (Scott Marshall), St Just, Penzance.

Hand-thrown stoneware pottery. Domestic ware and individual pieces.

Workshop open all the year round.

JOHN BUCHANAN, Anchor Pottery, The Sloop Craft Market, St Ives. Tells. St Ives 6051, Hayle 2106.

Hand-thrown stoneware pottery including coffee-sets, mugs, jugs, teapots, wine-sets, etc. Also individual and art pieces of every description.

The craft is demonstrated on the premises throughout the season.

DENNIS BULLOCK, Pottery Workshop, 4 Tamar Street, Saltash PL12 4EJ. Tel. Saltash 3864

Stoneware pottery. Domestic range, catalogue available. Limited number of personal commissions accepted.

Open daily 9 am–5 pm, Saturday until 1 pm. Closed Sunday.

JUNE CALVERT, Studio Potter, Trewellard Hill Farm, Pendeen, nr Penzance. Tel. St Just 708

Hand-thrown earthenware range of mugs, jugs, plates, bowls, coffee- and tea-sets, etc. All made on the premises.

Showroom open daily.

CAMELOT POTTERY & CRAFT CENTRE, Roger Irving Little, The Old Bakery, Boscastle. Tel. Boscastle 291

Hand-thrown traditional Cornish pottery, individual slipware, and the only makers of unique Mochaware. Craft section displaying for sale a wide selection of good hand-made craft items from Cornwall and the world.

Open all day, every day.

CELTIC POTTERY, The Old Schoolhouse, Wesley Place, Newlyn, Penzance. Showroom: 6 The Strand, Newlyn. Tel. Penzance 4375

Hand-thrown and cast individually decorated earthenware and stoneware by Maggie Fisher and Ev Stevens. Coffee-sets, mugs, dishes, etc.

Showrooms open daily—6 The Strand, Newlyn. Sloop Craft Market, St Ives.

CLOCKHOUSE POTTERY (Virginia Bamford), Fore Street, Tregony. Tel Tregony 666

Decorative and domestic earthenware hand-thrown on the premises.

Open daily Monday–Saturday 10 am–6 pm. Other times by appointment.

JOHN DAVIDSON, New Mills Pottery, Ladock Truro, situated eight miles east of Truro on A39 between Ladock and Fraddon. Tel Grampound Road 209 (0726-88209)

Hand-made stoneware for kitchen and table.

9 am–9 pm summer, otherwise 9 am–6 pm.

PETER E. DYKES, 'The Brooklets Cottage Pot-

tery', Bossiney Road, Tintagel, Cornwall. Tel. 247
Specialising in hand-thrown stoneware pottery.
THE FOSTER'S POTTERY COMPANY, Tolgus Hill, Redruth. Tel Redruth 5754
Earthenware pottery, coffee-sets, novelty gift-ware, also selection of hand-made domestic and decorative pottery.
Showroom open daily 9 am–5 pm. Conducted tours 9 am–3.45 pm. Closed Bank Holidays.
PAULA HUMPHRIS POTTERY WORKSHOP, Mill Hill, Polperro. Tel Polperro 439
Coiled stoneware pots, earthenware animal figures, decorative fish tiles.
Call at workshop door or Rose Cottage or telephone for appointment.
LAMB SWANN POTTERY, Adit House, Tresowas Hill, Ashton, nr Helston. Tel Germoe 2393
A wide variety of hand-made vessels in earthenware, stoneware and porcelain.
Visitors welcome.
LAMORNA POTTERY (Peter & Shirley Brown), Lamorna, nr Penzance. Tel. St Buryan 330. Situated on B3315 out of Penzance
Large selection of tableware, lamp-bases, vases and individual pieces in earthenware and terracotta. Glazes reflect the colours of this beautiful valley.
Open daily 9 am–9 pm. Ample car-parking.
LEACH POTTERY, St Ives. Tel. St Ives 6398
Domestic ware, oven-proof stoneware and porcelain. Also individual pots by Bernard Leach, Janet Leach and others.
Showroom open daily 9 am–5 pm, Saturday 9.30 am–12 noon. Also on sale in London at Liberty's, Marjorie Parr Gallery, Chelsea and Leach Pottery Showroom, Turret Book Shop at Kensington Church Walk, W8, David Mellor, 4 Sloane Square, London SW1.
E. T. LEAPER, Chapel Euny Farm, Brane, Sancreed, Penzance. Adjacent to Carn Euny Ancient Monument. Tel St Buryan 346
Coffee-sets, mugs, dishes, decorative glazes a speciality.
Normal business hours. Visitors welcome.
THE MARAZION POTTERY, Marazion. Tel Marazion 565
Hand-made domestic and decorative pottery.
Showroom open 9 am–9 pm June to September, 9 am–5 pm October to May.
MOSS POTTERY (Bernard & Maureen Moss),

Castle Gate, Ludgvan, Penzance. Tel. Penzance 2936
Hand-decorated earthenware. Designed, made and decorated on the premises.
PAUL MURRAY, Pottery Workshop, Praze-an-Beeble, Camborne. Tel. Praze 325
Hand-thrown domestic and table earthenware.
Open all day, every day.
NEWLYN HARBOUR POTTERY, Newlyn, Penzance (opposite Fish Market). Tel. Mousehole 508
Domestic pottery and individual pieces, ceramic tiles and jewellery by Dennis Lane.
THE ORIGINAL CORNISH POTTERY, Chapel Hill, Truro. Tel. Truro 2928
This hand-craft pottery on the site of which is a seventeenth-century kiln base, is one of the last five in Great Britain who were in production before the days of mass-production.
Visitors welcomed, 9 am–5 pm. Processes may be seen 10 am–12 noon and 2 pm–4 pm Monday to Friday.
PENDERLEATH POTTERY (Anthony & Christiane Richards), Cripples Ease (opposite Engine Inn), Nancledra, Penzance. Tel. Cockwells 462
Hand-made pottery coffee-sets, tankards, teapots. These are all made on the premises.
Open all day, every day.
PENTEWAN POTTERY, Pentewan.
Pottery can be seen in course of production on the premises. Also a fine selection of crafts including tapestry bedspreads and clothing.
9 am–5.30 pm (10 pm in Summer).
POLPERRO POTTERY, Crumplehorn, Polperro. Tel. Polperro 567
Hand-made stoneware, domestic and individual pieces.
Open all day.
MARY A. RICH, Penwerris Pottery, Cowlands Creek, Olk Kea, nr Truro. Tel. Truro 6926
A wide range of thrown stoneware and porcelain pots. Domestic ware and individual pieces. The workshop is situated at the head of Cowlands Creak, two miles from King Harry Ferry.
Please telephone for appointment.
SANCREED STUDIOS, Sancreed House, Sancreed, Penzance. Tel. St Bunyan 419
Hand-made domestic pottery and individual pieces by Michael Truscott. Pine and allied crafts.
Showrooms open 10 am–5 pm daily.
STUDIO CERAMICS, 'The Barbican', Battery

Road, Penzance Harbour. Tel. Penzance 5610
Art and domestic tiles, some slab pottery, including lamps. Individual tiles or in sets for walls, fireplaces or other decorative features.
Open most of the year (closed October). Out of season suggest telephoning first.
TOLCARNE POTTERY, The Coombe, Newlyn. Tel. Penzance 2884
Domestic and architectural ceramics in stoneware and porcelain.
Commissions for ceramic panels and murals accepted. Visitors by appointment.
TREGURNOW POTTERY, Newtown, St Buryan. Tel. St Buryan 469
Hand-thrown tableware (including coffee-sets and tea-sets). Traditional frog-mugs, animal figures and chess-sets by George and Margaret Smith.
Visitors by appointment only.
TREMAEN POTTERY LTD, Newlyn Slip, Penzance. Tel. Penzance 4364
Pottery designed and hand-built by Cornishmen in Cornwall. The style of this pottery is taken from the weathered natural stone which surrounds the Cornish Coast.
Showroom open all year round 9 am–5.30 pm.
TREMAR POTTERIES LTD, Trecarne, nr Liskeard. Tel. Liskeard 42771
Oven to table stoneware, complete range of tableware, slip casting and jolleying production techniques.
Workshops and showroom open daily to visitors 10 am–10 pm.
TROIKA POTTERY, Fradgan Place, Newlyn, Penzance. Tel. Penzance 5425
Hand-decorated semi-porcelain pottery.
JOHN VASEY POTTERY, Griggs Forge, Hayle.
Varied range of high-fired domestic stoneware, coffee-sets, casseroles, cider-jars, wine-sets and many individual pieces. Colourings 'Oxides' dug from local tin-mines.
Summer 9 am–dusk, Winter 9.30 am–5.30 pm.
WEST CORNWALL POTTERY, Pendeen, on B3306 between St Ives and Land's End. Tel. St Just 461
Oil-fired, hand-thrown stoneware. Mainly tableware and useful pots.
Summer 6 days, 9 am–7 pm. Winter 6 days, 9.30 am–5.30 pm.
DAVID WESTON, David Weston Pottery, West Wharf, Mevagissey. Also David Weston Gal-

lery, Pentewan.
Hand-thrown stoneware, sculpture and lamp-bases of thrown and slab construction. Ceramic figures.
Easter to October.
WEST CORNWALL POTTERY, 'Trepedn', Treen, Logan Rock, nr Porthcurno, on B3315 between Land's End and Penzance.
Oil-fired hand-thrown stoneware. Tableware, large vases, pitchers, etc.
Summer 11 am–9.30 pm every day. Winter—knock on the door.

Cumberland
ALLISON POTTERY AND STUDIO, 32–34 Main Street, Brampton. Tel Brampton 2685
Range of thrown and hand-built stoneware.
9 am–6 pm.

Derbyshire
ATLOW MILL POTTERY, Colin & Jenny Carr, Atlow, nr Ashbourne. Tel. Hulland Ward 279
Thrown and cast stoneware. Range of tableware, kitchenware and ovenware.
Almost always open. Please telephone.
L. & M. MOUNT, 10 Commercial Road, Grindleford, Sheffield S30 1HA. Tel. Grindleford 30455
Stoneware pottery. No cast-ware. Individual pieces. Hand-thrown and slab-built work.

Devonshire
BRANSCOMBE POTTERY, Branscombe, Seaton. Tel. Branscombe 248. Partners: Eric Golding, Michael Vaughan-Jones.
Hand-thrown reduction-fired stoneware. There is a standard range of table- and ovenware in a variety of glazes as well as individual bowls and vases, some of which are hand-decorated. Orders can be accepted for special items.
Visitors are welcome at any reasonable time.
BERNARD FORRESTER, Bramblemoor Studio Pottery, Broadhempston, nr Totnes, South Devon. Tel. Ipplepen 214
Individual stoneware, porcelain, earthenware pots decorated with iron, copper, manganese, cobalt and gold and silver lustre. Member of Devon Guild of Craftsmen, Fellow of the Society of Designer Craftsmen.
Visitors always welcome.
ALAN GRANT, Budleigh Pottery, Shandford

Cottage, Station Road, Budleigh Salterton.
A wide range of hand-thrown stoneware pottery. Oven-proof domestic ware, large cider-jars, tiles, stoneware jewellery and individual pieces.
Visitors welcome.
MICHAEL HATFIELD, Seckington Pottery Models, Winkleigh. Tel. Winkleigh 478
Ceramic sculptures of figures, portrait heads and animal studies. Detailed models of breeds of animals in clay or life-size in cement fondu for outside display.
Visitors welcome, advisable to telephone.
LIONEL HEATH, Old Forge Pottery, Shaldon, nr Teignmouth. Tel. Shaldon 2415
Hand-thrown stoneware pottery. Domestic ware and individual pots, coffee-sets, etc.
Showroom and workshop open daily all year round.
DAVID LEACH, Lowerdown Pottery, Bovey Tracey. Tel. Bovey Tracey 3408
A wide range of stoneware and porcelain as well as individual pieces, together with other crafts of a high standard.
9 am–6 pm Monday to Friday, 9 am–1 pm Saturday.
MICHAEL LEACH, Yelland Pottery, Fremington, Barnstaple. Tel. Instow 300
Decorative hand-made stoneware in catalogued shapes as well as individual pieces.
9 am–5 pm, Saturday 9 am–1 pm.
OLIVER MOSS, Riverside Studio, Axmouth, Seaton. Tel. Seaton 2625
Cast, jollied and thrown pottery. Decorated in coloured glazes. Good selection of other West Country pottery and handcraft.
9 am–10 pm Summer.
NEWPORT POTTERY (Denis & Wendy Fowler), 72 Newport Road, Barnstable (A361). Tel. Barnstaple 72103
Decorative and functional hand-made pottery.
Open 10 am–8 pm Monday–Saturday and by appointment.
THE OLD POUND POTTERY (Aubrey Coote), Membury, Axminster. Tel. Stockland 431
Pottery made here and by Wessex craftsmen on display. Full range of earthenware and stoneware.
Open Tuesday to Saturday 11 am–5.30 pm during season, other times please phone.
NICOLA RAFFAN, Lockhouse, Dunsford, Exeter. Tel. Christow 237

Wide range of domestic stoneware pottery.
Usually there, week-ends advisable to phone.
M. C. SKIPWITH, Lotus Pottery, Stoke Gabriel, Totnes. Tel. Totnes 303
Hand-made earthenware, stoneware and porcelain, domestic and individual pieces and occasional furniture and toys.
9 am–1 pm, 2 pm–6.30 pm.
WELCOMBE POTTERY, The Old Smithy Inn, Welcombe, nr Bideford, North Devon. Tel. Morwenstow 305. Clive C. Pearson.
A one-man pottery producing a wide range of domestic ware which includes oven- to tableware, coffee-, wine-, water- and tea-sets. Also many individual pieces, lamp-bases, etc, in stoneware and earthenware.
Open Winter Monday–Saturday. Summer 7 days 9 am–9 pm.

Dorset
ANSTY POTTERY, Little Ansty, Dorchester. Tel. Milton Abbas 568
K. and I. Gregory produce hand-made wood-fired ceramic urns, conservatory jardinières, large and small flower planters, tableware and ceramic sculpture. Specialised pieces done on commission.
Visitors phone for appointment.
CHARMOUTH POTTERY (Michael Hendrick), Charmouth, Dorset. Tel 594
Hand-made stoneware, high-fired earthenware, producing domestic items, mugs, jugs, bowls, coffee- and tea-sets, casseroles, large and small individual pieces.
Pottery and Showroom open Monday–Saturday 9 am–6 pm.
DAVID EELES, The Shepherd's Well Pottery, Mosterton, Beaminster. Tel. Broadwindsor 257 (Showroom on premises), Crewkerne–Bridport Road, A3066.
Pottery, stoneware, slipware and porcelain, oven-ware, tableware, lamps, cider and wine jars, platters, small and large individual pieces.
10 am–8 pm all days.
THE GARDEN STUDIO, Church Knowle, nr Corfe Castle, Wareham. Tel Corfe Castle 633. Simon & Tanya Dobbs.
Artist pottery, contemporary paintings and sketches.
Open at all times.
LESLIE GIBBONS, ATD, 'The Owl Pottery', 108

High Street, Swanage, Dorset.

Highly decorated hand-made earthenware (thrown and moulded), ceramic jewellery, hand-decorated tiles. Individual dishes with bold graphic designs and pictorial motifs in slip and majolica.

Resident. Open all year round, except Sunday and Thursday afternoons.

JO & GERRY HARVEY, Shroton Creative Workshops, Sheriffs Mead, Shroton, Blandford.

Hand-thrown stoneware, wide variety of domestic ware and individual pieces, commissions undertaken. Craftwork including dolls, leather goods, embroidered smocks.

Studio open Saturday and Sunday morning or by appointment.

Weekly pottery Summer courses, S.A.E. brochure.

ADRIAN LEWIS-EVANS, Stoney Down Pottery, Rushall Lane, Lytchett Matravers (100 yards east of the A350 Blandford–Poole road at Stoney Down Cross). Tel. Lytchett Minster 2392

Stoneware and porcelain. Ash glazed vases, pitchers, tankards. Dorset 'Owl' cider flagons, etc.

Nearly always open.

ROBIN & LESLIE LORD, Manor Close Pottery, St James's, Shaftesbury. Tel. Shaftesbury 2764

Stoneware and porcelain. Domestic and individual pieces. Garden pots, including Dorset Cress Hogs, Parsley Pots and Patio Planters. Electric ceramic table and night-lights.

Resident on premises so nearly always open. Visitors welcome.

TERESA MASTERS (Addison), Toller Pots, Manor Farm, Toller Porcorum, Dorchester. Tel. Maiden Newton 476

Individual thrown and hand-built pottery stoneware and earthenware. Many hand-painted or hand-decorated. Also paintings and drawings.

At home most days, but please phone if possible.

TICKNER POTTERY (Yetminster) Ltd, nr Sherborne. Tel. Yetminster 303

Earthenware, pottery, thrown and decorated by hand in a 300-year-old thatched cottage. Animal, bird and country sports themes, designed by John Tickner, a speciality.

10 am–6 pm Monday to Saturday.

Essex

MASHAY HALL POTTERY, Little Yeldham, nr Halstead. Tel Great Yeldham 284

Hand-made pottery, slip decorated earthenware, stoneware. Speciality : traditional salt-jars.

9 am–5 pm Monday to Friday. Week-ends by appointment.

THE NEWPORT POTTERY (Stephanie Kalan), London Road, Newport, nr Saffron Walden. Tel. Newport 358

Hand-made pottery : red ware, stoneware, porcelain, sculpture.

9.30 am–5.30 pm including Saturday and Sunday.

Gloucestershire

CAMPDEN POTTERY & CRAFT SHOP, Leasbourne, Chipping Campden

Hand-thrown pottery made on the premises. Other crafts available including weaving, wood- and stone-carving, corn-dollies, baskets and costume jewellery. Wooden toys a speciality.

Open 9.30 am–6 pm.

EVENLODE POTTERY (D. & D. Kunzemann), Evenlode, nr Moreton-in-Marsh

Domestic pottery in slipware, hand-thrown on premises. Potter resides on premises—open at any reasonable time.

THE FOREST OF DEAN POTTERY (Peter Saysell), Bream, nr Lydney, Mon–Glos border, 5 miles from Wye Valley. Tel. Whitecroft 414

All types of thrown and built pottery, stoneware and earthenware, specialising in architectural relief murals (external and internal). Oil-paintings, drawings, sculpture also produced on premises and displayed in gallery.

Living on premises, visitors welcome to gallery and studio.

JUDY LAWS, Sheep Street Studio, Sheep Street, Stow-on-the-Wold. Tel 0451 30220

Porcelain and terracotta jewellery—ceramics, wall panels designed and hand-made by Judy Laws. Permanent exhibition of wild-life paintings by A. Oxenham. Contemporary paintings by Michael Oxenham. Hand-weaving and pottery by artist craftsmen.

JENNY POOLE, Delves Cottage, Wigpool Common, nr Mitcheldean. Tel Drybrook 788

Small pottery in the Forest of Dean producing domestic slip decorated earthenware mugs, bowls, jugs and general ovenware. Brush decorated

stoneware goblets, bowls and individual items. Hand-painted majolica tiles.

Visitors welcome any time, but it is advisable to telephone first.

MARJORIE SMITH, 66 Prestbury Road, Cheltenham, Glos GL52 2DA. Tel. Cheltenham 52782

Original hand-modelled small sculptures in terracotta, etc, of children and other figures. Unique pottery character Owls—various designs and sizes. Tiles and tile panels—original designs —brilliant colours—also unusual 3D tiles. Member of the Craftsmen of Gloucestershire.

Visitors by appointment.

THE SNAKE POTTERY (Peter C. Brown), Green Street Cottage, Cam Green, Dursley. Tel. Dursley 3260

Range of unusual English traditional earthenware, hand-thrown from local clay : frog-mugs, puzzle-jugs, figure-mugs and jugs; slipware platters, decorated beer-mugs, etc. Inscribed and commemorative ware a speciality. Figure chess-sets made. Member of the Craftsmen of Gloucestershire.

Advisable to phone.

WINCHCOMBE POTTERY LTD, Winchcombe. Tel. Winchcombe 602462

Wide range of hand-made and domestic and individual stoneware.

Workshop and showroom open to visitors. Monday to Friday 9 am–5 pm, Saturday 9 am–1 pm. Closed Sunday. Situated on A46 1 mile from Winchcombe towards Broadway.

Hampshire

GRINDON POTTERY (Julian Grindon-Welch), White Cottage, Penwood, Burghclere, Newbury, Berkshire RG15 9ER. Tel. Highclere 253277

A small studio producing hand-made domestic stoneware, ceramic sculpture and garden pottery. Closed Sunday and Friday.

THE OLD FORGE POTTERY (Harry Clark & Clive Nethercott), 37 Durrants Road, Rowlands Castle. Tel. Rowlands Castle 2632

High-fired stoneware pottery; original designs; complete dinner-services made to order; commissions undertaken in ceramics and in wood— relief panels—sculpture, etc.

Open daily 9.30 am–6 pm including Saturday and Sunday.

ST MARYBOURNE POTTERY (David Maynard &

John Holden), Baptist Hill, St Mary Bourne, Andover. Tel. St Mary Bourne 384
Studio pottery, stoneware, specialising in kitchenware, work to order. Also assorted scented candles. The workshop is an old Baptist chapel situated in one of Hampshire's prettiest villages near the River Bourne.
9 am–6.30 pm October to April, 9 am–8 pm May to September.
SURREY CERAMIC CO. LTD, Kingwood Pottery, School Road, Grayshott, Hindhead (½ mile off A3 in Hampshire). Tel. Hindhead 4404
Earthenware and hand-made stoneware. Comprehensive range of containers for all flower arrangements. Ware for kitchen and informal use.
Open to visitors: Works and Gift Shop Monday to Friday, 9 am–5 pm. Gift Shop only, Saturday 9 am–1 pm.
SHEILA & DENIS WILLISON, Overstone Pottery, 260 Brook Lane, Sarisbury, Southampton SO3 6DR. Tel. Locks Heath 84474
Domestic and decorative ware. Tin glazed waxresist earthenware.
Visitors welcome. Open Tuesday–Sunday 9 am–6 pm C/D.

Herefordshire

WELLINGTON MILL (formerly Ross-on-Wye Pottery), Wellington Mill, Westhope Road, Wellington HR4 8AR. Tel. Canon Pyon 391
Decorative, pierced pottery, lamp-bases, dishes, candle-holders and plant pot-holders.
Workshop only.
URSULA & TONY BENHAM, Mill Pottery, Mill Lane, Wateringbury, nr Maidstone. Tel. Maidstone 812363
All hand-thrown stoneware. Wide variety domestic ware and individual pieces and large range of lamps. Displayed in eighteenth-century watermill.
Living on premises, visitors welcome.
VALERIE & RONALD JOHNSTONE, Dene Court, Woodchurch, nr Ashford, Kent. Tel. Woodchurch 274. 3 miles Tenterden.
Hand-thrown and hand modelled pottery and ceramic sculpture. Lamp-bases of original design. Also vases, tankards, casseroles, etc.
Closed Mondays. Visiting any hour. Situation 1 mile on Tenterden side of Woodchurch.
LANGTON POTTERY, by the Green, Langton, nr

Tunbridge Wells. Tel Langton 2014
Hand-made stoneware by Gordon Plahn. Oven- and tableware; water-, coffee- and tea-sets, plates, mugs, jugs, bowls, casseroles and individual pieces.
Week-days 9 am–6 pm.
COLIN & LESLIE PEARSON, The Quay Pottery, Wickham Lodge, 73 High Street, Aylesford, Maidstone. Tel. Maidstone 77916
Range of domestic stoneware, plates, cups and saucers, stewpots, coffee-sets, punch-sets, wine-goblets, bowls, etc. Also hand-built and thrown individual vases.
Visiting at most times including week-ends, but telephone call appreciated as this could avoid disappointment.
JOHN SOLLY POTTERY, 36 London Road, Maidstone. Tel. Maidstone 54623
Hand-made domestic and studio pots in slipware and high-fired earthenware. Also runs a Summer school, July to September. Brochure by request.
Hours of business 9 am–5.30 pm Monday to Friday, 9 am–mid-day Saturday.
DAPHNE & CHRISTOPHER WREN, Wye Pottery, Wye, nr Ashford. Tel. Wye 812251
Pottery and craft goods for sale. Pottery made on the premises.
Summer season, usually open 10 am–5.30 pm. Closed Sunday, Monday and pm Wednesday. Restricted hours during winter.

Lancashire

KATHY CARTLEDGE, Cobblestones, Raikes Road, Little Thornton, nr Blackpool. Tel. Thornton 2035
Small studio pottery producing tableware and architectural mosaics and murals.
Living on premises. Visitors welcome by appointment.
BARRY & AUDREY GREGSON, The Lunesdale Pottery, Farrier's Yard, Caton, nr Lancaster (barely 2 miles off M6 exit road No. 34 on A683 behind Ship Inn, centre of village. Ample car-park). Tel Caton 770284
Full range of earthenware and stoneware, hand-made on the premises for domestic and decorative use. Ceramic sculptures. Pottery figures.
Visitors always welcome. Resident.
KNEEN THORNTON POTTERY, Potters Barn, 2 Fleetwood Road North, Thornton Cleveleys, nr Blackpool. Tel. Cleveleys 5045

Individual hand-thrown pottery, in high fired earthenware, stoneware and porcelain. Domestic and decorative items. Large range of ceramic jewellery.
Open from June until Christmas 2 pm–5 pm daily. Resident. Visitors welcome any other time by appointment.
PILLING POTTERY, School Lane, Pilling, nr Preston, Lancs. Tel. Pilling 307
Craftsmen in ceramics. Very extensive range of hand-made pottery. Large retail craft shop. Wholesale enquiries welcome. Manufacturers of pottery equipment, kilns, wheels, etc. Wholesale price lists and equipment catalogue available.
Private tuition on the premises. Resident.

Leicestershire

MARION ALDIS, Zion House Pottery, South Croxton, Leicester LE7 8RL. Tel. Gaddesby 363
Hand-made stoneware with mainly wood-ash glazes. Tableware lamp-bases, animal sculpture, especially owls and bulls, wall decorations. Individual pieces. Named mugs and plates for children.
All day Saturday and Sunday. Advisable to telephone in week but open most of the time.
C. J. & J. CARTER (DipAD), 'The Studio', Highfields Farm, Grendon Road, Pinwall, nr Atherstone, Warwickshire.
We offer a selection of hand-made, high-quality items in semi-porcelain creamware. Tableware and individual pieces. Teapots and coffee-pots are a speciality.
Open Tuesday to Saturday (inclusive) during normal business hours.
MUGGINS, DAN MOOR & RAY DAVIES, Burton Bandalls, Cotes, Loughborough. Tel. 66582
Master-craftsmen producing a range of decorative wares including bottles, mugs, punch-bowl sets, etc, hand-thrown stoneware with modelled coloured clays and wide range of glazes.

Lincolnshire

ROBERT BLATHERWICK, The Old Bakery, Reepham, Lincoln.
Slipware and tin-glazed domestic pottery, tiles, ceramic jewellery and sculpture.
Open almost any time (resident).
PRU GREEN, Alvingham Pottery, Alvingham, Louth. Tel. South Cockerington 230

Hand-thrown pottery, earthenware, coffee-sets, decorated jars, beakers, dishes and jewellery. Gallery for local artists and craftsmen to exhibit work.
9.30 am–5.30 pm daily, including Sunday.

Norfolk
KEN & JENNY ALLEN, 1 Grammar School Road, North Walsham.
Large life-like pottery cats of most common breeds.
Open normal hours.
PIPPA CLOWES, The China Cottage, The Street, Coltishall, Norwich NOR 67Y.
Pottery and porcelain restoration.
Tuesday–Friday 9.30 am–5 pm.
BLO' NORTON POTTERY, Tony Apps, Corner Farmhouse, Blo' Norton, Diss. Tel. Garboldisham 420.
Hand-made stoneware, table and kitchenware. Individual pieces.
Living on premises. Visitors welcome.
MARY & TERRY CUTLER, Sheringham Studio Pottery and Workshops, 17 High Street, Sheringham. Tel. Sheringham 3403
Hand-thrown stoneware pottery and individual pieces.
Monday–Saturday 9.30 am–5.30 pm. July and August evenings and Sundays also.
CLIVE DAVIES POTTERY, Thorpe Hall Cottage, Withersdale, Harleston, Norfolk. Tel. Fressingfield 407
Reduced stoneware. Wide selection table and ovenware.
Visitors welcome.
EDGEFIELD POTTERY, Dawn & Terry Hulbert, Old Hall Cottage, Rectory Lane, Edgefield (on Holt–Norwich road). Tel. Saxthorpe 379
Stoneware pottery made on the premises. Hand-thrown tableware, also individual hand-built pots and sculptures of a distinctive nature.
Open all year round.
LUCINDA JEPHSON, Field Barn Cottage, Gt Dunham, King's Lynn. Tel. Litcham 283
Small studio pottery producing hand-made stoneware, earthenware, domestic and individual pieces.
Visitors welcome.
JETTY'S POTTERY (Jetty & Adrian Farncombe), 30 Church Street, Sheringham. Tel. Sheringham 3552

Hand-made earthenware. Wide range of functional tableware, lamps, mirrors, flower-holders, birds and sculptured and carved forms. All pieces individually made without the use of a wheel or slip-moulds.
Resident. Visitors welcome almost any time or phone.
JOHN JOYNER, The Loddon Pottery, Bugdon House, 5 Bridge Street, Loddon, Norwich. Tel. Luddon 647
Stoneware pottery displayed in the ancient kitchen of the eighteenth-century house.
Loddon, an old Broadland town on the River Chet, is 10 miles from Norwich on the A146. Resident. Visitors welcome. Demonstrations by appointment.
WEST MARSHALL, Whittington Pottery, Church Lane, Whittington, Stoke Ferry. Tel. Stoke Ferry 491
Hand-made stoneware pottery, domestic and individual pots, including tea- and coffee-sets, ovenware, mugs, jugs, vases, all sizes of bowls, and clay pipes.
Visitors welcome. Appointment advisable.
MILLHOUSE POTTERY (Alan Frewin), 1 Station Road, Harleston. Tel. Harleston 852556
A large range of hand-made traditional English slipware for kitchen and table use. Cider-jars, casseroles, pie-dishes, coffee-sets, store-jars, plates, cruets, salt-kilns, large decorated platters.
Monday–Saturday 9 am–6 pm, early closing Thursday. Open most Sundays.
STALHAM POTTERY, High Street, Stalham. Tel. Stalham 614
A wide selection of hand-made stoneware pottery, oven and tableware. Individual pieces.
Open Monday to Saturday (inclusive), 9.30 am–5.30 pm.
PRISCILLA THOMS, Magpie, Fersfield, nr Diss. Tel. Bressingham 396
Domestic stoneware thrown on continental kick-wheel, also large hand-built pots.
Resident. Visitors welcome.
JOHN & KATE TURNER, The Cottage (next door to the Ship Inn), Narborough, King's Lynn. Tel. Narborough 208
Hand-made stoneware, some porcelain, domestic ware and individual pieces.
Visitors always welcome. Always open.

Northumberland

PAT GINKS, Ford Pottery, Ford (7 miles north of Wooler)
Oven-proof stoneware, domestic ware, hand-thrown on the premises. Ash glazes.
Almost any time (resident).

Nottinghamshire
CHRISTOPHER S. ASTON, Yew Tree Cottage, High Street, Elkesley, nr Retford. Tel. Gamston 391 (on A1, 4 miles north of Tuxford on route between Lincoln and York)
Hand-made stoneware, domestic and individual pots.
Any day 10 am–6 pm.
WOOD END POTTERY (K. A. O'Donovan), nr Cuckney, Mansfield (on A616 between Cuckney and Creswell). Tel. Warsop 2599
Residential pottery courses. A wide range of domestic stoneware, ovenware and individual pieces, with an occasional selection of reproduction Roman pottery.
Any day 9 am–6 pm.

Oxfordshire
RUSSELL COLLINS, Netting Cottage, Netting Street, Hook Norton, nr Banbury, Oxon.
Domestic stoneware, some porcelain, individual pots.
Monday–Friday 9 am–6 pm. Saturday 9 am–1 pm. Sunday—phone first.
DEDDINGTON POTTERY (Jo Carson), The Tchure, Deddington
Hand-thrown domestic pottery, slipware made on premises.
Monday to Friday and Saturday morning. Saturday afternoon and Sunday by chance.
YELLOW POTTERY, Fawler (5 miles W. Woodstock)
High-fired stoneware—hand-thrown reduction-fired tableware—plates, bowls, coffee-sets, mugs and casseroles, etc. Free-standing non-functional slabwork forms with glaze and engobe surface treatment.
Callers are very welcome. The village of Fawler is situated midway between Stonesfield and Charlbury, approximately 5 miles west of Woodstock. Enquiries for orders and tuition welcome.

Shropshire
SEVERN GORGE POTTERY (Roy Evans), Blist Hill,

42

off Coalport Road, Coalport

Hand-made tableware, kitchenware, lamp-bases. Cider-flagons in earthenware and stoneware. Large pots a speciality. Printed bone-china plates and tiles of local views.

The Pottery is situated on the Ironbridge Gorge Museum Trust site at Blists Hill, in old brick-kilns. The site is extensive and affords an interesting exhibit of the Industrial Revolution together with good walks and interesting scenery.

Open 10 am–6 pm week-days, 10 am–7 pm week-ends. Closed Mondays.

JOHN TEMPLE, Bridgnorth Pottery, St Leonard's Close, Bridgnorth

Hand-thrown stoneware pottery, mostly domestic ware, some individual decorative pieces. There is a showroom open to the public.

Open Tuesday, Wednesday, Thursday, Friday, Saturday 9.30 am–5 pm.

Somerset

WAISTEL & JOAN COOPER, Studio Pottery, Culbone Lodge, Porlock (on public footpath to Culbone Church from Porlock Weir or Silcombe Farm). Tel. Porlock 539

Stoneware. All individual pieces, bowls, mugs, jugs, lamps, vases and special pieces, decorated with metal oxides or woodash glazes.

Studio usually open to public 10 am–7 pm.

ANNE & DAVID HISCOCK, Wedmore Pottery, Wedmore

Small studio pottery in rural Somerset producing tin-glazed earthenware; stoneware twig-vases, candle-sconces, and lamp-bases.

Display open 9 am–9 pm every day, and Wells Market every Saturday.

FISHLEY HOLLAND, The Pottery, Clevedon. Tel. Clevedon 2952

Glazed earthenware vases, jugs, tankards, coffee-sets, bowls, dishes and other ornamental work.

9 am–5.15 pm Monday to Friday, 10 am–12 noon Saturday.

BRYAN & JULIA NEWMAN, The Pottery, Aller, Langport. Tel. Langport 250244

Stoneware pottery. Domestic ware and ceramic sculpture.

9 am–8 pm daily.

NORTH STREET POTTERY, Ilminster. Tel. Ilminster 3175

Decorative and domestic pottery made here by

Connie Crampton. *Also work by other Somerset potters.*

Open June to September (inclusive) and at other times by arrangement. Tuesday to Saturday inclusive 11 am–5 pm.

QUANTOCK DESIGN, West Bagborough, Taunton. Tel. Bishop's Lydeard 429

Hand-made stoneware kitchenware, vases, individual pieces and general pottery with imprinted designs.

9 am–5 pm.

SANDFORD POTTERY (June Woods), Sandford House, Perry Green Lane, Wembdon, Bridgwater. Tel. Bridgwater 3222

High-fired earthenware and oxidised stoneware. Domestic ware and individual pieces.

Studio and showroom open most of the year; week-days 10.30 am–6.30 pm, half-day Wednesday.

LES SHARPE, The Pottery, Hinton St George, Crewkerne, Somerset. Tel Crewkerne 3630

Wide range of oven-, kitchen- and table-pots in stoneware.

Visitors welcome any day, any time.

NORMAN UNDERHILL, 5 Church Square, Midsomer-Norton, nr Bath and Wells. Tel. Midsomer-Norton 2520

Unique hand-made figurines in earthenware, mostly old English characters but some moderns.

Resident. Open every day but advisable to ring before visiting.

THE WELLS POTTERY, 72 St Thomas's Street, Wells.

High-fired decorated earthenware. Hand-thrown bowls, jugs, mugs, etc. Some individual pieces.

Resident.

WHITNELL CRAFT POTTERY, John Harlow, Fiddington, Bridgwater. Tel. Nether Stowey 663

Hand-made ovenware, tableware and individual pieces. Whole range matching in form and decoration. Other crafts for sale in large showroom on premises.

Resident. Open 9 am to 6 pm every day except Monday.

DAVID WINKLEY, Vellow Pottery, Vellow, nr Stogumber, Williton, Taunton. Tel. Stogumber 458

A very wide range of stoneware for domestic use— mugs, jugs, bowls, cooking-pots, coffee-sets, teapots, etc—together with individual pieces in stoneware and porcelain.

8.30 am–6 pm Monday to Saturday.

Staffordshire

SALLIE ROBINSON STUDIO POTTERY, 13 Boon Hill, Bignall End. Tel. Stoke-on-Trent 720523

Hand-made studio pottery and ceramic jewellery.

8.30 am–5 pm.

Suffolk

ALDRINGHAM CRAFT MARKET, nr Leiston. Tel. Leiston 830397

Studio pottery, garden and domestic ware.

BRETTENHAM POTTERY, The Forge, Brettenham, Suffolk IP7 7QP (nr Lavenham). Tel. Rattlesden 620

Formerly 'Intaglio Designs', this new workshop will be producing ceramic tiles and pottery.

Showroom open normal business hours.

BULMER BRICK & TILE CO. LTD, The Brickfields, Bulmer, Sudbury. Tel Twinstead 232

Hand-made bricks, roofing tiles, brickettes, moulded ware, terracotta, etc. Specialists in period restoration work.

All hours.

JAMES HART, Mudlen End Studio, Felsham, Bury St Edmunds (4 miles from Lavenham). Tel. Cockfield Green 470

Traditional potter and modeller. Hand-made models of old houses and buildings, heavy working horses, pastoral figures and pew groups.

Resident. Advisable to telephone.

NEEDHAM POTTERY, Wood Farm, Linstead Magna, Halesworth. Tel Linstead 301

Stoneware. A wide range of domestic ware is thrown, including mugs, plates, jugs, bowls, large cups and saucers, butter- and cheese-dishes, salt-jars, casseroles, etc.

Open any time for all enquiries.

ROBERT TARLING, Kersey Pottery, River House, Kersey, nr Ipswich. Tel. Hadleigh (Sfk) 2092

Hand-thrown domestic and decorative stoneware.

Resident.

JOAN WARNER, The Old Rectory, Westhall, Halesworth

Unique hand-built ceramics. Stoneware containers for 'Ikebana', sculpture and paintings.

By appointment please.

HENRY WATSON'S POTTERIES LTD, Wattisfield. Tel. Walsham-le-Willows 239

A wide range of domestic studio pottery in matt colours, a new kitchen brown glaze and also

brilliant red and orange glazes. This pottery is extremely functional and attractive.

8.30 am–4.30 pm Monday to Saturday. Closed Sunday.

ROBIN WELCH POTTERY. Tel Stradbroke 416
Range of domestic ash glazed stoneware as selected by the Design Centre. Individual pieces, sculpture and ceramic panels.

Showroom open 10 am–5.30 pm, by appointment, to see around workshop. Trade customers any time.

Surrey

CRANLEIGH POTTERY, The Old School, High Street, Cranleigh. Donald Marsh, NDD
Oxidised stoneware thrown to order.

Pottery shop open Monday to Friday.

GEOFFREY MAUND POTTERY, 13 Whytecliffe Road, Purley. Tel. 01-6683802
Hand-painted pottery.

Monday to Saturday, 9 am–5.30 pm.

THE POTTERY STUDIO, 37 Church Street, Leatherhead. Tel. Leatherhead 75127
Hand-made pottery, domestic and individual pieces, made on the premises by Eileen Stevens, also work by local potters. Stoneware and earthenware.

Sussex

BRICKHURST POTTERY (Keith & Fiona Richardson), Laughton, nr Lewes. Tel. Ripe 305
Traditional Sussex black metallic pottery (hand-made) and various coloured earthenware.

Open Monday, Wednesday, Friday, 9.30 am–5 pm, week-ends by appointment.

BRIDGEFOOT POTTERY, Stedham, nr Midhurst. Tel. Midhurst 2626
Individual pieces; repetition work by Ray Marshall.

Visitors welcome. Open Monday to Friday 10 am–5.30 pm, week-ends by chance.

MILLAND POTTERY AND GALLERY, Milland, Liphook
Hand-thrown tableware, mugs, jugs, bowls, etc. Individual pieces.

Visitors welcome. 9.30 am–5 pm, Saturday 9.30 am–1 pm. Bank Holiday Mondays.

EMMA PHILPS (Potter), Sharrods, Upper Dicker, Hailsham. Tel. Hellingly 451
Hand-made stoneware and earthenware; bowls, plates, dishes and other tableware; lamps; hand-

made tile tables.

Visitors welcome most week-days 2 pm–5.30 pm (closed Saturday) or any other time by appointment. Phone call advisable.

RYE POTTERY, Ferry Road, Rye. Tel. Rye 3363
Earthenware and stoneware made and decorated by hand. Tableware, vases, lamp-bases, cruets, coffee-sets, mugs, jugs, etc.

8.30 am–12.30 pm, 1.30 pm–5.30 pm. Saturday 9.30 am–12.30 pm, 2.30 pm–5 pm. Closed Sunday.

IDEN POTTERY, The Strand, Rye. Showroom: Conduit Hill, Rye. Tel. Rye 3413
Iden Pottery. Hand-made coffee-sets, tea-sets, lamp-bases, individual studio vases and bowls, ovenware.

9 am–12 noon, 1 pm–5 pm, 6-day week. Sunday afternoon.

Warwickshire

ELIZABETH BLUNDELL, Pumphouse Pottery, Avon Dassett, nr Leamington Spa. Tel. Farnborough (Warwicks) 317
Slipware casseroles and oven-pots, tea-sets, coffee-sets, plant-pots, mugs, jugs, bowls, etc.

8.30 am–6 pm Monday to Friday. 9.30 am–12.30 pm, Saturday and Sunday.

BARBARA CASS, The Arden Pottery, 31 Henley Street, Stratford upon Avon. Tel. Stratford upon Avon 4638
This workshop produces moderately priced hand-thrown stoneware of high artistic quality. Barbara Cass mixes all her own clays, colours and glazes which gives her work a personal distinction.

Workshop open for sales throughout the year, Monday to Saturday.

KENILWORTH POTTERY, 186 Warwick Road, opposite St John's Church, Kenilworth. Tel. Kenilworth 52725
Stoneware pottery by Sylvia Hardaker, for kitchens and table use, teapots, coffee-sets, casseroles, individual pots, etc.

Showroom open 10 am–5 pm Monday to Saturday.

RON MORGAN (Potter), Whitefriars Gate, Much Park Street, Coventry. Tel. Coventry 27560
Hand-made stoneware pottery.

Resident.

FRITZ & SONYA STELLER, Square One Design Workshop, The Myrtles, Smiths Lane, Snitterfield. Tell. Snitterfield 352

Sculpture, ceramics, stoneware pottery, ceramic murals.

Visitors to workshops and showroom welcome any time.

Westmorland

CERAMICS & GLASS, The Institute, Hawkshead, nr Ambleside
Domestic pottery and ceramic sculpture made in the workshop by Frank Singleton.

Open daily 10 am–6 pm. Sundays Whitsun to September.

AVIS & BERNARD LOSHAK, Esthwaite Pottery, Hawkshead, Ambleside. Tel. Hawkshead 241
Hand-made stoneware pottery. Pots for plants and flowers. Tableware.

Summer: 10.30 am–6.30 pm most days. Winter: by appointment or by chance.

Wiltshire

JOHN COLLETT, Townsend Farm, Littleton Drew, Chippenham. Tel. Castle Combe 782441
Wide variety of hand-thrown saltware and earthenware pottery by John Collett.

Workshop and showroom always on view.

ROBERT & SHEILA FOURNIER, The Fournier Pottery, Tanyard, Lacock, nr Chippenham. Tel. Lacock 266
Thrown and built stoneware. Tableware, kitchenware and individual pots.

Visitors welcome but please phone or write for appointment.

HARNHAM MILL POTTERY, West Harnham, Salisbury. Tel. Salisbury 22364
Hand-made stoneware by Beresford Pealing. The pottery and showroom in this twelfth-century mill are easily accessible by the Town Path over the water meadows from Crane Street in the centre of Salisbury, or by road through Harnham.

10.30 am–7 pm (including Sunday in Summer).

IVAN & KAY MARTIN, Cricklade Pottery, Cricklade, nr Swindon. Tel Cricklade 436
Hand-made domestic pottery in slipware and stoneware. Members of the Craftsmen of Gloucestershire.

9 am–6 pm Monday to Saturday.

ROSE VILLA POTTERY, 4–5 Water Lane, Salisbury. Tel. Salisbury 29317
Hand-thrown and hand-decorated stoneware by Josephine Chamberlain and Peter Revby. Wide variety of individual pots and pieces as well as

domestic ware.

Worcestershire

VICTORIA MULLINS, Avoncroft Pottery, Hampton Lovett, nr Droitwich
Hand-thrown and built stoneware and terracotta for domestic, decorative and garden use. Ceramic jewellery also produced.
Open 9 am–6 pm Monday to Friday and most Saturdays.

Yorkshire

'CLEVE POTTERY', Skipsea, nr Driffield (on Hornsea–Bridlington road). Tel. Skipsea 351
Cruets, preserves, beakers, tankards, vases, ashtrays, animal figures.
Shop open daily all year.
PETER DICK, Coxwold Pottery, Coxwold, York. Tel. Coxwold 344
Coxwold Pottery produces a range of hand-made pots for most uses; kitchen and tableware are a speciality. Impressed patterns and slip-trailing are used for decoration but wood-firing gives Coxwold pottery its special quality.
Visitors welcome to the shop 10 am–5 pm week-days. Phone in advance of week-end visits.
CURLEW POTTERY, 11 Crossgate, Otley. Tel. Otley 4188
Hand-made stoneware and earthenware. Domestic and individual pieces thrown in the showroom.
Tuesday to Saturday inclusive, 10 am–1 pm and 2 pm–4.30 pm.
E. A. & G. R. CURTIS, Littlethorpe Potteries, Ripon. Tel. Ripon 3011
Horticultural pottery manufacturers, specialising in hand-thrown terrace pots, etc.
9 am–6 pm. Appointments preferred.
HAWORTH POTTERY (Anne & Robert Shaw), 27 Main Street, Haworth, nr Keighley
Domestic pottery and ceramic sculpture, handmade in eighteenth-century weavers' cottage in romantic moorland Brontë village.
Visitors to workshop—showroom always welcome (including Sunday).
MOLLIE HILLAM, The Pottery, Paradise, The Moravian Settlement, Fulneck, Pudsey. Tel. Pudsey 71440
Hand-made stoneware pottery for the table, for the kitchen, and individual pieces.

10 am–6 pm. Open daily except Sunday.
WOLD POTTERY, Routh, Beverley. Tel. Leven 236
Hand-thrown pottery, coffee-cups, etc. Bowls and dishes impressed by real leaves or embossed with school, college, trade-mark or any other crest.
Pottery and shop open daily 10 am–mid-day. 1 pm–5 pm. Sunday by appointment. 4½ miles from Beverley.

WALES

Caernarvonshire

CONWAY POTTERY, Castle Street, Conway. Tel. Conway 3487
Hand-made stoneware pottery : coffee-sets, beakers, beer-mugs, casseroles, decorative bowls and dishes, jugs, oil- and vinegar-bottles, goblets and candle-holders.
Open Summer 9.30 am–9 pm. Winter 10 am–5 pm.
JOHN DAVIES, Gwynedd Pottery, in Fourcrosses, Pwllheli. Tel. Pwllheli 2932
Hand-made pots for use in the kitchen and on the table. Stoneware, reduction fired. Price list sent on request. Member of the Guild of North Wales Potters.
The pottery is remotely situated ¾ mile off the A499 road, 2½ miles NE of Pwllheli.
BERWYN JONES, Tucwmmwd Ceramics, Llanbedrog, Pwllheli. Tel. Llanbedrog 296
A new studio producing oil-fired reduced stoneware, specialising in hand-made tableware, pressed dishes and individually decorated pieces.
Open week-days 10 am–8 pm during season.
BILL & OLGA KINSMAN (Artist Potters), Bryn Coch Pottery, Nebo, Penygroes. Tel. Penygroes 367
Unusual wheel work and hand-modelled pottery, including animal and other studies in earthenware and stoneware. Specialising in individual pieces, most of which are not repeated. Glazes made from local materials give finishes not produced in other areas.
11 am–9 pm Monday to Friday and Sunday. Saturday 3.30 pm–9 pm.
LLANFAIR YM MAULLT STUDIO POTTERY, Penrhyn Castle, Bangor
Llanfair ym Maullt Pottery is situated in Penrhyn Castle and is open all the year. A wide range of useful and decorative pottery.

Always open.
PORTMADOC POTTERY, Snowdon Mill, Portmadoc. Tel. Portmadoc 2785
Dishes, plates, bowls, mugs, teapots, coffee-pots, vases, etc. Each piece individually hand-decorated in jewel colours.
Trade only, by appointment (9 am–4.30 pm). Retail sales from all Craftcentre Cymru shops.

Cardiganshire

ABATY POTTERY, Pontrhydfendigaid, Ystrad Meurig. Tel. Pontrhydfendigaid 667
Hand-thrown domestic stoneware.
Open all the year. Closed on Saturday and Sunday.
BARDON POTTERY, Constant Farm, Tregaron
Oil-fired stoneware. Hand-thrown tableware and individual pieces.
Resident.
TREGARON POTTERY LTD, Castell Flemish, Bronant, nr Tregaron. Tel. Bronant 639
A wide selection of hand-made stoneware pottery.
Open all year round.

Denbighshire

ACER LAS POTTERY, Saron, Denbigh LL16 4SN. Tel. Llanynys 320
Ceramic Welsh hand-craft by Gottfried. Specialising in fine hand-thrown earthenware. A large range of artistic ware of every description. This pottery is situated in one of Wales's most scenic areas and although isolated can be easily reached by car. Appointments are advisable so that directions can be given.
Home-made teas are available on fine days in the garden.
COPPERS YARD POTTERY (Alan Brunsdon & Maggie Humphry), Cerrigydrudion. Tel. Cerrigydrudion 422
Hand-made stoneware. Individual figurative pieces, table- and ovenware.
Resident. Almost any time.
DAVID FRITH POTTERY, Ruthin Road, Denbigh. Tel. Denbigh 2805
Hand-thrown tableware, pressed dishes, earthenware and stoneware.
Showroom 9 am–5.30 pm. Sunday in season.
LLANGOLLEN POTTERY, Regent Street, Llangollen. Tel. Llangollen 2249 and Chirk 2543
Wide variety of thrown and cast earthenware.
9.30 am–6 pm Monday to Friday. Indefinite

hours, Saturday and Sunday.

Flintshire

RA STUDIO AFON POTTERY, Afonwen Mill, Afonwen, nr Mold. Tel Caerwys 459
Makers of reproduction antique pottery, figurines and decorative silk-screen tiles.
8.30 am–5.30 pm (excluding Sunday).

Glamorganshire

HELYG POTTERY, Claypits, Ewenny, nr Bridgend
Tableware, individual pieces, slab-built pots (stoneware only).
Open every day 9 am–6 pm.
JOHN HUGHES GALLERY & POTTERY, The Broadway, Pontypridd. Tel 404859
Specialising in ceramic figures of Welsh mythological and native characters, coracle men, miners, kings and warriors. Also small amusing animal figures and highly glazed earthenware pottery.
Open daily and week-ends. Visitors always welcome.
G. SOUTHCLIFFE, Creigiau Pottery, Creigiau, 8 miles from Cardiff, off A4119. Tel. Pentyrch 207
Hand-made tableware, coffee-sets, etc, in various colours, and Welsh copper lustre traditional to Wales.
Monday to Friday 9 am–5 pm, Sunday 2.30 pm–5 pm, Saturday 10.30 am–5 pm. Closed for lunch daily 1 pm–2 pm.

Merionethshire

MAWDDACH POTTERY, Fairbourne
Unusual hand-made pottery, ceramic sculpture, mugs, dishes, flower-containers in stoneware and earthenware. Lamp-bases and individual pieces. Traditional Welsh slipware.
THE SEREN CENTRE, Berwyn Street, Bala. Tel Bala 385
Mel Mars Pottery—hand-made stoneware pottery and decorated tiles. Individual pieces as well as standard domestic lines. Member of Guild of North Wales Potters. Judy Keeling—silver and gold jewellery. Sheila Kerr—hand-loom weaving. Also shop/showroom, coffee-bar and art gallery. Visiting craftsmen during the summer. Craftsmen who would like workshop facilities for short periods should contact the Centre.
VIVIEN SHRIMPTON, Prysgau Pottery, Llwyn-gwril. Tel Fairbourne 386
Hand-made, individual pottery, wall-plaques, tiles. Hand-painted tiles or designs in relief. Variety of designs and sizes. Resident. Visitors welcome.

Pembrokeshire

BONCATH POTTERY LIMITED, Felin Wen, Boncath. Tel. Boncath 473
Earthenware with screen-printed decoration.
HAVEN CRAFT POTTERY, Commercial Row, Pembroke Dock
Specialising in commissioned work, sculpture and ceramic jewellery. Manufacturers of hand-thrown earthenware in unique glazes.
Open to public all year round 9.30 am–6.30 pm.
CENTRE 68 GALLERY AND WORKSHOP, Penmynydd, Dinas, Newport. Tel Dinas Cross 203
Earthenware pottery. Stone and enamelled copper, jewellery, paintings, drawings and prints (lino and screen). Ceramic sculpture.
Week-days 10 am–1 pm and 2 pm–7 pm. Easter and Spring weeks, June, July, August and September. By appointment other times.
CROCHENWAITH A CERAMEG CEMAES. Cemaes Pottery & Ceramics, Leonard Rees, Parc-y-Gilwen, Brynhenllan, Dinas. Tel 376
Domestic and decorative stoneware, ceramic panels and tiles.
Resident.
HAVERFORDWEST POTTERY (T. J. & A. P. Whalley), Haroldston House, Clay Lane, Haverfordwest. Tel. Haverfordwest 2611
Manufacturers of hand-thrown stoneware in unique glazes. Wide range of standard lines of tableware (coffee-services, tea-sets, casseroles, bowls, etc).
Business hours: Monday–Friday 9 am–1 pm, 2 pm–6 pm. Saturday only 9 am–1 pm. Closed Sunday.
JONES THE POTTER LTD, Cwm Ebrill, Moreton Saundersfoot. Tel. Saundersfoot 2267
Bill Jones produces a colourful range of earthenware, with the individuality of the hand-made pot, but also with the fine finish of a good craftsman. Visitors are always welcome at the pottery, which is delightfully situated on a hillside just off the main Tenby–Carmarthen road.
Accommodation available.
LANDSHIPPING POTTERY (John Vergette), Landshipping, Narberth (4½ miles off A4075 Haver-fordwest–Pembroke road). Tel. Martletwy 225
Earthenware pottery in original colours in traditional and modern designs. Also farm guest house accommodation available.
Resident. Any time.
'RICK FLETCHER POTTERY', Willesdon House, St Thomas's Green, Haverfordwest
A full range of domestic stoneware, oven to table-ware pottery in a unique swirl brush glaze. All pieces are individually hand-made and shown in the Design Centre, London, and Craft Centre of GB.
Visitors welcome to our showroom display.
Open Monday to Friday 10 am–7 pm.
SAUNDERSFOOT POTTERY, Wogan Terrace, Saundersfoot. Tel. 2406
A wide range of hand-thrown earthenware pottery by Carol Brinton with unique glazes in both modern and traditional designs.
Resident. Any time.
TENBY POTTERY, Upper Frog Street, Tenby. Tel. Tenby 2890
Hand-made pottery.
Summer: 10.15 am–1 pm, 2.15 pm–5.30 pm, 7.45 pm–9 pm. Closed Wednesday, Saturday evening, Saturday afternoon, and all day Sunday.
Winter: 10 am–1 pm, 2.15 pm–5.30 pm.

Radnorshire

DRAGON POTTERY, East Street, Rhayader. Tel. Rhayader 318
Hand-decorated pottery.
Open 1st June to 30th September—daily including Sunday, 9 am–6 pm 1st October to 31st May—Monday to Friday, 9 am–5 pm.
WYE STUDIO POTTERY (Adam Dworski), Clyro, Hay-on-Wye. Tel Hay-on-Wye 510
Hand-thrown pottery, plaques, sculpture and tiles.

SCOTLAND

Fireshire

CRAIL POTTERY, Crail. Tel Crail 413
Hand-made domestic pottery, ceramic sculpture and murals: mostly stoneware, wood-fired.
Monday to Friday 9 am–5 pm Summer.

Inverness-shire

CASTLEWYND STUDIOS LTD, Inverdruie, Avie-

more. Tel. Aviemore 645
Earthenware and stoneware, made and decorated by hand. Figures, animals and a range of pots (saut-buckets, mugs, jugs, plates, etc).
Open daily Monday to Saturday 9 am–5.30 pm. Extended during season.

Kirkcudbrightshire
JOHN DAVEY, Old Bridge Pottery, Bridge of Dee, Castle Douglas. Tel. Bridge of Dee 239
Domestic stoneware, lamp-bases, jugs, bowls, dishes and platters in brown and coloured glazes, decorated with wax resist. Individual pieces and ceramic sculpture.
8.30 am–6 pm daily Monday to Friday. Week-end visits by appointment.

Midlothian
GRAHAM MCVITIE CERAMICS, Tynehead Cottages, Tynehead, by Pathhead. Tel. Heriot 235
Small cottage pottery producing varied domestic and decorative stoneware, including sculpture, all of individual design.

Perthshire
JEAN C. HOWDEN, The Pottery, Muthill
Hand-thrown stoneware pottery. Finely finished bowls, mugs, coffee-sets, etc, in five beautiful colours.
Open from 9.30 am–5.30 pm all year round except Sunday.

Roxburghshire
IAN & ELIZABETH HIRD, The Kelso Pottery, The knowes, Kelso. Tel. Kelso 2027
Hand-made stoneware pottery—domestic and individual pieces, piggy-banks and 'feelies', candlesticks and decorated plates.
Studio open 9 am–6 pm Monday to Saturday.

Stirlingshire
BARBARA DAVIDSON POTTERY, 18 Main Street, Larbert. Tel. 4430
Hand-thrown pottery. All types of functional ware, including dinner-services. Also hand-made open textured lamps from local clay.
Showroom open Monday–Friday 9 am–5.30 pm, Saturday and Sunday 2.30 pm–5.30 pm. Commissions accepted for murals and special items.

NORTHERN IRELAND

Antrim
PORTRUSH POTTERY, 93–95 Main Street, Portrush. Tel. Portrush 3739
Earthenware pottery—functional, decorative.

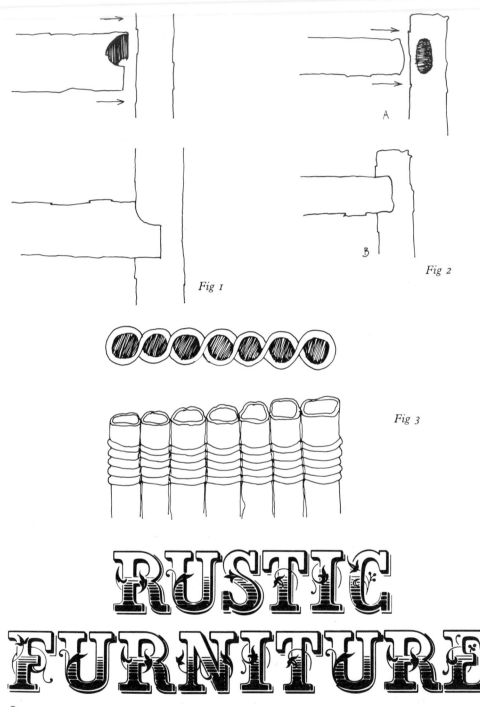

Fig 1

Fig 2

Fig 3

RUSTIC FURNITURE

RUSTIC WORK

This craft has sharply declined, probably because of the shift in taste away from wooden garden furniture to that made of tubular aluminium, stretched with plastic or canvas. There are signs, however, that the need for rustic work is now increasing once more, so that a knowledge of how to produce chairs and tables might be beneficial, either for a commercial venture or purely for the joy of making this delightful furniture oneself.

THE MATERIALS

The pleasure of this craft is that the material can be obtained in almost any county for the taking, or certainly very cheaply. Unhewn timber in the form of oak is preferable, but any of the hardwoods such as chestnut, beech or hornbeam are suitable. Even larch wood or Scots pine can be utilised, but most softwoods are unsuitable. As to obtaining the wood, there are a number of ways to do this. One way is to come to an agreement with a local forester or farmer who is growing copse on his land so that a steady supply of timber will be available. There are other sources where wood of the required size will be available for the taking (or with permission as the case may be), such as areas where tree-felling is taking place, or land is being cleared for farm or building use. As only thick branches of about 2 inches to 3 inches in diameter are needed for the main structure work, it will be found that this is rejected by timber merchants, farmers and foresters etc. and is normally burnt—so keep your eyes open.

TREATMENT

Opinions will differ as to whether the bark should be left on the poles or branches, or whether it should be stripped off so that the underlying wood can be stained and polished. If stripping the bark is preferred, then the timber must be allowed to dry or season for a number of weeks before working, otherwise the stain and polish will not take.

48

If copse wood is available, then there will probably be no clearing up of the poles such as removing any small side branches, twigs or growths. Always try and get straight branches but if there are side growths, then remove them right up to the main stem. Sometimes roots or unusually-shaped branches can be utilised in the construction of a piece of furniture. Look out for unusual graining in the different parts of a piece of timber so that it can be utilised and afterwards enhanced with polishing.

JOINTS AND CONSTRUCTION

There are a couple of ways to join pieces of rustic timber together. The simplest way is to nail the pieces together using wrought-iron nails, wire pattern or flathead nails. To ensure a good join between each piece it is necessary to carve a flat surface at the joints, using either an axe or a wood chopper *(fig 1)*.

A more sophisticated method of joining is obtained by cutting a mortice in one piece of the timber, (normally the vertical pieces) and using the cross piece as tenon which is thus inserted into the mortice, glued *(fig 2)* and then nailed.

Use the mortice and tenon joining method for constructing the parts of a piece of furniture where stress will occur, e.g. the back to the vertical uprights and the cross supports to the legs. Remember to drive home all nails thoroughly to avoid the danger of tearing clothing. Another good tip to remember when nailing pieces together is to support them behind, which will help the nails to be hammered in easily. When constructing the seat of a chair, or the top of a table, it is normal to lash together a number of logs as one would do in building a raft. The logs can be either nailed together, or just hammered on to a back support *(fig 3)*.

DECORATION

Finished pieces of furniture can be decorated with pieces of bark or small pieces of branches if need be but try and keep the design as simple as possible. The whole essence of rustic work is that it is a simple, sturdy and long-lasting method of making furniture, so bear this in mind.

RUSTIC-WORK CRAFTSHOPS TO VISIT

OLD FORGE COUNTRYCRAFTS (B. & A. Watkins), The Old Forge, Pimperne, Blandford Forum. Tel. Blandford 2288
Thatched bird-tables, rustic furniture. Carved coffee-tables, stools, plaques, house-name plates by skilled Dorset craftsmen. All types of fencing and hand-forged wrought ironwork of all kinds.
8 am–6 pm all days. Resident.
'RIDGEWELL CRAFTS', the Village Green, Ridgewell, Halstead (A604, 6 miles Haverhill). Tel. Ridgewell 272
Craftsmen in hand-made English elm furniture. 'Essex' oyster stools and reproduction spinning-chairs, farmhouse-type furniture and bar furniture for the licensed trade. Garden furniture.
J. A. TAYLOR, T/A COUNTRY WOODCRAFTS, Folly Farm, Gt Dunmow. Tel. Gt Dunmow 2547 (evenings only)
Hand-made oak and elm furniture a speciality— to order only.
Monday to Saturday 10 am–5 pm.
ASTON WOODWARE, Aston Hill (A40), Lewknor. Tel. Kingston Blount 51500
Designers and makers of garden and indoor furniture.
Week-days 9 am–6 pm. Week-ends by appointment.
RUSTIC CRAFTS LTD, Bixley Lane, Beckley, Rye. Tel. Beckley 275
Rustic and roundwood outdoor furniture, structures and requisites for gardens, parks and picnic areas. Special features include a stronger and improved mortise and tenon joint (Patent No 1,240,980) with a stress-relieving angled shoulder cut and matching recessed shoulder housing. A high standard of preservative treatment, including impregnation by means of vacuum-pressure plant.
Visitors welcome any time, but advisable to phone first.
MICHAEL THUT, Howe Lane, Nafferton, Driffield. Tel. Nafferton 361
Wooden garden furniture. 'Cottage'-type domestic furniture. Welsh dressers in oak and elm, monk benches and tables for patio and garden, flower-troughs and tubs in assorted hard-woods, bird-tables, nesting-boxes, etc.
Normal working hours. Visitors by appointment preferably.

IN THE USA

SOURCES OF MATERIALS

You might approach the owner of a fruit orchard during the springtime, when the trees are being pruned. Or if you live near a national forest, talk to the Forest Supervisor, who has authority to give away wood for private use. For a state forest, contact the State Forester's office.

BIBLIOGRAPHY

THE EARLY AMERICAN FURNITURE MAKER'S MANUAL, by A. W. Marlow/Macmillan, New York.
THE FOXFIRE BOOK, edited by Eliot Wigginton/Doubleday, New York.
HANDICRAFTS OF THE SOUTHERN HIGHLANDS, by Allen H. Eaton/Dover, New York.
REVERENCE FOR WOOD, by Eric Sloane/Ballantine, New York.
SHELL BOOK OF COUNTRY CRAFTS, by James Arnold/Hastings, New York.

AN INTRODUCTION TO SPINNING

SPINNING is one of the most fundamental processes ever discovered by man, so old that it almost has spiritual connections. Certainly it is one of the loveliest of all the crafts for it is the basic and starting point of many others, i.e. dyeing, weaving, printing. Spinning with a spindle is very easy to learn and once the knack of it has been acquired, a lot of yarn can be produced in a relatively short time. Using a spinning wheel is more complicated and as they are so very expensive and difficult even to make, we will not bother with it in this book.

Until a fleece has been obtained, there is nothing to stop you practicing and experimenting with other materials:

(a) TRAVELLERS' JOY (*Clematis Vitalba*) Old Man's Beard.

A common climbing perennial found widespread in the country which in the Autumn produces its unmistakeable greyish-white woolly plumes of hairy fruit. Try spinning the hairs.

(b) COTTON GRASS (*Eriophorum angustifolium*) Bog Cotton.

A widespread and common perennial grass found in bogs and swamps, mostly on acid soils in the north. The grass produces small, brownish green flowers which later form very conspicuous long white cottony seed 'bols'. Try spinning the fluffy bols.

(c) GLASS FIBRE.

(d) COTTON WOOL.

(e) HUMAN AND ANIMAL HAIR.

When walking through the country it is often possible to collect pieces of sheep wool that have become entangled in bushes or barbed wire. The best results, however will always be with the real wool (fleece), silk or flax, and of the three materials, wool is the easiest to spin for a beginner.

SPINNING WOOL

The basic principle of any spinning process is that of twisting together relatively weak fibres so that the resultant yarn has considerably more strength. The way the fibres are twisted together will determine the nature of the yarn. Tweed, for instance, is made up of yarn which has had its fibres all mixed up in a criss-cross fashion giving it a rough feel (*fig 1*). On the other hand, most wool knitting yarns have their fibres drawn out together which gives it a soft feel (*fig 2*).

Terminology

Certain terms will be used during this chapter which apply to the wool fleece and the spinning of that fleece. The following are simple descriptions which ought to be learnt.

STAPLE: Wool grows on sheep in locks, that hang in varying lengths according to (a) the region of the body of the sheep, (b) the breed of the sheep, and (c) the habitat of the sheep. Each lock is called a staple.

FIBRE: Each staple is made up of numerous hairs or fibres.

SCALE: Each fibre is made up of tiny scales which overlap each other from the root to the tip and this enables any foreign matter that may have got caught in the sheep's coat to gradually work its way out instead of remaining embedded.

CRIMP: Each staple is more or less 'crimped' which means that it contains a number of natural waves. The more crimps per inch in a staple, the finer the wool is judged for spinning and most of the best kinds have as many as 20 crimps per inch.

KEMP: This is the hair that grows usually on the legs and hind of the sheep and is not really appreciated for spinning because it is very coarse. It can be spun, but the resultant yarn will not be soft and it will be difficult to spin anyway. The wetter the sheeps habitat, the more kemp it will grow as rain runs off hair more easily than soft wool.

Fleeces

Britain offers a great number of sheep breeds, of which there are three basic types:

(a) DOWN BREEDS: These are sheep that inhabit the lower hills and down and normally give fleeces with short, fine staples.

(b) MOUNTAIN BREEDS: These are sheep that inhabit the hilly and mountainous districts and normally produce a long, coarse wool with plenty of kemp.

(c) LONG WOOLS: These are sheep native to the grass lowlands and coastal plains and normally produce a long, coarse wool.

Although there may not be the chance of choosing a particular fleece from a particular breed, the following will be more suitable for the hand spinner:

(a) SOUTH DOWN: A breed that inhabits the chalk hills around Lewes, Sussex. The fleece normally has short, very crimped staples with an average weight per fleece of $3\frac{1}{2}$–$4\frac{1}{2}$ lb.

(b) DEVON CLOSEWOOL: A breed native to Exmoor, with a fleece containing close, fine staples and an average weight per fleece of $4\frac{1}{2}$–6 lb. This wool is recommended for tweed.

(c) CHEVIOT: A descendant breed from the

Fig 1

Fig 2

Fig 3a

Fig 3b

ancient tan-faced sheep crossed with South-down and Merino breeds. It is a native of the Cheviot hills and the green southern hills of Scotland. Fleeces are compact with crisp staples of about 4 inches and an average weight per fleece of 4–4½ lb.

(d) SHETLAND: This breed produces an exceptional wool and if it is at all possible, try and get hold of fleeces from this breed which is a native of the Shetland and Orkney Isles. The fleece is made up of very fine wool with an outer coating of air. This breed does not have its coat shorn but 'rooed' or plucked.

(e) EXMOOR HORN: A breed that inhabits North Devon and parts of Somerset. The fleece is made up of soft lustrous wool with an average weight per fleece of 3½–4 lb.

(f) KENT: A native breed found on the marshes of Romney. A highly crimped staple of fine wool grows on this sheep with an average weight of 6–8 lb. Fleeces from this breed are highly recommended as they are plentiful, of high quality, and easy to spin.

Preparing the Fleece

Environmental conditions which may vary from season to season and from area to area have a considerable effect on the formation of the fleece. Wind, snow, dirt and the continual rubbing of a sheep's coat against rocks and vegetation all affect the quality of the various parts of a fleece and generally it will be found that the best wool comes from the shoulders and the most coarse from the lower back and belly.

Having obtained a fleece it must then be graded into the best, second best, third best, and so on. As already said, the best wool comes from the shoulders which normally produce the longest, and more crimped staples. The grading will begin with this wool and will end up with the coarse kemp. To do the grading, a large area like a room or shed should be cleared and clean paper laid on the floor. The fleece, which has probably been folded and tied in a particular way for transit purposes, must then be carefully unfolded and spread out on the floor. Experience will determine the best way to sort a fleece, but I have found that having five, large polythene bags (dustbin-liner size) ready and breaking down the

quality into five grades is a good form to stick to. Label the bags 1, 2, 3, 4 and 5 and put the best fleece in bag No. 1, the second best in bag No. 2 and so on. Reject any lumpy, body-soiled wool completely as this will save time later. Don't however, wash the fleece at this stage as it will remove the lanoline oil found naturally on the fibres, and this oil is an aid in the spinning process.

Spindles

Splindles can be bought in most craftshops, but considering what they are, it seems needless to waste money on them, as they are so easy to make. Basically, a spindle consists of two parts, a tapered stick jammed into a circular disc (*figs 3a, b*). Both parts can be separated simply by pulling apart. The tapered stick can have a notch at the top but this is not necessary and I prefer to have a notchless spindle. There are no "correct" dimensions for a spindle. Spindles are made in various sizes throughout the world. It is probably best to experiment for yourself until you find a personal size that fits your own spinning style.

The circular base can be cut out of 3 or 5 ply wood or something of a similar thickness and the spindle stem can be made from dowelling rod. Drill a ⅜-inch hole in the middle of the disc. The thickest part of the tapered stick should be slightly larger than this hole so that it will jam firmly into it. No spindle should be heavy in weight because this will break the yarn in the spinning process. On the other hand, a spindle that is too light will not spin properly.

TEASING & CARDING

Before the staples of wool can be spun, they must first be fluffed out into a light, airy mass and all dirt or foreign bodies removed. There are two ways to do this: teasing, which is purely a hand process, and carding, which uses two bat-like tools called carders. Of the two methods, carding is the more thorough and carded fibres will produce long, luscious soft yarn of the knitting wool quality. Teasing will produce a rough yarn suitable for tweed.

Teasing

Take one or two staples (use a 4th- or 5th-grade

Fig 4

Fig 5

Fig 7a

Fig 7c

Fig 6

Fig 7b

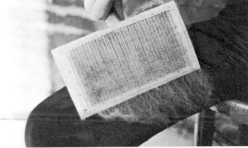

Fig 8

Fig 9

53

wool to practice with) and gently ease the fibres apart, picking out any bits and pieces in the process. The ideal consistency should be a light, fluffy ball, not unlike cotton wool. This will now be ready for spinning.

Carding

Carding is the hardest and most important part of any spinning process because it determines the quality of the yarn. It is difficult to correctly describe carding in a book because it is a very subtle process dependent on delicate hand movement and the way the wool is manipulated between the tools. For this reason, only a brief description will be given, as well as diagrams on how to make a pair of carders.

The tools used for this process are known as carders and consist of two bat-shaped pieces of wood, backed on one side with a piece of 'scratch card' *(fig 4)*. Scratch card is used in the textile industry for industrial carding and can be purchased in some ironmongers or do-it-yourself shops. It is often sold as a medium to iron velvet on and consists of material embedded with metal thongs. The wood for the base of the carders should be strong, either ash or a thick plywood. The sizes can be seen in *(fig 5)*. The scratch card can be fixed on to the wooden base by a strong glue and a row of staples around the outside.

Mark each carder 'left' and 'right' respectively and always remember to use the left hand carder in the left hand and the right hand carder in the right hand because the scratch card thongs gradually get worn in a certain direction with use.

To actually card, a few staples must first be stretched out over the surface of the left hand carder *(fig 6)* and with the other carder in the right hand, they should both be brushed over each other until the fibres are drawn out evenly *(fig 7a, b, c)*. This process should be repeated from one carder to the other for a few minutes until all the fibres are evenly distributed through the thongs *(fig 8)*. The fibres are then carefully removed in one layer using the thongs of the carder not carrying the wool fibres and gently rolled into a loose roll ready for spinning. This roll is often called a 'rove' *(fig 9)*.

54

PRODUCING A CONTINUOUS YARN

(a) Starting
Get hold of a yard of coarse wool yarn and tie onto the spindle as shown in *(fig 10)*. This is used to guide the fibres around itself into a yarn. Then, using your left hand, take a small handful of the carded wool (rove), and, with the spindle in the right hand, held between the finger and thumb, allow 9 inches of the coarse wool yarn to lie over the wool in the left hand and draw out some of the fibres and wrap them round the yarn as in *(fig 11)*.

(b) Twisting
Press your finger and thumb firmly on the carded wool and coarse wool yarn (left hand) a small way above the drawn out fibres. Then twist the spindle round in a clockwise fashion with your right finger and thumb *(fig 12)*. In doing this, the yarn and the wool fibres will begin to twist together, being prevented from running up into the rest of the wool because of the grip you are exerting with your left thumb and finger.

(c) Drawing out
As the spindle revolves in the clock-wise direction, move your right hand finger and thumb up to about $\frac{3}{4}$ inch of your left and grip the yarn. Then, let go a little of the left hand grip of finger and thumb and allow about 2–3 inches of yarn and fibres to pass down as you pull the left hand up *(fig 13)*.

(d) Releasing
Again exert pressure between your left hand finger and thumb on the fibres and then release pressure with the right so that the twist from the revolving spindle can run up the new stretch of fibres and yarn *(fig 14)*. Keep repeating these last two operations, the drawing out and the releasing until the fibres have begun to form a yarn. At all times the spindle must be kept turning in the same direction, do not let it reverse. This is quite a difficult art, not an operation that can be mastered in one go. The art of it is in drawing out with one hand, enough fibres from the handful of wool to make the yarn and in judging when, and how much, to release twist from the other hand so that a

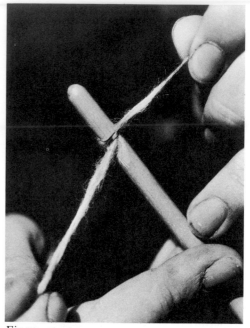

Fig 10

Fig 11

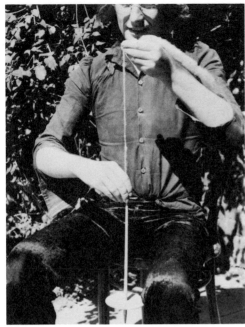

Fig 12

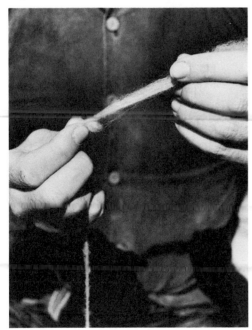

Fig 13

Fig 14

Fig 15

strong and even yarn is produced. Quite often in beginning to spin, you will find that the spindle will stop and start to spin the other way and so unwind all your effort. Don't be put off, just start again and you will eventually get the hang of it. Also, don't be discouraged by the lumpiness of your yarn at the beginning, experience will remedy this.

Winding on
In order to wind on the newly-spun yarn, remove it from the notch at the top of the spindle and also remove it from under the whorl and then wind it up and down crosswise on the spindle *(fig 15)*, allowing each successive layer to reach a little higher so that when full, it resembles a tight cone. Leave enough yarn undone so that it can be hitched as before. Keep repeating all the sequences and keep adding fleece until it has all gone.

Emptying the Spindle
Don't allow too much yarn to accumulate on the spindle as the heavy weight may break it. When it is reasonably full, push up the whorl which, in doing so, will eject the neatly wound cone. When winding from the cone, put it on a stand which you can make consisting of a stick held on to a wooden base, i.e. dowling rod about $\frac{1}{8}$ inch in diameter.

SERVICES

For any special information concerning spinning contact the following who are experts in this field:
HILDA BREED, Flansham Cottage, Cootham, Pulborough, Sussex.
RUTH HURLE, 47 East Street, Saffron Walden, Essex.
MISS MORFUDD ROBERTS, Bronberllen, Trefnant, Denbigh, North Wales.

SPINNING STUDIOS TO VISIT

H. POUNCEY, 'The Stables', Craigdarroch Estate, Moniaive. Tel. Moniaive 230
A woodcraft workshop set in the grounds of Annie Laurie's old home, specialising in spinning wheels, particularly Shetland, Hebridean and Scandinavian types. Full-size

55

*working wheels and half-size models. Match-
ing chairs, stools and tables, etc. Customers'
special orders for furniture undertaken.*
WHITE HORSE SPINNERS AND WEAVERS (AU-
DREY & CLEMENT CHARLES), Beech Bank,
Bratton, nr Westbury. Tel. Bratton 382
*Floor-rugs (mostly from hand-spun yarn),
tweeds, etc. Hand-spun/hand-knitted sweaters.
Open normal business hours (prior notice
of arrival appreciated). Week-ends by ap-
pointment.*
QUANTOCK WEAVERS, The Old Forge, Plains-
field, Over Stowey, nr Bridwater. Tel. Spax-
ton 239. Established 1930
*Hand-spun natural dyed wool a speciality in
tweeds, wraps, knee-rugs, scarves, etc.
Open most days from Easter to October,
from 10.30 am – 1 pm, 2.30 pm – 5 pm. Ad-
visable to telephone. Winter months by ap-
pointment only.*

MUSEUM

ULSTER MUSEUM, Stranmillis, Belfast, North-
ern Ireland. Full of wonderful exhibits for
those interested in spinning.

IN THE USA

SOURCES OF MATERIALS

*These mail order suppliers carry unspun,
unwashed fleece. Most also have wool carders
and spindles, and some have spinning wheels
or kits to make wheels. (Free catalogs are list-
ed; otherwise write for information.)*
CLEMES & CLEMES, 665 San Pablo Ave., Pi-
nole, Calif.
DHARMA TRADING CO., 1952 University Ave.,
Berkeley, Calif. 94704.
WARP, WOOF AND POTPOURRI, 514 N. Lake
Ave., Pasadena, Calif. 91101.
GREENTREE RANCH WOOLS, COUNTRYSIDE
HANDWEAVERS, 163 N. Carter Lake Rd.,
Loveland, Colo. 80537.
COLONIAL TEXTILES, 82 Plants Dam Rd.,
East Lyme, Conn. 06333.
THE WEAVER'S CORNER STUDIOS, P.O. Box
560125, Miami, Fla. 33156. *Free catalog.*
LAMB'S END, 165 West, 9 Mile, Ferndale,
Mich. 48220.

MIDWEST WOOL MARKETING CORP., 405 E. 14
Ave., N. Kansas City, Mo. 64116. *Free cata-
log.*
LIVING DESIGNS SOUTHWEST, 1712 Helena
Dr., Gallup, N.M. 81301. *Free catalog.*
SCHOOL PRODUCTS CO., INC., 312 E. 23 St.,
New York, N. Y. 10010. *Free catalog.*
THE SPINSTER, 34 Hamilton Ave., Sloats-
burg, N.Y. 10974. *Free catalog.*
THE OHIO WOOL GROWERS ASSOCIATION, 3900
Groves Rd., P.O. Box 27068, Columbus,
Ohio 43227. *Free letter.*
ARACHNE WEBWORKS, 2390 N.W. Thurman,
Portland, Oreg. 92710.
ARS NOVA CRAFT SHOP, P.O. Box 1388, Port-
land, Oreg. 97207. *Free brochure.*
BLACK SHEEP WEAVING AND CRAFT SUPPLY,
318 S.W. Second St., Corvallis, Oreg. 97330.
WILLIAM AND VICTORIA RALPH, Village of
Orwell, RD #1, Rome, Pa. 18837. *Free cata-
log.*

SOCIETY

HANDWEAVERS GUILD OF AMERICA, 998 Farm-
ington Ave., W. Hartford, Conn. 06107.
*Membership ($9 a year) includes access to a
textile and slide library and a quarterly
magazine,* SHUTTLE, SPINDLE & DYEPOT, *with
"how to" ideas, photos, and diagrams, prod-
uct reports, book reviews, and suppliers' ads.
The guild also publishes a number of pam-
phlets on the fiber arts and has a representa-
tive in every state who can provide local in-
formation.*

BIBLIOGRAPHY

HANDSPINNING — ART AND TECHNIQUE, by
Allen Fannin/Van Nostrand Reinhold,
New York.
THE JOY OF SPINNING, by Marilyn Kluger/
Simon & Schuster, New York.
SPIN, DYE, AND WEAVE YOUR OWN WOOL, by
Molly Duncan/Sterling, New York.
SPINNING WHEELS/available from the Ulster
Museum, Stranmillis, Belfast, Northern
Ireland, or from Museum Books, 48 E. 43
St., New York, N.Y. 10017.
YOUR HANDSPINNING, by Elsie Davenport/
Select Books, Pacific Grove, Calif.

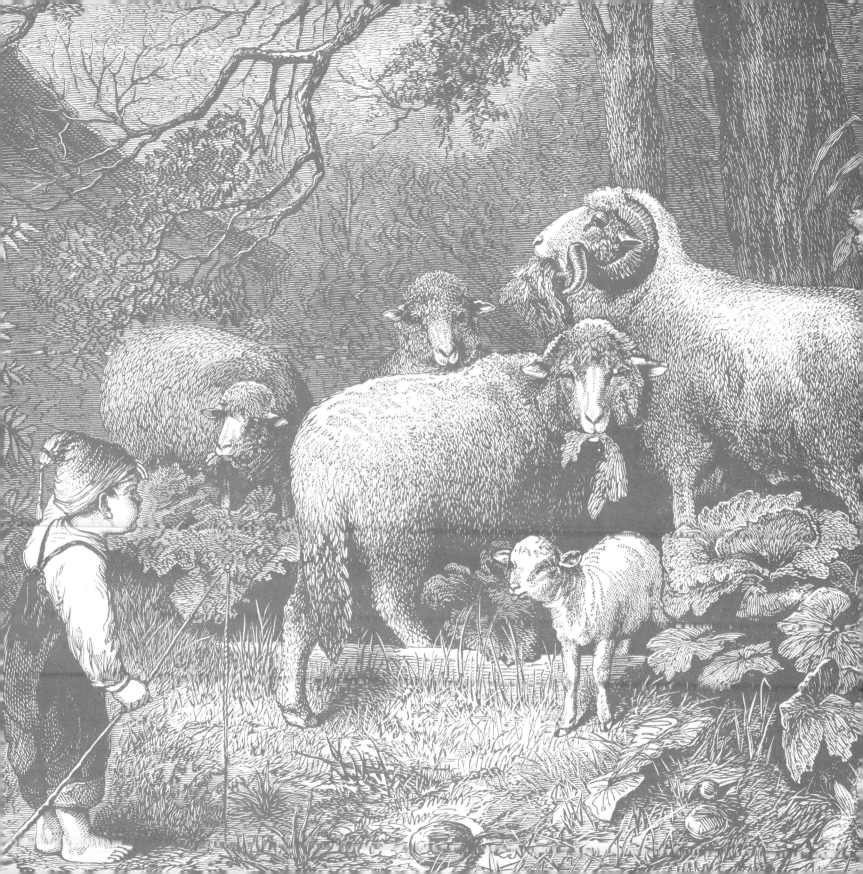

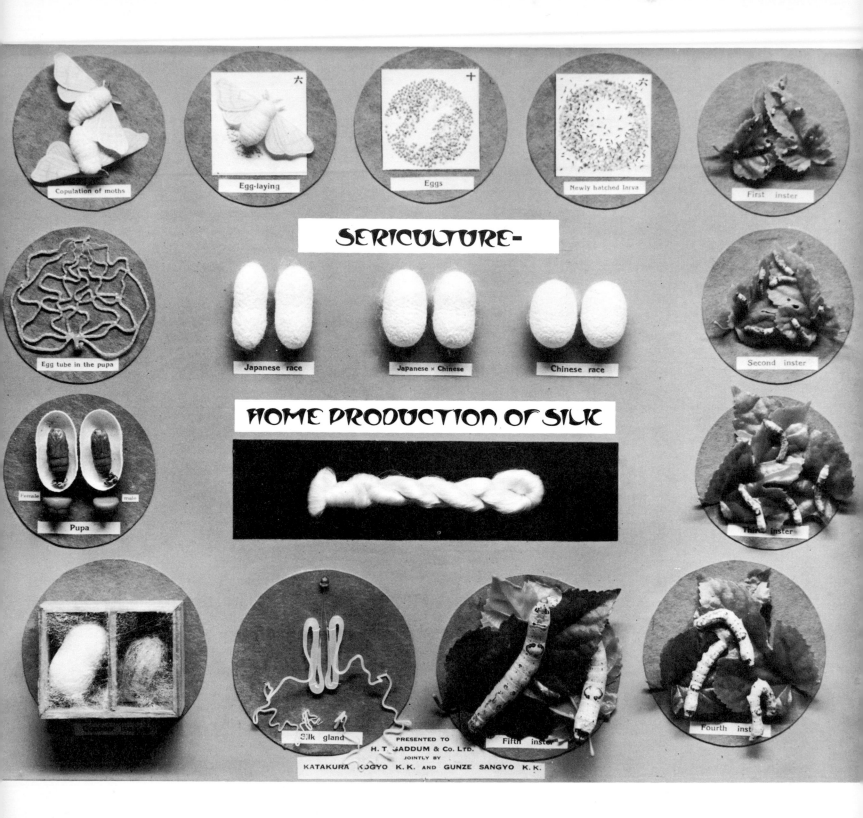

SERICULTURE—

HOME PRODUCTION OF SILK

Copulation of moths

Egg-laying

Eggs

Newly hatched larva

First inster

Egg tube in the pupa

Japanese race

Japanese × Chinese

Chinese race

Second inster

Pupa

Female male

Third inster

Silk gland

Fifth inster

Fourth inster

SILK IS PERHAPS THE WORLD'S LOVELIEST NATURAL FIBRE. IT HAS MANY EXCELLENT PROPERTIES THAT ENSURE A CONSTANT DEMAND FOR BOTH THE SPUN THREAD AND THE WOVEN FABRIC. THE PROPERTIES OF SILK WHICH PLACE IT SO HIGH IN VALUE ARE:

FINENESS : *A single strand from a cocoon is finer than human hair.*

LUSTRE : *No other natural fibre compares with the glossiness of silk.*

STRENGTH : *Silk has great strength in relation to its fineness and it retains its strength in use.*

SOFTNESS : *Nothing compares with a silk garment next to the skin.*

ELASTICITY : *The spun thread has remarkable 'give and take' and will stand up to hard wear without breaking or fraying.*

NON-FLAMMABLE : *Silk is the only natural fibre that is flame proof which makes it ideal when made up into fabric for children's or old people's nightdresses etc.*

PRODUCING SILK AT HOME

All things considered, it seems a worthwhile proposition to produce spun silk at home by rearing the silk worms from the egg stage and spinning the fibres from the cocoons into silk thread. Although producing silk on a small scale can never become a commercial venture (it takes 1,400 cocoons to make 1 lb of raw silk), enough thread can be produced over a period of time which should satisfy one's own personal needs. In any case, the whole process from egg to thread is an amazing one. The only objection to producing silk is the obvious distaste held by some to destroying the cocoon-bound silkworm in order to remove the silk fibres. The decision is therefore purely personal as to whether it is valid to produce silk at all.

Rearing the Silk Worms

Both eggs and caterpillars (silkworms) of the Silk Moth (Bombyx Mori) can be obtained from a number of butterfly farms and other specialists. The eggs of the Silk Moth are very tiny, each one being about the size of a pinhead, but once the eggs have hatched, the silkworms eat voraciously and grow up to 3 inches in length in five weeks. The ideal food for them to feed on is the leaves of the White Mulberry tree, but other material such as lettuce and mallow leaves are just as good, the only difference being in the quality of silk that is ultimately produced.

Silkworms must have a warm climate to live in and thought will be needed to ensure they have ideal conditions. High-sided boxes, such as empty cardboard packing-cases are ideal if the tops are cut off, making the sides about 1 foot high. Dry twigs can be placed in each box which gives the silkworms somewhere to climb on when not eating.

As the silkworms have enormous appetites, it is essential that they have a continual supply of fresh leaves each day during their five weeks of growth. After this, the silkworms will begin to spin themselves cocoons. This is done by secreting fluid silk mixed with a gummy saliva produced from two large glands called sericteria, through tiny openings in their throats. The fluid silk immediately hardens when it comes in contact with the air, and being sticky in nature, it readily adheres to itself which makes it a relatively easy matter for the silkworms to produce their silky tombs. Each cocoon normally takes from 3–4 days to complete and contains about 3,500 yards of fibre.

Preparing the Cocoon

In order to 'stifle' the cocoons, they must be dropped into boiling water for a few minutes. This immediately kills the silkworms and also softens the fibres. After removing the cocoons from the boiling water, they must then be left to soak for a couple of hours in warm water in order to thoroughly soften the fibres. This facilitates an easy removal of them in the winding-off process.

Winding Off

Each cocoon is made up of three layers of fibre. The outer layer is coarse and is the least lustrous so can be discarded for spinning purposes. Immediately underneath the outer layer is the best fibre, which is even, glossy and less confused in the way it has been wound by the silkworm. The inner layer is rather confused and generally useless for spinning purposes.

The photograph opposite, illustrating the life-cycle of the silkworm, shows specimens at each stage of development. Starting from the top left-hand corner and proceeding in a clockwise direction, we see (1) the mating of the moths, (2) the egg-laying, (3) the eggs, and (4) the tiny caterpillars hatching. Figs. (5–9) show silkworms in their five distinct ages, culminating in the two full-grown specimens (9). Within each silkworm are glands of silk (10). (11) illustrates the building of the cocoon, and (12) the pupa or chrysalis found by cutting the cocoon open; the egg tubes are shown in (13). In the centre are specimens of different types of cocoons, and below them a skein of raw silk.

Winding off is in itself a difficult process and only practice and experience will make it easier. The first thing is to lift up the outer fibre and for this a pointed wooden stick or some other suitable tool is used. The outer layer of fibre is wound off until the next layer is exposed. This middle layer of fibre is quite often the most difficult to lift off and to help things along, a little brush made of birch twigs is used which will lift off the fibres. The real skill comes when the fibres from a number of cocoons have to be wound off and at the same time spun together. As a general rule, a decent thread will need five fibres twisted together, so one thread from five cocoons, or two threads from two cocoons and one from another etc. are spun. The ideal thing for the silk thread to be wound on to is a cardboard tube of smallish dimensions (the tubes in the middle of toilet rolls are ideal). Obviously, one is going to get into a mess at first with winding off, but don't despair for it comes right in the end.

Preparing the Thread for Use

Before any of the spun silk can be used for dyeing, weaving or sewing purposes it must first be thoroughly washed in a soapy solution in order to remove the sticky gum on the spun fibres. The easiest way to do this without making a mess of the yarn is to wind the thread into a skein and tie the skein securely at one end with a piece of strong thread. In this way, the yarn can be thoroughly washed without any fear of knotting.

PLACE TO VISIT

LULLINGSTONE SILK FARM, Ayot House, Ayot St Lawrence, Hertfordshire.
Provides a live exhibition of the production of raw silk from the silkworm egg to the reeled hank. The farm has provided raw silk for two Coronations, the Investiture of the Prince of Wales, four royal weddings and other royal occasions. Facilities can be arranged for evening and school parties.

IN THE USA
SOURCES OF MATERIALS

Silk moth eggs:
NIDDY NODDY, c/o Irene Miller, Croton-on-Hudson, N.Y., 10520. *Write for information.*

White or Oriental Mulberry trees will grow almost anywhere in the United States. Mail order them from the following sources:
BOETHING TREELAND FARM, 23475 Ventura Blvd, Woodland Hills, Calif. 91364. *Free catalog.*
CALIFORNIA NURSERY CO., 36501 Niles Boulevard (Niles District), Freemont, Calif. 94536. *Free catalog.*
FIORE ENTERPRISES, Rte. 22, Prairie View, Ill. 60069. *Free catalog.*
OZARK NURSERY GARDEN CENTER, Rte. 2, Tahlequah, Okla. 74464. *Free catalog.*

PIKE'S PEAK NURSERY, Box 670, Indiana, Pa. 15701. *Free catalog.*
PLUMFIELD NURSERY, P.O. Box 410, Fremont, Neb. 68025. *Free catalog.*
TENNESSEE NURSERY, Tennessee Nursery Road, Cleveland, Tenn. 37311. *Free catalog.*
WAYSIDE GARDENS, Mentor, Ohio, 44060. *Catalog $2 (famous, often used as a reference).*

BIBLIOGRAPHY

In this country, silk was produced around the turn of the century until the 1940s. Old encyclopedias written when production was booming would be the most informative. Check your local library, where you may also find books on silk which are currently out of print.
LET'S LEARN ABOUT SILK, by Maud and Miska Petersham/Harvey House, Irvington-on-Hudson, N.Y.
SILK RAISING IN COLONIAL MEXICO, by Woodrow W. Borah/University of California, Berkeley, Calif. *Out of print.*
A SILKWORM IS BORN, by Ann Stepp/Sterling, New York.
SILKWORMS AND SCIENCE: THE STORY OF SILK, by Elizabeth K. Cooper/Harcourt Brace Jovanovich, New York.
THE STORY OF SILK, by William Legett/Lifetime Editions, New York. *Out of print.*

*Silkworm clambering a furry leaf to take
the sun:
spin and reel and weave in a hurry
till her thread is spun.
The wind blows,
the silkworm slows,
her body marking time,
gently lays a silky trail
along the leaves of lime.*

BRIDGET ST JOHN

With the increase of interest in spinning and weaving and the production of garments and accessories, there is a need for a comprehensive knowledge of dyeing techniques for the whole range of yarns, threads and fabrics, whether they be made from natural or synthetic fibres. We have therefore divided this chapter into two principle areas: (a) dyeing with natural dyestuffs that will include vegetables, flowers, lichens, barks, berries and minerals, and (b) dyeing with synthetic dyestuffs, manufactured from chemicals.

Before actually getting down to details, it may be worthwhile to explain why, when, and where to use the two types of dyestuffs. The most important point to remember is that natural dyes will only 'take' on natural fibres such as cotton, silk, wool and jute etc., and will be of no use to the man-made fabric range of polyesters, rayons, tricels and terylenes etc. Secondly, it is a totally false notion that the colours obtained from natural dyestuffs are better, brighter and more vibrant than those obtained from the synthetic dye range. Any and every colour from any natural material can be matched easily and perfectly with a dye from a tin. If it is bright, vibrant colours you need, then use a synthetic dye. In general, natural dyes give warm, delicate colours, especially from the plants and minerals available in Britain. The third point to remember is that natural dyeing processes are involved, uneconomical and wasteful, incorporating the use of vast quantities of natural dyestuffs and water. Great skill must be used in getting lengths of material to dye evenly with natural dyes and for this reason, it is advisable to dye only threads and yarns because these take the dye far more readily and evenly. So only dye yarns and threads with natural dyes unless you are prepared to spend a great deal of time in the process. Finally, we must also come down to cost and economics. Synthetic dyes are far more economical in both the amount of dye needed per 1 lb of material, as well as cost per tin. Natural dyestuffs, though free for the taking, will need time in collecting and invariably involve cost in travelling to the various parts of the country to pick up particular minerals and flora. Synthetic dyestuffs, though needing far less water, are not bio-degradable, whereas the opposite is the case with natural dyes. The final choice must be yours.

NATURAL DYESTUFFS

Use these dyestuffs only for cottons, calico, canvas, hessian, linen, jute, wool and silk. They are also suitable for yarns containing a mixture of synthetic and natural fibres, but remember that only the natural fibres will take the dye.

What to use
Any plant will give some colour, whether it be from the roots, stems, leaves, flowers or fruit. Sometimes, a different colour can be obtained from the various parts of a single plant, and these colours will not only vary with the district it is found growing in, but also vary according to the time of year it is harvested. Go out into the garden or the nearest bit of countryside and bring indoors as many samples of flowers, fruit, nuts, berries, moss, lichens, fungi etc. as you can, but be discreet in what is picked (never pick rare plants). Culinary vegetables and fruits are also a good source of colour.

The following is a comprehensive list of the sorts of plants to look out for, though others will be found in the course of experience. (It is a good idea to keep a dye book and to keep notes on the plants etc., picked, the time of year, the habitat and how the colour was extracted.)

BLACKS
Blackberry *(fruit)*	Flag Iris *(root)*
Elder *(fruit)*	Dock *(root)*
Meadowsweet	Oak Galls
Walnut *(bark)*	

BROWNS
Buckthorn *(fruit)*	Birch *(bark)*
Oak *(bark)*	Blackberry *(fruit)*
Various Lichens	Bird Cherry *(fruit)*
Walnut *(bark)*	Hop *(leaves)*
Sloe *(fruit)*	Larch
Onion Skins	Pine Cones *(fruit)*
Elm *(leaves)*	Horse Chestnuts *(skins)*
Juniper *(fruit)*	

GREYS
Hawthorn *(berries)*	Dogrose *(hips)*
Blackberry	Hypericum
French Marigold *(flower)*	Willow Leaves
	Yew Bark
Blackberry *(leaves)*	Red Cabbage
Privet	Broad Beans
Woody Nightshade	

REDS
Begonia *(red flower)*	Madder
Blackberry	Sorrel
St John's Wort	Bedstraw
Various Lichens	Alkanet

YELLOWS
Plum Leaves	Gorse
Alder	Bog Ashodel
Broom	Bracken
Dog's Mercury	Ash

BLUES
Blackberry *(fruit)*	Cornflower *(flower)*
Buckthorn *(fruit)*	Carrot *(root)*
Sloe *(fruit)*	Bear Berry *(fruit)*
Whortleberry *(fruit)*	Woad *(leaves, stems)*
Dogs Mercury	

GREENS
Cow Parsley *(leaves and stem)*	Apple *(skins)*
	Lily-of-the-Valley
Privet	Sorrel
Elder	Tansy
Ling	Reeds
Bracken	Horse Tail
Buckthorn	Ageratum *(flower)*
Alder	

ORANGES
Dahlia *(orange flower)*	Weld
	Canna *(red flower)*
Various Lichens	Beetroot *(root)*
Onion skins	

PURPLES
Elderberries	Birch Bark
Damson	Bryony

YELLOWS
Blackmustard	Apple Skins
Red Clover	Beech Nuts

Plane Leaves	Heather
Chamomile	Golden Rod
Yellow-Wort	Dyer's Greenwood
Pear	Weld
Weld	Calendular *(flower)*
Pine Cones	Dock *(leaves and*
Marigold	*stems)*
Various Lichens	Nettles *(leaves and*
Ling	*stems)*
Ragwort	Broad Beans
Poplar	Beetroot
Privet	

MORDANTS

Some natural dyestuffs will need nothing added to make the colour adhere to the cloth. Oak galls, lichens and walnut bark are three such dyestuffs and they are called SUBSTANTIVE. However, almost all vegetable dyes will need what is known as a 'MORDANT', a mineral which helps to adhere the colour to the yarn or fabric fibres by making a ground. The colour particles then adhere to the mineral ground instead of the fibres themselves. The most commonly used mordants of mineral origin are: Alum *(potassium aluminium sulphate)*; Chrome *(bichromate of Potash)* and Tin *(Ferrous sulphate or Copperas)*.

PRE-WASHING PROCESSES

To obtain good colours of even distribution, the yarn or fabric must be thoroughly washed and rinsed before being added to the dyebath. This washing process is known as 'SCOURING', and it should remove all dirt, oil, starch or sizing from the fibres.

Washing Wool

Use only natural soap and soft water. All skeins of yarn must be tied securely before washing (and dyeing) otherwise the resulting tangle will be a great headache afterwards. Tie the skeins in a figure of eight and don't tie them too tightly as this will prevent the water from penetrating thoroughly into the wool. It's often a good idea to tie the skeins with a different-coloured piece of wool, or in the case of dyeing, to use black wool or some medium such as string so that it is easily found and removed after the dyeing process.

Wash the wool in lukewarm water (95°F) and squeeze out the suds. Repeat the washing procedure again and then thoroughly rinse three or four times until the rinsing water is perfectly clear. Always handle the wool gently but wash speedily as this prevents the fibres from 'FELTING', i.e. going hard and fibrous. Always wash and rinse wool in the same temperature water and never wring it dry.

Washing Cotton

Dissolve the soap in hot, soft water (140°F). Wash as for wool and rinse thoroughly once. With the second rinse, have the water hotter and leave the material to soak for ½ hour. Give it two final rinses in lukewarm water.

Washing Silk

Raw silk is normally covered with a sticky gum which must be completely removed. Use ½ lb soap flakes for each 1 lb of silk. Tie the skeins of silk in a muslin bag and add to the hot soapy water. Bring to the boil and simmer for 1 hour, after which the silk should be given three rinses in hot water.

MORDANTING

Always use a separate bucket for each mordant and never mix them. Never use a tin mordant in a galvanished bucket as it will seriously corrode the surface. Each mordant must be thoroughly dissolved in the water solution before adding the material or yarn.

(1) ALUM *(potassium aluminium sulphate)*

To mordant wool with ALUM **use the following recipe.** (Heavy wool will need double the amount of alum):

1 lb wool, 4 oz alum, 1 oz cream of tartar and 4 gallons of water.

Dissolve the alum and cream of tartar in all the water. Thoroughly wet the wool before putting it in the mordant bath and squeeze out all excess water. Bring the solution with the wool to the boil, letting it simmer for 1 hour. Every now and then, turn the wool gently in the solution to ensure even penetration. Remove it from the heat and allow it to cool naturally, leaving the wool in the solution overnight. Next day, remove the wool, squeeze out all excess water and store, rolled in a dry towel until it is needed for dyeing. Do not rinse before dyeing.

To mordant cotton with ALUM **use the following recipe.**

1 lb cotton, 4 oz alum, 1 oz washing soda (sodium carbonate) and 4 gallons of water.

Dissolve the alum and soda in all the water. Thoroughly wet the cotton and squeeze out excess water. Add the cotton to the solution and bring to the soil, simmering for 1 hour. Remove from the heat and allow to cool naturally, leaving the cotton in the solution overnight. Next day remove the cotton and store as for wool.

Sometimes alum is used with tannin which has the effect of enhancing the dye colour. It is only really suitable for cotton and the process takes three days to prepare.

To mordant cotton with ALUM **and** TANNIN **use the following recipe.**

1 lb cotton, 8 oz alum, 2 oz washing soda and 1 oz tannic acid (or 1 oz powdered oak galls). Dissolve half the alum and half the soda in 4 gallons of water. Thoroughly wet the cotton in water, squeeze out all excess water and add it to the solution. Slowly heat the mixture to boiling point, simmering for 1 hour. Allow the cotton to remain overnight in the solution. Next day, remove the cotton, squeeze out all excess water and add to a solution of all the tannic acid in 4 gallons of water. Heat the solution to 140°–160°F and keep it at this temperature for 1 hour. Allow it to cool naturally after removing from the heat and allow the cotton to stand overnight in the solution. Next day, dissolve the remaining alum and soda in 4 gallons of water and repeat the heating and cooling process, allowing the cotton once again to stand overnight. Finally store as described above.

(2) CHROME *(Bichromate of Potash, Potassium Bichromate)*

To mordant wool with CHROME, **use the following recipe:**

1 lb wool, ½ oz chrome and 4 gallons of water.

Thoroughly dissolve the chrome in all the water and follow as for alum, except that added care is needed to keep the light away from the wool, not only while it is in the mordant solution, but also afterwards until it is needed. To prevent the light entering the mordant bath, cover it with a lid of some description. Store in complete darkness.

To chrome cotton, follow the same method as for cotton using the same recipe as for wool (above).

(3) TIN *(Stannous Chloride, Muriate of Tin)*

TIN **is not suited to mordanting cotton on its own and so the following recipe is for wool:**

½ oz tin, 2 oz cream of tartar and 4 gallons of water.

Follow the same method as described for mordanting with alum. Tin can be used in conjunction with alum, to give bright colours especially bright reds and yellows. Never over-do the use of tin as it can make wool fibres brittle.

(4) IRON *(Ferrous Sulphate, Copperas)*

This mordant is used after the fabric or yarn has been part-dyed. Use the following recipe:

1 lb wool/cotton, ½ oz iron, 2 oz cream of tartar and 4 gallons of water.

Add the material to the dye bath and bring it to the boil, simmering for ½ hour. Remove the material and add the iron and cream of tartar to the dye solution, thoroughly dissolving them in the dye solution. Return the wool to the dye bath and continue to simmer it for another ½ hour. This process is known as 'SADDENING'.

EXTRACTING THE DYE AND DYEING

There are a number of ways to remove the colour from the various plants, barks, fruit etc. We have described the three easiest ways. A mortar and pestle, or some other crushing device is helpful, e.g. a hammer and bread board.

1ST METHOD Thoroughly bruise or crush the dyestuff and place it in a stainless-steel saucepan, bucket or pot. (As a general rule use about 1 lb of dyestuff to every 1 lb of yarn or fabric.) Pour boiling water over the dyestuff until everything in the pot is well covered. Allow the dyestuff to steep in the water for three days, giving it a good stir each day. At the end of the three days, strain the contents of the pot through a piece of muslin into the dye bath. Before entering the yarn or fabric to the dye bath, thoroughly wet it and squeeze out all excess water. Bring the dye bath to the boil and simmer for 1 hour. (If there is not enough water/dye solution to cover the material completely, top up with clean water until it does so.) Never overboil yellow dyes as this tends to dull the colours. On the other hand, some colours may need longer boiling than ½ hour. Remember that the colour of the material in the dye bath will always be darker than when the material is dry, so always dye to a slightly darker colour than that which is desired.

2ND METHOD Place the bruised or crushed dyestuffs in a large stainless-steel pot and cover it adequately with cold water. Bring the pot to the boil and simmer for ½ hour. Allow to cool and then strain through muslin into the dyebath. For actual dyeing, follow the method described above.

3RD METHOD Place the bruised or crushed dyestuffs in a stainless steel or glass pot and cover with household ammonia. Steep for three days as described in the first method. Strain the contents of the pot through muslin into the dye bath and after thoroughly wetting the fabric or yarn, and squeezing out all excess water, add it to the ammonia solution. Leave the contents of the pot in a warm place for three days, or heat it to a temperature of (140° F) and keep at that heat for 1 hour. The colours obtained from using ammonia will be extremely vibrant, but the set-back is the awful smell. If you can stomach the stench of ammonia, then go ahead and try it. Remember to thoroughly rinse the dyed material after it has been removed from the dye bath.

SYNTHETIC DYEING

There is a vast range of chemical dyes available these days for with the ever-increasing production of new man-made fibres, dyes are made especially to suit them. However, not only can synthetic dyestuffs be used to dye man-made fibres, but also for natural fibres such as wool, silk and cotton. Because of the complexity of the synthetic range, we have chosen the major groups of dyes which will be more than adequate for the average needs.

Acid Dyes *(For dyeing wool, silk, rayon and nylon)*
The trade names of some acid dyes are: Amacid (AC), Calcocid (ACY), Intracid (CKC), Pontacyl (DUP).

METHOD
As with most synthetic dyes, acids are extremely concentrated and the tiniest amount of dye will produce a good strong colour. If synthetic dyes are going to be used quite regularly it will be extremely advisable to get hold of gram-weight scales, with weights from 1 gram up to 100 grams. It is also important to keep a dye book in order to be able to reproduce results. The colour percentage, which you should indicate for each colour sample, is the percentage of the weight of the dye to the weight of the wool or material that was dyed. (An easy way to test on a small scale is to dissolve the dye in water. For instance, if you dissolve 1 gram of dye in 1000 CC of water and use only 50 CC, you are using .05 grams of dye.) The colour percentage is used in the following formula to determine the exact weight of dye needed to dye a particular weight of cloth or yarn to the exact colour of your sample.

$$\frac{\text{Weight of Wool}}{1} \times \frac{\text{Colour percentage}}{100}$$

$$= \textbf{Weight of dye needed.}$$

Having worked out how much dye will be needed for a given weight of wool, dissolve it in a tiny amount of water and add it to the dye bath which should contain enough water to completely cover the material. Add a few drops

of ACETIC acid to the solution. If this reasonably mild acid cannot be got hold of, add a cupful of strong vinegar instead. After thoroughly wetting the material and squeezing out the excess water, add it to the dye bath and bring it to the boil. Once boiling, keep it simmering until the material being dyed has absorbed all the colour in the dye bath, so that the water is clear. When, and only when, the water is clear will the colour be the same as that of the sample in your dye book.

Remove the material from the dye bath and thoroughly rinse it in warm water. With wool, rinse it in hot water.

Direct Dyes *(For dyeing cotton, linen, viscose rayon and some wool)*
These are dyestuffs that need no mordant where vegetable or animal fibres are concerned, i.e. cotton, silk, etc.

Some trade names of direct dyes are: Calcomine (ACY), Erie (NAC), Pontamine (DUP).

METHOD
Exactly the same formula and method is used with these dyes as was described for acid dyes.

Reactive Dyes *(For dyeing cotton, wool, viscose)*
This range of dyes includes the famed 'Procion M' which is widely used for 'Tie-dye' and 'Batik'. The formula is split into two parts, being mixed separately, and then the two solutions added to each other. The formula is as follows :

Procion M. Part (a) Urea + water + dye
Part (b) Bicarbonate of soda + soda ash + water.

This is a cold water dyeing process and the solution is only good for two hours, after which it becomes ineffective.

METHOD
The material is first thoroughly wetted and all excess water removed. It should be then put in the dye solution and left there until the colour absorbed is the one required. Remember though, that any material in the dye bath will be darker wet than dry, so allow for this by

66

dyeing to a slightly darker colour than the one desired.

SERVICES

If you have a special problem concerning the use of natural dyes contact :
GWEN MULLINS, Shuttles, Graffham, Petworth, Sussex: *Mrs Mullins is an expert on the use of natural dyes.*

IN THE USA
SOURCES OF MATERIALS

Free catalogs are listed; otherwise write for information.

Natural dyes and mordants:
OWL AND OLIVE WEAVERS, 4232 Old Leeds Lane, Birmingham, Ala. 35213.
THE SHEEP VILLAGE, 2005 Bridgeway, Sausalito, Calif. 94965.
STRAW INTO GOLD, 5550 College Ave., Oakland, Calif. 94618. *Free catalog (send stamped, self-addressed envelope).*
COLONIAL TEXTILES, 82 Plants Dam Rd., E. Lyme, Conn. 06330.
WEAVER'S CORNER STUDIOS, P.O. Box 560125, Miami, Fla. 33156. *Free catalog.*
EARTH GUILD, INC., 149 Putnam Ave., Cambridge, Mass. 02139. *Free brochure.*
LAMB'S END, 165 West, 9 Mile, Ferndale, Mich. 48220.
THE SPINSTER, 34 Hamilton Ave., Sloatsburg, N.Y. 10974. *Free catalog.*
ARACHNE WEBWORKS, 2390 N.W. Thurman, Portland, Oreg. 92710.
BLACK SHEEP WEAVING AND CRAFT SUPPLY, 318 S.W. Second St., Corvallis, Oreg. 97330.

Chemical dyes (including Procion M dyes, now called Procion MX)
GLEN BLACK, 1414 Grant Ave., San Francisco, Calif. 94133. *Free brochure.*
NASCO WEST, P.O. Box 3837, Modesto, Calif. 95352. *Free catalog.*
KEYSTONE INGHAM CORP., 13844 Struikman Rd., Cerritos, Calif. 90701. *Accepts orders for Colorado and west. Free catalog.*
JEAN MALSADA, 18 Peachtree Pl. N.E., P.O. Box 28182, Atlanta, Ga. 30328.

KEYSTONE ANILINE AND CHEMICAL CO., 321 N. Loomis St., Chicago, Ill. 60607. *Accepts orders for east of Colorado. Free catalog.*
EARTH GUILD, INC., 149 Putnam Ave., Cambridge, Mass. 02139. *Free brochure.*
ALJO MANUFACTURING CO., 116 Prince St., New York, N.Y. *Free catalog.*
PYLAM PRODUCTS CO., INC., 95 – 10 218 St., Queens Village, N.Y. 11429. *Free brochure.*
GEORGE WELLS RUGS, INC., 565 Cedar Swamp Rd., Glen Head, N.Y. 11545.
ARACHNE WEBWORKS, 2390 N.W. Thurman, Portland, Oreg. 92710.
FAB DEC, Box 3062, Lubbock, Tex. 79410. *Free brochure.*
NASCO ARTS AND CRAFTS, Fort Atkinson, Wisc. 53538. *Free catalog.*

SOCIETY

HANDWEAVERS GUILD OF AMERICA, 998 Farmington Ave., W. Hartford, Conn. 06107. *Membership ($9 a year) includes access to a textile and slide library and a quarterly magazine, SHUTTLE, SPINDLE & DYEPOT, with "how to" ideas, photos, and diagrams, product reports, book reviews, and suppliers' ads. The guild also publishes a number of pamphlets on the fiber arts and has a representative in every state who can provide local information.*

BIBLIOGRAPHY

CONTEMPORARY BATIK AND TIE-DYE, by Dona Z. Meilach/Crown, New York.
DYE-CRAFT, by Jo Ahern Segal/available for 25¢ from RIT Consumer Service Dept., Best Foods Div., CPC Intl., Inc., 1437 W. Morris St., Indianapolis, Ind. 46206.
DYES FROM PLANTS, by Seonaid Robertson/Van Nostrand Reinhold, New York.
DYE PLANTS AND DYEING/available for $1.50 from Brooklyn Botanic Garden, Brooklyn, N.Y. 11225.
NATURAL DYES AND HOME DYEING, by Rita J. Adrosko/Dover, New York.
NATURAL PLANT DYEING/available for $1.50 from Brooklyn Botanic Garden, Brooklyn, N.Y. 11225.
SPIN, DYE, AND WEAVE YOUR OWN WOOL, by Molly Duncan/Sterling, New York.

TIE AND DYE, by Anne Maile/Ballantine,
New York.
THE USE OF VEGETABLE DYES, by Violetta
Thurstan/Dryad, Northgates, Leicester;
available from Museum Books, 48 E. 43 St.,
New York, N.Y. 10017.
VEGETABLE DYEING, by Alma Lesch/Watson-
Guptill, New York.
YOUR YARN DYEING, by Elsie Davenport/
Select Books, Pacific Grove, Calif.

Man's life is laid in the loom of time
To a pattern he does not see,
While the Weaver works and the shuttles fly
Till the doom of Eternity.

ANONYMOUS

WE WOULD have liked to devote a good deal more time to weaving than has actually happened as this is an important craft, not just because it is a logical end to the processes of spinning and dyeing wool or other fibres, but because it has such enormous possibilities in terms of what can be done creatively with threads and yarns. In the end, it was decided that just the basic process of what is called 'weaving' should be illustrated and that as much information as possible on further education and sources of materials, etc. would be more useful in such a limited space as this book.

Materials
Literally almost anything can be woven: wool, cotton, silk and linen threads and yarns, raffia, straw, paper, metal threads, strips of felt, old cloth, string, rope, nylon and much else.

The Basic Process
The six diagrams shown here illustrate the most basic of all looms. *(Figs 2–5)* show simple looms made from card with the warp threaded through. Here one would use a large darning

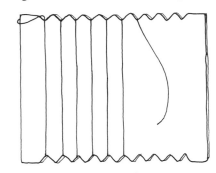

Fig 2

Fig 3

Fig 1

Fig 4

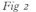

69

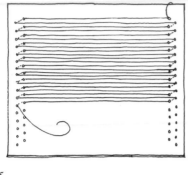

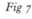

Fig 5

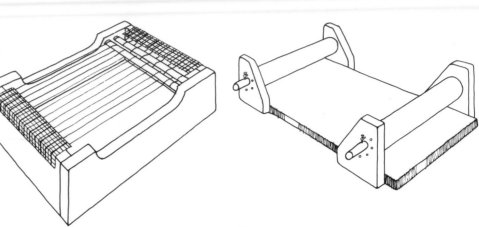

Fig 7

Fig 6

Fig 8

Fig 9

needle to thread through the warp. *(Figs 6 and 7)* show two simple looms constructed from wood. *(Fig 7)* is a box loom and the threads of the warp are wrapped round the outside. With these two looms, a ruler with the weft wrapped round is ideal for passing the yarn back and forth, although a shuttle is the proper piece of equipment to use *(fig 1)*.

In *(figs 8 and 9)* two roller looms are shown. The rollers have the warp threads wrapped round at each end and the weft thread would be passed through in the same way as mentioned above.

With the looms illustrated, although they are extremely simple, a good deal of creative weaving can be achieved. The important thing is to experiment with different threads and patterns and to enjoy what is basically a very simple process.

Terminology

BEAM. The bar or roller stretching across a loom.

BEAMING. The process whereby the warp threads are wound on to the back roller or beam.

BEATER. The piece of a loom which presses down the rows of weft threads.

BEATING. The process of pressing down the weft thread while weaving.

BREAST ROLL. The front beam of a loom.

CANE. A new warp.

CANE ROLL. The back beam of a loom.

CANE STICKS. Sticks used for fastening the warp in a beam.

CARD LOOM. The simplest of all looms; notched cardboard with warp threads wound to and fro over the notches *(see illustrations 2–5)*.

CROSS. A collection of warp threads crossed in the form of a figure of eight to keep them tidy.

CROSS STICKS. Smooth rods for keeping the cross in order.

DAMASK. A style of weaving introduced from Damascus.

DENT. One space between two wires on a reed.

DIAPER. A system of weaving small patterns.

DOUBLING. The winding of two or more threads together.

DRESSING THE LOOM. Setting up the looming in readiness for weaving.

ENTERING HOOK. A thin hook for drawing the warp threads through the eyes in a rigid heddle.

END. A warp thread.

ENDS PER INCH. A standard unit or measure in weaving of warp threads per inch.

EYES. The openings in a rigid heddle through which the warp threads are passed.

GATING. Adjusting a loom.

HAND SHUTTLE. A smooth slat of wood, notched at both ends, for holding the weft thread in order to pass it backwards and forwards between the warp threads (fig 1).

HARNESS. A collection of heddles.

HEDDLE. The metal loop containing the eye through which the warp threads are threaded and by which these threads are raised or lowered in order to pass through the weft thread. One of the simplest arrangements on a loom is with one heddle, where every other warp thread is passed through it. When the heddle is raised, it also lifts up thread numbers 1, 3, 5, 7, 9, 11, etc. and separates them from thread numbers 2, 4, 6, 8, 10 etc. Once raised, the weft thread can be passed through the gap between the two layers of threads. Having passed through the weft thread, the heddle is then lowered and the weft thread passed back through the layers of warp threads. In this way a simple 'under and over' woven fabric is made, commonly known as a 'tabby weave'.

JACQUARD. A loom invented by M. Jacquard and used in pattern weaving.

LOOM. Any device whereby a warp is supported and kept in order for weaving.

LOOP. A doubled over length of thread.

PATTERN DRAFTING. A plan in diagram form for warp threading.

PICK. A single row of weft.

REED. A comb-shaped device for keeping the warp ends in order and for beating the weft threads together.

REED HOOK. A thin hook for drawing the warp ends through the reed.

SELVAGE. The edge of the woven cloth.

SHAFT. The frame upon which the heddle or heddles are threaded.

SHED. An opening between the two layers of warp ends through which the weft thread is passed.

SLITS. Alternating openings in a heddle between the eyes through which the warp ends are passed.

SPACING. Arranging threads in groups.

SPREADING. The process of laying out the warp threads to a set pattern for weaving.

TABBY. A plain weave, i.e. under and over.

TAKE UP. The process of gradually winding on the woven cloth to the breast beam.

TAPESTRY. Tabby weaving, in mosaic using a loose weft.

TARTAN. A material striped in warp and weft.

TIE UP. The process whereby the warp ends are tied to the front roller or breast beam.

TWILL. A material which has a diagonal effect produced by the movement of the weft threads during weaving.

WARP. The longitudinal threads tied taut on to a loom.

WARP HOOK. See Entering Hook.

WARP STICKS. Smooth wooden pieces of wood, slat shaped which are placed between the warp threads during the process of tying the warp on to the cane roll or back beam of the loom.

WARPING. Preparing a warp.

WARPING-MILL. A device for warping large warps.

WARPING BOARD. A device, namely a frame or board with pegs inserted around which the warp threads are wound.

WEB. A piece of finished weaving.

WEAVE. The end result of interlacing ends and picks, i.e. warp and weft.

WEFT. The crossing thread of a warp.

YARN. Thread of any description. There are several basic yarns of which seven have been illustrated below.

(a) SPIRAL or CORKSCREW. Consists of a fine thread interfolded with a coarse thread.

(b) GIMP. Consists of a single tightly twisted core over which a loosely twisted thread has been folded.

(c) KNOT. Consists of a single twisted thread.

(d) SLUB. A thread spun tight and loose at regular intervals which produces 'bumps' in the yarn.

(e) SPIRAL SLUB. A twisted slub yarn.

(f) GIMP SLUB. A single twisted core over which a slub yarn has been folded.

(g) LOOP. An intertwining of a single fine thread and a loose thicker thread, played out at regular intervals to produce loops.

SERVICES

For any special information concerning weaving contact the following people who are experts in this field:

TADEK BEUTLICH, Gospels, Beacon Road, Ditchling, Sussex. *For information relating to man-made fibres.*

HILDA BREED, Flansham Cottage, Cootham, Pulborough, Sussex.

RUTH HURLE, 47 East Street, Saffron Walden, Essex.

MARIANNE STRAUB, c/o The Textile Department, Royal College of Art, Kensington Gore, London.

WEAVING STUDIOS TO VISIT

ENGLAND

Cambridgeshire

SPEEN WEAVERS & SPINNERS, Speen, Aylesbury. Tel. Hampden Row 303. Nearest towns, High Wycombe, Great Missenden, Princes Risborough

Hand-woven rugs, silks, linens, wools and cottons. Cot and full-sized blankets. Tapestries and tweeds.

Open daily, Saturday and Sunday inclusive, but please telephone before morning visit.

FENWEAVE, 37 & 39 Main Street, Witchford, nr Ely. Tel. Ely 2150.

Country workshop, looms working producing a variety of woollen, silk, linen, and cotton articles. Resident—almost any time.

Cornwall

MOUNT HAWKE WEAVERS, Mount Hawke, Truro. Tel. Porthowan 501. Also at Sloop Craft Market, St Ives and Barbican, Penzance

All articles hand-woven. Comprehensive range in modern colours includes floor-rugs, bedspreads, tweeds, evening-dress materials.

Weavers can be seen at work. Open every day.

VANESSA ROBERTSON, Chy-an-gwyador, Bojewyan Stennack, Pendeen, Penzance.

Hand-loom weaver, natural fibres and vegetable dyes.

Visitors by appointment only.

TWEENSTREAM WEAVERS, Tweenstream, Lowerton, nr Helston. Tel. Helston 2411 (03-265 2411).

Tweeds in exclusive colour blends, suit and skirt lengths, stoles and scarves, etc. Woven on the premises by the owners from yarn spun and/or dyed in Scotland.

Always open. Local road plan supplied on request to prospective visitors.

Cumberland

F. B. MERCER, Eastern Cottage, Hallbankgate, Brampton. Tel. Hallbankgate 309.

A craft producer of hand-woven tweeds suitable for ladies' skirts and costumes. Every process from weaving to finishing carried out entirely by hand.

Visitors welcome any time but advisable to ring as this is a one-man cottage industry.

Devonshire

THE BOVEY HANDLOOM WEAVERS (Angus Litster), 1 Station Road, Bovey Tracey. Tel. Bovey Tracey 3424.

Tweeds, ties, scarves, rugs and stoles, all in pure, new wool.

9 am–5.30 pm. Early closing 1 pm Wednesday.

AUNE VALLEY WEAVERS, Aveton Gifford, Kingsbridge. Tel. Loddiswell 240. On the main road from Kingsbridge to Plymouth.

A large selection of local and other tweeds, knitwear, sheepskin rugs, gloves, slippers.

Dorset

J. & N. WHITAKER HALL, Thursley, 26 High Park Road, Broadstone. Tel. Broadstone 3522.

Hand-weaving : ties, scarves, stoles, shawls, rugs, trolley-cloths, table-mats, cushion-covers, etc.

Visitors welcome 10 am–1 pm and 2.30 pm–5.30 pm most days, but please phone for appointment.

Essex

URSULA BROCK, Tolleshunt D'Arcy Hall, Maldon. Tel. Tolleshunt D'Arcy 225.

Hand-woven Jacquard silks.

By appointment.

Lincolnshire

NOELLE M. BOSE, 'Westoby', West End, Winteringham, nr Scunthorpe DN15 9NS. Tel. Winterton 729.

Hand-woven floor-rugs, knee-rugs, shoulder-bags, cushion-covers, table-mats and pram-covers. Curtain material tweed.

Visitors welcome any time.

Oxfordshire

JEAN ROBERTS, 110 Newland, Witney. Tel. Witney 5218.

Hand-woven floor rugs.

Resident, but best phone first.

VARDOC FABRICS LTD, Church Lane, Old Marston, Oxford. Tel. Oxford 42515.

Hand-loom and power-loom weavers. Pure wool neckties and head-squares.

9 am–5 pm Monday to Friday.

Suffolk

PETER COLLINGWOOD, Old School, Nayland, nr Colchester. Tel. Nayland 401.

Hand-woven floor-rugs, wall-hangings.

Any time, any day.

MARY JANE TOULSON, The Cottage, Old Street, Haughley, Stowmarket. Tel. Haughley 391.

Hand-woven floor-rugs and wall-hangings.

Resident.

Westmorland

FABRICATIONS, Design & Weaving Studio (Mr Neil Galloway), Grasmere.

Exclusive range of cloth designed and power woven in Grasmere by Neil Galloway. The latest range includes a selection of designs produced in the undyed natural colours of the Herdwick Sheep, native to the Lake District. A new workshop will be in production early in 1973.

HAND-LOOM WEAVER, Old Coach House, Grasmere (Chris Reekie & Sons). Tel. Grasmere 221.

Hand-weaving done on premises. Exclusive colours and designs. Mohair rugs, scarves, stoles a speciality.

Open every day.

Wiltshire

BEROWALD INNES, Pinkney Pound, nr Sherston, Malmesbury. Tel. Sherston 373.

Specialists in the hand-weaving of floor-rugs and wall-hangings, and also the working of heraldic embroidery (wool on canvas).

Resident (except from Christmas till Easter). Almost always in but advisable to telephone if possible.

WHITE HORSE SPINNERS AND WEAVERS (AUDREY & CLEMENT CHARLES), Beech Bank, Bratton, nr Westbury. Tel. Bratton 382.

Floor-rugs (mostly from hand-spun yarn), tweeds, etc. Hand-spun/hand-knitted sweaters. Tie-dyed pure silk squares and scarves, also hand-made buttons from local woods. Potpourri made from old English recipes.

Open normal business hours (prior notice of arrival appreciated). Week-ends by appointment.

Yorkshire

BRONTE TAPESTRIES, Storr Heights, Thornton, Bradford. Tel. Thornton 2409. STD 027484 2409.

A group of hand-loom weavers working in the village of Thornton, making a wide selection of hand-woven articles ranging from ties to tapestries, all kinds of clothing available in rich subtle colours and the most attractive range of rugs you have ever seen.

Open all days, telephone if possible week-ends. Colour brochure available on request, send S.A.E.

GREWELTHORPE HANDWEAVERS, Grewelthorpe, Ripon. Tel. Kirkby Malzeard 209.

A true country workshop in a 200-year-old barn. Fine worsted cloth hand-woven on the premises by Janie and Malcolm McDougall on their specially designed hand-loom. Browse round the craft-shop which contains the selected work of over 50 accredited craftsmen in all fields.

Open from 9 am to 6 pm or until dusk, whichever is later, all year including Sunday (closed Monday).

LOTTE PHILLIPS, 3 Cliffe Ash, Golcar, nr Huddersfield. Tel. Huddersfield 54321.

Individually designed, well-made, hand-woven articles: ties, belts, scarves, shoulder-bags, cushions, tabards, tonags, etc.

Any time, including evenings and week-ends, but please telephone first.

WALES

Breconshire

CAMBRIAN FACTORY LTD, Llanwrtyd Wells. Tel. Llanwrtyd Wells 211.

Welsh tweeds, rugs, head-scarves, ready-made skirts, skirts and gents' suits to measure, scarves, knitting-wool, socks, ties, tweed purses and handbags, blankets, quilts.

Monday to Friday, 8 am 5.30 pm; Saturday, 9 am–12 noon, 9 am–4.30 pm July to Sept.

Caernarvonshire

BRYNKIR WOOLLEN MILL, Golan, Garndolbenmaen, North Wales LL51 9YU. Tel. Garndolbenmaen 236.

Pure wool tapestry and honeycomb bed-covers, tweeds, flannels and tapestry cloth, small woollen gifts and knitting wool carded, spun and woven on the premises.

9 am–5 pm Monday to Friday. 9 am–noon Saturday in Summer.

HANNAH JONES LTD, Welsh Woollen Mills, Penmachno, Betws-y-Coed. Tel. Betws-y-Coed 352.

Pure wool tweeds, tapestry cloth, tapestry quilts, tailored garments, craft goods.

Mill open to the public all year round Monday to Friday, 9 am–4.30 pm.

Mill Shop open all year round Monday to Friday, 9 am–6 pm. Also on Saturday and Sunday during the Summer months.

TREFRIW WOOLLEN MILLS LTD, Vale of Conway Woollen Mills, Trefriw. Tel. Llanrwst 640462.

Manufactures from the raw wool of hand-knitting wools, travelling-rugs, tapestry and honeycomb quilts, plain and cellular blankets, tapestry and tweed by the yard.

Mill and Shop Monday–Friday 8 am–4.45 pm. Shop only Saturday 10 am–4 pm. Sundays in July and August 2.30 pm–5 pm.

Cardiganshire

CURLEW WEAVERS (GIL & KAY POULSON), Troedyraur Old Rectory, nr Rhydlewis. Tel. Rhydlewis 357.

Individual tweed, lightweight evening and wedding-dress fabrics; lightweight travel-rugs and bedspreads; ties and men's jackets; Curlew Tweedster clothes; puppets and numerous small articles; co-ordinated curtain and upholstery materials.

Visitors welcomed 8 am–5 pm Monday to Friday.

LERRY TWEED MILLS, Lerry Mills, Talybont. Tel. Talybont 235.

Manufacturers of hand-woven and home-spun tweeds. Stockists of tapestry quilts, tapestry cloth, rugs, blankets, small gifts and tapestry clothes.

Shop: 9 am–6 pm Monday to Saturday, Afterwards by appointment. Mill: 9 am–12.30 pm, 1.30 pm–5 pm Monday to Friday.

JOHN MORGAN & SON, Woollen Manufacturers, etc, Rock Mills, Capel Dewi, Llandysul. Tel. Llandysul 2356.

Blankets, tapestry quilts, table-mats, cushion-covers, tea-cosies, men's socks and stockings and other Welsh crafts.

Carmarthenshire

CAMBRIAN MILLS (FELINDRE) LTD, Dicfach, Felindre, Llandyssul. Tel. Felindre 209.

Blankets, quilts, honeycomb quilts, tapestry quilts, tapestry coats, gents' tweed ties, flannels, shirtings and traditional designs, ladies' and gents' shirts (made on premises), motor-rugs, head-squares, scarves and aprons.

Showrooms are open from Monday to Friday 8 am–5 pm and by appointment.

CORGI HOSIERY LTD, Ammanford. Tel. Ammanford 2104.

Hand-framed Intarsia botany, shetland, lambs-wool and cashmere knitwear and hosiery. Welsh tapestry, tweed or flannel hand-tailored garments, made to measure.

Visitors welcomed 8 am–4.15 pm.

CWMDUAD WOOLLEN MILLS, Cwmduad. Tel. Conwil Elfet 337.

Wide range of tapestry clothing, including capes, skirts and anoraks. Tapestry handbags and purses, sheepskin rugs, hats, gloves and slippers.

9 am–6 pm including Sunday.

JOHN JONES (DERW) LTD, Derw Mills, Pentrecourt, Llandysul. Tel Llandysul 3361.

Pure new wool tapestry quilts, tapestry cloth, lightweight worsted flannels and tapestry clothes, car-rugs, floor-rugs, blankets.

9 am–5 pm Monday–Friday.

D. LEWIS & SONS LTD, Rhydybont Mills (Est 1830), Llanybyther. Tel. 97/285.

Tapestry garments, quilts, blankets, tweeds, flannels, floor-rugs, gifts.

Merionethshire

THE WEAVER'S LOFT, Jubilee Road, Barmouth.

Weavers of pure new wool tapestry cloth. Stockists of tweed and flannel by the yard; clothing, tapestry bed-covers.

Weaving from 9 am–5 pm. Shop open 9 am–9 pm (7 days in Summer).

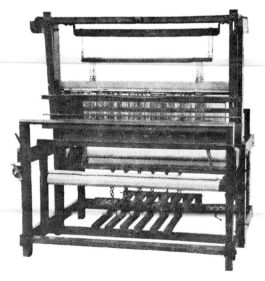

Harris loom

73

Pembrokeshire

WALLIS WOOLLEN MILL, Ambleston, nr Haverfordwest. Tel. Clarbeston 297.
Traditional fabrics, wide range of colours and designs, to International Woolmark standards. Tapestry bedspreads approved by Design Centre. High-class dressmaking at mill. Coats, capes, dresses, handbags and purses, etc. Shop at mill. Monday to Friday 10 am–6 pm.

SCOTLAND

Aberdeenshire

RUSSELL GURNEY WEAVERS, Brae Croft, Muiresk, Turriff AB5 7HE. Tel. Turriff 3544.
Exclusively designed hand-woven tweeds, dress materials and suitings in traditional and modern colour ranges. Estate checks designed. Hostess skirts in brushed worsted, lambswool, etc. Scarves and rugs, cushion covers in overshot patterns. Visitors welcome any time but telephone to avoid disappointment.

Dumfriesshire

MOFFAT WEAVERS, Mill, Ladyknowe, Moffat. Shop: High Street, Moffat. Tel. Moffat 20134.
Tweed, tartan, scarves, ties, knitwear, woollen and mohair rugs.
Mill: 7 days per week, 9 am–5 pm.
Shop: 6 days per week, 9 am–6 pm, Sunday 10.30 am–6 pm.

Renfrewshire

AGNES HAMILTON, Monica Hardie (Handloom Weavers), Pilmuir Farm, Newton Mearns. Tel. 041-639 1845.
Interesting and unusual designs of soft and floor-rugs, scarves, stoles, shawls and table-mats. Specialising in exclusive hand-woven christening-shawls.
10 am–6 pm (week-ends if requested).

NORTHERN IRELAND

Down

GERD-HAY-EDIE, FSIA, Mourne Textiles Ltd, Old Killowen Road, Rostrevor, Newry. Tel. Rostrevor 373.
Hand-woven tweeds; top-grade fashion for dresses, suits and coats. A few rugs, bedspreads and tweed curtains.

74

9 am–5.30 pm. Looms working five days a week. Saturday by appointment only, by phone.

IN THE USA

SOURCES OF MATERIALS

Most weaving supplies can be obtained from your local crafts shop. You may also want to try some of the suppliers from these lists or from the end of the chapter on spinning. (Free catalogs are listed; otherwise write for information.

Looms and other weaving equipment:
YARN DEPOT, INC., 545 Sutter St., San Francisco, Calif. 94102.
THREADBARE SHOP, Heritage Sq., Golden, Colo. 80401. *Free brochure.*
LOOMS AND LESSONS, c/o Ruth Nordquist Myers, 6014 Osage Ave., Downers Grove, Ill. 60515. *Free brochure.*
EARTH GUILD, INC., 149 Putnam Ave., Cambridge, Mass. 02139. *Free brochure.*
NORWOOD LOOM CO. AND WEAVING SHOP, Baldwin, Mich. 49304. *Free brochure (send stamped, self-addressed envelope).*
LECLERC CORP., Box 491, Plattsburg, N.Y. 12901. *Free catalog.*
ROBIN & RUSS HANDWEAVERS, 533 N. Adams St., McMinnville, Oreg. 97128.

Yarns of various kinds (including mohair, flax, chenille, cotton, spun wool and handspun wool, rya, imported yarns, cotton, camel's hair, and linen) and other weaving supplies.
CREATIVE HANDWEAVERS, P.O. Box 26480, Los Angeles, Calif. 90026.
THE HANDWEAVER, 111 E. Napa St., Sonoma, Calif. 95476.
NATURALCRAFT, 2199 Bancroft Way, Berkeley, Calif. 94704.
CONTESSA YARNS, P.O. Box 37, Lebanon, Conn. 06249.
YARN PRIMITIVES, P.O. Box 1013, Weston, Conn. 06880. *Free catalog.*
MEXISKEINS, P.O. Box 1624, Missoula, Mont. 59801.
FRED GOLDFRANK, 1421 Arlington St., Mamaroneck, N.Y. *Free samples.*

HENRY'S ATTIC, 81 Park Terrace W., New York, N.Y. 10034.
TAHKI IMPORTS, 336 West End Ave., New York, N.Y. 10023. *Free catalog.*
COLONIAL WOOLEN MILLS, INC., 6501 Barberton Ave., Cleveland, Ohio 44102.
LENOS HANDCRAFTS, 2037 Walnut St., Philadelphia, Pa. 19103. *Free brochure.*
CRAFT YARNS OF RHODE ISLAND, 603 Mineral Spring Ave., Pawtucket, R.I. 02862. *Free catalog.*
MAYATEX, 117 N. Concepcion, El Paso, Tex. 79115. *Free catalog.*
MAGNOLIA WEAVING, 2635 29th Ave. W., Seattle, Wash. 98199.
PAULA SIMMONS, Box 12, Suquamish, Wash. 98392.

SOCIETY

HANDWEAVERS GUILD OF AMERICA, 998 Farmington Ave., W. Hartford, Conn. 06107.
Membership ($9 a year) includes access to a textile and slide library and a quarterly magazine, SHUTTLE, SPINDLE & DYEPOT, with "how to" ideas, photos, and diagrams, product reports, book reviews, and suppliers' ads. The guild also publishes a number of pamphlets on the fiber arts and has a representative in every state who can provide local information.

BIBLIOGRAPHY

THE ART OF WEAVING, by Else Regensteiner/Van Nostrand Reinhold, New York.
BYWAYS IN HANDWEAVING, by Mary M. Atwater/Macmillan, New York.
CARD WEAVING, by Candace Crockett/Watson-Guptill, New York.
CREATIVE DESIGN IN WALL HANGINGS, by Lili Blumenau/Textile Book Service, Plainfield, N.J.
A HANDBOOK OF WEAVES, by G. H. Oelsner/Dover, New York.
SIMPLE WEAVING, by Marthann Alexander/Taplinger, New York.
STEP-BY-STEP WEAVING, by Nell Znamierowski/Western, Racine, Wisc.
THE TECHNIQUE OF WOVEN TAPESTRY, by Tadek Beutlich/Watson-Guptill, New York.

WEAVING IS FOR ANYONE, by Jean Wilson/ Van Nostrand Reinhold, New York.
WEAVING YOU CAN WEAR, by Jean Wilson/ Van Nostrand Reinhold, New York.

Weaving Pattern Books
A HANDWEAVER'S PATTERN BOOK, by M. Davidson/Spencer International, New York; available from The Unicorn, Box 645, Rockville, Md. 20851.
HANDWEAVING PATTERNS FROM FINLAND, by Pyssalo and Merisato/Branford, Newton Centre, Mass.
NEW KEY TO WEAVING, by Mary Black/Bruce (Macmillan), New York.
RECIPE BOOK, by Mary M. Atwater/ Macmillan, New York; available from Museum Books, 48 E. 43 St., New York, N.Y. 10017.

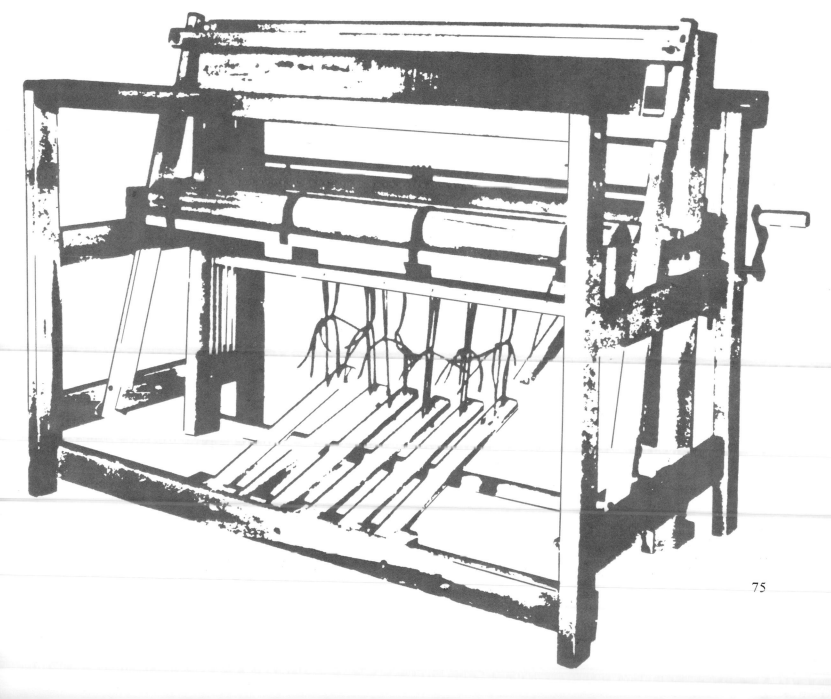

We are going to describe five methods of producing a rug and the method chosen must be determined on the economical factors involved. For instance, if a rug is needed quickly, without any loss of creativity in the design, then the woven technique or machine tufting technique may be the answer, even more so if rugs are to be produced commercially. Hand-made rugs always tend to take rather a long time to make so bear this in mind, unless a number of people can get together communally and work on the same rug. There is no reason why the various techniques shouldn't be mixed together, e.g. machine tufting and embroidered rugs.

Handworked Pile Rug

There are various methods of working a wool pile rug but the common way is to hook the wool pieces through the rug canvas or hessian to give a series of small tufts which collectively form a pile. The canvas or hessian takes the place of the warp and weft threads in a woven carpet. Special rug canvas can be purchased which is usually marked up in squares every 8 ridges so that the design to be worked can easily be translated from the design sheet to the canvas, rather like the way one uses graph paper. Special rug wool can be obtained already cut to the required length (about 2 inches) from craftshops, but it is a very expensive way to buy wool and bulk buying from a mill or wool supplier is far more economical. Also, by obtaining unbleached wool in bulk, it can be dyed any colour your design requires.

Method

Assuming bulk wool has been purchased, the first job is to cut it into 2 inch lengths. This can simply be done by binding the wool round a long slat of 1 inch wood and then cutting down the middle *(fig 1)*.

MAKING RUGS

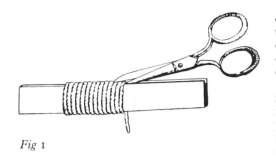

Fig 1

The pieces of wool are worked into the canvas or hessian with a special rug hook which pulls the wool through and knots it in one process. There are a number of different types of hook on the market. One type is like an ordinary crochet hook with a movable latch which prevents the hook from catching when drawn back through the canvas. Another type

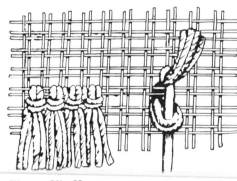

Fig 2 Slip Knot

is similar in action to a pair of pliers incorporating a simple device which knots the wool on the canvas in one go. Both are easy ways of producing what is simply a slip knot *(fig 2)*.

If a fine wool is being used then every hole in the canvas should be worked but if the normal 2 ply—cable wool is used, it may be knotted every alternate hole, depending on the thickness of pile desired. Try experimenting with different thicknesses of wool together in one rug, even string and other material can be knotted. After drawing out the design of the rug on the canvas (ink is best to mark the canvas) begin to work the wool. (If the canvas has any raw edges it may be best to turn in the

ends 1½ inches and work through the two thicknesses.) Work systematically from one end of the rug to the other. The following diagrams show how the wool is knotted on the canvas.

It will be found easier to work on a flat surface like a table and knot in rows from left to right so this leaves the finished part nearest yourself. When the rug is finished, back it with a close woven hessian. This can be done by either glueing with a P.V.A. medium, or sewing. In either case, the hessian must be turned in at the edges for 2 inches to form a clean edge.

Embroidered Rug

A heavy jute canvas is used here and worked with tapestry stitches. The finished product is a hard-wearing rug and uses about ¼ lb of wool per square foot. Some good stitches to use are: cross stitch, knotted stitch and chain stitch *(figs 3, 4 and 5)* but there are others worth experimenting with.

Fig 3 Cross Stitch

The rug can be backed in the same way as for hand-worked pile rugs, or left as it is and edged with blanket stitch *(fig 6)*.

Needlewoven Rug

These are quick and easy to make and are

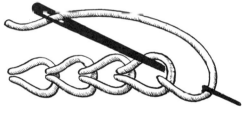

Fig 4 Knotted Stitch

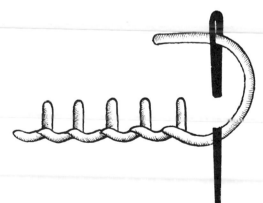

Fig 5 Chain Stitch

Fig 6 Blanket Stitch

strongly recommended for economic reasons. The work is normally done on heavy woollen material or jute. Basically, some of the warp or weft threads are removed and replaced by new ones using rug wool. If threads are removed at even distances then rather a fine geometric pattern can be built up. A canvas needle is all that is needed for this technique. Back the rug in the normal way or edge with blanket stitch.

Machine Tufted Rug

For those who want to concentrate more on design and who don't fancy long hours of knotting or stitching, then machine tufting may be the answer *(fig 7)*. Although new machines are expensive (about £148), second-hand ones can be got hold of and they are easily repaid in terms of output. Once the knack of using the machine has been mastered, and they are amazingly simple to use, then a 6-foot square carpet can be made in a day from start to finish.

Method

The machine uses wool at a phenomenal rate so that wool must first be wound on to bobbins either bought from a mill, or made at home (toilet rolls are a good thing to use). Always practice first on a scrap of material before attempting an actual rug as the distances between the rows of tufts must be even and of a uniform distance. Experience has shown that about $\frac{1}{8}$ inch is an optimum measurement. Making the rows of tufts too far apart will produce bare patches so watch out for this. Incidently, the machine will not take thick rug wool, knitting wool being about the best sort to use, nor will it take a large area of cloth because of the limited distance between the needle and the machine body. The best material to work on is strong, thick cotton or calico—don't use canvas.

Keep the design as simple and geometric as possible as manoeuvering the cloth is difficult when attempting to break away from straight lines. When the whole rug has been tufted (larger rugs can be made by sewing pieces together) it must be backed with a close-woven hessian or canvas because the machine does not knot, it only pushes the wool through and back again. The backing must be thoroughly glued with P.V.A. medium so be careful to do this part of the operation absolutely thoroughly. Turn in the edges of the backing material before glueing so as to make a clean, even edge.

The Machine Stitched Rug

A special tool that is used to machine-stitch material for rug use can be bought from The Singer Sewing Machine Company. It's called a 'Singercraft Guide' and is basically a two-pronged piece of metal on which the wool is wound evenly, thus enabling a line of machine stitching down to the centre of the two prongs *(see fig 8)*. This binds the wool to the backing material (normally thick cotton or calico for this method) and after machining, the guide is slipped out and the remaining wool loops are cut with a pair of scissors to produce two rows of tufts. This process is repeated over the whole area of the backing material until a solid pile of tufts has been achieved. The rug is then finished off in the normal way, by backing with hessian.

Rag Rug

There are two principle methods of producing a rag rug: in one the rags are pulled through the canvas with a large crochet hook, and knotted with a slip knot as in a handworked pile rug. In the other, the rags are twisted and sewn together or braided. Rag rugs are immensely cheap to make and are beautiful when finished. All sorts of rags can be used and are O.K. left the colours they are or dyed. Some good effects can be obtained by either mixing dyed and undyed rags together in one rug, or by part-dyeing the rags in a dark colour, i.e dark blue or dark brown, so that a whole range of beautiful muted colours are produced by the action of the dye on the existing colours of the rags.

1ST METHOD
Strong, open meshed hessian or sacking is best for a hooked rag rug. After determining the actual size of the rug, allow another 2 inches all round when cutting out the piece of hessian to allow for turning in and hemming. It may be found easier to work the hessian stretched over a wooden frame, but it is not essential. The rags should be cut into $\frac{1}{2}$-inch strips, the length being determined by the depth of pile required (about 2–3 inches).

Have a pile of rag strips on your lap and using a coarse crochet hook, simply hook the strips through, one at a time, to form loops in the hessian. The loops can either be knotted with a simple slip knot, or left as they are (as in a machine tuft) whereby the whole rug must then be firmly glued with P.V.A. medium to a

Fig 7 Tufting Machine

Fig 8 Singer Guide

close-woven hessian or canvas so as to prevent the rags from working their way loose.

It may be a good idea to work the rags with a longer length than the required pile, so that the finished rug can be trimmed with scissors to give an even surface—it all depends on the nature of the pile required.

2ND METHOD

Cut the rags into 2-inch widths. Turn each side of each piece in $\frac{1}{2}$ inch and iron flat; then fold over and hem on a machine so that about 1 inch width strips are formed. This is important as all the frayed edges are then concealed inside. Next, join the strips together end to end so that a number of lengths about $1\frac{1}{2}$ yards long are formed. Until these lengths are used it will be found helpful to wrap them round a cardboard tube to keep them nice and flat.

Take three lengths and begin plaiting them together as one would plait hair (fig 9). It is a good idea to produce a good number of plaits in one go otherwise it becomes a bore breaking off from braiding to produce more plaits. To make the finished rug, simply sew the plaits together in a circle, starting from the middle and working outwards. Use strong waxed thread for sewing. Any size of circular rug can be made by simply working in more and more plaits. Lovely effects can be obtained by playing with colour: for instance, making the centre a dark colour and working out to a bright colour, or by making bands of separate colours. This kind of rug needs no backing.

IN THE USA
SOURCES OF MATERIALS

Yarns can be obtained from the addresses listed at the ends of the weaving and spinning chapters.

Latex rug backing (commonly used in the United States) can be found in hardware stores.

The tufting machine described in this chapter is not available in the United States. However, Jean Malsada (listed below) sells an Electric Rug Hooker, for about $450, which looks like a drill and is driven by air and would serve the same purpose of speed. It

is used by the carpet industry for repairs and for custom designs. Much less expensive (about $13) and still faster than hand, is a tufting tool, which automatically punches and brings back the yarn. Various brands of tufting tool can be found in crafts shops or you can order the Speed Tufting Tool made by Rug Crafters (3895 S. Main, Santa Ana, Calif. 92707) from their catalog.

The Singercraft Guide has been discontinued in the United States, but you can probably order one from the Singer Sewing Machine Company in England (255 High St., Guildford, Surrey).

Punch needles, latchet hooks, shuttle hookers, and regular hooks are sold in the needlework departments of crafts stores, as are canvas, hessian (burlap), jute, and monkscloth. The latter can also be ordered from the following suppliers. (Free catalogs are listed; otherwise write for information.)

SOME PLACE, 2090 Adeline St., Berkeley, Calif. 94703.

TEXTILE CRAFTS, 856 N. Genesee Ave., P.O. Box 3216, Los Angeles, Calif. 90028. *Also has rug frames. Free catalog.*

VALLEY HANDWEAVING SUPPLY, 200 W. Olive Ave., Fresno, Calif. 93728.

JEAN MALSADA, INC., P.O. Box 28182, Atlanta, Ga. 30328.

LAMB'S END, 165 West, 9 Mile, Ferndale, Mich. 48220.

THE MANNINGS, RD#2, East Berlon, Pa. 17316. *Also has rug frames.*

COULTER STUDIOS, 118 E. 59 St., New York, N.Y. 10022.

GEORGE WELLS RUGS, INC., 565 Cedar Swamp Rd., Glen Head, N.Y. 11545. *Also has rug frames. Free brochure.*

CRAFT YARNS OF RHODE ISLAND, 603 Mineral Spring Ave., Pawtucket, R.I. 02862. *Free catalog.*

HOUSE OF KLEEN, P.O. Box 265, Hope Valley, R.I. 02832.

MAGNOLIA WEAVING, 2635 29 Ave. W., Seattle, Wash. 98199.

SOCIETY

HANDWEAVERS GUILD OF AMERICA, 998 Farmington Ave., W. Hartford, Conn. 06107. *Membership ($9 a year) includes access to a*

textile and slide library and a quarterly magazine, SHUTTLE, SPINDLE & DYEPOT, *with "how to" ideas, photos, and diagrams, product reports, book reviews, and suppliers' ads. The guild also publishes a number of pamphlets on the fiber arts and has a representative in every state who can provide local information.*

BIBLIOGRAPHY

THE COMPLETE BOOK OF RUG HOOKING, by Barbara J. Zarbock/Van Nostrand Reinhold, New York.

HOOKED RUGS AND RAG TAPESTRIES, by Ann Wiseman/Van Nostrand Reinhold, New York.

RUGMAKING, by Joan Droop/Branford, Newton Centre, Mass.

STEP-BY-STEP RUGMAKING/Western, Racine, Wisc.

TECHNIQUE OF RYA KNOTTING, by Don Wilcox/Van Nostrand Reinhold, New York.

TECHNIQUES OF RUG WEAVING, by Peter Collingwood/Watson-Guptill, New York.

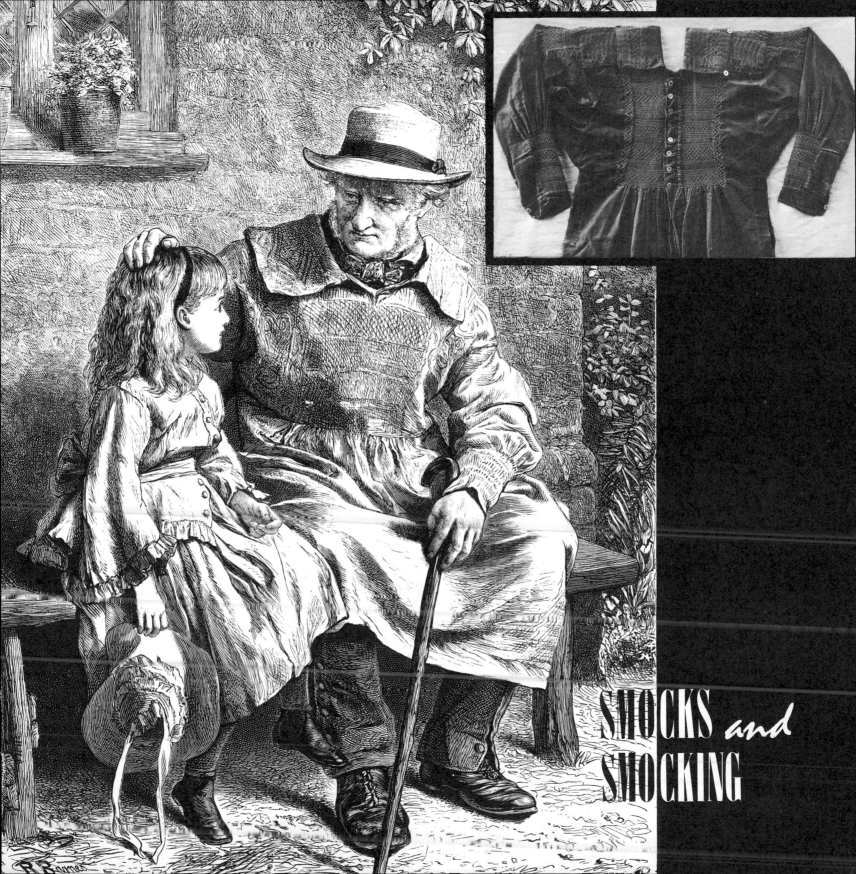

SMOCKS *and*
SMOCKING

THE TRADITIONAL English smock was popular for the very reason that it was a simple garment, easily made, economical in terms of the amount of material needed and above all, very hard-wearing. Since those early days, the smock has always made some sort of a come-back in popularity and has been altered and adapted according to contemporary taste. It is this flexibility and adaptability of the smock to current fashion that makes it so unique, and also the fact that there are a whole range of stitches to personalise each garment so that each one can be completely individual.

SMOCKING

The need of securing and, at the same time, ornamenting gathers in heavy materials (e.g. linen) gave rise to the special form of fancy gathering called 'smocking'. Smock is an old English word for shift or chemise, hence the term 'smocking' came to be applied to the ornamental gathering of the necks of these garments and also of the elaborate, beautifully-embroidered linen 'Smock-Frock' of the field labourers. A great variety of patterns exist, but they are all executed in the same way so one explanation will suffice for all.

Gathering

By 'gathering' the material, i.e. for the neck and sleeves of a smock, is meant the forming of small pleats by drawing up rows of stitching (*fig 1*). The gathers are made by a series of running stitches done very regularly in a straight line, always along the weft of the material. To make it a relatively easy matter in gathering the material, rows of transfer dots can be bought which are ironed on, thus giving a clear guide where to pass the needle and thread. Pick up only a small portion of material at each dot and be very careful to make each gather exactly the same. For each line of dots use one thread which must be knotted at one end to stop it slipping out. The threads once passed through the dots must then be drawn in to produce pleats which are set by placing the material on an ironing board, wrong side

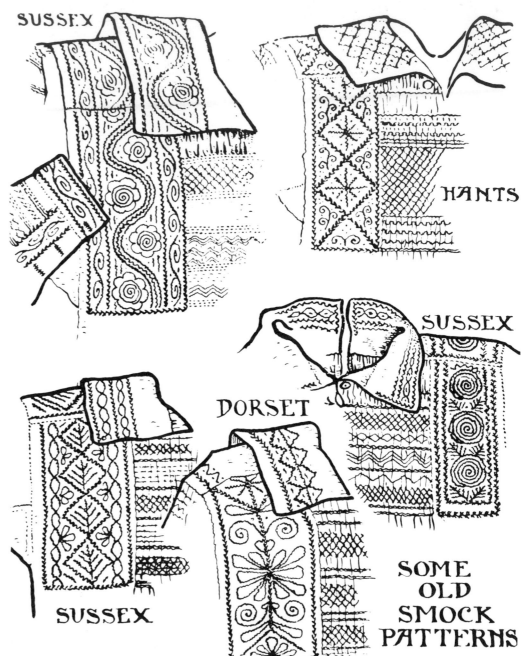

SUSSEX

HANTS

SUSSEX

DORSET

SUSSEX

SOME OLD SMOCK PATTERNS

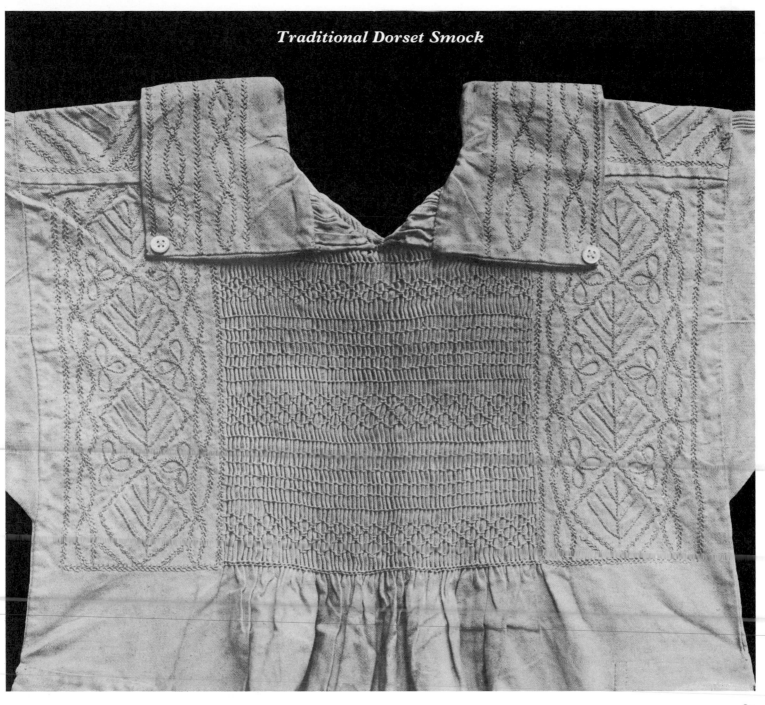

Traditional Dorset Smock

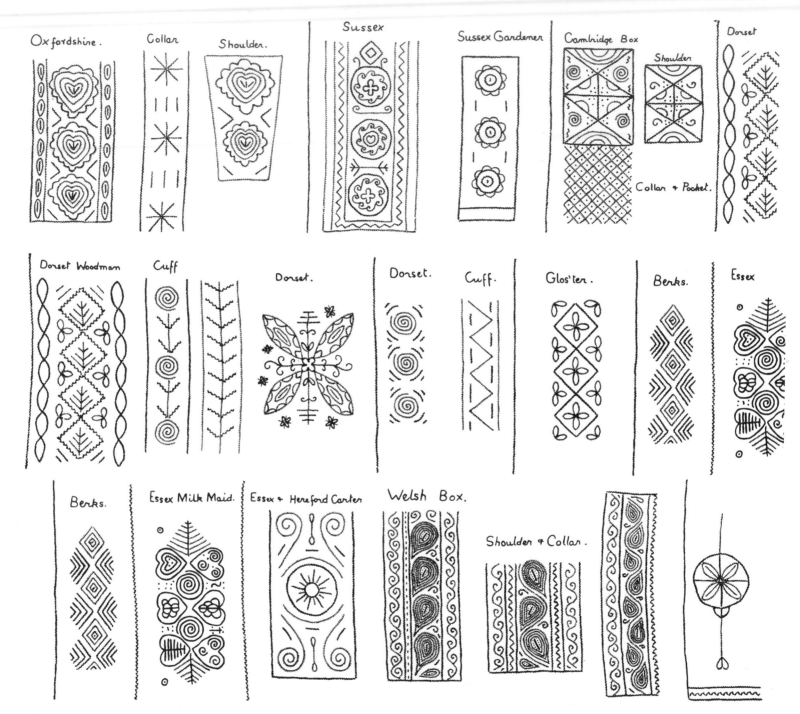

Oxfordshire. Collar Shoulder. Sussex Sussex Gardener Cambridge Box Shoulder Dorset

Collar & Pocket.

Dorset Woodman Cuff Dorset. Dorset. Cuff. Glos'ter. Berks. Essex

Berks. Essex Milk Maid. Essex & Hereford Carter Welsh Box. Shoulder & Collar.

84

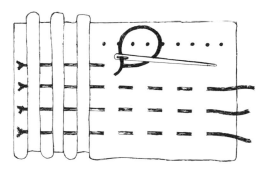

Gathering the Pleats
Fig 1

up, putting a damp cloth over the smocking and passing a hot iron lightly over it. Do not press. The gathering threads are then removed and the material is now ready for the decoration of the gathers, or 'smocking'. Incidentally, a contrasting coloured thread is helpful for gathering, as it makes it easy to see on the material.

Smocking (Design)
It is a good idea to plan out the design of the smocking on paper beforehand to get it nicely proportioned and the colours right. There are lots of pattern variations within the choice of stitches so a little experimentation on a spare piece of material may be helpful. The basic idea is to contrast straight stitches with diagonal stitches for visual interest. Colour combinations are very important too and will be a matter of personal taste, but try to get a good blending harmony of colour which will go well with the background material.

Materials
There are many materials which are suitable for smocking. Traditionally, linen was used but this is an expensive and somewhat heavy fabric. Cottons, poplin, lawn, organdie, silk, shantung, wool and voile are just some of the alternative materials. Avoid textured fabrics as these are difficult to gather.

Thread
Stranded cotton is the standard thread for smocking and is used in different strand thick-

nesses according to the weight of the backing material. For heavy materials such as linen, use four strands together; for standard materials such as cotton use three strands together and for light weight materials such as organdie use 2 strands.

Stitches

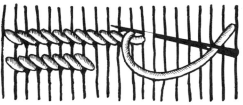

Outline Stitch

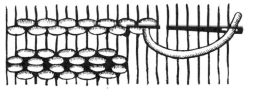

Cable and Double Cable Stitch

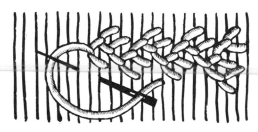

Feather Stitch

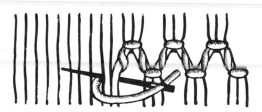

Vandyke Stitch

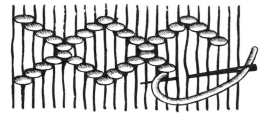

Trellis and Wave Stitch

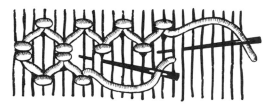

Diamond Stitch

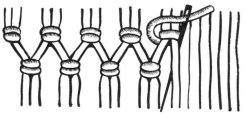

Honeycomb Stitch

IN THE USA

SOCIETY

THE EMBROIDERERS GUILD OF AMERICA, INC., 120 E. 56 St., Room 228, New York, N.Y. 10022. *60 local chapters. Membership ($12 a year) includes* NEEDLE ARTS QUARTERLY, *which has book reviews, articles, news about museum shows, and suppliers' ads. Classes in many forms of embroidery are available for members at the headquarters or by correspondence and the guild has an extensive reference library.*

BIBLIOGRAPHY

ENGLISH SMOCKS, by Alice Armes/Dryad,

Northgates, Leicester; available from Craftool Co., 1421 240 St., Harbor City, Calif. 90701.
SMOCKING, Leaflet No. 131/Dryad, Northgates, Leicester; available from Craftool (see above).
SMOCKING IN EMBROIDERY, by Margaret Thom/Drake, New York.

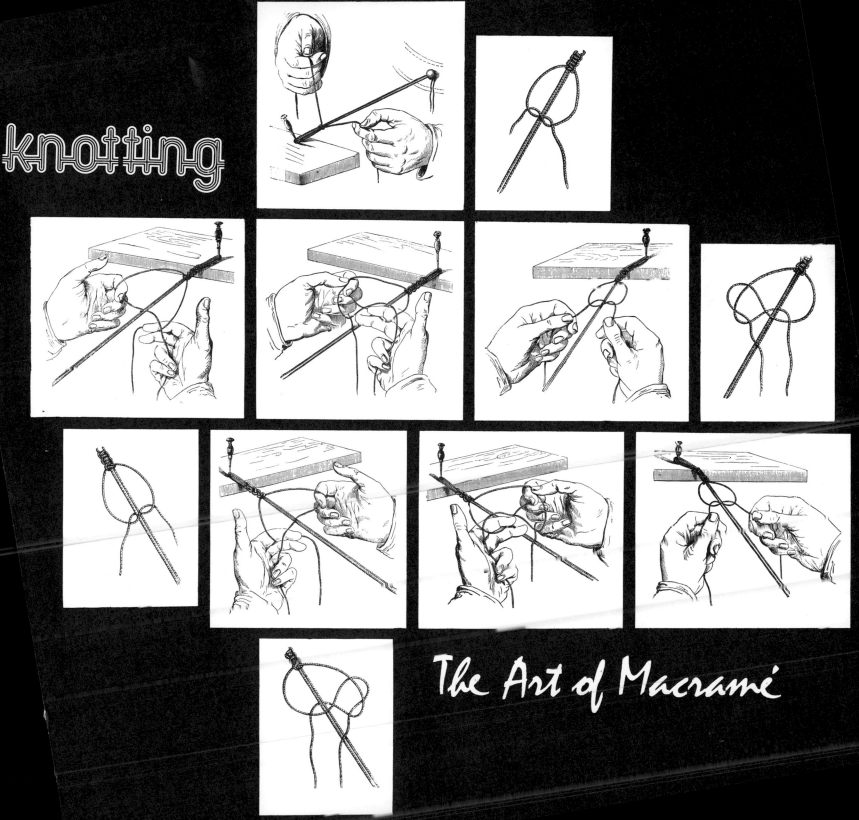

knotting

The Art of Macramé

CREATIVE KNOTTING or macramé as it is now commonly known, is another craft that has greatly increased in popularity in the last few years. The basic materials used in this craft are cheap and easy to obtain and as there are only two basic knots to learn, it can be an easy matter to produce, quickly and easily, all sorts of bags, belts, chokers, bracelets and other accessories, as well as wall hangings and three dimensional work. Attractive fringes and braids can also be made for curtains, fabrics and garments.

Materials
All the following are suitable yarns that will hold a knot without slipping:
Twines
Parcel strings
Rug wool
Cords (nylon & plastic)
Crochet cotton
Piping cord
Embroidery cottons
Synthetic metal yarns
Rope
Cellophane string.

Beads, shells and sequins etc. can be worked into the design.

Obviously, the particular piece of work being knotted will determine the size and nature of the material to be used, i.e. large for large objects and small for small objects. As a general rule, a piece of work will use up $3\frac{1}{2}$–4 times the length of finished work to length of yarn (i.e. 4 inches of knotted material needs 16 inches of yarn). Always work out a sampler first before starting an actual piece of work to see just how much yarn will be needed.

Equipment
All knotting is worked from a foundation thread which can be either tied to the back of a

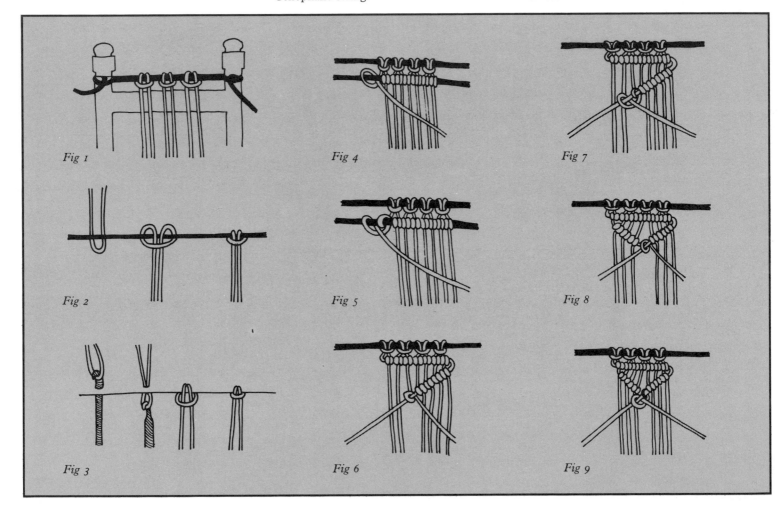

Fig 1 Fig 4 Fig 7

Fig 2 Fig 5 Fig 8

Fig 3 Fig 6 Fig 9

chair *(fig 1)*, or pinned down on to a board with drawing pins, and should be six inches longer than the width of the finished work. Apart from this, only the string or whatever is to be knotted, a pair of scissors and such things as beads and other embellishments will be required.

Setting on

(Fig 2) shows how the threads are first attached to the foundation string. *(Fig 3)* shows how this same method is used to attach threads to a piece of fabric for the beginning of a fringe or braid. The knot used is a reverse double half-hitch knot.

Basic Knots: (a) SIMPLE OR DOUBLE HALF-HITCH

This knot is the knot used for cording, useful to finish or start of a piece of work, or for the production of strong belts.

HORIZONTAL CORDING

Take four pieces of string and set on to the foundation string. This will now produce 8 pieces of hanging string. The knots are made by working these strings over a string bearer, which can be either an end string laid across all the others or a second foundation string, the same length as the first, introduced from the side. Working from side

to side, take the first string and knot it twice as in *(Figs 4 and 5)*. Take each string in turn and knot them in the same way until the end of the line. This stitch can be repeated left-to-right, right-to-left until you reach the required length, but within the body of the work one of the knotting threads should be used as bearer rather than a separate foundation thread.

DIAGONAL CORDING

(Figs 6 and *7)* show how, by laying the cord bearer at 45°, a diagonal line can be knotted.

CROSSED DIAGONAL CORDING

(Fig 8) shows how two cord bearers are used

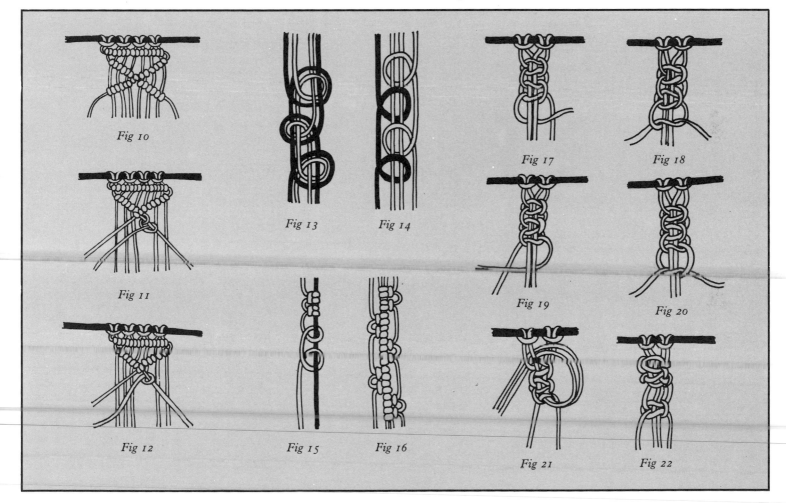

Fig 10

Fig 11

Fig 12

Fig 13

Fig 14

Fig 15

Fig 16

Fig 17

Fig 18

Fig 19

Fig 20

Fig 21

Fig 22

to form two diagonals that meet in the middle. The two bearers should then be knotted and carried on outwards as in *(figs 9, 10, 11 and 12)*.

BRAIDS USING THE HALF HITCH *(figs 13, 14, 15 and 16)*

THE FLAT KNOT
This is worked with four strings and is built up as shown below:

(a)	(b)	(c)	(d)
(fig 17)	*(fig 18)*	*(fig 19)*	*(fig 20)*
left under middle and over right	right over middle and through left	right under middle and over left	left over middle and under right

THE FLAT KNOT BUTTON
By threading the two centre threads up into the finished knotting every now and then, attractive knot balls can be made *(figs 21 and 22)*.

PLAITING
Plaiting can be very effective when used in conjunction with other knots.

JOSEPHINE KNOT
This is best worked on a flat surface like a wooden board as each knot can then be pinned to make working easier *(figs 23, 24, 25 and 26)*.

INCREASING
To add a new thread to a piece of work, it is simply attached by a reverse double half-hitch knot as used to get on threads to the foundation cord.

EDGINGS
Attractive edgings or 'picots' can be worked into a design. The diagrams below show some of them *(figs 27, 28, 29 and 30)*.

Beads and other decorative materials can be worked into the design and also strings or threads of different colours can be used to create a pattern, determined by the knot being used. By experimenting with the knots and various coloured strings and threads, some very beautiful results can be produced.

IN THE USA
SOURCES OF MATERIALS

You will probably be able to find string and twine at you local hardware store. Marine supply stores are also a good source of cord. Needlework shops or craft stores should have various yarns and threads and some beads. If you don't find what you want, you can order everything you need for macrame from the stores listed here. (Free catalogs are listed; otherwise write for information.)

OWL AND OLIVE WEAVERS, 4232 Old Leeds Lane, Birmingham, Ala. 35213.

LEMCO, P.O. Box 40545, San Francisco, Calif. 94149. *Free catalog.*

NATURALCRAFT, 2199 Bancroft Way, Berkeley, Calif. 94704.

HAZEL PEARSON HANDICRAFTS, 4128 Temple City Blvd., Rosemead, Calif. 91770. *Free catalog.*

WARP, WOOF AND POTPOURRI, 514 N. Lake Ave, Pasadena, Calif. 91101. *Wide selection of beads.*

CONTESSA YARNS, P.O. Box 37, Lebanon, Conn. 06249.

DICK BLICK CO., P.O. Box 1267, Galesburg, Ill. 61401. *Free catalog.*

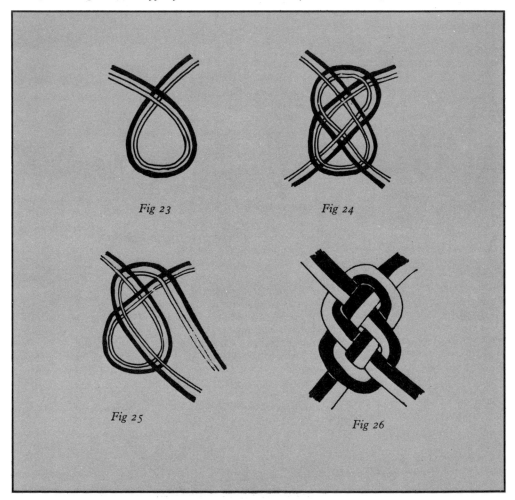

Fig 23 Fig 24

Fig 25 Fig 26

MACRAME AND WEAVING SUPPLY CO., 63 E. Adams St., Chicago, Ill. 60603.
BERGEN ARTS AND CRAFTS, P.O. Box 381, Marblehead, Mass. 01945. *Free catalog.*
J.L. HAMMETT CO., Hammett Pl., Braintree, Mass. 02184. *Free catalog.*
P.C. HERWIG CO, INC., 264 Clinton St., Brooklyn, N.Y. 11201.
CROWE & COULTER, Box 484 ACC, Cherokee, N.C. 28719.
YELLOW SPRINGS STRINGS, P.O. Box 107. 68 Goes Station, Yellow Springs, Ohio 45387. *Wide selection of beads. Free catalog.*
BLACK SHEEP WEAVING AND CRAFT SUPPLY,

318 S.W. Second St., Corvallis, Oreg. 97330.
J.E. FRICKE CO., 40 N. Front St., Philadelphia, Pa. 19106. *Free catalog.*
THE MANNINGS, RD#2, East Berlon, Pa. 17316.

SOCIETY

HANDWEAVERS GUILD OF AMERICA, 998 Farmington Ave., W. Hartford, Conn. 06107. *Membership ($9 a year) includes access to a textile and slide library and a quarterly magazine,* SHUTTLE, SPINDLE & DYEPOT, *with "how to" ideas, photos, and diagrams, product reports, book reviews, and suppliers' ads. The guild also publishes a number of pamphlets on the fiber arts and has a representative in every state who can provide local information.*

BIBLIOGRAPHY

BEADS PLUS MACRAME, by Grethe La Croix/Tower, New York.
COLOR AND DESIGN IN MACRAME, by Virginia Harvey/Van Nostrand Reinhold, New York.
DO YOUR OWN THING WITH MACRAME, by Lura La Barge/Watson-Guptill, New York.
FAR BEYOND THE FRINGE, by Eugene Andes/Van Nostrand Reinhold, New York.
GRADED LESSONS IN MACRAME, KNOTTING AND NETTING, by Louisa Walker/Peter Smith or Dover, New York.
INTRODUCING MACRAME, by Eirian Short/Fawcett World, New York.
MACRAME, by Constance Bogen/Trident, New York.
MACRAME, by Imelda Manalo Pesch/Sterling, New York.
MACRAME: THE ART OF CREATIVE KNOTTING, by Virginia I. Harvey/Van Nostrand Reinhold, New York.
MACRAME ACCESSORIES: PATTERNS AND IDEAS FOR KNOTTING, by Dona Z. Meilach/Crown, New York.
THE MACRAME BOOK, by Helene Bress/Scribner's, New York.
MACRAME YOU CAN WEAR, by Laura Torbet/Ballantine, New York.
STEP-BY-STEP MACRAME, by Mary W. Phillips/Western, New York.

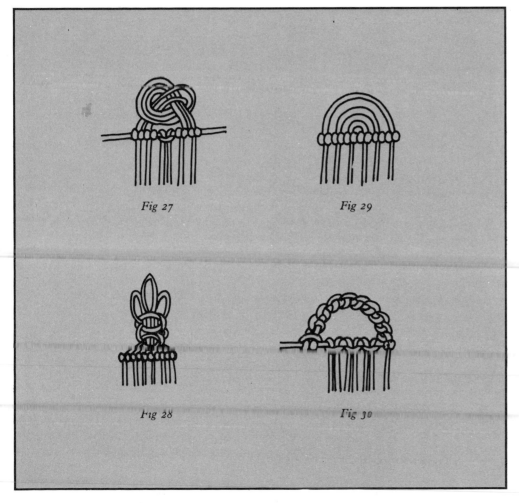

Fig 27

Fig 29

Fig 28

Fig 30

It seems strange that the only places ever entrusted with the graceful design of a sundial are always some dark corners of a village square or park or the pompous and extravagant grounds of a private estate. Even when the dial does reach the ordinary urban gardens it is invariably hidden next to the potting shed and always covered by brambles and bird droppings.

Surely this ancient monument to the passage of time needs to be preserved and with its lost charms and mystique given a purpose in today's society.

From the comfort of your own garden a really nice sun-clock can be assembled, but if by lousy council planning you have no garden, a ceiling in your home will do just as well. In this case, time is not recorded by a moving shadow but by a moving point of light, and a very bizarre effect it has too.

The idea of using a ceiling for a sundial may seem crazy at first but as you see it taking shape above your head you will be pleasantly surprised.

EQUIPMENT

The only equipment needed is very simple and can be all bought from Woolworths for a few shillings (apart from the wrist-watch which you can borrow for a day from somebody if you don't already have one). The rest of the list includes plenty of thin string; a pencil; a pleasing variety of coloured paints; one small paint brush; one small hand mirror; a piece of paper (the same size as the mirror); a coloured chalk; a box of drawing pins and a small tube of glue.

METHOD

Fix the mirror horizontally on to the bottom part of the window ledge and after making a hole about the size of a sixpenny piece in the paper, paste it to the mirror. If you now cast your eyes to the ceiling you will see (as long as the sun is shining) a small point of light. Now at five, ten or fifteen minute intervals, mark off in pencil the different positions of this spot. The way to do this is to check the time against the sun-dot and at 12.00 for example, you mark off that point, at 12.05 you do it again and so on. Keep this up all the time that sunlight can enter the room. Once the sun has moved round your house and the dot has disappeared, you will have a series of pencil marks stretching across the ceiling.

Now this is the tricky part. From the centre of your window, imagine a vertical line leading to the ceiling: where this imaginary line touches the ceiling draw a small X.

From this fixed position (X) with the aid of drawing pins, fasten a piece of string and allow it to pass through one of the pencil dots until it reaches the far wall, making sure it's well secured and taut. With a second piece of string, using the X as a starting point again, go through the motions once again, this time of course choosing a different dot. Do this again and again until all the dots have been married to the X by the strings.

Now run your block of coloured chalk (a light blue will be best because this will not alter the colour of your paints) along each string and pluck them separately as you would a guitar string. This action transfers the chalk on to the ceiling in nice clean lines. Once this has been done all the strings can then be taken down.

With extreme care, paint along each chalk line; there's no quick and easy method for doing this so just take things easy and it will turn out nicely.

You might like to choose different colours for different time sections. For example, red for hours, dark blue for half-hours and green for quarters, but that's a matter of personal judgement. It is very important that you paint these lines right across the ceiling to the far walls because in June, when the sun is high, the light spot will be near the window, in August, out in the middle of the ceiling and in Winter, with the sun low in the sky, far away towards the opposite wall.

If you still have some excess energy after all that, why not paint in the Zodiac Signs or the different stars that are visible all year round. But most important of all, don't forget to number the painted lines with the required times. These can either cut the lines at the different sections or be placed at the sides in the form of a semi-circle across the ceiling.

You might be lucky and have a room with two windows, one facing East and the other West. If that's the case then you can expect continual sunshine, but if you have only one window, say facing East the sunlight will only be limited to the morning or facing West, the afternoon.

If you've got an uncooperative landlord who wouldn't appreciate a sundial on his ceiling, the next best thing is to do everything as written, but instead of painting the hourly lines directly on to the ceiling, simply paint the strings in the chosen colours and gently tack them in to position.

Even if the sun refuses to shine this year, at least you'll have an incredible ceiling to gaze at.

A SUNDIAL WORKSHOP TO VISIT

GERALD DUNN, SUNCLOCK SPECIALIST, Great Downs, Tollesbury, Maldon CM9 8RD. Tel. Tollesbury 280

93

It's quite amazing how this craft has blossomed over the last few years for it is by far the most popularly practised craft around; with perhaps the exception of tie-dye and batik. Candles can now be made in all shapes, sizes, colours, with or without perfume and they are dead easy to make after a bit of practice. Materials are cheap and the outlets for candles are plenty, and the demand steady.

MATERIALS NEEDED

Candles are made from wax, and there are various types of wax available, including beeswax, bay-berry wax, paraffin wax and tallow. Of all these, paraffin wax is the cheapest and the most easily available. Refined paraffin wax must be used with stearic acid which then becomes 'candlewax': the basis of most manu-factured candles. The list of materials needed is as follows:

Paraffin wax, Stearic acid (or Stearin), a sturdy kitchen thermometer, a double pan boiler, various saucepans, oil essences (*for perfumed candles*), beeswax, or beeswax sheets (*for beeswax candles*), moulds (*these will be discussed later*), wax dyes and a sharp knife.

MIXING AND PREPARING THE WAX
(PARAFFIN)

The correct proportion of stearic acid to paraffin wax is 10%, stearic acid to wax, i e 1 lb stearic acid to 10 lb paraffin wax. As the wax normally comes in blocks, it must be broken down with a hammer into small pieces to enable it to be put in the double boiler for melting. Stearin, or stearic acid must be melted in a separate pan and if any wax dyes are going to be used, they should be added to this same pan. Wax dyes are normally ex-tremely concentrated so that only a tiny pinch will be needed to give quite a strong colour. If too much dye is used, the resulting candles will be very dark and will not 'glow' when lit. If a perfumed candle is to be made the oil essence (just a few drops) must also be added to the melted stearin.

The wax should be melted in the double boiler (easily made by putting one saucepan on to the top of another the same size, the one beneath being filled with water) and heated to a temperature of 180°F (or 82°C). The melted stearin (with or without dye and perfume) are added to the melted wax and thoroughly mixed. The resultant mixture is then poured into a warm jug which makes it easy to pour into the mould. It is very important that pouring temperature should be 180°F (82°C) at all times.

WICKS

The size of wick in relation to the size of the candle is very important, and the rule is: the larger the candle, the larger the wick. A small wick in a large candle will produce a pool of molten wax at the burning point and this will result in extinguishing the flame. On the other hand, too large a wick will produce a large smoky flame and the candle will burn itself out quickly. Experience alone will provide the right wick to use for each candle made.

Wicks can either be purchased from a reput-able candle supplier or be made by soaking lengths of bleached stranded cotton in boracic acid.

Methods

There are three ways of actually making a candle : by dipping, by using moulds, and by rolling with beeswax sheets.

Dipped Candles Fill a jar with the already-prepared candle-wax mixture, making sure that the jar is a bit taller than the intended length of the candle. Tie the wick to a stick and dip it in the wax mixture and remove it *(fig 1)* when the wax adhering to the wick is dry, repeat the process until the thickness of the candle is what you need and allow it to cool. When the candle is completely cold, trim the bottom with a sharp knife.

Interesting effects can be obtained by dipping the wick into, and out of, jars contain-ing different coloured wax. By finally dipping the finished candle in cold water immediately after the last dip in wax, a shiny surface can be achieved. Another way to use the dipping method is to mould the wax on the wick in your hands whilst it is still warm. By doing this, shapes can be worked, such as a pear shape, especially if with each dip, progressively less of the candle is dipped in the molten wax.

Moulded Candles This method involves pouring molten wax into some container of a particular shape, so that when the wax is cold, the mould can be removed, leaving the desired shape. There are a number of ways to make moulds, apart from those ready-made metal or

rubber moulds which can be bought from candle-making suppliers. Commercial moulds are a bit stereotyped and although they have the advantage of being longer-lasting, it would be better if you make up your own, personalised moulds.

The world is full of all sorts of junk that can be improvised as moulds. Empty 'squeezy' bottles, yoghurt cartons, toilet rolls, sheeting cardboard, food jars, cartons, rubber tubes and balloons etc. are all perfect for the job. Using such stuff as this may produce the inevitable duff candle now and then, but the wax can easily be melted down and used again. Always make sure that whatever the intended mould is it must be leakproof, otherwise you will have molten wax running everywhere.

Take the mould (an empty 'squeezy' bottle, for example) and cut the tip off the top with a pair of scissors. Make a small hole in the centre of the bottom and thread the wick through it and tie a knot to prevent it coming back through (fig 2). Tie the other end of the wick, which comes out the open top of the mould, tightly round a stick so that there is no slack, and fit it into two notches which can be cut at the top of the mould (fig 2). Any slack can be taken up at the base of the mould where the knot is by tying another knot. Next, pour the wax into the mould, saving some to top up with, because the cooling wax will contract in the mould. After thirty seconds, cool the mould in a bowl of cold water, but make sure that no water enters the mould. After an hour, a well will appear at the top, so break the skin and top up with the spare mixture. Now leave the candle for three or four hours, by which time it should be hard enough to remove from the mould.

As a general rule, rapid cooling in cold water will produce a hard, even, shiny surface whereas a slow cooling will result in a surface containing air bubbles which is also quite pleasing. To prevent the mould from toppling over in the cooling bath, a weight of some description may be necessary on top. When the candle has been removed from the mould, level the base with a sharp knife and trim the wick.

BEESWAX CANDLES

Beeswax can be purchased in sheets so that the

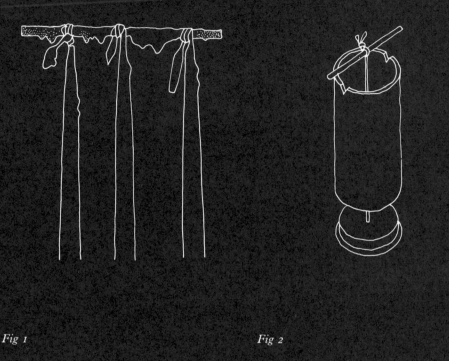

Fig 1

Fig 2

pouring process can be eliminated. Take a sheet of wax and cut it to the required height of the candle. Lay the sheet on a flat surface and place the wick at one end, making sure that the wick is longer at both ends than the width of beeswax sheeting. Next, begin rolling the wick in the sheet, very carefully, until the required thickness of candle has been reached. Press the end of the sheet into the body of the candle, warming it with the warmth from your hands and smoothing the ends in until the candle is a perfect cylindrical shape. Finally trim the wick and level the bottom, if needs be, with a sharp knife.

THE BASIC, PRIMITIVE CANDLE

In the old days, candles were made by dipping rushes into tallow, lard or wax and these were called rushlights. The rush commonly used was the Soft Rush (Juncus Effusus) *the most common rush in Britain.*

Method

The rind must be stripped from the cylindrical pithy stalks, leaving just two longitudinal pieces on either side of the pith to hold it together. This pith wick is then dipped into

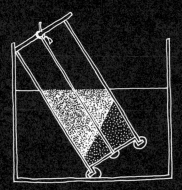

Fig 3

BALLOON CANDLES

Fill a balloon with water until it is of the required dimension needed for the candle. It should be then dipped into the molten wax and allowed to cool. This process should be repeated until a shell of good thickness has been reached whereupon the balloon can carefully be pulled away. When dipping, make sure that only about three-quarters of the balloon goes into the molten wax otherwise it will be impossible to pull it away from the wax shell. Next, pour a little molten wax into the shell and revolve it around the inside of the wax mould as one does with brandy in a brandy glass and allow it to cool. Repeat this process until the shell is really thick. Top the shell up with wax until it is half full and allow it to cool in the cooling bath. When it is rock hard, drill a hole through the middle, insert the wick and finally fill the wax shell to the top, allowing it to cool in the cooling bath. The bottom will need levelling off flat with a knife to allow the candle to stand upright. At all times, make sure no water gets into the top of the shell when cooling.

CAVITY CANDLES

To make a candle rather like gruyère cheese, chunks of ice are put in the mould and the molten wax poured over them. When the ice melts away, there will be cavities left and this produces some very interesting effects. It is important to remember with this technique that the wick must first be dipped a few times in wax before securing it in the mould, otherwise the water will get in and soak it, thus making burning impossible.

Finishes and textures A number of textures and finishes can be added to the surface of candles to increase their beauty. Molten coloured wax can be dripped or painted on to the surface, either in a rigid pattern or ad hoc. A hot knife or some other tool can be pressed into the surface so that indentations are made which will give nice textures. Alternatively, the surface can be cut into with a knife and either left as it is, or molten coloured wax poured in to the holes. Bits of coloured wax can be stuck on the outside by welding with a hot knife.

molten wax or tallow in exactly the same way as described on page 95 and when of a required thickness, the bottom should be levelled and the wick trimmed.

VARIATIONS

By improvising with various coloured wax, as well as using hard and melted wax, a number of interesting candles can be produced.

CHUNKY CANDLES

Fill the mould with small chunks of hard, coloured wax after having first inserted the wick in the way described above. Pour into the mould some molten wax, either white or of another colour and cool in the cooling bath.

MULTI-COLOURED CANDLES

Pour in some molten wax of one colour into a mould and allow it to cool until the surface is spongy. Pour in another coloured wax and repeat the operation until the mould has been filled. To give an interesting effect, the mould can be inclined at an angle to provide diagonal layers *(fig 3)*.

What is so exciting about making candles is the fact that there is so much room for experimentation. Try out as many techniques as you can, make up your own and get hold of as many different moulds as possible. If there are a few disasters, it doesn't matter because the wax can always be melted down and used again.

CANDLE-CRAFT STUDIOS TO VISIT

England
CORNWALL
ART CANDLES, 7 Walker Lines, Bodmin, Cornwall. Tel Bodmin 3258
Hand-made candles by Bob and Jill Bishop. Various shapes; special orders taken.
Open all week. Please telephone first.

Wales
DENBIGHSHIRE
'CANDLES IN THE RAIN' (Bill & Val Norrington), The Old Smithy, Nantglyn, nr Denbigh. Tel. Nantglyn 389
Specialist in unique, hand-made candles, leatherwork (handbags, belts, etc, made from hide), macramé and silk-screening.
Visitors welcome.

MERIONETHSHIRE
CELMI CANDLES, Cynfal House, Ffestiniog. Tel Ffestiniog 675
Hand-made candles in paraffin wax and beeswax, also wax sculptures. Permanent exhibition of pottery, slate and metal craft.
10.30 am – 6 pm Monday to Saturday.
2 pm – 5 pm Sunday (Summer only).

IN THE USA
SOURCES OF MATERIALS
Candle-making equipment and materials can be found in most craft and hobby stores or ordered from the suppliers below. (Free catalogs are listed; otherwise write for information.) The disadvantage of ordering wax by mail is that it is heavy and the shipping charge may be high. Sometimes you can get large quantities of wax (50 pounds or more) at a very good price from nearby oil companies, such as Atlantic-Richfield.

ARTISANS BENCH, P.O. Box 2253, Newport Beach, Calif. 92663.
GENERAL SUPPLIES CO., P. O. Box 338, Fallbrook, Calif. 92028.
NATCOL CRAFTS, INC., P.O. Box 299, Redlands, Calif. 92373. *Free catalog.*
YALEY ENTERPRISES, 129 Sylvester Rd., San Francisco, Calif. 94080. *Free catalog.*
PREMIER MFG. CO., P.O. Box 220, Arvada, Colo. 80001. *Free catalog.*
THE CANDLE MADE, 272 Great Rd. (Rte. 2A), Acton, Mass. 01720.
CELEBRATION, Box 28 Pentwater, Mich. 49449.
THE CANDLE FARM, 625 S. Church St., Mt. Laurel, N.J. 08057.
THE CANDLE BARN, INC., 20 Sterling Rd., Watchung, N.J. 07060.
PINEHURST SOAP AND CANDLE CO., P.O. Box 1148, Pinehurst, N.C. 28374. *Free catalog.*
THE WAX KETTLE, RD 2, Pine Grove, Pa. 17963. *Free catalog.*
AMERICAN HANDICRAFTS CO., 1011 Foch St., Fort Worth Texas 76107. *There are 300 American Handicrafts stores in the United States, so that you may be able to find a local branch. Free catalog.*
BARKER ENTERPRISES, 15106 10th St. S.W., Seattle, Wash. 98166.
POURETTE MFG. CO., 6818 Roosevelt Way N.E., Seattle, Wash. 98115.

SOCIETY

INTERNATIONAL GUILD OF CANDLE ARTISANS, c/o Mrs. Louis Strohmeyer, 1105 I St., Pettaluma, Calif. 94952. *To join, there is a $25 initiation fee and dues of $15 a year. The guild is made up of professionals and amateurs. It holds an annual convention, with a candle-making competition, and area and regional workshops. Members receive* CANDLELIGHTER, a monthly magazine with how-to articles, lists of suppliers, suppliers' ads, and book reviews.

BIBLIOGRAPHY

CANDLE ART: A GALLERY OF CANDLE DESIGNS AND HOW TO MAKE THEM, by Ray Shaw/William Morrow, New York.
CANDLE CRAFTING, by William Nussle/A. S. Barnes, Cranbury, N.J.
CANDLES AND CANDLECRAFTING, by Stanley Leinwoll/Scribner's, New York.
COMPLETE BOOK OF CANDLE MAKING, by William E. Webster with Claire McMullen/Doubleday, New York.
CREATIVE CANLDEMAKING, by Thelma R. Newman/Crown, New York.
GETTING STARTED IN CANDLEMAKING, by Walter E. Schutz/Macmillan, New York.
THE GREAT WAX WONDER – BOOK TWO, by Cherie Hooper/Hidden House Press, Palo Alto, Calif.
KITCHEN CANDLECRAFTING, by Ruth Monroe/A. S. Barnes, Cranbury, N.J.
MODERN ART OF CANDLE CREATING, by Don and Ray Olsen/A. S. Barnes, Cranbury, N.J.
TALL BOOK OF CANDLE CRAFTING, by Gary V. Guy/Sterling, New York.

Journal
AMERICAN CANDLEMAKER, P.O. Box 22227, San Diego, Calif. 92122. *Monthly, subscription $4.50. Articles, suppliers' ads, pamphlet-like.*

Jack be nimble, Jack be quick,
Jack Jump over the candle-stick.

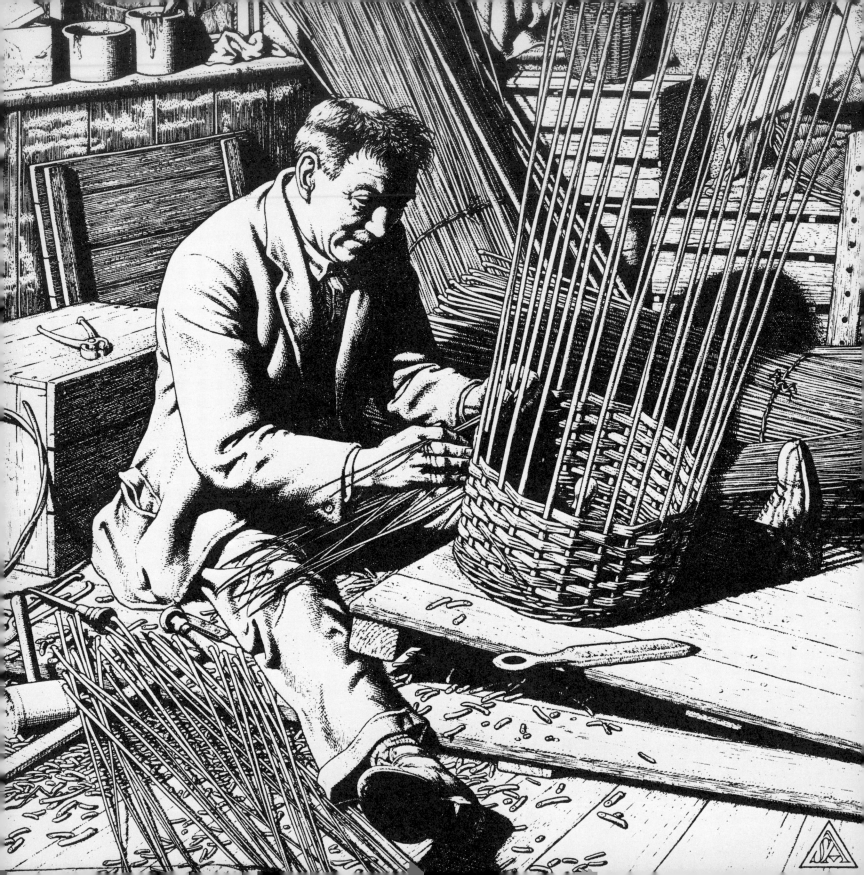

Hard and Soft Country Baskets

IT IS MOST LIKELY that there will always be a steady need for baskets of all shapes and sizes so that by taking up this craft, a decent living can always be assured. Most of the materials needed can be had for the taking from the countryside, thus making the cost of producing work on an economical basis a surety. We have split the definition of the sorts of basketwork into two main fields; hard basketry and soft basketry. With most of the 'soft' materials, other work can be made like mats, chair seatings etc, but this will have to be covered in perhaps another book, more fully than has been here.

HARD BASKETRY

This includes the use of cane, willows, dogwood and other twiggy material, a detailed list of which will shortly follow. As a general rule, select straight, one-year-old twigs with no side shoots which must be pliable enough to bend round the fist. The best time to collect material is between November and March and it should be stored in the dark until needed. Never hack any one tree or bush to bits, but rather select a few twigs from a number of plants so as not to despoil them. Use a pair of secateurs or a pruning knife to cut the twigs and make as clean a cut as possible. Never make a hole in a hedge by indiscriminate cutting as it may let out animals enclosed in a field.

Suitable material to collect

BRAMBLE (*Rubus Fruticosus*) Blackberry
Widespread and abundant in woods, hedges, and bushy and waste places and on heaths and cliffs. Can be picked when either green or red as in the Autumn. The prickles can be removed by rubbing the stems with a handful of rags. Stems have a uniform thickness.

CLEMATIS (*Wild or garden varieties*)
The joints of these plants will give a pleasant texture to a basket. Twigs have a uniform thickness.

DOGWOOD (*Thelycrania Sanguinea*)
Widespread and common in woods, thickets and hedges, especially on chalk and limestone. Use the wild variety which is fine but firm to handle, and the garden variety which is infinitely more pliable. Twigs tend to taper in thickness.

ELM (*Ulmus*)
The best parts to use will be found growing from the base of the trunk as side shoots. Twigs tend to taper in thickness.

HONEY-SUCKLE (*Lonicera Periclymenum*)
Widespread, common in woods, hedges and bushy places. Use both the wild and cultivated varieties. The bark should be peeled off as it tends to crack when worked. Twigs tend to taper in thickness.

IVY (*Hedera Helix*)
Widespread and abundant in woods, often carpeting the ground, in hedgerows and on walls and rocks. A versatile medium of varying beauty. Twigs have a uniform thickness.

HAZEL (*Corylus Avellana*)
Widespread and common in woods, hedgerows and bushy places. A fine material to work, with either the bark left on or peeled. Twigs tend to taper in thickness.

LARCH (*Larix Decidua*)
Select the straightest twigs and those that bend well—discard the rest. Twigs tend to taper in thickness.

LIME (*Tilia Europaea*)
Produces lovely black twigs which tend to taper in thickness.

PRIVET (*Ligustrum Vulgare*)
Twigs can be used although they tend to be short in length. Twigs tend to taper in thickness.

ROSE (*Rosa*)
Both the Dogrose and Guelder rose can be used as well as most of the cultivated varieties. Remove the thorns in the same way as for Brambles. Twigs have a uniform thickness.

SLOE (*Prunus Spinosa*) Blackthorn, Quickthorn.
Widespread and abundant in woods, scrub and hedgerows. Produces pleasant bright green shoots which are highly pliable. Twigs have a tendency to taper.

SNOWBERRY (*Symphoricarpos Rivularis*)
Fairly frequently naturalised in hedges, by

streams and in bushy places. Produces lovely silver green shoots which need care in handling. Twigs tend to taper in thickness.

WILD BROOM *(Sarothamnus Scoparius)*
Produces vivid green shoots which darken with age. Use both the wild and cultivated varieties. Twigs tend to taper in thickness.

WILLOW *(Salix)* Osier, Sallow
The most popular material to use in basketry (apart from cane) because of its flexibility and endurance to rough handling. There are three types commonly used: (1) *Salix Friandra* (ALMOND WILLOW) which is generally widespread and often found by fresh water. This willow produces high quality lengths. (2) *Salix Viminalis* (OSIER) which is widespread and common in moist places. This willow produces stout lengths more suited to large-sized baskets. (3) *Salix Purpurea* (PURPLE WILLOW) which is widespread and locally frequent near fresh water, especially in fens. This willow produces small slender lengths of great strength and are used for very best sorts of baskets. Strangely enough, although these willows grow wild, they give better quality lengths when cultivated in special 'Osier beds'. The main willow growing area is now to be found in Somerset in an area drained by the rivers Tone, Yeo and Parret. The best time to purchase these cultivated rods is in the Autumn when the annual willow auctions are held. When obtaining rods in this way, a great saving is made compared to buying material from craft shops.

Preparation
Almost all collected material with the exception of Bramble, Elm and peeled rods will need preparation known as 'fading' before it can be used. This is a drying process which renders the rods pliable. Bundles of rods of each specific variety should be tied and left out in the open, preferably under a bush or hedge for a specific time that will range from about two weeks to three months, depending on the thickness of the rods and the weather. The rods must not be allowed to dry out completely otherwise they will become brittle and will be then useless for working. When ready, the rods should feel 'leathery'. Should, however, they become too dry, soak them for a couple of days in a bucket of water, leave for

one day, and then keep wrapped in a damp cloth until needed for use.

Terminology
BASE or BOTTOM STICKS Short lengths forming the foundation of a basket lid or base.
BORDER The finishing edge of a basket side or lid, formed by pulling the side stakes down and weaving them into an ordered pattern.
BOW ROD A bent rod of stout dimensions used to form the heart of a handle.
PAIRING Two rods worked alternately under and over each other to form a twist.
PRICKING UP To insert side stakes to a base and bend up for the weaving of the sides of the basket.
RAND A single rod worked in front of one stake and behind another—basic basket weaving.
ROUND One complete movement made round the circumference of a basket or lid.
SLATH The interwoven sticks which form the bottom of a basket.
STAKES Rods used to form the foundation for weaving the sides of a basket. Side stakes should be thinner than the base or bottom sticks and are, as a general rule, about 8 inches longer than the intended height of the finished basket.
WALING The process by which three or more rods are worked (woven) in sequence in front of two, three or more side stakes and one behind.
WEAVERS Lengths used in the weaving of a basket being woven round the side stakes.

Sorting
Some degree of sorting is necessary as the various parts worked into the making of a basket must be of various lengths and thicknesses in relation to each other. Bottom sticks must be made from the thickest rods, then side stakes, and finally weavers, which should be the thinnest. Weavers should be as long as possible, at least long enough to form one round. All material must be worked damp so soak for an hour or so in water before use.

Method
This is for a simple, round basket. Take 6 bottom sticks, slit 3 in the middle and insert

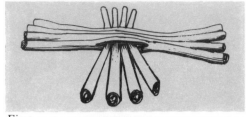

Fig 1

the other 3 through the slits *(fig 1)*. Take a good long weaver and make a loop tie in the middle *(fig 2)*. Next, open out the bottom

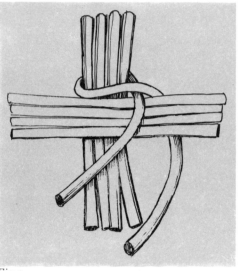

Fig 2

sticks like the spokes of a wheel and start weaving in and out with the two ends of the weaver. This is known as '*pairing*' *(fig 3)*. When the required diameter of the base has been reached, cut off what is left of the bottom sticks, and, taking a side stick for every end of bottom stick, sharpen their ends with a knife and insert each one by the side of the bottom stick ends *(fig 4)*.
Remember to make the height of each side stake 8 inches longer than the intended height of the finished basket. Once inserted, turn up (prick up) the side stakes and keep in place with a loop of string or cord *(fig 5)*.

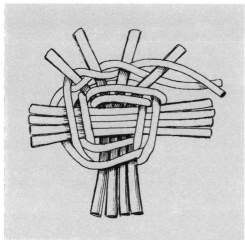

Fig 3

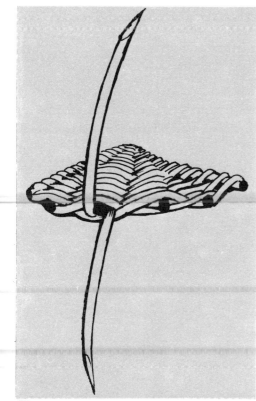

Fig 4

Fig 5

Waling

A basket is normally started off with 2 or 3 rounds of waling. Take three rods about side stake thickness and place each one behind three successive side stakes. Weave each rod as for the pairing on the base except that each must be worked in front of two stakes instead of one (fig 6). Work 2 or 3 rounds in this way.

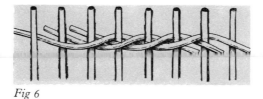

Fig 6

Weaving or Randing

Each weaver must be long enough to go round the whole circumference of the basket plus about 1 inch. Take the thickest end of the weaver (*butt*) and insert behind a side stake

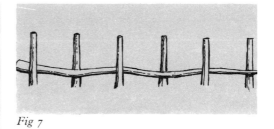

Fig 7

(*fig 7*). Begin weaving in front and behind each side stake until the end is reached which should end behind a side stake.

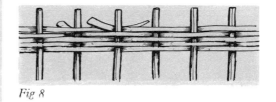

Fig 8

To join a new weaver to the basket, simply insert the same stake *(fig 8)* and continue weaving in the same way.

As a guide to how many weavers should be used on a basket, use as many as you have side stakes. When all the weavers have been worked, finish off with 2 or 3 rounds of waling.

Borders

Figures 9, 10, 11 and *12* show ways of nicely finishing the top of a basket, or the side of a lid. With borders 9, 10 and 11, known as scallop borders, a good length of side stake

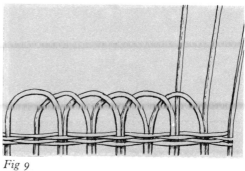

Fig 9

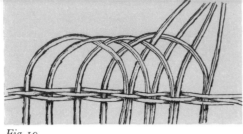

Fig 10

will be needed for bending over and working well into the weave. With border *12*, a trac border, only a couple of inches of side stakes will be needed.

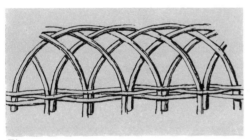

Fig 11

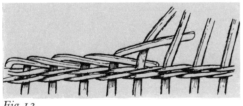

Fig 12

Handles
Take a good thick base rod, long enough to form a decent bow and sharpen both ends. Insert each end well down into the top waling each side of the basket. Next, take three thin weavers and insert through the top waling and plait over the handle rod to the other side, finishing off by inserting the ends into the top waling *(fig 13)*.

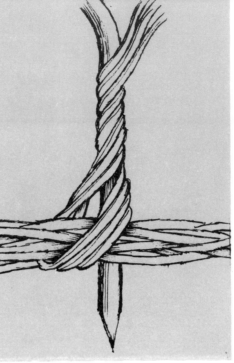

Fig 13

SOFT BASKETRY

Here we will discuss the use of rushes, reeds, sedges, grasses and rafia.

Grasses
There are many grasses which can be cut, dried and used for soft basketry. Look out for the following:

PURPLE MOOR-GRASS (*Molinia Caerulea*) Grows 1–3 feet high in marshes, fens and wet heaths and moors.

FLOTE GRASS (*Glyceria Fruitans*) Grows 2–3 feet high in and by slow-moving water.

GREAT WATER GRASS (*Glyceria Maxima*) Grows 3–8 feet high at the margins of fresh and brackish water.

MEADOW FESCUE (*Festuca Pratensis*) Grows 2–4 feet high in woods and on shady banks.

HAIRY BROME (*Bromus Ramosus*) Grows 3–5 feet high in woods and hedge banks.

MEADOW OAT (*Helictotrichon Pratense*) Grows 1–2 feet high in established grassland, especially on chalk and limestone.

FALSE OAT (*Arrhenatherum Elatius*) Grows 2–4 feet high in waste places and by roads.

MEADOW FOXTAIL (*Alopecurus Pratensis*) Grows 1–4 feet high on cultivated ground.

Rafia
Rafia is imported and is therefore an expensive medium to purchase. Nowadays, however, there are synthetic substitutes which can be used, as well as a medium called *Seagrass*, both sold in craft shops. We do not recommend using either, because of the price, but felt it right to mention them.

Reeds
The best reed in Britain is *Phragmites Communis*, which is our tallest grass growing 5–8 feet high in swamps. There are, however, other types of reeds found within two families: the BUR-REED family and the REEDMACE family. The only one worth mentioning is the BRANCHED BUR-REED (*Sparganium Erectum*), growing 1–2 feet high by fresh water.

Rushes
There are a number of species of rushes suitable for all sorts of rushwork. Look out for the following:

SOFTRUSH (*Juncus Effusus*) Flowering rush. Grows 1–4 feet high in damp grassy and marshy places. This rush is cultivated in the shallows of the Great Ouse, near St Ives in Huntingdonshire especially for the rush industry.

BULRUSH (*Scirpus Lacustris*) Great Green Rush. Grows 3–8 feet high in rivers and round lakes.

FALSE BULRUSH (*Typha Latifolia*) Great Reedmace, Catstail. Grows 3–8 feet high in swamps and by fresh water.

LESSER BULRUSH (*Typha Angustifolia*) Lesser Reedmace. Grows in swamps and by fresh water.

SEA CLUBRUSH (*Scirpus Maritimus*). Grows by the banks of estuaries and inlets near the sea.

Sedges
SEDGE (*Cladium Mariscus*). Grows 6 feet high in fens in East Anglia only.

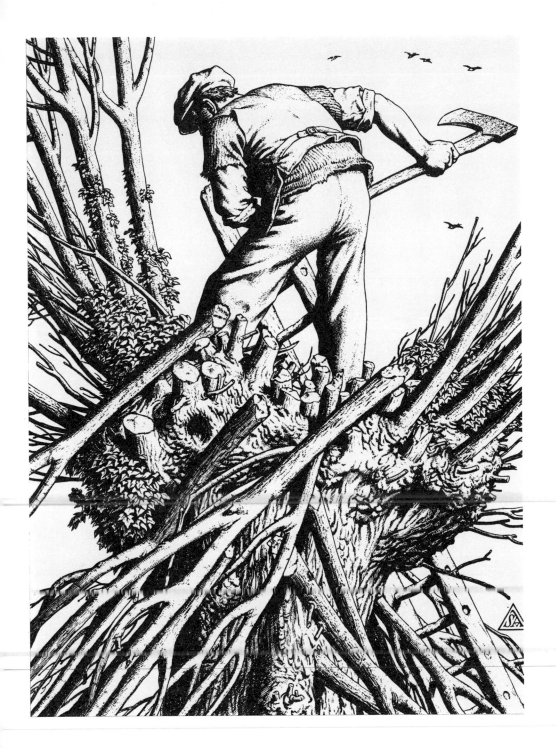

MOOR SEDGE (*Carex Binervis*). Grows 1–2 feet high in marshes and boggy woods on acid soil, as well as on moorland and rough grassy places.
BOTTLE SEDGE (*Carex Rostrata*). Grows 1–2 feet high in all kinds of wet peaty marshes.
POND SEDGE (*Carex Acutiformis*). Grows 3–5 feet high in swamps.
DROOPING SEDGE (*Carex Pendula*). Grows 3–5 feet high in damp clayey woods.
COMMON SEDGE (*Carex Nigra*). Grows 1–3 feet high in all kinds of wet peaty places.

Harvesting & Storing

Rushes and reeds are cut in mid-summer, about mid June through to August according to the weather. They are cut as low as possible with a fagging hook or sickle. When harvesting, it is important to keep them as flat as possible and a boat is usually needed to get access to the rushes and reeds. It is helpful if it is a flat boat like a punt which will facilitate the material being laid across flat. It is necessary to allow the rushes and reeds to dry out after harvesting and this can be done by either leaving them flat on the banks of the river, or by leaving them against wooden racks. Never allow the full sun to bleach them white. The drying process normally takes about three weeks when the material should then be stored in a cool dark out-house or loft. Another way is to lay the material in wire baskets fitted by a bracket to a wall in a shed or garage. It is always important to remember that rushes should only be cut from the same stock every other year, otherwise they will become thin and straggly in growth. The same goes for sedges and these should be dried and stored in the same way.

Terminology

BOLT A bundle of rushes, bound by a strap 45 inches in length.
BUTT The thick end of the rush nearest the root.
PARING WEAVE Two rushes worked under and over each other.
SPOKE Pieces cut from the 'butt' of a rush to form the beginning of a base for a basket.
TIP The top and thin end of a rush.
A bolt of rushes will normally be enough to make one fair-sized shopping basket.

106

Preparation

Once the rushes have dried, they must be gathered together into a sheaf and tied by a strap or length of thick string to form a bolt. As each rush is needed for use, it can be drawn out from the butt end of the bolt and the strap tightened as the bolt decreases in size. In this way, breakages are eliminated.

Just before use, the rushes should be laid out in the open and sprinkled with water from either a hose sprinkler or watering can, turning them over now and again. They must now be laid in a well damped blanket or felt, wrapped up tightly and then left for four hours out of sun and wind. Having done this, the rushes will be nicely softened for working and if no more than one or two are removed from the bundle at a time for working, they will remain in this soft, supple state for about two days. If any of the rushes become too dry and sticky, they must then be dried out completely and re-watered again.

Method

With rushes and reeds, there are so many ways of using them, whether for baskets, mats, furniture or accessories that we cannot possibly do any justice to a subject that would need a whole book to cover in any depth. We will, however, describe a very simple way of making mats and baskets. Further reading will be referred to in the bibliography.

To make simple use of rushes, reeds, grasses and sedges in 'soft' work, there are two principle ways of doing so; plaiting and tying. In the first case rushes and reeds are more suitable for here three lengths are plaited, using the three plait method, to form lengths ready to make up into the finished piece of work. In the second instance, sedges and grasses are taken in small handfuls and tied securely at 1-inch intervals with a strong waxed thread. By working new handfuls in as the first handful finishes, a continuous length can be made.

With either the plaited rushes *(fig 14)* or the tied sedges and grasses *(fig 15)* a mat can be simply made by curling the lengths round in a circle, working outwards and adding new lengths where needed *(fig 16)*, using wax

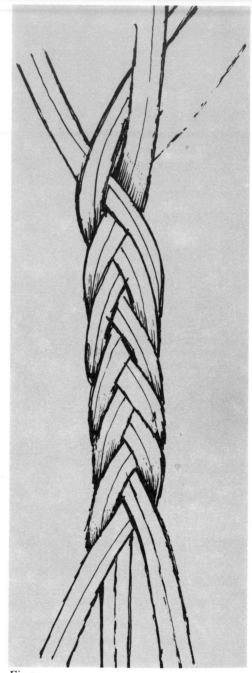

Fig 14

Fig 15

Fig 16

should be started in the same way as for a mat, i.e. from the middle and working outwards. But when the ultimate size of the base has been reached, the lengths must then be sewn upwards to form the sides, and finished off with a double row of lengths at the top. A handle can be made by plaiting three or more rushes together and sewing into the top *(fig 20)*.

Fig 18

thread to hold it all together (a canvas needle is best to sew the thread in this type of work). From this beginning, intricate patterns can be produced by bending the lengths to the required design. The following are some patterns to follow, but, you can easily make up your own. The essence of this method is to tie securely with the waxed thread *(figs 17, 18, 19)*.

To make a simple basket *(fig 18)* the base

Fig 17

Fig 19

107

Fig 20

Dyeing

Rushes, reeds, rafia and the family of grasses and sedges can be dyed various colours. Willow can also be dyed with a little more care. All these materials must be thoroughly soaked in water before plunging into the dye bath. The following dyes are recommended:

METHYLENE BLUE 2B
AURAMINE (yellow)
CHRYSOIDINE Y (orange)
METHYL VIOLET 2B PDR.
MALACHITE GREEN CRYSTALS
RHODAMINE B EX. (crimson)

If you wish to dye with vegetable dyes, the rushes, sedges, grasses or raffia should first be steeped in a mordant made of alum water. An ounce and a half of alum is dissolved in a pint of boiling water (large quantities of material will need more alum in proportion to water) and then the material must soak in this solution for at least twelve hours. Then while it is still damp, it must be put into the dye. See the chapter on vegetable dyes (p. 62) for details of dye colours.

WILLOW, CANE AND RUSHWORK STUDIOS TO VISIT

England
BEDFORDSHIRE
MRS P. M. MORGAN, Mill Lane, Pavenham, Bedford. Tel. Oakley 2393

Table-mats, rush baskets, assorted shapes and sizes. Rush-covered containers for bulbs, pot plants or flower arrangements. Rush chair seats renewed.
Any time by appointment.

DEVONSHIRE
DESMOND SAWYER, LSIA, The Key, Ferry Road, Topsham. Tel. Topsham 4615
Basketware and other gifts.
9 am–5.30pm.

GLOUCESTERSHIRE
BERNARD COTTON, 'Trout House', Warren's Cross, Lechlade. Tel. Lechlade 496
Rush-seating of chairs. Sets of early country chairs for sale.
BERTRAM JELFS, 'Goose Grout', Wraxall Road, Warmley, Bristol BS15 BDW. Tel. Bristol 673849
Only best quality English basketry in cane, willow and rush supplied. Cane furniture a speciality. Seating in cane, rush, seagrass, cord and willow skeining.
9 am–5 pm Monday to Friday.

NORFOLK
STANLEY BIRD (BASKETWARE) LTD, Seabird Works, 28 Southgates Road, Great Yarmouth. Tel. Great Yarmouth 3392
Manufacturers of baskets, hampers and willow and cane furniture.

SOMERSET
WILLIAM GADSBY & SON (BURROWBRIDGE) LTD, Burrowbridge, nr Bridgwater. Tel. Burrowbridge 259
Baskets and hampers, rustic willow furniture.
9 am–5 pm, except Sunday.

SUFFOLK
DEBEN RUSH WEAVERS, High Street, Debenham, Stowmarket. Tel. Debenham 349
Rush table-mats, place-mats, log-baskets, matting and carpets, shopping-baskets and other items. Osier baskets and chairs. Antiques restored and polished. Upholstery.
Workrooms open Monday to Friday 9 am–5 pm. Shop open Monday to Friday 9 am–5 pm.

SUSSEX
THOMAS SMITH (HERSTMONCEUX) LTD, Trug Factory, Herstmonceux. Tel. Herstmonceux 2137
Willow baskets with chestnut rim and handle for garden and floral décor.
9 am–5 pm; Saturday 9 am–12 noon.

WILTSHIRE
TOOLCRAFT, 2 Canon Square, Melksham (proprietress C. Holt-Wilson). Tel. Melksham 703041 or 708709 (STD 0225)
Stools and chairs woven to order. Range of styles and colours. Rocking-chairs for children a speciality. Also old rush chairs and cane chairs reseated.
Visitors welcome, but advisable to phone first.

YORKSHIRE
J. W. TAYLOR & SON (BASKET MAKERS AND WILLOW GROWERS), Ulleskelf, nr Tadcaster. Tel. Tadcaster 2138
All types of cane and wicker furniture for house and garden. Rustic fencing, chair caning, rush seating, Moses-baskets, log-baskets, stools made in rush, cane and willow. Also food-hampers, fishing-hampers, pigeon-hampers, pet-baskets, flower-baskets, linen- and blanket-boxes, etc.
9 am–9 pm daily.
BRIARDENE CRAFTS (MR M. WILKINSON), Moor Lane, Sherburn-in-Elmet. Tel. South Milford 2086
Craftsmen-made cane and rustic furniture. Any type of basket-work.
Open 7 days a week.
J. BURDEKIN, BASKET WORKS, Flushdyke, Ossett.
Over 100 years' experience in the making of all types of baskets, rush chairs and furniture.
Open Monday–Sunday, 8 am–7 pm.

Wales
FLINTSHIRE
JAMES JOHNSON & SON, Station Road, Bangor-on-Dee, nr Wrexham. Tel. Bangor-on-Dee 417
All kinds of baskets made to order and specification. Repairs undertaken. Also willow growing. Large selection of sun lounge furniture in cane, willow, bamboo.

9 am–9 pm, including Saturday and Sunday.
ROBYN & BETI ELLIS JONES, Oak Trees, Nant Patrick, nr St Asaph LL17 0BN, County of Clwyd. Tel. Trefnant 608
Rushwork: small rush articles for the table, flower arrangers' baskets a speciality.
Any time—best to telephone first.

IN THE USA
SOURCES OF MATERIALS

Listed below are mail order suppliers of materials for both hard and soft basketry. All have cane and various assortments of raffia, reeds, rush, and seagrass. (Free catalogs are listed; otherwise write for information.) Materials can also be bought in crafts stores. Often in the U.S. reed as well as raffia is imported.

If you are interested in using materials that you can gather, consult EARTH BASKETRY *(see bibliography). The author includes a list of 103 plants used by the Indians for baskets, tells where they grow in the United States, and explains how to prepare them.*

NASCO WEST, P.O. Box 3837, Modesto, Calif. 95352. *Free catalog.*

NATURALCRAFT, 2199 Bancroft Way, Berkeley, Calif. 94704.

H.H. PERKINS CO., INC., 10 S. Bradley Rd., Woodbridge, Conn. 06525. *Free brochure.*

DICK BLICK CO., P.O. Box 1267, Galesburg, Ill. 61401. *Free catalog.*

INDIAN SUMMER, 1703 E. 55 St., Chicago, Ill. 60615.

PEORIA ARTS AND CRAFTS SUPPLIES, 1207 W. Main St., Peoria, Ill. 61606.

CRAFT SERVICE, 337-341 University Ave., Rochester, N.Y. 14607. *Free catalog.*

THE WORKSHOP, P.O. Box 158, Pittsford, N.Y. 14534.

YELLOW SPRINGS STRINGS, P.O. Box 107, 60 Goes Station, Yellow Springs, Ohio 45387. *Free catalog.*

THE HANDCRAFTERS, 1 W. Brown St., Waupun, Wisc. 53963.

NASCO ARTS AND CRAFTS, Fort Atkinson, Wisc. 53538. *Free catalog.*

Dyes

PYLAM PRODUCTS CO., INC., 95-10 218 St., Queens Village, N.Y. 11429. *Free brochure.*

BIBLIOGRAPHY

ABORIGINAL (AMERICAN) INDIAN BASKETRY, by Otis T. Mason/Rio Grande, Glorieta, N.M.

BASKETRY, by Frederick J. Christopher/ Dover, New York.

BASKETRY THROUGH THE AGES, by Henry H. Bobart/Gale Research, Detroit, Mich.

BASKETS AS TEXTILE ART, by Ed Rossbach/Van Nostrand Reinhold, New York.

CANEWORK, by Charles Crampton/Dryad, Northgates, Leicester; available from Museum Books, 48 E. 43 St., New York, N.Y. 10017.

A CANEWORKER'S BOOK — FOR THE SENIOR BASKET MAKER, by Dorothy Wright/Dryad, Northgates, Leicester; available from Museum Books (see above).

EARTH BASKETRY, by Osma Gallinger Tod/ Crown, New York.

INDIAN BASKETWEAVING, by the Navajo School of Indian Basketry/Dover, New York.

INTRODUCING RUSHCRAFT, by K. Whitbourn/Branford, Newton Centre, Mass.

MODERN BASKETRY FROM THE START, by Barbara Maynard/Scribner's, New York.

NEW WAYS WITH RAFFIA, by Grete Kroncke/Van Nostrand Reinhold, New York.

TECHNIQUES OF BASKETRY, by Virginia Harvey/Van Nostrand Reinhold, New York. *Has annotated bibliography. Interesting chapter on materials and tools.*

WEAVING WITH CANE AND REED, by Grete Kroncke/Van Nostrand Reinhold, New York.

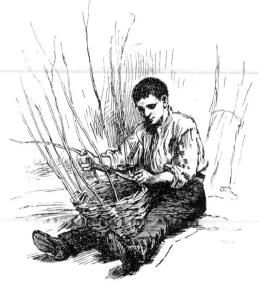

PAPER MAKING

Paper can be prepared from all fibrous substances, in particular those in the form of vegetation.

Wood is the most widely used in commercial paper making but tends to have rather limited possibilities when a variety of hand-made papers are sought. Plants on the other hand are very versatile, especially those species that are abundant on road verges or in meadows and woods throughout the country. Each species will produce a paper different in quality and texture from another; therefore a wide range of papers can be made for varying purposes.

EQUIPMENT

You will need a large saucepan (or pressure cooker), caustic soda, a bucket, bleaching powder, an earthenware jar (or large mixing jug), some scissors (or shears), a mallet, a large pestle and mortar (or a stone slab), a large plastic bin, a small tank, 2 yards of copper wire, some old blankets, a press (or large stones), a large dish, a wooden board and a thermometer.

Relevant items in the above list of equipment should not be made of naked iron as this metal is susceptible to rust and must be kept away from all pulp and paper.

METHOD

Collect your plants in late Summer or early Autumn and store on a stone floor, keeping them wet until they begin to decompose. In this way it will be easier for you to obtain the skeleton fibres essential for making paper.

When the material has sufficiently rotted, chop it into $\frac{1}{2}$-inch lengths and put into a large saucepan or pressure cooker filled with water. Add a good measure of caustic soda and boil for at least 3 hours making sure it doesn't boil dry. To test whether you have put in enough soda, the water should have a greasy feel to it when rubbed between the fingers. (Caustic soda is a strong alkaline and can cause burns if

not washed off immediately after testing.)

Empty the boiled material into a bucket and wash thoroughly till the water becomes clear. At the same time squeeze and pound the pulp with your hands so that the fleshy parts are removed in readiness for bleaching. Place the bleaching powder in an earthenware jar, fill with cold water and leave it to settle after stirring. Pour the bleach over the fibres and leave the mixture for at least 12 hours occasionally stirring with a stick. As the fibres will be damaged if they are too strongly bleached, it is best to test a small quantity first. In actual fact, a light fawn is the ideal colour to achieve when bleaching and should conditions allow, the final bleaching can take place outside in the sunlight.

Once again, wash the fibres thoroughly and after wringing out the surplus water, cut them into small pieces of no more than $\frac{1}{2}$ inch (a pair of shears will be ideal for this task). Crush the pulp with the pestle and mortar so that the fibres split lengthways (similar to bamboo) and continue crushing until the right consistency is obtained (the longer you crush the smoother will be the paper).

If a pestle and mortar isn't available a similar effect can be obtained by beating the pulp with a mallet on a stone slab, but the result will be a more uneven paper.

Should you require to store the pulp, a large plastic bin will be adequate. For periods of up to 4 months a preservative such as Santobrite can be added.

Before you actually begin making sheets of paper it may be best to produce a couple of sample sheets primarily to obtain information on texture, weight etc. Simply place a nylon kitchen sieve of about 8–10 inches in diameter into a tray filled with warm water and into this heap 2 or 3 cupfuls of pulp. Allow the pulp to move freely on the sieve and distribute it evenly with your hand. Lift the sieve away from the tray and after the excess water has drained away, place it in the sunlight or a warm room and allow it to dry. To peel off the sheet of paper, simply run the tip of a sharp knife around the edge to break contact with the frame. The thickness of course can be controlled by the amount of pulp put into the frame.

A more specialised frame is needed for the making of quality paper and here we suggest you construct a frame on to which a piece of perforated zinc has been nailed. Fabric can in fact be substituted for the zinc but both the paper and cloth need to be completely dry before being separated in the paper-making process. Zinc, on the other hand, is rigid enough to enable you to turn the frame upside down and press it on to a wet blanket for drying.

This method, of course, allows the frame to be in continuous use. For good-quality paper stack the alternate blankets and sheets of paper on top of each other and squeeze out the water by means of heavy weights or in a press. After pressing, separate the pile and allow the individual sheets to dry together with its blanket. This method is for the making of rather thin paper. For much thicker stock it is essential to keep more pulp on the mould and therefore a second frame has to be constructed.

This frame, known as the deckle, sits loosely upon the main frame and is a kind of lid which overlaps the sides slightly. This too should have perforated zinc nailed to it and the frame can be prevented from buckling if a number of thin wooden supports are fitted. The zinc too must be supported and this should be done by tacking parallel lengths of brass wire to the frame at 1 inch intervals.

Paper made from this process is known as 'wort' and possesses no watermark. Should you require your own insignia or decoration in the form of a watermark, a design can be fitted on to the upper surface of the mould. As the design is in relief, it prevents the same amount of pulp lying under it than on the rest of the mould and where this occurs the paper becomes thinner—hence the transparency when held up to the light. Good watermarks, by the way, can only be produced on paper made from finely-beaten pulp.

The method for making heavier paper with the use of the deckle is as follows:

At the side of your tank filled with pulp, place a large dish in which is a wooden board slightly larger than your mould. To the rear of this there should be a pile of saturated blankets one of which is laid in readiness on the board.

Fit the deckle in position over the mould and slowly lower the two vertically into the pulp at the far side of the tank. With a firm grip, continue lowering and slowly bring it into the horizontal position about an inch or two below the surface of the pulp. Now lift the mould so that it sits on the surface and shake slightly sideways and then forward to enable the fibres to matt together. Lift the mould away from the tank, tilt it on to one corner to drain for a few moments and then remove the deckle. Turn the mould upside down and press it on to the wet blanket. Now carefully raise the mould leaving the sheet of paper transferred to the blanket. This process can then be repeated after covering the paper with another saturated blanket and adding a cupful or so of fresh pulp to the tank.

After a number of sheets have been produced, place a wooden board on top of the pile and press to remove the excess water. Separate the individual sheets and blankets and leave to dry in the sunlight or in a warm room. Once dry, the sheets of paper can be removed from their blankets and pressed again for a short time.

Paper made in this manner is slightly absorbent and unsuitable as writing paper. It is well suited for various printing processes. Paper for writing or painting will need to be sized with gelatine. This can be done by heating the pulp slowly till it reaches 98°F and then adding the gelatine or by allowing the sheets of paper to mature for a week or so and then dipping them in a bath of size and pressing for a second time.

If you want sized paper quickly the first method is best as it cuts out an additional delaying process.

IN THE USA
BIBLIOGRAPHY

PAPERMAKING: THE HISTORY AND TECHNIQUE OF AN ANCIENT CRAFT, by Dard Hunter/ Knopf, New York.
For a simpler method, using household items and facial tissues, write for "How You Can Make Paper," a four-page booklet available free from: "Things To Do," AMERICAN PAPER INSTITUTE, 26 Madison Ave., New York, N.Y. 10016.

"just Strollin' along"

We had a pleasant walk today,
Over the meadows and far away,
Across the bridge by the water-mill,
By the woodside, and up the hill;
And if you listen to what I say,
I'll tell you what we saw to-day.

Amid a hedge, where the first leaves
 Were peeping from their sheaths so shy,
We saw four eggs within a nest,
 And they were blue as the summer's sky.

An elder-branch dipp'd in the brook,
 We wondered why it moved and found
A silken-hair'd, smooth water-rat
 Nibbling and swimming round and round.

Where daisies open'd to the sun,
 In a broad meadow, green and white,
The lambs were racing eagerly—
 We never saw a prettier sight.

We saw upon the shady banks
 Long rows of golden flowers shine,
And first mistook for buttercups
 The star-shaped yellow celandine.

Anemones and primroses,
 And the blue violets of spring,
We found whilst listening by a hedge
 To hear a merry ploughman sing.

And from the earth the plough turn'd up
 There came a sweet Refreshing smell,
Such as the lily of the vale
 Sends forth from many a woodland dell.

We saw the yellow wallflower wave
 Upon a mouldering castle wall,
And then we watched the busy rooks
 Among the ancient elm-trees tall.

And leaning from the old stone bridge,
 Below we saw our shadows lie,
And through the gloomy arches watch'd
 The swift and fearless swallows fly.

We heard the speckle-breasted lark
 As it sang somewhere out of sight,
And we tried to find it, but the sky
 Was filled with clouds of dazzling light.

We saw young rabbits near the wood,
 And heard a pheasant's wing go 'whir',
And then we saw a squirrel leap
 From an old oak-tree to a fir.

We came back by the village fields,
 A pleasant walk it was across them,
For all across the houses lay
 The orchards red and white with blossom.

Were I to tell you all we saw
 I'm sure that it would take me hours,
For the whole landscape was alive
 With bees, and birds, and buds, and
 flowers.

'THE SPRING WALK' BY THOMAS MILLER

RAMBLER'S RIGHTS[1]

THE DELIGHTS of walking the hills and dales, the moors and fens, the meadows and downs of Britain are manifold, but to most of those who set out to discover ancient footpaths and bridleways, a knowledge of the laws concerning rambling may be obscure or non-existent. What follows is a brief guide to the laws on footpaths, and further information may be obtained from The Ramblers' Association which has been working and fighting for many years to protect the 100,000 miles of public paths in the countryside of England and Wales.

WHAT IS A PUBLIC PATH?
A public path in the countryside is either a footpath or a bridleway. On footpaths the public have the right of passage on foot only. On bridleways they have the right of passage on horseback and on bicycle as well. Most paths in the countryside are unsurfaced tracks across fields, through woods or over uncultivated land. But legally they are no different from the metal-surfaced paths you may find in the built-up parts of towns and villages. Indeed,

[1] We are indebted to The Ramblers' Association for all the information supplied in this chapter.

legally, a public path in the country is part of the Queen's highway and subject to the same protection in law as a trunk road.

HOW DO I KNOW WHETHER A PATH IS A PUBLIC RIGHT OF WAY OR NOT?
The safest evidence is the definitive map of paths which all county councils were required to prepare by the National Parks and Access to the Countryside Act of 1949. Most counties in England and Wales now have such maps and you have the right to inspect them at the county and county district offices. Some counties sell copies of the definitive map. As the definitive maps are completed, the rights of way are marked in red on the latest edition of the Ordnance Survey one inch to the mile map for the area. But note: a path can be public even if it is not on the definitive map.

HOW DOES A PATH BECOME PUBLIC? MUST IT BE WALKED FOR 20 YEARS?
In legal theory, paths become rights of way because the owner 'dedicates' them to public use. In fact this rarely happens, but the law assumes that if people are allowed to use a path freely for upwards of 20 years then the owner intends dedication. Most public paths came about in this way. The converse is not true. A path does *not* cease to be public because it is unused for 20 years. The legal maxim is: 'Once a highway, always a highway.'
 Paths can also be created by agreement between highway authorities and owners or by compulsory order, subject, in the case of objection, to the Secretary of State for the Environment's consent. Creation orders are very rare and hard to obtain. (Highways Act, 1959, Sections 27 and 28 and Countryside Act, 1968, Schedule 3, Part 1.)

WHO OWNS THE PATH?
The owner of the property over which the path passes. The soil is his, but there is a right of passage over that particular strip of soil.

HOW WIDE SHOULD A PATH BE?
The theory is that the path should be whatever width was dedicated to the public. This width may be mentioned in the local enclosure award or in the statement accompanying the definitive

113

map. But in many cases the proper width will be a matter of what has been past practice on that particular path.

ARE HORSES ALLOWED ON PUBLIC PATHS?
Riders have a right to use bridleways, as the name implies. Fences and gates on these paths must be such that a rider can easily negotiate them without dismounting. Thus a locked gate on a bridleway is an obstruction. Riders have no right to use footpaths, but they often do and are not usually breaking the law in so doing. If use of a footpath by riders becomes a nuisance (e.g. by destroying the surface) the highway authority can make a byelaw forbidding riders to use that particular path. Alternatively riders can be physically prevented from using it by gateing the path and locking the gates (but then proper provision must be made for walkers). The owner of the land could also sue riders for trespass if they rode on a footpath without his permission.

IS IT ILLEGAL TO DRIVE CARS OR MOTORBIKES ON PUBLIC PATHS?
Anyone who drives a vehicle on to a footpath or bridleway is liable to a fine of up to £5 under section 18(1) of the Road Traffic Act, 1960.

WHEN IS A ROAD USED AS A PUBLIC PATH?
*RUPP*s as they are commonly known, are usually green lanes or unsurfaced tracks which have never carried enough traffic to merit maintenance. The great majority are unsurfaced and have never been much used by traffic except for packhorses in the old days and farm and access vehicles today. The classification of these ways as RUPPs was an invention of the National Parks Act of 1949 designed to ensure that they were recorded on the definitive maps and not lost completely. The classification is now in process of abolition and all RUPPs will eventually be reclassified as either footpaths, bridleways or byeways (Countryside Act, 1968, Schedule 3, Part III).

WHAT ARE THE HIGHWAY AUTHORITIES?
In rural areas they are usually the county councils. In urban areas they are the borough or urban district councils.

IS IT ILLEGAL TO PLOUGH UP A PATH?
There is no general rule. A few paths are held to have been 'dedicated subject to the right to plough'. On others there is a statutory right to plough provided the farmer gives at least a week's notice of his intention to the highway authority. But failure to restore the path to a reasonably usable condition is illegal. The farmer must restore the path within six weeks of giving notice, or within three weeks of starting to plough if he fails to give notice. If he thinks he cannot restore the path within the time limit he may apply for a temporary change of route (diversion) of the path to the highway authority. Such diversions are limited to three months and must be prominently advertised at either end of the diverted section. The statutory right to plough never applies to paths along the edge of fields. (Section 29, Countryside Act, 1968.)

CAN A FARMER KEEP A BULL IN A FIELD CROSSED BY A PUBLIC PATH?
In most counties it is forbidden by byelaw to keep a bull more than twelve months old at large in a field crossed by a right of way. Some counties permit bulls if accompanied by cows. Check with your county council. If there is no byelaw the farmer is within his rights.

WHAT IS TRESPASS?
The civil tort of trespass arises from the bare fact of unauthorised entry. However, unless he could prove injury to his property, a landowner could probably only recover nominal damages by suing in such a case. But of course you might have to meet his legal costs. Thus a notice saying Trespassers Will be Prosecuted, aimed for instance at keeping you off a private drive, may be effective but is pretty meaningless. Prosecution could only arise if you trespass *and* do damage, which forms the crime of malicious damage to property.

WHAT IS A MISLEADING NOTICE?
A misleading notice is one calculated to deter you from using a public right of way. For example a notice saying PRIVATE at the point where a public footpath enters a park. Such notices should be reported immediately to the highway authority. They are illegal

(Section 57 of the National Parks and Access to the Countryside Act) on paths shown on the definitive map.

WHO IS SUPPOSED TO LOOK AFTER THE STILES AND GATES ON A PATH?
Maintaining these is primarily the owner's responsibility, but the highway authority must contribute a quarter of the cost and more if it wishes. If the landowner fails to keep his stiles and gates in proper repair the authority can, after 14 days notice, do the job themselves and send the bill to the owner. (Section 28, Countryside Act, 1968.)

WHAT IS WAYMARKING?
Waymarking is a means of indicating the line or direction of a path at points where it may be difficult to follow. There are a variety of systems in use, ranging from splashes of coloured paint on walls and gates, through wooden arrows, stencilled paint arrows and metal discs to cairns of stones set up at intervals along moorland and mountain paths.

IF A PATH HAS BEEN PLOUGHED AND CROPS HAVE GROWN OVER IT, CAN I WALK THROUGH THE CROPS?
Yes. But be careful to do no damage. Stick as close as you can to the line of the path and go in single file. (But forgetting all legalities, I think it would benefit everyone concerned if you follow the edge of the crops round to the point where you meet the path.)

CAN I WALK WHERE I LIKE ON UNCULTIVATED LAND?
No. You can generally go as you please on uncultivated *common* land. But that is by custom, not of right. On privately owned mountains, moors and downs the situation is very different. Most of such land is preserved for sport or is used for grazing sheep. In some areas you will find nobody minds your walking over land of this kind. In others it is a different story. In a few areas, mostly in the Peak District National Park, sizeable stretches of such country have been opened to the public by access agreements between the planning authority and the landowner under the 1949 National Parks and Access to the Countryside Act.

114

WHAT IS AN OBSTRUCTION ON A PATH?
Anything which interferes with your right to proceed along it, e.g. barbed wire fence across the path or a heap of manure dumped on it. Overgrowing vegetation is not normally treated as an obstruction but is dealt with under path maintenance.

ARE ALL THE PATHS SUPPOSED TO BE SIGNPOSTED?
No. Under the Countryside Act (Section 27(2)) the highway authorities have a duty to put up a signpost at all junctions of footpaths and bridleways with metalled roads. But few counties have much signposting at the moment and the Act lays down no time limit within which this sizeable job must be done. Also parish councils can relieve the highway authorities of the obligation for particular paths in a parish.

WHICH LOCAL AUTHORITIES ARE RESPONSIBLE FOR KEEPING PATHS CLEAR?
In the countryside the rural district councils have a general duty under the Highways Act of 1959 'to assert and protect the rights of the public to use and enjoy all the highways in their district and to prevent, as far as possible, the stopping up or obstruction of those highways'. The highway authority (the county council usually) are statutorily responsible for maintaining the path. They also deal with ploughing problems, stiles and gates and footbridges. Parish councils have a useful power to maintain paths but no statutory obligation. Highway Authorities have the power under Section 134 of the Highways Act of 1959 to require owners to cut back overgrowth.

PUBLIC PATH CLEARING BY VOLUNTEERS[2]

As more and more people want to use the public paths and as more and more local authorities get around to signposting them, the sense of frustration on the part of individuals who try to walk the paths and find them overgrown or otherwise impenetrable grows.

In many districts today groups of the

[2] *Information taken from a Fact Sheet issued by The Ramblers' Association, with its kind permission.*

Ramblers' Association members, local amenity and footpath societies, parish councils and other bodies have decided that the answer to this problem is self-help. If the path is blocked take your coat off and go and clear it. That sounds simple and in essence it is, but there can be snags. There are easy ways and difficult ways of doing it. You need the right tools. You need the necessary permissions. This tells you what you need to know.

Value
The value of path clearance is obvious. It keeps paths open and gets them used. This in turn discourages any future attempts at extinguishment of the paths on grounds of lack of use. Path clearance is good publicity for the organisation undertaking it, which is thus seen to be doing a constructive job. Finally, a vigorous path clearance programme often serves to stimulate local authorities into stepping up their signposting programme and tackling problems such as ploughed and illegally obstructed paths. It is sometimes argued that volunteers who clear paths are doing the landowner's or local authority's work for them. Our experience is that voluntary effort of this kind stimulates those with legal responsibilities to discharge them more effectively.

Permission
Any individual may remove so much of an obstruction on a public path as may be necessary to enable him to pass. That does not entitle an organised party of people to go out for the specific purpose of clearing, e.g. an overgrown path. **You need permission.**

There are three sources of permission:

1 The *owner or tenant* of the land crossed by the path.
2 The *parish council.* Parish Councils are empowered (Section 46 of the Highways Act of 1959) to maintain public paths and they can allow individuals or organisations to act as their agents.
3 The *county councils* (or other highway authorities). They have ultimate responsibility for maintaining the path and again may give you permission to do so.

We advise getting permission from the owner or tenant in the first place. You will be surprised how often this is possible. Check the exact line of the path with the owner/tenant (or his representative). A walk along the path to be cleared with the estate agent, farm manager, gamekeeper or the owner or farmer himself is invaluable. You will learn a lot about how the land is managed and you will probably find yourself launched on a period of co-operation with an owner who previously seemed hostile to path-users.

Remember: farmers and landowners naturally fear trespass and vandalism. A system of clearly marked and easy-to-follow paths ensures that people know where they have a **right** to go and prevents unwitting trespass.

If the owner or tenant does refuse permission, then is the time to go to the parish council or county council.

Organising the Party
The first essential is for the working party to have a clearly nominated leader. His responsibilities are:

1 To see that everyone is using the proper tools and using them safely.
2 To see that the path is cleared to same width and standard throughout its length.
3 To see that the working party sticks to the correct line of the path.
4 To see that the path is left tidy and litter-free when the job is completed.

Tools
Beginners at the clearance game naturally tend to use the tools most readily available: the secateurs, sickles and shears which most gardeners have around. Of course you must use the tools which best fit the job in hand, but two weapons in particular have been found useful:

1 THE EVERSHARP SCYTHETTE: This tool is shaped like a golf club with a serrated edge on the business end and it works wonders on undergrowth. (See p. 119 for details.)
2 THE 'TOGGLE LOPPER'. In effect these are king-size secateurs. These are invaluable for the heavier cutting jobs on overgrown hedges. They are also very serviceable on saplings and branches up to about $1\frac{1}{4}$ inches in diameter. (See p. 119 for details.)

With these two weapons you are well equipped to deal with the main kinds of overgrowth both up in the air and down on the ground. The most serious obstacles which these tools will not cope with are tree stumps and branches thicker than $1\frac{1}{4}$ inches. These should be sawn back to ground level so as not to leave a stumbling block in the path. For these use a Rolcut folding pruning-saw convenient for carrying in a rucksack. This measures 11 inches when folded and costs £1.10. For heavier work a Sandvik 24-inch bow saw works wonders. To uproot difficult tree stumps a mattock is the ideal tool. It is like a pick axe with a 4-inch blade at right angles to the handle and a 2-inch blade parallel with the handle. It costs approximately £2. These are two specialist tools for more advanced clearing work but they are not essential to start with. The great advantage of 'Toggle Loppers' and 'Scythettes' is that they do not have blades as sharp as the normal sickle and are therefore much safer to use when parties of people are involved.

The leader of a clearance party has an important safety role. He should see that all members of the team are working far enough apart not to get in each other's way and he should also ensure that leather or gardening gloves are being worn to deal with hawthorn, brambles and nettles etc.

Width

How wide should your path be? A good working minimum, if you can achieve it, is 4 feet wide for a footpath and 6 for a bridleway. But there is no general legal requirement that a path should be of a certain width. There may be a note in the statement accompanying the definitive map, but this is unusual. In other cases the width will be governed by the local custom. In any case make sure you agree the width with the landowner or highway authority before starting work.

Bear in mind that on a bridleway, overhanging vegetation should be cut back to a height of 9 feet to allow riders through.

How Many People?

This is very difficult to estimate. It depends on the nature of the path, the experience of the leader and his team and the weather. It is the leader's job to estimate how many people he needs, but here is a rough guide. It will take 8 workers a day to clear 300 yards of really dense growth (e.g. when two hedges have grown together and intermeshed) to a width of 6 feet. A day's work is from say 10.00 am to 5.00 pm with a lunch break.

Clearing up

Arrangements must be made for disposing of the overgrowth, brushwood, etc., which has been cleared. The simplest method is a bonfire. Don't make the common beginner's error of siting your bonfire at one end of the path. It means a long walk for those clearing the other end to bring material to it. Put it in the middle and make sure that the fire is burnt out or safely damped down before leaving.

Which Paths?

If you are doing a pilot scheme or a one-off job, i.e. not part of a continuing programme of clearance over a given area, do a path which will give maximum return on the time and labour expended. Choose a path about which people have complained or one which will open the way to other linking walks. Often a few hundred yards of clearance opens up several miles of paths.

Relate the paths you choose for clearance to the highway authority's signposting programme. Many county councils are now putting up path signs on a significant scale for the first time ever. Often these signs advertise paths which have become completely impenetrable. A good idea is to choose newly signposted paths in this category.

If you clear a path which is not signposted, ask the highway authority to follow up your work by putting up a sign. After all you have been doing the authority's job for it (Section 38, Highways Act, 1959) and it is reasonable to expect a quid pro quo. The highway authority can also authorise you to waymark the path if this is appropriate. But they must consult the landowner first [*Countryside Act, Section 27(1) and (5)*]. You can always help things along by asking the landowner when you first approach him about clearance.

From the landowner's point of view the argument for waymarking is the same as that for clearance. Clear, well-marked paths prevent people straying.

Birds' Nests

Path clearance can damage bird life if undertaken at the wrong time of the year or without proper care.

Many species of birds nest in hedgerows and the nesting season runs roughly from the beginning of April to the end of August. Avoid clearance operations which involve drastic cutting back of hedgerows or heavy clearance of undergrowth during this period. Your main clearance season should be the Autumn and Winter. It is easier then anyway because the foliage is less. But public paths are not nature reserves and the clearance of light growth (nettles, brambles and the odd overhanging frond) is a legimate Summer activity. There are plenty of other things for path workers to do in the Summer, e.g. bridge-building, waymarking and stile repairs. Summer too is the time to start negotiating with landowners and local authorities for next winter's clearance programme.

Insurance

Some country councils require volunteer parties clearing paths as their agents to be insured against claims for damage, e.g. the lopping of a tree off the line of the path. And some volunteer groups feel happier if their own members are insured against injury. Consult an insurance broker about cover. It is not expensive. A typical rate to insure an organisation running regular clearance parties with a total membership of 150 is about £5 per annum.

Publicity

Work on clearing a path is never work wasted, but maximise its value by making sure you get what you are doing into the newspapers. Constructive volunteer work of this kind is a natural news story for your local press and can sometimes fill an odd spot on a regional TV magazine programme as well. Invite the news media at least a week in advance so that they can send a photographer and/or reporter to cover the operation. When inviting the press

'The Old Mill' by John Shelley.

indicate points of interest about the path, e.g. an archaeological site or a good view point. When the path has been cleared send the local papers a press release telling them the job has been done, how long it took and how many took part. Make sure you provide an address and (if possible) a telephone number to which the newspaper can refer for further queries.

SOURCES OF MATERIALS

Map-reading aid:
The Ramblers' Association has produced a handy device for obtaining grid references quickly and accurately. Called 'The Romer', it is printed on clear plastic and is available from the Association at 10p (including postage).

Path-clearing tools:
The 'Eversharp Scythette' costs £1 (including postage) and may be obtained from the manufacturer: T. & J. Hutton & Co. Ltd, Phoenix Works, Ridgeway, Sheffield. For orders of 1 dozen (send £8), the price of each 'Scythette' is reduced to 67p.

The 'Toggle Lopper' costs £3.85 and is manufactured by Rolcut, Blatchford Road, Horsham, Sussex.

In the USA
The Rolcut line is available from Walt Nicke (P.O. Box 667, Hudson, N.Y. 12534, *free catalog*), although he does not carry the Toggle Lopper. Various brands of lopper and grass-cutting whip (scythette), as well as other path-clearing tools, can be found in garden supply centers or at hardware stores.

SOCIETY

THE RAMBLERS' ASSOCIATION, 1–4 Crawford Mews, York Street, London W1M 1RT. *The R.A. is an association for all who enjoy walking in the countryside and wish to see its paths and beauty protected. Membership costs £1 per annum with concessionary rates for married couples, retired people, students and young people. Its 28,000 members receive the quarterly journal RUCKSACK free and this contains regular advertising by reputable equipment and clothing suppliers.*

The Ramblers' Association publishes two pamphlets on map-reading: MAPS FOR WALKERS *(free) and* MAP READING FOR THE COUNTRYGOER *(15p). The R.A. also operates a library of 1-inch maps for its members. These may be borrowed for a nominal charge. Many public libraries also lend O.S. 1-inch sheets.*

BIBLIOGRAPHY

Rambling is fine, but not in a bibliography, so we have divided this subject in the following way:

Forest Guides
The Forestry Commission has an outlet in the U.S. from which its publications can be ordered: PENDRAGON HOUSE, INC., 220 *University Ave., Palo Alto, Calif.* 94301.

ARGYLE FOREST PARK/The Forestry Commission, 25 Savile Row, London W1X 2AY. Price: 35p.

DEAN FOREST AND WYE VALLEY/The Forestry Commission. Price 32½p.

FORESTS OF CENTRAL & SOUTHERN SCOTLAND/ The Forestry Commission. Price: 62½p.

FORESTS OF NORTH EAST SCOTLAND/The Forestry Commission. Price: 25p.

GLAMORGAN FORESTS/The Forestry Commission. Price 25p.

GLEN MORE FOREST PARK/The Forestry Commission. Price 42½p.

NEW FOREST/The Forestry Commission. Price: 35p.

NEW FOREST OF DARTMOOR/The Forestry Commission. Price: 21p.

NORTH YORKSHIRE FORESTS/The Forestry Commission. Price: 65p.

EAST ANGLIAN FORESTS/The Forestry Commission. Price: 50p.

LOCAL GUIDES FOR WALKERS

England: The Eastern Counties

CIRCULAR WALKS AROUND SCUNTHORPE/Scunthorpe Civic Trust. Free.

THE FOOTPATHS OF LINTON DISTRICT, by Linton District Amenity Society's Rights of Way Group/available from the Society at: The Village College, Linton, Cambridgeshire. Price: 2½p (5p by post).

RAMBLES IN NORFOLK, by Mrs J. le Surf/available from the author at: 6 Atthill Road, Norwich NOR 8OJ. Price: 25p (28p by post).

RAMBLES IN RUTLAND, by Michael Fisher/available from The Uppingham Bookshop, High Street, Uppingham, Rutland. Price: 5p. (plus a foolscap S.A.E.).

RAMBLING IN LINCOLNSHIRE, by J. N. Cole/available from the author at: 18 New Road, Waltham, Grimsby, Lincolnshire. Price: 25p.

THIRTY MORE NORFOLK WALKS, by The Norwich District Footpath Society/available from A. R. Cartwright, 1 Bridle Road, Keswick, Norwich NOR 6OD. Price: 25p.

WALKS AND RIDES AROUND CAMBRIDGE/Cambridgeshire & Isle of Ely County Council. Available from G. Smith, 5 Garlic Row, Cambridge CB5 8HW. Price: 40p.

England: The Midlands and the Welsh Border

CHURCH STRETTON RAMBLES, by Robert Smart/available from the author at: Church Stretton, Shropshire. Price: 21p.

DOVEDALE GUIDE/Derbyshire Countryside Ltd, Lodge Lane, Derby. Price: 90p.

DOVEDALE GUIDE/available from the 'Come to Derbyshire' Association, 1 Uttoxeter New Road, Derby. Price: 12½p.

EDALE, LATHKILL, PADLEY VALLEYS, Nature Trail Booklets/The Peak Park Planning Board, Aldern House, Bakewell, Derbyshire. Price:

5p each.

GOYT VALLEY STORY/available from Clifford Rathbone, 'The Hollies', Bollington Road, Bollington, Macclesfield, Cheshire. Price: 25p.

INTER-HOSTEL WALKING ROUTES: COTSWOLDS/available from Mr A. J. Drake, 2 Beech Lodge, The Park, Cheltenham, Gloucestershire GL50 2RX. Price: 14½p (including postage) (Complete set of leaflets.)

CLEEVE HILL TO DUNTISBOURNE ABBOTTS. Price: 4p (including postage).

DUNTISBOURNE ABBOTTS TO CLEEVE HILL. Price: 4p (including postage).

CLEEVE HILL TO STOW-ON-THE-WOLD. Price: 4p (including postage).

DUNTISBOURNE ABBOTS TO CHEDWORTH ROMAN VILLA WITH CONNECTIONS TO STOW-ON-THE-WOLD. Price 3½p (including postage).

CHEDWORTH ROMAN VILLA TO DUNTISBOURNE ABBOTS. Price: 3½p (including postage).

STOW-ON-THE-WOLD TO CHARLBURY. Price: 4p (including postage).

CHARLBURY TO STOW-ON-THE-WOLD. Price: 4p (including postage).

INTER-HOSTEL WALKING ROUTES: FOREST OF DEAN AND WYE VALLEY/available as above.

MITCHELDEAN TO WELSH BICKNOR. Price: 3½p (including postage).

WELSH BICKNOR TO MITCHELDEAN. Price: 3½p (including postage).

ST BRIAVELS TO WELSH BICKNOR. Price: 3½p (including postage).

WELSH BICKNOR TO ST BRIAVELS. Price: 3½p (including postage).

NOTTINGHAMSHIRE WALKS, by John Brock/BBC Radio Nottingham. Available from BBC, 35 Marylebone High Street, London W1M 4AA. Price: 50p.

THE PENNINE WAY AND WALKING IN DERBYSHIRE/available from The Peak Park Planning Board, Aldern House, Bakewell, Derbyshire.

TWENTY WALKS IN MID-CHESHIRE/available from Phillip, Son & Nephew Ltd, 7 Whitechapel, Liverpool L69 1AN. Price: 27½p.

TWENTY WALKS IN S.W. LANCASHIRE/available as above. Price: 12½p.

TWENTY WALKS IN WIRRAL/available as above. Price: 25p.

WALKING AROUND CHIPPING CAMPDEN, by The North Cotswold Group of the Voluntary Warden Service/available from local shops or

by post from: F. A. Holland, Latymer, Chipping Campden. Price: 10p (including postage).

WALKING IN DERBYSHIRE/available from The Peak Park Planning Board, Aldern House, Bakewell, Derbyshire. Price: 22½p.

WALKS AROUND EDALE, by F. Heardman/available as above. Price: 4p.

WALKS AROUND DOVEDALE, by A. Bates/available as above. Price: 4p.

WALKS AROUND LONGDENDALE, by A. Bridge/available as above. Price: 4p.

WALKS IN LEICESTERSHIRE, by Leicestershire Footpaths Association/City of Leicester Publicity Department, Bishop Street, Leicester. Price: 33p.

WALKS IN THE DERBYSHIRE DALES/Derbyshire Countryside Ltd. Available from Clifford Rathbone, 'The Hollies', Bollington Road, Bollington, Macclesfield, Cheshire. Price: 25p.

WAYMARKED FOREST PATHS IN THE FOREST OF DEAN/available from Mr A. J. Drake, 2 Beech Lodge, The Park, Cheltenham, Gloucestershire GL50 2RX. Price: 4½p (including postage).

WAYMARKED FOREST PATHS IN HIGHMEADOW WOODS/available as above. Price: 4p (including postage).

ENGLAND:

The North and the Border

AN INTRODUCTION TO NATURE TRAILS & WALKS/available from The Lake District National Park Information Centre, Brockhole, Windermere, Westmorland. Free (but send postage).

ARNSIDE AND SILVERDALE/Dalesman Publishing Co. Ltd, Clapham (via Lancaster), Yorkshire. Price 15p (plus postage).

AROUND INGLETON AND CLAPHAM, by Ron and Lucie Pearson/Dalesman Publishing Co. Ltd, as above. Price: 20p (plus postage).

AROUND ULLSWATER AND PENRITH/Dalesman Publishing Co. Ltd, as above. Price: 12½p (plus postage).

A SHORT GUIDE TO THE ROMAN WALL, by R. G. Collingwood/Harold Hill and Son, Killingworth Place, Gallowgate, Newcastle-upon-Tyne. Price: 12½p.

A SHORT WALK FROM AMBLESIDE/available from The Lake District National Park Information

Centre, Brockhole, Windermere, Westmorland. Free (but send postage).

BORDER & DALES HOSTEL GUIDE, by The Border & Dales Regional Y.H.A. Group/available from the Group at: 30 Baliol Square, Lower Barn, Durham. (Price: 25p (including postage).

BOWNESS AND HAWKSHEAD/available from The Lake District National Park Information Centre, Brockhole, Windermere, Westmorland. Free (but send postage).

BUTTERMERE/The R.A. Lake District Area. Available from bookshops in the Lake District or from Mr R. Taylor, 62 Loop Road North, Whitehaven, Cumberland. Price: 10p (plus postage).

CENTRAL LAKELAND/Dalesman Publishing Co. Ltd, Clapham (via Lancaster), Yorkshire. Price: 12½p (plus postage).

CONISTON, by D. Cameron/The R.A. Lake District Area. Available from bookshops in the Lake District or from Mr R. Taylor, 62 Loop Road, North, Whitehaven, Cumberland. Price: 10p (plus postage).

THE COWN EDGE WAY, by The R.A. Manchester Area/available from The Area Sales Secretary: Mr S. McNab, 41 Slateacre Road, Gee Cross, Hyde, Cheshire. Price: 12½p (including postage).

EAST YORKSHIRE RAMBLES/available from A. Brown & Sons Ltd, Perch Street West, Hull, HU5 3UA. Price: 42p (including postage).

THE EASTERN FELLS, by A. Wainwright/The Westmorland Gazette, 22 Stricklandgate, Kendal. Price: 75p (plus postage).

ENNERDALE, by Roland Taylor/The R.A. Lake District Area. Available from bookshops in the Lake District or from Mr R. Taylor, 62 Loop Road North, Whitehaven, Cumberland. Price: 10p (plus postage).

ESKDALE, by Douglas Ramsden/The R.A. Lake District Area. Available as above. Price: 12½p (plus postage).

ESKDALE, by Roland Taylor/The R.A. Lake District Area. Available as above. Price: 10p (plus postage).

THE ENCHANTED HILLS/The Chorley Guardian, 32a Market Street, Chorley, Lancashire. Price: 37½p.

EXPLORING THE NORTH EAST AROUND ALNWICK/ H. O. Wade, 5 East View, Highfield, Rowlands Gill. Price: 15p (including postage).

EXPLORING THE NORTH EAST AROUND HEXHAM/ available as above. Price: 15p (including postage).

EXPLORING THE NORTH EAST AROUND MORPETH/ available as above. Price: 15p (including postage).

EXPLORING THE NORTH EAST AROUND SOUTH NORTHUMBERLAND/available as above. Price: 15p (including postage).

EXPLORING THE NORTH EAST AROUND THE COASTAL AREA OF OUTSTANDING NATURAL BEAUTY available as above. Price: 15p (including postage).

EXPLORING THE NORTH EAST AROUND THE NORTHUMBERLAND NATIONAL PARK/available as above. Price: 15p (including postage).

THE FAR EASTERN FELLS, by A. Wainwright/The Westmorland Gazette, 22 Stricklandgate, Kendal. Price: 75p (plus postage).

FOLLOW ANY STREAM/The Chorley Guardian, 32a Market Street, Chorley, Lancashire. Price: 37½p.

FORTY RAMBLES, by Ian Brodie/The Lancashire Evening Post, 127 Fishergate, Preston. (Gives detailed walks around Preston.) Price: 25p.

GRANGE AND CARTMEL/Dalesman Publishing Co. Ltd, Clapham (via Lancaster), Yorkshire. Price: 12½p (plus postage).

GRASMERE, by Roland Taylor/The R.A. Lake District Area. Available from bookshops in the Lake District or from Mr R. Taylor, 62 Loop Road North, Whitehaven, Cumberland. Price: 10p (plus postage).

GREEN PASTURES/The Chorley Guardian, 32a Market Street, Chorley, Lancashire. Price: 37½p.

GUIDE TO THE DERWENT VALLEY, by Roland Taylor/The R.A. Lake District Area. Available from bookshops in the Lake District or from Mr R. Taylor, 12 Loop Road North, Whitehaven, Cumberland. Price: 10p (plus postage).

HEATHER IN MY HAT/The Chorley Guardian, 32a Market Street, Chorley, Lancashire. Price: 37½p.

HIGH PEAK, by Eric Byne and Geoffrey Sutton/ Secker and Warburg Ltd. Price: £2.50.

KIDDOWICK AND NORTHERN LAKELAND/Dalesman Publishing Co. Ltd, Clapham (via Lancaster), Yorkshire. Price: 12½p (plus postage).

FURTHER WALKS FOR MOTORISTS IN THE DALES, by The R.A. West Riding Area/Gerrard

Publications, 6 Edge End Avenue, Brierfield, Nelson, Lancashire. Price: 42½p (plus postage).

LAKE DISTRICT WALKS FOR MOTORISTS, by J. Parker/Gerrard Publications (as above):

Central Area: Grasmere, Ambleside, Windermere, Coniston. Price: 50p (plus postage).

Northern Area: Keswick, Borrowdale, Ullswater. Price: 50p (plus postage).

Western Area: Buttermere, Wastwater, Eskdale west of Coniston and to the Coast. Price: 50p (plus postage).

THE LAKELAND PEAKS, by W. A. Poucher/ Constable & Co. Ltd. Price: £1.50.

LANGDALE, by Roland Taylor/The R.A. Lake District Area. Available from bookshops in the Lake District or from Mr R. Taylor, 62 Loop Road North, Whitehaven, Cumberland. Price: 10p (plus postage).

LET'S GO FOR A RAMBLE/The Manchester Evening News, 164 Deansgate, Manchester M60 2RD. Price: 12½p.

LET'S TAKE A WALK/The Chorley Guardian, 32a Market Street, Chorley, Lancashire. Price: 37½p.

MALHAMDALE/Dalesman Publishing Co. Ltd, Clapham (via Lancaster), Yorkshire. Price: 20p (plus postage).

MANX HILL WALKS, by The Manx Conservation Council Footpaths Group/available from 'Landsworth', Beach Road, Port St Mary, Isle of Man. Price: 25p (plus postage).

NIDDERDALE/Dalesman Publishing Co. Ltd, Clapham (via Lancaster), Yorkshire. Price: 12½p (plus postage).

NEWLANDS, by Roland Taylor/The R.A. Lake District Area. Available from bookshops in the Lake District or from Mr R. Taylor, 62 Loop Road North, Whitehaven, Cumberland. Price: 10p (plus postage).

NORTH YORK MOORS WALKS FOR MOTORISTS, by Geoffrey White/Gerrard Publications, 6 Edge End Avenue, Brierfield, Nelson, Lancashire. Price: 50p.

THE NORTHERN FELLS, by A. Wainwright/The Westmorland Gazette, 22 Stricklandgate, Kendal. Price: 75p (plus postage).

THE NORTH-WESTERN FELLS, by A. Wainwright/ The Westmorland Gazette (as above). Price: 75p (plus postage).

OVER THE FIVE-BARRED GATE/The Chorley Guardian, 32a Market Street, Chorley, Lan-

TEN WALKS FOR MOTORISTS IN THE WIRRAL, by 'Greenways'/available from The Belvedere Press (Publications), 22 Rake Lane, Wallasey, Cheshire. Price: 25p (plus postage).

THE TOWPATH TROD (Along the Leeds and Liverpool Canal), by The West Riding Area and the North-Eastern Branch of the Inland Waterways Association/available from Mr C. Speakman, 32 Ayresome Avenue, Roundhay, Leeds 8, Yorkshire. Price: 17½p (including postage).

TWO WALKS FROM GLENRIDDING(available from The Lake District National Park Information Centre, Brockhole, Windermere, Westmorland. Free (but send postage).

ULLSWATER, by Harry Appleyard/The R.A. Lake District Area. Available from bookshops in the Lake District or from Mr R. Taylor, 62 Loop Road North, Whitehaven, Cumberland. Price: 10p.

UPPER EDEN VALLEY, by Gordon Wood/Dalesman Publishing Co. Ltd, Clapham (via Lancaster), Yorkshire. Price: 12½p (plus postage).

WALKER'S MAP OF THE ISLE OF MAN/available from Manxtracks, Dhoon Platt, Maughold, Ramsey, Isle of Man. Price: 25p (including postage).

WALKING IN AIREDALE, by The R.A. Bradford Group/Dalesman Publishing Co. Ltd, Clapham (via Lancaster), Yorkshire. Price: 35p (plus postage).

WALKING IN CLEVELAND, by A. Falconer/available from S. Cardwell, 11a Lynton Gardens, Darlington, Co. Durham. Price: 25p.

WALKING IN HISTORIC YORKSHIRE, by Colin Speakman/Dalesman Publishing Co. Ltd, Clapham (via Lancaster), Yorkshire. Price: 40p (plus postage).

WALKING IN SOUTH YORKSHIRE, by J. L. Ferns/Dalesman Publishing Co. Ltd (as above). Price: 35p (plus postage).

WALKING IN THE CRAVEN DALES, by Colin Speakman/Dalesman Publishing Co. Ltd (as above). Price: 35p (plus postage).

WALKING IN THE DALES, by Col P. T. Straubenzee/available from the author at: Spennithorne House, Spennithorne, Leyburn, Yorkshire. Price: 19p.

WALKING IN THE ISLE OF MAN/available from The Island Tourist Board.

WALKING ON THE NORTH YORK MOORS, by The

R.A. N. Yorks and S. Durham Area/Dalesman Publishing Co. Ltd, Clapham (via Lancaster), Yorkshire. Price: 35p (plus postage).

WALKS AROUND HARROGATE, by The R.A. Harrogate Group/available from P. L. Goldsmith, 20 Pannal Ashgrove, Harrogate, Yorkshire. Price: 45½p (including postage).

WALKS AROUND LANCASTER, by The R.A. Lancaster and Morecambe Group/available from 22 Endsleigh Grove, Lancaster. Price: 23p (including postage).

WALKS AROUND RYLSTONE/available from C. Speakman, 32 Ayresome Avenue, Roundhay, Leeds LS8 1BE. Price: 5p.

WALKS FOR MOTORISTS IN THE DALES, by The R.A. West Riding Area/Gerrard Publications, 6 Edge End Avenue, Brierfield, Nelson, Lancashire. Price: 40p (plus postage).

WALKS FROM KENDAL, by The R.A. Kendal Group/obtainable from Mr M. Leak, 4 Woodgate, Kendal. Price: 15p (send S.A.E.).

WALKS IN BRONTË COUNTRY, by Alan Lawson/Gerrard Publications, 6 Edge End Avenue, Brierfield, Nelson, Lancashire. Price: 20p (plus postage).

WALKS IN HODDER COUNTRY, by Alan Lawson/Gerrard Publications (as above). Price: 22½p (plus postage).

WALKS IN LIMESTONE COUNTRY, by A. Wainwright/The Westmorland Gazette, 22 Stricklandgate, Kendal.

WALKS IN PENDLE COUNTRY, by Alan Lawson/Gerrard Publications, 6 Edge End Avenue, Brierfield, Nelson, Lancashire. Price: 20p (plus postage).

WASDALE, by Roland Taylor/The R.A. Lake District Area. Available from bookshops in the Lake District or from Mr R. Taylor, 62 Loop Road North, Whitehaven, Cumberland. Price: 10p (plus postage).

WEARDALE, by Douglas Ramsden/Dalesman Publishing Co. Ltd, Clapham (via Lancaster), Yorkshire. Price: 12½p (plus postage).

WENSLEYDALE/Dalesman Publishing Co. (as above). Price: 15p (plus 6p postage).

THE WESTERN FELLS, by A. Wainwright/The Westmorland Gazette, 22 Stricklandgate, Kendal. Price: 75p (plus postage).

THE WHITE ROSE WALK, by Geoffrey White/Dalesman Publishing Co. Ltd, Clapham (via Lancaster), Yorkshire. Price: 20p (plus postage).

WINDERMERE, by Joy Greenwood/The R.A. Lake District Area. Available from bookshops in the Lake District or from Mr R. Taylor, 62 Loop Road North, Whitehaven, Cumberland. Price: 10p (plus postage).

YORKSHIRE'S THREE PEAKS (Dalesman Publishing Co. Ltd, Clapham (via Lancaster), Yorkshire. Price: 20p (plus postage).

ENGLAND:

The South-East

ADUR TO ARUN, by H. L. Reeves/ Sheepdown Publications. Price: 50p.

AFOOT IN ESSEX, by Frank Dawes/Letchworth Printers Ltd, Norton Way, North Letchworth SG6 1BH, Hertfordshire. Price: 50p.

AFOOT IN HERTFORDSHIRE, by Frank Dawes/Letchworth Printers Ltd (as above). Price: 40p.

BERKHAMSTED, ASHRIDGE AND DISTRICT FIELD-PATH MAP, by The Berkhamsted Citizens Association/available from 7 Oxfield Close, Berkhamsted, Hertfordshire. Price: 35p.

BETWEEN KENNET & THAMES/The Parish Councils of Englefield, Pangbourne, Purley, Theale, Tidmarsh with Sulham and Tilehurst. Available from the Clerk to the Tilehurst Parish Council, 26 Bath Road, Reading, Berkshire. Price: 13p (including postage).

CENTRAL HAMPSHIRE, by P. H. Carne/Winchester Information Office. (Several leaflets.) Price: 1½p each.

A CIRCULAR WALK FROM KEMSING HOSTEL/The Y.H.A. Southern Regional Group, 58 Streatham High Road, London SW16. Free (but send S.A.E.).

COOKHAM FOOTPATH MAP/The R.A. East Berkshire Group. Available from Peter Nevell, 'Donnybrook', Altwood Road, Maidenhead, Berkshire SL6 4BP. Price: 13p (including postage).

COUNTRY WALKS, BOOK 1/London Transport, 55 Broadway, London SW1. Price: 30p.

COUNTRY WALKS, BOOK 2/London Transport (as above). Price: 30p.

CUCKFIELD WALKS, by The Cuckfield Society/available from 22 South Street, Cuckfield, Sussex. (Seven leaflets.) Price: 2½p each (including postage).

DISCOVERING WALKS IN THE CHILTERNS, by R. J.

Pigram/available from Shire Publications, 12B Temple Square, Aylesbury, Buckinghamshire. Price: 30p.

FIFTEEN WALKS AROUND FOLKESTONE, by Marjorie Walton/available from Cross's, 91 Sandgate Road, Folkestone, Kent. Price unknown.

FIVE COUNTRY WALKS AROUND SUNNINGHILL, by P. Hathaway/available from the author at: 41 Victoria Road, South Ascot. Price: 9p (including postage).

FOOTPATH MAP OF HENLEY-ON-THAMES N.W., by The Chiltern Society/available from Shire Publications, 12B Temple Square, Aylesbury, Buckinghamshire. Price: 12½p (including postage).

FOOTPATH MAP OF HENLEY-ON-THAMES S.W., by The Chiltern Society/available from Shire Publications (as above). Price: 12½p (including postage).

FOOTPATH MAP OF MARLOW, by The Chiltern Society/available from Shire Publications (as above). Price: 12½p (including postage).

FOOTPATH MAP OF SARRATT AND CHIPPERFIELD, by The Chiltern Society/available from Shire Publications (as above). Price: 12½p (including postage).

FOOTPATH MAP OF THE COUNTRYSIDE EAST OF OXFORD/The Oxford Fieldpaths Society, 325a Woodstock Road, Oxford. Price: 12½p (including postage).

FOOTPATH MAP OF WENDOVER & DISTRICT, by The Chiltern Society/available from Shire Publications, 12B Temple Square, Aylesbury, Buckinghamshire. Price: 12½p (including postage).

FOOTPATH WALKS AROUND POTTERS BAR, by Helen and Dick Baker for the Potters Bar Society Footpaths Group/available by post from 12 Oakroyd Close, Potters Bar, Hertfordshire. Price: 18p (including postage).

FOOTPATH WALKS AROUND ST ALBANS, by St Albans & District Footpath Society/available from 38 Carlisle Avenue, St Albans, Hertfordshire. Price: 23p (including postage).

FOOTPATH WALKS AROUND WELWYN GARDEN CITY, by The Mid-Hertfordshire Footpath Society/available from the Society's Secretary, Mr E. M. Bavin, 9 Handside Green, Welwyn Garden City, Hertfordshire. Price: 20p.

FOOTPATH WALKS IN MID-HERTFORDSHIRE FOR MOTORISTS, by The Mid-Hertfordshire Footpath Society/available from 24 Fearnley Road, Welwyn Garden City, Hertfordshire. Price: 30p (plus postage).

THE FOREST WAY, by Essex County Council/available from the County Council at County Hall, Chelmsford. Free.

FOURTEEN WALKS IN AND AROUND TONBRIDGE, by Tonbridge Civic Society/available from G. Hook, 56 Dry Hill Park Road, Tonbridge, Kent. Price: 35p (including postage).

A GUIDE TO THE PILGRIMS' WAY AND NORTH DOWNS WAY, by Christopher J. Wright/Constable & Co. Ltd. Price: £1.90.

HURLEY FOOTPATH MAP/The R.A. East Berkshire Group. Available from Peter Nevell, 'Donnybrook', Altwood Road, Maidenhead, Berkshire SL6 4BP. Price: 10p (plus postage).

Isle of Wight County Council Long-Distance Trail Leaflets:

BEMBRIDGE TRAIL

HAMSTEAD TRAIL

NUNWELL TRAIL

SHEPHERDS TRAIL

STENBURY TRAIL

TENNYSON TRAIL

WORSLEY TRAIL

A wallet, containing a leaflet on each trail, is available from County Hall, Newport, Isle of Wight. Free (but send postage).

THE LOST ROADS OF MEOPHAM, by James Cawley/Meopham Publications Committee, 'Wrenbury', Hook Green, Meopham, Kent. Price: 25p.

MAP OF FOOTPATHS AND BRIDLEWAYS AROUND HORSHAM/The West Sussex Gazette. Obtainable from Miss J. Edward, The Horsham Consumer Group, 109 Depot Road, Horsham, Sussex. Price: 20p.

MILFORD HOSTEL TO EWHURST GREEN HOSTEL (Footpath Route)/The Y.H.A. Southern Regional Group, 58 Streatham High Road, London SW16. Free (but send S.A.E.).

NINE CIRCULAR WALKS FROM KEMSING HOSTEL/The Y.H.A. Southern Regional Group (as above). Free (but send S.A.E.).

ON FOOT IN EAST SUSSEX/The Eastbourne Rambling Club. Available from 28 Kinfauns Avenue, Eastbourne. Price: 30p.

THE PENN COUNTRY, by The Chiltern Society/available from Shire Publications, 12B Temple Square, Aylesbury, Buckinghamshire. Price: 12½p (including postage).

THE PILGRIMS' WAY FROM WINCHESTER TO CANTERBURY, by Sean Jennett/Cassell & Co. Ltd. Price: £3.15.

PUBLIC FOOTPATHS, BRIDLEWAYS & BYWAYS IN BENENDEN PARISH (Maps & list of paths)/available from The Parish Clerk, Two Ponds, Benenden, Cranbrook, Kent. Price: 5p (plus postage).

PUBLIC RIGHTS OF WAY IN THE TATSFIELD/LIMPSFIELD AREA, by The Bromley & District Consumers' Group/available from the Group at 20 Abbotsbury Road, Bromley, Kent. Price: 10p (including postage).

RAMBLES IN HAMPSHIRE & SUSSEX, by Dennis Haggard/available from the author at Stroudbridge Cottage, Stroud, Petersfield, Hampshire. Price: 30p.

RAMBLING THROUGH KENT, by V. W. Morecroft/The Kentish Times. Available from the R.A. Southern Area, 1–4 Crawford Mews, London W1H 1PT. Price: 40p (plus postage).

RIGHTS OF WAY MAP FOR MAYFIELD PARISH/available from The Clerk to the Parish Council, 104 Stanmer Villas, Brighton, Sussex. Price: 40p.

ROMAN WAYS IN THE WEALD, by Ivan D. Margery/J. M. Dent & Sons Ltd. Price: £2.00.

SAFFRON WALDEN HOSTEL TO HARLOW HOSTEL FOOTPATH ROUTE/The Y.H.A. South-Eastern Countryside Committee, 58 Streatham High Road, London SW16. Free (but send S.A.E.).

SEVENOAKS RURAL DISTRICT RIGHTS OF WAY MAPS (Northern & Southern sections)/available from C. Ferguson, 19 Cyclamen Road, Swanley, Kent BR8 8HH. Price: 25p per section (including postage).

SEVENTEEN DOWNLAND WALKS FROM SHOREHAM, LANCING, SOUTHWICK AND PORTSLADE/available from Shoreham Urban District Council, The Town Hall, Shoreham BN4 5EJ. Price: 5p.

SHOREHAM WALKS, by Colin Ulph/available from Shoreham Urban District Council (as above). Price: 5p.

SIX WALKS FROM COBHAM/Meopham Footpaths Group. Available from J. Cawley, 'Wrenbury', Wrotham Road, Hook Green, Meopham, Kent DA13 0HX. Price: 5p (send foolscap S.A.E.).

SIX WALKS FROM HARVEL/Meopham Footpaths Group. Available as above. Price: 5p (send foolscap S.A.E.).

SIX WALKS FROM HODSELL STREET/Meopham Footpaths Group. Available as above. Price: 5p (send foolscap S.A.E.).

SIX WALKS FROM MEOPHAM GREEN/Meopham Footpath Group. Available as above. Price: 5p. (send foolscap S.A.E.).

SIX WALKS FROM NURSTEAD & ISTEAD RISE/ Meopham Footpaths Group. Available as above. Price: 5p (send foolscap S.A.E.).

SOUTH SUSSEX WALKS, by Lord Teviot and M. B. Quinion/BBC Radio Brighton. Price: 30p.

TEN WALKS AROUND BREDHURST/The Faversham Society. Available from The Swale Footpath Group, 'Scillonia', Lawson Street, Teynham, Sittingbourne, Kent. Price: 25p (including postage).

TEN WALKS AROUND FAVERSHAM/The Faversham Society. Available as above. Price: 25p (including postage).

TEN WALKS AROUND SITTINGBOURNE/The Faversham Society. Available as above. Price: 25p (including postage).

THAME FOOTPATH MAP/available from The Town Hall, Thame, Oxfordshire. Price unknown.

WALKING ALONG THE BASINGSTOKE CANAL, by D. Gerry/available from P. Walker, 6 Carlyon Close, Farnborough, Hampshire. Price: 15p.

WALKING AROUND HAWKHURST, CRANBROOK AND GOUDHURST, by the S.E. London & Kent R.A. Group/available from the Group at 1 Braeside Close, Sevenoaks, Kent. Price: 17½p (including postage).

WALKING AROUND OXFORD, by The Oxford Fieldpaths Society/The Oxford Illustrated Press, Shelley Close, Kiln Lane, Risinghurst, Oxford. Price: 30p.

WALKING WITH THE WEST ESSEX, by The West Essex R.A. Group/available from Fred Mathews, Glen View, London Road, Abridge, Essex. Price: 25p.

WALKS AROUND BINFIELD/available from The Clerk, Binfield Parish Council, Binfield, Berkshire. Price: 13p (including postage).

WALKS IN THE THAMES-SIDE CHILTERNS, by The Chiltern Society's Rights of Way Group/ available from Spurbrooks, Station Road, Bourne End, Buckinghamshire. Price: 50p.

WALKS ON ASHDOWN FOREST AND AROUND TUNBRIDGE WELLS, by H. Longley-Cook/available from The Waterdown Press, Winter Hill,

Frant, Tunbridge Wells. Price: 75p (including postage).

WALTHAM ST LAWRENCE AND DISTRICT FOOTPATH MAP/The East Berkshire R.A. Group. Available from Peter Nevell, 'Donnybrook', Altwood Road, Maidenhead, Berkshire SL6 4BP. Price: 10p (plus postage).

WESTERHAM OFFICIAL GUIDE (includes a map showing all footpaths in the parish)/available from Forward Publicity Ltd, Bell House, 36–38 High Street, Carshalton, Surrey. Price: 15p.

WINSLOW FOOTPATHS, by Joseph Lowrey/available from the author at: 23 Station Road, Winslow, Buckinghamshire. Price: 8p (including postage).

WYCOMBE N.W., by The Chiltern Society/available from Shire Publications, 12B Temple Square, Aylesbury, Buckinghamshire. Price: 12½p (including postage).

ENGLAND:

The South West

BRIDPORT AND WEST BAY—WALKS AND PICNIC SPOTS/available from John Hobson, c/o Carl Lentall & Co., Lyme Regis. Price: 7½p.

BRIEF GUIDE TO DARTMOOR, by Brian Le Messurier/David & Charles Ltd. Price: 12½p.

COASTAL PATHS OF THE SOUTH WEST, by Edward G. Pyatt/David & Charles Ltd. Price: £2.75.

COME WALKING IN DEVON/Devon County Council, County Hall, Exeter, Devon. Price unknown.

COUNTRYSIDE TRAILS BY CAR/available from The County Planning Officer, County Hall, Taunton, Somerset. Price: 5p.

EXMOOR COASTAL WALKS, by Tim Abbott/The Cider Press, Weymans, Gunswell Lane, South Molton, Devon. Price: 10p.

EXMOOR WALKS/The Cider Press (as above). Price: 13p (including postage).

FOOTPATH AND GENERAL GUIDE TO WEMBURY/available from The Clerk, Wembury Parish Council, Channel View, Andurn Estate, Down Thomas, Plymouth. Price: 10p (including postage).

FOOTPATHS IN BRIXHAM, by Mr H. L. Hamling/available from the author at: Brixham County Secondary School, Brixham, Devon. Price: 15p.

LYME REGIS—WALKS AND PICNIC SPOTS/available from John Hobson, c/o Carl Lentall & Co., Lyme Regis. Price: 7½p.

MOTORING AND WALKING IN AND AROUND EXETER, PLYMOUTH, TORQUAY, THE SOUTH HAMS (four separate guides) by Arthur Clamp/Westaway Guides, 159 St Margaret's Road, Plympton, Plymouth, Devon. Price: 12½p each.

MOTORING AND WALKING ON EASTERN DARTMOOR, by Arthur Clamp/Westaway Guides (as above). Price: 12½p.

MOTORING AND WALKING ON NORTHERN DARTMOOR, by Arthur Clamp/Westaway Guides (as above). Price: 12½p.

MOTORING AND WALKING ON SOUTHERN DARTMOOR, by Arthur Clamp/Westaway Guides (as above). Price: 12½p.

ANCIENT TRACKWAYS OF WESSEX, by H. W. Timperley and Edith Brill/J. M. Dent & Sons Ltd. Price: £2.75.

NATURE TRAIL NORTH HILL, MINEHEAD/available from The County Planning Officer, Somerset County Council, Bedford House, Park Street, Taunton. Price: 5p.

THE NEW FORESTS OF DARTMOOR/The Forestry Commission, 25 Savile Row, London W1X 2AY. Price: 12½p.

RAMBLES IN DORSET/available from The Southern National and Western National Omnibus Co. Ltd, Queen Street, Exeter, Devon. Free (but send foolscap S.A.E.).

RAMBLES IN WEST SOMERSET AND ON EXMOOR FROM MINEHEAD/available as above. Free (but send foolscap S.A.E.).

SEATON AND BEER—WALKS AND PICNIC SPOTS/available from John Hobson, c/o Carl Lentall & Co., Lyme Regis. Price: 7½p.

SHAFTESBURY: WALKS AROUND THE TOWN/available from Shaftesbury Tourist Board. Price unknown.

SHORT DORSET WALKS, by G. M. Robertson/Sherbourne Press. Price: 15p.

SOME DORSET WALKS, by G. M. Robertson/Sherbourne Press. Price: 15p.

STROLLS AROUND SIDMOUTH/The Sid Vale Association. Price: 12½p.

WALKS AROUND LYNTON AND LYNMOUTH/The Lyn Publicity Association, Lynton, Devon. Price: 4p.

WALKS IN WEST CORNWALL/The West Cornwall Footpaths Preservation Society. Obtain-

able from Mrs Graham White, Croft Hooper, Ludgvan, Penzance. Price: 28p (including postage).

WALKS ON NORTH HILL, MINEHEAD/available from The County Planning Officer, Somerset County Council, Bedford House, Park Street, Taunton. Price: 2½p.

WAYMARKED WALKS IN EXMOOR NATIONAL PARK (Nos. 1 and 2)/available as above. Price: 7½p and 12½p respectively.

WHERE TO WALK IN WESSEX, by The R.A. South-East Wiltshire Group/available from Wessex Tourist Services, 68 Endlass Street, Salisbury. Price: 20p (plus postage).

The following leaflets give detailed descriptions of the footpaths in the following areas and are available free of charge from The County Planning Officer, County Hall, Exeter: LUSTLEIGH, POSTBRIDGE, MANATON, DARTMEET, HOLNE, TWO BRIDGES.

SCOTLAND

ARRAN/The Scottish Youth Hostels Association, 7 Glebe Crescent, Stirling. Price: 6p (plus postage).

CAIRNGORMS/The Scottish Youth Hostels Association (as above). Price: 10p (plus 3p postage).

THE CAIRNGORMS, by Henry Alexander/The Scottish Mountaineering Club Trust. Price: £2.00.

CENTRAL HIGHLANDS, by C. R. Steven/The Scottish Mountaineering Club Trust. Price: £1.90.

EDINBURGH AND THE BORDER/The Scottish Youth Hostels Association, 7 Glebe Crescent, Stirling. Price: 7½p (plus postage).

GARTH AND GLEN LYON/The Scottish Youth Hostels Association (as above). Price: 6p (plus postage).

GLENCOE AND GLEN NEVIS/The Scottish Youth Hostels Association (as above). Price: 7½p (plus postage).

A GUIDE TO MELROSE AND THE SCOTT COUNTRY (includes a section of walks)/available from The Clerk to the Town Council, Melrose, Roxburghshire. Free.

GUIDE TO THE WESTERN HIGHLANDS, by W. H. Murray/Collins, Sons & Co. Ltd. Price: £1.80.

HILL WALKING IN ARRAN, by R. Meek/W. & R. Chambers Ltd, 11 Thistle Street, Edinburgh. Price: 22½p.

WALES

THE ASCENT OF SNOWDON, by E. G. Rowland/ available from Vector Production, Hafodty, Dinorwic, Deiniolen, Caernarvonshire. Price: 12½p (plus postage).

COLWYN BAY YOUTH HOSTEL—WALKS AND PLACES OF INTEREST IN COLWYN BAY AND DISTRICT/available from The Youth Hostels Association, North Wales and Isle of Man Regional Group, 40 Hamilton Square, Birkenhead, Cheshire L41 5BA. Free (but send postage).

ELENITH, by Timothy Porter/The Youth Hostels Association (South Wales Region). Available from The Y.H.A., 25 Park Place, Cardiff. (Describes walking routes in the 300 square miles of mountains S.E. from Plynlimmon.) Price: 18p (including postage).

FROM OFFA'S DYKE TO THE SEA THROUGH PICTURESQUE MID WALES, by Carl D. Ehrenzeller/available from St Christopher's Youth Hostel, Llandrindod Wells, Radnorshire. Price: 25p (plus postage).

HILL WALKING IN SNOWDONIA, by E. G. Rowland/available from Vector Production Hafodty, Dinorwic, Deiniolen, Caernarvonshire. Price: 20p (plus postage).

LLANBERIS AREA GUIDE (including valley and mountain walking routes)/Vector Productions Hafodty (as above). Price: 25p.

LOOKING AROUND NEWPORT (PEMBROKESHIRE)/ available from Newport Primary School, Newport, Pembrokeshire. Price: 30p.

NORTH WALES FOR THE COUNTRYGOER, by Jessica Lofthouse/Robert Hale & Co. Price: £1.75.

PEMBROKESHIRE COUNTRYSIDE/available from The Pembrokeshire Countryside Unit, Broad Haven, Haverfordwest (set of five leaflets). Price: 15p.

RAMBLES IN GLAMORGAN AND MONMOUTHSHIRE/ available from The R.A. South Wales Area, c/o Mr M. E. Trimble, 5 Meads Close, Newport, Monmouthshire. Price unknown.

RAMBLES IN NORTH WALES, by Roger Redfern/ Robert Hale & Co. Price: £1.25.

RAMBLING ROUND RADNORSHIRE, by Carl D. Ehrenzeller/available from St Christopher's Youth Hostel, Llandrindod Wells, Radnorshire. Price: 15p (plus postage).

128

SNOWDONIA NATIONAL PARK/available from The National Park Information Officer, Plas Tanybwlch, Maentwrog, Blaenau, Ffestiniog, Merioneth (leaflet detailing all Trail Guides). Free.

TEN WALKS IN GOWER, by S. Lee/The Gower Society.

THIRTY WALKS (MONMOUTH SECTION OF BRECONS NATIONAL PARK)/available from The National Park Information Centre, Monk Street, Abergavenny. Price: 5p (plus postage).

TWENTY WALKS IN NORTH WALES/Philip, Son & Nephew Ltd, 7 Whitechapel, Liverpool L69 1AN. Price: 25p.

WALKS IN AND AROUND MONMOUTH AND THE WYE VALLEY/The Monmouth Chamber of Commerce. Price: 2½p.

THE WELSH PEAKS, by W. A. Poucher/Constable & Co. Ltd. Price: £1.25.

WELSH WALKS AND LEGENDS, by Showell Styles/ John Jones Cardiff Ltd, 21 Duffryn Close, Cardiff. Price: 60p.

LONG-DISTANCE FOOTPATHS

Of the official long-distance footpaths sponsored by the Countryside Commission only five: the Pennine Way, the Cleveland Way, the Pembrokeshire Coast Path, the Offa's Dyke Path and the South Downs Way, are officially open. The other official routes are still in the process of development. Details of the latest progress appear regularly in the R.A.'s quarterly journal, RUCKSACK, which is free to members. The Dales Way, Cotswold Way and the North Buckinghamshire Way are 'unofficial' long-distance paths, i.e. not sponsored by the Countryside Commission.

After listing the main long-distance footpaths and suggesting suitable Ordnance Survey maps for each, there follows a bibliography of useful long-distance footpath publications.

Cleveland Way

This was opened on 24th May, 1969. It stretches 93 miles in a horseshoe-shaped route around the North York Moors National Park from Helmsley to Filey. The following 12-inch O.S. maps are required: 86, 91, 92, and 93.

Cotswold Way

This route, stretching for approximately 100 miles from Chipping Campden to Bath, was originally put forward by the R.A. and since adopted by Gloucestershire County Council. The following 1-inch O.S. maps will be required: 144 and 156.

Basic details of the route may be obtained from Mr A. J. Drake, 2 Beech Lodge, The Park, Cheltenham, GL50 2RX. Price: 7p (please send S.A.E.).

Dales Way

This is a 73-mile route from Ilkley near Leeds through the Yorkshire Dales National Park to Bowness on Windermere in the Lake District. This path has been devised by the West Riding Area of The R.A. and is open for walking through the greater part of its length. The following 1-inch O.S. maps will be required: 89, 90 and 96.

North Buckinghamshire Way

This 30-mile route was developed by the R.A. Southern Area from existing public paths between Chequers Knap (near Princes Risborough in the south) and Wolverton in the north. At the southern end the Way makes a junction with the Ridgeway (see below). The following 1-inch O.S. maps are required: 146 and 159.

North Downs Way

This 141-mile route stretches from Farnham in Surrey to Dover and was approved by the Minister of Housing and Local Government in July 1969, but 36 miles of rights of way are still to be negotiated. The eastern end of the path forks, providing a choice of routes to Dover, one looping northward to pass through Canterbury. Forty-three miles of the Way were officially opened between Hollingbourne, near Maidstone, and Canterbury and Dover on 29th May, 1972, and most of this section is in fact the Canterbury loop. The following 1-inch O.S. maps will be required: 169, 170, 172 and 173.

Offa's Dyke Path

This 168-mile, ancient boundary between England and Wales, stretches from Chepstow

to Prestatyn and was opened in July 1971. Some few small sections may still be under negotiation. The following 1-inch O.S. maps will be required: 108, 117, 118, 128, 129, 141, 142 and 155.

Details of completed sections and strip maps etc. may be obtained by writing to the OFFA'S DYKE ASSOCIATION, March House, Wylewm Street, Knighton, Radnorshire. Price: 5p (please send a foolscap S.A.E.).

Pembrokeshire Coast Path

Opened on 16th May, 1970, this 167-mile route stretches from Cardigan, round the coast of Pembrokeshire to Amroth. The following 1-inch O.S. maps will be required: 138, 139/151 and 152.

Pennine Way

This was opened on 24th April, 1965. It stretches 250 miles from Edale in the Peak District to the Cheviots and Kirk Yetholm. The following 1-inch O.S. maps are required: 102, 101, 95, 84, 83, 76, 77, 71 and 70.

Ridgeway

This route stretches from Ivinghoe Beacon, Buckinghamshire, to Avebury, Wiltshire, following the line of the Chiltern escarpment and the Ridgeway along the top of the Berkshire and Wiltshire Downs. This route has now been opened by the Countryside Commission. The following 1-inch O.S. maps are required: 157, 158 and 159.

There are no publications available at present, but a guide will be published shortly by The R.A. and The Chiltern Society.

South Downs Way

This 80-mile bridleway between Eastbourne and the Hampshire border is now virtually complete. It was officially opened on 15th February, 1972. The following 1-inch O.S. maps will be required: 181, 182, 183.

South-West Peninsula Coast Path

This consists of five separate schemes, approved between 1952 and 1963, which will eventually form a continuous route 515 miles long from Dorset to Somerset. Many sections are still under negotiation, but the Cornish part was formally opened in May 1973. The following 1-inch O.S. maps will be required: 163, 164, 174, 176, 177, 178, 185, 186, 187, 188, 189 and 190.

Wolds Way

This route has been approved in principle by the Countryside Commission and the East Riding County Council. It is a 66-mile path from Filey (linking with Cleveland Way) to North Ferriby and most of the route is open for walkers. The following 1-inch O.S. maps are required: 92, 93, 98 and 99.

LONG DISTANCE FOOTPATHS

THE CLEVELAND WAY, by Bill Cowley/Dalesman Publishing Co. Ltd, Clapham (via Lancaster), Yorkshire. Price: 42½p.

THE CLEVELAND WAY/The Countryside Commission (leaflet). Free.

THE CLEVELAND WAY, by Alan Falconer/H.M.S.O. Price: £1.80.

THE PEMBROKESHIRE COAST PATH, by E. & T. Roberts: *Cemeas to St Davids; Whitesand Bay to Neyland; Pembroke Dock to Amroth*/available from Garm, Llasnychaer, Fishguard, Pembrokeshire. Price: 5p each (plus postage).

CORNISH COASTAL FOOTPATHS/The Tor Mark Press, Trethellon House, St Aubyns Road, Truro, Cornwall. Price unknown.

THE CORNISH COASTAL PATH/The R.A. Available from the Association at 1–4 Crawford Mews, York Street, London W1H 1PT. Price: 10p (including postage).

CORNWALL COAST PATH, by The Cornwall Tourist Board/available from the Board at County Hall, Truro. Price: 25p (including postage).

THE COTSWOLD WAY: A WALKER'S GUIDE, by Mark B. Richards/Thornhill Press, 7 Russell Street, Gloucester. Price: 85p.

ALONG THE SOUTH DOWNS WAY, by Eastbourne Rambling Club/available from 28 Kinfauns Avenue, Eastbourne. Price: 25p (plus postage).

THE DALES WAY, by The R.A. West Riding Area/Dalesman Publishing Co. Ltd, Clapham (via Lancaster), Yorkshire. Price: 42½p (plus postage).

LYKE WAKE WALK, by Bill Cowley/Dalesman Publishing Co. Ltd (as above). Price 37½p.

OFFA'S DYKE PATH/The Countryside Commission (leaflet). Free.

OFFA'S DYKE PATH, ed. by Arthur Roberts/The R.A., 1–4 Crawford Mews, York Street, London W1H 1PT. Price: 10p (plus postage).

OFFA'S DYKE STRIP MAP No. 1: CHEPSTOW—ST BRIAVELS/available from Mr A. J. Drake, 2 Beech Lodge, The Park, Cheltenham, Gloucestershire GL50 XRX. Price: 7½p (including postage).

THE NORTH BUCKINGHAMSHIRE WAY, by The R.A./available from The Association at 1–4 Crawford Mews, York Street, London W1H 1PT. Price: 10p (including postage).

THE NORTH DOWNS WAY/The Countryside Commission (leaflet). Free.

THE PEMBROKESHIRE COAST PATH/The Countryside Commission (leaflet). Free.

PENNINE WAY COMPANION, by A. Wainwright/The Westmorland Gazette, 22 Stricklandgate, Kendal. Price: 90p.

THE PENNINE WAY/The Countryside Commission (leaflet). Free.

THE PENNINE WAY/The R.A./available from The Association at 1–4 Crawford Mews, York Street, London W1H 1PT. Price: 10p (including postage).

THE PENNINE WAY, by Tom Stephenson/H.M.S.O. Price: £1.50.

THE PENNINE WAY IN NORTHUMBERLAND, by Mr L. Herbert/available from the author at 18 King George Road, Newcastle-upon-Tyne NE3 2QA. Price: 4p.

ST IVES TO FALMOUTH/available from Pendragon House UK Ltd, Penwartha, Perranporth, Cornwall. Price: 25p.

THE SHELL BOOK OF OFFA'S DYKE, by Frank Noble/Queen Anne Press Ltd. Price: 60p.

THE SOUTH DOWNS WAY/The Countryside Commission (leaflet). Free.

THE SOUTH DOWNS WAY/The R.A. Available from The Association at 1–4 Crawford Mews, York Street, London W1H 1PT. Price: 7½p (including postage).

THE SOUTH WEST PENINSULA PATH, by Michael Marriott/Queen Anne Press Ltd. Price: 60p.

WOLDS WAY/The R.A. East Riding Area. Obtainable from D. Rubinstein, Dept of Economics and Social History, The University, Hull HU6 7RX. Price: 5p (including postage).

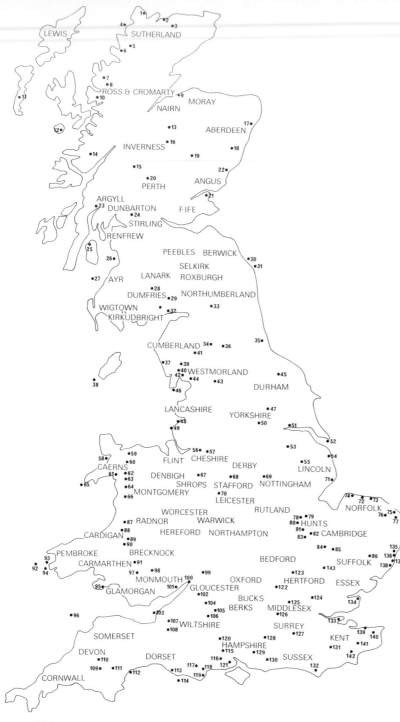

PRINCIPAL NATURE CENTRES AND RESERVES IN ENGLAND, SCOTLAND AND WALES

1 Borralie (O)	51 Humber Wildfowl Refuge (O)	100 Slimbridge Bird Observatory (OB)
2 Invernaver (O)	52 Spurn Bird Observatory (OB)	101 Blackcliff (F)
3 Strathy Bog (O)	53 Scotton Common (FO)	102 Westonbirt (F)
4 Handa Island (B)	54 Saltfleet (B)	103 Steep Holme (B)
5 Inchnadamph (O)	55 Lynwode Warren (B)	104 Fyfield (F)
6 Inverpoly (O, B)	56 Rostherne Mere (O)	105 Walker's Hill (O)
7 Letherewe Woods (O)	57 Cotterhill Clough (F)	106 Knap Hill (O)
8 Beinn Eighe (O)	58 Newborough Warren (O)	107 Rodney Stoke (F)
9 Culbin (F)	59 Coed Gorswen (O)	108 Sharpham Moor (OF)
10 Rassal Askwood (F)	60 Cym Glas Crafnant (OF)	109 Wistmans Wood (F)
11 Loch Druidibeg (B)	61 Coed Tremadoc (F)	110 Black Tor Copse (F)
12 Rhum (O)	62 Coed Cymerau (F)	111 Yarner Wood (F)
13 Craigellachie (F)	63 Coed Camlyn (OF)	112 Exe Estuary (OB)
14 Arriundle (F)	64 Rhinog (OF)	113 Abbotsbury (B)
15 Rannoch Moor (O)	65 Bardsey Bird Observatory (B)	114 Portland Bird Observatory (OB)
16 Glenfeshie (O)	66 Cader Idris (O)	115 Bramshaw (F)
17 Sands of Forvie (O)	67 Wybunbury Moss (O)	116 Mark Ash (F)
18 Kerloch Moor (B)	68 Dove Dale Ash Woods (F)	117 Morden Bog (EF)
19 Caenlochan & Corrie Fen (O)	69 Sherwood Forest (F)	118 Arne (O)
20 Ben Lawers (O)	70 Chartley Moss (O)	119 Hartland Moor (O)
21 Morton Lochs (B)	71 Gibraltar Point (O)	120 Blackmoor Copse (E)
22 St. Cyrus (O)	72 Blakeney Point (O)	121 Matley & Denny (OF)
23 Crarae (F)	73 Salthouse Broads (B)	122 Tring Reservoirs (O)
24 Loch Lomond (F)	74 Scotthead (B)	123 Knocking Hoe (O)
25 Gleann Diomhan (O)	75 Horsey Mere (OB)	124 Epping Forest (F)
26 Lady Isle (EB)	76 Hickling Dune Broad (OB)	125 Ruislip (OB)
27 Ailsa Craig (B)	77 Winterden Dunes (E)	126 High Standing Hill (F)
28 Tynron Juniper Wood (F)	78 Peakirk (E)	127 Box Hill (O)
29 Lochmaben (B)	79 Borough Fen (E)	128 Alice Holt (F)
30 Holy Island (EB)	80 Caster Hanglens (F)	129 Old Winchester Hill (F)
31 Farne Islands (EF)	81 Holme Fen Wood (OF)	130 Kingley Vale (F)
32 Cacrlaverock (B)	82 Walton Fen (E)	131 Bedgebury Pinetum (F)
33 Coom Rigg (O)	83 Monks Fen (OF)	132 Lullington Heath (O)
34 Moor House (O)	84 Wicken (O)	133 High Halstow (B)
35 Castle Eden Denes (EF)	85 Chippenham Fen (O)	134 Bradwell Bird Observatory (OB)
36 Upper Teesdale (O)	86 Mickfield Meadow (OE)	135 Wesleton Heath (OB)
37 Ravenglass Dunes (B)	87 Coed Raeidol (OF)	136 Minsmore Level (B)
38 Calf of Man (B)	88 Cors Tregaron (O)	137 North Warren (B)
39 North Fen (O)	89 Nant Irfon (F)	138 Orford Ness (F)
40 Russland Moss (OF)	90 Allt Ryd-y-Groes (OF)	139 Blean Woods (F)
41 Naddle Low Forest (F)	91 Craig Cerrig Gleisiad (O)	140 Stodmarsh (OB)
42 Neaming Wood (F)	92 Grassholm Island (B)	141 Wye & Crundale (O)
43 Ling Gill (OF)	93 Skomer Island (B)	142 Hamstreet Woods (F)
44 Meathop & Catrag Mosses (O)	94 Skokholm Observatory (B)	143 Hales Wood (F)
45 Farndale (O)	95 Gower Coast (B)	
46 Foulney Islands (B)	96 Lundy (B)	O = Ornithological
47 Askham Bogs (O)	97 Penmoeldlit (F)	F = Forest (Silviculture)
48 Southpoty Sanctuary (B)	98 Cym Clydach (OF)	B = Botanical
49 Ainsdale Sands (O)	99 Badgeworth (O)	E = Entomological
50 Fairburn (B)		

THE WOLDS WAY, by David Rubinstein/Dalesman Publishing Co. Ltd, Clapham (via Lancaster), Yorkshire. Price: 45p.

MAPS FOR WALKERS

Bartholomew's Maps
A complete catalogue of maps published by Bartholomew may be obtained by writing to JOHN BARTHOLOMEW & SON LTD, Duncan Street, Edinburgh EH9 1TA.

Although this company publishes a Lake District 1-inch Map, Bartholomew's most popular series is on the ½ inch to the mile scale. This is too small a scale for serious walking or hill-climbing but is most useful for route-planning and for cycling. Sixty-two sheets cover England, Scotland and Wales.

Ordnance Survey Maps
For most outdoor activities, Ordnance Survey maps on the scales of 1 inch and 2½ inches to the mile are the most suitable. Details of other scales may be obtained from Ordnance Survey (see below).

These maps may be obtained from any Ordnance Survey agent or from most book-sellers or stationers. A list of retail agents in *England* and *Wales* may be obtained by writing to Ordnance Survey, Romsey Road, Maybush, Southampton SO9 4DH and for *Scotland* by writing to the Scottish wholesale distributors, Thomas Nelson & Sons Ltd, 18 Dalkeith Road, Edinburgh EH16 5BS.

Enquiries about maps of *Northern Ireland* should be addressed to the Chief Survey Officer, Ministry of Finance, Ordnance Survey, Ladas Drive, Belfast BT7 9FJ. Enquiries about maps of the *Irish Republic* should be addressed to the Assistant Director of Ordnance Survey, Phoenix Park, Dublin.

1 INCH MAPS (1 : 63,360)
The 1 inch series covers the whole of Great Britain in 189 sheets and is the most popular scale for walking, rambling and mountaineering. Each sheet covers an area of approximately

N.B. For a note on map-lending facilities see p. 119.

700 square miles. The sheets in this series are being constantly revised and about 12 revised sheets are published each year. The most important revisions are those concerning rights of way. The whole series (excluding Scotland) will eventually be revised to show rights of way with special red symbols. The unrevised sheets carry symbols showing footpaths and tracks, stating that such representation is no evidence of the existence of a right of way. At present all but 4 of the English and Welsh sheets show rights of way for at least some of the area covered. Details of the newly revised sheets appear regularly in RUCKSACK, the quarterly journal of the Ramblers' Association.

A map of the 1 inch sheet lines for the whole of Britain and for the areas of England and Wales for which the revised sheets are available is shown on p. 130.

Please note that on some sheets only part of the total area has been revised. This is because some county councils have not produced a definitive map for those areas. The cost of 1 inch maps is 44p folded or 38p flat.

1 INCH TOURIST MAPS
These cover specific tourist areas and are based on the 1 inch series described above. The following sheets are available:

GREATER LONDON	CAMBRIDGE	BEN NEVIS & GLENCOE
THE NEW FOREST	NORTH YORKS MOORS	CAIRNGORMS
DARTMOOR	PEAK DISTRICT	LOCH LOMOND & THE
EXMOOR		TROSSACHS

In addition a 1-inch Tourist Map of the Snowdonia National Park is available.

The cost of Tourist Maps is 55p folded or 44p flat.

2½ INCH MAPS (1 : 25,000)
These maps are especially suitable for field studies, orienteering and other activities where greater detail is required. Many people prefer them for walking as they show field boundaries.

The First Series, in some 2,000 sheets, covers the whole of England, Wales and Scotland excluding the highlands and Islands. Some 70 sheets of the new Second Series are at present available: most of these cover *twice*

the area of the First Series (20 kilometres east to west by 10 kilometres north to south as opposed to 10 kilometres square) and are therefore extremely good value. Rights of way are shown on the Second Series if the information was available when the revision was prepared. An index for both series is available on request from Ordnance Survey or its Scottish wholesaler.

OTHER O.S. SCALES
Details of series at scales of 1 : 1,250, 1 : 2,500, 1 : 10,000, 1 : 10,560, 1 : 21,120, 1 : 100,000 and 1 : 625,000 may be obtained from Ordnance Survey or its Scottish wholesaler.

In the USA
Ordnance Survey maps can be ordered from International Map Co., 595 Broad Ave., Ridgefield, N.J. 07657. They cost $2.25 each. Write first for information.

West Col Mountain Maps
West Col Productions is introducing a new series of large-scale mountain maps. The first in the series, specially designed for climbers and ramblers, covers Snowdonia in two sheets on the scale of 1 : 25,000 (approximately 2½ inches to one mile).

Other maps in this series are in preparation. *We do not advise use of these maps except in conjunction with O.S. sheets.*

Further details may be obtained from West Col Productions, 1 Meadow·Close, Goring, Reading, Berkshire RG8 0AP.

National Park Guides

Her Majesty's Stationery Office (HMSO) has an outlet in the U.S. from which publications can be ordered: PENDRAGON HOUSE, INC., 220 *University Ave., Palo Alto, Calif.* 94301.

BRECON BEACONS NATIONAL PARK GUIDE/HMSO. Price: 50p.

DARTMOOR NATIONAL PARK GUIDE/HMSO. Price: 45p.

EXMOOR NATIONAL PARK GUIDE/HMSO. Price: 32½p.

LAKE DISTRICT NATIONAL PARK GUIDE/HMSO. Price: 42½p.

NORTHUMBERLAND NATIONAL PARK GUIDE/HMSO. Price: 37½p.

NORTH YORK MOORS NATIONAL PARK GUIDE/HMSO. Price: 45p.

PEAK DISTRICT NATIONAL PARK GUIDE/HMSO. Price: 45p.

PEMBROKESHIRE COAST NATIONAL PARK GUIDE/HMSO. Price: 75p.

SNOWDONIA NATIONAL PARK GUIDE/HMSO. Price: 32½p.

YORKSHIRE DALES NATIONAL PARK GUIDE/HMSO. Price: 45p.

GENERAL

The following series contain information on the general background of the footpath systems, but few contain great detail:

BATSFORD BRITAIN SERIES/B. T. Batsford Ltd.

COUNTY, PORTRAIT AND REGIONAL SERIES/Robert Hale & Co.

NEW NATURALIST SERIES/Fontana Books.

THE TRAVELLERS' GUIDE SERIES/Darton, Longman & Todd Ltd.

This series covers Suffolk and Essex, Derbyshire and the Peak District, and the Highlands of Scotland.

THE BACKPACKER'S HANDBOOK, by Derrick Booth/Robert Hale & Co. Price: £2.00.

CAMPING LIST/available from The National Trust, 42 Queen Anne's Gate, London SW1. Free (send foolscap S.A.E.).

THE CAMP AND TREK BOOK, by Jack Cox/Lutterworth Press. Price: 80p.

CAVES IN WALES AND THE MARCHES, by D. W.

Jenkins and Mason Williams/Dalesman Publishing Co. Ltd, Clapham (via Lancaster), Yorkshire. Price: 52½p.

THE CAVES OF DERBYSHIRE, by Dr Trevor D. Ford/Dalesman Publishing Co. Ltd (as above). Price: 52½p (plus postage).

CAVING, by James Lovelock/B. T. Batsford Ltd. Price: £1.25.

CLIMBING, by James Lovelock/B. T. Batsford Ltd. Price: £1.70.

THE COUNTRY CODE/The Countryside Commission. Free (send stamped, addressed label).

LAKELAND GEOLOGY, by E. H. Shackleton/Dalesman Publishing Co. Ltd, Clapham (via Lancaster), Yorkshire. Price: 75p (plus postage).

THE MOUNTAIN CODE/Central Council of Physical Recreation, 26 Park Crescent, London W1N 4EE. Free (but send postage).

MOUNTAIN RESCUE HANDBOOK/available from H. K. Hartley, 9 Milldale Avenue, Temple Meads, Buxton, Derbyshire.

MOUNTAIN RESCUE, R.A.F./HMSO. Price: 62½p.

MOUNTAINEERING, by Allan Blackshaw/Penguin Books Ltd. Price: £1.00.

MOUNTAINS OF BRITAIN, by Edward C. Pyatt/B. T. Batsford Ltd. Price: £1.25.

NATURE TRAILS IN BRITAIN/British Tourist Authority, 64 St James's Street, London SW1A 1NF. Price: 15p (including postage).

NATURE WALKS ON NATIONAL TRUST LAND/available from The National Trust, 42 Queen Anne's Gate, London SW1. Free (send foolscap S.A.E.).

PENNINE UNDERGROUND, by Norman Thornber/Dalesman Publishing Co. Ltd, Clapham (via Lancaster), Yorkshire. Price: 62½p.

RAMBLING AND YOUTH HOSTELLING ('Know the Game' Series)/Educational Productions Ltd, 17 Denbigh Street, London SW1. Price: 20p.

SAFETY ON MOUNTAINS/Central Council of Physical Recreation, 26 Park Crescent, London W1N 4EE. Price: 15p.

WILDERNESS CAMPING IN BRITAIN, by Eric Hemery/Robert Hale & Co. Price: £1.75.

IN THE USA (AND CANADA)

Listed here are organizations that promote walking.

NATIONAL (USA)

THE NATIONAL AUDUBON SOCIETY, 950 Third Ave., New York, N.Y. 10022; P.O. Box 4446, Sacramento, Calif. 95826. *The society has 600 branches and affiliates. Most of its walks are nature walks, emphasizing birdwatching.* THE DIRECTORY OF NATURE CENTERS *is available for $3 from its Nature Centers Planning Division in New York.*

NATIONAL CAMPERS AND HIKERS ASSOCIATION, 7172 Transit Rd., Buffalo, N.Y. 14222. *2900 chapters and 525 teen chapters. Magazine,* CAMPING AND TRAILERING GUIDE, *is included with membership, $10.*

NATIONAL HIKING AND SKING TOURING ASSOCIATION (NAHSTA), P.O. Box 7421, Colorado Springs, Colo. 80933. *A bimonthly newsletter is included with membership, $10; students $7.*

NATIONAL PARK SERVICE, Public Inquiry Office, Dept. of the Interior, 18th and C. N.W., Washington, D.C. 20240. *Most of the approximately 300 National Parks have walking and/or hiking paths. Brochures and maps are available free at the sites or on request from the Park Service. Also see* THE NATIONAL PARKS, by Freeman Tilden (Knopf, New York).

THE SIERRA CLUB, 1050 Mills Tower, 270 Bush St., San Francisco, Calif. 94104. *Has chapters in Alaska, Arizona, California, Connecticut, Colorado, District of Columbia, Florida, Georgia, Hawaii, Idaho, Illinois, Iowa, Kentucky, Louisiana, Massachusetts, Michigan, Minnesota, Missouri, Nevada, New Jersey, New Mexico, New York, North Carolina, Ohio, Oklahoma, Oregon, Pennsylvania, Texas, Utah, Washington, and Wisconsin.*

The Sierra Club's "Totebooks" include guidebooks with maps and descriptions designed to fit in a hip pocket or back pack. They range in price from $1.95 to $7.95 and can be ordered through the catalog, which costs 20¢.

Other organizations that may organize walks are: colleges and universities, American Youth Hostels, Boy Scouts, Campfire Girls, Four-H Clubs, Girl Scouts, Young Life Campaign, YMCA and YWCA,

churches, and state and local park and recreation departments.

NATIONAL (CANADA)

ALPINE CLUB OF CANADA, P.O. Box 1026, Banff, Alberta, ToLoCo. *Primarily a climbing club.*
CANADIAN YOUTH HOSTELS ASSOCIATION, 333 River Rd., Vanier City, Ottawa, K1L8B9.
NATIONAL CAMPERS AND HIKERS ASSOCIATION, 51 W. 22 St., Hamilton, Ontario.

REGIONAL (USA)

THE APPALACHIAN TRAIL CONFERENCE, P.O. Box 236, Harpers Ferry, W. Va. 25425. *Thirty-four clubs affiliated with the conference maintain the 2035-mile Maine—Georgia Appalachian Trail, which was named a National Scenic Trail in 1968. There are about forty other, non-maintenance affiliates. The conference publishes ten guidebooks with maps and information about following the trail, ranging in price from $4.25 to $8.25, as well as maps, a mileage factsheet, and other literature. Publication no. 17, which is available from the main office for 25¢, contains a list of publications and a description of the trail.*
THE FEDERATION OF WESTERN OUTDOOR CLUBS, 4534½ University Way N.E., Seattle, Wash. 98105. *The secretary will provide 47 club addresses or membership information, but cannot answer questions on trails or hiking.*
THE NEW ENGLAND TRAIL CONFERENCE, P.O. Box 145, Weston, Vt. 05161. *Publishes annual* NEW ENGLAND TRAILS. *Membership $10.*
NEW YORK-NEW JERSEY TRAIL CONFERENCE, GPO Box 2250, New York 10001. *Has fifty member organizations, including sub-units of the Adirondack Mountain Club, American Youth Hostels, Boy Scouts of America, and the Sierra Club. Publishes the* NEW YORK WALK BOOK *and walkers' maps (write for list).*
PACIFIC CREST CLUB, Camp Research, P.O. Box 1907, Santa Ana, Calif. 92702. *Publishes* PACIFIC CREST QUARTERLY, *subscription $4. This National Scenic Trail, which extends for 2594 miles from the Canadian to the* Mexican border, will probably not be completed until 1979 or 80 and is recommended only to experienced hikers. Maps are available at the Forest Service offices in Portland and San Francisco as are addresses of the offices along the trail. Be sure to check these offices (regional offices of the Forest Service in big cities and Forest Offices in small towns) before setting out for local maps and information about trail conditions.*

MAPS FOR WALKERS

For detailed information, the best maps are the U.S. Geological Survey topographic series, which come in various sizes and can be purchased for 75¢ from a USGS map office. The office will supply free an index map of the state you are interested in, from which you can determine which topo maps you will need and where in the state you can buy them. For maps of areas east of the Mississippi River, write to: Distribution Section, USGS, 1200 S. Eads St., Arlington, Va. 22202; for areas west of the Mississippi, write to: Distribution Section, USGS, Federal Center, Denver, Colo. 80224; for Alaska, write to: USGS, 301 First Ave., Fairbanks, Alaska 99701. Ask for the free booklet TOPOGRAPHIC MAPS, which explains the different scales and symbols and how to use the maps.

Canada has a National Topographical Series of maps, which can be ordered from Canada Map Office, Dept. of Energy, Mines and Resources, 615 Booth St., Ottawa, Ontario, Canada, KIA OE9.

BIBLIOGRAPHY

THE NEW COMPLETE WALKER, by Colin Fletcher/Knopf, New York. *Source of much of the information here about the U.S. He recommends as a list of books and pamphlets on walking ("exhausting to the numbing point")* THE GREAT OUTDOORS BOOKLIST *(1700 titles), available free from Walking News, P.O. Box 352, New York N.Y. 10013.*
ESTABLISHING TRAILS ON RIGHTS-OF-WAY, S/N 2416–00052/available for $1 from Superintendent of Documents, U.S. Government Printing Office, Washington, D.C. 20402.
FROM RAILS TO TRAILS/available for $1.50 from Superintendent of Documents, U.S. Government Printing Office, Washington, D.C. 20402.
RIGHT-OF-WAY: A GUIDE TO ABANDONED RAILROADS IN THE UNITED STATES, by Waldo Nielsen/Dutton, New York.

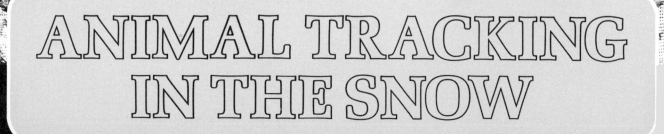

ANIMAL TRACKING
IN THE SNOW

Snow in corries and hollows drifting :
Lives move slowly and feet are shifting.
Measuring the riffs for another to sing,
Clothe with loving the promise of another
* spring.*

BRIDGET ST JOHN

ANIMAL TRACKING

**WHEN winter comes it is often
thought that all the animals are fast
asleep for all those cold snowy
months, when in actual fact it isn't
true at all. If any of you have walked
over white fields and meadows after
snow has fallen overnight, you may
have seen the tracks of animals,
criss-crossing in wild patterns on
the snow. Now, with a bit of practice,
you can begin to recognise the vari-
ous animal tracks; of the little
dormouse, the squirrel, the badger,
the fox and many others, as well as
innumerable bird tracks. The draw-
ings shown are just a handful of the
most common tracks you are likely
to come across.**

It is a worthwhile venture to immortalize
these tracks by making Plaster of Paris
casts which can then be brought home
and painted. They will form an interest-
ing addition to your other collections of
natural bric-a-brac.

Equipment
The basic equipment needed is as follows:
1. A bottle of clean water.
2. A packet of Plaster of Paris (the quick-
 drying sort).
3. A bowl and mixing spoon.
4. A quantity of paper clips.
5. Some strips of thin, flexible card about 10
 inches by 2 inches.
6. A pair of tweezers.
7. A clean rag.

METHOD

Having found a set of tracks, select the best
impression i.e. one that has the clearest print

Red Deer

Roe Deer

Hedgehog

Grey Squirrel

Red Squirrel

Badger

Woodmouse

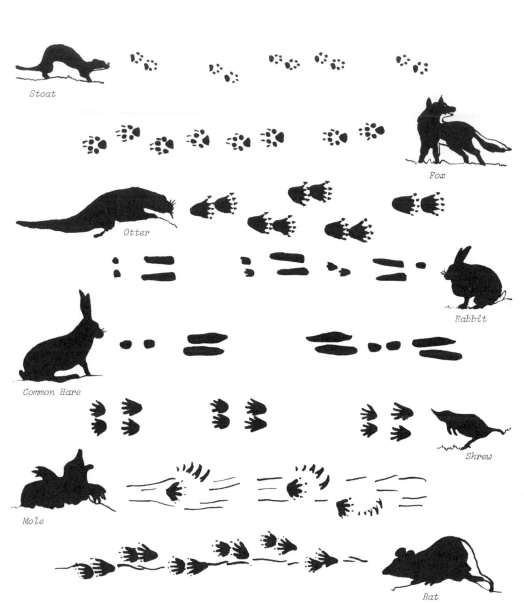

Stoat

Fox

Otter

Rabbit

Common Hare

Shrew

Mole

Rat

with no caving in of snow. Remove any bits of twig or dirt should there be any, using the tweezers for this. Take one of the cardboard strips and roll it round bringing the two ends together, thus making a cardboard circle, and secure together with a paper clip. The actual size of the cardboard ring must be adjusted to the size of the track for it must completely enclose the impression within its circumference. Press the ring into the snow so that it forms a wall completely encircling the track. Next, mix up a fair amount of Plaster of Paris making it reasonably runny but not ridiculously so. Carefully pour the mixture into the ring in a steady flow. Never pour directly into the deepest part of the track as this causes air bubbles in the cast. After reaching the top of the ring with plaster, give it a few taps to ensure a clean removal. When set, remove the cast, clean it as much as possible with the rag and then wrap up well in some newspaper so that it is safe from breakage. Once home, the casts can be decorated realistically with colours true to the species of animal which made the tracks, or they can be daubed with brightly coloured paints and lacquers and given a coat of varnish as a nice finishing touch.

IN THE USA

BIBLIOGRAPHY

FIELD GUIDE TO ANIMAL TRACKS, by Olaus J. Murie/Houghton Mifflin, Boston, Mass.
NATIONAL AUDUBON SOCIETY, 950 Third Avenue, New York, N. Y. 10022. The Educational Services Department sells for $2 a set of five Audubon nature charts. One of these shows footprints and trail patterns of 27 common animals. Good for track recognition in mud, sand and snow. Their catalog "Audubon Aids in Natural Science" contains an order form.

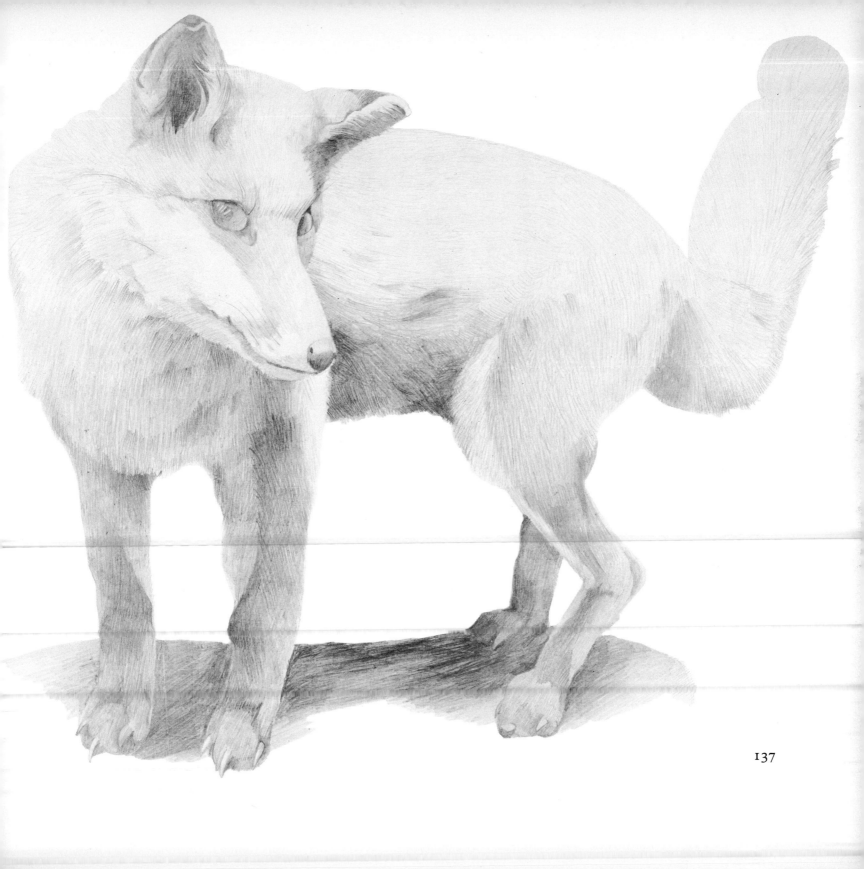

137

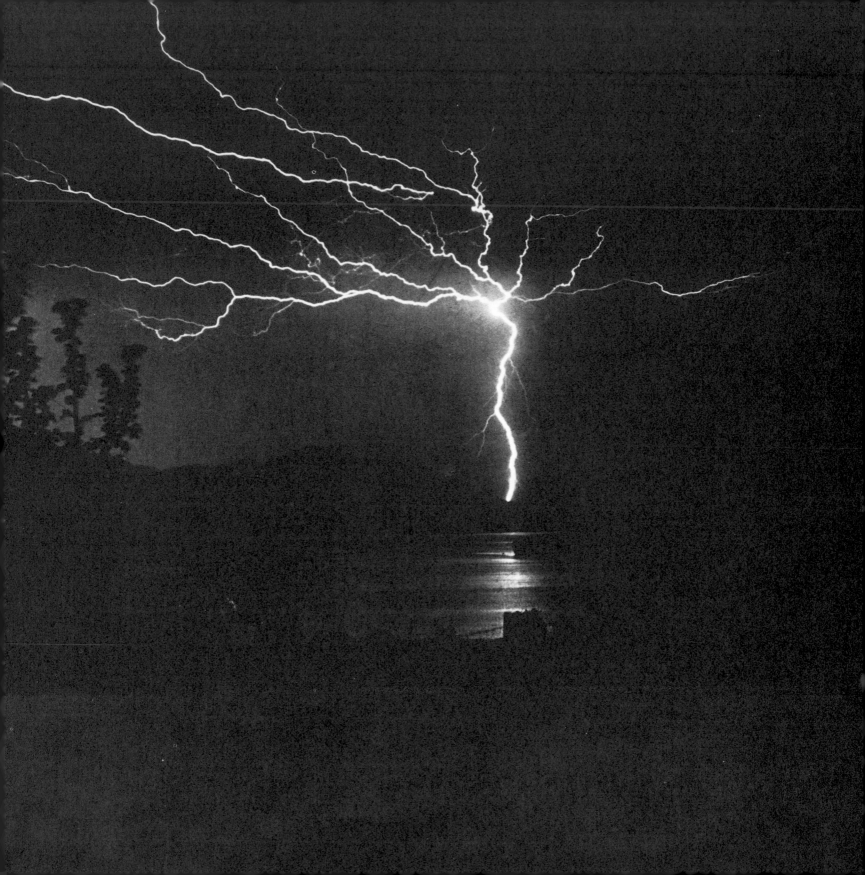

The Trees of Life

White birch, give me thy peace,
So quiet thou art.
Give me thy strength, dark pine,
Thy fearless heart.
Give me thy sensitiveness,
And oak, I pray,
Thy wise endurance give—
So shall I be
More lovely in my life,
More like a tree.

TERESA HOOLEY

OF ALL the ecological and environmental acts of goodwill a citizen can do for his country, planting trees must be on top of the list. Our lives, if we stop to consider it, depend on the existence of trees for without forests, and woods and copses and spinneys and plantations and even single trees we would all die. Trees are essential because:

(a) They produce oxygen and help purify the air.
(b) They provide shelter for wild life, as well as food.
(c) They provide shade from the sun and help reduce noise.
(d) They retain moisture in the soil and keep the water table high.
(e) They are things of immense beauty inspiring contemplation and wonder in all passers-by.
(f) They are of immeasurable benefit to the appearance of city, town, village and individual houses and can be used as a barrier to mask ugly buildings etc.

Trees can be grown from seed or bought as saplings from a reliable nursery. Obviously, it is far easier to plant saplings as these will have a better chance of survival and will be of a more mature shape. On the other hand, growing trees from seed is immensely cheap and good fun and there is nothing more satisfying than planting a forest tree sapling that was grown and tended from a tiny seed.

What trees to grow—a suitable list:

Abbreviations used:

L. Need for light to produce satisfactory growth.
M.S.T. Moderate shade tolerated.
S.T. Shade tolerant
Ht. Maximum height in feet.
Sp. Maximum spread in feet.

The botanical name is followed by the common name and some features to aid choice.

Large growing forest trees

Acer platanoides : NORWAY MAPLE: L. smoke resistant, suitable for specimen or avenue.
A. p. schwedlerii : L. fast growing, rich leaf colour.
A. p. Drummondii : PURPLE NORWAY MAPLE: L. fairly fast growing, good for town use, Ht. 60 Sp. 40.
A. pseudoplatanus : SYCAMORE: L. hardy, Ht. 80 Sp. 50.

A pseudoplatanus purpureum : PURPLE SYCAMORE: L. purple leaves in summer, good autumn colour.
Aesculus hippocastanum : HORSE CHESTNUT: L. large head, 'candle flowers', var flore-pleno does not produce conkers. Ht. 90 Sp. 60.
A. carnea : RED HORSE CHESTNUT: L. smaller, Ht. 30.
Carpinus betulus : HORNBEAM: M.S.T. tolerant of soil conditions, may be used in place of Beech as a hedge in heavy soil. Resembles Beech, Ht. 60 Sp. 50.
C. betulus fastigiata : HORNBEAM: M.S.T. as above but more suitable in narrow sites where headroom is limited.
Fagus sylvatica : BEECH: S.T. dense foliage, excellent as specimen, shelter tree or hedge Ht. 80–100 Sp. 70.
F. Sylvatica purpurea : PURPLE BEECH: S.T. as above, good contrast to green foliage.
Fraxinus excelsior : ASH: L. heavy to medium soil, elegant, graceful, Ht. 90 Sp. 70.
Liriodendron tulipifera : TULIP TREE: L. greenish white, scented flowers in July.
Platanus acerifolia : LONDON PLANE. M.S.T tolerant of atmospheric pollution.
Populus robusta : POPLAR: L. fast growing, slender, compact make good screens, roots may need to be controlled as they travel 30 or 40

feet and can invade drains.

P. tremula : ASPEN: L. used in gardens for the blind for scent and leaf movement, Ht. 40.

Quercus cerris : TURKEY OAK: L. dark foliage, faster growing than Common Oak, Ht. 100 Sp. 70.

Q. rubra : RED OAK: L. foliage turns dull red in autumn.

Q. coccinea splendens : L. not so vigorous as above, keeps bright purple-red leaves till December.

Tilia euchlora : LIME: L. withstands pollution, graceful, pendulous Ht. 40 Sp. 30, good street tree.

T. petiolaris : SILVER LIME: L. Ht. 60, Sp. 50.

T. platyphyllos rubra : RED TWIGGED LIME: Ht. 100.

Ulmus glabra : WYCH ELM: L. dense, Ht. 100 Sp. 50.

U. stricta var Wheatleyi : CORNISH ELM: L. erect, columnar. Ht. 100 Sp. 30.

Medium sized trees

Reaching an approximate height of 40 feet to 50 feet on maturity.

Alnus glutinosa : COMMON ALDER: Shallow roots, likes moisture, catkins in March.

Betula alba : SILVER BIRCH: L. good specimen tree, wind resistant, graceful, ornamental bark. Sparse foliage allows light to filter through.

B. pendula Youngii : WEEPING SILVER BIRCH: L. as above. Ht. 25–30 suitable for small garden.

Fraxinus excelsior diversifolia : SINGLE LEAVED ASH: L. withstands atmospheric pollution.

F. ornus : MANNA ASH: Panicles of white flowers in May.

Prunus avium : GEAN: L. white flowers in April–May, autumn tints, flore plena has double flowers.

P. padus : BIRD CHERRY: L. small, sprays of slightly scented flowers.

P. yodoensis : YOSHINO CHERRY: L. single, white, early flowering.

Salix alba : CRICKET BAT WILLOW: L. pyramidal tree with white silvery foliage, quick growing, tolerates wind, dislikes dry shallow soil, makes good shelter.

S. vitellina : GOLDEN WILLOW: L. striking golden bark, less vigorous than most willows.

S. chrysocoma : WEEPING WILLOW: L. Hardy with graceful weeping habit.

S. daphnoides acutifolia : Fast growing, red stems, early catkins.

Small trees

Approximate height on maturity rarely exceeds 30 feet.

Cotoneaster cornubia : L. good for town conditions, abundance of red berries in autumn.

C. frigidus : Semi-evergreen, as above, fast growing.

Crataegus oxycantha : HAWTHORN: L. hardy, wind resistant.

Other varieties include: *C. oxy rosea-plena*, double pink flowers; *C. oxy plena*, double white flowers; *C. coccinea pleana*, red form.

Cercidiphyllum japonicum : Good autumn colour, liable to damage from spring frost.

Gleditchia triacanthus : Resistant to air pollution.

Ilex aquifolium : HOLLY: M.S.T. compact evergreen, many varieties.

Laburnum alpinum : SCOTCH LABURNUM: Hardy, graceful, pendulous flower heads, seeds poisonous.

L. Vosii : As above with semi-sterile seed pods and large flower heads.

Malus eleyi : FLOWERING CRAB: L. good foliage, decorative fruits in autumn.

M. floribunda : JAPANESE CRAB: L. a profusion of pale pink flowers and crimson buds.

Morus nigra : BLACK MULBERRY: Capable of great antiquity, suitable near historic buildings.

Prunus amanogawa : JAPANESE FLOWERING CHERRY: L. upright habit of growth, pink semi-double flowers.

P. amygdalis : ALMOND: L. pink flowers on bare stems in March.

P. avium flore-pleno : DOUBLE FLOWERING CHERRY: L. taller.

P. serrulata : JAPANESE CHERRY.

P. subhirtella autumnalis rosea : Winter flowers, autumn colour.

Pyrus atropurporea : FLOWERING PEAR: L. ornamental, purple foliage.

P. tremula : ASPEN: L. used in gardens for the blind for scent and leaf movement, Ht. 40.

Quercus cerris : TURKEY OAK: L. dark foliage, faster growing than Common Oak, Ht. 100 Sp. 70.

Q. rubra : RED OAK: L. foliage turns dull red in autumn.

Q. coccinea splendens : L. not so vigorous as above, keeps bright purple-red leaves till December.

Tilia euchlora : LIME: L. withstands pollution, graceful, pendulous, Ht. 40 Sp. 30, good street tree.

T. petiolaris : SILVER LIME: L. Ht. 60 Sp. 50, S5.

T. platyphyllos rubra : RED TWIGGED LIME: Ht. 100.

Ulmus glabra : WYCH ELM: L. dense, Ht. 100 Sp. 50.

U. stricta var Wheatleyi : CORNISH ELM: L. erect, columnar. Ht. 100 Sp. 30.

Trees from Seed

Many species of trees can be grown from seed that has either been collected in the autumn, or from a reliable seedsman. Horse Chestnut, Oak, Sweet Chestnut, Elder, Yew, Beech, Hawthorn, Plane, Sycamore and Maple are just some of the trees where the seed is of sufficient size to make collecting easy. Only full ripe seed should be collected—avoid green, under-ripe or damaged seeds.

The seeds of Horse Chestnut, Sweet Chestnut and Oak should be planted in a rich loamy peat soil as soon as they have been collected in the autumn as this helps break down the hard shells and makes germination easy. The soil should be kept slightly moist during the winter months but do not over-water as this may rot the seeds.

Other seeds can be stored in a dry, cool place and planted in the early spring in a good seed compost. Germination will be quicker if the seeds are kept indoors after planting, or under glass. As soon as the seedlings have pushed through the soil, and are a suitable size for transplanting, they should be split into separate pots and put outside to harden off. With large seeds, such as acorns and conkers, as soon as the seed has emerged from the soil, they should be put into separate 10-inch pots in a good loam or potting compost and put outside to harden off.

At the end of the first year, it is advisable to plant the young trees out into a prepared piece of ground at a distance of 2 feet apart. They should be allowed to mature there for 3–4 years, when they will then be a reasonable size

to transplant to their permanent position. It may be necessary to dig up the trees each year during the first 4 years in the prepared ground to trim their roots, otherwise an extensive root system may prove difficult when digging them up for transplanting to their final position.

Ordering Trees

There are two grades of trees available, each suited to a particular purpose. In the first case, trees in bulk for plantations are ordered as 'transplants' and the size will range from 6 inches to anything up to 21 inches. The following table shows the method of describing such trees:

1 + 0 = *one-year-old seedling*
2 + 0 = *a two-year-old seedling*
1 + 1 = *a one-year-old seedling, transplanted and grown on for one year in a nursery.*

Individual trees are sold at a larger size and are older than the trees sold in bulk as described above. They come in three sizes: 'Bush trees', 'Standard' and 'Feathered' trees. Bush trees are the smallest having a stem ranging from 12 inches to 30 inches. Feathered trees consist of a straight stem with plenty of side or lateral shoots. Standards have no side shoots and come in 4 sizes:

Half standard = 3 feet 6 inches to 4 feet 6 inches.
Three-quarter standard = 4 feet 9 inches to 5 feet 3 inches.
Standard = 5 feet 6 inches to 6 feet.
Tall standard = 6 feet to 7 feet.

Conifers are not bound by any of the above grades but are ordered simply in height.

Soils and Preparation

Most trees grow for decades so it is worthwhile to make sure they have good soil suited to their needs and are planted correctly. It is very important to maintain the soil in good condition during the early years of growth otherwise drainage and air movement can be hindered.

There are four different types of soil:

CLAY SOILS
These soils are generally difficult to cultivate and poorly drained. To improve drainage, sharp sand or peat can be added which has the effect of opening up the soil, allowing the

Fig 1

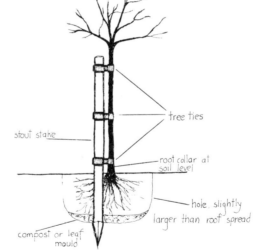

tree ties

stout stake

root collar at soil level

hole slightly larger than root spread

compost or leaf mould

Fig 2

movement of water and air necessary for roots to breathe.

PEAT SOILS
These soils contain up to as much as 60% organic humus matter. Drainage can be improved by digging in sharp sand or gravel.

SANDY SOILS
These soils have easy drainage so that in drought conditions, the surface can become hard and baked. By digging in peat and manure, the water retention value can be increased and the soil improved.

LOAM SOILS
The best sort of soils as they contain a general mixture of humus, silt clay and sand, and drainage, as well as water retention, is good.

Time of Planting

Trees must be planted in the Autumn or Spring, when they are dormant and leafless. Never plant in bad climatic conditions, i.e. hard frost, snow, rain. Conifers are best planted in the Spring and the roots must not be disturbed too much when doing so.

Handling

Until such times as the tree will be planted, the roots must be protected. The roots can be 'dug in' to soft moist soil and left there until planting time. Keep the soil moist at all times.

Planting

There are two methods of planting trees; one method for young seedling called 'notch' planting, and the other method for larger trees called 'pit' planting.

Notch Planting

Make two cuts in the soil with a spade at right angles and lift the triangular piece of turf, inserting the roots of the seedling into gap. Next, press the turf back into its original position, making sure that the root collar of the seedling is at ground level *(fig 1)*.

Pit Planting (a) THE HOLE

The hole must be dug deeper and larger than the root spread and can be either square or

circular in shape. The soil at the bottom of the hole must be loosened with a fork to a depth of 6 inches. A little bone meal or compost can be worked in the bottom if wished.

(b) STAKING

As a general rule, a stout stake must be driven in to support the tree against strong winds etc. The stake should be driven in to the windward of the tree and to one side of the hole about 3 inches from the centre. It must be high enough when firmly hammered in, to reach above the level of the tree's lowest branches.

(c) PLANTING (fig 2)

It is very important to remember that all broken or damaged roots must be clearly cut away before planting. The tree should then be placed in the hole with the stem placed as near to the stake as possible. Fine top soil must then be sprinkled amongst the roots until covered and then the rest of the hole filled up with the soil that was taken out of it. Gently tread down the soil as it is shovelled in and when the hole has been completely filled, firmly trample down right up to the stem. Be careful to plant up to the earth mark at the bottom of the stem and do not plant lower than this mark.

(d) TYING

It is best to tie the tree to the stake in three places for large trees and at least two places for smaller trees. The correct places to tie are: (i) near the ground, (ii) in the middle of the trunk, (iii) in the crown or amongst the lower branches. Special tree ties can be bought in gardening shops which are nailed to the stake and are unbuckled gradually over a period of time to allow for the increase in the tree's girth.

Aftercare

Keep a circle of bare soil about 2 feet in diameter around the tree during its early years of growth. This will prevent other root systems of grass or weeds competing for soil sustenance. The ground for 6 feet round any tree must be kept free of any ashes, cement, asphalt etc. Keep the roots moist at all times during the year and in times of dry weather, give two or three gallons of water to each tree every day. It is a good idea to protect the bark by placing

round the tree and stake a tree guard, which can be constructed of a piece of chicken wire curled round. This will prevent cats and other animals ripping the stem.

Any damaged branch or twig must be clearly removed with a knife and pruning will be necessary during the first few years after planting. The leading shoot upwards must be left untouched but any side branch should be reduced by half, pruned to an outward facing bud. A tree should be made to develop as symmetrically as possible so that a well-balanced form will develop as it grows older. Study the forms of mature trees and try to encourage young trees to grow in the same way.

Fig 3

Laws Concerning Trees

Many fine trees are now protected by a Tree Preservation Order (see below) which means that no one whatsoever, even the owner, may cut it down or cut off any of its branches. If the tree dies, the owner must immediately replace it with one of the same species. Your local authority will have a list of preserved trees in your district, so check them out and keep a watchful eye for vandals who may attempt to fell or damage a listed tree.

Tree Preservation Orders

A Tree Preservation Order is made under the provisions of Section 29 of the Town and Country Planning Act, 1962. A Tree Preservation Order, therefore, becomes a registerable charge against a property with penalties for contravention as set out in Section 62(1) of the principle Act, as amended by Section 15 of the Civic Amenities Act 1967. These Sections of the Acts are framed to prevent the needless destruction or maltreatment of trees and are neither intended nor used to interfere with the requirements of good arboriculture or forestry. Properly administered, an Order can strengthen the hand of the discerning owner of trees, but the existence of a T.P.O. does not in any way exonerate the owner of a preserved tree from his responsibilities as established in Common Law.

All records of listed trees, protected with a T.P.O. can be found in your local Land Charges Office. The vigilance of the public is continually needed to get T.P.O.s put on fine trees. In this way, trees can be protected from developers and ignorant people who have no regard for them. Tree Preservation Orders are promoted by Local Planning Authorities and any enquiries or information should be dealt with by them only.

Apart from single trees, parklands, woodlands and whole landscapes in prominent positions in rural areas can be included in a T.P.O.

TAPPING TREES[1]

The sap of certain trees can be tapped and used as a nourishing addition to any diet. Delicious syrups can be obtained by boiling down the sap, and unique-tasting wines easily made by the natural fermentation of the sap, without sugar.

What Trees to Tap

The following list contains trees that have been successfully tapped. Only mature trees must be tapped otherwise severe damage will occur if young trees are used. There may be any number of different types of trees that could be tapped, but as to the quality of the sap, or whether the sap is safe to consume is another

[1] *We are indebted to John Allen of 35 Fairfield Avenue, Bollington, Macclesfield, for sending notes and information on this subject.*

matter. We suggest extreme caution when experimenting on new species, and to avoid those trees completely that have poisonous parts in their make-up, e.g. Yew and Laburnam.

SILVER BIRCH *(Betula Verrucosa)*
Birch trees were not only tapped in this country, but also in many parts of the Continent. The following extract is taken from *Natural History Rambles*, by M. C. Cooke, published in 1879. 'The sugary sap of the Birch as it rises in March is collected in some northern counties of Europe and converted into wine. Loudon states that a birch has been known to yield in the course of one season, a quantity of sap equal to its own weight. During the seige of Hamburg by the Russians in 1814 almost all the birch trees in the neighbourhood were destroyed by the Boshkirs and other barbarian soldiers in the Russian service by being tapped for their sap.'

LIME *(Tilia europaea)*
Produces a wonderful tasting syrup from its sap of great nourishing value.

SYCAMORE *(Acer pseudoplatanus)*
Again, quoting from *Natural History Rambles*, M. C. Cooke says, 'The sap of this tree contains sugar, and experiments have been made from time to time to obtain a kind of sugar from evaporation. Sometimes an ounce of sugar can be refined from a quart of sap, but the proportion varies. This sap has also been converted into a kind of wine.'

MAPLE *(Acer saccharum)*
A tree widely tapped commercially for its sap which is converted to maple syrup, of pancake fame.

How to Tap
All one needs for this is a beaker or some other container to collect the sap, some plasticine, a small hand-drill, with a drill bit of $\frac{3}{8}$ inch in diameter and a glass tube 6 inches long, the same diameter as the drill bit. Tapping can only be done between March and August when the sap is rising continually in the tree.

First, drill a hole with the drill about $1\frac{1}{2}$ to 2 inches deep into the tree trunk at chest height or below and at a 45° angle *(fig 3)*. Insert the tube into the hole and plug the point of entry into the trunk with plasticine which will prevent any sap leaking. The sap will immediately begin to trickle down the tube and there may be bits of wood chips at first from the drilling. If this happens, clean out the tube by blowing and re-insert in the hole. It is extremely important not to overlap any one tree so that once a pint or quart of sap has been collected, the tube should be removed and the hole firmly plugged with plasticine (this is very important). It is far better to take a little from a number of trees than to bleed one to death.

Making the Syrup
If the sap is left for too long after collection it will start to ferment because of its high sugar content and so it is advisable to turn it into syrup immediately on getting home. To make the syrup, simply boil the sap in a saucepan until the water has mostly evaporated, pour the residue into jam jars, and store until needed. The syrup is a delicious substitute for honey and can be spread on bread, pancakes or used in cooking.

Making the Wine
Because the sap has a high sugar content, it is not necessary to add more. The sap should be placed in a fermenting jar or a glass or earthenware jug with a little yeast (see p. 183, the winemaking chapter), and allowed to stand for 3 weeks. The liquid should then be strained through muslin, poured into wine bottles and left uncorked for a month. Finally, cork the bottles and keep at least six months before opening for use.

MAKING A TREE SURVEY[2]

A TREE SURVEY PROVIDES a record of the number, name and quality of the trees in a particular locality at a given time.

It's easy to see that such a survey can be enjoyable for its own sake and that the knowledge of the locality gleaned from it can be fascinating. But how is it *useful*?

In the first place, the pressures on the countryside—housing and industrial developments, roads—mean that valuable assets are sometimes lost through lack of foresight. If local authorities don't know where the assets are—be they trees, hedgerows, historic sites, or whatever—they can't protect them. This isn't to say that recording the presence of a single oak will automatically preserve it in perpetuity—but the fact of a record will at least ensure that it is *considered*, when developments are mooted.

The other important justification for a tree survey is the state of the law. Over the past ten years, various legal provisions have made it clear that trees are now to be regarded as positive amenities. Devices such as the Tree Preservation Order, and government grants to aid local authorities in tree-planting schemes, record a welcome concern on the part of the government that England should stay green. *But the laws can only be made to work if information about the location and the state of trees is available.*

Much of such a recording must be a labour of love.

PLANNING THE SURVEY

1 Reasons for Survey
(a) To keep a check on the changing scenery of the locality.
(b) To make a record for historical purposes.
(c) To have available a record for a Branch of the Council for the Preservation of Rural England or amenity society to refer to when requests for help on preserving trees are made, and other purposes.
(d) To co-operate with County Planning Departments and in particular with their Landscape Sections.

2 Practical Considerations
The tree survey is best carried out by people living in or near the chosen areas so that a continual check can be made and changes easily recognised. It is more conveniently carried out by two people working together.

[2] *Taken, with kind permission from the Council for the Protection of Rural England's leaflet 'Making a Tree Survey'.*

Spot checks by qualified people should be made.

MAPS

Grid system Ordnance Survey maps are recommended, covering 2 square kilometres, that is, on a scale of 1:2500 or 25 inches to a mile. It is useful for each surveyor to have two sheets, one for using in the field, and one for a fair copy to be returned to the County Planning Department (if working with their co-operation) or for your own permanent record.

It is most important that the map number and date are clearly visible on every record.

3 Field Techniques

The ideal form of field notebook is a small clip-board with loose-leaf ruled papers, previously columned and headed. It is best to use one map in the field and subsequently to transfer the results to another master or fair-copy map.

It has been found easier to begin a survey at the western edge of the map and, taking the major roads first, work up the left-hand side and down the right, labelling the trees in order and then following with the minor or cross roads.

The common name of the tree is normally used but one can be more specific if one wishes. Cultivated fruit trees and small mature flowering shrubs are not usually included.

It would be advisable to go over the same area at least every three years and record any changes that have taken place. The advantage of having someone living in the area, with responsibility for updating the records at regular intervals, is clear.

RECORDING

The trees are roughly classified under the following headings:

Classification	Code
(a) Single trees	T
(b) Areas or linear belts with trees (e.g. hedges with significant trees)	A
(c) Groups of trees (up to approx. 60)	G
(d) Woods	W
(e) Hedgerows	H

Single trees = T

These are recorded on the map as a dot with the letter code T and its sequential number, e.g. ·T₁ ·T₂ ·T₃ etc. The clip-board record gives the number, the name, trunk diameter at breast height and amenity value.

Areas or linear belts of trees = A

These are recorded on the map by outlining the area with a line and labelling with the letter A and its sequential number. They include belts or linear groups where there are too many to label singly and only one or two trees in depth. They can also include overgrown hedges which have significant trees in them.

Groups = G

These are recorded on the map by outlining the group with a line and labelling with the letter G and its sequential number. Groups are more than two trees in depth and up to about 60 trees in number.

All the tree types are listed.

Woods = W

These are recorded on the map by outlining the area and labelling with the letter W and its sequential number. They include large areas of trees or woodlands and they may be adjacent to groups or areas. One should name as many species as can be seen, either directly or through binoculars; add a question mark if the identity is in doubt.

Hedgerows = H

These are recorded on the map as vvvvv with the letter H and its sequential number. They include hedges without significant trees but do not include scrub. One should note the main species present in any one hedge.

Notes

Name This can be checked, if one is uncertain, by asking a specialist or visiting the tree at different times of the year so that leaves, flowers, fruit can be observed. Comment on any special features.

Height This can only be estimated and may be done by simple trigonometry or by taking the height of a person standing against the tree and seeing how many times that height goes into the height of the tree.

The diameter and height of the tree together give some idea of the age of the tree. (*A fairly accurate method of determining the age of a tree is as follows. Measure the diameter of the tree at chest height in inches and then multiply by four. Oaks and pines should be multiplied by six.*)

Diameter Usually measured at a point 4 feet above ground.

Amenity Value This is perhaps the most important factor from the point of view of the landscape situation and therefore of great concern to the CPRE, yet it is the most difficult to estimate. The following should be considered:

Is it a well shaped specimen?

Is it a healthy tree or is part of it dead or dangerous?

Does it suffer from fungal attack or is it just a poor specimen or over-mature?

Is it a rare species?

Does it add to the value of the locality?

Is it a landmark or has it 'local history' value?

Is it a young tree of good potential?

Amenity for the purposes of this survey has been divided into three grades, **A**, **B** and **C**.

A = fine specimens of trees or groups of trees, healthy and in a good position enhancing the surroundings. There is usually no difficulty in assessing such trees.

C = poor specimens, not growing well, often with dead branches and adding little or nothing to the surrounding scenery. There are also usually fairly easy to assess.

B = all remaining trees fall into this category.

SOCIETY

THE FORESTRY COMMISSION, 25 Savile Row, London W1X 2AY. *Responsible for the production of timber for industry, as well as providing recreation for the public, and conservation for wild life in the forests. Carries out research into all aspects of forestry management, tree propagation, and health.*

The Commission has created seven Forest Parks which are open to the public: the Forest of Dean in Gloucestershire, Snowdonia in North Wales, Glen Trool in Galloway, Glen More in the Cairngorms, the Queen Elizabeth Forest Park between the Trossachs and Loch Lomond, Argyll Forest Park in Argyllshire, and the Border Forest Park covering parts of Cumberland, Northumberland, and Roxburghshire.

There are also forest trails for walkers in over sixty Commission forests. Details of them are in the free Commission pamphlet SEE YOUR FORESTS. *Other publications of the Forestry Commission are:*

BEDGEBURY, Kent (National Pinetom) official guide.

BRITAIN'S NEW FOREST.

CONIFERS IN THE BRITISH ISLES.

EXOTIC FOREST TREES IN GREAT BRITAIN.

FOREST PARKS.

RECREATION IN YOUR FORESTS.

These publications can be ordered through the Forestry Commission's outlet in the U.S.: PENDRAGON HOUSE, INC., *220 University Ave., Palo Alto, Calif.* 94301.

IN THE USA

Shade tree surveys are organized by cities and communities or voluntary groups, sometimes in cooperation with state environmental and conservation agencies.

SOURCES OF MATERIALS

In the United States trees are usually sold by age (1+0, 2+0, etc.) or by height (but not by category—bush, standard, etc.). If you don't find what you want in local nurseries, you can mail order from the suppliers below (free catalogs are listed; otherwise write for information) or consult SEED AND PLANTING STOCK DEALERS (A Directory of Dealers Who Sell the More Common Forest and Shelterbelt Seeds and Plants), which has a list of about 150 trees and where to obtain them. It is available free from the Forest Service, U.S. Dept. of Agriculture, Washington, D.C. 20250.

Under the Agricultural Conservation Program, the Department of Agriculture works with the states to assist private landowners in starting, improving, and harvesting trees. They will pay up to 80% of the cost of planting trees and improving young stands. For

general information, see the brochure PUBLIC ASSISTANCE FOR FOREST LANDOWNERS, PA 893; for complete information the pamphlet FORESTRY ASSISTANCE PROGRAMS IN COOPERATION WITH STATE FORESTRY AGENCIES. Both are available from the Forest Service.

Tree seeds:

R.S. ADAMS, P.O. Box 561, Davis, Calif. 95616. *California tree seeds.*

F. W. SCHUMACHER CO., HORTICULTURISTS, Sandwich, Mass. 02563. *Free catalog.*

HERBST BROTHERS, SEEDSMEN, 1000 N. Main St., Brewster, N.Y. 10509.

GARDENS OF THE BLUE RIDGE, Ashford, N.C. 28603. *Eastern seeds.*

W. ATLEE BURPEE CO. Box 6929, Philadelphia, Pa. 19132. *Free catalog.*

GURNEY SEED AND NURSERY CO., Yankton, S.D. 57078.

Seedlings, transplants, and trees:

BRIMFIELD GARDENS NURSERY, 245 Brimfield Rd., Wethersfield, Conn. 06109.

WESTERN MAINE FOREST NURSERY CO., Fryeburg, Maine. 04037. *Free pamphlet.*

BOUNTIFUL RIDGE NURSERIES, INC., Princess Anne, Md. 21853. *Free catalog.*

STARR BROS., Louisiana, Mo. 63353. *Free catalog.*

HENRY LEUTHARDT NURSERIES, INC., Montauk Highway, E. Moriches, Long Island, N.Y. 11940.

GOSSLER FARMS NURSERY, 1200 Weaver Rd., Springfield, Oreg. 97477.

MUSSER FOREST, INC., Indiana, Pa. 15701. *Free catalog.*

SOCIETY

AMERICAN FORESTRY ASSOCIATION, 1319 18th St. N.W., Washington, D.C. 20036. *A citizens association concerned with promoting interest in conservation problems. Membership, $7.50 a year, includes use of their library, a discount on their publications, the right to use their Answer Department for specific problems, and a subscription to the monthly* AMERICAN FORESTS. *The magazine has articles on forests, soil, water preservation and control, the use of wood, recreation,* and wildlife, and many pictures. The association's publications include two excellent books about trees. KNOWING YOUR TREES, by G. H. Collingwood and Warren D. Brush ($7.90), is an encyclopedia of trees in America with descriptions and more than 900 illustrations. GROWING YOUR TREES, by Youngman and Randall ($2), discusses varieties of trees for different geographic areas and uses, buying, planting, and caring for trees, and overall information about trees.

BIBLIOGRAPHY

DWARF FRUIT TREES FOR THE HOME GARDENER, by Lawrence Southwick/Garden Way, Charlotte, Vt. *For both beginner and advanced fruit grower.*

ENGLAND'S TREES, by Miles Hadfield/Shire, Aylesbury, Buckinghamshire; International Publications Service, New York.

A FIELD GUIDE TO TREES AND SHRUBS, by George A. Petrides/Little, Brown, Boston, Mass. *Identifies 645 species growing in northeastern and north-central U.S. and southeastern and south-central Canada; illustrations.*

FORESTS OF CENTRAL ENGLAND, by Jack Gould/Shire, Aylesbury, Buckinghamshire; International Publications Service, New York.

GROWING NUTS IN THE NORTH, by Carl Weschcke/Garden Way, Charlotte, Vt. *The best of the author's 33 years' experience. He wants you to enjoy the experience and avoid his mistakes. Delightfully written.*

HOW TO PRUNE ALMOST ANYTHING, by John Philip Baumgardt/Garden Way, Charlotte, Vt. *Discusses objectives of pruning, tools, and methods; excellent, complete book.*

THE INTERNATIONAL BOOK OF TREES, by Hugh Johnson/Simon & Schuster, New York. *Trees of whole earth arranged clearly by tree families. Marvelous photos with easy, accurate captions.*

THE OBSERVER'S BOOK OF TREES AND SHRUBS/Frederick Warne & Co., London and New York.

PRUNING HANDBOOK, by the Sunset Editors/Lane Magazine and Book Co., Menlo Park, Calif. *Booklet describing pruning system for ornamental and fruit trees, berries,* grapes, roses, and vines. Explains how plants grow and lists pruning tools and their uses.

TREES FOR ARCHITECTURE AND THE LANDSCAPE, by Robert L. Zion/Van Nostrand Reinhold, New York. *Lists many types of trees for each state, trees appropriate for the city, and trees that tolerate moist or dry soil or resist various pests.*

TREES OF NORTH AMERICA: A GUIDE TO FIELD IDENTIFICATION, by Frank Brockman/Garden Way, Charlotte, Vt. *Over 594 species identified by brief text, range maps, and many very beautiful color illustrations.*

TREES, SHRUBS, AND VINES, by Arthur T. Viertel/Syracuse University, Syracuse, N.Y. *Guide covering all ornamental species in the eastern U.S.*

For fast, unromantic identification of trees, these shirt pocket books are available for 75¢ from Nature Study Guild, Box 972, Berkeley, Calif. 94701.

MASTER TREE FINDER. *Area east of Rockies.*

PACIFIC COAST TREE FINDER.

ROCKY MOUNTAIN TREE FINDER.

WINTER TREE FINDER. *Area east of Rockies.*

The following bulletins are available for 50¢ each from Garden Way Publishing, Charlotte, Vt. 05445.

HARDY NUT TREES FOR NORTHERN HOMESTEADS. *Full of good information.*

RAPID GROWING SHADE TREES. *Answers basic questions, and includes detailed list of trees with growing heights and a map showing which trees grow best in different geographic areas.*

The following publications are available free (while the supply lasts) from the Publications Division, Office of Communication, U.S. Dept. of Agriculture, Washington, D.C. 20250.

CHESTNUT BLIGHT, FPL 94.

DWARF FRUIT TREES: SELECTION AND CARE, L 407.

COLOR IT GREEN WITH TREES, PA 791.

GROWING BOXWOODS, G 120.

GROWING FLOWERING CRABAPPLES, G 135.

GROWING HOLLIES, G 130.

MAPLE DISEASES AND THEIR CONTROL: A

NED TOOKE

150

The Living Fence

The hedgerow is a fascinating place, I'm sure you will agree, but how much do you really know about the plants and animals which make up this intricately-balanced community? The hedgerow is a vast nature reserve: some counties have miles and miles of hedgerows, other areas have relatively little of this particular kind of habitat. The history of the hedgerow itself is rather an interesting one, so perhaps it might be a good idea to glimpse into its formation.

In early settlements the ground around the village was often afforested. Clearings were made, and increased in size as the population grew. These clearings were necessary for people to grow their crops. Generally there were three large fields, and these were sub-divided into a number of much smaller plots. One of the three large fields was left fallow each year, and crops were grown on each field for two successive years only. The third year it was given over to rough grazing, and in this way the field was also manured by the animals which fed there. Although the fields were, in turn, divided into strips, there were no hedges or fences and a man could hold pieces of land in different parts of the village without physical obstruction. As the population of the British Isles increased there was, quite naturally, the need to produce more food. There were always dominant characters in each village, either holding the title of Squire or Lord of the Manor. During the eighteenth and nineteenth centuries these influential people brought pressure to bear so that Acts of Parliament were passed so that the lands could be enclosed into farm fields: these were under the direct ownership of the Squire or Lord of the Manor. The 'poor' people had very little say in the matter, and suffered great hardship. However, the idea was, in principle, a sound one, in that the greater fields allowed for easier and more productive cultivation. With the increase in population it was vital that more food should be produced.

The Acts of Enclosure, to give these measures their correct name, saw the formation and widespread planting of hedges. These were useful in that they divided the larger fields, and also because they kept in, or out, farm animals. Other hedges grew up accidentally. Many hurdles and wooden-type fences had been, and still were, used between some strips of land. These also heralded the beginnings of the hedgerow as rough scrub and plants would grow up in this area, eventually developing into hedges. Many of the hedges which were purposely planted, were placed on the top of banks, on either side of which there were often drainage ditches. When landowners decided to plant hedges they needed to choose a species which would grow quickly and often they selected hawthorn, because it possessed these qualities. Once grown, it presented a virtually impenetrable barrier to animals by virtue of its thorny nature and dense growth. Unless checked, such hedges would grow wild, spreading into adjoining fields and periodically, usually every two or three years, perhaps more when fully grown, they would be trimmed. Layering was also a feature of the countryman's craft and branches would be partially cut through, being bent and interwoven to make a very strong hedge. Because the branches were not fully cut through they would continue to grow and many hedges are still to be found where hawthorn is the dominant plant. Within quite a short time of planting, other plants would be found. Animals would also seek a refuge in the hedge bottom, and birds would build their nests among the stable branches.

However, a hedgerow haunt is not a home for isolated species, but an interwoven network of living plants and animals, whose very livelihood and well-being will depend one on another. The species of plant which makes up the main part of the hedge will determine, to some extent, the animals and plants which will be found there. Hawthorn will, in a good season, provide a host of berries for many species of birds. Other plants will also provide an abundance of food for other birds, and for animals as well. Sloe, elderberry and dog rose are useful sources of food for birds and animals in Autumn.

Climbing plants will take advantage of the hedge, especially where the latter have been left unchecked. The flowers of the bindweed are a well-known feature of most hedges, and these will be joined by other climbing species like white bryony, traveller's joy, woody nightshade and ivy. The climbing plants are often accompanied by scrambling species like cleavers and the wild and dog rose. The latter will, in time, provide sturdy stems to support itself quite adequately, independent of the rest of the hedge. By Autumn most of the hedge foliage will have disappeared, and will re-appear in the following Spring, with new-found energy and growth. Some of the plants found here will occur in the hedge bottom, and will bear flowers before the main leaf canopy appears above, to blot out much of the sunlight so essential for plants to make their food. These plants which grow in the hedge bottom include those which grow quickly and spread outwards, so that the hedge does not shade them too much. Stinging nettles, hedge-parsley and jack-by-the-hedge are all perennials which fall into this category. Having grown quickly they will have a foothold in the hedge before the leaves appear above. There are only a few plants which can grow and flourish in the hedge bottom where there is little light. Such shade-loving plants include the primrose and the violet, together with cuckoo-pint. These plants will have produced their flowers before the main leaves appear on the hedge, clothing it in its suit of green.

Plants can be considered residents of the hedge, and there are many species of animals which are also residents. However, there are others which come and go, being regular visitors to the hedgerow habitat. The reasons for their comings and goings will vary from species to species, but there are two basic reasons why they visit the hedge: they will come in search of food and they will also look to the hedge for shelter.

Spiders are to be found in most hedgerows and their activities can best be observed during the Autumn when they are at their most active. It is a great delight to see a hedge adorned with a million sparkling strands of silk from a thousand spiders' webs, when the sun shines on the dew-encrusted hedge. There are many other invertebrate members of the hedgerow

scene, and the caterpillars of many species of butterfly will be found feeding voraciously during late Spring through to early Autumn. It is interesting to note that some species of butterflies are to be found feeding exclusively on a single species of plant. Many such species may become extinct.

Mammals will also visit the hedgerow, and the very familiar hedgehog is one of these. He will choose a hedge bottom for his Summer retreat, and an even more sheltered one for his Winter hibernatory period. Sleeping in the hedge bottom by day, he will leave at dusk in search of food. Mice, voles, rabbits and shrews are all residents of the hedgerow habitat, and they are joined by birds, lizards and snails.

Visitors to the habitat include owls, searching for the abundance of wild mammals to be found and weasels and foxes are out to catch their prey. Butterflies and moths will frequent the area to sample the nectar from the many hedgerow flowers. Occasionally, visitors will include snakes and other species of birds. If there are trees in the hedge, then there is usually an even greater variety of wildlife: squirrels may build their dreys in its branches, and owls may nest in its trunk; caterpillars will feed on its leaves, and insects will lay their eggs in its flowers.

The hedge is an important wildlife refuge for birds. Some will sit on the highest boughs, singing and displaying, proclaiming that they have claimed the territory for their courtship period. Here the birds will build their nests, lay their eggs and raise their young. Long-tailed field mice will also make their nests in the hedge bottom, burrowing underneath the soil to make a number of chambers which will be used for sleeping and for storing food.

It is impossible to list all the species of the hedgerow, but as a habitat for wildlife it is of great importance. It has been considered as *the* most important wildlife reserve in the country, but each year it has been estimated that some 5,000 miles of hedgerow are removed, to make way for bigger fields to produce more food. This is not always an advantage, as many farmers have found in the Fenland area, where hedgerows have long since vanished in many parts. When dust storms occur they cause a great deal of damage, blowing away seeds,

burying plants, and filling dykes.

Perhaps one day someone will understand more fully the intricate relationships which exist in the hedgerow, and instead of uprooting them they will plant more, so that future generations can enjoy the wealth of wildlife which the hedgerow habitat offers to the patient observer. *By Ron Wilson*

MAKING A HEDGE SURVEY[1]

Dating a hedgerow

Dr Max Hooper of the Nature Conservancy has established that in general it is possible to date a hedge by the number of kinds of shrub growing in it. Examine any 30-yard length of hedge: there will tend to be approximately one species of shrub for every hundred years. So a hedge with 5 species of shrub within a 30 yard length is probably about 500 years old; 9 species of shrub should mean roughly 900 years. And so on. Where the rule does not apply, there are likely to be other explanations. (Thus in part of Shropshire, Dr Hooper found five species of shrub in hedges he knew from documentary sources to be only 200 years old. The explanation for this apparent inconsistency was that, contrary to the national pattern—which is that hedges are originally planted as one species, generally hawthorn—in this part of Shropshire the original hedges were planted as *mixed* hedges. Or again, on the very acid soils in parts of the North and West of England, hedges are little more than gorse banks. Dr Hooper's rule does not apply where the acidity of the soil does not permit the ready growth of shrubs.) But in general, the dating of hedges by the Hooper method is reliable within certain margins of error (say 100 years either way).

Hedge survey

A hedgerow survey of a parish would be a most valuable contribution to local history, and could be welcomed by your County Archivist. In parts of England where hedges are especially at risk, it will probably be possible to get the co-operation of the Planning Authority. The intention of such a survey should be to draw together as much material as possible on the history of your parish hedges and to document it thoroughly.

Having checked with your CPRE branch and County Naturalists' Trust that no hedge survey has already been undertaken in your parish, you should follow the broad ground-rules set down here.

[1] *By kind permission of the Council for the Protection of Rural England.*

Many hedges can be recorded along public roadsides, bridle paths and footpaths. If you wish to examine a hedge on private land, it is vital that you first obtain permission from the owner or tenant.

For each hedge you survey, you will require a form which records the significant features in several 30 yard stretches of the hedge. The form was developed by the Cambridgeshire and Isle of Ely Naturalists' Trust.

The survey should clearly identify the hedges described. It is important to sketch a map (1) to give an Ordnance Survey map reference (2) and to give as much information as possible about the locality (3). Each hedge should be examined in 30 yard lengths (4) estimated by pacing out 30 yards on the ground. The dominant species (5) is the kind of tree or shrub which appears to be most abundant in the hedge.

Certain species of flowers, climbing plants and all rarities are of particular interest (6); be sure to record mercury, bluebell, oxlip, crested cow-wheat, if they are present. Remember, however, that for the purposes of hedge-dating, climbers, such as black bryony, white bryony, honeysuckle, and blackberry do not count. Under Further Comments (7) the kind and number of trees in the hedge should be identified. You should also note here whether the hedge appears to be planted (e.g. a hedge of mixed species surrounding a park), whether the hedge appears to be in immediate danger, whether it supports abundant fauna, etc.

Finally, Historical References (8). This section should include any additional *documentary* reference you are able to establish relating to a particular hedge. There are a number of available source documents: Anglo-Saxon charters, the records of medieval monasteries, parish maps, early estate maps, tithe maps, and early Ordnance Survey maps are some of them. Your County Records Office (and your County Archivist) will help guide you to sources for your parish. The relevant volumes of the *Victoria County History* will be indispensable.

But perhaps the most fascinating document of all is *the hedge itself*, using the Hooper method of dating by the number of shrubs contained in the hedge. The value of a hedge survey does not necessarily depend on its being tied into other historical matter.

How is a hedge survey useful? The survey is likely to be of great potential assistance to the Planning Authority. At present, nobody cares that an historic hedge may be lost, because nobody knows anything of its history. But an authoritative survey could provide details of its age and interest and such factors could weigh heavily in the decision of a Planning Authority or even, tactfully presented, of a farmer. So the survey will be a positive contribution to planning the survival of hedges that might otherwise be uprooted. Unlike trees, hedges *per se* are not subject to Preservation Orders. This makes it especially important to rouse and inform public opinion when hedges of particular interest are in jeopardy. Secondly, the survey will be welcomed as a contribution to local history, and as a source of material for other local historians. Finally, the survey will give you a deep and lasting understanding of the way in which the landscape of your parish reflects its varied history. The beauty of the English countryside is the product of hundreds, even thousands of years of man's endeavours. We must look after it.

SOCIETIES

THE COUNCIL FOR THE PROTECTION OF RURAL ENGLAND, 4 Hobart Place, London SW1W 0HY.

The CPRE is a registered charity formed to protect and enhance the beauty of the English landscape, and to ensure that changes, which are inevitable, are for the best whenever possible. The Council is concerned at the tendency in some areas for hedges to be uprooted and destroyed, regardless of their historic or amenity value.

BIBLIOGRAPHY

HEDGES AND LOCAL HISTORY/available from the Standing Conference on Local History, 26 Bedford Square, London WC1D 3IIU. Price 55p.

MAKING A HEDGE SURVEY/available from The Council for the Protection of Rural England (as above).

*Early autumn evening
is long, dark shadows
stroking the warm green richness
of the Kentish fields*

JOHN RICE

Attracting Butterflies and Birds

How many gentle flowers grow
In an English Country Garden?
I'll tell you of some I know
And those I miss I hope you'll pardon.
There are daffodils, hearts season flocks,
Meadow sweet and lilies, stocks,
Gentle lupins and tall hollyhocks,
Roses, foxgloves,
Snowdrops and forget-me-nots
In an English Country Garden.

How many insects find their home
In an English Country Garden?
I'll tell you of some I know
And those I miss I hope you'll pardon.
There are dragonflies, moths and bees
Spiders falling from the trees
Butterflies sway in the mild, gentle breeze,
There are hedgehogs that roam
And little gnomes
In an English Country Garden.

How many song birds make their nests
In an English Country Garden?
I'll tell you of some I know
And those I miss I hope you'll pardon.
There are babbling coo-cooing doves
Robins and the warbling thrush,
Bluebird, lark, finch and nightingale,
We all smile in the spring
When the birds start to sing
In an English Country Garden.

THE PRESSURES on our wildlife are increasing yearly with alarming effects on both their food supplies and habitats. As urban expansion, encroaches slowly into the countryside, the creatures living there have little choice but to perish, move on, or adapt to the changes. Some have perished, some have moved on, but many have used their natural ingenuity to adapt to urban life and are flourishing quite well. It is therefore on this point of adaptation that we can be of real help to our wildlife. If nothing can be done to prevent the eating away of open land, at least something positive can be done to make life in the new towns and suburbs as attractive to wild creatures as possible. Most people own a garden, however, small and with little cost it can be transformed into a mini-nature reserve, the sort of place that will attract bees, birds, butterflies and perhaps the odd mammal or two.

Although many species are threatened, there are a number of things the individual can do:

The most important point to remember is that wildlife will need two basic requirements; food and shelter. Food must come from nectar-giving flowers, nut and berry bearing trees and shrubs, and shelter can be provided by planting trees and shrubs with thick or dense foliage. If the garden, or at least a good part of it, can be left 'wild', then all the better. This need not necessarily be a corner of tangled weeds, although this is very beneficial, but can be an area planted with specialist wild flowers, ornamental flowers and grasses, and shrubs which will only need a little attention now and again.

ATTRACTING BUTTERFLIES

One must approach this aspect of the ecological garden in two ways; firstly by providing nectar-bearing flowers for the butterflies and secondly by providing food for the caterpillars once the butterflies have been attracted and encouraged to lay eggs.

Caterpillar Food

A list appears at the end of the chapters on natural cosmetics and companion plants showing where the various flowers and plants can be purchased. Once the garden has been stocked with suitable food plants, the actual insects can be introduced as well (see sources of materials at the end of this chapter).

ASPEN (*Populus tremula*)
Food of the Poplar Hawk Moth, Big Poplar Sphinx.
ASH (*Fraxinus excelsior*)
Food for the Privet Hawk Moth.
BEECH (*Fagus sylvetica*)
Food of the Imperial Moth.
BIRCH (*Betula*)
Food of the Kentish Glory, Camberwell Beauty (Mourning Cloat).
BLACKTHORN (*Prunus spinosa*) Sloe
Food of the Swallowtail, Black Veined White.
BRAMBLE (*Rubus fruticosus*)
Food of the Gatekeeper, Ringlet, Green Hairstreak, Brown Hairstreak, Whiteletter, Grizzled Skipper.
BUCKTHORN (*Rhamnus cathartica*)
Food of the Green Veined White, Brimstone.
BURDOCK (*Arctium minus*)
Food of the Painted Lady.
CABBAGE
Food of the Large White (Cabbage Butterfly).
CARROT
Food of the Swallowtail.
CLOVERS (*Trifolium*)
Food of the Clouded Yellow, Clouded Sulphur, Orange Sulphur.
DANDELION (*Taraxacum officinale*)
Food of the Tiger Moth.
DOCK (*Rumux*)
Food of the Small Copper (American Copper), Large Copper, Tiger Moth.

ELM (*Ulmus*)
Food of the Camberwell Beauty (Mourning Cloat), Large Tortoise Shell (Compton's Tortoise Shell), Lime Hawk.

FENNEL (*Foeniculum vulgare*)
Food of the Black Swallowtail.

GORSE (*Ulex europaeus*)
Food for the Silver Shredded Blue.

GRASSES
Many caterpillars feed on the many types of grasses growing in the British Isles, including the Small Heath, Large Heath Speckled Wood, and Wall Brown.

HAWTHORN (*Crataegus monogyna*)
Food of the Lackey.

- A FARM-HOUSE GARDEN -

THE CATERPILLAR'S SONG

Caterpillars, come, draw near:
Though we be worms and earthbound here
Tomorrow we shall sing and fly
O'er all the earth and all the sky

Our present lot might seem quite poor
With little room for more than chores
Which we perform to stay alive
In order that our flesh may thrive

Laboring thus without a rest
Braced with burdens till our deaths
We none the less shall re-arise
One day as noble butterflies

Therefore now I sing this song
Letting you know 'tis nature's way
To make resplendent butterflies
From lowly worms and humble clay

— TIM RIVERS

HOP (*Humulus lupulus*)
Food of the Comma.
HORSERADISH (*Armoracia rusticana*)
Food of the Green Veined White.
LILAC
Food of the Privet Hawk Moth, Chersis Sphinx.
LIME (*Tilia*)
Food of the Lime Hawk.
LUCERNE (*Medicago falcata*)
Food of the Clouded Yellow, Clouded Sulphur, Orange Sulphur.
MUSTARD, GARLIC (*Alliaria petiolata*)
Food of the Green Veined White, Orange Tip.
NETTLE, STINGING (*Urtica dioica*)
Food for the Painted Lady, Peacock, Tortoise Shell, Red Admiral.
OAK (*Quercus*)
Food of the Hairstreak.
PLUM (*Prunus*)
Food of the Cecropia.
POPLAR (*Populus*)
Food of the Poplar Hawk Moth, Eyed Hawk Moth, Puss Moth, Big Poplar Sphinx.
PRIVET (*Ligustram vulgare*)
Food of the Privet Hawk Moth, Chersis Sphinx.
SALLOW (*Salix*)
Food of the Eyed Hawk Moth, Puss Moth, Camberwell Beauty (Mourning Cloat), Large Tortoise Shell (Compton's Tortoise Shell), Purple Emperor, Kentish Glory.
SCABIOUS (*Knautia arvensis*)
Food of the Bee Hawk Moth.
SCOTS PINE (*Pinus sylvestris*)
Food of the Pine Hawk Moth.
SORREL (*Rumex*)
Food of the Small Copper (American Copper).
SPURGE (*Euphorbia*)
Food of the Spurge Hawk Moth.
THISTLE (*Cardaus and Cirsium*)
Food of the Red Admiral, Painted Lady.
WILD CHERRY (*Prunus avium*)
Food of the Tiger Swallowtail.
WILLOW (*Salix*)
Food of the Eyed Hawk, Puss Moth, Camberwell Beauty (Mourning Cloat), Large Tortoise Shell (Compton's Tortoise Shell), Tiger Moth.

158

WILLOWHERB (*Epilobium*)
Food of the Elephant Hawk Moth.

Butterfly Food
Butterflies love sweet-scented flowers oozing with nectar and as a general rule, prefer small, rather simple flowers, such as the old cottage perennials. Take your choice from the following list:

ALLYSUM (white)	MALLOW
AGERATUM	MARJORAM
ARABIS (pink & white)	MIGNONETTE
AUBRETIA	MICHAELMAS DAISY
BLUEBELL	PINK THRIFT
BIRDSFOOT TREFOIL	PRIMROSE
BUDDLEIA (the butterfly bush)	POLYANTHUS
	PETUNIA
BRAMBLE	PHLOX
CATNIP	RUBUS
CANDYTUFT	RAGWORT
COMFREY	SWEET WILLIAM
CLOVER	SINGLE FRENCH MARIGOLD
CAMPION	
COWSLIP	SEDUM
DANDELION	SOAPWORT
DAISY	SEA HOLLY
EVERLASTING PEA	SENECIO
EGLANTINE ROSE	SCARLET GERANIUM (common)
FOXGLOVE	
GOLDEN ROD	SWEET ROCKET
HELIOTROPE	SWEET WILLIAM
HEBE	THYME
HEATHERS	THISTLE
HONEY SUCKLE	VERBENA
KNAPWEED	VALERIAN
LILAC	WALLFLOWER (purple & yellow)
LAVENDER	
LAVENDER	
MYRRH	
MEADOW CRANESBILL	

Many wild flowers can be bought as seeds and either raised in a good quality seed compost under glass and transplanted out when of sufficient size, or the seeds raked lightly into the surface of the soil and allowed to germinate naturally. Some seeds may lie dormant in the soil for more than a year, so don't despair if nothing happens at first.

ATTRACTING BIRDS[1]

Somewhere to live
When replacing habitat for birds, you must fulfil two of their basic requirements—food and shelter. Food and shelter? Feeding birds and providing nestboxes does help. But there is more that you can do. You can provide a suitable habitat by growing plants on which the birds rely. Birds are part of nature—dependent like all animals and plants on other animals and plants. They are part of a food chain—a food chain which in turn depends on the soil and climate.

Planning for the birds
How do you set about planning out your garden nature reserve? The basic requirements of food and shelter often go together. Therefore, if you grow plants for food, you will provide shelter as well. Plants for food fall into two groups—those that are eaten by the birds and those that attract insects that are eaten by the birds. The birds that visit your garden can be divided into three basic categories—those that eat mainly vegetable matter, those that eat mainly animal matter such as insects and those that will eat almost anything.

No garden is flat
When planning your planting, remember that a garden has more than one level. It has a range of levels from the top of well-grown trees to the ground. So choose plants that will give you a wide range of heights.

The plants for the seed-eaters can range from the smaller varieties of daisies to the pyracantha that can grow up the walls of a house. Seeds of many herbaceous plants will attract members of the finch family. The most obvious of these is the sunflower. It is easy to grow and if left to go to seed is particularly attractive to goldfinches. Other suitable flowers include cosmos, china aster, scabious, evening primrose, antirrhinum and michaelmas daisy.

If you have a large garden and tolerant neighbours, you can leave a 'wild' area, where thistle, knapweed, teasel, groundsel and field

[1] *By courtesy of The Royal Society for the Protection of Birds.*

poppy can grow. Nettles are also valuable because they provide food for insects, which in turn provide food for birds.

Michaelmas daisies and other pink and mauve late-flowering plants such as ice plant, buddleia and veronica seem to be particularly attractive to butterflies and other insects. Amongst insect-attracting plants, one of the most successful is the giant hogweed. This will grow to 12 or 14 feet and will attract many flying insects, and therefore fly-catching birds. Remember to warn children not to play with this plant because it can cause very unpleasant skin irritation.

The berry-bearing shrubs are a valuable source of food for members of the thrush family in the winter. You may even attract the redwing and fieldfare, winter visitors from Scandinavia. Researches by the Royal Society for the Protection of Birds into the shrubs that birds prefer have shown the following to be most popular:

ELDER (mainly *Sambucus nigra*)
YEW *(Taxus baccata)*
Cotoneaster horizontalis
Cotoneaster simonsii
Cotoneaster waterii
AUTUMN OLIVE *(Elaeagnus umbellata)*
RUSSIAN OLIVE *(Elaeagnus augustifolia)*
RED CHOKEBERRY *(Aronia arbutifolia)*
BLACK CHOKEBERRY *(Aronia melanocarpa)*
BARBERRY *(Berberis darwinii)*
HOLLY *(mainly Ilex aquifolium)*
FLOWERING CURRANT (mainly *Ribes sanguineum)*
HONEYSICKLE *(Lonicera species)*
HAWTHORN (mainly *Crataegus monogyna)*
WAYFARING TREE *(Viburnum lantana)*
BLACKBERRY *(Rubus fruticosus)*
ROWAN *(Sorbus aucuparia)*
FIRETHORN *(Pyracantha coccinea)*
CRAB APPLE (mainly *Malus pumila)*
PRIVET (mainly *Ligustrum vulgare)*

Some of these plants make excellent hedges. Hawthorn is particularly effective because it provides both food and nest sites. In fact, some gardeners prefer it to the more usual privet hedge which can be a nuisance because it takes so much nutrient from the soil. Remember that some of the bushes suggested have berries that are harmful to man and domestic animals, but not to birds.

Birds which eat berries will also eat fruit in winter. They are not as fussy as humans and can be attracted by windfalls and damaged fruit put out during the cold weather.

Trees are a source of food as well as shelter for birds. If you want to plant trees, pick native rather than exotic species. Not only are they better adapted to the climate, they are also part of the pattern of our native flora and fauna. Of the native trees, the oak is undoubtedly the most productive; a mature oak supports so much life that it is almost a habitat in itself. However, oaks need space and take a long time to reach maturity. Therefore, you may prefer to choose a quicker-growing species such as ash, elm, silver birch or willow. Like other plants, trees do have a preference for certain soil types and therefore you should plant species already growing in your area or take a nurseryman's advice. Remember to ascertain how much room a tree takes up when fully grown before you plant it.

Ash seeds or 'keys' provide food for a number of species and have been proven to lessen the damage of bullfinches on buds in orchard areas. Silver birches attract numerous small insects which all the species of tits eat. Many insects, especially moths, lay their eggs on willow leaves and their grubs are eaten by robins, tits, wrens and dunnocks. If you buy an elm, make sure it is one of the varieties which are less susceptible to Dutch elm disease.

Dead trees can be left, unless they have died through a disease, such as Dutch elm disease. Rotting trees provide nest-holes and a plentiful supply of insect food in the rotting bark. If you think a dead tree is unsightly, grow a climbing plant such as clematis up it.

The importance of water
Throughout the year, birds need water for bathing and drinking. Birdbaths are the obvious way to do this. They can be purchased from garden shops and centres but often they are expensive, aesthetically unpleasing and badly designed, so that they do not fulfil their prime purpose. Basically, almost any receptacle is suitable as long as birds can reach the water and the sides are not slippery. A simple bath can be made from an upturned dustbin

lid sunk into the ground or supported by three bricks.

In winter, freezing can be a problem. A small receptacle raised on bricks over a lighted nightlight can avoid this. If your birdbath is large or if you have a pond, you can use a thermostatic immersion heater designed for ponds. They can be bought from aquaria suppliers. Make sure you have a well-insulated lead. On no account use chemicals to lower the water's freezing point.

Your own pool
A garden pool is more effective than a birdbath as long as it has a shallow ledge around the edge. It will be used by birds for drinking and bathing. A pool very soon attracts a range of wildlife including creatures such as frogs, newts, and dragonflies. It also attracts other insects on which wagtails and flycatchers will feed.

Making a suitable pool is quite easy. First dig a hole approximately 5 feet by 4 feet. The deepest part should be between 1 foot and 2 feet but the bottom should slope gradually to a shallow end. Remove all sharp stones and lay a 9 feet by 8 feet sheet of 1,000 gauge polythene into the hole, allowing 2 feet spare around the edges. Trap the edges by replacing turf. Spread soil over the base of the pool to a depth of 3 or 4 inches, fill with water, allowing a week to settle before planting, and grow aquatic plants in the soil.

Nesting sites
Natural nesting places for birds are often not available in gardens. Hedges have been removed (or on modern estates just not provided), rotting trees which provide nest-holes have been chopped down and a thick undergrowth is not tolerated.

Many of the bushes and trees recommended for feeding birds also provide cover for nesting Particularly valuable are bramble and hawthorn which offer protection from predators.

The most obvious way to compensate for the lack of natural nest-sites is to put up nest-boxes. However these are only suitable for certain species. Many types are sold commercially and when you buy one, avoid those with ledges beneath the entrance which might help

predators to get to the nest. Ornamentation is unnecessary from the birds' point of view—cupolas, balustrades, thatch or windows mean nothing to the birds. All they want is somewhere in which to nest safely.

Ideally, nestboxes should be put up in November but the early spring is not too late. Fix your nestbox to a tree or wall. For the birds' sake, avoid places which cats can easily reach and try not to have the hole facing south because the midday sun may be too hot for the nestlings. For your sake, find places where you can watch easily.

Tits, tree sparrows and house sparrows, starlings, nuthatches and pied flycatchers are all hole-nesters and will use nestboxes. For tits an entrance hole $1\frac{1}{3}$ inches in diameter is sufficient and too small for starlings and house sparrows. Spotted flycatchers, pied wagtails and robins will use nestboxes with open fronts. They will also nest in old kettles and flower pots. If you leave the door of your garden shed or greenhouse open throughout the breeding season, you may well attract robins, song thrushes, blackbirds, wrens, spotted flycatchers, pied wagtails or swallows to nest inside. Ensure that there are no open paint pots or tins of creosote because young birds may well fall into these when they leave the nest.

Many species will nest in holes in walls. If you remove a brick from a wall, you may well

get pied wagtails, spotted flycatchers or wrens nesting in the hole. For details of the many types of nest-box that can be bought or made, you should read BIRD NEST-BOXING by Norman Hickin and the BTO GUIDE, NESTBOXES. Both are available from the RSPB whose address is given on p. 16.

At the end of each nesting season, clean out your nestbox in order to remove parasites. The remains of old nests may deter birds from nesting next year.

The making of the nest box
Get yourself some wood (plywood is best but it really doesn't matter) about $\frac{1}{4}$ inch thick, and cut out the front and back which are 8-inch-sided triangles. Drill the entrance hole in one of the two pieces; $2\frac{1}{2}$ inches below the apex and also a $\frac{2}{3}$ inch hole for the perch—4 inches below the apex. Cut a key-hole shape (using two drill sizes) in the other piece of wood directly opposite the entrance hole. Now for your sides Cut two pieces of wood $8\frac{3}{4}$ inches by 6 inches and mitre the top edges. Glue and panel-pin the sides to the front and back, overlapping the front by 1 inch. Cut another piece of wood $8\frac{1}{4}$ inches by 5 inches for the base and bevel the edges to 60°. Screw the base to the front and back edges and then glue a $1\frac{5}{8}$ inches-long dowel rod into the perch hole. Finally, paint the outside of the box thoroughly.

Nesting
When birds nest in your garden, leave them alone as much as possible. If you must look, make it a quick visit every other day. Be very careful not to leave signs of your visit such as broken twigs or trodden foliage because this might lead predators to the nest.

Leave young birds alone
Young birds away from the nest, apparently without their parents, have normally not been deserted. They have probably just left the nest and are not yet flying freely. Do not attempt to catch them, their parents will return when you leave. To try rearing them yourself would be difficult and would probably end in failure. It is also illegal to do this unless the bird has been deserted or was injured. Further details are available in TREATMENT OF SICK AND INJURED

BIRDS and WILD BIRDS AND THE LAW each of which can be obtained by sending 5p in stamps to the RSPB.

Birdtables and feeding devices
In very hard weather, feeding birds can be important in helping them to survive, but remember that during the rest of the year, the main value of feeding birds is making it easy for you to watch them.

A variety of birdtables is sold and they range from the elaborate 'rustic' type to simple platforms. Which you choose is really a matter of individual taste. Many birdtables have roofs and while these are not vital, they do give some protection to food, especially from snow.

You can suspend birdtables from a branch or from a wall bracket, or you can support the table on a post driven into the ground or on a movable stand. Avoid 'rustic' stands which are easily climbed by cats or grey squirrels.

Squirrels are inveterate birdtable feeders and it is difficult to keep them off the table. Many ingenious ideas have been tried but the squirrels' acrobatic ingenuity will often win. A table with a very smooth circular pipe around the post or a basket suspended on a long wire from a high branch will usually beat them.

House sparrows and starlings are considered nuisances on birdtables by some people and there is a variety of 'sparrow-proof' feeding devices—from baskets to coils of wire. They can be filled with nuts, fat or kitchen scraps. Unfortunately, some feeding devices can be dangerous and before you buy you should look carefully for sharp edges which can cut birds' feet, or springs which can trap birds by the feet or wings, or openings in which the birds themselves could become trapped.

Whatever feeding devices you choose, they should be moved occasionally because there is a danger that rotten food can accumulate in the ground, harbouring disease and encouraging rats.

Be considerate to your neighbours. Extravagant feeding can encourage birds to the extent that they become a nuisance.

*When the ground is covered with a crust of
 frozen snow,
Don't forget the hungry birds that flutter
 to and fro.
Searching vainly for a worm, a berry
 or a seed,
A sip of water and some crumbs will satisfy
 their need.*

*Feed the feathered mendicants that gather
 at your door,
They'll reward you with a song when
 Spring comes round once more.
Feed God's little minstrels when the
 world is cold and white.
Feed them and remember they were made
 for your delight.*

SOCIETIES

THE ROYAL SOCIETY FOR THE PROTECTION OF BIRDS, The Lodge, Sandy, Bedfordshire. *The most popular wild life charity in Britain which does an excellent job in helping to protect birds as well as encouraging interest and respect for wild life. Its monthly bulletins,* BIRDS *and* BIRDLIFE, *are issued free to members. The Society also runs film shows and gives lectures on bird conservation. From the United States, write first for information before ordering the various publications.*

IN THE USA
SOURCES OF MATERIALS

DUTCH MOUNTAIN NURSERY—"Berries for the Birds," 798 N. 48th Street, Route 1, Augusta, Mich. 49012. *Catalog 25¢. For twenty years this firm has been professionally handling plants which attract birds. Their list is informative—it tells you what tree or shrub you can plant where to attract which kinds of birds. If you become seriously involved in this as an environmental movement, you can join the F. B. I.—Fruit for Birds International.*

INSECT LORE PRODUCTS, P. O. Box 1591, Shafter, Calif. 93263. *Will mail order The Painted Lady and Buckeye in various stages of development.*

SOCIETIES

THE LEPIDOPTERISTS' SOCIETY, c/o Stanley S. Nicolay, 1500 Wakefield Drive, Virginia Beach, Va. 23455. *A worldwide organization for both amateurs and professionals interested in butterflies and moths. The society publishes a quarterly* JOURNAL *and a bimonthly "News of the Lepidopterist Society" bulletin which contains a section of notices on buying, selling, and exchanging various species. Membership and subscription fee (which includes back issues of the publications for the year you join) is $10.00 per year for a student, $13 per year for an active member, and $20 per year for an honorary member.*

THE NATIONAL AUDUBON SOCIETY, 950 Third Ave., New York, N. Y. 10022; P.O. Box 4446, Sacramento, Calif. 95806. *A nonprofit, educational organization with 600 branches and affiliates, interested in the preservation, conservation, and restoration of natural resources. Membership costs $15 a year and entitles you to their bimonthly magazine,* THE AUDUBON. *The Audubon Society publishes another bimonthly magazine, entitled* AMERICAN BIRDS, *which costs $8 a year.*

The Educational Services Department of the Society in New York sells for $1.80 a 16-page illustrated booklet entitled BIRD ATTRACTING, *which features plants, baths, and feeders. The Department also has a set of five Audubon Nature Charts for $2, one of which shows 68 common birds and provides space for recording observations on up to 25 species. To obtain either publication, write for the catalog "Audubon Aids in Natural Science," which has an order form.*

BIBLIOGRAPHY

BIRDS IN THE GARDEN AND HOW TO ATTRACT THEM, by Margaret McKenny/Grosset & Dunlap, New York.

FAMILIAR GARDEN BIRDS OF AMERICA, by Henry H. Collins, Jr., and N. R. Boyajian/Harper & Row, New York.

HUNGRY BIRD BOOK: HOW TO MAKE YOUR GARDEN THEIR HAVEN ON EARTH, by Robert Arbib and Tony Soper/Taplinger, New York.

NEW HANDBOOK OF ATTRACTING BIRDS, by Thomas P. McElroy/Knopf, New York.

POCKET GUIDE TO BIRDS: HOW TO IDENTIFY AND ENJOY THEM, by Alan D. Cruickshank/Pocket Books (Simon & Schuster), New York.

THE UNOFFICIAL COUNTRYSIDE, by Richard Mabey/Scribner's, New York.

The following publications are for sale by the Superintendent of Documents, U.S. Government Printing Office, Washington, D.C. 20402:

ATTRACTING BIRDS, Conservation Bulletin 1, 25¢.

AUTUMN OLIVE: FOR WILDLIFE AND OTHER CONSERVATION USES, L 458, 30¢.

INVITE BIRDS TO YOUR HOME: CONSERVATION PLANTINGS FOR THE NORTHEAST, PA 940, 25¢, THE MIDWEST PA 982, 30¢, THE SOUTHEAST and THE NORTHWEST (prices not yet set).

PLACES TO VISIT

MEYERS' BUTTERFLY FARM, 119 Cherry Hill Road, Parsippany, N. J. 07054. *Offers a wealth of information for people interested in attracting and breeding butterflies and moths. Mrs. Meyer has found Orange Glory (commonly known as Wild Milkweed) to be particularly successful for attracting Swallowtails. The Meyers give demonstrations illustrating the life cycle of Lepidoptera, using live specimens. Please call if you wish to make an appointment to visit. Educational institutions and organizations may wish to write for a price list of available species. Individuals are discouraged from making such requests.*

MAC RICHTER, *a 91-year-old Lepidopterist, runs a butterfly museum at Freehold-Oak Hill Rd., East Durham, N.Y. 12423, which is open to the public for a minimal fee every day during the summer and by appointment throughout the rest of the year. He also has a butterfly farm and for 25¢ will send you a list of such salable materials as cocoons and butterfly eggs.*

For any plant, be it tree, bush, flower or vegetable, to live and flourish in the soil, there must be a good supply of humus in that soil, for the simple reason that humus (decayed organic matter or compost) contains essential nutrients which plants need, and what is more important, these nutrients are in the right proportion for plants to absorb. Humus also improves the condition of soils; breaking down heavy clay soils and giving body and life to sandy and chalky varieties so that root systems can get a good anchorage to feed the plants they serve. Added to this there is the fact that a soil rich in humus retains moisture more readily than a soil lacking in organic matter, so that the need for constant watering of plants is eliminated.

What now follows is a comprehensive guide to making compost using six different methods: ranging from the very simplest of techniques to those more complicated so that at least one will be found suitable for your needs.

WHAT AND WHAT NOT TO COMPOST

A good compost, when it is ready, should be a deep brown or black colour and should have no bad odours, indeed, it will generally have a sweet smell. However, care must be taken as to what sort of stuff is put on the compost heap because certain materials will not rot or if they do, may need certain conditions in which to do so. All the following will make good compost: leaves, grass cuttings, dead flowers, nut shells, egg shells, tea leaves, weeds, cuttings from most herbs and shrubs, sawdust, wood-clippings, shredded rags, hair, wood ash, fish bones, seaweed, all animal manures, hay, straw, paper (provided it is thoroughly shredded and soaked in water) and waste from the vacuum cleaner. Never put the following on a compost heap: metal, glass, plastic, bulk paper, thick twigs or branches, oily or greasy materials.

Bulky material such as old swedes and turnips etc., will need shredding into small pieces before it will rot down. Bearing in mind that a compost heap is at its most efficient when constructed of a mixture of materials, never put a mass of one sort of material in one place to rot down, as nine times out of ten it will take ages to do so and the finished result will not be pleasing.

SOURCE OF MATERIALS

Apart from weeds, leaves and cuttings from your own garden, always save the vegetable waste from the kitchen. Neighbours are a good source of material—get them to dump their own waste into a pile in your garden (provided, of course, that they aren't composting themselves). If you live in the countryside, or near stables you will be able to get manure for next to nothing. If you live in the town, greengrocers are a good bet. Go down to your local man with a barrow and bring home his cabbage, cauliflower, sprout cuttings etc. Also, when the trees in your street begin to shed their leaves in Autumn, there will be tons of leaves for the taking, but get there before the road sweepers come around.

1st Method

This is just about as basic as you can get. Simply spread the waste and leaves etc. on the surface of the soil or dig it in. This method makes the soil look a bit unsightly, but it works. This is composting at its most fundamental.

2nd Method

Once a good bucketful of waste has been collected, dig a hole about 1 foot deep and bury it. Do this for every bucketful, systematically over the whole plot of ground. Alternatively, dig a trench and spread the waste along the bottom before covering with soil.

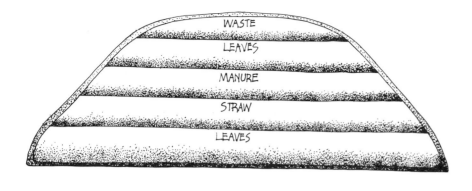

Fig 1

Fig 2

3rd Method

From the two methods just described, the next step up in composting is to make piles of waste, thoroughly mixed and if possible, shredded. Covering it with black plastic sheeting will aid decomposition as this keeps the heat stable—an essential factor in the breaking down of organic matter.

4th Method

This is known as the 'indoor' method and it works on the theory that a heap of organic material will decompose more readily if it is constructed of layers of different types of material. Construct the heap with 6 inch layers of material and try to work in a layer or two of some animal manure *(fig 1)* as these will act as an 'activator' and help to break down the heap quickly. Other 'activators' to use if manure is not available are: dried blood, bone meal, sewage sludge and wood ash.

Any weeds or diseased plants should be placed in the centre of the heap as the heat generated there through decomposition will kill off bacteria and destroy seeds. When the pile has reached about 3 feet high, leave it and begin another: don't make compost heaps too high. Also, to give extra aid to decomposition, air holes must be made and these can easily be constructed by driving in a stake or crowbar at various places. Keep the compost heap moist at all times as a dry heap will not decompose. Conversely don't drown it either, as this prevents a heap from building up a good heat.

5th Method

This is known as the anaerobic method, and for this a large box should be constructed as in *(fig 2)*, consisting of a double compartment with the bottom of each compartment lined with bricks in two double rows which act as air-draughts. The box can be constructed of any old timber or logs and it is a good idea to coat the finished job with a wood preserver or creosote.

Before building the compost heap, begin with a fair amount of twiggy material which will act as a false bottom, thus preventing organic material from blocking up the air draughts. Build up the heap in layers (as in Method 4). When the first box has been filled, start building up in the other compartment and what is most important, cover each finished compartment with black polythene sheeting. This is by far the best method of producing good quality compost.

6th Method

This method utilises specialist activators which can be bought on the market and which are sprinkled on every 6 inch layer of material. These activators are mostly of a chemical origin but there are one or two herbal types and these are to be preferred if possible. The benefit of commercial activators is the speed with which they break down organic matter into rich compost. If you feel lazy and don't mind paying the price, then perhaps this method will suit you.

IN THE USA

SOURCES OF MATERIALS

Untreated seeds are available from the following (write for information):

VITA GREEN FARMS, P.O. Box 878, Vista, Calif. 92803.

DE GIORGI CO., Council Bluffs, Iowa 51501.

NICHOLS GARDEN NURSERY, 1190 N. Pacific Hwy., Albany, Oreg. 97321. *Free price list.*

P. L. ROHRER & BRO., INC., Smoketown, Pa. 17576.

GEO. W. PARK SEED CO., INC., 67 Cokesbury Rd., Greenwood, S.C. 29647. *Free catalogs.*

Compost Activators available from the following (write for information):

BENSON-MACLEAN, Bridgetown, Ind. 47836.

CONSOLIDATED RENDERING CO., Springfield, Mass. 01100, and Boston, Mass., 02100. *Dried sheep manure.*

EARP LABORATORIES, INC., 20 West St., Red Bank, N.J. 07701.

QUAKER LANE PRODUCTS, Box 100, Pittstown, N.J. 08867. *Dried cow manure.*

SCHIFF AGRICULTURAL ENZYMES DIVISION, S. Hackensack, N.J. 07610. *Biorg.*

BIO-DYNAMIC COMPOST STARTER, Threefold

165

Farm, Spring Valley, N.Y. 10978. *Bacteria and enzymes.*
MAEGEO DEHYDRATING CO., Lexington, N.C. 27292. *Dried cow manure, Fertal-Gro.*
WAYSIDE GARDENS, 7 Mentor Ave., Mentor, Ohio 44060. *Dried cow manure.*
HOFFMAN, Landisville, Pa. 17538. *Dried sheep manure.*
ORGANIC COMPOST CORPORATION, Germantown, Wisc. 53022, Tampa, Fla. 33600, and Oxford, Pa. 19363. *Cattle manure, Fertrilife.*

SOCIETIES

Lists of about 200 local organic gardening clubs in the United States and about 20 regional organic farming groups are available free from Rodale Press, 33 E. Minor St., Emmaus, Pa. 18049.

BIBLIOGRAPHY

THE BASIC BOOK OF ORGANIC GARDENING, by Robert Rodale/Ballantine, New York.
THE BASIC BOOK OF VEGETABLE GROWING, by W. E. Shewell-Cooper/Drake, New York.
BOUND TO THE SOIL, by Barbara Kerr/Humanities, New York.
THE COMPLETE BOOK OF COMPOSTING, by J. I. Rodale/Rodale, Emmaus, Pa.
COMPOST: A COSMIC VIEW WITH PRACTICAL SUGGESTIONS, by Carolyn Goldsmith/Harper & Row, New York.
COMPOST: WHAT IT IS, HOW IT IS MADE, WHAT IT DOES, by H. H. Koepf/Biochemical Research Laboratory, Threefold Farm, Spring Valley, N.Y. 10977.
CONTROL OF SOIL FERTILITY, by G. W. Cooke/Hafner, Riverside, N.J.
EVERYTHING YOU WANT TO KNOW ABOUT ORGANIC GARDENING, by G. J. Binding/Pyramid, New York.
HOW TO GROW VEGETABLES AND FRUIT BY THE ORGANIC METHOD, by J. I. Rodale/Rodale, Emmaus, Pa.
THE MULCH BOOK, by Stu Campbell/Garden Way, Charlotte, Vt.
MULCHES FOR YOUR GARDEN, G 185/available free from Publications Division, Office of Communication, Dept. of Agriculture, Washington, D.C. 20250.
NUTRITION AND THE SOIL: THOUGHTS ON FEEDING, by Lionel J. Picton/Devin-Adair, Old Greenwich, Conn.
ORGANIC GARDENING WITHOUT POISONS, by Hamilton Tyler/Van Nostrand Reinhold, New York.
SILENT SPRING, by Rachel Carson/Houghton Mifflin and Fawcett World, New York.

Journals

COMPOST SCIENCE, 33 E. Minor St., Emmaus, Pa. 18049. *Bimonthly, subscription $6. Promotes composting rather than dumping or trashing. Academic, articles based on scientific research.*
ORGANIC GARDENING AND FARMING, 33 E. Minor St., Emmaus, Pa. 18049. *Monthly, subscription $6.85. Articles, book reviews, suppliers' ads. Encourages people to recycle their wastes.*

Companion Plants

THERE EXISTS in the vegetable kingdom, a natural relationship between various plants which is both sympathetic and beneficial, enabling one plant to help another in the process of germination, flowering and bearing fruit. Technically this relationship is known as symbiosis but it is commonly known under the heading of 'companion planting' for the simple reason that some plants act as companions to others. What is even more remarkable is the fact that the whole process can be reversed so that a plant will not grow very well when next to one particular species, but will indeed flourish again when placed next to another variety. This indicates that there is both a repelling and attracting influence between all plants. Different forms of plant interaction have now been discovered and this information can be used to advantage, not only in gardening, but in farming as a whole, to produce higher yields and healthier crops, thus eliminating to a greater extent, the need for excessive feeding and pesticides.

This process is known as Bio-Dynamic farming or gardening and is now being practiced more and more because it really works. So next time you come to plan out the vegetable or flower garden, whether by planting seedlings or sowing seeds, take note of the following list and do yourself and your plants a favour.

APPLE TREES *(Malus)*
Plant chives round the base to prevent scab. Plant nasturtiums round the base to prevent woolly aphis. Potatoes and apple trees repel each other.

ANISE *(Pimpinella anisum)*
Anise and coriander aid each other.

ASPARAGUS *(Asparagus officinalis)*
Plant tomatoes next to asparagus. Parsley also aids asparagus.

BASIL *(Ocimum Basilicum)*
Rue hates basil so plant them well away from each other.

BEANS (*Phaseolus and Vicia*)
Plant carrots next to beans. Other aids are beets, cucumbers, cabbages, leeks, celeriac and corn, but carrots are best, except for early potatoes. Runner beans are suppressed by onions.

BEECH TREES (*Fagus*)

BEETS (*Beta vulgaris*)
Beets grow better if sown alongside dwarf beans, kohlrabi, and onions, but are repelled by beans.
Ferns and beech trees repel each other.

BIRCH TREES (*Betula*)
These trees produce leaves that help kill disease in soils. Always add the leaves to a compost heap as they aid decomposition.

BORAGE (*Borago Officinalis*)
Strawberries and borage aid each other and bees love borage.

CABBAGE (*cauliflowers, broccoli, savoys, kale, Brussel sprouts, kohlrabi*)
All the cabbage family are aided by strongly aromatic plants. Early potatoes are an aid as well. Cabbages and strawberries repel each other, as do cabbages and tomatoes.

CHAMOMILE (*Matricaria Chamomilla*)
Chamomile aids onions and cabbages.

CARRAWAY (*Carum Carui*)
Carraway aids peas but repels fennel.

CARROTS (*Daucus carota*)
Carrots suffer greatly from carrot fly, which is diminished by the presence of leeks, salsify, rosemary, wormwood and sage. Do not store apples near carrots as they turn the carrots bitter.

CAULIFLOWER (*Brassica oleracea*)
Cauliflower is aided by celery.

CELERIAC (*Apium graveolens rapeceum*)
Both scarlet runner beans and leeks aid celariac.

CELERY (*Apium graveolens*)
Dwarf beans, leeks, tomatoes and cabbages aid celery.

CHERRY TREES (*Prunus*)
Potatoes are less prone to blight when grown near cherry trees but wheat is suppressed by this fruit.

CHERVIL (*Anthriscus cerefolium*)
Chervil and radishes are companions.

CHIVES (*Allium schoenoprassum*)
Chives aid carrots.

CORN (*Zea mays*)
Sweet corn aids early potatoes and is aided by peas, beans, dill and cucumbers.

CUCUMBERS (*Cucumis sativus*)
Cucumbers are aided by sweet corn, lettuce, celeriac, radishes, kohlrabi and sunflowers. But don't plant potatoes next to cucumbers.

DANDELION (*Taraxacum Officinale*)
Dandelions inhibit the growth of many plants because they emit ethylene gas.

DEAD NETTLE (*Lamium Album*)
Dead nettle is generally beneficial to most vegetables.

DILL (*Anethum graveolens*)
Dill aids cabbages, lettuce, onions and cucumbers.

ELM TREES (*Ulmus*)
Grapes trained on elm trees bear excellent fruit.

EUPHORBIA (*Euphorbiaceae*)
Euphorbias or 'spurges' as they are commonly known, protect tender plants because of the warmth they stimulate in the soil. One species of spurge, *Euphorbia lactea*, helps repel moles, mice and rats if planted in the vicinity of the animals' territory.

FENNEL (*Foeniculum Vulgare*)
Fennel repels carraway, tomatoes, dwarf beans, kohlrabi, coriander and wormwood.

FERNS (*Pteridophyta*)
Compost made from ferns is beneficial to tree seedlings, except beech (*Fagus*) which it repels.

FLAX (*Linum usitatissimum*)
Flax aids the growth of carrots and helps reduce the possibility of disease in potatoes.

FOXGLOVE (*Digitalis purpurea*)
The cut flowers of foxgloves infused in water and used for the drinking water of other cut flowers will help to prolong their life. Foxgloves also aid the growth of many trees.

FRENCH MARIGOLDS (*Tagetes Patula*)
Marigolds aid tomatoes, roses and most vegetables.

FRUIT TREES
Fruit trees in general are aided by tansy, chives, horseradish, nasturtiums, southernwood and stinging nettles.

GARLIC (*Allium sativum*)
Garlic is a great aid to roses, but repels peas and beans.

GLADIOLI
Gladioli are a strong repellent to peas and beans.

GOOSEBERRY (*Ribes grossularia*)
Gooseberries are aided by tomatoes.

GRAPES (*Vitis*)
Hussop, mustard and elm trees aid grapevines.

GRASS
Grass suppresses the root growth of fruit trees.

HERBS
A great many herbs are beneficial additions to any plot of flowers or vegetables by controlling biologically the diseases and insect pests peculiar to individual flowers or vegetables. Such herbs as basil, borage, chervil, chives, dill, hyssop, lavender, parsley, sage and thyme are just some that are worth planting apart from the fact they are delicious for cookery.

HORSERADISH (*Cochlearia armoracia*)
Horseradish aids potatoes.

HYSSOP (*Hyssopus officinalis*)
Hyssop aids grapevines but repels radishes.

KOHLRABI (*Brassica*)
Kohlrabi is aided by beets and onions but repels tomatoes.

LAVENDER (*Lavendula officinalis*)
A beneficial plant to most vegetables.

LEEKS (*Allium porrum*)
Carrots and celery both love leeks.

LETTUCE (*Lactuca sativa*)
Lettuce is aided by strawberries, carrots and radishes. Lettuce aids onions.

LILY OF THE VALLEY (*Convallaria majalis*)
Lily of the valley repels mignotte and narcissus.

MAPLE (*Acer*)
The leaves of maple are an excellent preservative if stored with apples, potatoes, carrots and other root vegetables during Winter.

MARJORAM (*Origanum*)
Marjoram aids most vegetables.

MINT (*Spearmint, applemint, eau-de Cologne mint, etc.*)
The mint family strongly repel ants, moths and other bugs and insects.

NASTURTIUM (*Tropaelum Majus*)
Nasturtiums aid apple trees, radishes and potatoes and strongly repel many insects and bugs.

OAK (*Quercus*)
The leaves of oak are an excellent repellant of

slugs, snails and other garden pests, if used as a mulch among plants.

ONIONS *(Allium)*
Onions love beets, chamomile, lettuce and carrots but repels peas and beans.

PARSLEY *(Petroselinum Crispum)*
Parsley aids roses and tomatoes.

PEAS *(Pisum)*
Peas are aided by cucumbers, carrots, sweetcorn, radishes, beans and turnips, and especially by potatoes.

PINE *(Pinus)*
Pine needles aid the growth of strawberries and wheat.

POTATO *(Solanum tuberosum)*
Early potatoes love sweetcorn, beans, peas and cabbage. Horse radishes, if only one or two are planted, aid potatoes. Potatoes increase in the likelihood of getting blight when planted near tomatoes, raspberries, cucumbers, cherry trees and sun flowers.

PUMPKINS *(Cucurbita pepo)*
Pumpkins repel potatoes but aid sweet corn.

RADISHES *(Raphanus sativus)*
Radishes aid peas and lettuce but are repelled by hyssop.

RASPBERRY *(Rubus)*
Raspberries repel blackberries.

ROSEMARY *(Rosmarinus Officinalis)*
Rosemary loves sage and aids carrots.

ROSES *(Rosa)*
Roses are aided by parsley, garlic and mignonette. Boxwood suppresses roses.

RUE *(Ruta graveolens)*
Rue repels basil.

SAGE *(Salvia Officinalis)*
Sage aids cabbage, rosemary and most other vegetables.

SAVORY *(Satureia Hortensis)*
Summer savory aids onions and green beans.

SHALLOTS *(Allium ascalonicum)*
Shallots repel peas and beans.

SOUTHERNWOOD *(Artemesia Abrotanum)*
Southernwood aids fruit trees and cabbages.

SPINACH *(Spinacia oleracea)*
Spinach and strawberries love each other.

SPRUCE *(Picea)*
A mulch of spruce needles aid strawberries.

STINGING NETTLE *(Urtica Dioica)*
Stinging nettles make most plants more resistant to disease.

STRAWBERRIES *(Fragaria)*
Strawberries are aided by lettuce, spinach, dwarf beans, borage, pine needles and spruce needles. Cabbage and strawberries repel each other.

SUNFLOWER *(Helianthus annus)*
Sunflowers stunt the growth of potatoes and are inhibited themselves when grown near this root crop. Cucumbers grow well next to sunflowers.

TANSY *(Tanacetum Vulgore)*
Tansy repels many harmful insects.

THYME *(Thymus Vulgaris)*
Thyme is beneficial to most plants in the garden.

TULIP *(Tulipa)*
The growth of wheat is suppressed by tulips.

TOMATOES *(Lycopersicon esculentum)*
Tomatoes aid cabbages, parsley and asparagus. Tomatoes repel apricot trees, gooseberries and lower the resistance of potatoes to blight.

TURNIPS *(Brassica rapa)*
Turnips aid peas.

VALERIAN *(Valeriana Officinalis)*
Valerian is beneficial to most vegetables.

WALLFLOWER *(Cheiranthus)*
Wallflowers aid apple trees.

IN THE USA

SERVICES

Refer to the Services section at the end of the chapter on natural cosmetics.

SOURCES OF MATERIALS

To locate nurseries and garden centers in your area consult your yellow page directory. You can also mail order from the nurseries listed below.

HENRY FIELD SEED AND NURSERY CO., 407 Sycamore Street, Shenandoah, Iowa 51601. *Free catalog.*

FARMER SEED AND NURSERY CO., Faribault, Minn. 55021. *Free color catalog.*

W. ATLEE BURPEE CO., Box 6929, Philadelphia, Pa. 19132. *Free color catalogs twice annually.*

GEO. W. PARK SEED CO., INC., Greenwood, S.C. 29646. *Free color catalogs.*

L.L. OLDS SEED COMPANY, Madison, Wisc. 53701. *Color catalog 15¢.*

BIBLIOGRAPHY

COMPANION PLANTS, by Helen Philbrick and Richard B. Gregg (revised edition)/Devin-Adair, Old Greenwich, Conn.

GARDENING WITHOUT WORK, by Ruth Stout/Devin-Adair, Old Greenwich, Conn.

USING WAYSIDE PLANTS, by Nelson Coon/Hearthside, Great Neck, N.Y.

Drying, Pressing, and Preserving Flowers

Care and patience are all that are needed for this craft as a
hurried, clumsy job can ruin specimens. Almost any flower,
grass, leaf or berry can be preserved in some way and although
we have listed suitable specimens to try out, in some of the
processes you should experiment with whatever you can obtain.

173

Lord what is life : 'Tis like a flower,
That blossoms, and is gone !
We see it flourish for an hour,
With all its beauty on :
But Death comes like a wintry day,
And cuts the pretty flower away.
 ANON

174

PRESSING

You will need the following materials, according to which method you use:

1 Botanical drying paper or blotting paper.
2 Some sheets of glass about 6 inches square to 1 foot square.
3 A bookbinder's press, a cool iron, or book weights etc.
4 Sheets of cardboard.

1st Method

On a piece of cardboard, lay a sheet of the botanical or blotting paper that has been heated gently in an oven. Lay on top of this your specimen taking care to arrange the leaves and flowers in a pleasing way (prune any leaves or stems if necessary). Lay over the specimen another sheet of hot drying paper and finally top the whole lot with a sheet of cardboard. Next, either place the 'sandwich' in a press under gentle pressure, or weight down under some heavy books or other suitable objects. Every day for the next four weeks, remove from the pressure and replace the drying paper with fresh, hot sheets. An expensive but perfect method of pressing flowers.

2nd Method

On a sheet of drying paper, lay out your specimen nicely and cover with another sheet of drying paper. Apply a cool iron and press until most of the moisture has been removed, replacing the sheets of drying paper as it becomes necessary. Finally, put the specimen under pressure between sheets of drying paper and cardboard for 1 week. This method is more suitable for fleshy specimens.

3rd Method

On a sheet of drying paper, lay out your specimen and cover with another sheet of drying paper. Sandwich this between sheets of newspaper and lay the lot under a carpet. Leave it there for six weeks to three months according to the specimen (i.e. more fleshy specimens will need longer to dry out). With this method, leaves, sprays and autumn foliage can be suitably pressed.

4th Method

On a sheet of drying paper, lay out your specimen and then carefully lay on top a sheet of glass. With this method, you can see just how the specimen will look after pressing, and final alterations can be made before finally covering with newspaper and putting in the press, or under a weight of books. This method takes about 6–8 weeks to dry according to the fleshiness of the specimen.

Almost any specimen can be dried and pressed with one of the above methods. When pressing leaves, remember to use only mature specimens otherwise blistering can occur.

DRYING

Most people have a reasonable access to a piece of countryside and even on grass verges by roadsides or on building sites, plenty of material can be found. When out on your travels, look out for the following :

FLOWERS (WILD)	FRUIT & CATKINS
Bullrush	Alder
Carraway	Ash
Chervil	Beech
Cow Parsnip	Crab Apple
Dill	Dogrose
Hogweed	Hawthorn
Lovage	Hazel
Masterwort	Juniper
Ribwort Plantain	Larch
Rosebay	Maple
Saxifrage	Mistletoe
Sweet Cicely	Oak
Tansy	Pine
Teasle	Snowberry
Thistle	Silver Birch
Travellers Joy	Woody Nightshade
Yarrow	

FOLIAGE
Grasses and Sedges
Ferns
Maple
Beech

Most of this material will have dried naturally so will be ready to use, but should any further drying be necessary, simply stand in a jar in a warm room for a few weeks. Berries may be varnished when completely dry.

1st Method

This is for drying flowerheads. Flowers should be bunched together and tied at the stems, using no more than half a dozen flowerheads per bunch. Hang each bunch upside down in a cool, dark place such as a cellar or shed. Always keep out of sunlight and prevent the bunches from getting damp.

The only special treatment necessary applies to Hydrangea flower heads. Wait until the flowers have begun to 'flush' in the Autumn whilst still on the plant before attempting to cut them for indoor use. The flowers should then be placed upright in a vase containing a 2-inch depth of water and when all this water has been used up, they should then be left to dry naturally.

The following cultivated flowers are well suited for drying purposes:

Acroclinium	Eryngium
Achilea	Helichrysum
Amaranthus	Solidago
Astilbe	Monkshood
Anaphalis	Stachys Lanata
Delphinium	Rhodanthe
Echinops	Stachys

2nd Method

This is for drying grasses, rushes, sedges and ferns. With some of these, nature drys them out naturally but if further drying is necessary, hang them up in small bunches as with the flower heads. A good point to remember is to try and pick specimens of grass when the stamens are just beginning to appear at the bottom of the spike. Never pick anything on a wet or damp day or when there has been a heavy dew.

The following is just a few names of the many grasses, rushes, sedges, etc., to be found growing in most areas quite commonly:

GRASSES	SEDGES
Cats Tail	Moor Sedge
Crested Hair Grass	Bottle Sedge
Crested Dogs Tail	Pond Sedge
Common Couch	Drooping Sedge
Common Cord Grass	Common Sedge
Meadow Fescue	
Ratstail Fescue	FERNS
Cocksfoot	Bracken
Purple Moor Grass	Hard Fern
Heath Grass	Harts Tongue
Giant Fescue	Black Spleenwort
Red Fescue	Common Spleenwort
Quaking Grass	Male Fern
Wood Melick	Lady Fern
Hairy Brome	Common Poly-pody
Bearded Couch	
Wild Oat	
Meadow Oat	
White Bent.	

PRESERVING

Sometimes, a very fleshy specimen will not press or dry successfully and so artificial preserving is the answer. However, these three following methods can be used to preserve almost anything.

1st Method (GLYCERINE)

This method is more suited to evergreen foliage with shiny leaves such as laurel, holly, rhododendron etc. Glycerine has an unusual effect on specimens for, after treatment, those stored in the dark will have a different colour from those left in the light. In this way, a whole range of colours can be achieved.

Specimens must be chosen from plants which are fully mature—never use any damaged, blotched or diseased leaves. Dilute the glycerine in hot water at the rate of two parts of water to one part glycerine. Crush the end of the stems of the specimens and after standing them overnight in water, put them upright in a vase of the cold glycerine mixture. The length of time needed for this process to complete will vary considerably as some leaves such as Beech will take nearly a month, whilst Rhododendron and Holly will only take about four days. The sign to watch out for is when the glycerine can be seen clearly in the veins of the leaves. Then the whole specimen should be removed from the mixture and allowed to dry for a few days in a cool, dark place.

The following plants can be preserved in this way:

Berberis	Laurel
Beech	Lime
Box	Camellia
Cotoneaster	Mahonia
Choisya	Magnolia
Eucalyptus	Pear
Holly	Rhododendron
Oak	Sweet Chestnut

2nd Method (BORAX)

This method is more suited to fleshy specimens and those with delicate petals. A quantity of powdered borax and an airtight box will be needed. Put a good quantity of the borax in the bottom of the box and then lay the specimen in the powder, making sure that it is thoroughly covered, especially the petals. Shut the box

tightly and leave it for about 3–4 weeks. Then the specimen should be removed and all the excess borax carefully blown off it.

3rd Method (SILICA GEL)

This method is used in exactly the same way as with borax, except that more care must be taken to keep it from the light. This process takes only about two weeks to complete.

Both borax and silica gel will need sifting after use to prevent lumping.

Dyeing Specimens

Should you wish to colour seedheads, grasses and ferns etc. after they have been dried, then there are a number of ways of doing so. The easiest and by far the cheapest, is to use a fabric dye such as a Dylon cold-water dye, or Procion M dye. In both cases, these dyes are cold-water dyes—never use a hot-water dye otherwise you will absolutely ruin the specimens. The flowerheads or grasses must be tied in small bunches and left submerged in the dye for a couple of hours but before plunging them into the dye bath, soak the specimens thoroughly for 12 hours as this helps the dye to penetrate into the fibres. After dyeing, the bunches should be hung up to dry somewhere warm.

Another way to colour specimens is to dip them in paint and good effects can be had from using both oil- and water-bound paints. Try using lacquers, emulsion, gloss and varnish as well. Some wood stains can also give pleasing colours. Apart from dipping in paint, brushing the paint on is a good way and much more economical, but more care must be taken.

The recipe for Procion dye will be found on p. 66. For dyeing with vegetable dyes, use the method described at the end of the basketry chapter (see p. 108).

Other Uses

There is a definite craft in mounting wild flowers, leaves and grasses under glass and then framing them to form a picture. It would take time to give a detailed plan on how to do this but here are a few rules which can be remembered as well as a couple of ways to mount the specimens:

1 Always allow a reasonable space around the arrangement otherwise the finished picture

may look out of proportion.

2 Dried flowers have delicate colours so avoid mounting them on lurid, bright-coloured card. White and black are the most successful 'colours', but experiment with dark greens, dark blues and other sombre colours.

3 Use the tiniest amount of glue to stick specimens to the mount and always use a clear glue such as Bostik. The glueing is the hardest part of the whole process so be very, very careful as delicate wild flowers fall to bits in clumsy hands.

4 Choose a simple frame and avoid heavy or pompous frames as these will kill the delicacy of the mounted specimens.

As well as mounting under glass, specimens can be glued to card and then covered with a layer of clear self-adhesive cellophane or plastic such as Transpaseal or Fablon. This method of mounting is ideal for making use of specimens when constructing greetings cards, as the clear plastic coating gives perfect protection from handling.

IN THE USA
SOURCES OF MATERIALS

Unless bookbinding is being considered as well, buying a book press is an expensive business as books themselves are just as effective for pressing botanical specimens.

Botanical blotting paper for pressing flowers should be available in your local crafts shop. If not, try using paper towels or mail order from: DICK BLICK CO., P.O. Box 1267, Galesburg, Ill. 61401. 15¢ a sheet.

Silica Gel should also be available through your local crafts source, but if not, you can mail order from:
AMERICAN HANDICRAFTS, 508 6 Ave., New York, N.Y. 10011. (Saul) Or look for one of the store's 300 branches.
ADVENTURES IN CRAFTS, 218 E. 81 St., New York, N.Y. 10028. (Dee Davis)
CASWELL-MASSEY CO., LTD., 518 Lexington Ave., New York, N.Y. 10017.

To obtain various dyes used in coloring flowers and ferns, look at the mail order outlets

for Procion M dyes listed at the end of the chapter on dyeing.

BIBLIOGRAPHY

THE ART OF DRYING PLANTS AND FLOWERS, by Mabel Squires/Garden Way, Charlotte, Vt.
DRIED FLOWER ARRANGEMENT, by Edwin Rohrer/Van Nostrand Reinhold, New York.
THE DRIED-FLOWER BOOK, by Nita C. Carico and Jane C. Guynn/Doubleday, New York.
DRIED FLOWERS: THE ART OF PRESERVING AND ARRANGING, by Nina De Yarburgh-Bateson/Scribner's, New York.
DRIED FLOWERS FOR DECORATION, by Violet Stevenson/Drake, New York.
ENCYCLOPEDIA OF FLOWER ARRANGING, by Shelia MacQueen/International Publications Service, New York.
GETTING STARTED IN DRIED FLOWER CRAFT, by Barbara A. Amlick/Bruce (Macmillan), Riverside, N. J.
PRESSED FLOWER COLLAGES AND OTHER IDEAS, by Pamela McDowall/Scribner's, New York.
PRESSED FLOWER PICTURES: A VICTORIAN ART REVIVED, by Pamela McDowall/Scribner's, New York.

Leaf Lace

The best sort of leaves to skeletonise are those that are evergreen, i.e. holly, laurel, mahonia and rhododendron, but any thick, veiny leaves will do: magnolia, for instance, skeletonises beautifully.

There are two ways to remove the fleshy tissue from a leaf. One is to put it in a saucepan with a handful of washing soda, cover it with water and after bringing it to the boil, allow it to stand for about $1\frac{1}{2}$ hours. The second way is to mix together 4 tablespoonfuls of caustic soda and $\frac{1}{2}$ pint sodium hypochlorite with one pint of water and bring to the boil. Drop in the leaf and simmer until the leaf is limp whereupon it should be removed by first running cold water into the pot to displace the soda solution (don't put your hands in it).

With both of these methods, the leaf, after boiling, must then be gently scraped with a tooth-brush to remove the tissue. Great care is paramount because the leaf veins are very delicate. When all the tissue has been removed, place the skeleton between two layers of blotting paper to dry. If a light-coloured skeleton is desired, it can be dropped into a solution of domestic bleach overnight and then thoroughly rinsed and dried.

177

posies, petals, & pot-pourris.

This gripping scent is theme and subject,
Whereas—however well they look—
The flowerbeds, the lawn, the garden,
Are but the cover of a book.
FROM 'JULY', BY PASTERNAK

There may have been many occasions when you wished that you could bring indoors the smells of the countryside and garden; new-mown hay and the smell of the fields, or the sweet perfumes of the herbery and herbacious border, and keep these smells with you into winter. Well, to a certain extent, you can do this if the flowers and leaves of your choice are preserved in a potpourri or sachet. Many ancient peoples knew how to do this with their incense and perfumes, and there has always been a need for sweet odours in the home, especially so today. In some cases, the scents of certain flowers will help repel insects, while others help to ward off mould and other bacteria which might well destroy books and clothing.

There are two ways to use these flower mixtures. In the first case, a potpourri, is normally a varying mixture of spices, herbs and dried leaves and flowers and is left in open bowls around the house so that its sweet odours fill the room or rooms. In the second case, a sachet, is normally either one special herb or flower, e.g. lavender, or a special mixture, which is packed into a muslin bag and then left in clothes drawers, under pillows, in book cases and to scent bed linen or repel insects etc.

MATERIALS

Apart from the flowers or leaves chosen to dominate the general odour of a mixture, other types of botanicals will be needed as 'fixatives' which help prolong the life of a mixture. A general list is now shown of all the common fixatives available, as well as other botanicals which may be included to add colour to a mixture.
Allspice: Used as a fixative for spicy mixtures.
Ambrosia: Use the herbal scented leaves only as a blending influence in a mixture.
Bachelor's Buttons: Use the flowers as a colourful additive to a mixture.
Balsam of Peru: Use as a fixative.
Balsam of Tolu: Use as a fixative.
Basil: Use the leaves of common basil in mixtures to give a spicy scent. Purple basil is a good colour additive.

Bay: Use the leaves to give a 'carnation' aroma to mixtures.
Black Malva: Use the deep purple flowers as a colour additive.
Borax: Use as a fixative.
Cardomon: Use the whole seeds as a spicy, fragrant addition to mixtures.
Calamus: This root has many uses. It is most commonly used as a fixative for prolonging the strengths of other botanicals, but is equally good as an insect repellant.
Calendula: Use the flowers as a colour additive.
Carraway: Use the seeds as a spicy ingredient in mixtures.
Cedarwood Chips: Cedarwood has a strong aroma so care must be taken that it does not overpower more delicate scents. A good fixative and an equally good repellant.
Cloves: One of our strongest fragrant spices and a good fixative.
Coriander: Use the seeds as a spicy ingredient to mixtures.
Cinnamon: Use as a fixative. Commonly used in rose potpourris.
Costmary: Use the leaves in mixtures. Gives linen a pleasant smell if used in a sachet.
Gum Benzoin: A common fixative usually applied at the rate of 1 oz of gum to 2 quarts of flowers.
Gum Storax: A common fixative used at the same rate as gum benzoin. Both these gums are better if finely ground.
German Rue: A lovely addition to any mixture.
Hollyhock: Use the flowers to colour mixtures.
Lavender: Best if used on its own in sachets for scenting linen etc., or used with discretion in mixtures.
Lemon Geranium: Use the leaves or dried stems in mixtures and sachets for scenting linen.
Lemon Fruit: Use the dried peel as a fixative.
Lemon Verbena: A sweet fragrance that must be used with subtlety in mixtures.
Mace: A spicy smell for a spicy mixture.
Marjoram: A herbal scent very useful in a herb-dominant mixture.
Mint (*Eau de Cologne, Apple, Orange, Spearmint*) : All the mints are very strong and care

178

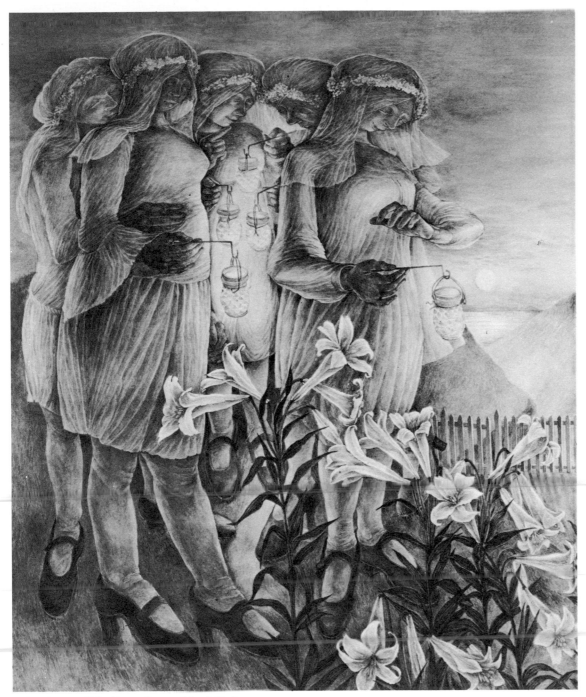

'The Approach' by Betty Swanwick, A.R.A.

179

must be taken when adding them to any mixture.

Nutmeg: A spicy addition to a mixture.

Oils *(i.e. Oil of Bergamot, Oil of Lavender, Oil of Eucalyptus)* : Use these oils very sparingly as fixatives.

Orange Fruit: Use the dried peel as a fixative.

Orris: Use the root as a fixative. Thoroughly recommended as its fragrance improves with age.

Patchouli: Another powerful fragrance. Use the leaves with discretion.

Rose: The most popular and perhaps the most beautiful addition to any mixture. The best aromas come from the Damask and Old English roses such as: Ispahan, Omar Khayyam, Belle Amour, Hebes Lip, Boule de Neige, Madame Isaac Pereire, Celestial, Zephirine Drouhin, Ruskin, Moss Salet, Musk Buff Beauty and Alba Celestial.

Rose Geranium: A wonderfully delicate fragrance which goes well with other geraniums and lemon verbena.

Rosemary: Use the leaves in herbal mixtures. It also goes well with Rue.

Sage: Use the leaves in herbal mixtures.

Sandalwood: The wood chips are best used as a fixative for rose mixtures.

Southernwood: Use on its own in sachets as a good moth repellent and for scenting sheets and line, or as an additive to mixtures.

Sweet Fern: Use the leaves in mixtures to give a pine-type fragrance.

Sweet Melilot: Can be used alone in sachets or the vanilla-fragrant flowers can be in pot-pourri mixtures.

Tangerine Fruit: Use the dried peel as a fixative.

Woodruff: A lovely fragrance, reminiscent of new-mown hay. Use on its own in sachets or in mixtures.

Winter Savoury: A good insect repellant, especially against fleas. Use in sachets for the bedding of pet dogs and cats etc.

Wormwood: A good moth repellent. Use alone in sachets or as an additive to mixtures.

Vetiver: Use the root as a fixative.

HARVESTING THE BLOSSOM AND LEAVES

As a general rule, never pick bruised, damaged or infected flowers and leaves as this will almost certainly ruin a mixture. Flowers are best picked just before their peak of opening. The day must be dry, and always try to collect material about mid-morning, when the sun has dried up the dew. Never pick anything in the afternoon as the strength of the fragrance will have begun to diminish.

Drying off the blossom and leaves is important too. Lay the leaves or blossom in single layers on sheets of paper in a cool, dry place; turning every day for 2–3 weeks until they are perfectly dry. Avoid piling them in heaps as this will brown and rot blossom and leaves alike.

RECIPES

Pot Pourris

We will give some standard recipes but you can experiment yourself with your own favourite ingredients. Apart from the ingredients mentioned, you will need a number of wide-necked glass or earthenware jars (never use plastic containers).

Several pounds of coarse salt are also needed, but cooking salt is just as good except that it is more expensive. Incidentally, all the jars must have air-tight lids.

ROSE POT POURRI Damask rose petals are best, but pick what you will. Put 2-inch layers with a light covering of salt in a glass or earthenware jar until it is absolutely full and then tightly cover it with the lid. Store it in a cool dark place for one week. After storing, empty the mixture out on to a big sheet of paper and loosen all the petals from the salt into a bowl. Mix together the following ingredients:

1 oz orris root (ground or at least finely crushed); $\frac{1}{2}$ teaspoon ground cloves; $\frac{1}{2}$ teaspoon ground cinnamon; $\frac{1}{2}$ teaspoon ground mace; 6 drops Oil of Geranium; 20 drops Oil of Eucalyptus; 10 drops Oil of Bergamot.

Add the petals to this mixture, thoroughly mix and return all of it to the jar. Cover it tightly and store it for 2 weeks before using.

ANOTHER ROSE POT POURRI Put an equal quantity of rose and lavender blossom in a large bowl and add $\frac{1}{2}$ lb ground orris root. To every 2 lb of this mixture add 2 oz each of crushed cloves, ground cinnamon, ground allspice and lemon peel. Mix thoroughly and then it is ready for use.

OLD ENGLISH POT POURRI Mix in a bowl, equal amounts of rose petals, lemon verbena leaves, geranium leaves and any other flowers or leaves of your choice. To every 1 lb of this mixture, add $\frac{1}{4}$ lb salt, $\frac{1}{4}$ lb Barbados Sugar, and $\frac{1}{2}$ oz each of ground orris root, cinnamon, cloves, gum storax and gum benzoin. Put the whole, thoroughly-amalgamated mixture in to a jar and store it with the lid off for a week, stirring every day. After this, pour it into a bowl for use.

ANOTHER OLD ENGLISH POT POURRI Take two bowls. In one put flower petals of your choice with an equal amount of mixed rose and lavender blossom. In the other bowl, mix together 4 oz ground orris root, 4 oz gum benzoin, 2 oz ground cinnamon, 2 oz whole cloves, 1 oz cardomon seeds and 6 lb of coarse salt. Next, fill each glass or earthenware jar with alternate 1-inch layers of mixture No. 1 and mixture No. 2 until full. Compress each layer down firmly with a flat piece of wood. Fasten the lids tightly and leave the mixture to mature for 3 months by which time the pot pourri should be ready for use.

A SPICY POT POURRI Mix together in a bowl $\frac{1}{2}$ oz each of cloves, ground cinnamon, ground nutmeg, allspice, borax and ground orris root. Add 1 lb of salt and a handful of either orange, tangerine or lemon peel. Thoroughly mix and the pot pourri is then ready for use.

Sachets

Almost anything will be O.K. on its own in a sachet, but more common ones generally contain eau-de-cologne mint, spearmint, lavender or woodruff.

LAVENDER SACHET The whole flowerhead plus about 1 foot of the stem must be cut from the plant and bunches tied together at the stems

and hung upside down, should be stored in a cool dark place until absolutely dry. The flowerheads when nice and brittle, can then be broken off the stems and packed into muslin bags, ready for use.

The following two recipes are for special sachets:

VIOLET SACHET Mix together 4 lb wheat starch, 1 lb ground orris root, 1 drachm oil of cloves and 1 drachm oil of bergamot. Mix thoroughly and fill muslin bags with the mixture, carefully sealing them. This mixture will strongly resemble the perfume of violets, especially if attar of lemon is added.

ROSE SACHET Mix together 1 lb rose petals, ½ teaspoonful of rose oil, ½ lb sandalwood chips, and 3 oz of rose geranium leaves. Fill muslin bags with this mixture as above.

Oil Extraction

The oils of various botanicals can be obtained either from a chemist or a good herbalist, but if you would like to extract them yourself, the following method is a good one.

Obtain a fair amount of cotton tissue or wadding from a chemist. Saturate the wadding with olive oil and cut it up into 1 foot-square pieces. Take a metal or glass tray and place on it one of the saturated pieces of wadding. Sprinkle on top a layer of whatever botanical you intend extracting the aroma from, and on top of this place another piece of saturated wadding. Go on like this, layer by layer until you have used up all the flowers or leaves. The oil-sodden wadding will then soak up the odour of the botanicals. Ideally, the flowers or leaves should be replaced with fresh ones each day but this may be impossible. After three days, press the oil from the wadding and store it in covered bottles until ready for use.

Pomanders

These are oranges impregnated with whole cloves and lightly dusted with cinnamon orris root or allspice and are generally used to scent clothes in wardrobes and linen etc. They are very easy to make, cheap to produce and can either be left as they are, or encased in a decorative pottery shell.

Materials

You will need some good-sized oranges, a fair quantity of whole cloves, some ground cinnamon, ground orris root or ground allspice, a roll of ¼ inch wide Sellotape, some lengths of coloured ribbon, a bradawl, a small screwdriver or some other pointed instrument, and a roll of silver paper.

METHOD

Leave the oranges to dry and thus dehydrate for a couple of weeks. Next, put a band of Sellotape round the middle of each orange (this is to mark the place where you will secure and tie the ribbons to hang the finished pomanders by). Then, making holes about ⅛ inch to ¼ inch apart, pierce the surface of each orange with the bradawl or screwdriver, leaving the Sellotape band untouched. The distance between each hole must be such that when the cloves are pressed into them, there should be a very small space between each clove to allow for further shrinkage of the orange. When all the oranges have been impregnated with cloves so that only the Sellotape band remains showing, lightly dust the orange with cinnamon or the spice of your choice, and wrap up each one in silver paper. Store them in a dry place for about 6–8 weeks. Finally, remove the pomanders from their silver paper and tie round each a length of pretty ribbon and finish it in a bow.

The clay shells mentioned earlier, should be made in two halves. After firing, they should be glued together with a pomander inside. Each clay ball must have a number of holes about ¼ inch in diameter to allow the aroma to escape. Decorate them as you wish.

IN THE USA

SOURCES OF MATERIALS

You can grow many of the herbs yourself, in a garden or even a window box. The ingredients may also be obtained locally or ordered from the garden centers and nurseries listed at the end of the chapter on natural cosmetics.
THE HERBARY AND POTPOURRI SHOP, P.O. Box 543, Orleans, Mass. 02653. *Sells dried herb seasonings as well as culinary herbs and seeds for planting. Among other items available are pomander kits. Free brochure.*
CASWELL-MASSEY CO. LTD., 518 Lexington Avenue, New York, N. Y. 10017. *Stocks various oils and extracts. Free catalog.*
HERBARIUM, INC., Route 2, Box 620, Kenosha, Wisc. 53140. *An herbal outlet for botanical drugs and spices. Write for information.*

BIBLIOGRAPHY

COUNTRY CRAFTS, by Valerie Janitch/Viking, New York.
THE HERBALIST, by Joseph E. Meyer (rev. ed.)/Sterling, New York.

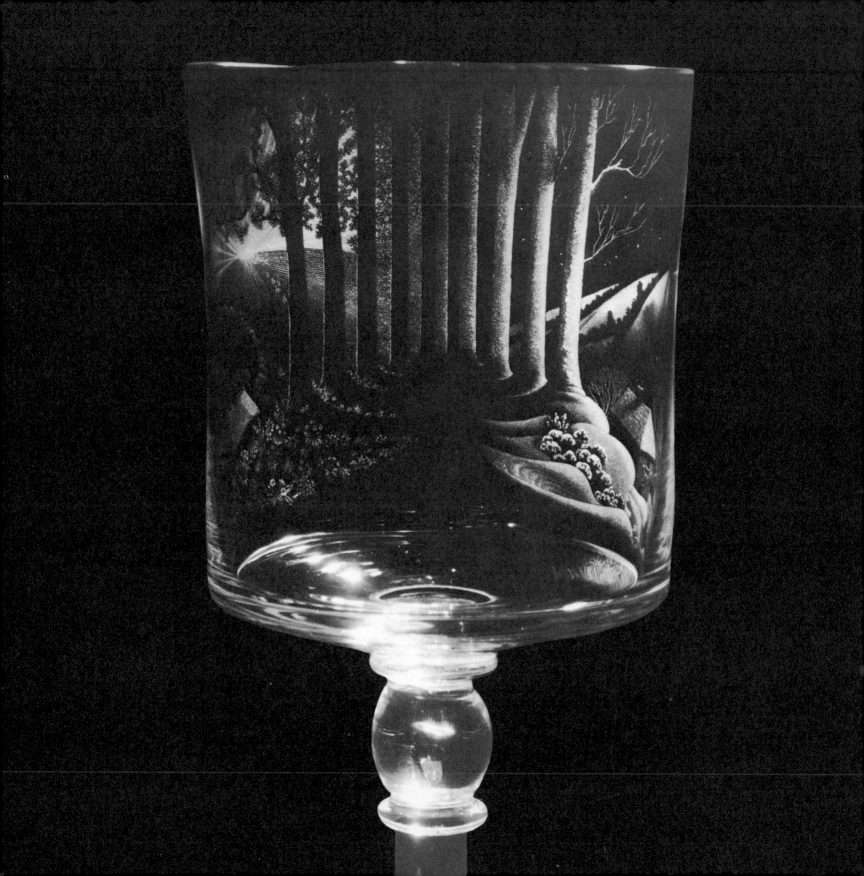

Wayside Wines and Other Delights

ALTHOUGH WRITERS ABOUT wine have involved themselves in a lot of pomp and circumstance, the basic processes involved are simple and whether expensive wine-making equipment, or second-hand make-do material is used, the fundamentals of the art are the same. Wine can be made from virtually anything edible growing in the field, wayside or garden: from the leaves, stems, flowers, fruit or roots of wild and cultivated plants so that the range of wine available, given a good cross-section of recipes, is almost infinite. By keeping to, and sticking to, one or two important rules, subtle and beautiful wines can be made at all times of the year so that a continuous stock is available for use.

Terminology and processes

CLARIFIERS

Sometimes a wine will remain cloudy even after a number of strainings so that a '*clarifier*' has to be added to induce the floating particles to sink to the bottom of the jar or bottle so that the clear liquor can be strained off. There are a number of clarifiers good for this purpose:

(a) EGGWHITES

One white of an egg beaten into a pint of new wine and well dissolved should be added to the main stock of liquor at the rate of one eggwhite to every 15–20 gallons.

(b) EGG SHELLS

The shells must first be baked in a slow oven until they are brittle and then crumbled into a fine dust. To each bottle of new wine, one good pinch is added which should be sufficient to clear the cloudiest wine.

(c) ISINGLASS

Isinglass can be obtained from any chemist. Only one quarter of an ounce must be used to every 10 gallons of liquor as too much isinglass can have a detrimental effect on the wine. The isinglass should first be dissolved in a little warm wine and then added to the main stock.

With both eggshells, eggwhites and isinglass, the effect on the wine does not alter the taste.

(d) SUGAR CANDY

Add a small piece to each bottle but allow for the extra sweetness when working out the sugar content for a sweet, medium, or dry wine.

(e) PECTIC ENZYME

This is used generally for fruit wines such as apple, pear, plum and cherry which are difficult to clear after the fermenting process. A teaspoonful of pectic enzyme should be added to each gallon of liquor at the onset of fermenting.

Fermenting

This is simply the action of the yeast on the prepared liquor or '*must*'. During this process, the yeast feeds on the sugar and gives off carbon dioxide which rises up in bubbles to the surface of the liquid. It also gives off alcohol. The ratio of carbon dioxide to alcohol is roughly 50–50.

Flavouring

This comes from the plants or parts of edible plants that form the flavour of the wine. A more detailed analysis follows later on in the chapter.

Lees

This is the sediment that forms at the bottom of the jars during fermentation.

Must

The '*must*' is the prepared liquid which ferments and contains the flavouring, water, and possibly a clarifier. Sugar and yeast are added to the must later.

Nutrient

A yeast nutrient is added to a wine to boost the action of the yeast where the liquor may have a deficiency in trace elements, especially acid. To overcome this, a whole lemon's juice should be added during the fermentation process.

Racking

By '*racking*' is meant the syphoning off clear wine from the lees. All wines should be racked *at least* twice before use.

Sugar

The amount of sugar per gallon of liquid determines the sweetness of a wine, i.e. sweet, medium or dry. As a general rule, 2 lb of sugar per gallon will produce a dry wine and 3–3½ lb of sugar per gallon will produce a sweet wine.

Yeast

Yeast is a tiny plant organism which feeds off the sugar content in the wine. The yeast feeds until the sugar content is exhausted, or, until there has been so much alcohol produced that the yeast is then killed. In dry wines the yeast has exhausted the sugar supply and in sweet wines the yeast has been killed off by a high alcohol content.

There are a number of yeasts available that are used for the fermentation process. Most are easily obtained from bakers, health food shops or wine-making specialists. The basic types are:

(1) BAKER'S YEAST:
Use only fresh baker's yeast as it tends to deteriorate quickly. This is a fast-acting yeast and is generally the cheapest.

(2) DRIED YEAST:
Available from health food shops and some grocery shops. With dried yeast, there is the advantage of it not 'going off' as it keeps for ages.

(3) WINE YEAST:
There are now a number of special wine yeasts available which have been specially cultivated for the fermenting of specific wines. For instance, there are champagne yeasts, sherry yeasts and so on. There is also an all-purpose wine yeast which is suitable for making most wines. With all these special yeasts, the instructions (which are usually on the pack) *must* be followed carefully.

(4) NO-YEAST RECIPES:
Some fruit wines such as plum or apple may be made without the addition of a prepared yeast to the must because there may be wild yeast on the skins of the fruit. Using a no-yeast recipe is strictly a hit-and-miss business because some strains of wild yeast are of poor quality and will produce a low alcohol content. If one of these recipes is being used, then the fruit *must* be absolutely fresh, i.e. picked and prepared the same day. Also, as wild yeasts tend to grow only on fruit, then only fruit wines can be made this way.

Water
For most recipes the water must be lukewarm for the yeast to work properly, with an ideal temperature of 65°–75°F. This temperature must be kept constant during the fermenting process.

Equipment essential for the job (see diagram)
(1) Large, deep bowls or plastic pails for holding the must.
(2) Glass or polythene funnels in two sizes: 5 inch for fermentation jars and 2½ inch for bottles.
(3) Fermentation jars. These are special jars obtainable from wine suppliers with a special airlock or fermentation trap fitted in the neck. Although one can improvise with empty cider flagons and use three layers of cotton material tightly tied over the necks as a substitute for an airlock, it is well worth obtaining the proper equipment because it helps to keep out harmful bacteria that can ruin a good wine.
(4) A measuring jug.
(5) A plastic strainer of a good-quality fine muslin.
(6) Three feet of rubber or plastic ½-inch tubing for racking purposes.
(7) A large saucepan for boiling the flavouring if necessary.
(8) New corks and foil caps.
(9) A good quantity of wine bottles of varying sizes up to 1 gallon capacity.

The Basic Process of Producing a Standard Wine
(1) The flavouring, whether it be fruits, nuts, berries, roots, leaves or flowers must first be crushed, pressed, boiled or soaked to extract the flavour.
(2) Water is added to the flavouring in a plastic pail (never use metalware for wine making) and if necessary, the pectic enzyme should be added as well. Stir thoroughly and cover tightly with a lid. Keep the must warm.
(3) The sugar and yeast should be added to the lukewarm must. If bakers yeast is being used, it should first be creamed with some of the warm must. Generally, one heaped teaspoon per gallon is a good guide for an all-purpose yeast. Stir the whole contents of the must thoroughly and leave for three days to 'short' ferment. Keep the air out by keeping a lid on the bowl or pail.
(4) On the 4th day, the must should be strained through muslin into the fermentation jars by means of a large funnel. If necessary, add a clarifier at this stage. Never fill the jar right to the brim but allow an inch of air below the air lock or cloth covering.
(5) Topping up. Always keep some of the must back to top up the level of liquor as during the second or 'long' fermentation process, the level will decrease.
(6) The wine should be left in the fermentation jar until the fermenting of the must has finished. The best way to determine this if an airlock is being used, is to listen out for any hissing or 'singing', i.e. the escaping of carbon dioxide gas. While hissing is to be heard, the fermenting process is still going on. Another way of testing is to look out for the carbon dioxide bubbles rising to the surface. When no more bubbles can be seen, the fermentation is over.
(7) Racking. Immediately following fermentation, the new wine must be syphoned off from the lees into clean sterilized wine bottles. The best way to do this is to place the fermentation jar on a table and using the length of rubber or plastic tube, draw the liquid (by sucking) into 1 gallon wine bottles placed on the floor or lower level. If the wine still appears cloudy after syphoning, then add a clarifier to each bottle. Leave the wine in a cool place, firmly corked, for three months.
(8) Second racking. After three months, repeat the syphoning process and this time syphon into sterilized wine bottles firmly corked.
(9) Leave for another three months and rack a third time and then bottle for use. The corks must be brand new and firmly inserted into the bottles by using a wooden mallet or similar tool. Corks are more easily inserted if they are first soaked in cold water for a few hours and then dipped into boiling water immediately prior to use. Incidentally, a good way to drive a cork firmly home is to push the bottle firmly against a hard surface like a wall, twisting it as you push.
(10) Store the bottles on their sides for 4–6 months at least before use. Remember to label each bottle with the name of the wine and any other details such as the date of bottling etc.

Some Important Points to Remember
(1) Cleanliness is essential. Sterilize all equipment such as corks, bottles, pails and jars before use, otherwise harmful bacteria may affect the wine. Boiling water is the best medium for sterilizing.
(2) All fruit and flowers etc. must be harvested on a warm sunny day and pick only perfect fruit and undamaged flowers and leaves.
(3) In the first days of fermenting it is essential that air is kept out of the pail or bowl by covering firmly with a lid.

(4) Never use metalware in any part of a wine-making process.
(5) Always use brand new corks and undamaged wine bottles.
(6) Never bottle wine that is still heavily fermenting (see later).
(7) Rack all wines at least twice and preferably three times.
(8) Keep wines stored for at least 4–6 months before use after corking.
(9) Don't use too much sugar in a recipe.
(10) Don't ferment a small amount of wine in a large jar as the air may ruin the wine.

APPLES
Wash and boil the fruit before preparing the must, mashing well. Pectic enzyme will probably need to be added. Don't forget to remove the apple stalks.

BILBERRIES
Simply squeeze and mash, adding pectic enzyme.

BLACKBERRIES
Squeeze the fruit by hand.

BLACKTHORN (Sloes)
Mash thoroughly.

BLUEBERRIES
Mash and add pectic enzyme.

COWSLIP FLOWERS
The green parts of the flowers, the 'receptacles', should be removed. Generally, cowslip wine improves with the addition of the juice and rind of an orange or two.

ELDER FLOWERS
The florets must be first removed from the heads before preparing a must.

FENNEL
Fennel wine needs the flavouring of beetroot juice to bring out its flavour. To each handful of fennel, 3 lb of beetroot is needed. The beetroot must first be sliced and boiled in $1\frac{1}{2}$ gallons of water, strained and mixed with the sugar and then poured on to the fennel to make the must.

HAWTHORN BERRIES
The hard berries must be thoroughly mashed. A mallet is useful for this purpose.

MAY BLOSSOM
Remove all twigs and foreign bits before adding to the must.

NETTLES
The addition of root ginger improves a nettle wine.

Flavourings
Here are a few tips concerning some flavourings that are commonly used. When using wild fruit and flowers be careful to avoid poisonous species. A complete guide to wild flavourings is featured on the following page.

185

PRIMROSE FLOWERS
Should be treated like cowslips by removing the green parts of the flowers. The addition of the rind of an orange or two will greatly enhance the quality of primrose wine.

A Guide to Possible Wild Flavourings: Fruit

BARBERRY *(Berberis vulgaris)*
BILBERRY *(Vaccinium myrtillus)*
BLACKBERRY *(Rubus fruiticosus)*
BLACKCURRANT *(Ribes nigram)*
BIRD CHERRY *(Prunus padus)*
BLACK BULLACE *(Prunus domestica)*
CHERRY PLUM *(Prunus cerasifera)*
CLOUDBERRY *(Rubus chamaemorus)*
COWBERRY *(Vaccinium vitis)*
CRANBERRY *(Vaccinium oxycoccus)*
CROWBERRY *(Empetrum nigrum)*
CRAB APPLE *(Malus sylvestris)*
DEWBERRY *(Rubus caesius)*
ELDER *(Sambucus nigra)*
GOOSEBERRY *(Ribes uva-crispa)*
GUELDER *(Viburnum opulus)*
HAWTHORN *(Crataegus monogyna)*
JUNEBERRY *(Amelanchier intermedia)*
JUNIPER *(Juniperus communis)*
MEDLAR *(Mespilus germanica)*
OREGON GRAPE *(Mahonia aquifolium)*
PEAR *(Pyrus communis)*
RED CURRANT *(Ribes rubrum)*
RASPBERRY *(Rubus idaes)*
ROWAN *(Sorbus aucuparia)*
ROSE-HIP *(Rosa canina)*
SLOE *(Prunus spinosa)*
STRAWBERRY TREE *(Arbutus unedo)*
WHITEBEAM *(Sorbus aria)*
WILD SERVICE TREE *(Sorbus forminalis)*
WILD STRAWBERRY *(Fragaria vesca)*

Flowers

Although we have listed many flowers, it will be impossible to make a wine from the rarer sorts as there will not be enough flowers to make a must. In any case, picking wild flowers is, on the whole, to be discouraged, but with the excessively common wild flowers, as well as those which have become naturalised in gardens, it is possible to produce beautiful and delicate flavoured wines.

BROOM *(Sarothamnus scoparius)*

COWSLIP *(Primula veris)*
CHAMOMILE *(Chamomile nobile)*
DANDELION *(Taraxacum officinale)*
ELDER *(Sambucus nigra)*
HAWTHORN *(Crataegus monogyna)*
HEATHER *(Calluna vulgaris)*
HOP *(Humulus lupulus)*
HARDHEAD *(Centaurea nigra)*
LIME *(Tilia europaea)*
PRIMROSE *(Primula vulgaris)*
SWEET VIOLET *(Viola odorata)*
WILD ROSE *(Rosa canina)*

Special Flavourings and Fragrances

Many botanicals such as certain leaves, nuts, bark, seeds etc., which possess the property of imparting a special flavour or fragrance, can be used to give a wine character, or be utilised in the production of brandies and liqueurs. The best way to draw out a flavour or fragrance in any part of a plant is to steep it for some time in either alcohol or water. With water steeping, the liquid can be added to a wine must and in this way the wine will be enriched. With alcohol steeping, however, the spirit must not be added to any part of the wine making process but used as a drink in its own right, i.e. liqueurs or brandy etc. Flowers and leaves and especially strong-flavoured materials need less steeping time than such hard materials as barks, nuts, berries, seeds, roots, gums, resins etc. The following list is a rough guide to just some of the many botanicals available. Where direct steeping in the finished wine is possible we have mentioned this:

ALKANET *(Anchusa)*
Use the root, steeped in alcohol only. An excellent colouring for port wine as the root imparts a deep red colour.

ANGELICA *(Angelica sylvestris)*
Use the root and seed in cordials and liqueurs to impart a subtle flavour and mellow fragrance. Can be steeped in finished wine.

BALM *(Melissa officinalis)*
Imparts a delicate flavour to wines with the added pleasure of a pleasing aroma. Use the leaves only. Can be steeped in finished wine.

BASIL *(Osymum basilicum)*
Use the leaves to give relish to a wine.

BURNET *(Poterium sanguisorba)*
The stalks of this herb give a spicy flavour to wine.

CALAMUS
Use the root, steeped in water or spirits. Imparts an aromatic taste to wine and beer. Can be steeped in finished wine.

CARRAWAY *(Carum carvi)*
The oil and seeds imparts a pleasing flavour to spirits, liqueurs and wines. Can be steeped in finished wine.

CARDOMON *(Elettaria cardamomum)*
The seed imparts a strong aromatic fragrance and a bitter flavour to wines, spirits and beer. Can be steeped in both water and alcohol. Can be steeped in finished wine.

CHAMOMILE *(Anthemis nobilis)*
The flowers impart an aromatic fragrance to wine.

CLARY *(Salvia horminoides)*
Use the flowers to flavour beer. The use of clary in wine has the effect of sweetening the flavour.

CLOVES
Steep the cloves in alcohol or in finished wine.

CORIANDER *(Coriander sativum)*
Use the seed and steep in alcohol. Gives a lovely flavour to brandies. Can be steeped in finished wine.

DAMIANA
The aromatic leaves should be steeped in alcohol only. Good for flavouring liqueurs. Can be steeped in finished wine.

FLAXSEED *(Radiola linoides)*
The seed should be used to give body to wines. Instead of steeping, the seed should be boiled which releases the mucilage.

DOGWOOD *(Thelycrania sanguina)*
Steep the ripe fruit of this flowering shrub in

brandy which gives a unique flavour.

SAGE (*Salvia officinalis*)
Use the whole of this herb in making beer, steeping it in the must with the rest of the ingredients.

GENTIAN
A bitter flavour is imparted by this plant. Steep in water or alcohol.

GINSENG ROOT
Steep in alcohol only. Can be steeped in finished wine.

HYSSOP (*Hyssopus officinalis*)
Use the leaves and flowers only which impart a unique flavour to wines and cordials. Can be steeped in finished wine.

JUNIPER (*Juniperus communis*)
Use the berries for flavouring gin. The flavour is imparted in water or alcohol. Can be steeped in finished wine.

MEADOW SWEET (*Filipendula vulgaris*)
Both the flowers and the leaves of this plant impart a delicate almond odour which can be utilised in both liqueurs and wines. Use only the leaves for steeping.

OAK (*Quercus robur*)
The bark of this tree can be used for colouring all sorts of drinks as steeping will produce a lovely brown colour. The bark also yields a slightly bitter flavour.

ORANGE
Use the peel of fresh, unsprayed and undyed oranges to impart a distinctive orange aroma to wines and other liquors. Instead of steeping in water, the peel can be added to the prepared liquor and left for a few days before removing.

ROSEMARY (*Rosemarinus officinalis*)
The leaves of this lovely herb should be steeped in white wine and left until the liquor has drawn out the flavour.

SAFFRON (*Colchicum autumnale*)
The bright orange pollen of this crocus-like flower can be used to colour wines and other drinks. It should added afterwards when fermenting has finished.

SLOE (*Prunus spinosa*) Blackthorn
Use the berries to flavour gin or in the preparation of raisin or currant wines. The berries have a distinctive acid taste and impart a lovely red colour to some wines. Can be steeped in finished wine.

WOODRUFF (*Galium odoratum*)
Steep the whole of this herb, excluding roots, in any dry white wine and remove when the desired flavour has been acquired.

WORMWOOD (*Artemesia absinthium*)
When used with Angelica, Fennel and Cardamon, a good tasting Vermouth can be made. Can be steeped in finished wine.

YARROW (*Achillea millefolium*)
Use the leaves in the preparation of beers, adding a few leaves to the must.

RECIPES

Flower Wine Recipes

ROSE PETAL WINE: 3 quarts scented roses (petals); 3 lb sugar; juice of two lemons; $\frac{1}{2}$ pint fresh strong tea; 1 teaspoon of dried yeast; seven pints of water. ($\frac{3}{4}$ oz of bakers yeast may be used for this and other recipies.)

The petals should be picked when they drop off easily from the bush when shaken. Spread the petals on to a piece of muslin and gather up into a bag. Place the bag in a pail or bowl and pour on 4 pints boiling water. Put the sugar and 3 pints of water in a saucepan and dissolve over a slow heat after which the liquid should also be poured into the pail. Add the tea, yeast and lemon and proceed as for a normal wine.

ELDER FLOWER WINE: 2 pints elder flowers; 3 lb sugar; $\frac{1}{2}$ lb sultanas; juice of 2 lemons; $\frac{1}{2}$ pint fresh strong tea; 1 teaspoon of dried yeast; seven pints water.

Gather up the flowers in muslin as for the rose petals and proceed exactly the same way.

DANDELION WINE: 3 quarts dandelion petals; juice of 2 lemons; juice of 1 orange; $\frac{1}{2}$ pint fresh strong tea; 1 teaspoon dried yeast, 7 pints of water. For sweet wine use 3 lb sugar; dry wine use 2 lb.

Place all the petals in a pail and cover with 4 pints boiling water. Add all the ingredients except the sugar which should be dissolved in 2 pints of boiling water, and the yeast and added afterwards. Proceed as for normal wine. The yeast must only be added after the must has cooled.

CLOVER WINE: 1 gallon clover blossom (red or white); 1 gallon water; 3 lb sugar; 2 lemons; 2 oranges; 1 teaspoon dried yeast.

Crush the lemons and oranges and place in the pail with the flower heads. Pour over them the water, which has been boiled with all the sugar. Allow to cool to lukewarm and add the yeast. Proceed as for normal wine.

COLTSFOOT WINE: 1 gallon coltsfoot flowers, 1 gallon water; 2 lemons; 2 oranges; $3\frac{1}{2}$ lb sugar; 1 teaspoon dried yeast.

Proceed as for clover wine.

GOLDEN ROD WINE: 1 pint golden rod flowers; 1 gallon water; $3\frac{1}{2}$ lb sugar; $\frac{1}{2}$ lb crushed raisins; 6 oranges; a teaspoon dried yeast.

Proceed as for clover wine except the raisins must be added to the must with the other ingredients.

LIME BLOSSOM WINE: 3 pints lime tree blossom; 1 gallon water; 1 lb crushed raisins; 1 lb washed whole wheat; 2 teaspoons dried yeast.

The blossom must be dried in the sun which brings out the flavour. Boil the blossom in all the water for 30 minutes and when cool, place in a pail and add the wheat, sugar and raisins. Stir well and then add the yeast. Proceed as for normal wine but keep for at least 1 year before use. An exquisite wine.

Fruit Wines

BARLEY WINE: 1 lb pearl barley; 1 lb raisins; 1 large potato, 1 lemon; 1 orange; 1 gallon water; 4 lb brown sugar; 1 teaspoon dried yeast.

Crush the orange and the lemons finely and

place in a pail with the potato which must be washed and diced. Pour over these the water, boiling, and add the wheat, raisins and sugar. Add the yeast when cool and proceed as for normal wine.

BLACKBERRY WINE: 1 gallon blackberries; 1 gallon water; 4 lb sugar; 1 teaspoon wine yeast.

Boil the fruit in the water for a few minutes and let it stand in a pail for seven days. Strain the contents through muslin on to the sugar which has been put in another pail, and add the yeast. Proceed as for normal wine.

CHERRY WINE: 6 lb cherries; 1 gallon water; 4 lb sugar; 1 teaspoon sugar.

Dice and stone the cherries and boil in all the water for $\frac{1}{2}$ hour. Strain through muslin into the pail and when lukewarm, add the sugar and yeast. Proceed as for normal wine.

CRAB APPLE WINE: 1 gallon crab apples; $3\frac{1}{2}$ lb brown sugar; $\frac{1}{2}$ lb raisins; 1 gallon water; 1 teaspoon dried yeast.

Wash and slice the crab apples and pour over them all the water in a pail. Stand for two weeks and then strain through muslin on to the sugar and raisins in another pail. Add the yeast and proceed as for normal wine.

CRANBERRY WINE: 2 lb raisins; 1 gallon cranberries; 1 gallon water; $3\frac{1}{2}$ lb sugar; 1 slice of toast; 1 teaspoon dried yeast.

The cranberries must be crushed and placed in a pail. Pour over boiling water and leave for 1 week, thoroughly stirring every day. Strain the mixture through muslin into another pail with the rest of the ingredients and proceed as for normal wine.

ELDERBERRY WINE: 1 gallon elderberries; 12 lb sugar loaf; 3 oz bruised whole ginger; 2 gallons water; 1 teaspoon yeast.

Boil everything, except the yeast, in all the water for $\frac{1}{2}$ hour and strain through muslin. Add the yeast and proceed as for normal wine.

HAWTHORN BERRY WINE: 4 lb berries; 4 oranges; 2 lemons; 6 lb brown sugar; 2 gallons water; 1 teaspoon dried yeast.

Put the berries in a pail and pour over all the water which must be boiling. Stand for 1 week and stir thoroughly every day. Crush and dice the oranges and lemons and place in another pail with the sugar and strain the berries through muslin on to these ingredients. Add the yeast and proceed as for normal wine.

Other Wines, Meads, Beers and Liqueurs etc.

OAK LEAF WINE: 1 gallon oak leaves; 2 oranges; 1 lemon; 4 lb sugar; 1 gallon water; 1 teaspoon yeast.

Stand the oak leaves in a pail for 24 hours after covering with the gallon of boiling water. Strain into another pail with the rest of the ingredients and proceed as for normal wine. (Use only young oak leaves).

BRAMBLE TIP WINE: 1 gallon young bramble tips; 3 lb sugar; 1 gallon water; 1 teaspoon dried yeast.

Boil the tips in all the water for $\frac{1}{2}$ hour and strain into a pail. When cool, add the sugar and yeast and proceed as for normal wine.

CARROT WHISKY: 6 lb carrots; 1 lb raisins; 1 lb whole wheat; 2 oranges; 2 lemons; 4 lb sugar; 1 gallon water; 1 teaspoon dried yeast.

Boil the washed carrots whole in all the water until tender. Crush and dice the oranges and lemons and put in a pail over which the strained, boiling carrot juice should be poured. Add the sugar and stir thoroughly. When cool, add the rest of the ingredients and proceed as for normal wine.

CELERY WINE: 4 lb celery; 1 gallon water; 2 lemons; 1 orange; $3\frac{1}{2}$ lb sugar; 1 teaspoon dried yeast.

Cut the celery into small pieces after washing and boil in all the water until tender with the lemons and oranges which must be crushed and diced. Strain into a pail with the sugar and when cool add the yeast, proceed as for normal wine.

DAMSON GIN: Damsons; cloves; sugar-candy; essence of almonds; unsweetened gin

Preserving jars will be needed to make this drink. First prick holes in all the damsons with a fork and half fill each preserving jar with the fruit. To every bottle, add 2 oz crushed sugar candy, 1 whole clove and a few drops of almond essence.

Fill up now to the brim of each jar with the unsweetened gin and keep firmly airtight in a warm place for three months. Strain the mixture through muslin and firmly cork in wine bottles, storing until needed for use.

NETTLE BEER: 2 lb young nettle tips; 2 lemons; 1 lb brown sugar; 1 oz cream of tartar; 1 gallon water; 1 teaspoon dried yeast.

Boil the nettles and the lemons, crushed and diced, in all the water for 15 minutes. Strain into a pail with all the sugar and cream of tartar. When cool, add the yeast. Ferment for 3 days in a warm place, then 2 days in a cool place and strain into strong wine bottles. Cork firmly and tie-down the works with wire fasteners (champagne fasteners obtainable from wine specialists are ideal). Keep one week and drink—don't leave this beer bottled longer than this.

CIDER: 12 lb apples; 1 lb raisins; 1 gallon water; 1 teaspoon dried yeast.

Mince the apples and place in a pail with the water and the rest of the ingredients. Leave in a warm place for 2 weeks, stirring thoroughly each day. Strain through muslin and proceed as for normal wine.

ROSE HIP MEAD: 3 lb rosehips; 4 lb honey; 2 lemons; 1 gallon water; 1 teaspoon dried yeast.

Boil the hips in all the water for 10 minutes and allow to cool. Thoroughly mash the hips in the water and then strain through muslin. Pour the liquid into a pail, add the honey and juice of the lemons and after stirring thoroughly, add the yeast. Proceed as for normal wine.

ELDERFLOWER CHAMPAGNE: 1 pint elderflowers; 2 lemons; $1\frac{1}{2}$ lb sugar; 2 tablespoons wine vinegar; 1 gallon of water.

Pour the boiling water on to the sugar in a pail and when cool, add all the other ingredients. Leave standing for 24 hours and then strain. Bottle and cork in strong bottles using champagne wire fasteners.

obtained quite easily by making a 'plant' which will give a continuous supply of beer over a period of time.

Mix ½ oz bakers yeast in 1 pint warm water in a big jug. Then for every day in the following week, feed the mixture with one heaped teaspoon of ground ginger and one of sugar. Leave now for 24 hours and then strain through a double thickness of muslin. Place the sediment back into the jug, add four cups of cold water and divide into two separate plants. The plant must be separated each week otherwise it will suffocate and die. The plants are then fed in exactly the same way for another week and divided again etc. Obviously, one plant will have to have a home found for it or be destroyed otherwise one ends up with a thousand and one plants in no time at all.

The strained liquor from the plant must be placed in a pail, with four pints of water, the juice of two lemons and 1 lb of sugar dissolved in boiling water. Mix thoroughly and bottle in strong bottles, being careful not to bring the level of beer higher than within 2 inches of the cork. Keep bottled for one week before drinking.

HOME-MADE BEER: 1 lb malt extract; 2 handfuls good dried hops; ½ lb sugar; 1 gallon water; 1 teaspoon dried yeast.

Dissolve the malt extract in 4 pints of warm water, adding the sugar afterwards and stirring well. Take 1 pint of the remaining ½ gallon of water and boil all the hops in it, simmering for ten minutes. Strain the liquid into the malt and sugar solution and repeat with each of the remaining 3 pints of water until all the flavour has been extracted from the hops. While the must is lukewarm, add the yeast. The fermentation will be strong so be ready for any frothing over the top of the fermenting jar. When the bubbles are just barely rising in the liquor (after about three days), bottle in strong jars and use after a week, though the beer will keep for two months or so.

IN THE USA
SOURCES OF MATERIALS

Check out your local hardware shops, pharmacists, health food shops, and department stores for all the winemaking equipment mentioned. Other specialist suppliers, such as the following recommended by the American Wine Society, *can be found in your yellow pages. (Catalogs are indicated for stores that definitely mail order; otherwise write for information.)*

THE INTERNATION GOURMET, 2308 Memorial Parkway S.W., Huntsville, Ala. 35801.

WINES AND THE PEOPLE, 1140 University Ave, Berkeley, Calif. 94702. *Catalog.*

THE COMPLEAT WINEMAKER, 1201 Main St., St. Helena, Calif. 94574. *Catalog.*

BACCHANILLIA, 273 Riverside Ave., Westport, Conn. 06880.

COSE DE MARTO, Box 8037, Town & Country Plaza, Pensacola, Fla. 32505.

THE WINE MAKER, 1752 W. 95 St., Chicago, Ill.

THE VINEYARD, 6016 Stellhorn Rd., Ft. Wayne, Ind. 46805.

BLYTHE VINEYARDS, Box 389, LaPlata, Md. 20646.

NEW ENGLAND WINE MAKING SUPPLY, 517 Worcester Rd., Natick, Mass. 01760.

VENDRAMINO WINE CO., 13273 Michigan Ave., Dearborn, Mich. 48126 *Catalog.*

SEMPLEX OF U.S.A., P.O. Box 12276, Minneapolis, Minn. 55412. *Catalog.*

E.S. KRAUS SALES, P.O. Box 451, Nevada, Mo. 64722.

INTERSTATE PRODUCTS, INC., P.O. Box 1, Pelham, N.H. 03076.

THE WINEMAKERS SHOP, Bully Hill Rd., Hammondsport, N.Y. 14840.

VINO CORPORATION, 961 Lyell Ave. (Box 7885), Rochester, N.Y. 14606. *Catalog.*

WINE HOBBIES, P.O. Box 17597, Charlotte, N.C. 28211.

JIM DANDY WINE SUPPLIES, P.O. Box 30230, Cincinnati, Ohio 45230.

THE VINEYARD SHOP, 7731 E. 21 St., Tulsa, Okla. 74112.

PORTER'S OF OREGON, 125 W. 11, Eugene, Oreg. 97401.

WINE HOBBY U.S.A., 100 N. 9 St., Allentown, Pa. 18102. *Many stores in eastern U.S.A.*

PRESQUE ISLE WINE CELLARS, 9440 Buffalo Rd., North East, Pa. 16428. *Catalog.*

ARBOLYN ASSOCIATES, P.O. Box 663, W. Columbia, S. C. 29169. *Catalog.*

OLD DOMINION WINEMAKER, 10376 Main St., Fairfax, Va. 22030.

THE RICHARD WINEMAKERS SHOP, 662B No. 3 Rd., Richmond, B.C., Canada.

WINE UNLIMITED, 130 Pitt St., W. Windsor

HOCK: 6 medium-sized potatoes; 3 lemons; 2 oranges; 4 lb sugar; 1 lb raisins; 1 gallon water; 1 teaspoon dried yeast.

Crush the raisins, potatoes and fruit and place in a pail with all the other ingredients. Proceed as for normal wine.

TEA WINE: 4 pints tea; 2 lb sugar; ½ lb raisins; 2 lemons.

Crush and dice the lemons, chop up the raisins and place in a pail with all the other ingredients. Leave standing for 1 month and then strain and bottle. Proceed as for normal wine.

GINGER BEER PLANT: Ginger beer can be

12, Ontario, Canada.

Nationwide

SEARS, ROEBUCK AND CO., Dept. 139, 2650 E. Olympic Blvd, Los Angeles, Calif. 90051; Dept. 139, 4640 Roosevelt Blvd., Philadelphia, Pa. 19132. *Retail store or general catalog.*

WINE ART OF AMERICA, 4324 Geary Blvd., San Francisco, Calif. 94118. *Throughout U.S. and Canada.*

SOCIETY

AMERICAN WINE SOCIETY, 4218 Rosewold Ave., Royal Oak, Mich. 48073. *A national, nonprofit organization devoted to educating its members and the general public about all aspects of wine—production, use, and appreciation. Membership ($12.50 a year) includes a subscription to the AMERICAN WINE SOCIETY JOURNAL, published quarterly, and special bulletins. The JOURNAL features news of Society and chapter activities, guest editorials, book reviews, recipes, and other useful information.*

COURSES

If you are interested in taking a course in some area of wine appreciation or production contact either your local YMCA or a college in your area to find out what they have to offer.

BIBLIOGRAPHY

AMERICAN WINES & WINEMAKING, by Philip M. Wagner/Knopf, New York.

THE ART OF MAKING WINE, by Stanley F. Anderson and Raymond Hull/Hawthorn, New York.

BETTER WINEMAKING AND BREWING FOR BEGINNERS, by C. B. A. Turner/Transatlantic Arts, Levittown, N.Y.

THE COMPLETE BOOK OF WINEMAKING, by H. E. Bravery/Macmillan, New York.

HOME MADE COUNTRY WINES, by Dorothy Wise/Wehman, Hackensack, N.J.

HOME WINEMAKER'S HANDBOOK, by W. S. Taylor and R. P. Vine/Universal Publishing & Distributing Corp., New York.

QUICK AND EASY WINEMAKING FROM CONCENTRATES AND FRUIT JUICES, by B. C. Turner and Philip Delmon/Hippocrene Books, New York.

SUCCESSFUL WINEMAKING AT HOME, by H. E. Bravery/Arc Books, New York.

THE WINEMAKER'S COMPANION, by B. C. Turner and C. J. Berry/Simon & Schuster, New York.

The following English publications are available in paperback through the British Book Center, Inc., 966 Lexington Avenue, New York, New York 10021:

ADVANCED HOME BREWING, by Ken Shales.

THE AMATEUR WINEMAKERS RECIPES, by C. J. Berry.

BREWING BETTER BEERS, by Ken Shales.

DURDEN PARK BEER CIRCLE BOOK OF RECIPES, by Wilf Newsom.

FIRST STEPS IN WINEMAKING, by C. J. Berry.

GOOD WINES OF EUROPE, by Cedric Austin.

HINTS ON HOME BREWING, by C. J. Berry.

HOW TO MAKE WINES WITH A SPARKLE, by John Restall and Donald Hebbs.

LIGHTHEARTED WINEMAKING, by Duncan Gillespie.

MAKING MEAD, by Bryan Acton and Peter Duncan.

PLANTS UNSAFE FOR WINEMAKING, by T. Edwin Belt.

PRESERVING WINEMAKING INGREDIENTS, by T. Edwin Belt.

SCIENTIFIC WINEMAKING: MADE EASY, by J. R. Mitchell.

THE WHYS AND WHEREFORES OF WINEMAKING, by Cedric Austin.

THE WINEMAKER'S COOKBOOK, by Tilly Timbrell and Bryan Acton.

THE WINEMAKER'S DINING BOOK, by Tilly Timbrell.

THE WINEMAKER'S GARDEN, by Duncan Gillespie.

WINEMAKING AND BREWING, by F. W. Beech and A. Pollard.

WINEMAKING WITH CANNED AND DRIED FRUIT, by C. J. Berry.

Bulletins on home winemaking (free bulletins are indicated; otherwise write for information):

BEGINNERS BOOK OF WINE MAKING, by Konnerth/Presque Isle Wine Cellars, 9440 Buffalo Rd., North East, Pa. 16428.

FRUIT JUICES, CIDER AND WINES, by Mac Gregor and coauthors/Research Station, Summerland, B.C., Canada. *Free.*

HOME WINE MAKING IN SMALL QUANTITIES, by Crowther/Ontario Dept. of Agriculture Publication No. 321. *Available free from author at: Horticultural Products Laboratory, Horticultural Experiment Station, Vineland Station, Ontario, Canada.*

HOMEMADE WINE, by Robinson/Cornell Extension Bulletin No. 1119. *Available from: Mailing Room, Roberts Hall, Cornell Univ., Ithaca, N.Y. 14850.*

HONEY WINE, by R. A. Morse/*Reprints available free from the author at: Dept. of Entomology, College of Agriculture, Cornell Univ., Ithaca, N.Y. 14850.*

LEAFLET ON HOME WINEMAKING, by Carroll/Dept. Food Science, N.C. State Univ., Raleigh, N.C. 27607. *Free.*

MAKING MEAD OR HONEY WINE, by Caron/Dept. of Entomology, U. of Maryland, College Pk., Md. 20742. *Free.*

WINE MAKING AT HOME, by Amerine & Marsh, 1969/Wine Publication, 690 Market St., San Francisco, Calif.

WINE MAKING FOR THE AMATEUR (Bulletin 549)/Cooperative Extension Service, Ohio State U., 2120 Fyfe Rd., Columbus, Ohio 44691. *Free.*

Journals

AMATEUR ENOLOGIST, Wine Art Sales Ltd., Box 2701, Vancouver 3, B.C., Canada. *Quarterly, subscription $3. All-around publication for home winemaker; recipes and informative articles.*

THE AMATEUR WINEMAKER, Andover, Hants, England. Agent in the U.S.A.: Semplex, Box 7208, Minneapolis, Minn. *Monthly subscription $6. Especially useful for those interested in making wines out of fruits other than grapes and concentrates.*

CELLAR NOTES, Presque Isle Wine Cellars, 9440 Buffalo Road, North East, Pa. 16428. *Subscription $1. Published intermittently; well-versed and very informative on home winemaking.*

WINES AND VINES, 703 Market St., San Francisco, Calif. 94103. *Subscription $10. A wine trade magazine published monthly. Amateurs will find much general information and advertising.*

LEGAL REQUIREMENTS FOR HOME WINEMAKING

Each head of a household is permitted to make up to 200 gallons per year by the federal government with certain restrictions as to its use. A permit (form 1541), together with information about the regulations may be obtained free by applying to your Assistant Regional Commissioner, Alcohol and Tax Division, Internal Revenue Service.

The Internal Revenue Service has issued a 120-page revision of federal regulations concerning wine. Entitled WINE, it is Publication 146 (Rev. 7-70) and sells for 55¢ from the Superintendent of Documents, U.S. Government Printing Office, Washington, D.C. 20402.

No doubt there are quite a few folk who have chewed over the idea of keeping some hens behind the potting shed. If you are one of them, the most important factor to consider at the beginning is the amount of space available in your garden. An area approximately 6 feet by 4 feet should be set aside for the housing of your birds, plus about 5–6 feet for use as a run. This run isn't necessary if you fancy the idea of a few hens goosestepping around your garden, but don't forget they have some bad habits and one of them is scratching holes all over the place and eating new and tender shoots once they've been unearthed.

Siting

When choosing a site it is essential for the comfort of the birds, to construct the house facing south, with plenty of window space on the side where most light can enter. Do not forget to choose a position in your garden which is high and relatively dry—not a low, damp spot. Now, as mentioned before, the ideal size for keeping six hens in comfort should be 6 feet by 4 feet and a house of this size or thereabouts can be bought for £30 to £40, which is incredible as it can be made for easily half that much with timber from your local wood yard.

Chicken Shack

Remember, when building your house that light and warmth is essential for your hens—not to mention the egg supply—so be meticulous about the construction. Have the windows built so that they can easily be opened wide or shut tight depending on the weather. If wire netting is fixed behind the window frames, they can be kept open night and day during the Summer. Also, if possible, build a window below the roosting perches and a droppings board at the end of the house as near the floor as you can, so that the hens will have plenty of light in the mornings to see to scratch around

Chickens From Scratch

193

other day and remove any droppings or matted portions which may accumulate, and change this litter without fail every three months.

On the Nest

A good laying hen will spend something like six or seven hours a week in her nest box, so it must be made as comfortable as possible and well-protected from draughts. Check the nests regularly for any hard or harsh nesting materials and check also to see if it is big enough for the hen to sit at ease: the nest should never be less than 12 to 14 inches square or she may suffer from cramp. Some egg producers, for fear of insects invading their nest boxes, spray or squirt insect powder all over the place, but this should be avoided at all costs. Instead, change the nesting material as often as possible, at the same time scrubbing it out with hot water and vinegar should there be any bugs around.

As with other household pets (and presumably this is what they will become), pullets should be house-trained too and in this case they must be taught to lay their eggs in the proper place instead of dropping them anywhere which could lead them to being smashed. Simply place one china egg (the sort we all used to use in egg and spoon races and available possibly from your local sports shop) in each

in. This will keep them warm and contented while waiting for you to roll off your hammock and give them their breakfast. For some reason, chickens love to scratch and scuttle around, so a section must be allocated in the house or pen for such a purpose. Ideally, the house should have a wooden floor and in the pen, grass, but whatever the case, the litter should be piled up to a depth of about 6 inches —especially in the Winter months. This litter can be of coarse sawdust, bracken, dry leaves, straw, chaff or peat—any of which will make fine scratching material. Rake it over every

nest box and good old Mother Nature will do the rest.

Little Boxes

Construct the nest boxes about 1 foot off the floor at the end of the hen house to allow more room for the hens to pursue their favourite pastimes. At the same time place a strip of wood across the bottom of the nests to stop the nesting material from falling out. For a quiet life, allow one box for every two fowls you decide to keep, as normally the majority of eggs are laid before mid-day so the last thing you want is to have three egg-bound chickens all squawking and clambering for the same nesting box. Ideally it would be good to have one box per hen but this isn't always possible. Another important requirement which can be overlooked is a droppings board. This should be fixed about 2 feet from the floor and 2 to 3 inches below the perch. Clean it each day if possible by scraping the droppings into a bucket and lightly cover the board with either sawdust or sand. Never let the droppings build up on the board as this can harbour disease.

There are many little details to watch out for when building the house and one of these concerns the perches. Keep all perches the same height, for if not, all the hens will scramble for the highest and trouble could easily develop. Also remember to allow about 9 to 10 inches per bird when making the perch as this is a nice comfortable space for them to roost. There are various thicknesses recommended for perches, but the favourite seems to be one of 2 inches square with the top edges well rounded off and the lower edges only very slightly rounded. It is very important to secure the perch firmly at each end so that there isn't the slightest hint of a wobble, as this is extremely disturbing for your hens and not too good for the egg supply. Never allow your hens to sleep in the nesting boxes at night. One way of doing this is to quietly visit the house after dark and gently put the culprit back on the perch. A couple of nights of doing this should see the end of this habit. One other important factor to watch out for is the food container. This must be large enough to allow all the birds to eat at the same time for if not, a timid bird that has to fight its way to the grub will never get close enough and will certainly become ill. Construct a simple trough for the food as this is much better than a bowl. A strip of wood across the top will stop the hens from fouling or scattering the contents about the house or run.

The water trough, and especially its positioning is quite important as this can determine a good or bad egg supply. To begin with, the water trough must be in such a position that it is impossible for the hens to kick dirt or litter into it and one nice idea is to attach it to the outside of the house if possible. But should this prove too troublesome, another method is to have the trough fixed on the wall at a suitable height so the birds can drink easily from it but find it impossible to foul it up. Either method is fine but you must remember to change the water daily or some dreaded disease may set in. Also, and this only applies to the winter months or when frost is in the air, empty it each night and in the morning before the birds wake up and fill the trough with tepid water. This will ensure that the hens drink sufficient for the production of eggs and their own personal requirements. The making and laying of eggs gives our feathered friends quite a thirst and if they are forced to drink very cold water they will become ill. In the Summer the drinking water can be washed out and filled with clean water in the evening all ready for the hens the next morning. But keep the trough in a shady spot—never in the sunlight.

Beside the water trough you must also build a shallow box with two sections in it for holding a quantity of grit and oyster shell. Flint is a *must* for all fowls as it is used to grind up the food in the gizzard and the oyster shell or limestone provides the pure lime necessary for the hen to make egg shells.

Chicken Feed

We now come to foodstuffs which, naturally it is just as important to keep clean. One idea which you may find useful is to hang a netted bag from the roof of the run or house the same height as the chickens' heads. This can then be filled with all sorts of goodies which cannot be fouled up. Once again, the cold months can be a bit of a swine as you must on no account feed chickens with any kind of frozen food until it is well thawed out. If you have any trouble keeping the food away from the icy mornings, a couple of good, fresh mangel-wurzels or swedes chopped in half and nailed to the wall of the house will suffice till mid-day. Never toss food on to the ground—the nailing method is both clean and simple and at the end of the day the empty mangel shells can be cleaned and chopped up for the stock-pot as a special treat later in the week. In actual fact the general feeding of your hens is quite a simple matter as the majority of foodstuffs are kitchen scraps. Any stale bread or cake should be baked or dried in an oven and then crushed before being used and any which isn't going to be used immediately can be stored in an old biscuit tin for later. Potato peelings and small potatoes can be given but they must be boiled first. Naturally, not everyone will have enough spare green food and leftovers to keep 6 hens in trim, but don't forget there is an unlimited supply at your local market place, and sackfuls can be collected at the end of the day, all free of charge.

When making a stock-pot out of all the odds and ends, use as little water as possible and on no account serve the hens with sloppy food.

A crumbly, moist consistency is their favourite and your birds will enjoy every beakful. Check, when serving, that the hens will each receive about 8–10 oz twice a day: once in the morning and once in the late afternoon. The afternoon meal should be given in time for the birds to eat it in comfort and to allow them ample time to find their roosting perches before it gets dark. Never let your hens go to roost with an empty or half empty crop. In actual fact it's probably better for them to have a slightly bigger meal in the afternoon, so they will still have a full crop when they eventually settle down for the night. Unlike us, they won't be troubled with indigestion. One of the most basic and stable foods to give your laying hens is mash, and good mash is made up with the following ingredients: 3 parts of bran, 3 parts of ground oats, 3 parts of maize meal, 1 part of alfalfa meal and 1 part of fish meal plus a sprinkling of salt.

The Runs

We now come to the run, and for this an area of 5–6 feet must be marked out preferably covered with grass. Earth is fine but it must be dug over frequently. In the case of a grass run, it would be best to keep the grass very short and, providing you don't feed the hens on it, it will last quite a long time.

Admittance to the run should be by means of a pop-hole for the birds to come and go, but for the convenience of access to the run, there should also be a door leading from the house to the run and the pop-hole should be built in the door. On the inside of this door, fix a well-made slide so that the pop-hole can be securely held every night to keep your neighbours' cat and other predators at bay. This also helps to prevent draughts from coming into the hen house. Across the top of the run build some kind of roof and attach some canvas or sacking to it that can be drawn down over the sides in a storm.

Lastly, sprinkle a liberal amount of scratching litter plus some oyster shell or limestone grit in the run to keep your hens amused and at the same time provide some useful exercise.

Well, that's about it really for the house and

pen—just remember that chickens are like us in that they like to be warm and cosy in the Winter and cool in the Summer so a few well-built windows and shutters wouldn't come amiss.

Stocking

Now to the most difficult part—the actual stocking of the hen house.

Probably the simplest method of stocking your house will be with hens that are already laying, as opposed to buying 16–20 week-old pullets or even 8-week-olds which are a little more difficult (we shall come to these little characters in a minute).

The first point to remember after buying your chickens is that it's quite reasonable not to expect them to lay for a little while as the change in surroundings upsets them a bit: but here are a couple of tips which may be of help. Try as much as you possibly can to keep the birds under the conditions to which they have been accustomed and to give them similar food. But in an attempt to cut out trial and error feeding methods, check first on what food they have been getting so that you can match it—in time you will be able to alter it to your own requirements.

There are many birds on the market that will do you proud but we suggest that you buy a breed which is not too active and will be content in a small house or run. Possibly the most likely choice would be Rhode Island Red or Light Sussex or even a cross between the two would be fine. Both breeds are hardy, quiet and docile and normally make good layers, but make sure you give them 2 feeds per day as well as plenty of fresh green food and water. Protect them too from very cold or wet conditions as laying hens should *never* get cold or wet feet! There isn't a great deal of difference between keeping laying hens or 16–20 week-old hens except that the latter should be made even more comfortable with plenty of fresh, clean litter and for the first few days anyway, should be given food as tempting as possible. They won't begin laying their eggs for at least 6–12 weeks so don't start worrying.

Eight-week-old chicks are a different matter

and although they won't need a broody hen for comfort and warmth, they will need some kind of heating plus plenty of clean straw mixed with fresh, dry litter to snuggle into. For the first few weeks it would be a good idea to give them greater warmth and a feeling of security by sectioning off a part of the house for their use—not forgetting of course to cover up the nest boxes as these fluffy little characters will soon foul them up. Perches aren't really necessary at this stage as the chicks won't use them until they are at least 3 months old. Eight-week-old chicks can have similar food to that recommended for the older birds except in this case it should be finely chopped up and given to them in a large bowl—making sure it stays reasonably clean. Allow them to play in the garden or run if they want to but not if the ground is damp as this can cause them harm.

Complaints Dept.

Here are a few remedies for the commonest of complaints likely to affect your hens:

COMMON COLD: Mix together 4 oz syrup of scillae, 4 oz syrup of mulberry, and $\frac{1}{2}$ oz of the following—vin. ipecac., spirit of nitre, chlorodyne and paregoric, making 10 oz in all.

Dose: One or two dessertspoonfuls of the mixture in half a pint of water or stirred into 2 lb of mash.

BRONCHITIS & WHEEZING: Exactly the same mixture as above but give one teaspoonful to the patient on a little scalded milk and bread (moist *not* soggy) or the same amount in a drop of warm water.

DIARRHOEA: Mix together 1 oz of bismuthi carb, and $\frac{1}{4}$ oz salol.

Dose: Give as much as will cover a $\frac{1}{2}$p piece on a little scalded milk and bread (moist *not* soggy).

GAPES CURE: Mix together $\frac{1}{4}$ oz pure creosote in 4 oz of pure glycerine.

How to apply: Dip a small feather into the mixture and carefully thrust it down the hen's throat, twisting the feather while slowly withdrawing it so as to dislodge the gape worms from the throat and windpipe.

RED MITE KILLER: To 1 pint of paraffin, add 2 oz of oil of camphor or 4 oz of creosote.

How to apply: Scrub all perches and wood-work etc.

IN THE USA

SOURCES OF MATERIALS

One way to get started is to take advantage of the services offered in every state by the Agricultural Extension Service of the Department of Agriculture. Farm advisors, extension agents, or county agents (depending on where you live) provide agricultural advice and services to the public and pass on the latest technology. They are available for consultation and house calls in any area of agriculture or related fields (including turf care, home gardening, livestock, pest or rodent control, soil and water conservation, among others), and also provide a wide range of literature on these subjects.

Since the state tests all flocks of chickens for pullorum disease under a national inspection plan, you can get from your Agricultural Extension Office a list of breeders in your area who have pullorum-clean flocks. The office is usually listed in the phonebook under the county.

In the United States, your most likely choice of breed would be the Rhode Island Red or Plymouth Rock. Material for litter can be purchased from local feed dealers, and you should ask your extension agent about what kind of run to have, which depends on the soil and climate of your state. Ladino clover is probably the most popular.

BIBLIOGRAPHY

DISEASES OF POULTRY, by P. Seneviratna/ Williams & Wilkins, Baltimore, Md.

HERBAL HANDBOOK FOR FARM AND STABLE, by Juliette de Bairacli Levy/MeadowBrook Herb Garden, Wyoming, R.I. 02898.

THE HOMESTEADER'S HANDBOOK TO RAISING SMALL LIVESTOCK, by Jerome D. Ballinger/Rodale, Emmaus, Pa.

LIVESTOCK AND POULTRY PRODUCTION, by Clarence E. Bundy and Ronald V. Diggins/Prentice-Hall, Englewood Cliffs, N.J.

PRODUCING EGGS AND CHICKENS WITH A MINIMUM OF PURCHASED FEED/Garden Way, Charlotte, Vt. Bulletin, 50¢.

STARTING RIGHT WITH POULTRY, by G. T. Klein, Garden Way, Charlotte, Vt.

The following publications are available free (while the supply lasts) from the Publications Division, Office of Communication, U.S. Dept. of Agriculture, Washington, D.C. 20250.

FARM POULTRY MANAGEMENT, F 2197.

RAISING LIVESTOCK ON SMALL FARMS, F 2224.

Journal

COUNTRYSIDE AND SMALL STOCK JOURNAL, Countryside Publications, Waterloo, Wisc. 53594. *Monthly, subscription $9. Articles on animals and farming, includes regular section on poultry: "The Poultry Yard."*

Raising Goats

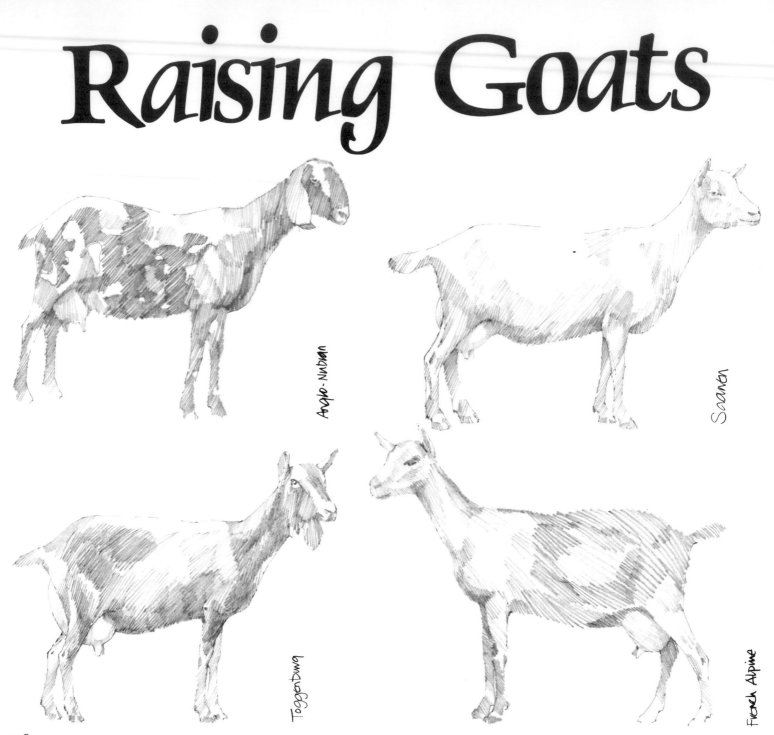

Anglo-Nubian

Saanen

Toggenburg

French Alpine

When you consider the small amount of cash needed to keep a goat in comfort for one week (probably no more than a medium-sized dog) and in the case of a nanny, the good fortune of being rewarded with at least four pints of good wholesome milk a day, it is odd that the humble goat has rarely been welcomed by people with a patch of spare ground in their gardens.

BREEDS AVAILABLE IN THIS COUNTRY:

THE ANGLO NUBIAN Nicknamed the 'Jersey Cow of the goat world' (due to its high butter-fat percentage), is a large beast with a fine skin and glossy coat. Its only handicap is that the top teeth tend to overlap the bottom set, thereby making the biting of grass and twigs difficult. This can be overcome in stall-fed animals by chopping or grinding their foodstuffs.

THE TOGGENBURG Once bred in the valley of Toggenburg in Switzerland, this animal is now very popular in England due mainly to its quiet and gentle temperament and fine looks. The Toggenburg is a rather small animal and has white or light fawn markings down each side of the face and from the knees (or hocks) to the feet. There is also a wide strip of white round about the tail and rump that spreads towards the thighs. These animals, although not very heavy milkers are extremely consistent in their yields and pride themselves in their long lactation (milking) periods. The Toggenburg butter-fat percentage is about average

BRITISH TOGGENBURG Normally thought of as an improved version of its Swiss brother, this goat, although identically marked, is in fact larger and more finely coated. Unlike its Swiss equivalent the British Toggenburg is a good milker with a reasonably high butter-fat percentage

THE SAANEN This is yet another Swiss breed, similar in many ways to the Toggenburg especially in its size and nature. This breed is ideal for anyone with limited space for its placid nature makes it content with less-than-ideal grazing. These goats are excellent milkers and well known among goat handlers for their extremely long lactation periods. Their butter-fat percentage is about average.

BRITISH SAANEN These goats are rather heavily built in comparison with other breeds. They are nevertheless very good milkers with a fine length of lactation.

THE BRITISH ALPINE Fully bred in England, these goats, although black in colouring, have white or fawn markings similar to the Toggenburg. The British Alpine is a fairly large beast and is quite striking due to the high colour contrast in its appearance. This goat has a gentle nature and is nice to work with, but it probably needs more exercise than most of the other breeds. They are extremely good milkers with an average butter-fat percentage.

BRITISH Really quite attractive in appearance, these goats can be of any colour and often have white markings on the body. They are very good milkers both in quantity and quality and are well known for some of the highest recorded yields in this country.

ENGLISH These goats are stocky little characters, with thick coats in varying shades of greys, fawns and browns. Unfortunately they are not very good milkers.

HOUSING A GOAT

Although it is an extremely hardy creature, the goat, like the rest of us, cannot stand draughts and is therefore very susceptible to colds: so please bear this in mind when you decide on its shelter. An unused garage or shed would naturally be ideal, but if you have no outbuildings available, one will have to be constructed.

Basically the sort of stall needed is just the same as a dog kennel except it must of course be much larger (at least six feet or so square) with a door similar to that found on a horse's stable. To this can be added as many windows as can sensibly be constructed. In the summer they can be sprayed or painted with lime-wash or green distemper to keep the goat house cool. Inside the goat's house it is necessary to build a trough and hay-rack plus a strong wooden bench or platform for sleeping. Although it need only be a couple of inches off the ground, the goat prefers this to the cold floor. Always keep the floor covered with a good layer of

straw and never allow the stall to turn into a smelly heap.

If more than one milker is to be kept, then separate stalls must be provided as it is not advisable to allow them to run loose together in case one should dominate the house. Stalls are advisable too, as it is necessary to feed each goat according to her milk yield. These really only need to be 4 feet high and 2–2½ feet wide. Inside them there should be small hay-racks about 15 inches deep and 12 inches wide at the top, with wooden slats constructed at 1½-inch intervals. To the left of the stall, a metal ring should be fastened for tying the goat up when milking. This can vary in height according to the height of the goat, but generally it will need to be some 2 feet off the ground. Don't forget to allow enough rope to enable the goat to move its head freely up and down but not enough for it to back out of the stall. Keeping water in the stalls should be avoided as it can become rather messy if spilt.

FEEDING

On the question of foodstuffs, you will find no problem at all in keeping your goat content and happy as long as you realize that it eats quite a lot. If you live in the countryside this food situation will be very easy to deal with, but in town you will have to be a bit more ingenious. All sorts of vegetables can be got very cheaply by visiting market places or green-grocers, asking at cafes and restaurants or just knocking on people's doors. Even from your own home, foodstuffs like boiled potatoes, dried bread, cabbage leaves and pea-pods etc. will help maintain a steady diet. Hay and straw can be a problem for town dwellers because the prices can be fairly steep, so if possible, it will be best to buy in bulk.

The supply of straw or hay can always be bought from market harvesters who are the suppliers of shops and stalls in the towns. Should you be fortunate enough to live in the country, it will be a very simple matter to give your goats an added treat by taking them for a regular walk along any country lane and allowing them to nibble at the trees, hedgerows and grasses. Be careful, however, as there are some shrubs which can be dangerous to your

animals such as yew trees, foxglove, privet berries, ivy berries, ragwort, deadly and woody nightshade, rhododendrons, acorns, laburnum, walnut and any variety of bulbs. In Winter, due to seeding, the grasses and weeds lose their food value, to such an extent that some produce will have to be cultivated in your garden. A nice batch of kale and carrots should be grown if possible along with oats and peas and fed to the animals whilst still green. Small branches and pieces of bark can be dried and sorted for the winter months too.

KIDDING

Kidding (in theory), possesses no more problems than any other animal that you may have at home. Altogether you will have something like 145 days from mating to prepare not only yourself, but the goat house and a few pieces of equipment too. Try if you can not to leave this till the last minute as the last thing your goat will want if she needs help when delivering her young, is to wait while you flap around.

The simple essentials needed for a normal delivery is a sterilized bucket (for washing your hands and arms in thoroughly), disinfectant, soft tissue paper and towelling (for the cleaning of the new born kid[s]). You will soon become aware that your goat is about to come into labour by a marked increase in her appetite, especially for hay. Other signs include the tightening up of the udder due to an influx of milk. Her tail will be carried much higher than normal and she will become fidgety as well as breathing rapidly or even panting. She will show definite signs of being in pain by making distress noises and will insist on ruffling up her straw and lying down only to rise in a few minutes and start the procedure all over again. There isn't a great deal you can do at this point but to show kindness and sympathy.

After a while a thick, white discharge will appear only to be followed by another similar in appearance to the white of an egg. It is at this stage that you must quickly, but thoroughly, wash your hands because soon your goat will begin kidding. Shortly after the second discharge, she will begin to show signs of straining —nothing much at first but gradually building up until at long last a shiny substance (mucus) is exuded followed soon after by the water bag in which the kid is huddled. Don't break the bag even though the goat appears to be in great

pain as this will hinder not help the delivery. After a few moments your goat will begin to strain much harder causing the water bag to break internally, thereby allowing the kid's forefeet and the tip of its nose to become visible. Should your goat appear to be in great pain, it is essential for you to help. Simply take hold of the kid's two feet pulling them gently downwards as the goat strains. In case they are much too slippery to hold on to, it's a good idea to wrap a towel around them and then continue. Sadly the goat may cry out when the head fully appears, but by then the delivery will soon be over and you should comfort her as much as possible.

Once the head is free, your goat may wish to rest for a while before continuing to strain with renewed energy, when she will then give birth to the remainder of her kid.

In most cases when a second kid is delivered, it tends to come hind-feet first. This is quite normal but speed is of the essence for if there should be a delay it may suffocate. As soon as the hind-feet become visible, take a firm hold as described before and gently pull.

The two methods described are for normal births but it's very easy for something to go wrong, such as the failure of the kid to appear due to some slight malpositioning or its size. If this is the case don't hang around but contact a vet immediately.

As soon as the kid(s) has been born, all the mucus should be removed from its mouth and nose to enable it to breathe properly. If the delivery has been rather a long affair, the little chap may be extremely weak and unable to breathe, in which case the kid must be carried into the fresh air and given artificial respiration. This is done by holding the front legs and slowly pressing them backwards and forwards causing the kid to gasp, thereby filling its lungs. Once this has been done, the kid can then be helped back to its mum and she will clean him.

After cleaning away the afterbirth and laying down fresh straw, give your proud mum a warm oatmeal drink with a tablespoonful of treacle (if she's partial to it) or some honey.

IN THE USA
SOURCES OF MATERIALS

One way to get started, as with the chickens, is to consult your Agricultural Extension

Office (see p. 197). Since goats are tested for tuberculosis and brucellosis, the agent will be able to supply you with lists of reliable purebred and commercial breeders in your area.

The breeds most commonly available in the United States are Anglo Nubians, Toggenburgs, Saanens, and Alpines (or French Alpines).

Feed stores are the most common source of straw and hay.

SOCIETY

AMERICAN DAIRY GOAT ASSOCIATION, P.O. Box 186, Spindale, N.C. 28160. *Organization of breeders, owners, and dairymen. Membership $7.50 for the first year; $5 thereafter. A pamplet describing their services,* WHAT HAPPENS WHEN DAIRY GOAT OWNERS WORK TOGETHER? *will be sent free. Other publications are:* DAIRY GOATS—WHY? WHAT? AND HOW? *(10¢),* WHY GOAT MILK? *(5¢), and* DAIRY GOATS—BREEDING/FEEDING/MANAGEMENT *($1.25).*

BIBLIOGRAPHY

GOAT HUSBANDRY, by David Mackenzie/ Transatlantic Arts, Levittown, N.Y.

GOATS, by Wilfred S. Bronson/Harcourt, Brace, Jovanovich, New York.

HERBAL HANDBOOK FOR FARM AND STABLE, by Juliette de Bairacli Levy/Wehman Bros., Hackensack, N.J.; available from MeadowBrook Herb Garden, Wyoming, R.I. 02898.

THE HOMESTEADER'S HANDBOOK TO RAISING SMALL LIVESTOCK, by Jerome D. Ballinger/ Rodale, Emmaus, Pa.

RAISING LIVESTOCK ON SMALL FARMS, F 2224/available free (while the supply lasts) from the Publications Division, Office of Communication, U.S. Dept. of Agriculture, Washington, D.C. 20250.

STARTING RIGHT WITH MILK GOATS, by Helen Walsh/Garden Way, Charlotte, Vt.

Journals

COUNTRYSIDE AND SMALL STOCK JOURNAL, Countryside Publications, Waterloo, Wisc. 53594. *Monthly, subscription $9. Articles on animals and farming, directories of breeders, places to order equipment, a regular goat section: "The Goat Barn."*

DAIRY GOAT JOURNAL, P.O. Box 1908, Scottsdale, Ariz. 85252. *Monthly, subscription $4. Information on equipment, goats for sale, goat cheese recipes, suppliers' ads.*

A Crystal Garden

A crystal garden is a delicate piece of beauty that can be made very easily and costs next to nothing in materials. It can be made in a small goldfish bowl, a glass jar, or even a bottle, and can be very simple in design, or as involved as you like. Apart from the container, the only other essential materials are coarse sand, a tin of water glass (the stuff thrifty mothers preserved eggs with in the old days) and a few packets of various crystals. The best crystals to use are as follows: Epsom Salts, Zinc Sulphate, Ferrous Sulphate, Cobalt Nitrate, Manganese Sulphate and Cadmium Nitrate. (Although these crystals are pretty well harmless, they don't taste very nice so avoid getting any in your food and keep them out of the way of children.)

METHOD

Fill the bottom of the glass container with a layer of coarse sand. Coloured sand and the ornamental chippings sold in tropical fish shops can be also used, but remember that crystal trees are very delicate and beautiful in themselves and any brightly-coloured material may over-power their effect. There are, however, a number of ways to set the crystal growths off. For instance, a miniature garden can be made out of plasticine and carefully positioned in the sand. By making little trees, garden seats, ornamental birds etc., a fantasy world can be created, especially if pieces of coral, shells and pebbles are incorporated in the design.

Before actually making the garden grow, decide whether the crystal growths are to form ad lib all over the bottom of the jar, or whether they are to grow in selected places. If it is the latter that is desired, then the crystals must first be carefully positioned in their respective places. Absolutely beautiful effects can be got by making little plasticine trees and bushes, and pressing a few crystals into the branches. (Be careful not to press the crystals right in otherwise they cannot grow.) The next step is to mix up a solution of water and water glass, which is made by dissolving three tablespoonfuls of waterglass to a pint of hot water. Make sure that enough solution has been mixed to fill the container and then very carefully, pour it gently into the container until it is full. If the crystals have already been positioned, they will immediately start to grow but if a wild garden is desired, then the crystals are dropped into the jar and will start to grow wherever they fall.

After about ten minutes, the crystals will have grown into beautiful tree-like forms. It is best to avoid moving the container around too much in case any of the growths get damaged, so try to have the container as near to its position as possible when actually making the garden.

IN THE USA
SOURCES OF MATERIALS

Coarse sand is obtainable from the sea shore or from suppliers of building materials.

Plasticine and other synthetic clays are sold in arts and crafts supply stores.

All the other materials mentioned here can be found in drugstores or wherever chemicals are sold.

201

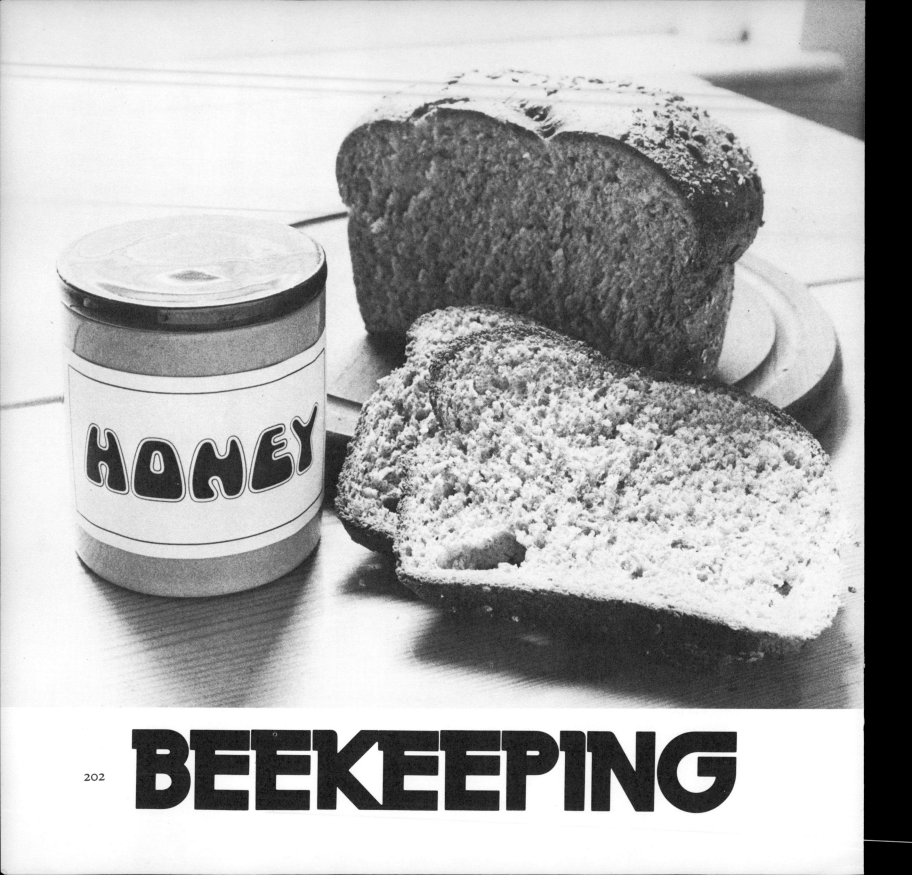

BEEKEEPING

Normally when one considers the role of bees in this country, one usually thinks of them as only producers of honey and wax; but this is small compared to the part they play as pollinators of flowers and many varieties of hard and soft fruits. Many farmers today realize the importance of keeping bees in their gardens, for they have discovered that their presence means heavier fruit crops as each year progresses. In actual fact, bee keeping has never been as popular as it is now: even people in large towns are keeping apiaries on their rooftops where the bees will fly over two miles to collect nectar from flowers and crops in gardens and outlaying districts. Naturally the quantity of honey collected is not near as much as country bees who are within easy reach of orchards and heather crops, but the joy of eating good fresh honey is the same.

Although there are many intricacies in bee-keeping, many problems will work themselves out with practice and clear thinking. But so you don't get ploughed under with too many difficulties, we suggest that you start with only one hive. In due course, as you get more acquainted with working with bees, you can then purchase a second or even a third.

There are quite a few manufacturers of bee equipment in this country who, once they realize that you are a beginner, will try and persuade you into buying the 'essentials' needed for successful bee keeping; but do your utmost to ignore them.

For example—there is a small hand tool on the market which the manufacturers will insist on is absolutely essential for the dismantling of your hive and which no other tool will achieve—this is rubbish. A hefty screwdriver from your shed will do exactly the same job. There are a couple more examples which we could give but you will realize what they are once you get your hive. There is only one hand-tool which, to our knowledge cannot be improvised, and that is a 'smoker'. This is a tin with bellows attached and once it has been filled with either dried bark, 'cow-chips', peat or old rags will, once it has been set alight,

smoulder all the time that you are working with your bees. In short, when bees smell smoke they automatically think of fire. This in turn leads them to stuff themselves with honey which in turn makes them lazy and less inclined to sting.

Proper clothing is another essential, but can be overcome by just making sure that you don't have any gaps for the bees to enter, e.g. trouser bottoms, shirt or blouse sleeves, fly-holes (could be very nasty) and even button-holes! A veil must be worn at all times to protect your eyes, ears, nose and mouth, so instead of buying one at a ridiculous price, why not make one? It is quite easy and only needs one and a half yards of black Bretonne net and a stiff-brimmed hat to keep the net away from your face. (Black net is best as it gives much clearer vision than white or green). Sew the net into a long bag and drape it over the hat. Thread a long piece of elastic round the back of the veil so that the middle will fit into the back of the neck. The ends are then brought through to the front (about 5 inches apart), passed under the arm pits and tied behind the back. Gloves should be avoided if possible as they are too clumsy for such delicate work. Unfortunately you will get stung at first, but as time goes on you'll know how to handle the bees and the occasional sting will be no more than a minor irritation.

Whilst on the subject of stings, never pull out the sting between your forefinger and thumb because attached to each sting there is a small sac of poison and if you're not careful, you will squirt all the poison into the wound. If you have time, simply push the sting out with a finger nail or failing that, just rub it out against your clothing.

The positioning of your hive is extremely important, not just for your bees, but your neighbours too. If you can, have your hive facing south so that the bees have the advantage of the morning sun; but never face them towards the north. Keep your hive away from heavy shade, busy roads or livestock as it has been known for bees to sting an animal to death. A good idea is to face the hive towards a high hedge or clump of trees so they have to fly high as they leave, thereby flying well over the heads of neighbours and animals alike.

Also put your hive where the bees have easy access to water as they require it for keeping the hive cool in summer; in winter you will probably have to supply the water yourself.

The hive is the costliest piece of equipment needed, but there are many different designs on the market so you will have no difficulty in choosing one. The average price for a good hive is around £25, but if you advertised for a second-hand one in the various bee-keeping journals you should pick one up for much less. This price includes all the interior equipment essential for the harvesting of honey and can be bought direct from the makers. (See p. 207 for sources of hives.)

In most cases when you buy a hive, you will also get a colony of bees. This will contain (dependant on the price) a young queen, 12,000 workers, a few hundred drones and a brood in all stages of development. But should you want to buy your bees separately (as in the case of a second-hand hive) you can expect to pay about £9 for 24,000 workers (in all cases a young queen, drones and brood are included): £8.50 for 18,000 and £6.50 for 12,000 workers. A good queen can be purchased for around £1.30 but the price varies slightly during the year.

The function of the queen (or mother) is simply to populate the hive. She is the only perfectly-developed female in the hive and in the summer months may lay up to two thousand eggs per day which hatch out into drone and worker bees. She can be recognised by her sheer size in comparison with the rest of the colony.

The worker bee, on the other hand, is an undeveloped female and the smallest in the hive. She spends all her time building cells for the queen to lay more eggs in; collecting nectar and pollen: feeding the young larvae and any other household chores which may arise.

But in the case of the drone bees they are simply there to fertilise the young queen. Towards the end of the honey season, when their services are no longer required, the drones are turned out of the hive by the workers and left to die. They can be distinguished quite easily by their size—they are smaller than the queen but larger than the workers.

There are in fact four different species of bees available, the most common and favourite of which is the Italian variety. They are especially suitable for the beginner because due to its slowness of action, it is less inclined to sting, therefore making it easier to work with. The other varieties are nowhere near as docile and are much quicker and hot-headed that normally only professional keepers know how to handle them.

There are many essential factors to consider when the important time of wintering down your bees arrives. This should be done in September, so that by the time Spring arrives they will be in such good condition that they will be ready when the nectar flow begins.

1　A good supply of food is of course a must and during these winter months 25 lb of food is consumed. But just in case there is a really cold Spring, the bees must be bedded down with at least 30 lb of supplies or they might possibly starve to death.

During the summer months the bees will provide you with something like 35 to 40 lb of honey (or more) but out of this, 30 lb must be given back for the colony to survive, so make sure that you don't take more than your quota.

In most cases, the professional keeper takes 35 lb of honey from each hive, gives back 5 lb and substitutes the other 30 lb with white sugar mixed with water. Although there are lots of books which recommend this practice, we must stress the importance of *not* using this method. The use of white sugar is totally wrong in any situation but even the use of brown sugar must be avoided as this can cause dysentery amongst the bees and is still no exchange for their proper food—honey.

2　Keep your hive as weatherproofed as possible. Do not put it beneath a tree as the continual dripping of rain will cause unrest amongst the bees. In snow, to prevent too much sun-light reflecting up into the hive, place a small fence or something similar in front of the opening. (Bees have been known to fly out in such conditions, thinking it Spring, but dying in the cold air.)

3　Keep all openings free from leaves etc. as this can cause bad ventilation, resulting in the bees becoming ill. In some cases you will find a few dead bees in the entrance, but don't worry

as this is quite normal. Simply clear them away so that they don't hinder the air circulation.

4　Try not to disturb your bees at all. If you must check the hive, do it quickly and quietly. Make sure that the hive is firmly fastened down and the roof secure.

5　If needed, renew your queen bee before the winter. There is no set time as to how long a queen should be kept, but bear in mind that she will have to give you plenty of young during these six months ready for the spring.

6　Make sure that you check for disease just before the last bee settles in for Winter. The most common malady is European Foul Brood (EFB). In this disease, the worker, and the drone larvae die giving off a nasty 'glue-pot odour'. Nosema is another serious complaint and is quite similar to dysentery. But if you're in any doubt at all about recognising or curing a disease, contact your nearest veterinary surgeon who, if unable to help, will put you in touch with someone who can.

There is one setback which you must expect to come across when you own a hive, and that is swarming. At any time during the summer the queen can summon her workers and drones and together they will disappear over the rooftops.

There are many reasons for this. One could be lack of space in their hive, or a decline in nectar in their area; even the weather can cause swarming. Real prime swarms generally appear from mid-May to mid-June and unfortunately there isn't a great deal you can do about it except perhaps to rub a few leaves of lemon balm (Mellissa officinalis) around the inside of the hive which I'm told tends to attract bees and therefore may deter them from leaving.

Another method is the clipping of the queen's wings. In so doing, should her bees swarm, it is impossible for her to fly with them; and as they are her subjects, they would not leave without her. But this is horribly cruel because all you need to do is to collect the swarm (once it has settled) is to place an open box beneath them and brush the cluster of bees into it with a branch.

Honey is produced in two forms—comb and extracted. If the honey is required for bottling, a 'super' (designed for the collecting of surplus honey) should be used; each one holding some

shallow frames and fitted with a sheet of wired wax foundation. As the honey flow gets under way, the worker bees build out the cells, fill them up with honey and secure (cap) them with a thin layer of wax. These cappings are then sliced off the supers with a knife, placed in a honey extractor and by centrifugal force, separated from the cappings and the honey drained off.

On the other hand, comb honey can be got by fitting square wooden sections to the supers, each containing a thin piece of wax foundation. In the same manner as above, the bees build out the foundation, fill the cells with honey and seal them over. When finished, the comb honey is cut away from the wooden frames in one piece and is equally as nice to eat.

The first thing to remember when dealing with honey is not to collect it too early from the hives; the simple reason being that the surplus honey is needed for the expansion of the colony. The best time is when the honey flow is at its highest. No precise time can be given for this occurrence, so you will have to use your own observation and discretion when judging the time to begin collecting from the hives.

Although it is not absolutely necessary to have a suitable workshop where you can store your extracting equipment, it is best to keep all your activities well away from your house as the wasps and bees will soon make it their business to enter and forage around for goodies. If you have a small shed, this will be ideal except one or two modifications will be needed.

In the first place make sure there are no holes in the wood or around the door for the bees to enter and secondly, a bee escape will have to be installed in the window. This can be easily done by fixing a piece of glass half an inch shorter than the window frame, so that there is a space at the bottom. Half an inch outside this, another strip of glass should be fixed, but this time only 2 inches deep. What happens is that if any bees are carried into the workshop they will automatically make for the light, climb up the inside glass, but on reaching the top, drop to the bottom and start climbing again: this time they will climb up the small piece of glass and so get out. For some reason, bees rarely reverse their actions so it is quite

bee-proof.

Inside your shed, a small bee-proof cupboard should be constructed in which your supers and honey can be kept quite safely.

The essential extracting equipment is a bit expensive but should you want some pure honey to slap between your bread you don't really have any alternative.

The only necessary piece of machinery needed is the extractor itself. For one capable of producing 36 lb of honey you will probably not get it for less than £16; other extractors in this price range are £18 and suitable for holding 46 lb of honey, or £22 for a 63 lb extractor. For only one hive the £16 one will be fine. In each case the basic principle is the same: the rapid revolution of the combs inside the extractor causes the honey to fly outwards against the tank wall and run down to the bottom, where it is drained off into tins ready for cleaning.

Here again, if you are not careful, you may be persuaded into buying equipment which you don't really need—the storage tank is a prime example. This tank, priced around £8 is designed for the separating and straining of honey, but the same result can be got by straining the honey through a cone-shaped strainer and into the waiting honey jars: all the honey impurities will be trapped and can be disposed of in due course.

The removing of the honey from the supers is quite straightforward and if you follow a set pattern you should have no trouble at all. Before you open the hive to take out the supers it is advisable to make sure that the hive is relatively free from bees and a way this can be done is by fitting a 'Porter escape' over the entrance to the brood chamber in the morning. This simple mechanism is designed to allow the bees to fly out of the hive but completely prevents them from returning.

Carefully take out the supers (this technique will vary according to the make of hive) and carry them into your workshop. This should be done preferably when the weather is warm, but not too hot as the heat may melt the honey before it can be extracted properly. With a hot knife (one which has stood in hot water for a few minutes) cut off the honey combs from the supers and place them in the extractor until the

Common garden bee and Field cuckoo bee.

machine is full. Slowly turn the extractor handle until you begin to hear the honey pattering against the cylinder sides and then increase the revolutions for a while until the combs are empty. Whilst this is taking place, the honey in the base of the extractor must be drained off into some large tins and put aside for straining.

Once all the honey has been extracted from the combs and drawn off, the equipment must

then be cleaned out. This can be done by closing the valve where the honey has drained out and filling it with a gallon of cold water. Keep swilling this round until the inside is spick and span and drain off. (This water can be saved to make mead or honey vinegar later on.) Carefully dry the inside with a clean cloth and store the extractor away with another piece of cloth draped over it for protection.

The method by which the bees wax can be

obtained is as follows. Wash the combs in warm water and place them in a pan of hot water over a low flame. As it melts, the finer impurities will rise to the top where they should be skimmed off. Leave both the wax and water to cool, pour off the water and remove the wax from the pan. This wax can then be moulded into small cakes by placing it in a small pan, set into a larger one of boiling water. Once it has melted it can then be poured into a mould and left to set. The choice of mould is up to you but a jelly mould or a cup is good enough.

Bees-wax mixed with other ingredients is ideal for many household uses as the examples here show:

Beeswax & Turpentine Polish: Melt one pound of beeswax, and as it cools down, stir in a quart of turpentine. If it seems too thick, more turpentine can be added.

Furniture or shoe cream (a): Cut into small pieces, 8 oz beeswax, 1 oz white wax, 1 oz Castile soap and boil for twenty minutes in a quart of rain water. When the mixture is nearly cold, add a quart of turpentine and shake until a good cream is formed.

Furniture Cream (b): 1 pint turpentine, 1 pint of rain water, 2 oz white wax, 3 oz beeswax, 2 oz Castile soap, $\frac{1}{3}$ oz spermaceti. Melt all the wax and stir in the pint of turpentine. Boil the soap in the rain water, mix it all well together and add the spermaceti when cool.

Black Wax: Melt together 2 oz beeswax and $\frac{1}{2}$ oz burgundy pitch and add $1\frac{1}{2}$ oz of fine ivory black.

Fruit Bottle Covers: 2 oz beeswax, 4 oz resin, $\frac{1}{2}$ oz vaseline. Melt these together in a tin and brush evenly over pieces of linen or calico. When a cover is required for use, apply to the hot jar and press down firmly.

Country folk in all the four corners of the world recognise honey as containing many medicinal characteristics. Lots of people think of honey as the best cure for a sore throat (which it probably is) and, due to its antiseptic qualities, *is one of the most useful things to apply to abrasions and burns.*

Honey Tea: For severe digestive disorders a tablespoon of honey dissolved in a cupful of hot water will be beneficial to take several times a day. Sip it slowly on an empty stomach.

Honey and Lemon Tea: Add the juice of half a lemon to a tablespoonful of honey dissolved in a cupful of hot water. This is very good for liver disorders and complexion blemishes. If it is taken as hot as possible before going to bed, it will often ward off a cold.

Honey and Yarrow: To an infusion of yarrow, add a good teaspoonful of honey and drink it hot at bedtime and on rising in the morning. This is widely recommended for influenza and as a tonic.

Honey and Milk: Mix a teaspoonful of honey with a cupful of warm milk and take it last thing at night as an ideal cure for insomnia. It is also highly recommended for stomach ulcers and anaemia.

Honey and Glycerine: A really nice cure for a cold or a sore throat is a mixture of 2 teaspoonfuls of honey and 1 teaspoonful of glycerine in a cupful of hot water.

Linseed and Honey: Boil 1 oz of linseed in a pint of water for half an hour. Strain, add the juice of a lemon and sweeten the mixture with honey. Drink this hot at bedtime.

Cough Candy: Boil horehound leaves in water, strain through muslin and add as much honey as desired to the liquor. Boil until the candy can be made into a soft ball when dropped into water. Pour the mixture into greased tins and leave it to set.

Honey is also ideal for ointments and cosmetics and is widely known as having great value in curing certain skin troubles.

Honey and Glycerine: In equal parts this mixture is ideal for bruises, and chaps on the face or hands.

Cure for Chilblains: Mix 1 tablespoonful of honey with an equal quantity of glycerine, the white of an egg and enough flour to make a fine paste. (A teaspoonful of rose water is helpful.) Wash the affected parts well with pure soap and warm water, dry thoroughly and spread the paste over. Wrap up with a cotton cloth, as this ointment is very sticky.

As with other natural foods like milk, fruit, green leaves and nuts, honey is at its best when eaten raw, but that doesn't mean to say it isn't beneficial when mixed with other good things and baked in an oven.

Grapefruit and Honey: Simply scoop a hole in the pulp of the fruit and put in two or three teaspoonfuls of honey. (Very nice this one.)

Honey Plum Butter: Wash some plums and cook them gently in water till soft. Pass them through a sieve and for each cup of pulp add half a cup of honey. Cook slowly until thick and jelly-like and then pour the mixture into hot sterilised jars, sealing them securely.

Plain Honey Cake: Beat together well $\frac{1}{2}$ pint of sour milk, 6 oz Barbados sugar and 4 oz of honey. Work all this well into 10 oz of wholemeal flour and bake the mixture in buttered tins from a half to three-quarters of an hour and serve hot.

Honey Gems: Add 6 oz honey to 1 pint of sour milk. Mix in enough wholemeal flour to make a soft dough and bake the mixture in heated tins.

Mead: There are numerous recipes for this drink, some of which contain herbs, spices and fruit etc., but the simple fermented liquor is equal to anything more complicated.

If made with fresh honey, 4 lb should be used to each gallon of water and some folk think it improves the flour if lemon peel is added. Boil the honey and water for an hour, skim any frothy impurities from the surface and pour it into a tub or any large receptacle. Add 1 oz of yeast per gallon either by mixing it first in warm water or floating it on the liquor on a piece of toast. When fermentation has started, strain off the liquor into a clean vessel,

but keep it lightly covered until it has stopped working. When the fermentation has stopped, pour the liquor into bottles and cork them securely. You should then leave the mead in a temperature of about 70°F for a year. (A kitchen is probably the ideal place for storing.)

Honey and Oatmeal: This non-alcoholic drink is made by putting 2 tablespoonfuls of oatmeal into a quart jug nearly filled with fresh boiling water. Cover the jug and let it stand for 24 hours. In another jug dissolve 3 tablespoonfuls of honey in a little boiling water and the juice of 2 lemons. Strain the oatmeal water into this and it is ready for use. This drink may be made with pearl barley instead of oatmeal and lime juice instead of lemons.

IN THE USA
SOURCES OF MATERIALS

In the United States, bees are usually sold separately from hives, and are priced according to weight. A three-pound package would probably include a queen and between 10,000 and 12,000 bees.

Your agricultural extension agent (see p. 197) should be able to supply you with names and addresses of nearby apiaries and shops for beekeeping equipment, and answer any questions you may have. Included in the bibliography are several pamphlets published by the government which the agent may also be able to provide.

From most of these suppliers you can mail order bees and beekeeping equipment.

DADANT AND SONS, INC., Hamilton, Ill. 62341. *Free catalog.*

DIAMOND INTERNATIONAL CORP., Apiary Dept., Chico, Calif. 95926. *Free catalog.*

WALTER T. KELLEY BEE SUPPLY SUPER MARKET, Clarkson, Ky. 42726. *Free catalog.*

LOS ANGELES HONEY CO., 1559 Fishburn Ave., Los Angeles, Calif. 90063. *Free catalog.*

A.I. ROOT CO., P.O. Box E, Medina, Ohio 44256. *Free catalog. No longer sells package bees because of the vicissitudes of mailing.*

SOCIETY

AMERICAN BEEKEEPING FEDERATION, c/o Bob Banker, Rte. 1, Box 68, Cannon Falls, Minn. 55009. *Membership $10 a year. Annual convention and quarterly newsletter. Publishes special literature for hobbyists and has lists of beekeepers and suppliers throughout the U.S.*

BIBLIOGRAPHY

BEEKEEPING, by John E. Eckert and Frank R. Shaw/Macmillan, New York.

BEEKEEPING, by Lillee D. Zierau/Samhar, New York.

BEEKEEPING: THE GENTLE ART, by John F. Adams/Garden Way, Charlotte, Vt.

BEES, by Karl Von Frisch/Cornell University, Ithaca, N.Y.

COMPLETE GUIDE TO BEEKEEPING, by Roger A. Morse/Dutton, New York.

THE DANCING BEES, by Karl Von Frisch/Harcourt Brace Jovanovich, New York.

FIRST LESSONS IN BEEKEEPING, by C.P. Dadant/Dadant and Sons, Inc. (see sources of materials).

FOLK MEDICINE, by D. C. Jarvis/Fawcett World, New York.

HERBAL HANDBOOK FOR FARM AND STABLE, by Juliette de Bairacli Levy/MeadowBrook Herb Garden, Wyoming, R.I. 02898. *Includes a section on herbal cures for bee illnesses.*

THE HIVE AND THE HONEY BEE, edited by Roy A. Grout/Dadant and Sons (see sources of materials).

HOW TO KEEP BEES AND SELL HONEY, by Walter T. Kelley/Walter T. Kelley Bee Supply Super Market (see sources of materials).

QUEEN REARING, by Harry H. Laidlow, Jr., and J. E. Eckert/University of California, Berkeley, Calif.

SELECTING AND OPERATING BEEKEEPING EQUIPMENT, U.S. Dept. of Agriculture/available for 15¢ from Superintendent of Documents, Government Printing Office, Washington, D.C. 20402.

The following bulletins are available free (while the supply lasts) from the Publications Division, Office of Communication, U.S. Dept. of Agriculture, Washington, D.C. 20250.

BEEKEEPING FOR BEGINNERS, G 158.
USING BEES TO POLLINATE CROPS, L 549.

Journals

THE AMERICAN BEE JOURNAL, Hamilton, Ill. 62341. *Monthly, subscription $5. Includes market news, practical information, scientific reports, industry news, and suppliers' ads.*

GLEANINGS IN BEE CULTURE, c/o A.I. Root Co., Box E, Medina, Ohio 44256. *Monthly, subscription $5. Covers entire field of beekeeping, including articles about the latest developments and easiest new methods and historical articles; suppliers' ads.*

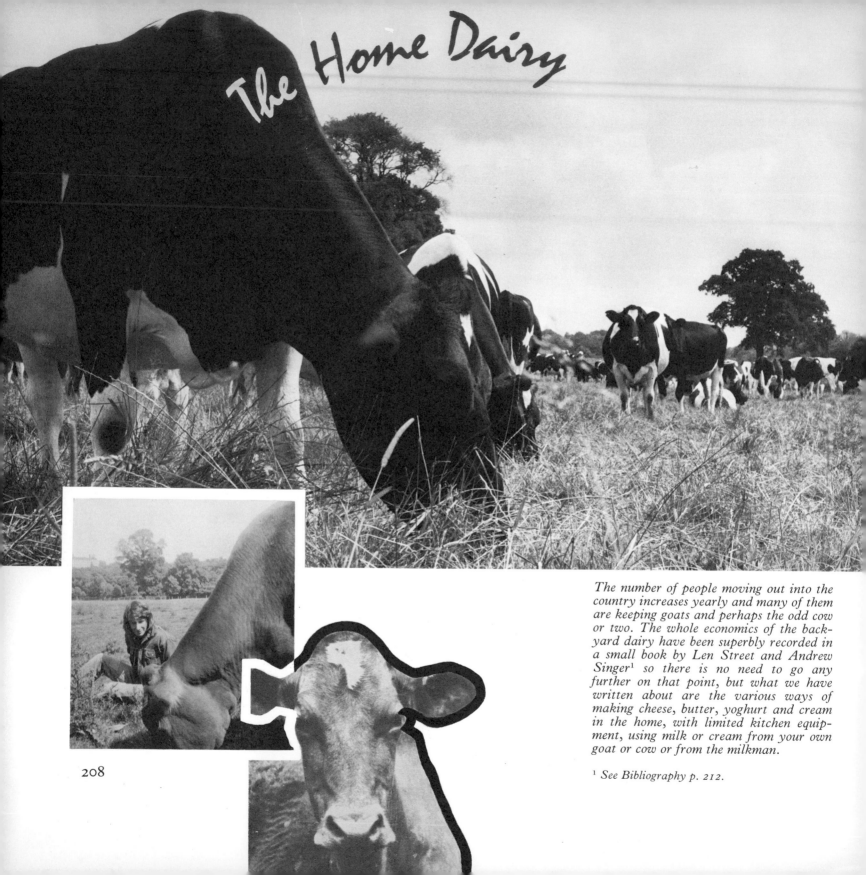

The Home Dairy

The number of people moving out into the country increases yearly and many of them are keeping goats and perhaps the odd cow or two. The whole economics of the back-yard dairy have been superbly recorded in a small book by Len Street and Andrew Singer[1] so there is no need to go any further on that point, but what we have written about are the various ways of making cheese, butter, yoghurt and cream in the home, with limited kitchen equipment, using milk or cream from your own goat or cow or from the milkman.

[1] See Bibliography p. 212.

208

Cheese is simply the curd of milk coagulated, separated from the whey and pressed into a mould or processed into many differing forms. There are, however, two basic types of cheese: '*Lactic cheese*' which needs no rennet to coagulate the curds and is produced by allowing milk to sour for a certain time and then straining, and '*Rennet*' cheese, a normally hard cheese that has rennet as a ripening agent to coagulate the curds. As vegetarians we will only deal with easily-produced soft '*lactic*' cheeses, because rennet is a substance obtained from animal sources. However, there are one or two ways of separating milk using a rennet 'substitute'. Both marjoram and sorrel (when crushed and their juices extracted) will coagulate the curds. The juice of one or the other herbs can be used, or mixed together, and by experimenting with different quantities and mixtures, an efficient substitute can be prepared.

There may arise certain difficulties where pasteurised milk from the milkman is concerned. If left to sour, it may go bad and end up smelling highly unpleasant. This is because the process of pasteurisation kills off the natural bacteria in the milk and so becomes highly susceptible to outside bacteria. To overcome this, the juice of one or two lemons should be added to every gallon of milk. If the milk still goes bad, try using more lemon juice.

Cottage Cheese (1ST METHOD)
Allow a quantity of milk (*preferably skimmed : skimmed milk is what is left after the cream has been removed*) to sour well until it begins to coagulate and then strain through muslin. The remaining curds can either be mixed with cream and served as a delicious cottage cheese, or pressed between two flat bread boards or plates so that a solid form is made.

Cottage Cheese (2ND METHOD)
Use only soured skimmed milk. Heat the milk gently until the curds begin to appear and after removing from the heat, allow to cool naturally. Strain as described above.

Pot Cheese
Add together in a saucepan, 2 quarts of sour milk and 1 quart of buttermilk. Heat till nearly boiling and the curds appear. Remove the curds from the whey and put them in a muslin bag, tie tightly and allow to drain for an hour or longer. Remove the curds from the bag, add a little salt and then mould the pieces into balls. Let the balls cool for a few hours and then serve.

Cream Cheese
(1) DOUBLE-CREAM CHEESE
Obtain as much double cream as you can (1 lb of cheese is obtained from about 1 pint of double cream) and lay a piece of muslin around the inside of a sieve or colander and pour the cream into it. Keep at a temperature of about 40°F (fairly low) for about 12 hours. Place a lid or some other flat object over the cream and add weights to lightly press it for about 4 hours, then serve.

(2) ORDINARY CREAM CHEESE
To your muslin-lined sieve or colander add as much single cream or rich fresh milk as you can add and simply leave for three or four days. Nothing to it, and ready to eat.

Quark Cheese
Obtain as much natural yoghurt as possible and let it sour. Drain the yoghurt through muslin bags and serve as desired.

Indian Soft Cream Cheese
For this cheese, tartaric acid is needed (available at many chemists). Heat a quantity of milk to the boil and then remove from the heat. Stir in a cupful of tartaric acid and hot water ($\frac{1}{4}$ of a teaspoonful to each cup) at the rate of one cupful to every $1\frac{1}{2}$ pints of milk, and stir well until the curds appear. Strain the mixture into muslin bags and press the curds to form 'hard' blocks.

With all these cheeses, chopped herbs such as sage, chives and garlic etc., can be added in the final stages which will produce delicious alternatives to the plain recipies.

CREAM

Cream is the fatty part of milk that separates and rises to the surface. It has to be skimmed from the top of the milk and this is possible in a number of ways. The easiest way is to pour the fresh milk into a wide shallow pan and leave it for about 24 hours until the cream has separated. By using a saucer, the risen cream can then be scooped off the surface. Another method is to pour the milk into a large glass container like a wine fermenting jar and leave again for 24 hours. Then, using a rubber tube, and by inserting it down into the jar just below the bottom level of the cream, the skimmed milk can be syphoned off, leaving just the cream behind. For both these methods, the milk must be left to separate in a cool place. Use the remaining skimmed milk for cheese making.

Clotted Cream
Stand the fresh milk in a heat-proof pan in a cool place for 24 hours. Only allow 8 inches depth of milk for each pan. Next, heat the milk very gently to 160°F until the cream begins to form at the sides. Remove from the heat and allow to cool. The clotted cream can then be skimmed from the surface.

BUTTER

Butter is obtained from cream by '*churning*', i.e. shaking the cream until it coagulates into a lump. What is left is called buttermilk and should not be thrown away as it can be used to make cheese. Butter can be made from either ordinary skimmed cream or clotted cream.

METHOD
To make butter successfully, the temperature for churning needs to be correct, about 50°–60°F, and slightly warmer in cool weather and cooler in warm weather. The simplest way to make butter is to put the cream in a bottle and shake it for a couple of hours. This invariably is a tiring process and it is easier to put the cream in a bowl and activate it with a spoon for about half an hour until the colour changes. The grains of butter will then soon appear and after straining through a muslin bag, wash them in water to remove the buttermilk and squeeze the grains into one lump.

If you own a foodmixer, this is by far the easiest method. Set the machine up on the slowest speed with the cake-mixing attachment

fitted. Add the cream slowly, mixing all the while until all the cream is in the mixing bowl. Wait for the colour change again and when the butter grains have appeared, strain as described above, and wash with water. The remaining grains are then similarly squeezed into one lump.

Home-made butter will be a very pale colour and if the familiar golden yellow colour is desired, then annatto, a vegetable colouring, can be added. Salt can also be added if desired. The rate of salt per 1 lb of butter is a matter for personal taste but normally, 1 teaspoonful is used for each 1 lb.

YOGHURT

Yoghurt is made by adding a 'culture' or bacteria to milk, which then breeds in the milk and produces a creamy substance with a distinctive soured flavour. There are a number of cultures available on the market, the most easily available being *Lactobacillus Bulgaris*, a culture supposedly originating from Bulgaria. There are also innumerable yoghurt culture kits, yoghurt making machines and yoghurt thermos activators etc. available, but they are all totally unnecessary and a gross waste of money. If you can just get hold of a few lumps of the culture, that is all that is needed, for it breeds in milk reasonably quickly so that after a few weeks, large quantities of yoghurt will be produced and the culture will then have to be split and one half given away to a friend. A culture I was given about two years ago has been split in this way about two dozen times and the culture sent all over the country.

Having obtained the culture all one needs is a glass bowl (don't use steel or plastic). Pour in a pint of milk and add the culture. The culture looks rather weird—white lumps rather like pieces of polystyrene. Part cover the bowl with a plate and put it in a warm place. The quantity of resulting yoghurt will vary according to the proportion of culture to milk and the temperature at which they are left. For instance, a little culture in a lot of milk in a cool place will create yoghurt very slowly. As a general guide, half a cupful of the culture to 1 pint of milk in a warm place will take about 24–30 hours to make a solid bowl of yoghurt.

To separate the culture from the yoghurt a metal strainer or sieve is needed. Simply pour the contents of the bowl into the strainer and work the yoghurt through gently with a wooden spoon. All that will be left in the strainer will be the lumps of culture, which are then placed back in the bowl and covered with another pint of milk. A sort of greyish mould will appear on top of the milk when the culture is working but don't worry about this as it is all good stuff and disappears on straining. One important point is to try and get a strainer with a medium-sized mesh: too fine a mesh will tend to liquify the yoghurt.

The strained yoghurt can then be eaten immediately, or left for another day which tends to thicken its consistency.

There are other methods for yoghurt making, but all of them involve special temperatures and other complications: anyway, no yoghurt tastes as good as that which is obtained from a culture.

IN THE USA

SOURCES OF MATERIALS

It is most convenient and least expensive to purchase the materials mentioned in this chapter from your local druggist. However, if you are unable to find any of the ingredients used to make cheese, butter, cream, or yoghurt, you may wish to try some of the following suggestions.

Cheese

CHR. HANSEN'S LABORATORIES, INC., 9015 West Maple Street, Milwaukee, Wisc. 53214. *Carries both animal and vegetable rennet. Booklet 10¢ (postage).*

HOME CHEESE MAKING, P.O. Box 2206, Madison, Wisc. 53701. *Will mail order a rennet-like product called Marzyme, which is derived from a vegetable source.*

If you are unable to obtain tartaric acid used in making Indian Soft Cream Cheese you may substitute citric acid, which can be purchased in a drugstore, or you can buy sour salt in the spice section of your local supermarket.

SWITZERLAND CHEESE ASSOCIATION, 444 Mad-ison Avenue, New York, New York 10022, will send you a free kit on *"Everything You Need to Know To Make Cheese In The Same Manner The Swiss Have Been Using For 2000 Years."* This kit includes illustrated, step-by-step instructions for making your own cheese, a glossary of cheesemaking terms, a 36" × 26" wall chart illustrating cheesemaking in Switzerland, and other interesting items.

Butter

CHR. HANSEN'S LABORATORIES, INC. *(see above) sells Annatto, used for coloring butter and cheese, and Pocket Type Dairy Thermometers ($7 each). Please send check or money order when ordering.*

Chr. Hansen's also offers, a free, illustrated chart on "How to Make Butter on the Farm." The chart, arranged so that you can have the important steps in buttermaking in front of you while you work, is a summary of the Department of Agriculture's Farmers' Bulletin No. 876, which is no longer available.

SEARS, ROEBUCK AND CO., Dept. 139, 2650 E. Olympic Blvd., Los Angeles, Calif. 90051, or Dept. 139, 4640 Roosevelt Blvd., Philadelphia, Pa. 19132. *In the "Suburban, Farm and Ranch Catalog" you will find butter churns.*

Yoghurt

To obtain cultures for making yoghurt you may use one of many sources. First, consult your yellow pages for health food stores in your area. Otherwise you can mail order from:

CHR. HANSEN'S LABORATORIES, INC. (see above).

NEW JERSEY LABORATORIES, INC., P.O. Box 748, New Brunswick, N.J. 08903.

BIBLIOGRAPHY

CHEESE AND FERMENTED MILK FOODS, by Frank V. Kosikowski/Edwards Brothers, Inc., Ann Arbor, Michigan. *If this rather expensive but highly informative book full of illustrations is in your library, it is well worth looking at.*

CHEESE VARIETIES AND DESCRIPTIONS, AH 54, U.S. Department of Agriculture/available

for 65¢ from the Superintendent of Documents, Government Printing Office, Washington D.C. 20402.

THE COMPLETE YOGURT COOKBOOK, by Karen Cross Whyte/Ballantine, New York.

MAKING HOMEMADE CHEESES AND BUTTER, by Phyllis Hobson/Garden Way, Charlotte, Vt.

MAKING YOUR OWN CHEESE AND YOGURT, by Max Alth/Funk & Wagnalls, New York.

Further Useful Information

UNITED KINGDOM

JOURNALS

Some of these may be of interest to Americans. Write for subscription price and further information.

AGRICULTURAL ABSTRACTS/Bee Research Association, Hill House, Chalfont St. Peter, Gerrards Cross, Buckinghamshire SL9 oNR. *Quarterly.*

AMATEUR WINEMAKER/C. J. J. Berry and M. F. Berry, South Street, Andover, Hampshire. *Monthly.*

BEE CRAFT/The British Beekeepers Association, Available from the secretary, 17 West Way, Capthorne, Sussex. *Monthly.*

BEEKEEPING/Devon Beekeepers' Association, 36 Seaton Down Road, Seaton, Devon. *Eight times a year.*

BEE WORLD/Bee Research Association, Hill House, Chalfont St. Peter, Gerrards Cross, Buckinghamshire SL9 oNR. *Quarterly.*

BIRDS AND COUNTRY MAGAZINE/available from 79 Surbiton Hill Park, Surbiton, Surrey. *Quarterly.*

BULLETIN OF THE AMATEUR ENTOMOLOGIST SOCIETY/Available c/o K. H. Bobe, 50 Winn Road, Lee, London SE13.

CERAMIC DIGEST/Ceramic Digest Ltd., 34 Townsend Drive, St. Albans, Hertfordshire. *Quarterly.*

CERAMIC REVIEW/The Craftsmen Potters Association, William Blake House, Marshall St. London W1. *Bimonthly.*

CERAMICS/Turret Press Ltd., 65–66 Turnmill St., London EC1 M5 RA. *Monthly.*

ENTOMOLOGIST GAZETTE/353 Hanworth Road, Hampton, Middlesex.

ENTOMOLOGIST MONTHLY MAGAZINE/c/o Nathaniel Lloyd & Co. Ltd, Burrell Street Works, Blackfriars, London SE1.

THE ENTOMOLOGIST RECORD/c/o F. W. Buyers, 59 Gurney Court Road, St. Albans, Hertfordshire. *Monthly. Illustrated magazine devoted to insects with reports on collecting trips, distribution habits, and study techniques.*

FARMERS WEEKLY/Agricultural Press Ltd, 161–166 Fleet Street, London EC4P 4AA.

HOME BEER & WINE MAKING/Foremost Press Ltd, P.O. Box 1, Wirral, Cheshire L46 0TS. *Monthly.*

IRISH BEEKEEPER/Federation of Irish Beekeepers, Boston Park, Cork, Eire. *Monthly.*

JOURNAL OF THE SOCIETY OF DYERS & COLORISTS/P.O. Box 244, Grattan Road, Bradford 1, Yorkshire. *Monthly.*

JOURNAL OF THE SOIL ASSOCIATION/The Soil Association, Walnut Tree Manor, Houghley, Stowmarket, Suffolk. *Quarterly.*

THE MONTHLY JOURNAL/The British Goat Society, c/o Mrs. May, Lion House, Rougham, Bury St. Edmunds, Suffolk.

POTTERY QUARTERLY/Murray Field House, Northfields, Tring, Hertfordshire. *Irregular.*

POULTRY WORLD/Agricultural Press Ltd., 161–166 Fleet Street, London EC4P 4AA. *Weekly.*

SCOTTISH BEEKEEPER/Standard Printing Works, Grange Place, Kilmarnock. *Monthly.*

SPAN-SOIL ASSOCIATION NEWS/New Bells Press, Walnut Tree Manor, Houghley, Stowmarket, Suffolk. *Monthly.*

STAR AND FURROW/Bio-Dynamic Agricultural Association, Broom Farm, Clent, Stourbridge, Worcestershire. *Bimonthly.*

THE WEAVERS SPINNERS & DYERS ASSOCIATION QUARTERLY JOURNAL/available from 84 Lordship Park, London N16 5UA.

COURSES

THE REYNTIENS TRUST LTD, BURLEIGHFIELD HOUSE, Loudwater, Buckinghamshire.

The Reyntiens Trust was formed in 1970 to encourage education in the arts, and to promote courses and exhibitions at Burleighfield House Studios and Gallery. It is administered by Patrick Reyntiens and Anne Bruce.

Burleighfield House was built in 1864 by Ford, the inventor of blotting paper, whose factory until lately existed in Loudwater. The house is set in a 7-acre romantic over-grown Victorian garden, and its stables and buildings have been converted to make a variety of well-equipped studios. A recent addition is a large new studio complex under one roof in its grounds.

Courses are intended to provide tuition and facilities for students of all ages and at different stages of development, including the professional. Subjects include Drawing, Painting, Pottery, Construction and Stained Glass. Lithography and Etching are taught in the studios of Burleighfield Printing House. The major course at Burleighfield is Stained Glass and although it is possible to attend this course by the day, it is generally understood to be a residential course. A children's weekend art school is also held at Burleighfield.

For further details of the courses available at Burleighfield write to the address above.

WEST DEAN COLLEGE, Chichester, Sussex.

West Dean College, owned by the Edward James Foundation, is unique for the vast range of courses it offers in traditional crafts, many of which are now threatened with extinction. The Foundation also owns approximately six thousand acres of farms and woodlands; some one-hundred-and-fifty farmhouses and cottages; two country houses, magnificent collections of paintings, furniture and other objets d'art, some of which are on loan to the Tate Gallery, the Royal Pavilion at Brighton, the Victoria and Albert Museum and the Worthing Museum and some of which are in the College. An arboretum of seventy acres adjoining the lands of the Foundation contains many rare and magnificent trees and has been made available to the Foundation for the furtherance of its education work. The Foundation has leased areas of land to the National Environmental Council for a nature reserve and to the Weald and Downland Open Air Museum at Singleton.

A selection of the following list of subjects will be used in future programmes as the College develops:

GROUP 1 *(subjects which lend themselves to short courses)*
Basketry, Butter making, Calligraphy, Candle making, Car and cycle maintenance, Cheese making, Clog making, Collage, Cookery: country fare, national, international, Crochet, Crook making, Fan making, Flower arrangement, Glove making, Horn —working in, Knitting, Millinery, Netting, Pipe making, Raffia work, Rope work, Rug making, Rush weaving, Smock making, Soft furnishing, Straw crafts, Straw marquetry, Tortoiseshell—working in, Toy making, Trug making, Upholstery, Walking stick making, Wax—working in, Willow work, Wine making.

GROUP 2 *(subjects which may be taken at various levels)*
Angling crafts: Fly, rod and tackle making, Archery crafts: bow making and fletching, Blacksmithing, Boat building, Bookbinding, Brazier's work, Canoe making, Cartography, Carving: various media, Ceramics, Chair making, Design for crafts, Drawing —general course, Dress and fashion, Dye making and dyeing, Embroidery—machine, Wall panels and fabric pictures, Modern Embroidery design, Embroidery—hand (various types), Fabric printing, Farriery, Furniture making, Goldsmithing, Hand papermaking, Heraldry, Illuminating, Jewellery—general and lapidary, Lace-making (various types), Leatherwork, Letter cutting—metal, stone, wood, Marquetry, Metal casting—fine, Metal inlay work, Musical instrument making, Painting (various types), Pewter work, Picture print making, Puppetry and marionettes, Sculpture (various media), Sign making, Silversmithing, Spinning, Taxidermy, Weaving, Welding, Wire working (gold and silver), Wood turning and treen, Woven tapestry, Wrought iron-work.

GROUP 3 *(subjects to be studied in depth on extended courses)*
Armourer's work, Glass and crystal making, Glass engraving, Clock making, Gunsmithing, Millwrighting, Organ building, Porcelain, Saddlery and harness making, Stained glass work, Stone masonry—advanced, Wheelwrighting.

GROUP 4 *(major subjects which must be subdivided to make up a course)*
Antiques—conservation of: ceramics and china, furniture, pictures, objets d'art,
Building and restoration: Bricks, handmade, Brickwork, Chalk—building in, Cob—building in, Cobble paving, Drystone walling, Flint walling, Gesso work, Gilding for inscriptions, Lead moulding, Painter-stainer's work, Pargetting, Pisé, Plaster work, Slate work, Stone masonry—including restoration, Wattle and daub,

Home maintenance: Carpentry, Electrical maintenance, Heating systems, Painting and decorating, Plaster work.

GROUP 5 (mainly out-door activities)
Archery, Beekeeping, Coppice work, Coracle making, Fence making, Fencing, Field archaeology, Gamekeeping, Gate making, Hedging, Hurdle making, Ladder making, Natural History (with outings), Sheep shearing, Stile making, Thatching.

GROUP 6 (general interest subjects mainly lecture based)
Archaeology, Architecture, Art appreciation, Astronomy, Costume design (theatre) and make-up, The English Country Church, The English Country House, The English Country Life, Fashion design, Folk art: general, canals, circuses, fairgrounds, gipsies etc.
History of: Antiques, Art, Ceramics, Church brasses, Costume and fashion, Crafts, Falconry, Gardens, Heraldry, Horology (including sundials), Horse brasses, Jewellery, Mills—wind, water and tide, Musical instruments, Puppets and marionettes, Signs—inn, shop and ships' figureheads, The theatre, Weather vanes, Industrial archaeology, Interior decoration, Local history, Meteorology, Monuments and church brasses, Musical appreciation, Photography, Production and organisation of craft workshops, Theatre design.
Write to the College at the address given above for details of courses in which you are interested.

CRAFT OUTLETS

Bedfordshire
BEDFORD CRAFTS CENTRE, Emma Russell, 6 Newnham Street, Bedford.
A large selection of craftwork, hand made by British craftsmen and craftswomen, including pottery, glass, rush-work, woodware, jewellery, lamps, alabaster, hornware, hand-woven ties, soft toys and many other items.
DOREEN CHETWOOD, Woodlands Craft Centre, Thurleigh Road, Milton Ernest, Bedford.
Craftwork from Bedfordshire—pottery, jewellery, toys, hobby-horses, woodwork, mobiles, crochet, rush-work, corn-dollies, lace and Woodlands pottery.
Art exhibitions are often held.
SERENDIB, 15 Market Place, Woburn. Colin and Marianne Mulrenan.
A wide range of hand-crafts from all over Britain, including work by many local craftsmen. Serendib was the name given to Ceylon by Arab traders of 1,500 years ago where they found many exotic and rare products.
CARRIE LOVELL, ARTS AND CRAFTS, Slicketts Lane, Edlesborough, nr Dunstable.
Shed in the garden containing large stock of pottery (by Brendan Maund), pillow lace, tatting, crochet jewellery, soft toys, corn-dollies, basket-work, shell pictures, candles, etc.
THREEHOUSEHOLDS GALLERY, Threehouseholds, Chalfont St Giles.
Local artists and craftsmen display paintings, pottery, enamels, woodcraft, etc., in a seventeenth-century setting.

GRAHAM & ANNE FLIGHT, The Craft Shop, 12 High Street, Bassingbourn.
Stoneware and earthenware pottery, prints, enamels, embroidery and collage pictures, toys, knitted and crochet goods and a selection of hand-made craft goods.
PRIMAVERA, 10 King's Parade, Cambridge.
Famous for pottery, glass, textiles, jewellery, toys, lamps.

Cornwall
'THE BARBICAN', Battery Road, Penzance Harbour.
Craft workshops, crafts direct from the makers. Silver jewellery, weaving, needlework, leatherwork, ceramic tiles. Also a craft and pottery shop and a gallery for local paintings and sculpture.
THE SLOOP CRAFT MARKET, St Ives.
Here you can see craftsmen at work.
CARNSEW GALLERY, 15 Penpol Terrace, Hayle.
The work of Cornish artists and craftsmen: ceramic sculpture and murals; paintings; fine studio pottery and porcelain by Tolcarne Pottery, Newlyn.
CELTIC CRAFTS (CORNWALL), Tregony, Truro.
A full range of hand-made West Country craft goods.
CELTIC CRAFTS (LLYSWEN WELSH CRAFT CENTRE):
Church Street, Mevagissey,
Couch's Great House, Polperro,
30 Fore Street, St Ives.
Wide range of tapestry clothing, including capes, skirts and anoraks. Tapestry handbags and purses, sheepskin rugs, sheepskin coats, hats, gloves and slippers.
CONTEMPORARY CRAFTS, 5 The Esplanade, Fowey.
Hand-made copper, pewter and silver jewellery, copper enamelling.
THE CRAFT SHOP, 'Private Bag', 2 Mill Road, Padstow, Cornwall.
Specialists in hand-crafts of all descriptions.
THE CRAFTSMEN'S CENTRE, The Quay, Polperro.
Specialising in West Country craftware. Studio pottery, sheepskin slippers, gloves, etc. Tweeds, ties, rugs, wooden tableware, lamps and toys.
THE CRAFTSMEN'S SHOP, 30 Fore Street, St Ives.
Quality baskets, toys, weaving and jewellery.
CRIFTCRAFT, St Germans, Saltash.
Comprehensive range of Cornish craft-made goods including woodwork, pottery, toys, etc.
CRITERION HOTEL, Cawsand, nr Plymouth.
High-class pottery, jewellery, wood and stoneware, lamps and tweeds, etc., hand-made in the West Country.
FOGOU KNITWEAR AND CRAFTS, Withy Cottage, Porthallow, nr St Keverne, Helston.
Knitwear, basketry, hand-made toys, studio pottery, crochet work, dolls' clothes, camphor-driven model ships, all locally made. Garments knitted to order including Aran.
KERNOWCRAFT ROCKS & GEMS LTD, 9 Old Bridge Street, Truro.
Everything for the lapidary enthusiast—rough and polished gemstones, polishing machines and accessories, jewellery mounts, polished agate dishes and paper weights, stone carvings, books and mineral specimens. Illustrated catalogue available.
MAYFIELDS, The Wharf, St Ives.
West Country stoneware and earthenware, ceramic

jewellery. Tiles, mosaics, table-lamps, silver and pewter jewellery.
NEW CRAFTSMAN, 24 Fore Street, St Ives.
Contemporary furniture and kitchenware, glass, pottery and weaving.
THE SALT CELLAR, Coverack.
Old fisherman's loft converted into shop to sell Cornish craftwork, including hand-made studio pottery, glassware, wood sculpture, silver jewellery, etc. Miniature camphor-propelled model ships are made and sold on the premises.
TAMAR RIVER GALLERY, The Quay, Calstock.
Museum of ship-building, salmon fishing, mining, horticulture and other local interests.
Crafts shop selling a wide range of local hand-made goods.
THIRTY-EIGHT, The Wharf, St Ives. E. H. & M. S. Popple.
Robin Nance hand-made furniture, standard-lamps, turned wooden bowls. West Country hand-thrown pottery, weaving and batik.
TREMAEN CRAFT MARKET, Market House, Penzance.
Retailing all varieties of Cornish craftwork.
TROIKA SHOP, 61 Fore Street, St Ives.
Cornish crafts, pottery, jewellery, clothes, dolls and boutique.

Cumberland
BARKERS OF LANERCOST, Holmefoot, Lanercost, Brampton.
Hand-made goods produced by local craftsmen: couture knitwear, silverware, jewellery, ceramics, fine prints, soft toys and dolls, Roman reproductions in bronze, resin and pot, collage and embroidered pictures. Hookie rugs, Cumbrian bonnets, weaving, stained glass, leatherware, candles.
FINE DESIGNS (RICHARD & ALLAN FISHER), 22 St John's Street and 35 Lake Road, Keswick.
Workshops for woodsculpture, also jewellery in fine metals and stone-setting. Retail craft shops specialising in studio pottery—art metalwork, etc. Producers of reproductions of lakeland wood-carvings. Editions of animal sculptures in bronze and silver.
GREENRIGG POTTERY AND HANDMADE CRAFTS STUDIO, Caldbeck.
A specially selected collection of handcrafts—pottery, Herdwick knitted goods, jewellery, leather and suède work, lamp-shades and local stone products.
KESWICK INDUSTRIAL ARTS, Greta Bridge, Keswick.
Craftsmanship in silver, stainless steel, copper and brass, hand-made by local craftsmen. Brochures of tableware, jewellery and church furnishings posted by return.
LAKELAND RURAL INDUSTRIES, Grange-in-Borrowdale, Keswick.
Old-established specialists in hand-beaten stainless steel and copper in many decorative and practical forms made on the premises. Church and other furnishings designed and made to order. Other Lakeland craftwork on permanent display, e.g., pottery, hand-woven rugs, scarves, etc., pictures, wood-turning, jewellery, soft toys, horn goods, hand-wrought iron-work, local slate and other items.

THE OLD SMITHY, Caldbeck, Wigton.
An unusual craft shop specialising in locally made hand-knitted garments, crochet, pebble jewellery, clogs, shell-work, pottery, Aran and Icelandic knitting wools. Icelandic and Norwegian garments, sheepskins, slippers, baskets, toys, tweeds. Shetland knitwear, pure wool suits, dresses and trouser-suits from the Scottish glens and islands.
ROOKIN HOUSE FARM, Caravan Site and Pony Riding Centre, Troutbeck, nr Penrith.
A wide range of local crafts, of particular interest to horse enthusiasts.

Derbyshire
THE SMITHY, Water Street, Bakewell DE4 1EW.
Crystal, bone china, porcelain and pottery. Antique and reproduction objets d'art. Wrought-iron brackets, lamps, screens, wind-vanes, gates, candelabra, etc.
TIDESWELL DALE ROCK SHOP, Commercial Road, Tideswell.
Jewellery and ornamental work in natural stone. Mineral specimens for the collector, supplies and materials for the lapidary.

Devonshire
CASTLE CRAFT CENTRE, Joan & Basil Elliott, 25 South Street, Torrington.
Decorative candles, pottery, leathercraft, turned wooden goods and rag dolls.
'LITTLE MEADOW COTTAGE INDUSTRY', Mr & Mrs B. P. Hutchins, 'Little Meadow', Venton Lane, Widecombe in the Moor.
Specialists in cane and wicker: cribs, chairs, ottomans, linen-boxes and allied furniture. Other local craftsmen's work offered when available, i.e. plant-troughs, stonework, woodwork and local pictures.
BETTINA MERRIAM, 46 High Street, Honiton.
Craft and kitchen shop offering pictures, pottery, woodcraft, glassware. Kitchen co-ordinates including famous 'Muff' tea-cosy.
CHAGFORD GALLERIES, 20 The Square, Chagford.
British original paintings and hand-made goods. Pottery by leading craftsmen, jewellery, alabaster, weaving, toys, pinewood furniture, wood turnery, glass and enamelling.
DOONE VALLEY WOOCRAFTS, Brendon (4 miles Lynton), North Devon.
Wide selection of West Country crafts. Decorative hand-made pottery. Coffee-sets, vases, table-lamps, ovenware, Sheepskin goods. Large stock of Dartington tweeds and rugs. Woodware, turned bowls, platters, coffee-tables, etc.
GALLERIE MARIN, Appledore.
Original marine paintings by Mark Richard Myers and Peter M. Wood. Wood-carvings by Jack Whitehead and Norman Gaches. Glass engraved by John Ford. Ship jugs and traditional pottery by Harry Juniper. Nautical books, locally made rope mats, traditional Appledore jerseys, ships in bottles, nautical gear and a variety of small gifts in the same connection.
HAND-MADE GOODS, 11 Sycamore Avenue, Dronfield, Derbyshire.
THE LILIAN GALLERY, West Country Arts & Crafts,

15 Market Street, Appledore.
Pottery, basketry, wood-turnery, paintings, original brass-rubbings, art candles. Cottage crafts: sewn, knitted and crocheted. Ceramic cartoons. Sheepskins and leathercrafts. Small wrought-iron items, picture framing.
LOTUS GALLERY, Stoke Gabriel, Totnes.
West Country crafts, pottery, paintings and sculpture.
SERENDIPITY OF SHALDON, nr Teignmouth.
Hand-made glass, pottery, candles, paintings, garden furniture by local craftsmen, hand-made modern jewellery, soft toys. A changing scene of other crafts, kitchenware and many other items of interest.
SIDMOUTH POTTERY & CRAFT SHOP, 74 Temple Street, Sidmouth.
Specialising in pottery but has a range of other craft work.
OTTERY POTTERY, Mill Street, Ottery St Mary.
A wide variety of pottery and other craftwork including batik silk scarves, corn-dollies, turned wood, basketware, glass and candles.
WOODTURNERS (SOUTH DEVON), New Road, Modbury, South Devon.
Quality hand-made fruit- and salad-bowls, bread- and cheese-boards, table- and standard-lamps, furniture, coffee-tables, bench-stools, name-boards, etc. Also pottery, weaving, basket-work, painting, screen-printed fabrics, sheepskins, tapestry work, etc. You may watch woodenware being made.

Dorset
GUILD CRAFTS (POOLE) LTD, The Brewery, Fontmell Magna, nr Shaftesbury.
Potters and woodworkers. Workshop tours. Retail shop.
PILGRIMS CRAFT CENTRE, Shillingstone, nr Blandford.
Hand-made chunky pine furniture in refectory style. Tables, chairs, benches, dressers and four-poster beds. Also a display of paintings and pottery. All goods made by local village craftsmen. Furniture made on the premises.
DAVID EELES (THE POTSHOP), 18 Barrack Street, Bridport.
Pottery, stoneware, slipware and porcelain ovenware, tableware lamps, cider- and wine-jars, platters, small and large individual pieces hand-made furniture, jewellery.
'FLEURSEC' (primary producers and retailers), The Studio, West Street, Corfe Castle.
Dried flowers, grown and processed on the premises. Also pottery, jewellery and many other hand-crafts from the four South-Western counties.
GALLERY 24, Bimport, Shaftesbury.
Paintings, pottery and selected work by artists, craftsmen and designers.
WEST COUNTRY CRAFTS CENTRE, Top of the Hill, Charmouth.
A wide range of craftsmen-made goods, including pottery, jewellery, toys, coffee-tables and stools, Dartington Tweeds, rugs and glass, original oil-paintings and prints.

Durham
MEANDER, 58 Saddler Street, Durham.

The purpose of Meander is to promote local art and craft by providing a place where these can be exhibited and sold. Exhibits cover a wide range of skills, including paintings, prints, tapestries, pottery, decorative candles, hand-made jewellery, leather craft, brass-rubbings, historic seals, etc.
Special exhibitions are held from time to time.

Gloucestershire
CAMPDEN POTTERY & CRAFT SHOP, Leasbourne, Chipping Campden.
Hand-thrown pottery made on the premises. Other crafts available including weaving, wood and stone carving, corn-dollies, baskets and costume jewellery. Wooden toys a speciality.
COUNTRY CRAFTS, The Chestnuts, Bourton-on-the-Water, also at Welsh Crafts, High Street, Bourton-on-the-Water, and Celtic Crafts, Digbeth Street, Stow-on-the-Water.
Wide range of tapestry clothing, including capes, skirts and anoraks. Tapestry handbags and purses, sheepskin rugs, hats, gloves and slippers.
RIVERSIDE STUDIO POTTERY, Riverside, Priding, Saul.
Craft pottery centre, work by many well-known potters. Hand-made pottery, tankards, lamp-bases, jugs, traditional frog-mugs, high-temperature tableware, extruded ceramics, pottery animals, birds.

Hampshire
COUNTRY COUSINS, Commercial Road, Bournemouth.
HEAD RETAIL STALL, Tricorn Market, via Clive Rogers, 70 Marmion Road, Southsea.
Studio pottery, Welsh tapestry clothing and other British tweeds. Hand-woven shawls and rugs. Ceramic jewellery. Suèdecraft.
THE POTTERY & CRAFTS SHOP, High Street, Bishop's Waltham.
A wide range of pottery and stoneware, both functional and decorative. Wooden tableware, hand-carved leather stools, handbags, belts, etc., suèdecraft, candles, sheepskin rugs, jewellery in silver, pewter, copper and wood, original paintings in watercolour and oils.
STRAWBERRY FAYRE, High Street, Stockbridge.
Traditional village industry. Hand-made patchwork, crochet, medieval furniture and children's toys.

Herefordshire
'CEEJAY', 5 High Street, Ross-on-Wye.
Baskets, wrought iron, wooden ware, pottery, jewellery, leather handbags. Welsh tapestry goods and tweeds, sheepskin rugs, hand-beaten stainless steel and copper, glass and hornware and numerous types of toys.
THE CRAFTS SHOP, Bell Square, Weobley.
Hand-made crafts by British craftsmen. A wide selection of corn-dollies, toys, basketware, stoneware, slipware, jewellery, woven goods, hornware, woodware, etc.
SELDA, The Bridge, Leintwardine.
Pottery, weaving, wood, glass, baskets, toys hand-made by studio craftsmen and the handicapped.
THE SOCIETY OF CRAFTSMEN'S SHOP AT THE OLD KEMBLE GALLERIES, 29 Church Street, Hereford.
Work by members of the Society, many of them local, including pottery, jewellery, metal and ceramic sculp-

tures, weaving, pictures, gloves and greetings cards. A small gallery is available for exhibitions.

THE SPINNING WHEEL, 25 Church Street, Hereford.
Wide range of tapestry clothing, including capes, skirts, and anoraks. Tapestry handbags and purses, sheepskin rugs, hats, gloves and slippers.

Kent

BARRONNE CRAFTS, 126a High Street, Edenbridge, Kent.
Domestic and creative pottery, jewellery, leather and basket-work, candles, soft toys and dried flower plaques.
KENT CRAFT, 37 Upper Stone Street, Maidstone.
Pottery, jewellery, toys, corn-dollies, candles, wrought iron. Lapidary section includes polished gemstones, rough rock, tumblers, findings and specimens.

Lancashire

THE OLD SMITHY, Cartmel, nr Grange-over-Sands.
Hand-beaten stainless steel and copper for the home, and certain church furnishings, hand-wrought iron-work, pottery, hand-weaving, soft toys, and many other local crafts.

Lincolnshire

'THE GREEN PARROT', Arts and Crafts Centre, Tealby.
Craft-work from Lincolnshire and neighbouring counties includes pottery, wood-craft, leatherwork, furniture, lamp-shades, jewellery, soft toys and paintings.
NEWSONS OF ENFIELD, 1 Windmill Hill, Enfield.
A very large range of hand-thrown stoneware and earthenware, domestic and purely decorative, collected from potters' studios all over the country; dolls and toys.

Norfolk

THE 'COUNTRY & COTTAGE CRAFTS' PROJECT, Coltishall.
Cottage, period and contemporary furniture in oak, pine, etc. Domestic and studio pottery; turned wood-ware; wrought iron; local stone jewellery; rush-work; basketry; brass-rubbings; flower pictures; soft toys; corn-dollies; tweeds; chess-sets and boards: needlecraft.
SAXTHORPE POTTERY (KEITH & JOAN CORRIGAN), Norwich NOR 15Y.
Hand-made pottery, kitchenware and other hand-made pieces. Exhibitions of paintings, weaving, hand-made furniture and allied crafts of Norfolk.
ELM HILL CRAFT SHOP, 12 Elm Hill, Norwich NOR 70K.
Pottery, rush-weaving, jewellery, toys, etc.
THE KELLING STUDIO, Kelling, nr Holt.
Collection of local artists' and craftsmen's work including paintings, pottery, wrought iron, wood carving and jewellery.
MATELLA, 17 High Street, Sheringham.
Pottery, corn-dollies, wooden and soft toys, jewellery and leather goods, pictures and prints, etc.
PALGRAVE CRAFTS AND ART GALLERY, 25 St Nicholas Street, Diss.
Hand-made goods, wrought iron, pottery, toys, fire-backs, jewellery, fancy goods, copper canopies, fire-backs and baskets.
THE PILGRIMS CRAFTS CENTRE, Bacton-on-Sea.
Pottery, weaving baskets, toys, jewellery, woodwork,

antiques, etc.
STUDIO 69, 40 Elm Hill, Norwich NOR 70K.
Contains a department entirely devoted to the needs of brass-rubbers, with a permanent exhibition of rubbings in the Cellar Gallery. The first floor galleries display the works of local artists.

Northamptonshire

THE CRAFTS CENTRE, Pilton Lane, Wadenhoe.
Patchwork, pillow lace, original oil-paintings and watercolours, old needlework restored, wrought iron, wood-turning, dried flowers, enamel on copper, knitting, crochet and tatting, smocking children's clothing.

Northumberland

THE CRAFT CENTRE, Harbottle, Morpeth.
Country saleroom, hand-work from Northumbrian craft-workers, professional and amateur.
THE HORSELESS CARRIAGE, Warkworth, Morpeth.
Hand-woven and hand-printed fabrics, bygones, pottery, Lindisfarne liqueur honey and marmalade, Elsenham & Ledbury high-quality preserves, Border knitwear, old prints, books on Northumbria, maps for tourists, walking-sticks.

Oxfordshire

MICHAEL & HEATHER ACKLAND, Coniston House, New Street, Deddington.
Jewellery, pottery, basketware, glass, wooden bowls, picture-framing, including work by local craftsmen. Silver jewellery designed and made on the premises.
HAND-MADE, St Michaels Street, Oxford.
MADE BY HAND, George Street, Oxford, Oxon.
THE OLD FORGE, Lower High Street, Burford.
Local pottery, weaving, metal work, paintings, rugs, knitting and crochet.
MRS A. G. RHODES, Hill House, Hardwick Road, Whitchurch-on-Thames, Reading RG8 7HH.
Small private gallery which features hand-crafted things for household and personal use. Emphasis on usefulness, few-of-the-kind.
STOCKLANDS, Little Clarendon Street, Oxford.
'THE TABLE SHOP', 25 Couching Street, Watlington.
A wide selection of tables, benches and chairs, together with pottery and other hand-made goods.

Shropshire

DRAGON CRAFTS, St Alkmund's Square and 5 St Mary's Street, Shrewsbury.
Local and Welsh crafts: hand-thrown pottery, wood-work, art, wrought ironwork, Welsh tapestry quilts and clothing, sheepskin products, perfume, jewellery, etc.
LUDLOW WELSH CRAFT CENTRE, 13 Tower Street, Ludlow.
Bedspreads, handbags and purses, pottery, sheepskins and gloves, jewellery and perfume. Specialists in tapestry clothing, including coats, capes, skirts and anoraks.
STANDISH-TAYLOR, School Gardens, Shrewsbury.
British crafts including hand-thrown pottery by master craftsmen. Antique stripped pine furniture, Shropshire yew tables, rush log and shopping-baskets. Norfolk rush-mats, runners and carpets made to order. Jewellery, large selection of British basketry, hand-

woven ties and head-squares, salad-bowls and toys, kitchenware, etc.
WELSH & TRADITIONAL CRAFTS (G. M. NEAL), Shrewsbury Market, Barker Street, Shrewsbury.
Honeycomb and tapestry quilts, coats, capes, anoraks, purses and stoles. Sheepskin slippers and mitts. Celtic jewellery, Cambrian tweeds and socks, perfume and pomanders.

Somerset

MUCHELNEY POTTERY (JOHN LEACH), Muchelney, Langport.
Hand-made stoneware, domestic shapes, stewpots, casseroles, mixing-bowls, jugs and store-jars. Craft shop open, displaying high standard of Somerset and West Country crafts, woodwork, leather, hand-loom weaving, hand-screen printed fabrics. Batik scarves, baskets and pottery.
THE BANTAM SHOP, Dunster, nr Minehead.
Wide selection of hand-made goods. Pottery made on the premises.
CELTIC CRAFTS, The Avenue, Minehead.
Tapestry clothing, including capes, skirts and anoraks. Tapestry handbags and purses, sheepskin rugs, hats, gloves and slippers.
THE CRAFT SHOP, Blagdon, Bristol BS18 6TH.
Specialises in unusual cane furniture. Complete range Welsh tapestry; tweed and lambswool skirts, skirt packs, matching sweaters, Suede garments. Silver and craft jewellery. Pottery, Ceramic figurines. Pewter ware, wood-, leather goods, handbags, Sheepskin slippers, kitchen sets. Baskets of all types.
DAVID EELES (THE POT SHOP), Watergore, nr South Petherton.
Pottery, stoneware, slipware and porcelain, ovenware, tableware, lamps, cider- and wine-jars, platters, small and large individual pieces.
GIFTCRAFTS, 46 High Street, Glastonbury.
KITCHENCRAFT, Union Street, Yeovil.
Craftsman-made local pottery, woodware, glassware, candles.
JEAN & PETER MARTIN, 15–16 Pulteney Bridge.
Coloured and scented candles, jewellery, wooden toys, hand-made clothes, pottery, cards, hand-woven rugs, natural perfume oils, wickerware, hand-printed silk scarves, etc.
MILVERTON CRAFT WORK SHOP (Beth Designs), Fore Street, Milverton, nr Taunton.
Somerset crafts, corn-dollies, pottery, basketwork, woodware, weaving, toys, ties, tweeds, leather-crafts, lamps, etc. Specialising in unusual, quality hand-made soft toys, furnishings and pressed flower pictures.
THE TINKER'S BAG (JIM LEE), 27b Belvedere, Lansdown Road, Bath.
British hand-made pottery, woven goods, hornwork, etc.
WESSEX CRAFTS, Langport.
West Country craftware, basketry in natural and stained willow and cane (including the traditional 'shacklebasket' and 'Willow Queen' rattlewattles), pottery, wood- and stone-carvings, jewellery, enamels, ropecraft, knitted and crochet work, unusual hand-made toys and dolls, thatch animals and models, corn-dollies, framed old maps.

Staffordshire

ALSTONFIELD CRAFT CENTRE, The George Inn, Alstonfield, Dovedale.
Hand-thrown pottery, leather goods, watercolours, collages, woven and crocheted goods, jewellery, toys, basketware, wrought ironwork, shelves, tables, lamps.
W. E. M. TILDESLEY, ARTS, CRAFTS & HOME INDUSTRIES, 38b High Street, Eccleshall, Stafford.
Soft and wooden toys, tapestry and picture-framing, our own design tapestry frames, silver and enamel jewellery, lace bobbins, fancy goods, ironwork, pictures, lamp-shades, Staffordshire alabaster, horn work, harness, carts, etc, for model horses.

Suffolk

ALDRINGHAM CRAFT MARKET, Leiston Road, Aldeburgh, East Suffolk.
MARY LOE, High Street, Nayland.
Useful things made by craftsmen mostly in East Anglia, including pottery, woodware, rushwork, baskets, corndollies and jewellery.
THE POTTERS WHEEL, Walberswick, Suffolk.
ST EDMUNDS POTTERY & COUNTRY CRAFTS, 74–75 Whiting Street, Bury St Edmunds.
Corn-dollies, beaten copperware, pewter, enamelled and silver jewellery, soft toys, leather, tweeds, tapestry garments, tie and dye, semi-precious stones cut and polished, pottery, rushwork.
SNAPE CRAFT SHOP, Snape Bridge, Saxmundham, Suffolk.
J. B. TOYS, 'Gayhurst', Hitcham, nr Ipswich.
Hand-made wooden toys and pine furniture manufactured on the premises. A variety of other craft products for sale.
VOUT, LAND O' GREEN GINGER, 74 Whiting Street, Bury St Edmunds, Suffolk.

Surrey

ALICAT CRAFTCENTRE AND GALLERY, 52 Friars Stile Road, Richmond.
Jewellery, pottery, glass, woodwork, wall-hangings, rushwork and toys. Regular exhibitions of the work of leading British potters.
CRAFTWORK, 38 Castle Street, Guildford, Surrey.
Pottery, jewellery, glass, silver, rugs and wall hangings.
THE HARRIS CRAFT SHOP, 21 West Street, Reigate.
Pottery, jewellery, woven scarves, ties, etc. Wrought iron, original pictures, lamps, small sculptures.
'TOBYCRAFT GALLERIES', High Street, Ripley, nr Guildford.
Original paintings, lamps, jewellery, pottery, wrought iron, leather goods. Welsh tapestry, ponchos, jackets, spreads, etc.

Sussex

THE DOVECOTE, Michelham Priory, Upper Dicker, nr Hailsham.
Wide range of traditional Sussex crafts, including pottery, ironwork and trugs. August exhibition sponsored by Sussex Small Industries Committee, with demonstrations of potting, thatching, weaving and other crafts.
FORUM GALLERY, 16 Market Street, Brighton.
Gallery specialising in original contemporary prints
and drawings, hand-made jewellery, wood-carving and pottery figures, chess-sets, and individual pottery. Also good selection of standard ware.

Warwickshire

PETER DINGLEY, 16 Meer Street, Stratford upon Avon.
A selection of modern British crafts—pottery, wood-carving, fabric pictures, wall-hangings, hand-blown glass, and other products. Also silk squares, hand-painted on the premises.
GRUMMEL DESIGN (R. & J. E. MAVER), 61 Smith Street, Warwick.
Wide range of hand-made designs in teak, rosewood and local woods. Pottery, silver jewellery, soft toys, lamps, thread pictures, ornamental candles and holders, animal carvings, etc.
(RAY & LIZ KEY) 'KEY CRAFTS', 1c Clay Lane, Coventry (from March: 19 Vine Street, Evesham, Worcestershire).
Quality hand-made wood-turning made on the premises by Ray Key. Bowls, platters, table- and standard-lamps, cheese-boards, ash-trays, egg-cups, candle-holders, etc. Other crafts, studio pottery, candles, basketware, corn-dollies, jewellery, rushware, etc.

Wiltshire

ABBEY CRAFTS & TEA ROOMS, Market Cross, Malmesbury (Jean & David King).
Rural crafts in pottery, stone, leather, suède, deer skin, horn, reed, wicker, wood, pewter, metals, wrought iron, linen, wool, corn, flowers, and hand-made toys.
CHATTELS, 19 Sheep Street, Devizes.
Toys, pottery, Victorian-style aprons, woodwork, jewellery, macramé, corn-dollies, greeting-cards, brass-rubbings and home-made preserves and chutneys. Furniture and other articles in wood can be made to order and customers' own designs if required.
'INSPIRE GALLERY', 40 Fisherton Street, Salisbury.
Contemporary paintings (changing exhibitions); prints, posters, stoneware goblets, etc, earthenware houses; enamel and silver jewellery, candles, exotic oils, chess-sets, modern furniture, immortal flowers, lights.
THE OLD FORGE, Bridge Street, Bradford-on-Avon.
Country crafts, hand-thrown pottery, tapestry blankets, hand-made glass, teak, leather and suède, basket-work, corn-dollies, books, toys, candles and pine furniture.

Worcestershire

THE BIRD CAGE, 6a Market Place, Evesham.
Stoneware, ceramics, corn-dollies, hand-weaving, jewellery, soft toys, hornware, wood-turner, rushwork, basketry.

Yorkshire

COUNTRYCRAFTS, 44 Lower Petergate, York.
Hand-woven ties, scarves, knee-rugs, hand-thrown pottery and woodcraft.
CRAFTSMEN, 33 Goodramgate.
Hand-thrown pottery, weaving, rush-work, hand-made jewellery, wooden toys.
THE JAM POT, Slaidburn, Via Clitheroe (J. & M. Bolton).
Cutters and polishers of semi-precious stones, makers of lapidary machinery, mineral specimens of the British Isles and world wide, lapidary supplies, wood-turnery and wood-craft in a wide range.
THE POTTER'S WHEEL, Minster Gates, York.
Craft-work made exclusively in Yorkshire. Hand-thrown earthenware and stoneware pottery, woodware and stainless steel jewellery.
LES & AUDREY ROBINSON, The Craft Centre, Thorpe in Balne, nr Askern, Doncaster.
Weaving, basket-work, pottery made in the centre. Other hand-made goods. Practical work facilities available for visitors by arrangement.
THE VILLAGE CRAFT CENTRE, Hungate Lane, Hunmanby, nr Filey.
Hand-forged ironwork, cane chairs, rocking-chairs, hand-thrown pottery, leatherwork, woodwork, etc.

WALES

Anglesey

GLEASON & JONES, The Cottage Crafts Shop, Castle Street, Beaumaris.
Welsh tapestry and honeycomb quilts. Ladies' and children's clothing and accessories in Welsh tapestry, tweed and flannel, Sheepskin gloves, rugs, slippers and coats, oil-paintings of local interest. Welsh pottery, dolls and horse-brasses. Local honey in local pottery a speciality.
W. & E. HORNER, Ship's Bell, Moelfre Bay.
Welsh tapestries, coats, suits, dresses, capes, handbags, purses, bedspreads and cushion-covers. Pottery, jewellery, ships' hanging and table-lamps, etc.

Breconshire

CLOTH HALL CRAFTS, Llanwrtyd Wells.
Decorative candles, pottery, ceramics, enamelled jewellery, leather belts, bags and other hand-made articles.
CURIO AND WELSH CRAFT SHOP, Groe Street, Builth Wells; and at 7 Lion Street; and 22 High Street, Kington.
Welsh tapestry and honeycomb quilts, ladies' and children's clothing and accessories in Welsh tapestry, tweed and flannel. Sheepskin gloves, rugs, slippers and coats, oil-paintings of local interest. Welsh pottery, jewellery, dolls and horse-brasses. Local honey in local pottery.
LLYSWEN WELSH CRAFT CENTRE, Llyswen, Brecon.
Tapestry bedspreads, handbags and purses, hand-made Welsh pottery, sheepskins, sheepskin slippers, jewellery, tapestry clothing, including coats, capes and skirts. Children's tapestry capes, hats and tweed caps and a wide range of Welsh perfumes.

Caernarvonshire

BRYN AFON STUDIO, Trefriw.
Jewellery made in our own workshop in sterling silver, pewter and stainless steel. Also pottery, Welsh slate goods, sheepskin slippers, corn-dollies, carved Welsh love-spoons, walking-sticks, hand-made dolls, miniature spinning-wheels, pressed-flower pictures, hand-knitted sweaters, bags, etc.
BRYNKIR WOOL SHOP, Castle Square, Caernarvon.
All products of the Brynkir Woollen Mill.

CRAFTCENTRE CLOTHES, 8 St George's Place, Llandudno.
Welsh tapestry clothing. Welsh tweed, flannel and tapestry by the yard. Sheepskin mitts and hoods.
CRAFTCENTRE CYMRU, 8 Pool Street, Caernarfon.
CRAFTCENTRE CYMRU, Stanley Buildings, Castle Street, Conway.
CRAFTCENTRE CYMRU, 45 High Street, Criccieth.
CRAFTCENTRE CYMRU, 6 St George's Place, Llandudno.
CRAFTCENTRE CYMRU, 75 High Street, Porthmadog.
Pottery, Welsh tapestry clothing, slate goods, house name-plates and model ships made to order; sheepskin rugs, mitts, hoods and slippers, carved wooden love-spoons, tapestry quilts, wrought iron sculptures, Welsh dolls, books, honey, fudge and beauty products.
WELSH CRAFTS, 10 High Street, Conway.
WELSH CRAFTS, 92 High Street, Porthmadog.
GWYNEDD CRAFTS, Beddgelert.
Pottery, tapestry, clothes, quilts, sheepskin products, jewellery, slate-craft, perfumes, cosmetics, woodcare, dolls. Anglesey fudge, honey, etc.
R. & E. HUMPHREYS, Siop-y-Plas, Llanbedrog.
Welsh crafts, small tapestry hand-crafts, sheepskin rugs, pottery, glass, copper, brassware jewellery, shells and shell-craft. Blenders of Arandelle perfumes—Hwyrnos Haf, Lelog Wen, Grug-y-Mynydd, etc.
HANNAH JONES LTD, Welsh Woollen Mills, Penmachno, Betws-y-Coed.
Pure wool tweeds, tapestry cloth, tapestry quilts, tailored garments, craft goods.
Mill open to the public all year round.
F. & V. PHILIPSON, The Log Cabin, Station Square, Betws-y-Coed.
Sheepskins, sheepskin slippers, gloves and hats. Welsh tapestry bed-covers, Welsh tapestry and tweed clothing, cane- and basket-work.
'SANDBACH'S', 78a Mostyn Street, Llandudno.
Pottery, slate clocks, lamps and tables. Jewellery ranging from inexpensive stone to sterling silver.
THE WEAVER'S LOFT, 7 Castle Street, Conway.
Tapestry and tweed clothing, tapestry bed-covers, pottery, slate-craft including house-names. Sheepskin rugs and slippers. Celtic jewellery. Baskets and woodwork, honey.
YR EFAIL, Gwyndy, Llanystumdwy, Criccieth.
Craft gifts in slate, pottery and jewellery. Hand-made toys. Paintings. Antiquities and bric-à-brac.

Cardiganshire

THE CRAFT CENTRE, 11–13 Terrace Road, Aberystwyth.
CRAFT DESIGN CENTRE OF WALES, Rhan o Atom.
A permanent exhibition and sales showroom for artist-craftsmen producing high-quality items in Wales. Traditional and contemporary design in clay, wood, stone, metal, glass, precious metals and gems.
CORNEL CREFFT, 5 Stryd y Baddon (5 Bath Street), Aberystwyth.
Welsh tapestry clothing ('Lili Lon' for children), tapestry quilts, handbags, table-mats. Pottery, wood, stone, slate crafts.

QUIXOTE (MONA & GARTH HATHERLEY), 4 College Row, Cardigan.
Craft shop specialising in local pottery and tweeds, tapestry made-ups, woodware, rugs. Woodwork and pottery made on the premises.
WELTEX SPORTSWEAR, The Welsh Wool Shop, 11 Bridge Street, Aberayron.
Welsh thorn-proof tweed fishing hats, deerstalkers and skirts. Flannel shirts and dresses. Tapestry coats, anoraks, capes and skirts. Also tapestry and honeycomb quilts and blankets and a variety of Welsh pottery, woodware and other crafts.

Carmarthenshire

CORGI WELSH CRAFTS, Wind Street, Ammanford.
Wide range of Welsh crafts including hand-tailored garments, made to measure and exclusive 'Corgi' sweaters and socks.
THE OLD FORGE, Abergorlech.
Crafts: antiques, pottery, old maps and prints. Old oil-lamps, globes and spare parts, electrified lamps, lamps repaired, tapestries. Sheepskin rugs, slippers, etc.
THE SPINNING WHEEL, 2 King Street, Carmarthen.
Wide range of tapestry clothing, including capes, skirts and tabards. Tapestry handbags and purses, bedspreads, sheepskin rugs and slippers.

Denbighshire

'STUDIO 69', Station Road, Llanrwst.
All original work in the form of paintings, sculpture, copperware, pottery, taxidermy.
BETTINA CRAFTS, Bridge Street, Llangollen.
Wide range of tapestry clothing, including capes, skirts and anoraks. Tapestry handbags and purses, sheepskin rugs, sheepskin coats, hats, gloves and slippers.
CRAFTCENTRE CYMRU, 28 Penrhyn Road, Colwyn Bay.
Pottery, Welsh tapestry clothing, tapestry quilts and handbags, slate lamps, ash-trays, fans; carved wooden love-spoons; Welsh dolls, fudge, honey and books; sheepskin rugs, mitts, slippers and hoods.
NICE THINGS, 20 Market Street, Llangollen.
Kitchenware and pine furniture.
SIOP CLWYD, Vale Street, Denbigh.
Welsh tapestry quilts, made-up garments, wood-craft, love-spoons, leather goods, slate work, ornamental candles, local-made pottery.
WELSH SHOP OLD MILL AND COTTAGE IN THE VILLAGE, Tynllan, Llanarmon Dyffryn Ceiriod, nr Llangollen.
Welsh tapestries, honeycombs, travel-rugs, pottery, wrought iron, basketware, walking-sticks, sheepskin, garments in tapestry, ladies' and gents' hats in Welsh tweed, skirts, socks, golf-hose, purses, handbags, perfumery, slate craft, etc. Local honey.
WELSHCRAFTS', Abbey Road, Llangollen.
Welsh tapestry, quilts, honeycomb blankets, travel-rugs, tweeds, hand-woven scarves, ties, etc. Baskets, woodwork, old maps and prints, hand-made pottery, wrought ironwork, etc. Copper, pewter and silver jewellery.

Flintshire

BARROW CRAFTS, High Street, St Asaph.

Welsh tapestries and tweeds, sheepskin clothing and rugs, knitwear, pottery and china.
CELTIC CRAFTS LTD, Nannerch, nr Mold and 36 Well Street, Ruthin.
Wide range of tapestry clothing, including capes, skirts and anoraks. Tapestry handbags and purses, sheepskin rugs, hats, gloves and slippers. Paintings and prints.
CRAFTS UNLIMITED, The Old Mill, Nanarch, nr Flintshire.

Glamorganshire

DINAS WELSH CRAFTS, Ewenny, Bridgend.
Tapestry quilts and clothes (coats, capes, skirts, dresses, etc), tweed, flannel and tapestry by the yard; honey, pottery, jewellery, woodwork, perfume.
INTERCRAFT, Boverton Road, Llantwit Major.
Tapestry, tweed and flannel, local-made soft toys, pottery, woodware, jewellery, perfume, honey, slate, prints, etc.
THE POTTER'S WHEEL, Cathedral Green, Llandaff, nr Cardiff.
Traditional Welsh copper lustre jugs and grey stone glazed tableware. Welsh tapestry and Celtic jewellery, Welsh perfume and love-spoons.
WELSH COTTAGE CRAFT SHOP, Oystermouth, Swansea.
Specialists in Welsh fashion—Welsh tapestry garments and accessories, tapestry by the yard. Jewellery in silver, pewter, copper and stainless steel. Welsh pottery, Welsh perfumes, honeys, ties and scarves. Locally carved love-spoons, leather goods.
WELSH COTTAGE CRAFT SHOP, Pennard, Gower, Swansea.
Welsh tapestry garments and accessories, tapestry by the yard. Welsh pottery, perfume, honey, ties, scarces, love-spoons. Good selection of leather goods.
WELSH COTTAGE CRAFT SHOP, Sketty, Swansea.
Welsh tapestries, new soft flannels in bright modern colours, Welsh tweeds, large range of garments and accessories, handbags, purses, etc. Hand-made jewellery, Welsh pottery in stoneware, copper lustre, and earthenware. Locally carved love-spoons—love-spoons made to order.
WELSH FASHION CRAFT, Marments Ltd, Queen Street, Cardiff.
Welsh tapestry and flannel—coats, capes, suits, dresses, maxi-skirts, evening-dresses, wedding-dresses, etc.
WELSH FASHION CRAFT, Oystermouth, Mumbles, Swansea.
Welsh tapestry and flannel—coats, capes, suits, dresses, max-skirts, evening-dresses, wedding-dresses, suède garments.

Merionethshire

PHILIP WILCOCK, Furniture Maker, Llyn, Barmouth Road, Harlech.
Hand-made furniture, individually designed. Carved woodware.
BRAICHGOCH SLATE QUARRIES LTD, Corris, Machynlleth.
Manufacturers and distributors of slate craftwork, clocks, lamps, sundials, barometers, jewellery, etc.
CILDERI CRAFTS AND CURIOS, Tan-y-Bwlch, nr Maentwrog.
Welsh handcrafts, local honey and preserves, sheepskin

rugs, pictures, books on handcrafts and the district.
CRAFTCENTRE CYMRU, Copper Hill Street, Aberdyfi.
CRAFTCENTRE CYMRU, Cambrian House, Bala.
CRAFTCENTRE CYMRU, 91a High Street, Bala.
CRAFTCENTRE CYMRU, High Street, Barmouth.
Pottery, Welsh tapestry clothing. Slate clocks and fans; house name-plates and model ships made to order; sheepskin rugs, mitts and slippers; carved wooden love-spoons; suède clothing and handbags; tapestry quilts and table-mats; wrought iron sculptures; Welsh dolls, honey, fudge and perfume.
MEREDITH & SMITH LTD, Y Tanws, Dolgellau.
Sheepskin rugs, mitts, gloves and coats. Leather and suède coats, wallets and purses, etc.
QUARRY TOURS LTD, Llechwedd Slate Caverns, Blaenau Ffestiniog.
Slate-craft pottery and jewellery, candles, tapestries and Welsh perfumes. Geological samples on sale.
Y CREFFTWR, High Street, Bala.
Pottery, jewellery, weaving, walking-sticks, candles, leather goods, wrought ironwork, paintings, etc. Hand-made corn-dollies, wild-flower pictures, period costume dolls, original prints, etc. Also sheepskins, Welsh honey.

Monmouthshire

CRAFTS OF BRITAIN, Mrs D. G. Bonelle, 3 St Mary Street, Monmouth.
High-quality hand-crafts all made in Britain.
THE OLD FORGE CRAFT SHOP (NANCY E. JAMES), Llanellen, nr Abergavenny.
Ladies' and children's fashions in Welsh tapestry and tweed, hand-made pottery, jewellery, glassware, rush-work, sheepskin leather goods, cashmere, etc.
WELSH COUNTRY CRAFTS, Tintern, nr Chepstow.
Traditional Welsh tapestry, capes, etc., bed-covers, blankets, local hand-woven ties, head-squares and tweeds. Welsh natural sheepskins, mitts, slippers, etc. Welsh national dressed dolls. Hand-worked copper-ware, jewellery, woodware, hand-thrown pottery.
WELSH CRAFTS SHOP (WYNFORD WEST), 416 Chepstow Road, Newport NPT 8JH.
Tapestry quilts, high-class fashion-wear to measure, hats, bags, purses, Welsh dolls, pottery, yew tables, horse- and pony-brasses, perfumes, jewellery, honey, socks.
WELSH RURAL CRAFTS SHOP, Rhadyr, nr Usk.
Antique prints and maps. Celtic jewellery, perfumes, local paintings, pottery and woodcrafts, tapestries and tweeds. Welsh national-dressed dolls.

Montgomeryshire

CRAFTCENTRE CYMRU, Llangurig, nr Llanidloes.
Welsh tapestry clothing, quilts, handbags. Slate lamps, ash-trays, clocks, Caldey perfume, Aberaeron honey and fudge, Welsh books, dolls, carved wooden love-spoons. Rush and wicker work, antique maps and prints of Wales, sheepskin slippers, rugs, mitts and hoods. Pottery.
'CREFFTAU CAIN', High Street, Llanfyllin.
Pottery, bellows, Celtic jewellery, stone, copper, pewter, steel and silver jewellery. Welsh tapestry quilts, handbags, purses, etc. Tapestry and tweed 'tailored' garments, also by the yard. Sheepskin rugs and slippers. Basketry. 'Natural' walking-sticks, ties,

brassware. Tweed hats, mohair.
'DAVEY', Welsh Crafts, 6 Short Bridge Street, Newtown.
Welsh tapestry, tweed, sheepskin, pottery, paintings and jewellery. Hand-knitted Arans, etc.
Y GIST DDERW, Llangynog.
Welsh pottery, rushwork, slate lamps, clocks, etc. Horse-brasses, copperwork, honey, marmalade, fudge. Dolls, perfumed, decorated candles, Welsh honeycomb cot-blankets, Welsh tapestry items. Skirt lengths. Locally made Welsh wool socks. Flannel shirts. Local oil-paintings. Gemstone jewellery.

Pembrokeshire

THE CRAFT SHOP, The Pebbles, St Davids.
Materials by the yard, clothing with matching accessories, traditional quilts, pottery, Caldey perfumes and silver Celtic jewellery.
ANN & MARK JEFCOATE, The Strand Craft Shop, Saundersfoot.
Welsh woollen goods, hand-thrown pottery and other country workshops' products.
THE PEMBROKESHIRE CRAFT & GIFT SHOP, 27 Bridge Street, Haverfordwest.
Quality craftwork, most of which are made in Pembrokeshire or have a direct connection with Pembroke.
E. A. WINN-JONES, THE WELSH SHOP, 1 Bridge Street, The Harbour, Tenby.
Welsh tapestry quilts, coats, capes, skirts, table-mats, etc. Pottery, slateware, Welsh tweed garments, ties, woollen blankets, rugs, Welsh flannel, knitwear, perfumes, costume dolls and wrought ironwork.

Radnorshire

LLANDRINDOD WELSH CRAFT CENTRE, Lindens Walk, Llandrindod Wells.
Tapestry bedspreads, handbags and purses, hand-made Welsh pottery, sheepskins, sheepskin slippers, jewellery. Tapestry clothing including coats, capes and skirts. Children's tapestry capes, gents' tweed caps and hats and a wide range of Welsh perfumes.
BRYAN W. POCOCK, Ithon Craft Shop, Llanbister, Llandrindod Wells.
Welsh tapestry products, sheepskin, suède and leather goods and garments. Welsh studio pottery, woodware, jewellery, perfumes, toys, copperware, Welsh cloth by the yard, love-spoons, candles.

SCOTLAND

Argyllshire

THE CRAFT CENTRE, 5 Hillfoot Street, Dunoon PA23 7DR.
Scottish, Welsh and Irish crafts. Hand-made porcelain and stoneware, sheepskin rugs, mohair rugs and stoles. Hand-woven tapestry and honeycomb quilts, hand-woven place-mats. Pewter, silver and ceramic jewellery.

Berwickshire

SEA CREATURES (JOHN AITCHISON), 'West Winds', Burnmouth, Eyemouth.
Real shellfish preserved for ornaments and displays, lobster, hermit, spider, green crabs, etc, world-wide shells, mother-of-pearl, tropical shell and gemstone

jewellery. Shellcraft, marine paintings, ships-in-bottles, paper-weights, marine antiques and curios, model lobster-pots. Woollens, pottery and various other craftwork.

Inverness-shire

CASTLEWYND STUDIOS LTD, Inverdruie, Aviemore.
Earthenware and stoneware, made and decorated by hand. Figures, animals and a range of pots (saut-buckets, mugs, jugs, plates, etc).
CULLODEN CRAFT CENTRE, Little Cullernie Balloch, nr Inverness.
Crafts and produce made in the Highlands and elsewhere.

Midlothian

HIGHLAND HOME INDUSTRIES LTD, 94 George Street, Edinburgh EH2 3DQ.
Head Office and main showroom for hand-knitted woollens and tweeds made in the Highlands and Islands. Only authentic Scottish craft goods and productions in twelve retail shops throughout Scotland. Mohair, woollen and tweed weaving centre, Morar, Inverness-shire. At Aberdeen, Elgin, Fort Augustus, Gairloch, Glenesk, Golspie, Iona, Lochboisdale, Morar, Strath-peffer, Ullapool, Poolewe.

Morayshire

FINDHORN STUDIOS LTD, Pineridge, Findhorn Bay, Forres.
Health food and craft shop. As part of a community venture, hand-made craftwork in original designs will be made available. These include leatherwork, weaving, macramé, candle-craft, pottery, woodwork, screen-printing.
BATA BEG, Findhorn.
Hand-made gifts collected from all over Scotland. Articles of sea-side and yachting interest.
LAICHMOOR, 24 Batchen Street, Elgin.
Tweeds, tartans, knitwear, kilts and skirts tailored. Scottish crafts of every description.

Perthshire

GLENOGLE TWEEDS, The Shieling, Lochearnhead.
Knitwear in cashmere and lambswool. Extensive range of Scottish hand-woven tweeds and tartans, also Harris, Shetland and Fair Isle products. Rugs of cashmere and wool mohair and sheepskin. Horn work, pottery and jewellery.
PERTHSHIRE CRAFTS LTD, The Ell Shops, The Square, Dunkeld.
Deerskin and tilt marble articles made in Dunkeld. All Scottish products including engraved crystal, woollen goods, etc, also work of other Scottish craftsmen.
THE STABLE GIFT SHOP, Kilmahog, Callander.
Specialists in sheepskin and deerskin rugs and Scottish craft goods. This company also manufactures the 'Clan' range of game fishing-rods.

NORTHERN IRELAND

Antrim

BALLINDERRY ANTIQUES, Ballinderry Upper, Lisburn.
GIFTS AND CRAFTS, 2 Castle Street, Carrickfergus.

THE IRISH CRAFTS SHOP, 71 Main Street, Portrush.
NATIONAL TRUST INFORMATION & CRAFT CENTRE,
Giants' Causeway, Bushmills.

Armagh
LITTLE ORCHARD POTTERY, Cranagill, Portadown.

Belfast
JOHN MAGEE LTD, 4 Donegall Square West.
NATIONAL TRUST INFORMATION & CRAFT CENTRE,
Malone House, Barnett Demesne, Belfast BT9 5PU.
NATIONAL TRUST INFORMATION & CRAFT CENTRE,
10 Royal Avenue
ULSTER BOUTIQUE, 60–64 Wellington Place, 29
College Street, Belfast.

Down
COUNTY CRAFTS, Heather Garrett, 4 Shore Street,
Donaghadee.
MAGPIE TWEEDS, 40 High Street, Bangor.
NATIONAL TRUST INFORMATION & CRAFT CENTRE,
Castle Ward, Strangford.
THE TWEED SHOP, 12 Main Street, Hillsborough.

Fermanagh
FERMANAGH COTTAGE INDUSTRIES, 14 East Bridge
Street, Enniskillen.

SPECIALIST BOOKSHOPS

ANSFORD BOOKS, Lower Ansford, Castle Cary,
Somerset. *Specialists in natural history.*
CLEARWATER BOOKS, 130 Andover Road, Orpington,
Kent. *Specialises in rural crafts, village life and
husbandry.*
DESIGN CENTRE, 28 Haymarket, London WC1.
*Books on art, design and crafts for sale, as well as
registers and directories for reference.*
DRUMMOND, 30 Hart Grove, London W5. *Specialises
in countrycrafts, horticulture and wild flowers.*
P. KENNEDY, 285 New Hall Lane, Preston, Lanca-
shire. *Specialists in natural history and gardening.
Second-hand books also available.*
LANDSMAN'S BOOKSHOP, Buckenhill, Bromyard,
Hereford. *Specialises in farming, gardening and
forestry. Second-hand books also available.*
THE ECOLOGY BOOKSHOP, 45 Lower Belgrave Street,
London SW1.
ROBINSON & WATKINS, Cecil Court (off Charing
Cross Road), London WC1. *An excellent environ-
mental section.*
STOBART & SON LTD, 67–73 Worship Street, London
EC2A 2EL. *Specialises in handicrafts. Catalogue on
request.*
*N.B. Sometimes quite useful and nostalgic craft and
country books are out of print and difficult to obtain.
If you have no luck in local jumble sales or second-hand
book shops, try the following firm which, although it is
one of the largest second-hand book dealers in the
country, gives very good service.*
RICHARD BOOTH (BOOKSELLERS) LTD, Hay Castle,
Hay-on-Wye, via Hereford.

MUSEUMS

Most museums display examples of local
craftwork, but these may vary in quality and
extent. For a complete list of museums with
a subject index of the collections they keep
consult: MUSEUMS AND GALLERIES IN GREAT
BRITAIN AND IRELAND/ABC Travel Guides
Ltd, Oldhill, London Road, Dunstable
(annually, published in July); International
Publications Service, New York.

BRITISH CRAFTS CENTRE

BRITISH CRAFTS CENTRE
43 Earlham Street, London WC2H 9LD. Tel:
01-240 3327
*The aim of the British Crafts Centre is to show the
best work by leading British craftsmen. The Centre
runs a gallery at the Earlham Street address, display-
ing examples of jewellery, silver, glass, ceramics,
textiles, weaving, woodwork, furniture, leatherwork
and other crafts. One-man and group exhibitions are
held frequently and all items on display are for sale.*

HOW TO ORDER BOOKS FROM ENGLAND

*If you want to order books published in England,
here are four major English bookstores which are
used to mail ordering overseas. Write for prices.*
B.H. BLACKWELL, LTD. 50 Broad St., Oxford
OX1 3BQ.
DILLON'S UNIVERSITY BOOKSHOP LTD., 1 Malet St.,
London, WC1 E 7 JB.
HATCHARD'S LTD. 187 Piccadilly, London W1V
9DA.
W. HEFFER AND SONS LTD, 20 Trinity St., Cam-
bridge CB2 3NG.

TOURIST INFORMATION

*If you wish to travel to England, one of the offices of
the* BRITISH TOURIST AUTHORITY *can provide you
with all the information you will need. Write or
call:*
612 S. Flower St., Los Angeles, Calif. 90017, tel:
(213) 623-8196.
John Hancock Center, Chicago, Ill. 60611, tel:
(312) 787-0490
680 Fifth Ave., New York, N.Y. 10019, tel: (212)
581-4708.
1712 Commerce St., Dallas, Tex. 75201, tel: (214)
748-2279.
151 Bloor St. W., Toronto 5, Ont. tel. (410) 925-
0328.
602 W. Hastings St., Vancouver 2, Br. Col. tel:
(604) 682-2604.

AMERICAN CRAFTS COUNCIL

The American Crafts Council (44 W. 53 St., New York, N.Y. 10019, tel.: 977-8989) is a "national, non-profit educational and cultural organization founded in 1943 to stimulate interest in the work of contemporary craftsmen." Membership, open to anyone interested in crafts, is about $12.50 a year. It includes discounts on ACC publications and a subscription to the bimonthly CRAFT HORIZONS, with articles about many different crafts and notices and reviews of national and international arts events. The Crafts Council maintains a museum in New York City, the Museum of Contemporary Crafts, which shows the work of established and emerging artists in a variety of craft media, and also an excellent reference library. The Regional Program of the Council sponsors fairs, workshops, and other educational projects throughout the country under the aegis of regional assemblies of craftsmen.

The Research and Education Department maintains a unique portfolio system of data on contemporary American craftsmen and operates a nationwide slide sales/rental service, "Your Portable Museum," including work in metal, wood, clay, glass, and various other media. It also publishes exhibition catalogs from the museum and several useful reference works listed below. Order forms can be obtained from the Publication Department of the ACC.

GRANTS

NATIONAL ENDOWMENT FOR THE ARTS, Washington, D.C. 20506, has several categories in which craftspeople may apply for grants. Free information on the "Expansion Arts Program" and the "Visual Arts Program" is available from the Crafts Coordinator. "Guide to Programs of the National Endowment for the Arts"(Stock No. 3600-00017), a comprehensive 60-page booklet which contains all the National Endowment's financial assistance information in the arts, may be purchased for 95¢ from the Superintendent of Documents, U.S. Government Printing Office, Washington, D.C. 20402.

STATE ARTS COUNCILS in some states have programs to fund crafts programs. Contact your state Arts Council for details.

U.S GOVERNMENT PRINTING OFFICE

U.S. GOVERNMENT PRINTING OFFICE, Superintendent of Documents, Washington, D.C. 20402. The departments and agencies of the federal government issue publications each month, written by experts, on various areas of interest. Some of these are free from the departments, and some are sold by the GPO. You can write to the GPO and ask to receive the free biweekly list of Selected U.S. Government Publications (newly issued or still popular publications available for sale) or for the free listing of publications on a particular subject area. You may also want to order ENCOURAGING AMERICAN CRAFTSMEN, S.N. 3600-0010, which costs 45¢.

A number of publications of the Department of Agriculture are cited in this book. The complete LIST OF AVAILABLE PUBLICATIONS, which contains sections on Animal Science, Plant Science, and Soil Science, can be ordered free from the Publications Division, Office of Communications, U.S. Dept. of Agriculture, Washington, D.C. 20250. You may also be able to get it and some of the publications at the Agricultural Extension Office in your state.

Farmer Cooperative Service

Detailed information on how to form cooperatives is contained in the publications listed below, which may be obtained by writing to Publications, Farmer Cooperative Service, U.S. Department of Agriculture, Washington, D.C. 20250.

THE COOPERATIVE APPROACH TO CRAFTS, Program Aid No. 1001.

HOW TO START A COOPERATIVE, Educational Circular 18.

IS THERE A CO-OP IN YOUR FUTURE?, FCS Information 81.

WHAT ARE COOPERATIVES? FCS Information 67.

The Farmer Cooperative Service will also soon have ready a MANUAL OF CRAFT ASSOCIATIONS (FCS INFORMATION 1001), *which lists local associations by state and the services they provide. Write for information.*

Small Business Administration

The Small Business Administration (SBA) issues a wide range of publications designed to help owner-managers and prospective owners of small businesses. Listed below are titles which may be of interest to persons engaged in selling crafts. They may be requested from SBA, Washington, D.C. 20416.

HANDICRAFTS AND HOME BUSINESS, SBB No. 1.

SELLING BY MAIL ORDER, SBB No. 3.

GIFT AND ART SHOPS, SBB No. 26.

SPECIAL HELP FOR SMALL BUSINESSES, SMA No. 74.

FURTHER READING

General Reference

CONTEMPORARY CRAFTS MARKET PLACE, American Crafts Council/Bowker, New York. *$13.95 (paper). An updating and extension of the ACC's other publications, this includes 1,000 shops and galleries, 300 national, regional, and local groups, 275 courses, 100 distributors of audiovisual materials, 6 directories of suppliers (clay, fiber, glass, metal,* wood, and miscellaneous), a packing, shipping, and insurance section, and a publications section with books and periodicals.

GUIDE TO THE CRAFT WORLD (2nd edition). *A directory of artists and craftsmen, shops, galleries, and studios, craft instruction, craft publications, and special services, which will be available from the publishers of* ARTISAN CRAFTS *in early May. A free brochure and price information can be obtained from Box 179-FA, Reeds Spring, Mo. 65737.*

NATIONAL GUIDE TO CRAFT SUPPLIES, by Judith Glassman/Van Nostrand Reinhold, New York. *Information on mail order suppliers, fairs and shows, schools and classes, organizations, galleries, periodicals, and a complete bibliography. Price to be announced.*

REFERENCE BIBLIOGRAPHIES: CLAY *($3);* ENAMEL *($2);* GLASS *($2.50);* WOOD *($3),* American Crafts Council (see above). *Bibliographies on the history and processes of craft media; include periodicals.*

Catalogs of Crafts Books

ARIEL BOOKSELLERS, INC., Mail Order Dept., P.O. Box 500, New Paltz, N.Y. 12561. *Free.*

BOOK BARN, "Books for Craftsmen," P.O. Box 256, Avon, Conn. 06001. 50¢.

CRAFT AND HOBBY BOOK SERVICE, P.O. Box 626, Pacific Grove, Calif. 93950. *Annual book list* 50¢, *"Books for the Weaver and Needleworker." Almost all current American publications, some Scandinavian works, and some publications of their own. All books are described in detail.*

CRAFTOOL COMPANY, INC., 1421 W. 240 St., Harbor City, Calif. 90710. *Complete catalog $1, Dryad instruction book list free. Mail order supplies, kits, and a well-chosen list of books for most crafts. Many of the books are shown in the catalog and all are described in detail. The how-to books, published by the English firm Dryad, are excellent.*

MUSEUM BOOKS, INC., 48 E. 43 St., New York, N.Y. 10017. *Publishes every three years a "Catalog of Essential Books on Handicrafts, Design, Applied Arts" (50¢). This descriptive list covers about 50 crafts (the 1973/74 edition has 133 pages), and includes both beginner's guides and specialized works.*

THE UNICORN, Box 645R, Rockville, Md. 20851. *This firm has a very extensive catalog of books for craftsmen (50¢). It attempts to carry all craft books in print in the U.S. and also imports books from abroad. A "Quarterly Guide to Craft Books" is available for $2 a year. It seems to be best on handweaving and needlework, including quilting, patchwork, and rughooking.*

General Crafts Journals

ARTISAN CRAFTS, Star Rt. #4, Box 179-FA, Reeds Spring, Mo. 65737. *A quarterly publication for persons who are professionally involved or seriously interested in crafts. Single copies are available for $1.50. A subscription is $5.00 per year.*

CRAFT HORIZONS, 44 West 53rd Street, New York, N.Y. 10019. *A bimonthly publication devoted en-*

tirely to contemporary crafts throughout the world. The magazine, read by professional craftspeople and educators, covers creative work in clay, enamel, fiber, glass, wood, etc., and discusses the technology, the materials, and the ideas of the artist. A subscription is $12.50 per year (including membership in the American Crafts Council—see above).

CRAFT/MIDWEST, Box 42, Northbrook, Ill. 60062. A quarterly publication which contains organizations, books, exhibits, events, and articles on various crafts. It is directed to producing craftsmen, especially in the Midwest. A subscription is $6.00 per year, $15.00 for 3 years.

CREATIVE CRAFTS, P.O. Box 700, Newton N. J. 07860. Published 8 times per year, this magazine covers techniques for a variety of crafts including shells, thread design, finger weaving, and quilting. Its listings of dealers and studios include suppliers in Canada. A subscription is $4.50 per year.

WESTART, P.O. Box 1396, Auburn, Cal. 95603. A semi-monthly newspaper for artists, craftspeople, and art patrons containing an "over-view of the West Coast art scene." A subscription is $4.00 per year.

Courses

BY HAND: A GUIDE TO SCHOOLS AND A CAREER IN CRAFTS, by John Coyne and Tom Hebert/Dutton, New York. $8.95, $3.95 (paper). A comprehensive guide to over 750 craft programs. Designed for easy use as a reference tool, the book lists, state by state, the college courses available, giving addresses and, where possible, telephone numbers. Similar information is given for arts centers, workshops, crafts cooperatives, and apprenticeship programs. For major entries, the authors evaluate the level of instruction offered and its value to beginners or advanced students.

DIRECTORY OF CRAFT COURSES, American Crafts Council (see above). $4.00. Annual listing of universities, colleges, junior colleges, private workshops, museum schools, and art centers that offer craft courses and degrees.

Suppliers

CRAFT SUPPLIERS: FIBER; CRAFT SUPPLIERS: CLAY, American Crafts Council (see above). $3. each. Directories of supplies and their sources with addresses and catalog information.

THE MAIL-ORDER CRAFTS CATALOGUE, by Margaret A. Boyd/Chilton, Radnor, Pa. $12.50. Lists over 1600 mail order sources of more than 6500 craft supplies, indexed by item, category, and supplier's location.

1974 SUPPLIERS DIRECTORY, Handweavers Guild of America, 998 Farmington Ave., W. Hartford, Conn. 06107. $2. A listing of firms specializing in supplies and equipment for weaving, spinning, and dyeing; updated biannually.

Buying and Selling Crafts

CRAFT SHOPS/GALLERIES USA. American Crafts Council (see above). $3.95. A nationwide directory of outlets that sell American crafts, compiled biannually. Listed are state, city, shop name, address, hours, and crafts sold.

THE CRAFTSMAN'S SURVIVAL MANUAL, by George and Nancy Wettlaufer/Prentice-Hall, Englewood Cliffs, N.J. $8.95. A book offering practical information about pricing, selling at shows and to shops, taxes, insurance, and other business skills which are important to current or would-be craftsmen. A good bibliography section is also included.

HANDBOOK AND RESOURCE GUIDE FOR NEW CRAFT GROUPS, Commission on Religion in Appalachia, Inc., 864 Weisgarber Rd., Knoxville, Tenn. 37914. $1 postpaid.

THE HANDCRAFT BUSINESS, Vol. 10 No. 8, Small Business Reporter, Bank of America, Department 3120. P. O. Box 37000, San Francisco, Cal. 94137. $1 postpaid.

HOW TO MAKE MONEY WITH YOUR CRAFTS, by Leta W. Clark/William Morrow, New York. $6.95. A comprehensive handbook for any craftsperson who wants to sell the products he or she makes—from the hobbyist who produces a few things at home, to the young designer who wants to launch a new business, to the professional already in business who needs additional advice, to the craft association.

SELLING WHAT YOU MAKE, by Jane Wood/Penguin, Baltimore, Md. $2.25 (paper).

SELLING YOUR CRAFTS, by Norbert N. Nelson/Van Nostrand Reinhold, New York. $3.95 (paper).

Miscellaneous Catalogs

THE CATALOGUE OF AMERICAN CATALOGUES, by Maria Elena De La Iglesia/Random House, New York. $4.95 (paper). Among many other things, are sections on "Gardening" and "Hobby & Professional Equipment," with thorough descriptions of shop offerings and catalog information.

GARDEN WAY PUBLISHING, Charlotte, Vt. 05445. Catalog $1 (credit toward order). Catalog consists of books carefully selected from other publishers and some of Garden Way's own, all described in detail. Topics include: Plain Living, Books for the Home Gardener, How To and Home Repair, Cooking: Plain and Fancy, Animal Care, and Country Crafts and Helpful Pastimes.

THE GARDENER'S CATALOG/William Morrow, New York. $6.95. Has articles on Trees, Bees, Herbs, Organic Gardening, Composting, Drying Flowers, and "Friends of the Garden" and various lists of sources of materials.

THE UPDATED LAST WHOLE EARTH CATALOG/Point (distributed by Random House, New York). $5.

WHOLE EARTH CEPILOG/Penguin Books, Baltimore, Md. $4. Both have sections on "Craft" and "Land use," which cover most of the traditional English country crafts. Sources of materials are recommended and books are described in detail.

CANADA

CANADIAN GUILD OF CRAFTS, 29 Prince Arthur Ave., Toronto, Ontario M5R 1B2. The guild aims to foster and develop Canadian crafts. It runs a shop and gallery in Toronto. Membership ($10 a year) includes the bimonthly journal CRAFT DIMENSIONS ARTISANALES (CDA), which features news of the association, exhibits, artists and craftsmen, books, conferences, etc., across Canada.

ONTARIO CRAFT FOUNDATION, 8 York St., 7th Fl., Toronto, Ontario M5J 1R2. A nonprofit organization dedicated to the development of crafts in Ontario. Membership ($5) includes their monthly magazine, CRAFT ONTARIO. The December 1974 issue is devoted to listing suppliers of raw materials for craftsmen throughout Canada and the United States and also contains a brief list of magazines relating to various crafts. This issue will be sent free on request to residents of Ontario; others must pay the membership fee.

PUBLICATIONS

THE BUSINESS OF CRAFTS is a free publication cosponsored by the Ontario Craft Foundation and the Canadian Guild of Crafts. It is designed to provide both the leisuretime and professional craftsman with certain information necessary to anticipate problems and to answer some of the many administrative questions that arise in craft work. For a copy write to the Ontario Craft Foundation (see above).

ONTARIO CRAFT DIRECTORY is a free publication sponsored by the Canadian Guild of Crafts and the Ontario Craft Foundation in cooperation with the Sports and Recreation Bureau of the Ontario Ministry of Community and Social Services. The directory offers a geographical list of craftsmen, shops, and local and provincial guilds. For a copy write to the Ontario Craft Foundation (see above).

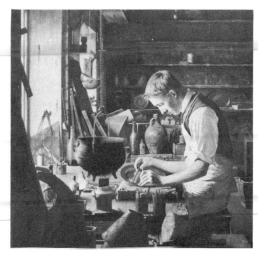

GLOSSARY

APPLE STALKS/apple stems.

BALL CLAY/extremely fine grained, plastic sedimentary clay. Although ball clay contains much organic matter, it fires white or near white in color. It is usually added to porcelain and white ware bodies to increase plasticity.

BARBADOS SUGAR/Raw, brown sugar which can be found in health food stores.

BENTONITE/an extremely plastic clay, formed by decomposed volcanic ash and glass, which is used to render short clays workable.

BISCUIT or BISQUE/unglazed ware.

BOSTIK/ Epoxy glue.

BURGUNDY PITCH/Resinous juice of the spruce fir, sometimes called white pitch.

CHLORODYNE/British patent medicine unavailable in the U.S. Consult a veterinarian for a substitute.

COB/Mixture of clay and straw used as a building material.

CONKER/Cobnut, fiberlike fruit.

COPSE or COPPICE/small saplings which grow from the stump of a tree which has been cut back. These branches are straight and limbless and provide excellent material for furniture making.

CWT/hundred weight.

DISTEMPER/White or tinted wash for walls, ceilings, etc.

DRAWING PIN/thumbtack.

DREY/Squirrel's nest.

EUROPEAN FOUL BROOD/More common in the U.S. is American Foulbrood. In addition to a disagreeable odor, diseased colonies have cells with sunken, darkened, greasy looking cappings, often with irregular holes or perforations and dead larvae inside.

FABLON/Brand name for Scotch tape.

FAGGING HOOK/Hooked stick used to reap corn and leave no stubble; draws the corn toward the reaper.

FIRECLAY/a clay having a slightly higher percentage of fluxes than pure clay (kaolin). It fires tan or gray in color and is used in the manufacture of refractory materials such as bricks, muffles, and so forth for industrial glass and steel furnaces. It is often quite plastic and may be used by the studio potter as an ingredient of stoneware bodies.

FRIT/a partial or complete glaze that is melted and then reground for the purpose of eliminating the toxic effects of lead and of the solubility of borax, soda ash, and so forth.

FROG/the hollowed out portion of one or both faces of bricks.

GORSE/Furze; low, much-branched spiny shrub with yellow flowers.

GROG/hard fired clay that has been brushed or ground to various particle sizes. It is used to reduce shrinkage in ceramic products such as sculpture and architectural terra cotta tiles, which, because of their thickness, have drying and shrinkage problems. From 20%–40% grog may be used depending on the amount of detail ing. Rug Making: burlap; in the U.S. monkscloth is often used instead because it is stronger.

LINSEED/flax seed.

LUCCA OIL/High grade olive oil; one brand name is Bertolli.

MAIZE/corn.

MANGEL or MANGEL-WURZEL/variety of beet.

MARL/soil consisting of clay and carbonite of lime.

ORIENTEER/To exactly determine the position of something with regard to the points of a compass.

PLANE TREE/Sycamore or Buttonwood.

POLYFILLER/Spackle.

POLYTHENE/Plastic.

PVA MEDIUM/All-purpose resin glue.

SANTOBRITE/Monsanto product, available only wholesale in U.S. Swimming pool chemicals could be used instead to keep bacteria content down.

SECATEURS/scissors or shears, especially pruning shears.

SELLOTAPE/Scotch tape.

SHINGLE BEACH/With coarse, round detritus or alluvial material differing from ordinary gravel only in the larger size of the stones.

SLIP/clay in liquid suspension.

SLURRY/creamy mixture of clay.

SPINNEY/a small wood with undergrowth; coppice, thicket.

STRANDED COTTON/also called floss; one brand is DMC.

SWEDE/rutabaga.

TRANSPASEAL/brand name for Scotch tape.

TREACLE/Molasses.

TUMP/hillock, mound, molehill, ant hill, tussock.

WAXED THREAD/waxed linen (expensive); could use nylon monofilament in baskets instead.

CONVERSION OF POUNDS TO DOLLARS: as of February 1975 the exchange rate was £1 = $2.38. This figure is subject to change. Call your local bank for the current figure.

SIZE OF A HALF PENNY: Approximately the size of a quarter. In reference to mixtures for curing ailing hens, use a pinch.

SIZE OF A SIX PENNY: Approximately the size of a dime.

TEMPERATURE CONVERSION OF CENTIGRADE TO FAHRENHEIT: $(C \times 9/5) + 32 = F$

224

17th Edition

How to Form a

Nonprofit

Corporation

in California

Attorney Anthony Mancuso

SEVENTEENTH EDITION APRIL 2017

Editor	DIANA FITZPATRICK
Cover Design	SUSAN PUTNEY
Production	SUSAN PUTNEY
Proofreading	IRENE BARNARD
Index	ACCESS POINTS INDEXING
Printing	BANG PRINTING

ISSN: 2327-218X (print)
ISSN: 2327-2171 (online)

ISBN: 978-1-4133-2405-1 (pbk)
ISBN: 978-1-4133-2406-8 (epub ebook)

This book covers only United States law, unless it specifically states otherwise.

> ### Please note
>
> We believe accurate, plain-English legal information should help you solve many of your own legal problems. But this text is not a substitute for personalized advice from a knowledgeable lawyer. If you want the help of a trained professional—and we'll always point out situations in which we think that's a good idea—consult an attorney licensed to practice in your state.

Acknowledgments

The author extends a special thanks to my editor, Diana Fitzpatrick, and to all the hardworking people at Nolo.

About the Author

Anthony Mancuso is a corporations and limited liability company expert. A graduate of Hastings College of the Law in San Francisco, Tony is an active member of the California State Bar, writes books and software in the fields of corporate and LLC law, and has studied advanced business taxation at Golden Gate University in San Francisco. He also has been a consultant for Silicon Valley EDA (Electronic Design Automation) and other technology companies. He is currently employed at Google in Mountain View, California.

Tony is the author of many Nolo books on forming and operating corporations (profit and nonprofit) and limited liability companies. Among his current books are *Incorporate Your Business*; *How to Form a Nonprofit Corporation*; *The Corporate Records Handbook*; *Form Your Own Limited Liability Company*; and *LLC or Corporation?* His books and software have shown over 500,000 businesses and organizations how to form and operate a corporation or an LLC. Tony is a licensed helicopter pilot and has performed for years as a guitarist.

Table of Contents

Appendixes

Your Legal Companion for Forming a Nonprofit Corporation in California

Forming a nonprofit corporation may sound like a daunting task that you should hand over to a lawyer as quickly as you can—after all, aren't there a lot of paperwork and filings, and complicated IRS nonprofit tax laws to learn? There is paperwork, and you will need to deal with the IRS, but the truth is, you can do it yourself. Forming a nonprofit corporation in California is actually a fairly straightforward process. And, with the help of our line-by-line instructions, you can also obtain tax-exempt status from the IRS for your newly formed nonprofit corporation. Thousands of people have gone through the entire process of incorporating a nonprofit and obtaining 501(c)(3) tax-exempt status with this book to guide them.

Along the way, there may be decisions you need to make where you should seek professional advice. We'll let you know when you need outside help. And even if you do decide to hire a lawyer to handle some of the work for you, the information in this book will help you be an informed client—and get the most for your money.

This book explains, in plain English, how to incorporate your nonprofit in California and obtain 501(c)(3) tax-exempt status from the IRS. We show you how to:

- prepare and file nonprofit corporation articles and bylaws
- apply for and obtain 501(c)(3) tax-exempt status from the IRS
- satisfy IRS conflict-of-interest and excess-benefit guidelines
- qualify as a 501(c)(3) public charity
- prepare minutes for your first board meeting, and
- take care of postincorporation filings and tasks.

There are legal and tax technicalities that nonprofits must deal with in exchange for the substantial benefits they receive as nonprofits. We give you the information and tools you need both to form your tax-exempt nonprofit and understand the practical and ongoing issues related to running a nonprofit.

We know that any legal process can be challenging. We hope this book, with its step-by-step approach to incorporation and obtaining tax-exempt status from the IRS, will help you through the legal hoops and over the hurdles of incorporating your nonprofit in California and obtaining tax-exempt status from the IRS. Congratulations on taking your first steps toward success in your new nonprofit endeavor!

Get Forms, Updates and More Online

You can download forms in this book at:

www.nolo.com/back-of-book/NON.html

If there are important changes to the information in this book, we will post updates there.

Is Nonprofit Incorporation Right for You?

Deciding to form a nonprofit corporation will be a big step for you and the members of your group. It will involve more paperwork and government forms, on both the state and federal level, than anyone will like; and you'll have to conduct your business within the legal framework of various state and federal laws. Fortunately, there are big payoffs to all this work and attention, including the ability to attract donors and grant funds, obtain real and personal property tax exemptions and special nonprofit mailing rates, avoid corporate income taxes, and shield officers and directors from legal liability. Before starting down the path of nonprofit incorporation, however, you'll want to learn a little more about who can form a nonprofit and the consequences of doing so. In this chapter, we'll explain.

- the kinds of groups that can—and can't—form a nonprofit using this book
- the benefits you'll enjoy as a nonprofit—and some of the disadvantages to choosing this route
- how nonprofits can raise start-up funds and earn money, should they wish to do so
- the process you'll go through (following the instructions in this book) to incorporate and obtain your tax-exempt status, and
- for those considering incorporating in another state, considerations to bear in mind before doing so.

Is Your Group a Nonprofit That Can Use This Book?

A for-profit corporation can be formed for any lawful purpose. Nonprofit corporations, however, must be established under California law for one of three broad purposes: (1) for the benefit of the public (a public benefit corporation), (2) for religious purposes (a religious corporation), or (3) for the mutual benefit of the members of the nonprofit (a mutual benefit corporation). It's easy to form a nonprofit corporation in California: Just prepare articles of incorporation that say you are formed for one of these three broad nonprofit purposes and then file your articles with the California Secretary of State. This creates your legal corporate entity. However, having a nonprofit corporation recognized by the California Secretary of State is only your first hurdle. The next important step is to obtain the necessary state and federal corporate income tax exemptions for your nonprofit corporation. To obtain these exemptions, your nonprofit must be formed for one or more specific purposes described in the income tax statutes.

This book has been written specifically for nonprofit corporations that want to qualify for a federal income tax exemption under Section 501(c)(3) of the Internal Revenue Code. This means your nonprofit corporation must be formed for religious, charitable, scientific, literary, and/or educational purposes. If you want to organize as a religious purpose group, we will show you how to form a California religious nonprofit corporation. If you want to organize as a nonprofit to engage in any of the other 501(c)(3) tax-exempt purposes, we will show you how to form a California public benefit corporation. This book is not for groups that want to form a mutual benefit corporation, because mutual benefit nonprofits usually obtain their tax exemption under a subsection of Section 501(c) other than 501(c)(3). It is also not for certain special types of nonprofits (including some public benefit corporations) that do not fall under Section 501(c)(3). (See discussion below, "Special Types of California Public Benefit Corporations," and "Mutual Benefit Corporations.")

When thinking about incorporating your nonprofit, consider which purpose you fall

Corporation Basics

You don't have to understand all there is to know about corporations in order to follow this book or form your nonprofit. But there are a few basic concepts you'll want to have under your belt as you go through the process. Here they are, with special emphasis on any differences between for-profit corporations and nonprofits:

- **A corporation is a separate legal entity.** A corporation is a legal entity that allows a group of people to pool energy, time, and money for profit or nonprofit activities. It acquires legal existence after its founders comply with their state's incorporation procedures and formalities. The law treats a corporation as a separate "person," distinct from the people who own, manage, or operate it. The corporation can enter into contracts, incur debts, and pay taxes. Corporations are either for-profit (business corporations) or nonprofits.

- **For-profit, or business, corporations versus nonprofits.** Business corporations can be formed for any legal purpose. They can issue shares of stock to investors in return for money or property, or services performed for the corporation. Shareholders receive a return on their investment if dividends are paid or if, upon dissolution of the corporation, any

corporate assets remain to be divided among the shareholders after payment of all creditors. Nonprofits, on the other hand, generally cannot issue shares of stock or pay dividends under state law (unless they are some type of hybrid such as consumer or producer co-ops). The federal tax code also prohibits 501(c)(3) tax-exempt nonprofit corporations from paying dividends or profits to their members or other individuals. When a 501(c)(3) tax-exempt nonprofit corporation dissolves, it must distribute its remaining assets to another tax-exempt nonprofit group.

- **In-state and out-of-state corporations.** Corporations formed in California are known in California as "domestic" corporations. Corporations formed in other states, even if physically present and engaging in activities in California, are called "foreign" corporations. For example, a corporation formed in California is a domestic corporation as far as California is concerned, but a foreign corporation when considered by other states. At the end of this chapter, we give you more information on doing business outside California and deciding whether to incorporate in another state.

under for Section 501(c)(3). Once you know you fall within one of the 501(c)(3) purposes, you can rest assured that this book can help you through the process. First we'll help you create your corporate entity in California by showing you how to prepare and file articles of incorporation for a public benefit or religious corporation. Then we'll show you how to obtain your state and federal nonprofit income tax exemptions for 501(c)(3) status.

Public Benefit Corporations

Under state law, public benefit corporations are corporations formed for a "public purpose" or "charitable purpose." Most groups forming public benefit corporations also want to qualify for Section 501(c)(3) status. These groups usually organize for one of the specified purposes under Section 501(c)(3)—charitable, scientific, literary, or educational. All of these 501(c)(3) purposes are considered "charitable" purposes

under California law. For example, a school or educational facility would organize as a California public benefit corporation formed under state law for "charitable" purposes but its 501(c)(3) purposes would be "educational." The public purpose classification under state law is for groups that want to form civic league or social welfare public benefit corporations (see discussion below on civic leagues and social welfare groups). Don't worry—we show you how to fill in your articles so you put in the right purposes under California law and also satisfy the federal and state tax exemption requirements.

Religious Corporations

Just as the name indicates, religious corporations are formed primarily or exclusively for religious purposes. These groups can qualify as religious organizations under both state incorporation law and Section 501(c)(3). You need not set up a formal church to form a religious nonprofit corporation; these groups can have a general religious purpose. For example, a group organized to promote the study and practice of a particular religion could incorporate as a religious nonprofit

Special Types of California Public Benefit Corporations

This book covers the incorporation of California public benefit and religious nonprofits that want to obtain their tax exemption under Section 501(c)(3) of the Internal Revenue Code. There are several other types of California public benefit corporations that obtain tax exemption under *other* sections of the Internal Revenue Code or that must meet special state law requirements. Below, we list several of the most common types of these special California nonprofit corporations. If you plan to form one of these special nonprofits, you'll need to do your own research or get legal help to form your corporation—this book does not cover the incorporation of these special groups. (See "Where to Go for Help for Non-501(c)(3) Nonprofits," below.)

- **Civic leagues and social welfare groups.** Civic leagues and social welfare groups are formed as California public benefit corporations and seek their exemption from federal corporate income taxation under Section 501(c)(4) of the Internal Revenue Code. Because this book covers only nonprofits exempt under Section 501(c)(3) of the Internal Revenue Code, you won't be able

to use this book to incorporate these types of public benefit corporations. (See "Special Nonprofit Tax-Exempt Organizations," in Appendix B, for a list of organizations that qualify for tax-exempt status under a subsection of 501(c) other than Subsection 3.)

- **Medical or legal service corporations.** These are nonprofit corporations operated to assume or defray the cost of medical or legal services. These corporations may be organized as California public benefit corporations or mutual benefit corporations. Special provisions of the California Corporations Code apply (see California Corporations Code §§ 10810–10841).

- **Humane societies.** A humane society, formed to prevent cruelty to children or animals, can be formed as a California public benefit corporation. The Department of Justice must perform a criminal history check on all incorporators and issue a certificate before the secretary of state will accept the articles of incorporation for filing (California Corporations Code §§ 10400–10406).

corporation. It is unlikely that the California Secretary of State's office, where you'll file your articles of incorporation, will question whether your religious activities are genuine. This type of debate is more likely to occur (if it occurs at all) when you apply for your state or federal tax exemptions.

Mutual Benefit Corporations

This book is not intended for mutual benefit corporations. Unlike public benefit corporations and religious corporations, these groups usually qualify for tax-exempt status under a subsection of 501(c) other than 501(c)(3).

Examples of mutual benefit corporations include trade associations, automobile clubs, and social groups, such as tennis clubs. Chambers of commerce, boards of trade, and mechanics' institutes, which are generally formed to promote trade and commerce, can organize as mutual benefit corporations or as regular, for-profit corporations. Cooperatives, comprising producers or consumers organized for their mutual benefit, can also qualify as mutual benefit nonprofits with special added restrictions applicable to them.

Because these groups do not qualify for tax-exempt status under Section 501(c)(3), they are not entitled to many of the benefits enjoyed by public benefit and religious corporations. For example, contributions to mutual benefit corporations are normally not tax deductible, and other benefits (such as special nonprofit mailing rates and real and personal property tax exemptions) are not available to mutual benefit corporations. Mutual benefit corporations also cannot distribute gains, profits, or dividends to those designated in their articles or bylaws as members, but may provide them with other benefits such as services and facilities. On the other hand, members of a mutual benefit corporation can own part of the corporation. When the corporation dissolves and all its debts and liabilities are paid, the remaining assets, gains, and profits can be distributed to its members.

Do-Good LLCs and Corporations— The Latest in Limited Liability Entities

A number of states enable the formation of hybrid entities (LLCs and/or corporations) that can make a profit yet also do good. For example, some states (although not California at present) authorize the formation of a low-profit LLC (also called an L3C) that can be formed for an educational or charitable purpose but also can make a profit. States initially created this special type of hybrid entity to allow foundations to more easily distribute funds to a qualified social-purpose organization, but the IRS has not yet formally approved L3Cs for this purpose.

Closer to home, California allows the formation of flexible purpose corporations and benefit corporations, which can be formed to do good works as well as to make money. The advantage of these new California entities is that they can allow the principals to spend time and money trying to do good without having to worry about stakeholders being upset (and suing them) for not spending all their time trying to turn a profit. Because these entities are formed to make money, they do not qualify for a 501(c)(3) corporate income tax exemption.

All of the above hybrid entities are sometimes loosely referred to as B corporations. However, this term really refers to a certification that a socially-responsive corporation, LLC, or other entity can seek, as opposed to a separate type of corporation or other distinct legal entity (see www.bcorporation.net for more information).

Benefits of the Nonprofit Corporation

Now that you understand that this book is intended for nonprofits organized for religious, charitable, scientific, literary, and/or educational purposes that want to qualify for a tax exemption under Section 501(c)(3) of the Internal Revenue Code (and hopefully your nonprofit is among them), let's look at the benefits you'll enjoy as a 501(c)(3) tax-exempt nonprofit corporation. The relative importance of each of the following benefits will vary from group to group, but at least one of them should be very significant for your organization.

If you finish this section and conclude that nothing here is very important for your group, you'll want to consider whether it makes sense to incorporate at all. Many groups accomplish their nonprofit purposes just fine as unincorporated nonprofit associations, without formal organizational paperwork or written operational rules. If you can continue to accomplish your nonprofit purposes and goals informally, you may be happier staying small.

Tax Exemptions

Nonprofit corporations are eligible for state and federal exemptions from payment of corporate income taxes, as well as other tax exemptions and benefits. At federal corporate tax rates of 15% on the first $50,000 of taxable income, 25% on the next $25,000, and 34% and higher on income over $75,000, it goes without saying—at least if you expect to earn a substantial amount of money (from services, exhibits, or performances, for example)—that you'll want to apply for an exemption. The California corporate income tax exemption is equally attractive, as are county real and personal property tax exemptions. Chapters 3, 4, and 5 cover tax exemptions in detail.

Where to Go for Help for Non-501(c)(3) Nonprofits

If you want to form a nonprofit for any purpose other than one recognized under Section 501(c)(3) of the Internal Revenue Code, this book is not for you. For example, if you are a civic league or social welfare group that wants nonprofit status, you will want to organize as a public benefit corporation under Section 501(c)(4) of the Internal Revenue Code. Or, if your group is a California mutual benefit corporation, you will seek tax-exempt status under a subsection of 501(c) other than 501(c)(3). This book is not intended for these special types of nonprofits.

If you are a special nonprofit that is not covered by this book, you can find legal forms and tax exemption help online. For sample articles of incorporation for mutual benefit corporations and public benefit civic leagues and social welfare groups, go to the California Secretary of State website (the Business Entities section). If you are seeking tax exemption for a nonprofit under a subsection of 501(c) other than 501(c)(3), go to the IRS website at www.irs.gov and obtain IRS Package 1024. The IRS 1024 package contains forms and instructions to use to apply for a nonprofit tax exemption under Internal Revenue Code Sections 501(c)(2), (4), (5), (6), (7), (8), (9), (10), (12), (13), (15), (17), (19), and (25). The California Franchise Tax Board website at www.ftb.ca.gov has state tax exemption application forms to download and use to apply for your state corporate income tax exemption for these special non-501(c)(3) groups. IRS Publication 557 and IRS Form 1024 also contain information and instructions on forming some of these special purpose nonprofits.

SEE AN EXPERT

Get the help of a competent tax adviser as soon as you decide to incorporate. Make sure you choose someone experienced in the special field of nonprofit bookkeeping. Ask the adviser to help you (especially your treasurer) set up a good record-keeping system. Have the tax helper periodically review the system to be sure that you have met accepted bookkeeping standards and have filed your tax forms on time.

Receiving Public and Private Donations

One of the primary reasons for becoming a 501(c)(3) nonprofit corporation is that it increases your ability to attract and receive public and private grant funds and donations.

- **Public sources.** Tax-exempt government foundations (like the National Endowment for the Arts or Humanities, the Corporation for Public Broadcasting, or the National Satellite Program Development Fund) as well as private foundations and charities (such as the Ford Foundation, the United Way, or the American Cancer Society) are usually required by their own operating rules and federal tax regulations to donate their funds only to 501(c)(3) tax-exempt organizations.
- **Private sources.** Individual private donors can claim personal federal income tax deductions for contributions made to 501(c)(3) tax-exempt groups. At death, a complete federal estate tax exemption is available for bequests made to 501(c)(3) groups.

In short, if you plan to ask people to give you significant amounts of money in furtherance of your nonprofit purpose, you need to demonstrate to your donors that you have 501(c)(3) tax-exempt status.

Protection From Personal Liability

Protecting the members of your group from personal liability is one of the main reasons for forming a corporation (either profit or nonprofit). Once you're incorporated, in most situations directors or trustees, officers, employees, and members of a corporation won't be personally liable for corporate debts or liabilities, including unpaid organizational debts and unsatisfied lawsuit judgments against the organization, as they normally would be if they conducted their affairs without incorporating. Creditors can go after only corporate assets to satisfy liabilities incurred by the corporation—not the personal assets (car, home, or bank accounts) of the people who manage, work for, or volunteer to help the nonprofit corporation.

EXAMPLE: A member of the audience sued a nonprofit symphony orchestra when the patron fell during a concert, claiming that the symphony (which also owned the concert hall) provided an unsafe ramp. The patron won a judgment that exceeded the orchestra's insurance policy limits. The amount of the judgment in excess of insurance is a debt of the corporation, but not of its individual directors, members, managers, or officers. By contrast, had the orchestra been an unincorporated association of musicians, the principals of the unincorporated group could be held personally liable for the excess judgment amount.

In a few situations, however, people involved with a nonprofit corporation may be personally liable for the corporation's liabilities. Here are some major areas of potential personal liability:

- **Taxes.** State and federal governments can hold the corporate employee who is responsible for

reporting and paying corporate taxes (usually the treasurer) personally liable for any unpaid taxes, penalties, and interest due for failure to pay taxes or file necessary returns. With proper planning, your nonprofit corporation should be tax exempt, but you may still have to file informational returns and annual reports with the secretary of state, as well as pay employee withholding and other payroll taxes and taxes on income unrelated to your nonprofit purposes. IRS penalties for delinquent tax payments and returns are substantial, so keep this exception to limited liability in mind—particularly if you will be the treasurer.

- **Dues.** Members of a nonprofit corporation are personally liable for any membership fees and dues they owe the corporation. In most cases, this is a minor obligation since dues are normally set at modest amounts.

- **Violations of statutory duties.** Corporate directors are legally required to act responsibly (not recklessly) when managing the corporation. They may be held personally financially liable if they fail to act responsibly. Personal liability of this sort is the exception, not the rule. Generally, as long as directors attend meetings and carry out corporate responsibilities conscientiously, they should have little to worry about—the corporate limited liability shield insulates directors from all but the most reckless and irresponsible decisions.

- **Intermingling funds or other business dealings.** A nonprofit corporation must act so that its separate existence is clear and respected. If it mixes up corporate funds with the personal funds of those in charge, fails to follow legal formalities (such as failing to operate according to bylaws, hold director meetings, or keep minutes of meetings), or

risks financial liability without sufficient backup in cash or other assets, a court may disregard the corporate entity and hold the principals responsible for debts and other liabilities of the corporation. In legalese, this is known as "piercing the corporate veil." Piercing the veil is the exception, not the rule, and only happens when a court decides that it is necessary to prevent a gross injustice or fraud perpetuated by the founders or principals of a corporation.

- **Private foundation managers.** If the nonprofit corporation is classified as a private foundation, foundation managers can be held personally liable for federal excise taxes associated with certain prohibited transactions. They may also be held personally liable for penalties and interest charged for failing to file certain tax returns or pay required excise taxes. (As explained in Chapter 4, a private foundation is a 501(c)(3) corporation that does not qualify as a public charity—you'll see that most 501(c)(3) nonprofits can qualify as public charities and are not subject to the private foundation requirements.)

- **Loans.** When a nonprofit corporation takes a loan to cover its operating costs or buys property subject to a mortgage, banks and commercial lending institutions sometimes insist on the personal guarantee of its directors or officers. If the directors or officers agree to personally guarantee the loan or mortgage, the protection that they would normally enjoy as a result of their organization's corporate status goes away. It is somewhat unusual for nonprofit directors or officers to sign a personal guarantee. Obviously, if they do, they will be liable to repay the loan if the corporation cannot do so.

Separate and Perpetual Legal Existence

A corporation is a legal entity that is separate from the people who work in it. Again, one benefit of this separate existence is that corporate liabilities are not the liabilities of the managers, officers, or members of the corporation (known as the corporate characteristic of limited liability). Another benefit is that this corporate legal person is, in a sense, immortal; the nonprofit corporation continues to exist as a legal entity despite changes in management or other corporate personnel caused by the resignation, removal, or death of the people associated with it. It may, of course, be dissolved or drastically affected by the loss of key people, but its inherent perpetual existence makes it more likely that the group's activities will continue, an attractive feature to the private or public donor who prefers funding activities that are organized to operate over the long term.

Employee Benefits

Another benefit of the nonprofit corporation is that its principals can also be employees and, therefore, eligible for employee fringe benefits not generally available to the workers in unincorporated organizations. These benefits include group term life insurance, reimbursement of medical expenses, and coverage by a qualified corporate employee pension or retirement income plan.

Formality and Structure

The formal corporate documents—the articles, bylaws, minutes of meetings, and board resolutions—that you'll prepare as a nonprofit will actually be quite useful to your organization. They'll outline the group's purposes, embody its operating rules, and provide structure and procedures for decision making and dispute resolution. This is important for any collective activity, but for nonprofit groups it is vital, especially if the board includes members of the community with diverse interests and viewpoints. Without the clear-cut delegation of authority and specific operating rules in the articles and bylaws, running the organization might be a divisive, if not futile, affair.

Miscellaneous Benefits

Additional advantages are available to nonprofits that engage in particular types of activities or operations. These benefits can be helpful, and in some cases are critical, to the success of a nonprofit organization. Here are examples of some of the benefits available to certain types of tax-exempt nonprofits:

- Your nonprofit may qualify for exemptions from county real and personal property taxes.
- 501(c)(3) organizations receive lower postal rates on third-class bulk mailings.
- Many publications offer cheaper classified advertising rates to nonprofit organizations.
- Nonprofits are the exclusive beneficiaries of free radio and television public service announcements (PSAs) provided by local media outlets.
- Many stores offer lower membership rates to nonprofit employees.
- Nonprofit employees are often eligible to participate in job training, student intern, work-study, and other federal, state, and local employment incentive programs (where salaries are paid substantially out of federal and state funds).
- 501(c)(3) performing arts groups are qualified to participate in the performance programs sponsored by federally supported colleges and universities.

- Certain 501(c)(3) educational organizations are eligible for a tax refund for gasoline expenses (for example, in running school buses).

EXAMPLE: A senior citizens' botany club began as an informal organization. Initially, six members took a monthly nature walk to study and photograph regional flora. Everyone chipped in to buy gas for whoever drove to the hike's starting point. Recently, however, membership increased to 15 and the group decided to collect dues from members to pay the increased expenses— gas money, guidebooks, maps, and club T-shirts—associated with more frequent field trips. To avoid mixing club monies with personal funds, a treasurer was designated to open a bank account on behalf of the organization. Several people suggest that it is time to incorporate the club.

Does incorporation make sense at this time? Probably not. There is no new pressing need to adopt the corporate form or to obtain formal recognition as a tax-exempt nonprofit. Most banks will allow an unincorporated group without a federal Employer Identification Number or IRS tax exemption to open up a non–interest-bearing account. However, should the club decide to seek funding and contributions to spearhead a drive to save open space in the community, it might be a good idea to incorporate.

The Disadvantages of Going Nonprofit

If your group has come together for 501(c)(3) tax-exempt purposes, and if reading about the benefits of becoming a nonprofit above

prompted a "Wow! We would really like to be able to do *that!*" then chances are you've decided to tackle the rules and forms necessary to establish your status as a legal nonprofit. Before jumping in, however, take a minute to read the following descriptions of some of the hurdles and work you'll encounter along the way, especially if you have been operating informally (and successfully) without financial or employee record keeping or controls. If any of the following appear insurmountable to you, think again about incorporating.

Official Paperwork

One disadvantage in forming any corporation is the red tape and paperwork. You'll begin by preparing initial incorporation documents (articles of incorporation, bylaws, and minutes of first meeting of the board of directors), and an IRS income tax exemption application. Although this book will show you how to prepare your own incorporation forms and income tax exemption application with a minimum of time and trouble, the process will still take you a few hours at the very least. You and your compatriots must be prepared for some old-fashioned hard work.

After you've set up your corporation, you'll need to file annual information returns with the state (the Franchise Tax Board and the attorney general) as well as the Internal Revenue Service. Also, you will need to regularly prepare minutes of ongoing corporate meetings, and, occasionally, forms for amending articles and bylaws. The annual tax reporting forms will require the implementation of an organized bookkeeping system plus the help of an experienced nonprofit tax adviser, as explained below. Fortunately, keeping minutes of these meetings is not all that difficult to do once someone volunteers for the task (typically the person you appoint

as corporate secretary). Sample forms for amending nonprofit articles are available from the California Secretary of State's website. Go to the Business Entities section and click on "Forms, Samples, and Fees."

Annual nonprofit informational tax returns do present a challenge to a new group unfamiliar with state tax reporting forms and requirements. Other record-keeping and reporting chores, such as double-entry accounting procedures and payroll tax withholding and reporting, can be equally daunting. At least at the start, most nonprofits rely on the experience of a tax adviser, bookkeeper, or other legal or tax specialist on the board or in the community to help them set up their books and establish a system for preparing tax forms on time. (See Chapter 11 for recommendations on finding legal and tax professionals for your nonprofit.)

Incorporation Costs and Fees

A main disadvantage of not forming your 501(c)(3) nonprofit on your own is the extra cost of having to pay an attorney to prepare the incorporation forms and federal tax exemption application for you. Putting some time and effort into understanding the material in this book can help you eliminate this added cost, leaving you with only the state and IRS filing fees. If you use IRS Form 1023-EZ, the streamlined federal tax exemption application, the total fees to incorporate are approximately $305—a $30 state filing fee for your articles of incorporation and $275 for the IRS Form 1023-EZ application (plus some additional costs if you want certified copies). For nonprofits that use the longer Form 1023 application and anticipate gross receipts of $10,000 or less, the IRS fee goes up to $400. IRS fees go up an additional $450 to a total of $850 for nonprofits that use the Form 1023 application and anticipate gross receipts of more than $10,000.

Time and Energy Needed to Run the Nonprofit

When a group decides to incorporate, the legal decision is often part of a broader decision to increase not just the structure, but the overall scope, scale, and visibility of the nonprofit. With a larger, more accountable organization come a number of new tasks: setting up and balancing books and bank accounts, depositing and reporting payroll taxes, and meeting with an accountant to extract and report year-end figures for annual informational returns. Although these financial, payroll, and tax concerns are not exclusively corporate chores, you'll find that most unincorporated nonprofits keep a low employment, tax, and financial profile and get by with minimum attention to legal and tax formalities.

EXAMPLE: A women's health collective operates as an unincorporated nonprofit organization. It keeps an office open a few days a week where people stop by to read and exchange information on community and women's health issues. The two founders donate their time and the office space and pay operating costs (such as phone, utilities, and photocopying) that aren't covered by contributions from visitors. The organization has never made a profit, there is no payroll, and tax returns have never been filed. There is a minimum of paperwork and record keeping.

The founders could decide to continue this way indefinitely. However, the founders want to expand the activities and revenues of the collective. They decide to form a 501(c)(3) nonprofit corporation in order to be eligible for tax-deductible contributions and grant funds from the city, and to qualify the group to employ student interns and work-study students. This will require them to prepare and file articles of incorporation and

a federal corporate income tax exemption application. They must select an initial board of directors and prepare organizational bylaws and formal written minutes of the first board of directors' meeting.

After incorporation, the group holds regular board meetings documented with written minutes, sets up and uses a double-entry bookkeeping system, implements regular federal and state payroll and tax procedures and controls, files exempt organization tax returns each year, and expands its operations. A full-time staff person is assigned to handle the increased paperwork and bookkeeping chores brought about by the change in structure and increased operations of the organization.

This example highlights what should be one of the first things you consider before you decide to incorporate: Make sure that you and your coworkers can put in the extra time and effort that an incorporated nonprofit organization will require. If the extra work would overwhelm or overtax your current resources, we suggest you hold off on your incorporation until you get the extra help you need to accomplish this task smoothly (or at least more easily).

Restrictions on Paying Directors and Officers

As a matter of state corporation law and the tax exemption requirements, nonprofits are restricted in how they deal with their directors, officers, and members. None of the gains, profits, or dividends of the corporation can go to individuals associated with the corporation, including directors, officers, and those defined as members in the corporation's articles or bylaws. State self-dealing rules apply as well, regulating action by the board of directors if a director has a financial interest in a transaction.

Finally, with respect to California public benefit corporations (if you form a 501(c)(3) tax-exempt nonprofit corporation for nonreligious purposes, you will form a California public benefit corporation), a majority of the board of directors cannot be paid (other than as a director), or related to other persons who are paid, by the corporation. This can represent a significant restriction because it eliminates the close-knit organization many picture when they think of a small, grassroots nonprofit corporation.

Restrictions Upon Dissolution

One of the requirements for the 501(c)(3) tax exemption is that upon dissolution of the corporation, any assets remaining after the corporation's debts and liabilities are paid must go to another tax-exempt nonprofit, not to members of the former corporation.

Restrictions on Your Political Activities

Section 501(c)(3) of the Internal Revenue Code establishes a number of restrictions and limitations that apply to nonprofits. Here, we discuss a limitation that may be very significant to some groups—the limitation on your political activities. Specifically, your organization may not participate in political campaigns for or against candidates for public office, and cannot substantially engage in legislative or grassroots political activities except as permitted under federal tax regulations.

EXAMPLE: Society for a Saner World, Inc., has as one of its primary objectives lobbying hard to pass federal and local legislation that seeks to lessen societal dependency on fossil fuels. Since a substantial portion of the group's efforts will consist of legislative lobbying, the group's 501(c)(3) tax exemption

probably will be denied by the IRS. Instead, the group should seek a tax exemption under IRC Section 501(c)(4) as a social welfare group, which is not limited in the amount of lobbying the group can undertake. Of course, the benefits of 501(c)(4) tax exemption are fewer too—contributions to the group are not tax-deductible and grant funds will be more difficult to obtain (see "Special Nonprofit Tax-Exempt Organizations," in Appendix B).

Oversight by the Attorney General

The California Attorney General has broad power to oversee the operations of California public benefit corporations, more so than it does with other California nonprofits. (Remember: If you form a nonreligious 501(c)(3) tax-exempt corporation, you will be forming a California public benefit corporation.) The state can even take the corporation to court to make sure it complies with the law.

By contrast, California religious purpose nonprofit corporations have wider flexibility in managing their internal affairs. If a religious corporation does not set up its own operating rules, provisions of the nonprofit law will apply to its operations by default. These are less stringent than those that would apply to a public benefit corporation under similar circumstances.

How Nonprofits Raise, Spend, and Make Money

Most nonprofits need to deal with money—indeed, being able to attract donations is a prime reason for choosing nonprofit status. Nonprofits can also make money. Nonprofit does not literally mean that a nonprofit corporation cannot make a profit. Under federal tax law and

state law, as long as your nonprofit is organized and operating for a recognized nonprofit purpose, it can take in more money than it spends in conducting its activities. A nonprofit may use its tax-free profits for its operating expenses (including salaries for officers, directors, and employees) or for the benefit of its organization (to carry out its exempt purposes). It cannot, however, distribute any of the profits for the benefits of its officers, directors, or employees (as dividends, for example).

This section explains how nonprofits raise initial funds and how they make money on an ongoing basis.

Initial Fundraising

A California nonprofit corporation is not legally required to have a specified amount of money in the corporate bank account before commencing operations. This is fortunate, of course, because many beginning nonprofits start out on a shoestring of meager public and private support.

So, where will your seed money come from? As you know, nonprofit corporations cannot issue shares, nor can they provide investment incentives, such as a return on capital through the payment of dividends to investors, benefactors, or participants in the corporation (see "Corporation Basics," at the beginning of this chapter).

Nonprofits have their own means and methods of obtaining start-up funds. Obviously, the most common method is to obtain revenue in the form of contributions, grants, and dues from the people, organizations, and governmental agencies that support the nonprofit's purpose and goals. Also, if you are incorporating an existing organization, its assets are usually transferred to the new corporation—these assets may include the cash reserves of an unincorporated group, which can

help your corporation begin operations. You can also borrow start-up funds from a bank, although for newly formed corporations a bank will usually require that incorporators secure the loan with their personal assets—a pledge most nonprofit directors are understandably reluctant to make.

Often, of course, nonprofits receive initial and ongoing revenues from services or activities provided in the pursuit of their exempt purposes (ticket sales, payments for art lessons or dance courses, school tuition, or clinic charges).

For information on meeting California's special fundraising rules, see "State Solicitation Laws and Requirements," in Chapter 5.

Making Money From Related Activities

Many nonprofits make money while they further the goals of the organization. The nonprofit can use this tax-exempt revenue to pay for operating expenses (including reasonable salaries) and to further its nonprofit purposes. For example, an organization dedicated to the identification and preservation of shore birds might advertise a bird-watching and -counting hike for which they charge a fee; the group could then use the proceeds to fund their bird rescue operations. What it cannot do with the money, however, is distribute it for the benefit of officers, directors, or employees of the corporation (as the payment of a patronage dividend, for example).

EXAMPLE: Friends of the Library, Inc., is a 501(c)(3) nonprofit organized to encourage literary appreciation in the community and to raise money for the support and improvement of the public library. It makes a profit from its sold-out lecture series featuring famous authors and from its annual sale of donated books. Friends can use this tax-exempt profit for its

own operating expenses, including salaries for officers and employees, or to benefit the library.

Making Money From Unrelated Activities (Unrelated Income)

Nonprofits can also make money in ways unrelated to their nonprofit purpose. Often this income is essential to the survival of the nonprofit group. This unrelated income, however, is usually taxed as unrelated business income under state and federal corporate income tax rules. While earning money this way is permissible, it's best not to let unrelated business activities reach the point where you start to look more like a for-profit business than a nonprofit one. This can happen if the unrelated income-generating activities are absorbing a substantial amount of staff time, requiring additional paid staff, or producing more income than your exempt-purpose activities. If the unrelated revenue or activities of your tax-exempt nonprofit reach a substantial level, the IRS can decide to revoke the group's 501(c)(3) tax exemption—a result your nonprofit will no doubt wish to avoid.

EXAMPLE: Many thousands of books are donated to Friends of the Library for its annual book sale, one of its major fundraising events. Although the sale is always highly successful, thousands of books are left over. Friends decides to sell the more valuable books by advertising in the rare and out-of-print books classified sections in various magazines. The response is overwhelming; soon, there are six employees cataloging books. In addition, Friends begins a business purchasing books from other dealers and reselling them to the public. Such a situation could attract attention from the IRS and prompt it to reconsider Friends' 501(c)(3) tax-exempt status.

Making Money From Passive Sources

Although it's not typical for the average non-profit, a nonprofit corporation can make money from passive sources such as rents, royalties, interest, and investments. This income is nontaxable in some cases.

Your Path to Nonprofit Status

Nonprofit organizations first obtain nonprofit corporate status with the California Secretary of State—a simple formality accomplished by filing articles of incorporation. Then they go on to obtain a corporate income tax exemption with the Internal Revenue Service. California recognizes your federal tax exemption, so you don't have to prepare a separate state tax exemption application. In sum, your path to nonprofit status is a basic two-step process—first you incorporate with the California Secretary of State, then you apply for tax-exempt recognition from the Internal Revenue Service (you'll notify the California Franchise Tax Board of your federal income tax exemption). When you're done with this book, you'll have completed each of these steps.

State Law Requirements for Nonprofits

The California Secretary of State must officially recognize all California nonprofit corporations. To obtain state recognition, you'll file articles of incorporation with the secretary of state's office stating that your organization is entitled to receive nonprofit corporate status. This book covers the basic requirements for obtaining recognition by California's Secretary of State as a nonprofit corporation. The California Nonprofit Corporation Law (California Corporations Code §§ 5000–9927) governs the organization and operations of California nonprofit corporations.

We focus on public benefit corporations in this book (those formed for public or charitable purposes) because these corporations make up the majority of nonprofit corporations eligible for exemption under Section 501(c)(3) of the Internal Revenue Code. Requirements for religious corporations are noted only if they are different from the requirements for public benefit corporations.

Tax-Exempt Status Under Federal and State Tax Law

Both state and federal tax laws apply to California nonprofit corporations. To obtain tax-exempt status, nonprofits must comply with initial and ongoing requirements under the federal Internal Revenue Code. California tax law parallels the federal law. In most ways, understanding and complying with state and federal tax rules is more important (and more challenging) than fulfilling the state corporate law requirements. This book focuses on nonprofit corporations seeking tax-exempt status under Section 501(c)(3) of the Internal Revenue Code, which are nonprofits organized for religious, charitable, educational, scientific, or literary purposes.

Incorporating in Another State—Don't Fall for It

Corporations formed in a particular state are known in that state as domestic corporations. When viewed from outside that state, these corporations are considered foreign. A foreign corporation that plans to engage in a regular or repeated pattern of activity in another state must qualify to do business there by obtaining a certificate of authority from the secretary of

state. For example, a corporation formed in Nevada that intends to do regular business in California is a foreign corporation here, and must qualify the corporation with our secretary of state.

Incorporators who plan to operate in another state besides California have naturally considered whether it makes sense to incorporate in that other state. Maybe the incorporation fees or corporate taxes are lower than those in California or the nonprofit statutes are more flexible. Then, the reasoning goes, one could qualify the corporation in California as a foreign corporation. As tempting as this end run may appear, it's not usually worth it. This section explains why, and also advises you of out-of-state activities that you can engage in without worrying about qualifying in another state.

Qualifying as a Foreign Corporation in California Will Cost You More

The process of qualifying a foreign corporation to operate in California takes about as much time and expense as incorporating a domestic corporation. This means that you will pay more to incorporate out-of-state since you must pay the regular California qualification fees plus out-of-state incorporation fees.

Multiple Tax Exemptions

Your corporation will still be subject to taxation in each state in which it earns or derives income or funds. If the state of incorporation imposes a corporate income tax, then the nonprofit corporation will need to qualify for two state corporate tax exemptions—one in California, the state where the corporation will be active, and one for the state of incorporation. Similarly, double sales, property, and other state tax exemptions may often be necessary or appropriate.

Multiple State Laws

Your out-of-state corporation will still be subject to many of the laws that affect corporations in California. Many of California's corporate statutes that apply to domestic corporations also apply to foreign corporations.

Out-of-State Activities Below the Radar

For the above reasons, most readers who flirt with the idea of incorporating in a state other than California would be well advised to skip it. This doesn't mean, however, that you'll have to trim all of your activities to stay within California. Fortunately, there are many things nonprofits can do as a foreign corporation in another state without obtaining a certificate of authority from the secretary of that state. Here are some that are recognized in many (but not all) states:

- maintaining, defending, or settling any legal action or administrative proceeding, including securing or collecting debts, and enforcing property rights
- holding meetings of corporate directors or of the membership and distributing information to members
- maintaining bank accounts and making grants of funds
- making sales through independent contractors and engaging in interstate or foreign commerce
- conducting a so-called isolated transaction that is completed within 30 days and is not one of a series of similar transactions, and
- exercising powers as an executor, administrator, or trustee, so long as none of the activities required of the position amounts to transacting business.

When Out-of-State Incorporation Makes Sense

There may be a few of you for whom incorporation in another state makes sense. If you plan to set up a multistate nonprofit with corporate offices and activities in more than one state (a tristate environmental fund for example), you may want to consider incorporating in the state that offers the greatest legal, tax, and practical advantages. To help you decide where to incorporate, you can refer to the secretary of state's website for each state where you operate. Type "nonprofit resource libraries" into your browser's search box—you'll find a host of online resources at your disposal. An experienced nonprofit lawyer or consultant can also help you determine which state is the most convenient and least costly to use as the legal home for your new nonprofit corporation.

References to IRS Articles and Materials

Throughout the book, there are references to IRS articles and materials that you can download from Nolo's website (see Appendix A for the link). Some of this material includes articles and information made available by the IRS on its website as part of its Exempt Organizations Continuing Professional Education Technical Instruction Program, which regularly publishes articles for tax-exempt organizations. The IRS has the following statement on its website regarding this material: "These materials were designed specifically for training purposes only. Under no circumstances should the contents be used or cited as authority for setting or sustaining a technical position."

In other words, use this material to learn about IRS tax issues, but don't expect to be able to rely on it if you end up in a dispute with the IRS. Nolo includes this material as a convenience to the reader and as an alternative to directing you to the IRS website. This material is taken directly from the IRS website at www.irs.gov (enter "EO Tax Law Training Articles" in the search box at the top of the main website page, then follow the links to "Exempt Organizations Continuing Professional Education Technical Instruction Program" main page, where you'll find a link to an alphabetical index of the articles, "Exempt Organizations CPE Topical Index"). If you are interested in one of the issues, you should check the IRS website for any updated articles or information on your topic.

Legal Rights and Duties of Incorporators, Directors, Officers, Employees, and Members

ven though a corporation is a legal person capable of making contracts, incurring liabilities, and engaging in other activities, it still needs real people to act on its behalf to carry out its activities. These people decide to incorporate, select those who will be responsible for running the organization, and actually manage and carry out the nonprofit's goals and activities.

This chapter explains the rights and responsibilities of those in your group who will organize and operate your nonprofit corporation. These incorporators, directors, officers, members, and employees have separate legal rights and responsibilities. Later, after your nonprofit is up and running, you may want to refer back to this chapter if you have questions regarding the powers and duties of these important people.

The Importance of Protecting Your Corporate Status

Before you start looking for people to help run your nonprofit, take a moment for a reality check: Many potential helpers will hesitate to become involved because they've read in the press about a few notorious, high-visibility lawsuits where nonprofit directors have been held personally liable for misconduct by executives of the nonprofit (for example, the executive of a large, public membership nonprofit misappropriates program funds to buy a yacht or high-priced apartment for personal use). On a more down-to-earth level, a potential treasurer for your nonprofit may hesitate to serve if that person thinks he or she will be personally responsible for the organization's tax reporting penalties, or a potential director may be worried about being personally sued by a fired employee of the nonprofit. Fortunately, these types of personal liability are extremely rare. Most nonprofits should be able to assure potential director and officer candidates that the nonprofit will be run accountably and sensibly without undue risk of tax or legal liability for the directors.

One obvious way to reassure candidates is to purchase directors' and officers' liability insurance from an insurance broker who handles nonprofit corporate insurance (called D&O errors and omissions insurance). This type of insurance, however, is expensive and usually beyond the reach of newly formed small nonprofits. Also, D&O coverage often excludes the sorts of potential liabilities that your directors and officers may be worried about (personal injury and other types of legal tort actions, claims of illegality, or intentional misconduct and the like). If you decide to investigate the cost of D&O insurance, you will want to make sure to go over the areas of coverage and exclusion in the policy very carefully before you buy in.

California nonprofit law recognizes that nonprofits often can't afford D&O liability insurance with adequate claim coverage and it contains provisions that help limit *volunteer* directors' and officers' exposure to liability. Corporations must also indemnify (advance or pay back) a director for legal expenses incurred in a lawsuit under certain conditions. These special California statutes are discussed in more detail in "Directors," below, and they can provide added comfort to people considering serving as a California nonprofit corporation director or officer. Again, we believe the best and most practical way to reassure directors and officers to hitch their wagon to your nonprofit organization's star is to be able to show them you will operate your nonprofit fairly, responsibly, and safely without undue risk of lawsuits by employees or complaints by the public.

Incorporators and Their Role as Promoters

An incorporator is the person (or persons) who signs and delivers the articles of incorporation to the secretary of state for filing. In practice, the incorporator is often selected from among the people who serve as the initial directors of the corporation. Once the corporation is formed, the incorporator's legal role is finished.

During the organizational phase, it's not unusual for an incorporator to become a "promoter" of the corporation. An incorporator's promotional activities can quickly go beyond enthusiastic talk about the organization. Promotional activities may involve obtaining money, property, personnel, and whatever else it takes to get the nonprofit corporation started. Arranging for a loan or renting office space will require signatures and promises—to repay the loan and pay the rent. But will the newly formed corporation automatically become responsible? Future directors may hesitate to join a new organization that is saddled already by contracts negotiated by an eager (but perhaps unsavvy) promoter. The promoters themselves will naturally be nervous that they'll be personally responsible if the incorporation plans go awry. And what about the third parties? They may not be inclined to do business with promoters unless they are assured that there will be a responsible party at the other end. After explaining how a promoter must approach every transaction—with the corporation's best interests in mind—we'll show you how to address the concerns of the eventual directors, the promoters themselves, and the third parties with whom they do business.

A Promoter Must Act With the Corporation's Best Interests in Mind

When an incorporator acts as a promoter, he or she is considered by law to be its fiduciary. This legal jargon simply means the incorporator has a duty to act in the best interests of the corporation, and must make full disclosure of any personal interest and potential benefits derived from business transacted for the nonprofit.

> **EXAMPLE:** When the incorporator/promoter arranges to sell property he or she owns to the nonprofit corporation, the incorporator must disclose to the nonprofit's board of directors both any ownership interest in the property and any gain she or he stands to make on the sale.

Directors Must Ratify a Promoter's Actions

Most of the time, a nonprofit corporation won't be bound by an incorporator's preincorporation contract with a third party unless the board of directors ratifies the contract or the corporation accepts the benefits of the contract. For example, if a nonprofit board votes to ratify the lease signed by an incorporator before the date of incorporation, the corporation will be bound to honor the lease. Similarly, if the nonprofit moves into its new offices and conducts business there, their actions will constitute a ratification and the nonprofit will be bound.

Promoters Can Avoid Personal Liability

Fortunately, if promoters carefully draft documents—such as any loan papers and leases—they can avoid the risk of personal liability in the event that the corporation doesn't ratify the deal (or if the corporation never comes into being). Incorporators will not be personally liable for these contracts if they sign in the name of a proposed corporation, not in their individual name, clearly inform the

third party that the corporation does not yet exist and may never come into existence, and tell the third party that even if it does come into existence, it may not ratify the contract.

Convincing Third Parties to Do Business With a Promoter

As you might imagine, a cautious third party may balk at doing business with an individual whose yet-to-be-formed nonprofit may repudiate the deal. One way to provide some assurance to a third party is for an incorporator to personally bind to the contract—in essence, become a guarantor for the loan, lease, or other contract. Understandably, few incorporators will be able or willing to put their personal finances on the line, unless they are absolutely sure that the corporation will in fact be formed and will ratify the deal. The other solution is to incorporate quickly—which you can do with the help of this book!

> **EXAMPLE:** An incorporator/promoter enters into an agreement to lease office space for its organization. Six months later, the organization obtains nonprofit corporate status. The newly formed nonprofit is not bound by the lease agreement unless its board of directors ratifies the agreement or the organization used the office space during the preincorporation period.

Directors

Directors meet collectively as the board of directors, and are responsible—legally, financially, and morally—for the management and operation of your nonprofit corporation. A nonprofit in California must have at least one director, although many nonprofits have three or more. Often, the people who formed the corporation (the incorporators) also become the corporation's first directors and they are also the ones who prepare and file the articles of incorporation. Although there are no residency requirements (you can have out-of-state directors) or age requirements, your directors should be over the age of 18 to avoid contractual problems.

Selecting Directors

Choosing directors is one of the most important decisions you will make when organizing your nonprofit. Here are some important things to consider that will help you make the best possible choice for your organization.

Commitment to Your Nonprofit's Purpose

Your directors are a crucial link between your organization and its supporters and benefactors. Make sure that the members of the community that you plan to serve will see your directors as credible and competent representatives of your group and its nonprofit goals. Their status and integrity will be crucial to encouraging and protecting public trust in your organization, and their connections will be vital to attracting recognition, clients, donations, and other support.

- Consider members of the communities you will serve who have a proven commitment to the goals of your organization. There may be more than one community you'll want to consider. For example, your draw may be local (city, county, or state), regional, or national. If you are an environmental group concerned with issues in the southern part of the state, you have both a geographic community (people in the area) and a community of interest (environmentalists generally). Your board should reflect a cross section of interested and competent people from both these communities.

- Look for people with contacts and real-world knowledge and experience in the specific area of your nonprofit's interest. If you are starting a new private school or health clinic, someone familiar with your state's educational or public health bureaucracy would be a big help.

- If your organization is set up to do good works that will benefit a particular group, don't overlook the value of including a member of that recipient group. You may learn important things about your mission and get valuable buy-in from the beneficiaries of your hard work.

Business Knowledge and Expertise

Directors' responsibilities include developing and overseeing organizational policies and goals, budgeting, fundraising, and disbursing a group's funds. The board of directors may hire an administrator or executive director to supervise staff and daily operations, or it may supervise them directly. Either way, your board of directors should be a practical-minded group with strong managerial, technical, and financial skills. In making your selection, try to find people with the following skills and experience:

- **Fundraising experience.** While many large nonprofits have a staff fundraiser, smaller groups often can benefit from the advice of an experienced board member.

- **Experience managing money.** A professional accountant or someone with expertise in record keeping and budgeting can be a godsend. Many nonprofits get into difficulty because their record-keeping and reporting techniques aren't adequate to produce the information required by the federal and state governments. Many are simply inattentive to financial responsibilities, such as paying withholding

taxes or accounting properly for public or private grant monies.

- **Useful practical skills.** Do you need the professional expertise of a doctor, lawyer, or architect; or operational assistance in areas such as public relations, marketing, or publishing? If so, make finding one of these professionals a high priority during your board search.

Public Officials Are a Good Choice

The IRS likes to see that you have a representative (and financially disinterested) governing body that reflects a range of public interests, not simply the personal interests of a small number of donors. While it's by no means required, the presence of a sympathetic public official on your board can enhance its credibility with both the IRS and the community.

Avoid Conflicts of Interest

When selecting board members, you may need to inquire about, or at least consider, a prospective member's agenda or motives for joining the board. Obviously, people who want to join for personal benefit rather than for the benefit of the organization or the public should not be asked to serve. This doesn't mean that everyone with a remote or potential conflict of interest should be automatically disqualified. It does mean that any slight or possible conflict of interest should be fully recognized and discussed. If the conflict is limited, directors may be able to serve constructively if they refrain from voting on certain issues.

The bylaws included in this book have conflict-of-interest provisions that contain rules and procedures for avoiding or approving

transactions, including compensation arrangements, that benefit the nonprofit's directors, officers, employees, or contractors. (See Article 9 of the bylaws and "Limitation on Profits and Benefits," in Chapter 3, for more information on this topic.)

Develop a Realistic Job Description

Your board of directors should be prepared to put time and energy into the organization. Make sure every prospective director has a realistic and clear understanding of what the job entails. Before you contact prospective candidates, we suggest that you prepare a job description that specifies at least the following:

- the scope of the nonprofit's proposed activities and programs
- board member responsibilities and time commitments (expected frequency and length of board meetings, extra duties that may be assigned to directors), and
- the rewards of serving on your board (such as the satisfaction of working on behalf of a cause you care about or the experience of community service).

A clear and comprehensive job description will help with decision making and will also help avoid future misunderstandings with board members over what is expected of them.

Train Your New Directors

The organizers of a nonprofit corporation often need to give initial directors orientation and training about the nonprofit's operations and activities. This training should continue so that board members can handle ongoing operational issues as well. For example, if your nonprofit corporation is organized to provide health care services, board members may need to learn city, state, and federal program requirements that impact your operations, and should get regular updates on changes made to these rules and regulations.

> **TIP**
>
> **Choose the right number of directors.** You'll want enough to ensure a wide basis of support (particularly with respect to fundraising), but not so many as to impede efficiency in the board's operation. Boards with between nine and 15 directors often work well.

Paying Your Directors

Nonprofit directors usually serve without compensation. We believe this is generally wise. Having nonprofit directors serve without pay reinforces one of the important legal and ethical distinctions of the nonprofit corporation: Unlike its for-profit counterpart, its assets are used to promote its goals, not for the private enrichment of its incorporators, directors, agents, members, or employees.

If you compensate directors, do so at a reasonable rate, related to the actual performance of services and established in advance by a board resolution. (See Article 9 of the bylaws included in this book for specific procedures to follow when approving compensation arrangements.) Most nonprofits reimburse directors only for necessary expenses incurred in performing director duties, such as travel expenses—typically a gas or mileage allowance—to attend board meetings. Sometimes directors are paid a set fee for attending meetings.

The bylaws included with this book contain conflict-of-interest and compensation approval policies that help a nonprofit obtain its 501(c)(3) tax exemption. These policies require disinterested members of the board or a committee of the board (such as a compensation committee) to approve all

compensation paid to directors, officers, and others who exert control over a nonprofit (substantial contributors, higher-paid employees, or contractors). Before approving the compensation, the board or committee must determine that the pay is comparable to the amounts paid to others who serve in similar roles for similar organizations. (For more information on these bylaw provisions, see Chapter 7, the sample bylaws for a public benefit corporation, special instruction 12.)

Public Benefit Corporations and the "51% Rule"

If you form a California public benefit corporation and choose to compensate your directors for performing nondirector services for your corporation, you'll need to understand the 51% rule, a state law provision applicable to public benefit corporations (California Corporations Code § 5227). This rule specifies that a majority of directors of a public benefit corporation cannot be interested persons. A director is interested if he or she is receiving payment from the corporation for services rendered in the past 12 months to the corporation in any capacity *other than* as a director, or is related to such a person (for example, a director also serves and is paid as an officer or consultant to the corporation). Under the statute, related means a brother, sister, ancestor, descendant, spouse, brother-in-law, sister-in-law, son-in-law, daughter-in-law, father-in-law, or mother-in-law of any such paid person. This means that a majority of the board, including relatives of board members, cannot be paid as officers, employees, or independent contractors of the corporation.

> **EXAMPLE:** A 501(c)(3) education nonprofit corporation, organized as a California public benefit corporation, has three directors on its board, each of whom is paid a modest amount for attending board meetings. All three directors can be paid for attending meetings without violating the 51% rule. One of the board members is also paid a salary as the organization's chief operating officer and another director is also paid as a legal consultant to the nonprofit. The nonprofit is in violation of the 51% rule because only one-third of the board is "disinterested," not the required 51% or greater. If the board member who is the legal consultant agrees to render legal advice and services for free, the nonprofit will be in compliance with the 51% rule because then two-thirds of the board would be disinterested (only one board member, the chief operating officer, would be interested).

The California Attorney General enforces the 51% disinterested director rule. How will the attorney general know if you're in violation of the rule? Every year, you'll file a Periodic Report form (Form RRF-1) with the attorney general's office, in which you'll be asked about your directors' interested or disinterested status. If you are a public benefit corporation and the attorney general learns that a majority of your board (including relatives of board members) is not disinterested, it will, at the very least, send your corporation a letter requiring compliance.

Larger nonprofit corporations and those that rely on grant funds (where even stricter conflict-of-interest rules often apply) will already be familiar with director compensation limitations and are less likely than their smaller counterparts to run into problems with the 51% rule. Smaller groups, however, tend to rely more heavily on the same group of people (and their family members) to act as directors and also as officers, employees, and independent contractors of their organization. These smaller public benefit corporations may need to look for extra, unrelated people to fill some of the directors' positions so that the more active

directors (or their family members) can also be paid salaries as officers or employees.

The following examples highlight some of the problems that small nonprofits run into with the 51% disinterested directors rule.

EXAMPLE 1: Your public benefit corporation has four directors: you, your sister Blanche, and two unrelated persons, Bob and Ray. Bob's brother-in-law, Alfredo, is one of the paid officers of the corporation. If you get paid for doing occasional work during the year as an independent contractor, your corporation has violated the 51% rule. Why? Because you are an interested person (you are getting paid during the current year for services other than acting as a director) and your sister Blanche is an interested person (she is related to you). Even if you replace Blanche with an unrelated unpaid board member, your public benefit corporation board will still be in violation of the 51% rule because Bob is an interested person as well (his brother-in-law is a paid employee of the corporation). Remember, a majority of the board cannot be paid for nondirector work or be related to anyone who is paid by the corporation.

EXAMPLE 2: A two-person board consists of two unrelated, unpaid people who run a small, nonprofit public benefit corporation. From time to time, they consult the spouse of one of the directors, who is an accountant and does not charge the corporation. After a big project, they decide to make a token payment to the accountant for all the tax work done on the project. Whoops! The director who is the accountant's spouse just became an interested person for this calendar year and because there are only two people on the board, the board is now in violation of the 51% rule.

Term of Office

You can set the term of office for your directors in your bylaws (if you don't, the law provides that directors of public benefit and religious corporations can serve for only one year). Should you decide to set the term, you'll need to abide by the rules for public benefit corporations and religious corporations.

Public Benefit Corporations

The maximum term for directors of a public benefit corporation depends on whether the corporation has members. (For a discussion of members, see "Membership Nonprofits," below). If the public benefit corporation has members, the maximum term is four years; without members, the maximum term is six years. A director whose term has expired, however, can be reelected immediately and can serve an unlimited number of additional consecutive terms.

Public benefit corporations can get around the four-year (or six-year) term limitation by including a special provision in their bylaws authorizing the designation, instead of election, of directors. The bylaws can provide that one or more persons, usually the more active directors, are authorized to designate the other directors for any prescribed term. Generally, public benefit corporations with members can use this procedure for only one-third of their authorized number of directors.

Religious Corporations

Religious corporations can set up their own rules for the term, election, selection, designation, removal, and resignation of directors. These rules can be specified in the corporation's articles or by-laws.

TIP

We suggest a three-year term for directors.
You'll get the most out of what a director has to contribute and will ensure continuity in operations. In return, the director will get the satisfaction of long-term service and hopefully will see some goals fulfilled.

Staggered Elections for Board Members

In the interest of continuity, staggered elections of board members may be a good idea. For example, rather than replacing the entire board at each annual election, you may wish to reelect one-third of the board members each year to serve a three-year term. To start this staggered system out with a 15-member board—five of the initial directors would serve for one year, five for two years, and the remaining five for the full three-year term. At each annual reelection, one-third of the board would be elected to serve three-year terms.

Quorum Rules

For the board of directors to take action at a meeting, a specified number of directors of the corporation—called a quorum—must be present. Unless otherwise provided in the bylaws, a majority of the number of directors in office represents a quorum. Most small nonprofits restate this majority quorum rule in their bylaws.

If you want a lower quorum requirement, you can provide for it in your bylaws, subject to certain restrictions. A public benefit corporation must have a quorum of at least two directors, or one-fifth of the total number of directors, whichever is larger. A public benefit corporation with only one director, however, may of course have a one-person quorum. Religious corporations can choose any quorum requirement they wish.

EXAMPLE: A public benefit corporation with five directors must have at least a two-director quorum. A 15-director public benefit corporation must have at least a three-person quorum.

Voting Rules

Once a quorum is present at a meeting, a specified number of votes is needed to pass a board resolution. Unless otherwise stated in the articles or bylaws, a resolution must be passed by a majority vote of the directors present at a meeting where there is a quorum. In some cases, the votes of interested directors cannot be counted. This is discussed more in "How to Avoid Self-Dealing," below.

EXAMPLE: The bylaws of a corporation with ten board members specify that a quorum consists of a majority of the board and that action by the board can be taken by a majority of the directors present. This means that a quorum of at least six people (a majority of the ten-person board) must be present to hold a board meeting and, at the very least, four votes (a majority of the six members present at a meeting) are required to pass a resolution. If eight of the ten directors attend the meeting, action must be approved by at least five votes—a majority of those present at the meeting.

If a quorum is present initially at a meeting and one or more board members leave, action can sometimes still be taken even if you lose your quorum. As long you can still obtain the number of votes that represents a majority of the required quorum stated in the bylaws, the board can take action even though a quorum is no longer present at the meeting (this is known as the initial quorum rule). Going back to the example above, in a ten-director board,

the required quorum for board action is six directors (a majority of the ten) and at least four votes (a majority of those present) are needed to take board action. Under the initial-quorum rule, two directors can leave the meeting and the four remaining votes will still be sufficient to pass a resolution. Why? Because a quorum was initially present and four board members, representing a majority of the required quorum of six, can vote to pass a resolution.

TIP

Get a quorum by teleconferencing. Your board of directors doesn't necessarily have to meet in person to take action. Directors can take action (following their regular voting rules) using a conference telephone call or other means of electronic transmissions. See Article 3 of the bylaws (on the Nolo website; see appendix A for the link).

Executive Committees

The board of directors can delegate some or even a significant part of the board's duties to an executive committee of two or more directors. This arrangement is often used when some directors are more involved in running and managing the nonprofit's affairs and business than others. Even the passive directors, however, should still keep an eye on what their more active colleagues are up to and actively participate in regular meetings of the full board. To encourage passive directors to stay involved, courts have held the full board responsible for the actions of the executive committee.

Fortunately, keeping the full board abreast of executive committee actions isn't very difficult. The full board should receive regular, timely minutes of executive committee meetings and should review and, if necessary, reconsider important executive committee decisions

at each regularly scheduled meeting of the full board. The full board should retain the power to override decisions of the executive committee.

There are certain actions that can't be delegated to an executive committee. Specifically, an executive committee cannot be given authority to:

- approve action that requires approval by the membership
- fill vacancies on the board or other committees
- fix directors' compensation
- alter bylaws
- appoint committees, or
- use corporate funds to support a nominee to the board after more people have been nominated than can be elected.

Don't confuse this special executive committee of directors with other corporate committees. The board typically appoints several specialized committees to keep track of and report on corporate operations and programs. These committees act as working groups that are more manageable in size and help make better use of the board's time and its members' talents. They may include finance, personnel, buildings and grounds, new projects, fundraising, or other committees. These committees, often consisting of a mix of directors, officers, and paid staff, do not normally have the power to take legal action on behalf of the corporation; their purpose is to report and make recommendations to the full board or the executive committee.

EXAMPLE: The board of directors appoints a finance committee charged with overseeing the organization's fundraising, budgeting, expenditures, and bookkeeping. The corporation's treasurer chairs the committee. Periodically, this committee makes

financial recommendations to the full board. The board could also appoint a personnel committee to establish hiring and employment policies and to interview candidates for important positions. A plans and programs committee might be selected to put together the overall action plan for accomplishing the goals of the organization. Any action taken based on a committee's report or recommendation would be subject to approval by the board.

Directors Must Act Carefully

Corporate directors and officers have a legal duty to act responsibly and in the best interests of the corporation—this is called their statutory "duty of care." The statutes defining this phrase use general, imprecise legal terms that are not very helpful in understanding what exactly it means. As a result, the meaning of the term has developed over time as judges and juries, faced with lawsuits, decide whether a director's acts did (or did not) live up to the duty of care. Fortunately, most of it boils down to common sense, as the following discussions show.

Personal Liability for Directors' Acts

In general, you shouldn't be overly concerned about the prospect of personal liability for your directors. Broadly speaking, courts are reluctant to hold nonprofit directors personally liable, except in the clearest cases of dereliction of duty or misuse of corporate funds or property. In the rare cases when liability is found, the penalties are usually not onerous or punitive—typically, the court orders directors to repay the losses their actions caused.

Ordinary negligence or poor judgment is usually not enough to show a director breached his or her duty of care. Instead, there generally must be some type of fraudulent or grossly negligent behavior. Volunteer directors and executive officers of nonprofits enjoy extra protection from personal liability. These personal immunity laws are discussed in detail in "Special Protections for Volunteer Directors and Officers," below.

> **EXAMPLE:** A committee of the nonprofit advises the board of an unsafe condition on the corporation's property. The committee recommends certain remedial actions to get rid of the problem. If the board fails to implement any remedial measures or otherwise take steps to deal with the problem, a court could hold the directors personally liable for any ensuing damage or injuries.

Although the risk of being held personally liable is small, there are some things a director can and should do to minimize the risk of personal liability. Most importantly, all directors, whether active participants or casual community observers, should attend board meetings and stay informed of, and participate in, all major board decisions. If the board makes a woefully wrongheaded or ill-advised decision that leads to monetary damages, the best defense for any board member is a "No" vote recorded in the corporate minutes.

Also, all boards should try to get an experienced financial manager on their board or use the services of a prudent accountant who demands regular audited financial statements of the group's books. Legalities aside, what is most likely to put nonprofit directors at risk of personal liability is bad financial management, such as failing to pay taxes, not keeping proper records of how much money is collected and how it is disbursed, and commingling funds, either directors' personal funds with corporate funds or mixing restricted with nonrestricted funds.

Reliance on Regular Business Reports: A Safe Haven

To help directors accomplish their managerial duties, directors can rely on information from reliable, competent sources within the corporation (officers, committees, and supervisory staff), or on outside professional sources (lawyers, accountants, and investment advisers). If this information later turns out to be faulty or incorrect, the directors will not be held personally liable for any decision made in reliance on the information, unless the directors had good reason to question and look beyond the information presented to the board and failed to do so.

For example, if a nonprofit's treasurer tells the board that the organization has sufficient cash to meet ongoing payroll tax requirements, and the report seems reasonable (perhaps because the nonprofit has a budget surplus), the IRS will probably find that the individual board members were entitled to rely on the treasurer's report, even if there is not enough money to pay the taxes. However, if the board knows or should have known that the nonprofit is having a difficult time paying its bills despite reports to the contrary by the treasurer, and the board does not direct the treasurer to make sure to set money aside to pay payroll taxes, the IRS may try to hold board members personally liable for unpaid taxes.

Investment Decisions Involving Corporate Assets

Directors of a public benefit corporation must use more caution when making investment decisions than when they decide routine business matters. That's because when they make investment decisions involving corporate funds, directors have an added duty of care under California nonprofit law to avoid speculation and protect those funds—a stricter standard of care than the normal standard discussed above. According to this stricter standard of care, directors must "avoid speculation, looking instead to the permanent disposition of the funds, considering the probable income, as well as the probable safety of the corporation's capital." (California Corporations Code § 5240(b)(1).)

This stricter investment standard does not apply to religious corporations. Directors of religious corporations are held to the lighter duty of care for the investments of nonprofit funds.

> **EXAMPLE:** The treasurer of a performing arts group tells the group's directors that the group has a hefty surplus of funds because of its recent road tour. The board decides to invest this money in a stable asset mutual fund rather than one of several high-risk equity funds that reported double-digit declines in the last several quarters. If challenged by the attorney general or a complaining member, the directors should be able to show that they've met the statutory investment standard—they attempted to preserve the capital of the corporation by investing in a stable fund with a predictable positive return track record rather than a riskier fund that was more likely to lose money.

Directors Must Be Loyal

A director has a duty of loyalty to the corporation. This means that the director must give the corporation a "right of first refusal" on business opportunities he or she becomes aware of as a director. If the corporation fails to take advantage of the opportunity after full disclosure, or if the corporation clearly would not be interested in the opportunity, the director can then take personal advantage of the opportunity.

EXAMPLE: Bob is a volunteer director on the board of Help Hospices, a nonprofit hospice and shelter organization. He agrees to shop around for a low-rent location in a reasonably safe neighborhood for the next nonprofit hospice site. He learns of three low-rent locations, one of which would also be ideal as a low-cost rental studio for his son who wants to move out of his parents' house as soon as possible. Bob reports all three locations to the board, and tells them that he plans to apply for a lease in his son's name on one of the rental units only if the board decides that it is not interested in leasing the space for nonprofit purposes. This type of specific disclosure is exactly what is required for Bob to meet his duty of loyalty to the nonprofit. Bob can apply for the lease for his son if the board gives him the go-ahead after deciding the nonprofit is not interested in leasing the space for itself.

How to Avoid Self-Dealing

Directors must guard against unauthorized self-dealing—that is, involving the corporation in any transaction in which the director has a material, or significant, financial interest without proper approval. Any transaction that has a material financial impact on a director can trigger the self-dealing rules. Once the self-dealing rules are triggered, the transaction must be properly approved before it can be consummated (see the California Corporations Code § 5233 for public benefit corporations; § 9243 for religious corporations).

The self-dealing rules and proper approval requirements can arise in many different types of transactions, including the purchase or sale of corporate property, the investment of corporate funds, or the payment of corporate fees or compensation.

EXAMPLE: A board votes to authorize the corporation to lease or buy property owned by a director, or to purchase services or goods from another corporation in which a director owns a substantial amount of stock. Either of these could be considered a prohibited self-dealing transaction if not properly disclosed and approved, because a director has a material financial interest in each transaction and neither falls within one of the specific statutory exceptions.

A corporation must follow one of several distinct procedures to approve a transaction involving the corporation and one or more directors with a material financial interest in the transaction. Some of these procedures are similar to the duty of disclosure rules discussed above for directors who want to take advantage of an opportunity that could benefit the corporation. Self-dealing transactions, however, are ones where the corporation has decided to pursue the opportunity and the transaction will benefit the director.

If proper self-dealing procedures are not followed, the corporation, any of its directors or officers, or the California Attorney General can, on the attorney general's motion or upon complaint to the attorney general by a nonprofit insider or member of the public, sue the directors for the return of assets or repayment of money obtained through the self-dealing transaction.

See Article 9 of the bylaws included in this book for specific procedures to follow when approving transactions that benefit directors, officers, employees, or contractors associated with the nonprofit.

Get Attorney General Approval

The safest and most effective way to handle a situation where there is potential for self-dealing is to obtain the attorney general's approval of

the transaction. You can do this before or after the deal is consummated (before is better).

If you don't want to seek the attorney general's approval, you can simply notify the attorney general of the transaction (and get approval of the transaction from the board, as explained in the next section). This is not as good a safeguard for your deal as getting attorney general approval, but it does limit the time in which a lawsuit can be filed to two years from the date of the written notice. Without attorney general approval or notice, the attorney general has up to ten years after the transaction is consummated to file a lawsuit, and anyone else has up to three years.

California religious nonprofits have extra leeway in self-dealing situations. See the *California Attorney General's Guide for Charities*, available on the Nolo website (see Appendix A for the link), that contains a statement regarding the attorney general's overall hands-off policy with respect to the oversight of religious corporations.

RESOURCE

Go over the *California Attorney General's Guide for Charities*. It has information on seeking attorney general approval and sending a notice of transaction to the attorney general, and provides detailed information on how to comply with other nonprofit reporting and filing requirements. You can browse or download the *California Attorney General's Guide for Charities* (plus occasional separate supplements), at the California Attorney General's website at www.oag.ca.gov (go to the charities section and you will find a link to it there). Or, you can download a copy from the Nolo website (see Appendix A for the link).

The *Guide* contains excellent summaries of the legal responsibilities and liabilities of nonprofit directors under California law, as well as practical information on fundraising, fiscal management, and other important nonprofit issues. We recommend all California nonprofits obtain a copy of this valuable sourcebook.

Obtain Approval From Disinterested Board Members

If you don't have the time to get the attorney general's approval for a self-dealing transaction, the transaction can be approved by a disinterested board, or committee of the board, upon a showing of certain facts. This approach is a lot less safe than getting attorney general approval, but it may be appropriate if you are absolutely certain a self-dealing transaction is completely fair to your nonprofit, even though a director is incidentally benefited by the transaction. For the board approval to be valid, it must occur before the transaction is entered into and the director who has a financial interest in the transaction cannot vote, although the director can be counted for purposes of determining whether a quorum is present. In addition, the board must:

- have full knowledge of the economic benefit to the interested director
- determine that the transaction is fair and benefits the corporation, and
- determine that it is the best business deal that the corporation can make.

A properly authorized committee of the board can make these findings, as long as the board ratifies the committee's findings as soon as possible.

For religious corporations, the board or committee must simply determine that the transaction is fair or in furtherance of the religious purposes of the corporation.

Exceptions to Self-Dealing Rules

Exceptions to the self-dealing rules allow corporations to make certain decisions without having to follow the strict procedures that might otherwise apply. Here are some actions that might financially benefit a director but can be approved by normal board action:

- a board resolution fixing the compensation of a director or officer of the corporation
- a transaction that is part of the public, charitable, or religious program of the corporation, as long as it is approved without unjustified favoritism and benefits directors or their families only because they are in the class of persons intended to be benefited by the particular corporate program, and
- a transaction involving less than 1% of the corporation's previous year's gross receipts or $100,000, whichever is less, provided the interested director has no knowledge of the transaction.

Loans and Guarantees

Any loan or guarantee to a director of a public benefit corporation must be approved by the attorney general. Excluded from this requirement is a director's repayment obligation to a corporation for premiums paid on a life insurance policy, provided the obligation is secured by the proceeds of the policy and its cash surrender value. Loans made to an officer for the purchase of a principal residence are also not subject to this requirement, as long as the loan is necessary, in the board's opinion, to secure the services or continued services of the officer and is secured by real property in California.

Is Your Nonprofit a Socially Responsible Organization?

Do you need to certify your nonprofit as a socially sustainable organization (such as the B corporation certification, as discussed in "Do-Good LLCs and Corporations—The Latest in Limited Liability Entities," in Chapter 1)? Many larger profit-making corporations are instituting socially responsible practices and processes and acquiring certifications in an attempt to satisfy a broader range of stakeholders—not only shareholders, but also employees, suppliers, creditors, and members of the community served or impacted by the organization. They commit to maintaining a low carbon footprint, implementing fair labor practices, socially-responsible investment practices, and long-range corporate planning strategies (as opposed to seeking short-term profits regardless of the long-term financial, social, and environmental impact of doing so). Strangely, perhaps, these socially responsible initiatives typically are being undertaken by large, publicly-traded profit-making corporations, and not by mid-sized or smaller nonprofits.

However, if your nonprofit interfaces with one of these sustainability-certified companies, it may be asked to obtain a certification too. More specifically, if you are deemed to be in the "supply chain" of a certified company as a vendor of services, a creditor, or simply an organization to which it donates money, goods, or services, the certified company may be required, as part of its certification, to make sure you too are certified.

On the accounting front, sustainability standards similar to FASB (Financial Accounting Standards Board) rules are being developed by the SASB (Sustainability Accounting Standards Board) so that publicly-traded and other entities can report their sustainability metrics to agencies such as the SEC (Securities and Exchange Commission) and to the public. If you interface with an SASB reporting company, you may be asked to prepare and report SASB metrics to it and to the public as well. Look up "SASB" online for more information.

Loans and guarantees to directors of religious corporations do not require the approval of the attorney general. Instead, they must be made under the general duty of care guidelines discussed above, in "Directors Must Act Carefully."

SEE AN EXPERT

Consult a lawyer before approving any loans or providing any guarantees to directors. Because a nonprofit's activities cannot in any way benefit individuals involved in its operations, it's easy to see why a loan to a director from tax-exempt funds might appear questionable, even if it falls outside the attorney general's approval rules. If you plan to make a loan or guarantee to a director, check with a lawyer to make sure you comply with the applicable attorney general approval rules, and make sure the loans and guarantees are fair and in furtherance of the nonprofit's goals and activities.

Special Protections for Volunteer Directors and Officers

Special laws protect volunteer directors from personal liability for actions taken in connection with their duties as directors. These laws were passed to provide incentive and protection to people willing to serve on boards and work on behalf of nonprofit organizations. The protections offered by these laws have not proved to be of major significance. They can be helpful, however, particularly for small nonprofits during the early years when they often can't afford director and officer liability insurance yet need to attract outside people to help with their organizations.

Of course you should do everything possible to minimize potential risks involving your group's activities at the outset. For example, make sure that employees perform their work in a safe manner and that anyone required to perform a skilled task is properly trained and licensed. In addition, the corporation should obtain insurance coverage whenever possible for any specific known risks: motor vehicle insurance to cover drivers of corporate vehicles, and general commercial liability insurance to cover the group's premises. This will help reduce the risk of any personal liability for directors. And make sure your nonprofit meets all payroll and corporate tax return requirements imposed by the state and the IRS. Failure to withhold and pay payroll taxes or file timely corporate information returns can lead to hefty penalties and fines against the organization and the individuals responsible for the nonprofit's tax filings.

Public Benefit Corporations

California's nonprofit law protects a volunteer director or executive officer (such as the president, vice president, secretary, or treasurer) of a public benefit corporation from personal liability for negligent acts or omissions committed in the performance of his duties (California Corporations Code § 5239). This protection applies only to certain third-party lawsuits for monetary damages, such as a personal injury claim against a director by a participant in a fundraising event. To get this protection, the following conditions must be met:

- the act or omission must be within the scope of the director's or executive officer's duties
- the act or omission must be performed in good faith
- the act or omission must not be reckless, wanton, intentional, or grossly negligent, and
- damages caused by the act or omission must be covered by a liability insurance policy (either in the form of a general liability policy, a directors' and officers' (D&O) liability policy, or a policy issued personally to the director or executive officer), *or*, if there is no such policy, good faith efforts must have been made to obtain liability insurance.

It is important to remember that these laws protect only *volunteer* directors and executive officers of public benefit corporations. You can be reimbursed for expenses such as gas mileage or receive a per diem payment and still be considered a volunteer. You cannot, however, receive a salary, fee, or other consideration for services to the corporation. The law isn't intended to cover day-to-day ministerial actions of corporate employees.

If the nonprofit does not have the insurance as mentioned in the final point above, the organization must be able to show that it made good faith efforts to obtain it. Fortunately, the law gives some meaning to the term, good faith efforts. Here are the rules:

- If you are a 501(c)(3) public benefit nonprofit and your annual budget is less than $25,000, you can show this good faith effort if your corporate records prove that you made at least one inquiry each year for $500,000 in general liability coverage, and that the quotes received equaled or exceeded 5% of your annual budget for the prior year.
- Larger nonprofits should get one or more quotes for coverage per year and keep a record of the dates of their contacts with insurance brokers, agents, and companies, the types and amounts of coverage sought, and quotes or responses received from each contact. Documentation of this sort should also be kept if a larger nonprofit gets less insurance than it originally sought.
- Volunteer directors and executive officers must also make reasonable efforts on their own to obtain insurance and these efforts should be carefully documented.

EXAMPLE: The Better Books Network has an annual budget of $20,000. The Treasurer contacts a nonprofit insurance broker and gets a quote for $500,000 worth of general liability coverage at a cost of more than $1,000 (more than 5% of the nonprofit's previous annual budget). Under the statute, they qualify as having made a reasonable effort to obtain insurance. They don't have to take the policy; they just have to be able to show that they asked for and obtained this quote (by making a note in the corporate records and, if possible, attaching a faxed or written copy of the quote obtained from their insurance broker). They must obtain similar quotes for all years in which they hope to take advantage of this statutory escape hatch.

A volunteer director or officer may still be personally liable to the corporation for negligence in actions brought by other directors in the name of the corporation or by the attorney general. And the corporation itself remains liable for damages to third parties, even if its directors and officers fall under the protection of these rules. Also, if a plaintiff sues for something other than monetary damages (such as a court order for restitution), these rules do not apply.

There is a separate provision of California's nonprofit law (California Corporations Code § 5047.5) that protects volunteer directors and officers of public benefit corporations in a manner similar to the protections offered by Section 5239. To qualify under this section, the public benefit corporation must be tax-exempt under Section 501(c)(3) of the Internal Revenue Code, have an annual budget of less than $50,000, and take out a general liability insurance policy of at least $500,000. Larger 501(c)(3) tax-exempt corporations must be insured for at least $1 million. This section specifically requires that the nonprofit obtain a general liability policy, whereas Section 5239 requires only that you be able to show the nonprofit made attempts to obtain insurance.

Religious Corporations

Section 9247 of the California Corporations Code protects volunteer directors and officers of California nonprofit religious corporations in a manner similar to Section 5239, discussed above. Section 5047.5, discussed above, also applies to religious nonprofits that are tax-exempt under Section 501(c)(3) of the Internal Revenue Code.

Indemnification for Lawsuits

Generally, a California corporation must indemnify (reimburse) a director for legal expenses incurred in a lawsuit related to the performance of his duties as director, if the director wins the lawsuit. If the director loses the lawsuit, he can still be reimbursed for legal expenses if the board, membership, or the court approves the payment and finds that the director was acting in good faith and in a manner he or she believed to be in the best interests of the corporation.

Indemnification is more difficult to obtain if the lawsuit involves self-dealing or if the indemnification is for judgments, fines, or settlements in actions brought by the corporation itself or by the California Attorney General.

Insurance

A nonprofit corporation can purchase insurance to cover a director's legal expenses, judgments, fines, and settlements incurred in connection with a lawsuit or other proceeding brought against the director for either a breach of duty to the corporation, or simply because of that person's status as a director of the corporation. Of course, D&O liability insurance can be costly and beyond the reach of many small nonprofits. Insurance cannot, as a matter of California law, be purchased to cover any liability that arises from breaking the self-dealing rules discussed above.

Officers

A California nonprofit corporation must have at least three officers: a president (or chairperson of the board), secretary, and treasurer (as the chief financial officer). Typically, officers are selected from the board of directors. One person may fill one or more of the officer positions, except that the person who holds the office of secretary or treasurer cannot also be the president. There are no residency or age requirements for officers.

Duties and Responsibilities

The powers, duties, and responsibilities of officers are specified in the corporation's articles or bylaws, or by resolution of the board of directors. Generally, officers are in charge of supervising and implementing the day-to-day business of the corporation. This authority does not usually include the authority to enter into major business transactions, such as the mortgage or sale of corporate property. These kinds of major transactions are left to the board of directors. If the board wants the officers to have the power to make one or more major business decisions, special authority should be delegated by board resolution.

Officers have a duty to act honestly and in the best interests of the corporation. Officers are considered agents of the corporation and can subject the corporation to liability for their negligent or intentional acts if their acts cause damage and are performed in the scope of their employment.

Officers May Bind the Corporation

Generally, the actions and transactions of an officer are legally binding on the corporation. A third party is entitled to rely on the apparent authority of an officer and can require the corporation to honor a deal, regardless of

whether the officer was actually empowered by the board to enter into the transaction. To avoid confusion, if you delegate a special task to an officer outside the realm of the officer's normal duties, it's best to have your board pass a resolution granting the officer special authority to enter into the transaction on behalf of the corporation.

And, of course, any action taken by an officer on behalf of a corporation will be binding if the corporation accepts the benefits of the transaction or if the board ratifies the action, regardless of whether or not the officer had the legal authority to act on the corporation's behalf.

Compensation of Officers

Officers can receive reasonable compensation for services they perform for a nonprofit corporation. It is appropriate to pay officers who have day-to-day operational authority, and not to pay the officers who limit themselves to presiding over the board of directors or making overall nonprofit policy decisions. In smaller nonprofits, it is more common for officers and directors to also assume staff positions and be paid for performing these operational tasks. Remember, though, that under the 51% disinterested directors rule, only 49% of the directors of a public benefit corporation can receive compensation as officers or for another nondirectorial position of the same corporation.

> **EXAMPLE:** In a larger nonprofit organization, a paid executive director or medical director (these are staff positions, not board of director posts) might oversee routine operations of a medical clinic, and the paid principal or administrator (also staff positions) will do the same for a private school. However, in a smaller nonprofit, the corporate president or other officer may assume these salaried tasks.

The bylaws included with this book contain conflict-of-interest and compensation approval policies that help a nonprofit obtain its 501(c)(3) tax exemption. These policies require disinterested members of the board or a committee of the board (such as a compensation committee) to approve all compensation paid to directors, officers, and others who exert control over a nonprofit (substantial contributors, higher-paid employees, or contractors). Before approving the compensation, the board or committee must determine that the pay is comparable to the amounts paid to others who serve in similar roles for similar organizations. For more information on these bylaw provisions, see, in Chapter 7, "Bylaws for a Public Benefit Corporation," special instruction 12, in "Instructions for Completing Your Bylaws."

The California Nonprofit Integrity Act of 2004 contains special California rules for the approval of executive compensation. Under the law, the board or a committee of the board of all "charitable" nonprofits (generally, public benefit nonprofits except schools and hospitals) must review and approve as "just and reasonable" any compensation paid to the nonprofit's president (or chief executive officer) and treasurer (or chief financial officer). Compensation includes salary, benefits, and any other amounts paid. You must obtain board or committee approval initially upon hiring the officer, when the term of employment is renewed or extended, and whenever the officer's compensation is modified. However, separate approval of the CEO and CFO's compensation is not required if compensation is modified for substantially all employees.

If you already have a nonprofit CEO or CFO who is an at-will employee with no employment contract, your board should review and approve the officer's compensation. If you are organizing

your nonprofit and are appointing your initial officers, you should add your finding as to the reasonableness of CEO, CFO, and other officer compensation in the Compensation of Officers resolution in your Minutes of First Meeting of the Board of Directors, prepared as explained in "Prepare Minutes of Your First Board of Directors' Meeting," in Chapter 9.

Here are some Internet resources you can use to learn more about the rules under the California Nonprofit Integrity Act of 2004:

- Go to the California Attorney General's website at http://oag.ca.gov. Go to the Publications section, click on "Charities/ Nonprofits," and search for the "Summary of New Law: Nonprofit Integrity Act of 2004."
- To read the sections of California law amended or added by the Act, go to the official California Legislative Information website at http://leginfo.legislature.ca.gov. Select "California Law" and go to Government Code Sections 12581, 12582, 12583, 12584, 12585, 12586, 12599, 12599.1, 12599.3, 12599.6, and 12599.7, and Business and Professions Code Section 17510.5.

Loans, Guarantees, and Immunity Laws

Loans and guarantees to officers are governed by the same rules that apply to loans and guarantees to directors (see "Loans and Guarantees," above). The special personal immunity laws for volunteer directors of nonprofits also apply to volunteer executive officers of nonprofit corporations. These laws are discussed in detail above, in "Loans and Guarantees." The executive officers who fall under the protection of the personal immunity laws are the president, vice president, secretary, treasurer, and anyone who assists in establishing the policy of the corporation, at least with respect to their policy-making decisions. A corporation can also insure or indemnify its officers against personal liability for their actions on behalf of the corporation.

Employees

Employees of nonprofit corporations work for and under the supervision of the corporation and are paid a salary in return for their services. Paid directors and officers are considered employees for purposes of individual income tax withholding, Social Security, state unemployment, and other payroll taxes the employer must pay. Employees have the usual duties to report and pay their taxes, and the usual personal liability for failing to do so.

Employee Immunity

Employees are generally not personally liable for any financial loss their acts or omissions may cause to the corporation or to outsiders, as long as they are acting within the course and scope of their employment. If the harm is done to outsiders, it is the corporation, not the employees, that must assume the burden of paying for the loss.

> **CAUTION**
>
> **Employees may be personally liable for taxes.** An important exception to the rule of employee nonliability concerns the employee whose duty it is to report or pay federal or state corporate or employment taxes. The responsible employee (or officer or director) can be held personally liable for failure to report or pay such taxes. The IRS may take a broad view as to who is "responsible" for such duties (see "Federal and State Corporate Employment Taxes" in Chapter 10.)

Employee Compensation

Salaries paid to officers or regular employees should be reasonable and given in return for

services actually performed. A reasonable salary is one roughly equal to that received by employees rendering similar services elsewhere. If salaries are unreasonably high, they are apt to be treated as a simple distribution of net corporate earnings and could jeopardize the nonprofit's tax-exempt status. Nonprofits should avoid paying discretionary bonuses at the end of a good year—this may look like a payment from the earnings and profits of the corporation, a no-no for nonprofits. In reality, since the pay scale for nonprofit personnel is usually lower than that of their for-profit counterparts, most of this cautionary advice shouldn't be needed.

Employee Benefits

Among the major advantages associated with being an employee of a corporation are the employment benefits it can provide, such as corporate pension plans, corporate medical expense reimbursement plans, and corporate group accident, health, life, and disability insurance. Generally, amounts the corporation pays to provide these benefits (such as the payment of insurance premiums by the corporation) are not included in the employee's individual gross income and therefore are not taxed to the employee. Also, the benefits themselves (such as insurance proceeds) are often not taxed when the employee receives them. These corporate employee benefits can sometimes be an important collateral reason for forming a nonprofit corporation. They are often more favorable than those allowed noncorporate employees.

The nonprofit itself enjoys a tax break when offering benefits in certain situations. Benefits are deductible by a nonprofit corporation if taxes are owed by the corporation in connection with an activity that uses the services of these employees. For example, if a nonprofit generates $20,000 in gross revenue unrelated to its exempt purposes,

but pays wages of $10,000 plus benefits of $5,000 to generate this income, its net unrelated business income is reduced to $5,000.

Nonprofits may establish some of the employee benefits plans available to employees of business corporations. The rules are complicated, however. For information on setting up qualified employee plans and other benefits, consult your tax adviser or a benefits plan specialist.

Membership Nonprofits

California nonprofit law assigns a very specific meaning to the terms member and membership nonprofit. At the time you incorporate, you must decide whether to establish a formal membership structure for your nonprofit. If you choose to have a membership structure, your members will be the ones who approve or disapprove major corporate decisions. In a nonmembership structure, the board of directors makes the major corporate decisions. Most smaller groups choose not to form a membership corporation because it is simpler to operate without members.

Nonmembership Corporations

First, then, let's review how the majority of nonprofits run—without a formal membership. In a nonmembership corporation, only the directors participate in the legal affairs of the corporation. This structure avoids the extra time, work, and expense involved in having major corporate decisions subject to formal member approval.

California nonprofit law gives members the right to approve various corporate decisions. However, if the nonprofit's articles and bylaws do not provide for members, the law specifically says that directors act in the place of members whenever membership approval of an action is required. So if you read the California

nonprofit law and see references to approval by members, this means approval by directors in a nonmembership nonprofit. In addition, in a nonmembership corporation, any membership action can be approved by regular board approval (normally majority vote) even if there is a greater membership vote requirement for the action specified in the nonprofit law.

There may be many interested people associated with a nonmembership organization—folks who pay annual dues or fees to support the organization or to receive attendance privileges, mailings, or discounts to events—but they're not members as the term is legally defined. These people are often called supporters, patrons, contributors, advisors, or even members, but they don't participate in the legal affairs of the nonprofit because they have not been specifically granted legal membership rights by the corporation.

> EXAMPLE: Susan, a patron of the Art Museum, has a museum membership that entitles her to free admissions, participation in educational programs and events, use of a special facility, or attendance at exhibition previews. The membership does not give Susan any say in the museum's operation and management, which she would have if she were a legal, formal member.

If you already know that your nonprofit will not have members, you may skip the rest of this section. If you're not sure about whether to have members, this section should guide you in your decision. And should you decide to form a membership nonprofit, you'll need to refer back to this discussion as you go about the normal steps of setting up and running your nonprofit.

Who Is a Member Under Law?

Under California nonprofit law, a member is someone who is given the right in the corporation's articles or bylaws to vote for the election of directors, the sale of substantially all of the assets of the corporation, a merger of the corporation, or its dissolution (California Corporations Code § 5056). A member also means any person who is designated a member in the corporation's articles or bylaws and has the right to vote on amendments to the corporation's articles or bylaws. Sometimes a nonprofit will refer informally to its members or charge admission fees, dues, or assessments to enroll and maintain an informal nonprofit membership. These people, even if referred to informally as members, are not members under law unless you set up a membership structure in your articles and bylaws and give them specific voting rights.

Members Elect and Remove Directors

Members elect the directors in a membership corporation. The election must take place at a regular membership meeting or, subject to some exceptions, can be by written ballot. Regular meetings of members should coincide with the time for reelection of directors. There are specific rules that govern director nomination and election procedures.

Special meetings of members for the purpose of removing directors can be called by 5% or more of the members. If the corporation has fewer than 50 members, removal of directors must be approved by a majority of all members. Normal voting requirements apply to the removal of directors if the corporation has 50 or more members.

Members Amend Bylaws and Articles

The voting members may, on their own, adopt, amend, or repeal provisions of the bylaws. This can be done by unanimous written consent, by written ballots received from at least a quorum of members, or by a majority of a quorum vote at a meeting. Because a quorum for a

membership meeting can be greater or less than a majority of the total membership voting power (see quorum rules, below), a relatively small percentage of membership votes may be sufficient to change the bylaws.

> **EXAMPLE:** If a nonprofit corporation has 20 voting members, each with one vote, and the bylaws require that less than a majority (eight) be present at a meeting to represent a quorum, then five members can change the bylaws at a meeting.

We think it is wise for the bylaws to contain higher quorum and voting requirements when it comes to changing the bylaws—amending the bylaws is a major decision and should be decided by a substantial number of members of the corporation.

Once formal members have been admitted, a bylaw or bylaw amendment fixing or changing the authorized number of directors can only be passed by the members and not by the board. With few exceptions, members must also approve a board resolution to amend the articles of incorporation, following normal membership voting rules.

Members Approve Mergers and Consolidations

The principal terms of an agreement to merge or consolidate the nonprofit corporation with another corporation usually must be approved by the members.

Members Approve the Sale of Corporate Assets

Members of a nonprofit corporation must approve a board resolution to sell substantially all of the corporation's assets, unless the sale is made for the purpose of securing the payment or performance of any corporate contract, note, bond, or obligation, or is in the regular course of business (this latter exception won't normally apply—few nonprofit corporations are organized for the purpose of selling corporate assets).

Classes of Membership

If you decide to set up a membership structure in your bylaws, you can establish different classes of membership, such as voting and nonvoting membership classes. For example, a large botanical society might have one class of voting members who elect the board of directors, and an informal nonvoting membership consisting of persons who receive the society's magazine and newsletters.

If you have different memberships, the rights, privileges, restrictions, and obligations associated with each class of membership must be stated in the articles of incorporation or bylaws. In addition, the corporation must maintain a membership book containing the name, address, and the class of membership, if applicable, of each member.

Membership Quorum and Voting Rules

Unless the articles or bylaws state otherwise, each member is entitled to one vote on any matter submitted for approval to the members. Again, it's possible to have several classes of membership with different voting rights attached to each membership. A quorum for a membership corporation is a majority of all members, unless the bylaws provide for a different number (which can be greater or less than a majority). If you provide for a membership quorum of less than one-third of all members, then special notice of members' meetings will be required if less than one-third of the members actually attend the meeting.

Larger membership nonprofits rarely call and hold meetings with the expectation that members will attend and vote at the meeting

in person. Rather, membership proxies (written votes) are usually solicited by mail well in advance of the meeting. The corporate secretary tallies and reports these votes at the membership meeting. The main business of the membership—the reelection of the board—is usually accomplished through this proxy-by-mail procedure in large membership nonprofits.

Membership Action to Dissolve the Nonprofit

A majority of all of a membership corporation's members (not just a majority of members present at a meeting at which a quorum is present) can elect to voluntarily dissolve the corporation for any reason. The board of directors with normal membership approval (the votes of a majority of a quorum) can also elect to voluntarily dissolve the corporation. In a few special cases, the board can, on its own, elect to dissolve the corporation without obtaining membership approval.

Lower membership vote requirements are imposed for an involuntary dissolution. An involuntary dissolution, discussed in more detail in Chapter 10, is a dissolution for a specific reason, usually indicating a failure on the part of the corporation to effectively carry out its corporate purposes. For an involuntary dissolution, one-third of the votes of all the members of the corporation is required. The votes of members who have participated in any of the acts which form the basis for requesting involuntary dissolution cannot be counted.

Expelling Members

A member cannot be expelled unless it is done "in good faith and in a fair and reasonable manner." There is a specific procedure that public benefit corporations can use to be sure that their procedure for expulsion of a member is fair and reasonable. We've included this procedure in the bylaw provisions for public benefit membership corporations contained in this book. The law doesn't address what constitutes a good faith reason for expulsion—it only deals with the procedure for expulsion. There have been a number of court cases that have ruled on the fairness of specific reasons for expelling members, but there's no general rule. If a question involving the expulsion of members arises, see a lawyer.

A member can resign from the corporation at any time. The rights of a member cease upon his expulsion, death, termination from membership, or upon dissolution of the corporation.

Complying With Securities Laws

Memberships in a nonprofit corporation are considered securities and, as such, are regulated by laws governing the offer and sale of securities. Generally, the offer to sell or the sale of securities requires the approval of the California Commissioner of Corporations, often involving the preparation and filing of complicated and costly documents. Obtaining this approval is called qualifying the sale of securities and, as you might guess, most small corporations wish to avoid having to obtain this approval.

Fortunately, nonprofit corporations exempt under Section 501(c)(3) of the Internal Revenue Code will, in most cases, be eligible for an automatic exemption from qualifying the issuance of their memberships. To qualify for this automatic exemption:

- the issuer must be organized exclusively for educational, benevolent, fraternal, religious, charitable, social, or reformatory purposes, and not for profit
- no part of the net earnings of the issuer can inure to the benefit of any member or other individual, and
- the promoters of the nonprofit corporation must not expect, intend to, or actually

make a profit directly or indirectly from any business or activity associated with the organization or operation of the nonprofit organization, or from remuneration received from such nonprofit corporation.

These requirements are basically the same as the requirements for obtaining 501(c)(3) status, so you shouldn't have any trouble meeting them. In fact, these requirements are a little looser than the Section 501(c)(3) requirements because they include additional purposes. Except for memberships issued by a group organized and operated for social purposes, memberships that meet the first two requirements above are also exempt from registration with the Securities and Exchange Commission under Section 3(a)(4) of the federal Securities Act.

Requirements for Section 501(c)(3) Tax Exemption

Corporations, like individuals, are normally subject to federal and state income taxation. One reason to establish a nonprofit corporation is to obtain an exemption from corporate income taxes. Exemption is not automatic—a corporation must apply and show that it is in compliance with nonprofit exemption requirements to receive it. This chapter focuses on the federal tax exemption available to nonprofits under Section 501(c)(3) of the Internal Revenue Code and what is required to obtain tax-exempt status under this provision. Once you obtain your federal 501(c)(3) exemption, you can qualify for a state income tax exemption. In Chapter 8, we will take you line by line through the federal tax exemption application.

You'll notice in going through the material in this chapter that many IRS tax exemption requirements are broad and seemingly applicable to a wide range of activities, both commercial and noncommercial. In fact, many commercial organizations are engaged in activities that could qualify for 501(c)(3) tax-exempt status. For example, there are for-profit scientific organizations that perform research that could qualify as 501(c)(3) scientific research. Similarly, many commercial publishing houses publish educational materials that could qualify the organization for 501(c)(3) status.

So why do only some organizations obtain tax-exempt status? Because a corporation must choose to apply for tax-exempt status from the IRS. Many organizations that might be eligible for 501(c)(3) status prefer to operate as commercial enterprises because they do not want to be subject to the moneymaking, profit distribution, and other restrictions applicable to nonprofits. (See Chapter 1 for a discussion of these restrictions.) By defining and organizing your activities as eligible for 501(c)(3) status and then seeking tax-exempt status from the IRS, you distinguish your organization from similar commercial endeavors.

Section 501(c)(3) Organizational Test

Under Section 501(c)(3) of the Internal Revenue Code, groups organized and operated exclusively for charitable, religious, scientific, literary, and educational purposes can obtain an exemption from the payment of federal income taxes. The articles of incorporation of a 501(c)(3) corporation must limit the group's corporate purposes to one or more of the allowable 501(c)(3) purposes and must not empower it to engage (other than as an insubstantial part of its activities) in activities that don't further one or more of these tax-exempt purposes. This formal requirement is known as the 501(c)(3) organizational test.

A group can engage in more than one 501(c)(3) tax-exempt activity. For example, a group's activities can be characterized as charitable and educational, such as a school for blind or physically handicapped children.

A nonprofit cannot, however, engage simultaneously in a 501(c)(3) exempt purpose activity and in an activity that is exempt under a different subsection of Section 501(c). Thus, a group cannot be formed for educational *and* social or recreational purposes because social and recreational groups are exempt under Section 501(c)(7) of the Internal Revenue Code (see "Is Your Group a Nonprofit That Can Use This Book?" in Chapter 1 for a discussion of non-501(c)(3) tax-exempt groups). As a practical matter, this problem rarely occurs, because the non-501(c)(3) subsections are custom-tailored to specific types of organizations, such as war veterans' organizations and cemetery companies.

Valid Purposes Under Section 501(c)(3)

Now let's take a closer look at the most common 501(c)(3) purposes—charitable, religious, scientific, literary, and educational—and the requirements for each of these purposes. In addition to the valid purpose requirements discussed in this section, there are other general requirements that all 501(c)(3) groups must comply with to obtain 501(c)(3) status. These other requirements are discussed below, in "Other Requirements for 501(c)(3) Groups."

Humane Societies and Sports Organizations

There are other, less commonly used exemptions available under Section 501(c)(3) that we do not cover in this book. For example, groups organized to prevent cruelty to children or animals or to foster national or international amateur sports competitions can claim a tax exemption under Section 501(c)(3). However, these groups must meet narrowly defined 501(c)(3) requirements, and, for humane societies, special state requirements. See IRS Publication 557 for specifics on each of these special 501(c)(3) groups and contact the state attorney general's office for special incorporation requirements for humane societies.

Charitable Purposes

The charitable purpose exemption is the broadest, most all-encompassing exemption under Section 501(c)(3). Not surprisingly, it is also the most commonly used exemption.

Benefit to the Public

The word charitable as used in Section 501(c)(3) is broadly defined to mean "providing services beneficial to the public interest." In fact, other 501(c)(3) purpose groups—educational, religious, and scientific groups—are often also considered charitable in nature because their activities usually benefit the public. Even groups not directly engaged in a religious, educational, or scientific activity, but whose activities indirectly benefit or promote a 501(c)(3) purpose can qualify as a 501(c)(3) charitable purpose group.

Groups that seek to promote the welfare of specific groups of people in the community (handicapped or elderly persons or members of a particular ethnic group) or groups that seek to advance other exempt activities (environmental or educational) will generally be considered organized for charitable purposes because these activities benefit the public at large and are charitable in nature.

Groups that advance religion, even if they do not have a strictly religious purpose or function, are often considered charitable purpose organizations under Section 501(c)(3). The IRS reasons that the advancement of religion is itself a charitable purpose. Examples of some of these charitable purpose groups include:

- **Monthly Newspaper.** A group that published and distributed a monthly newspaper with church news of interdenominational interest was held to accomplish a charitable purpose because it contributed to the advancement of religion.
- **Coffeehouse.** A nonprofit organization formed by local churches to operate a supervised facility known as a coffeehouse was found to have a valid 501(c)(3) charitable purpose because it advanced religion and education

by bringing together college age people with church leaders, educators, and leaders from the business community for discussions and counseling on religion, current events, social, and vocational problems.

- **Genealogical Research.** An organization formed to compile genealogical research data on its family members to perform religious observances in accordance with the precepts of their faith was held to advance religion and be a charitable organization under 501(c)(3).
- **Missionary Assistance.** A missionary group established to provide temporary low-cost housing and related services for missionary families on furlough in the United States from their assignments abroad was held to be a charitable purpose organization under Section 501(c)(3).

Other examples of activities and purposes that have met the IRS organizational test for charitable purpose (and possibly another 501(c)(3) purpose as well) include:

- relief of the poor, distressed, or underprivileged
- advancement of education or science
- erection or maintenance of public buildings, monuments, or works
- lessening the burdens of government
- lessening neighborhood tensions
- elimination of prejudice and discrimination
- promotion and development of the arts
- defense of human and civil rights secured by law
- providing facilities and services to senior citizens
- maintaining a charitable hospital
- providing a community fund to support family relief and service agencies in the community

- providing loans for charitable or educational purposes, and
- maintaining a public interest law firm.

Class or Group of Beneficiaries

A charitable organization must be set up to benefit an indefinite class of people, not particular persons. The number of beneficiaries can be relatively small as long as the benefited class is open and the beneficiaries of the group are not specifically identified.

EXAMPLE 1: A charitable nonprofit corporation cannot be established under Section 501(c)(3) to benefit Jeffrey Smith, an impoverished individual. But Jeffrey Smith can be selected as a beneficiary of a 501(c)(3) charitable group whose purpose is to benefit needy individuals in a particular community (as long as he is a member of that community).

EXAMPLE 2: A foundation that awards scholarships solely to undergraduate members of a designated fraternity was found to be a valid charitable organization under 501(c)(3), even though the number of members in the benefited group is small.

EXAMPLE 3: A nonprofit formed to set up a free wireless local area network to help underprivileged and elderly members of the community connect to their community and get greater access to employment was found not to have a 501(c)(3) charitable purpose. The IRS viewed the nonprofit, which was founded and controlled by a for-profit technology company, as promoting the for-profit corporation's business brand and the commercial interests of businesses where the wireless hotspots would be located.

The following groups, all charitable in nature and benefiting a defined but indefinite group of people, were found to be valid charitable purpose organizations under Section 501(c)(3):

- an organization formed to build new housing and renovate existing housing for sale to low-income families on long-term, low-payment plans
- a day care center for children of needy, working parents
- a group created to market the cooking and needlework of needy women
- a self-help housing program for low-income families
- homes for the aged where the organization satisfies the special needs of an aged person for housing, health care, and financial security (The requirements for housing and health care will be satisfied if the organization is committed to housing residents who become unable to pay and if services are provided at the lowest possible cost.)
- an organization that takes care of patients' nonmedical needs (reading, writing letters, and so on) in a privately owned hospital
- an organization that provides emergency and rescue services for stranded, injured, or lost persons
- a drug crisis center and a telephone hotline for persons with drug problems, and
- a legal aid society offering free legal services to indigent persons.

Health care nonprofits, whether hospitals or less formal, noninstitutional health care facilities or programs, can qualify as charitable 501(c)(3) organizations. However, the IRS is particularly concerned about conflicts of interest and business dealings between doctors who do work for the nonprofit and also rent space or have other commercial dealings with the nonprofit. The IRS recommends that the health care nonprofit form

a community board and have conflict-of-interest provisions in their bylaws.

The Affordable Care Act added new requirements for charitable hospitals. (See IRS Notice 2010-39 and Notice 2011-52 and ask your tax adviser for more information.)

Services Need Not Be Free

Section 501(c)(3) charitable organizations are not required to offer services or products free or at cost. Nevertheless, doing so, or at least providing services at a substantial discount from the going commercial rate, can help convince the IRS of your group's bona fide charitable intentions. Charging full retail prices for services or products does not usually demonstrate a benefit to the public. Other restrictions applicable to a nonprofit's ability to make money are discussed below in "Other Requirements for 501(c)(3) Groups."

Religious Purposes

For Section 501(c)(3) purposes, a religious purpose group can be either a loosely defined religious organization that practices or promotes religious beliefs in some way or a formal institutional church. Groups formed to advance religion often qualify as charitable purpose organizations under Section 501(c)(3).

Qualifying as a Religious Organization

Traditionally, the IRS and the courts have been reluctant to question the validity or sincerity of religious beliefs or practices held by a group trying to establish itself as a religious purpose organization. As long as the organization's beliefs appear to be "truly and sincerely held" and their related practices and rituals are not illegal or against public policy, the IRS generally does not challenge the validity of the

religious tenets or practices. However, the IRS will question the nature and extent of religious activities (as opposed to religious beliefs) if they do not appear to foster religious worship or advance a religious purpose, or if they appear commercial in nature.

> **EXAMPLE:** A group that holds weekly meetings and publishes material celebrating the divine presence in all natural phenomena should qualify as a religious purpose group. However, an organization that sells a large volume of literature to the general public, some of which has little or no connection to the religious beliefs held by the organization, could be regarded by the IRS as a regular trade or business, not as a tax-exempt religious organization.

A religious group need not profess belief in a supreme being to qualify as a religious organization under Section 501(c)(3).

Religious corporations also have the widest flexibility in managing their internal affairs. (See the *Attorney General's Guide for Charities* available on the Nolo website (see Appendix A for the link), which contains a statement regarding the attorney general's overall hands-off policy with respect to oversight of religious corporations.)

Qualifying as a Church

You can also qualify under the 501(c)(3) religious purpose category as a church, but doing so is more difficult than simply qualifying as a 501(c)(3) religious organization. One of the advantages of qualifying as a church is that a church automatically qualifies for 501(c)(3) *public charity status*—a status that all 501(c)(3) groups want to obtain, as we explain later, in Chapter 4.

RESOURCE

The IRS has a guide to assist churches and clergy in complying with the religious purpose requirement of the Internal Revenue Code. The publication is intended to be a user-friendly compilation, set forth in question-and-answer format. You can download the guide, IRS Publication 1828, *Tax Guide for Churches and Religious Organizations*, from the Nolo website (see Appendix A for the link). Or you can find a copy of the publication on the IRS website. Most church and religious-purpose groups will find the information in this publication extremely helpful when preparing their federal exemption application (see Chapter 8).

Under IRS rulings, a religious organization should have the following characteristics to qualify as a church (not all are necessary but the more the better):

- a recognized creed or form of worship
- a definite and distinct ecclesiastical government
- a formal code of doctrine and discipline
- a distinct religious history
- a membership not associated with any other church or denomination
- a complete organization of ordained ministers
- a literature of its own
- established places of worship
- regular congregations, and
- regular religious services.

Courts have used similar criteria to determine whether or not a religious organization qualifies as a church. In one case, the court looked for the presence of the following "church" factors:

- services held on a regular basis
- ordained ministers or other representatives
- a record of the performance of marriage, other ceremonies, and sacraments
- a place of worship

- some support required from members
- formal operations, and
- satisfaction of all other requirements of federal tax law for religious organizations.

All religious purpose groups that claim church status must complete a special IRS schedule with specific questions on some of the church characteristics listed above. We discuss this tax application and the special IRS schedule for churches in Chapter 8.

Traditional churches, synagogues, associations, or conventions of churches (and religious orders or organizations that are an integral part of a church and engaged in carrying out its functions) can qualify as 501(c)(3) churches without difficulty. Less traditional and less formal religious organizations may have a harder time. These groups often have to answer additional questions to convince the IRS that they qualify as tax-exempt churches.

> **EXAMPLE:** A nonprofit "online ministry" and "virtual church" that provided ministry materials and services (through online sales) was denied IRS classification as a church because, in the IRS's view, its website did not qualify as a "place of worship," nor did the persons who accessed the website constitute "a congregation assembled for worship."

Some churches stand a greater chance of being audited by the IRS than others. Not surprisingly, the IRS is more likely to examine and question groups that promise members substantial tax benefits for organizing their households as tax-deductible church organizations.

Scientific Purposes

Groups that engage in scientific research carried on in the public interest are also eligible for tax-exempt status under 501(c)(3). Under IRS regulations, research incidental to commercial or industrial operations (such as the normal inspection or testing of materials or products, or the design or construction of equipment and buildings) does not qualify as a scientific purpose under Section 501(c)(3). In an IRS case involving a pharmaceutical company, the company's clinical testing of drugs was held not to be "scientific" under Section 501(c)(3) because the clinical testing in question was incidental to the pharmaceutical company's commercial operations.

Generally, research is considered in the public interest if the results (including any patents, copyrights, processes, or formulas) are made available to the public; that is, the scientific research must be published for others to study and use. Research is also considered in the public interest if it is performed for the United States or a state, county, or city government, or if it is conducted to accomplish one of the following purposes:

- to aid in the scientific education of college or university students
- to discover a cure for a disease, or
- to aid a community or region by attracting new industry, or by encouraging the development or retention of an existing industry.

> **EXAMPLE:** An organization was formed by a group of physicians specializing in heart defects to research the causes and treatment of cardiac and cardiovascular conditions and diseases. The physicians practiced medicine in a private practice facility that was separate and apart from the organization's research facility, which was used exclusively for the research program. Although some patients from the physicians' private practice were accepted for the research program, they were selected on the same criteria as other patients. The IRS found that the physician's research group met the scientific purpose organizational test for Section 501(c)(3) purposes.

If you are applying for a scientific exemption under Section 501(c)(3), your federal exemption application (covered in Chapter 8) should show that your organization is conducting public interest research and you should provide the following information:

- an explanation of the nature of the research
- a description of past and present research projects
- how and by whom research projects are determined and selected, and
- who will retain ownership or control of any patents, copyrights, processes, or formulas resulting from the research.

RESOURCE

For a list of the specific information the IRS requires from scientific groups, see "Scientific Organizations," in IRS Publication 557, *Tax-Exempt Status for Your Organization.*

Literary Purposes

This is a seldom-used Section 501(c)(3) category because most literary purpose nonprofits are classified as educational by the IRS. Nevertheless, valid 501(c)(3) literary purposes include traditional literary efforts, such as publishing, distribution, and book sales. These activities must be directed toward promoting the public interest as opposed to engaging in a commercial literary enterprise or serving the interests of particular individuals (such as the proprietors of a publishing house). Generally, this means that literary material must be available to the general public and must pertain to the betterment of the community.

A combination of factors helps distinguish public interest publishing from private publishing. If you publish materials that are clearly educational and make them available to the public at cost, or at least below standard com-

mercial rates, then you might qualify as a 501(c)(3) literary purpose organization. However, if your material seems aimed primarily at a commercial market and is sold at standard rates through regular commercial channels, chances are that your literary organization will be viewed by the IRS as a regular business enterprise ineligible for a 501(c)(3) tax exemption. For example, publishing textbooks at standard rates will probably not qualify as a tax-exempt literary purpose under Section 501(c)(3) because the activity is more private than public in nature. On the other hand, publishing material to promote highway safety or the education of handicapped children is likely to qualify as a bona fide 501(c)(3) literary purpose.

EXAMPLE: A publishing house that only published books related to esoteric Eastern philosophical thought applied for 501(c)(3) literary exemption. Their books were sold commercially but at modest prices. The IRS granted the tax exemption after requesting and reviewing the manuscript for the nonprofit's first publication. The IRS found that the material was sufficiently specialized to render it noncommercial in nature.

Educational Purposes

The type of educational activities that qualify as educational purpose under 501(c)(3) are broad, encompassing instruction both for self-development and for the benefit of the community. The IRS allows advocacy of a particular intellectual position or viewpoint if there is a "sufficiently full and fair exposition of pertinent facts to permit an individual or the public to form an independent opinion or conclusion. However, mere presentation of unsupported opinion is not (considered) educational."

If a group takes political positions, it may not qualify for an exemption (see discussion on political activities in "Other Requirements for 501(c)(3) Groups," below). An educational group that publishes a newsletter with a balanced analysis of issues, or at least with some room devoted to debate or presentation of opposing opinions, should qualify as a 501(c)(3) educational purpose group. If its newsletter is simply devoted to espousing one side of an issue, platform, or agenda, the educational purpose tax exemption may not be granted.

Examples of activities that qualify as educational purpose include:

- publishing public interest educational materials
- conducting public discussion groups, forums, panels, lectures, and workshops
- offering a correspondence course or a course that uses other media such as television or radio
- operating a museum, zoo, planetarium, symphony orchestra, or performance group
- serving an educational institution, such as a college bookstore, alumni association, or athletic organization, or
- publishing educational newsletters, pamphlets, books, or other material.

RESOURCE

See *Education, Propaganda, and the Methodology Test* for guidelines used by the IRS and courts to determine if a nonprofit qualifies as an educational purpose organization under Section 501(c)(3). You can download a copy of the document from the Nolo website (see Appendix A for the link).

Formal School Not Necessary

To qualify as a 501(c)(3) educational organization, a group does not need to provide instruction in traditional school subjects or organize as a formal school facility with a regular faculty, established curriculum, and a regularly enrolled student body.

CAUTION

You may need formal school attributes for other reasons. Groups setting up nontraditional schools aren't required to have a regular faculty, full-time students, or even a fixed curriculum to qualify for a 501(c)(3) educational purpose tax exemption. As a practical matter, however, they may need some or all of these things to qualify for state or federal support, participate in federal student loan programs, and obtain accreditation.

Child Care Centers

Providing child care outside the home qualifies as a 501(c)(3) educational purpose under special provisions contained in Internal Revenue Code Section 501(k) if:

- the care enables parent(s) to be employed, and
- the child care services are available to the general public.

A child care facility that gives enrollment preference to children of employees of a specific employer, however, will not be considered a 501(c)(3) educational purpose organization.

Private School Nondiscrimination Requirements

If you set up a 501(c)(3) private school, you must include a nondiscrimination statement in your bylaws and publicize this statement to the community served by the school. This statement must make it clear that the school does not discriminate against students or applicants on the basis of race, color, or national or ethnic origin.

Here is a sample statement taken from IRS Revenue Procedure 75-50:

NOTICE OF NONDISCRIMINATORY
POLICY AS TO STUDENTS
The [name of school] admits students of
any race, color, national and ethnic origin
to all the rights, privileges, programs,
and activities generally accorded or made
available to students at the school. It does
not discriminate on the basis of race, color,
national and ethnic origin in administration
of its educational policies, admissions policies,
scholarship, and loan programs, and athletic
and other school-administered programs.

RESOURCE

Additional information on the history and
status of 501(c)(3) private school nondiscrimination
requirements is on the IRS website (www.irs.gov),
in a tax topic update titled *Private School Update*.
For further information on IRS private school
antidiscrimination rules and procedures, see IRS
Revenue Procedure 75-50 and Private Schools, in IRS
Publication 557, available on the Nolo website (see
Appendix A for the link).

RESOURCE

You can download copies of the following
IRS-related material from the Nolo website (see
Appendix A for the link):

- *Tax-Exempt Status for Your Organization*
- *Private School Update*, and
- IRS Revenue Procedure 75-50.

Other Requirements
for 501(c)(3) Groups

In addition to being organized primarily for
one or more allowable tax-exempt purposes, a
nonprofit must not engage in other activities
that conflict or substantially interfere with its

valid 501(c)(3) purposes. This section discusses
some of the requirements that keep a 501(c)(3)
from straying too far from its exempt-purpose
activities.

For more information on these rules, see
*Every Nonprofit's Tax Guide: How to Keep Your
Tax-Exempt Status & Avoid IRS Problems*, by
Stephen Fishman (Nolo).

Unrelated Business Activities

To obtain 501(c)(3) status, a corporation cannot
substantially engage in activities unrelated to the
group's tax-exempt purposes. Or, put differently,
your nonprofit corporation can conduct activities
not directly related to its exempt purpose as long
as these activities don't represent a substantial
portion of your total activities. Some unrelated
activity is allowed because as a practical matter,
most nonprofits need to do some unrelated
business to survive. For example, a nonprofit
dance group might rent unused portions of its
studio space to an outside group for storage.
Another nonprofit might invest surplus funds to
augment its income.

Most groups need not be overly concerned
with this limitation unless activities unrelated
to exempt purposes start to involve a significant
amount of the group's energy or time, or if
these activities produce "substantial" income.
If the activities are themselves nonprofit, they
should be included in the organization's exempt
purposes and classified as related activities.
The IRS keeps an eye out for tax-exempt
groups that regularly engage in profit-making
businesses with little or no connection to their
exempt purposes (a church running a trucking
company). Business activities necessary to
further the group's exempt purposes, such as
hiring and paying employees and paying rent
for space used for the group's exempt purpose,
are considered related activities.

Most new nonprofits work full time simply tending to their exempt purposes and do not explore unrelated moneymaking activities until later, if at all. However, if you plan to engage in unrelated business from the start, be careful. It's hard to pin down exactly when these activities become substantial enough to jeopardize the corporation's tax-exempt status. Also, income derived from unrelated business activities is subject to federal and state corporate income tax, even if it is not substantial enough to affect the group's 501(c)(3) tax-exempt status.

RESOURCE

For more information on the federal unrelated business income tax that applies to nonprofit 501(c)(3) groups, see *UBIT: Current Developments* (available on the Nolo website; see Appendix A for the link).

Limitation on Profits and Benefits

A 501(c)(3) nonprofit corporation cannot be organized or operated to benefit individuals associated with the corporation (directors, officers, or members) or other persons or entities related to, or controlled by, these individuals (such as another corporation controlled by a director). In tax language, this limitation is known as the prohibition on private inurement and means that 501(c)(3) groups can't pay profits to, or otherwise benefit, private interests.

Two specific 501(c)(3) requirements implement this prohibition on self-inurement:

- no part of the net earnings of the corporation can be distributed to individuals associated with the corporation, and
- upon dissolution, the assets of a 501(c)(3) group must be irrevocably dedicated to another tax-exempt group (another 501(c)(3) or a federal, state, or local government for a public purpose).

Note that a nonprofit can pay reasonable salaries to directors, officers, employees, or agents for services rendered in furtherance of the corporation's tax-exempt purposes.

Excess Benefit Rules

The IRS has adopted strict rules and regulations regarding the payment of money, benefits, or property to nonprofit directors, officers, sponsors, donors, and others associated with the nonprofit. The main purpose for these rules, called the excess benefit rules, is to make sure nonprofit organizations do not pay out lavish benefits or skim off program funds to line the pockets or serve the private interests of individuals associated with the nonprofit. The excess benefit rules are also called the IRS intermediate sanctions, a euphemism that is meant to have an appropriately harsh ring. These rules are contained in Section 4958 of the Internal Revenue Code and Section 53.4958 of the IRS Regulations.

The excess benefit rules apply to individuals associated with 501(c)(3) nonprofit public charities. (As explained more fully in Chapter 4, in all likelihood you will be forming a public charity nonprofit.) The individuals subject to the rules include nonprofit directors, officers, and trustees as well as major sponsors, donors, or anyone else in a position to exercise substantial influence over the affairs of the nonprofit. The rules also apply to family members and entities owned by any of the individuals subject to the rules.

Under the rules, an excessive benefit transaction is any transaction where the nonprofit gives cash, property, or anything of value to a recipient that exceeds the value of the services performed by the recipient (or the value of any other cash, property, or thing of value given to the nonprofit by the recipient). If a nonprofit pays $100 to an officer who has contributed

$75 worth of services, the excess benefit is $25. Of course, the IRS is looking for much bigger numbers, sometimes in the realm of thousands, or hundreds of thousands of dollars' worth of extra benefits paid by the nonprofit to directors, officers, consultants, sponsors, and donors.

The sanctions include a tax that must be paid by both the recipient of the excess benefit as well as the nonprofit managers (the directors and executive officers) who approved the excess benefit transaction. The recipient of the excess benefit can be assessed a 25% tax on the excess benefit, and the manager or managers who approved it can be assessed a 10% tax, with a limit on a manager's liability capped at $20,000 per transaction. A director must object to the transaction to be excluded from those considered to have approved it—silence or abstention at a board meeting that results in the excess benefit payment is not a defense. The recipient must repay or return the excess benefit to the nonprofit or the recipient will be charged an additional 200% tax. The message is clear—if you receive an undeserved benefit from your nonprofit, you and others in your nonprofit may have to pay large penalties.

The IRS regulations add detail about the scope and operation of the excess benefit rules. For example, disqualified persons is broadly defined to include all sorts of people paid by or associated with the nonprofit organization. Excess salaries, contract payments, benefits, privileges, goods, services, or anything else of value paid or provided to almost anyone associated with your nonprofit can potentially trigger the excess benefit tax rules.

The regulations also contain a safe-harbor provision for deals or decisions that provide an economic benefit to a director, officer, contractor, or other key nonprofit person. To qualify for the protection of the safe harbor rule, a number of conditions must be met, including:

- disinterested members of the board or committee must approve the transaction in advance
- the decision must be based on comparability data reviewed and relied on by the board that shows the property is transferred at fair market value or compensation is paid at a rate similar to that paid by other organizations for comparable services, and
- the decision must be documented in the corporate records at the time the transaction is approved.

Falling within the safe harbor provision creates a presumption that your deal or decision was fair. The IRS can rebut this presumption if it obtains evidence to the contrary.

If you are interested in reading more information about these rules, you can use the resources listed below.

 RESOURCE

The following information on the excess benefit rules and regulations is available on the Nolo website (see Appendix A for the link):

- IRC Section 4958, *Taxes on Excess Benefit Transactions*
- IRS Regulations Section 53.4958-0, *Table of Contents* (contains the IRS regulations promulgated under Section 4958)
- Final 4958 regulation changes. See *Internal Revenue Bulletin* No 2008-18, T.D. 9390, and
- *Intermediate Sanctions (IRC 4958) Update.*

The last thing you want to have happen is to subject board members, officers, contractors, sponsors, donors, and others who deal with your nonprofit to the prospect of having to pay back money or the value of benefits previously paid out or provided by your nonprofit plus very hefty taxes, interest, and penalties.

Conflict of Interest Provisions

Article 9 of the bylaws included in this book contains rules and procedures for approving or avoiding conflict-of-interest transactions, including compensation arrangements. This bylaw provision contains the conflicts-of-interest language recommended by the IRS (included in the sample conflict-of-interest policy in the instructions to IRS Form 1023, in Appendix B). It also has language for the approval of compensation arrangements that attempts to comply with the safe harbor provisions of the excess benefit rules (see Article 9, Section 5). You will need to become familiar with Article 9 of your bylaws and refer to those provisions whenever your board, or a committee of your board, decides to set or increase salaries, enter into contracts, or approve deals with individuals or other organizations.

If you have any question about whether a transaction, contract, compensation decision, or other economic decision is reasonable or whether it may be outside the safe harbor provisions of the excess benefit rules, ask a nonprofit lawyer for help.

Limitation on Political Activities

A 501(c)(3) corporation is prohibited from participating in any political campaigns for or against any candidate for public office. Participation in or contributions to political campaigns can result in the revocation of 501(c)(3) tax-exempt status and the assessment of special excise taxes against the organization and its managers. (See Internal Revenue Code §§ 4955, 6852, and 7409.)

Voter Education Activities

Section 501(c)(3) groups can conduct certain voter education activities if they are done in a nonpartisan manner (see IRS Revenue Ruling 78-248). If you want to engage in this type of political activity, we recommend you consult an attorney. Your organization can request an IRS letter ruling on its voter education activities by writing to the address listed in IRS Publication 557, Chapter 3, "Political Activity."

RESOURCE

For information on restrictions on political candidate campaign activity by 501(c)(3) organizations, see *Election Year Issues*. It also contains information about other laws and restrictions applicable to political campaign nonprofits—non-501(c)(3) groups organized primarily to support or oppose political candidates under Internal Revenue Code § 527. You can download a copy of the document from the Nolo website (see Appendix A for the link).

Influencing Legislation

Section 501(c)(3) organizations are prohibited from acting to influence legislation, "except to an insubstantial degree." In the past, courts have found that spending more than 5% of an organization's budget, time, or effort on political activity was substantial. More recently, courts have tended to look at the individual facts of each case. Generally, if a nonprofit corporation contacts, or urges the public to contact, members of a legislative body, or if it advocates the adoption or rejection of legislation, the IRS considers it to be acting to influence legislation.

Lobbying to influence legislation also includes:

- any attempt to affect the opinions of the general public or a segment of the public, and
- communication with any member or employee of a legislative body, or with any government official or employee who might participate in the formulation of legislation.

However, lobbying to influence legislation does not include:

- making available the results of nonpartisan analysis, study, or research

- providing technical advice or assistance to a government body, or to its committee or other subdivision, in response to a written request from it, where such advice would otherwise constitute the influencing of legislation
- appearing before, or communicating with, any legislative body with respect to a possible decision that might affect the organization's existence, powers, tax-exempt status, or the deductibility of contributions to it, or
- communicating with a government official or employee, other than for the purpose of influencing legislation.

Political Expenditures Test

Under the political expenditures test in IRC Section 501(h), limitations are imposed on two types of political activities: lobbying expenditures and grassroots expenditures. Lobbying expenditures are those made for the purpose of influencing legislation, while grassroots expenditures are those made to influence public opinion.

For examples of these two types of activities, see IRS Publication 557, the "Lobbying Expenditures" section. The monetary limits are different for each of the categories and the formulas for computing them are somewhat complicated.

If your 501(c)(3) nonprofit elects the political expenditures test, you must file IRS Form 5768, *Election/Revocation of Election by an Eligible Section 501(c)(3) Organization To Make Expenditures To Influence Legislation*, within the tax year in which you wish the election to be effective. A copy of this form can be downloaded from the Nolo website (see Appendix A for the link).

Also excluded from the definition of lobbying efforts are communications between an organization and its members about legislation (or proposed legislation) of direct interest to the organization and the members, unless these communications directly encourage members to influence legislation.

EXAMPLE: A Housing Information Exchange keeps its members informed of proposed legislation affecting low-income renters. This should not be considered legislative lobbying activity unless members are urged to contact their political representatives in support of, or in opposition to, the proposed legislation.

In determining whether a group's legislative activities are substantial in scope, the IRS looks at the amount of time, money, or effort the group spends on legislative lobbying. If they are substantial in relation to other activities, 501(c)(3) tax status might be revoked and, again, special excise taxes can be levied against the organization and its managers. (See IRC § 4912.)

The Alternative Political Expenditures Test

Since it is impossible to know ahead of time how the IRS will assess the substantiality of a group's legislative activity, the IRC allows 501(c)(3) public charities (most 501(c)(3) groups will qualify as public charities—see Chapter 4) to elect an alternative expenditures test to measure permissible legislative activity. Under this test, a group may spend up to 20% of the first $500,000 of its annual expenditures on lobbying, 15% of the next $500,000, 10% of the next $500,000, and 5% of its expenditures beyond that, up to a total limit of $1 million each year.

CAUTION

Some groups can't use the political expenditures test. This expenditures test and its provisions for lobbying and grassroots expenditures are not available to churches, an integrated auxiliary of a church, a member of an affiliated group of organizations that includes a church, or to private foundations.

If your nonprofit corporation plans to do considerable lobbying activity, mostly by unpaid volunteers, then electing the expenditures test might be a good idea. Why? Because the minimal outlay of money to engage in these activities will probably keep you under the applicable expenditure limits. If you didn't make this election, your 501(c)(3) tax exemption might be placed in jeopardy if the IRS considers your political activities to be a substantial part of your overall purposes and program.

If you plan to engage in more than a minimum amount of political lobbying or legislative efforts, you need to decide whether it is to your advantage to elect the expenditures test based on the facts of your situation. If you find that these alternative political expenditures rules are still too restrictive, you might consider forming a social welfare organization or civic league under Section 501(c)(4) of the Internal Revenue Code—this exemption requires a different federal exemption application, IRS Form 1024, and does not carry with it all the attractive benefits of 501(c)(3) status (access to grant funds, tax deductible contributions, etc.). (See "Is Your Group a Nonprofit That Can Use This Book?" in Chapter 1, and IRS Publication 557 for further information on 501(c)(4) organizations.)

CAUTION

Additional limitations. Federally funded groups may be subject to even more stringent political expenditure tests than those discussed here (for example, political activity and expenditure restrictions imposed by the federal Office of Management and Budget).

RESOURCE

For a thorough discussion of the rules that apply to lobbying activities by 501(c)(3) organizations and detailed information on the Section 501(h) political expenditures test election, see *Lobbying Issues*, available on the Nolo website (see Appendix A for the link).

Political Action Organizations

The IRS can also challenge a 501(c)(3) group's political activities by finding that it is an action organization: one so involved in political activities that it is not organized exclusively for a 501(c)(3) tax-exempt purpose. Under these circumstances the IRS can revoke the organization's tax-exempt status. Intervention in political campaigns or substantial attempts to influence legislation, as discussed above, are grounds for applying this sanction. In addition, if a group has the following two characteristics, it will be classified as an action organization and lose its 501(c)(3) status:

1. Its main or primary objective or objectives—not incidental or secondary objectives—may be attained only by legislation or defeat of proposed legislation, and

2. It advocates or campaigns for the attainment of such objectives rather than engaging in nonpartisan analysis, study, or research and making the results available to the public.

In determining whether a group has these characteristics, the IRS looks at the surrounding facts and circumstances, including the group's articles and activities, and its organizational and operational structure.

The point here is to be careful not to state your exempt purposes in such a way that they seem only attainable by political action. Even if you indicate that your activities will not be substantially involved with legislative or

lobbying efforts, the IRS may decide otherwise and invoke this special classification to deny or rescind 501(c)(3) status.

If the IRS classifies a group as an action organization, the group can still qualify as a social welfare group under 501(c)(4).

> **EXAMPLE:** A group that has a primary purpose of "reforming the judicial system in the United States" will likely sound like a political action organization to the IRS, because this sounds like a political goal that must be accomplished mostly by political means. However, if the group rephrases its primary purpose as "educating the public on the efficacy of mediation, arbitration, and other alternative nonjudicial dispute resolution mechanisms," it stands a better chance of having the IRS approve its application, even if it lists some political activity as incidental to its primary educational purpose.

CAUTION

Check the Federal Election Commission website (FEC). Politically active groups should go to the FEC website at www.fec.gov to read about the ever-changing federal election campaign laws and how they may impact their nonprofit's political activities.

RESOURCE

The IRS provides illustrations for clarification on what constitutes political campaign activities. IRS Revenue Ruling 2007-41 has 21 fact situations that help explain when the IRS will and will not consider a group to be conducting unpermitted political campaign activities. (See Appendix A for a link to the Revenue Ruling.)

Information for Specific Questions About Your Group's Activities

Even after reading through this chapter, you might still have some questions about whether your specific nonprofit activities meet the IRS definition of educational, charitable, or religious purposes under Section 501(c)(3) of the Internal Revenue Code. Or, after you take a closer look at Chapter 4, you might wonder whether your nonprofit can qualify for special public charity treatment as a school or church.

Answers to these types of questions used to be left to the expertise of highly paid lawyers and tax professionals—this is no longer true. It is remarkably easy to find out more about how the IRS might look at your nonprofit organization when it reviews your tax exemption application. The IRS website disseminates most of the material necessary to answer many technical questions as long as you are persistent enough to search the site thoroughly and uncover the material. Specifically, IRS publications and regulations, as well as the technical manuals the IRS examiners use when reviewing tax exemption applications, are available online.

This chapter refers to special IRS training materials from the IRS website and includes this material on the Nolo website (see Appendix A for the link). We describe how each of these articles helps explain and illustrate a specific issue related to obtaining and maintaining a 501(c)(3) tax exemption. There is a lot more helpful material on the IRS website, and we encourage you to browse it to learn as much as you'd like about nonprofit organization tax issues.

Here is one way to search the IRS site for nonprofit tax exemption answers:

Go to the main page of the IRS website, at www.irs.gov, and click "Help & Resources," then "Charities & Non-Profits" link. This page contains special nonprofit tax topics, resources, and links to additional information. If you don't find what you're looking for, type a word or phrase in the search box that succinctly describes your question.

For a more advanced approach, you can go directly to the Internal Revenue Manual by typing "Internal Revenue Manual" in the search box and clicking on the link. This will take you to a table that lists different sections of the IRS procedures manual used by IRS examiners and field agents. Part 7 is the main area of interest for nonprofit groups applying for their 501(c)(3) tax exemption. Select this link, then scroll down the heading list until you see the heading, "7.25 Exempt Organizations Determinations Manual." Click on the link under this heading to "7.25.3, Religious, Charitable, Educational, Etc., Organizations." This chapter contains examples of groups that have and have not qualified under each of the 501(c)(3) tax-exempt purposes.

If you want to learn even more, you can examine any IRS rulings and cases that you uncover in your website search. Rulings are compiled in *IRS Cumulative Bulletins*, the most recent of which are available for browsing on the IRS website. Type "Internal Revenue Bulletins" in the search box and then select the volume for the year when the ruling was issued. Scroll through the beginning table of contents to find the page where the ruling begins (the first four numbers of a ruling indicate its year—for example, Ruling 2004-51 was issued in 2004, so you would look at the *Bulletin* for 2004 to find the text of the ruling). Most years have more than one *Bulletin* volume, and some rulings are placed in the next year's volume. It takes persistence to track down rulings, but they can be enormously helpful in understanding why the IRS accepted or rejected a nonprofit organization's application for a 501(c)(3) tax exemption. (For more information on doing your own research, see Chapter 11.)

RESOURCE

For an in-depth discussion and analysis of the requirements that apply to each type of 501(c)(3) nonprofit, supplemented annually with the latest IRS and court rulings in each area, see *The Law of Tax-Exempt Organizations*, by Bruce R. Hopkins (John Wiley & Sons, New York, N.Y.).

Public Charities and Private Foundations

In this chapter, we explain why it is not enough to simply obtain your 501(c)(3) tax-exempt status—you also need to be recognized as a 501(c)(3) public charity. Getting this extra recognition is essential to make your life as a nonprofit easier to manage. Even though the last thing you may be interested in at this point is delving into more tax technicalities, it will help you enormously to have a general understanding of the distinction between public charity and private foundation tax status before you do your federal tax exemption application. You will understand the importance of some of the most technical questions on the application and you'll know how to answer questions to show you qualify for public charity tax status.

We help you get through this information by explaining the different public charity classifications and requirements in plain English. You don't need to master this material. In fact, many nonprofits let the IRS decide which public charity category works for them. For now, simply read through the information to get a general understanding of the concepts. You can come back to this chapter when you do your federal tax exemption application and reread the sections that apply to you.

Throughout this chapter, we refer to the Internal Revenue Code sections that apply to the different public charity classifications. You don't need to pay attention to these section references. They will be useful later as a reference when you prepare your federal tax exemption application.

How to Start Out as a Public Charity

A new 501(c)(3) group can qualify as a public charity for the first five years if it reasonably expects to receive qualifying public support. We explain how to fill in your 501(c)(3) tax exemption application to apply for public charity status in Chapter 8.

The Importance of Public Charity Status

The IRS classifies all 501(c)(3) tax-exempt nonprofit corporations as either private foundations or public charities. Initially, most 501(c)(3) corporations are presumed to be private foundations. It's extremely important to understand that your group, too, will initially be viewed as a private foundation. The problem with this classification is that private foundations are subject to strict operating rules and regulations that don't apply to groups classified as public charities. You'll want to get yourselves out from under this presumption because, like most 501(c)(3) groups, you would probably find it impossible to operate under the rules and restrictions imposed on private foundations. To avoid this classification, you will want to apply for public charity status when you apply for your federal 501(c)(3) tax exemption.

A few special groups are not presumed to be private foundations and do not have to apply for public charity status—the same groups that are not required to file a 501(c)(3) tax exemption application. We think it's foolhardy in most cases not to apply for, and obtain, official notification from the IRS that you are a public charity. (For a discussion of this issue, see "Do You Need to File Form 1023?" in Chapter 8.)

How to Qualify for Public Charity Status

As explained above, almost all 501(c)(3) nonprofits want to overcome the private foundation presumption and establish themselves as a public charity. There are three basic ways to do this:

- **Form one of the types of nonprofits that automatically qualify.** Particular types of nonprofit organizations, such as churches,

schools, or hospitals, automatically qualify for public charity status because of the nature of their activities.

EXAMPLE: A church that maintains a facility for religious worship would most easily obtain *automatic* public charity status. A church qualifies for recognition as a public charity because of the nature of its activities rather than its sources of support.

- **Derive most of your support from the public.** If your group receives support primarily from individual contributions, government, or other public sources, you can qualify for public charity status as a publicly supported organization.

EXAMPLE: An organization formed to operate a center for rehabilitation, counseling, or similar services that plans to carry on a broad-based solicitation program and depend primarily on government grants, corporate contributions, and individual donations would most likely seek public charity status as a *publicly supported organization.*

- **Receive most of your revenue from activities related to your tax-exempt purposes.** If your group receives most of its revenue from activities related to its tax-exempt purposes, you can qualify under a special public charity support test that applies to many smaller nonprofits.

EXAMPLE: An arts group deriving most of its income from exempt-purpose activities (lessons, performances, and renting studio facilities to other arts groups) would probably choose the *support* test. This public charity test, unlike those that apply to publicly supported organizations, allows groups to count income derived from the performance of their exempt purposes as qualified support.

RESOURCE

For additional information on the rules that apply to each of the three public charity tests, see *Public Charity or Private Foundation Status Issues under IRC §§ 509(a)(1)–(4), 4942(j)(3), and 507.* You can download a copy of the document from the Nolo website (see Appendix A for the link). For information on the public charity requirements associated with each type of automatically recognized public charity (churches, schools, hospitals, and others), see the section titled, "Type A. Organizations That Engage in Inherently Public Activity (IRC 509(a)(1) and IRC 170(b)(1)(A)(i)–(v))." For information on the public charity test we call the public support test, see the section titled, "Publicly Supported Organizations Described in IRC §§ 509(a)(1) and 170(b)(1)(A)(vi)." For information on the public charity test we call the exempt activities support test, see the section titled, "Publicly Supported Organizations Described in IRC § 509(a)(2)."

You Can Let the IRS Decide Your Public Charity Classification

It's sometimes hard to figure out whether your organization will meet the public support test or the exempt activities test discussed below. To make this decision, an organization must second-guess future sources of support and tackle quite a few tax technicalities. Fortunately, if you have doubts, the IRS will help. Simply check a box on the federal tax exemption application and the IRS will decide this question for you based upon the financial and program information you submit with your application.

For the specifics on making this election, see the Chapter 8 instructions to Part X, Line 5(i), of the federal tax exemption application.

Automatic Public Charity Status

The IRS automatically recognizes certain 501(c)(3) groups as public charities because they perform particular services or engage in certain charitable activities. The following groups automatically qualify:

Churches

Religious purpose groups that qualify as churches for 501(c)(3) tax exemption purposes also automatically qualify as a public charity. (IRC §§ 509(a)(1) and 170(b)(1)(A)(i).) Qualifying as a church under Section 501(c)(3) is more difficult than qualifying as a 501(c)(3) religious purpose organization. To qualify as a church, the organization must have the institutional and formal characteristics of a church. (See "Religious Purposes," in Chapter 3.) If your religious purpose 501(c)(3) group does not qualify as a church, it can still qualify for public charity status under one of the other public charity tests, described below.

Schools

Certain educational institutions that have the institutional attributes of a school automatically qualify as public charities. (IRC §§ 509(a)(1) and 170(b)(1)(A)(ii).) Generally, these are educational organizations whose primary function is to present formal instruction. These schools usually have a regular faculty and curriculum, a regularly enrolled body of students, and a place where their educational activities are carried on.

This school category for automatic public charity recognition is geared toward primary or secondary preparatory or high schools, and colleges and universities with regularly enrolled student bodies. The further an educational group strays from the institutional criteria mentioned above, the harder it will be to qualify as a public charity. This doesn't mean that less structured educational institutions can't automatically qualify for public charity status as schools, it just may be more difficult. Nontraditional groups have a better chance of obtaining automatic public charity status if they have some conventional institutional attributes, such as regional accreditation and a state-approved curriculum. If your educational purpose 501(c)(3) group does not fall within this school category for automatic recognition, it can still qualify for public charity status under the public support test or exempt activities support test, described below.

Hospitals and Medical Research Organizations

Nonprofit health care groups that operate charitable hospitals or facilities and whose main function is to provide hospital or medical care, medical education, or medical research automatically qualify as public charities. (IRC §§ 509(a)(1) and 170(b)(1)(A)(iii).) These charitable hospitals generally have the following characteristics:

- doctors selected from the community at large who are part of the courtesy staff
- a community-oriented board of directors
- emergency room facilities available on a community-access basis
- admission of at least some patients without charge (on a charitable basis)
- nondiscrimination with respect to all admissions (particularly Medicare or Medicaid patients), and
- a medical training and research program that benefits the community.

Other 501(c)(3) health care organizations, such as rehabilitation groups, outpatient clinics, community mental health programs, or drug treatment centers, can qualify as hospitals if their principal purpose is to provide hospital or medical care. A health organization that uses consultation

services of certified medical personnel such as doctors and nurses will have an easier time meeting the hospital criteria. The IRS does not, however, recognize convalescent homes, homes for children or the aged, or institutions that provide vocational training for the handicapped as fitting within this public charity category.

Medical education and research organizations do not qualify under these IRC sections unless they actively provide on-site medical or hospital care to patients as an integral part of their functions. Medical research groups must also be directly and continuously active in medical research with a hospital, and this research must be the organization's principal purpose.

TIP

Hospitals and other tax-exempt health care organizations may want to adopt a community board and a conflict-of-interest policy in their bylaws. We explain how hospitals and medical care groups can modify the conflict-of-interest provisions in the bylaws included in this book to add provisions recommended by the IRS. (See Chapter 8, "Filling Out the Schedules.")

Public Safety Organizations

Groups organized and operated exclusively for public safety testing automatically qualify for public charity status. Generally, these organizations test consumer products to determine their fitness for use by the general public. (IRC § 509(a)(4).)

Government Organizations

Certain organizations operated for the benefit of a governmental college or university (such as a state college or university) automatically qualify as public charities. (IRC §§ 509(a)(1) and 170(b)(1)(A)(iv).) Most likely, you won't be forming a corporation of this sort, but we

mention it because this type of organization is included in the list of public charities on the federal tax exemption application form.

Supporting Organizations

Organizations operated solely for the benefit of, or in connection with, one or more of the above organizations, or publicly supported groups or groups that meet the exempt activities support test (described below in "Public Support Test" and "Exempt Activities Support Test"), are also automatically classified as public charities (except those that benefit a public safety organization). (IRC § 509(a)(3).)

RESOURCE

For further information on organizations listed above, see IRS Publication 557, *Tax-Exempt Status for Your Organization*, "Section 509(a)(1) Organizations." For supporting organizations, see Publication 557, "Section 509(a)(3) Organizations." Also, note that federal rules have been enacted as part of the Pension Protection Act of 2006 that impose additional requirements on supporting organizations and private foundations that fund them. Ask your tax adviser for more information.

Public Support Test

To be classified as a publicly supported public charity, a group must regularly solicit funds from the general community. It must normally receive money from government agencies and/ or from a number of different private contributors or agencies. (IRC §§ 509(a)(1) and 170(b)(1)(A)(vi).) The term "normally" has a special meaning in this context, which is explained below. We call this public charity test the public support test because the main requirement is that the organization must receive a substantial portion of its funds from broad-based public support sources.

In general, museums, libraries, and community centers that promote the arts should qualify under this public charity test if they rely on broad-based support from individual members of the community or from various public and private sources. Organizations that expect to rely primarily on a few private sources or occasional large grants to fund their operations will probably not meet the requirements of this section. This support test is difficult for small, grassroots groups to meet because income from the performance of tax-exempt purposes does not count as qualifying public support income—a source of support commonly relied upon by these groups.

To determine whether your group qualifies as a publicly supported public charity, you will need to do some basic math and understand some technical rules. Try not to get overwhelmed or discouraged by this technical material. For now, you can simply read through the information to get a sense of the basic criteria for this test and whether or not you might qualify. You can revisit anything that might seem applicable to you later when you fill in your federal tax exemption application.

More importantly, you may decide to let the IRS figure out which public support test works for you. In most cases, unless you know your nonprofit easily fits within the automatic public charity classification, the best and easiest approach is to let the IRS decide whether the public support test (covered in this section) or the exempt activities support test (discussed below) works for your nonprofit. After all, the technical staff on the IRS Exempt Organizations Determinations staff knows this material inside out. Why not use their expertise and let them apply the public charity support tests to your group's past and projected sources of public support, which you will disclose in your federal tax exemption application?

RESOURCE

For more detailed information on qualifying as a public charity using the public support test, see IRS Publication 557, *Tax-Exempt Status for Your Organization,* "Publicly Supported Organizations." You can download a copy of IRS Publication 557 from the Nolo website (see Appendix A for the link). Also check the IRS website at www.irs.gov under "Help & Resources," then "Charities & Non-Profits."

How Much Public Support Do You Need?

The IRS will usually consider an organization qualified under the public support test if it meets one of the following tests:

- The group normally receives at least one-third of its total support from governmental units, from contributions made directly or indirectly by the general public, or from a combination of the two (including contributions from other publicly supported organizations), or

- The organization receives at least one-tenth of its support from these sources *and* meets an additional "attraction of public support" requirement (we discuss the attraction of public support test below).

We call this one-third or one-tenth figure "public support." To keep your percentage high enough, you'll want the IRS to classify as much of your income as possible as public support (the numerator amount), and keep your total support figure (the denominator amount) as low as possible. This will make your final percentage of public support as high as possible. Of course, the IRS has many rules, and exceptions to the rules, to define public support and total support. We provide a guide to the basic technical terms used, below.

Some basic math must be used to estimate your organization's percentage of support. As we explain later, only certain types of

support can be included in the numerator of the fraction—the support funds classified as qualified public support. The denominator of the fraction includes the organization's total support, which includes most sources of support received by the nonprofit. You will want as much support as possible to show up in the numerator as qualified public support. If some support received by the nonprofit does not qualify as public support, then it is better to have the support also excluded from the total support. This will keep the excluded support from reducing your public support percentage since both the numerator and denominator will be left intact.

What Is Public Support?

Qualified public support (support included in the numerator of the fraction) includes funds from private and public agencies as well as contributions from corporate and individual donors. However, the IRS limits how much qualified support your group can receive from one individual or corporation. Also, some membership fees can be included as qualified support. We discuss these special rules in more detail, below.

What Does "Normally" Mean?

An organization must "normally" receive either one-third or one-tenth of its total support from public support sources. This means that one tax year won't make or break your chances of meeting the test—the IRS bases its decision on five years' cumulative receipts. Your organization will meet either the one-third or one-tenth support test for the current tax year if, during the current tax year and the four prior tax years (five years total), its cumulative public support equals one-third or one-tenth of its cumulative total support.

If your nonprofit meets the support test in the current year (based on support received over the five-year testing period that includes the current tax year and the previous four tax years), it will be classified as a public charity for the current and the next tax year.

EXAMPLE: Open Range, Inc., is a nonprofit organization for medical research on the healthful effects of organic cattle ranching. ORI's cumulative total support was $60,000 for year 1 through year 5, and its cumulative public support was $25,000. The organization will, therefore, be considered a publicly supported public charity for year 5 and the following tax year. This remains true even if, for one or more of the previous four years or the current tax year (which we're assuming is year 5), public support did not equal one-third of the total support—it's the cumulative total that counts.

EXAMPLE: If World Relief, a 501(c)(3) nonprofit, meets the public support test for the current year because of grants and contributions received from the public (during the five-year testing period that ends on and includes the current year), the nonprofit will be classified as a public charity for both the current year and the next year. Let's assume that in the next year World Relief fails the support test (using the new five-year testing period). It retains its public charity status for that year because it met the support test in the prior year. But if World Relief also fails the support test in the year after that (using a new five-year testing period), it will lose its public charity status as of the start of that tax year. In other words, it will be classified as a private foundation as of the beginning of the tax year after next.

What Is a "Government Unit"?

Money received from a government unit is considered public support. Government units include federal or state governmental agencies, county, and city agencies, and so on. The most common example of governmental support is a federal or state grant.

The 2% Limit Rule

Direct or indirect contributions from the general public are considered public support. Indirect contributions include grants from private trusts or agencies also funded by contributions from the general public, such as grants from Community Chest or the United Fund.

However, there is a major restriction applicable to these contributions. The total contributions from one individual, trust, or corporation made during the current and preceding four tax years can be counted only to the extent that they do not exceed 2% of the corporation's total support for those five years. Contributions from government units, publicly supported organizations, and unusual grants are not subject to this 2% limit. These exceptions are discussed below.

> **EXAMPLE:** If your total support over the current and previous four-year period was $60,000, then only $1,200 (2% of $60,000) contributed by any one person, private agency, or other source can count as public support.

Note that the total amount of any one contribution, even if it exceeds this 2%, five-year limitation, is included in the corporation's total support. Paradoxically, therefore, large contributions from an individual or private agency can have a disastrous effect on your status as a publicly supported charity. You get to include such contributions as public support only to the extent of 2% of the current and previous four years' total income, but the total income figure is increased by the full amount of the contribution. This makes it more difficult for you to meet the one-third or one-tenth public support requirement.

> **EXAMPLE:** On Your Toes, a ballet troupe, received the following contributions:
>
> | Year 1 | $10,000 | from individual X |
> | Year 2 | 20,000 | from individual Y |
> | Year 3 | 50,000 | from business Z, a one-owner unincorporated dance supply business |
> | Year 4 | 10,000 | additional contribution from individual X |
> | Year 5 | 10,000 | additional contribution from business Z |
> | | $100,000 | Total Support |

All support for the five-year period is from contributions, direct or indirect, from the general public. However, in view of the 2% limit, On Your Toes will have trouble maintaining its publicly supported public charity status. While all contributions count toward total support, only $2,000 (2% x $100,000) from any one contributor counts as public support.

Therefore, the troupe's public support for this period is only $6,000 ($2,000 from each contributor, X, Y, and Z), which falls $4,000 short of the minimum one-tenth public support requirement.

Now, suppose On Your Toes received $2,000 each from 50 contributors over the five-year period. It still has $100,000 total support, but because no one contributor gave more than 2% of the five years' total support, it can count the entire $100,000 as public support.

💡 **TIP**

Increase your chances of qualifying as a publicly supported public charity. One way to do this is to solicit smaller contributions through a broad-based fundraising program and don't rely constantly on the same major sources. This way, you'll beat the 2% limit and have a better chance of qualifying contributions as public support.

Exceptions to the 2% Limit Rule

There are two major exceptions to the 2% limit.

Money From Government Units or Publicly Supported Organizations

Contributions received from a government unit or other publicly supported organization are not subject to the 2% limit, except those specifically earmarked for your organization by the original donor.

> **EXAMPLE:** Ebeneezer Sax gives $1 million to National Public Music, a national government foundation that promotes musical arts. NPM then gives your organization the million dollars as a grant. If Sax made the contribution to NPM on the condition that the foundation give it to your organization, it is considered earmarked for you and the 2% limit applies. If not, the limit doesn't apply—and you can count the whole donation as public support.

Except for earmarked contributions or grants, you can rely on large contributions or grants from specific government agencies or other publicly supported organizations every year, since all such contributions will be counted as public support.

Money From Unusual Grants

Another major exception to the 2% limit is for unusual grants from the private or public sector. A grant is unusual if it:

- is attracted by the publicly supported nature of your organization
- is unusual—this means you don't regularly rely on the particular grant and it is an unexpectedly large amount, and
- would, because of its large size, adversely affect the publicly supported status of your organization (as we've seen, because of the 2% limit, large grants can cause trouble).

If a grant qualifies as an unusual grant, you can exclude the grant funds from both your public support and total support figures for the year in which they are given.

> **EXAMPLE:** The National Museum of Computer Memorabilia, Inc., is a nonprofit corporation that operates a museum of computers and artificial intelligence memorabilia. Years 1 through 4 are difficult ones and the museum raises very little money. But in year 5 the organization receives an unexpected windfall grant. A look at the receipts helps illustrate the importance of the unusual grant exception. All amounts are individual contributions from the general public unless indicated otherwise:

Year 1	$1,000	from A
Year 2	1,000	from B
Year 3	1,000	from C
Year 4	1,000	from D
	1,000	from E
Year 5	100,000	from Z, a private grant agency
	$105,000	Total Receipts

Assume that the 2015 grant qualifies as an unusual grant. The total support computation for the five-year period would be:

		
Year 1	$1,000	from A
Year 2	1,000	from B
Year 3	1,000	from C
Year 4	1,000	from D
	1,000	from E
Year 5	0	the $100,000 grant drops out from total support
	$5,000	Total Support

Because the total support is $5,000, the museum can only count a maximum of 2% times $5,000, or $100, received from any one individual during this period as public support. Therefore, the public support computation for this period looks like this:

		
Year 1	$100	from A
Year 2	100	from B
Year 3	100	from C
Year 4	100	from D
	100	from E
Year 5	0	the $100,000 contribution also drops out from the public support computation
	$500	Total Public Support

The museum meets the 10% support test because total public support of $500 equals 10% of the total support of $5,000 received over the five-year period. If the organization also meets the attraction of public support requirement (which must be met by groups whose public support is less than one-third of total support), it will qualify as a publicly supported public charity for year 5 and year 6. (If you meet the five-year support test, you qualify as a public charity for the current and next tax year.)

If the $100,000 contribution did not qualify as an unusual grant, the nonprofit would not meet the 10% public support test. Total support would equal total receipts of $105,000; a maximum of 2% times $105,000, or $2,100, from each individual and the grant agency would be classified as public support. Public support received over the five-year period would consist of $1,000 from individuals A, B, C, D, and E, and the maximum allowable sum of $2,100 from the grant agency, for a total public support figure of $7,100. The percentage of public support for the five-year period would equal $7,100 ÷ $105,000, or less than 7%, and the group would not meet the support test in year 5. Again, you can see how a large grant can hurt you if it does not qualify as an unusual grant.

Membership Fees as Public Support

Membership fees are considered public support as long as the member does not receive something valuable in return, such as admissions, merchandise, or the use of facilities or services. If a member does receive direct benefits in exchange for fees, the fees are not considered public support. These fees are, however, always included in the total support computation.

What's Not Public Support?

We've already mentioned some sources of support that are excluded because of special circumstances (they exceed the 2% limit or are paid by members in return for something of value). There are additional types of support that are never included as public support. The following types of income are not considered public support and, in some cases, are also not included in the total support figure (in which case they would drop entirely from the percentage of one-third or one-tenth support calculation).

Unrelated Activities and Investment

Net income from activities unrelated to exempt purposes as well as gross investment income, which includes rents, dividends, royalties, and returns on investments, are not considered public support. Both these types of income are added to the total support figure (they stay in the denominator of your one-third or one-tenth support calculation).

Sales of Assets or Performing Tax-Exempt Activity

The following types of income are not considered as public support or part of total support (as with unusual grants, they drop out of both computations):

- **Gains from selling a capital asset.** Generally, capital assets are property owned by the corporation for use in its activities. Note that capital assets do not include any business inventory or resale merchandise, business accounts or notes receivable, or real property used in a trade or business. Gains from selling these noncapital asset items are characterized as gross investment income and are not considered public support, but are added to the total support figure.
- **Receipts from performing tax-exempt purposes.** Examples include money received from admissions to performances of a tax-exempt symphony, fees for classes given by a dance studio, and tuition or other charges paid for attending seminars, lectures, or classes given by an exempt educational organization.

Since we're dealing with tax laws, you'd probably expect at least one complicating exception. Here it is. If your organization relies primarily on gross receipts from activities related to its exempt purposes (such as an educational nonprofit that receives most of its support from class tuition), this exempt-purpose income will *not* be considered public support.

Instead it will be computed in total support (so it will decrease your percentage of support calculation by making the fraction smaller). If your group falls in this category, it will probably not be able to qualify as a publicly supported public charity and should attempt to qualify under the public charity exempt activities support test, discussed below.

Attraction of Public Support Test

Groups that can't meet the one-third public support requirements can qualify for public charity status if they receive at least one-tenth of their total support from qualified public income sources and meet the additional attraction of public support requirement. Only groups trying to qualify for public charity status using the one-tenth (as opposed to one-third) public support requirements must satisfy this attraction of public support test. The IRS considers a number of factors in determining whether a group meets the test. Only Factor 1, below, must be met; none of the other factors are required.

The IRS looks favorably on organizations that meet one or more of the attraction of public support factors listed below. Meeting as many of these factors as possible will not only help you obtain public charity status, it also shows that you satisfy the basic 501(c)(3) tax-exempt status requirements—namely, that your nonprofit is organized and operated in the public interest and has broad-based community support and participation.

Factor 1. Continuous Solicitation of Funds Program

Your group must continually attract new public or governmental support. You will meet this requirement if you maintain a continuous program for soliciting money from the general public, community, or membership—or if you

solicit support from governmental agencies, churches, schools, or hospitals that also qualify as public charities (see "Automatic Public Charity Status," above). Although this factor concerns broad-based support, the IRS allows new groups to limit initial campaigns to seeking seed money from a select number of the most promising agencies or people.

Factor 2. Percentage of Financial Support

At least 10% of your group's total support must come from the public. However, the greater the percentage of public support, the better. Remember that if your public support amounts to one-third or more, you do not have to meet the attraction of public support factors listed in this subsection.

Factor 3. Support From a Representative Number of People

If your group gets most of its money from government agencies or from a broad cross section of people as opposed to one particular individual or a group with a special interest in your activities, it will more likely meet the attraction of public support requirement.

Factor 4. Representative Governing Body

A nonprofit corporation whose governing body represents broad public interests, rather than the personal interest of a limited number of donors, is considered favorably by the IRS. The IRS is more likely to treat an organization's governing body as representative if it includes:
- public officials
- people selected by public officials
- people recognized as experts in the organization's area of operations
- community leaders or others representing a cross section of community views and interests (such as members of the clergy, teachers, and civic leaders), or

- for membership organizations, people elected under the corporate articles or bylaws by a broad-based membership.

Factor 5. Availability of Public Facilities or Services

If an organization continuously provides facilities or services to the general public, the IRS will consider this favorably. These facilities and services might include a museum open to the public, an orchestra that gives public performances, a group that distributes educational literature to the public, or an old-age home that provides nursing or other services to low-income members of the community.

Factor 6. Additional Factors

Corporations are also more likely to meet the attraction of public support requirement if:
- members of the public with special knowledge or expertise (such as public officials, or civic or community leaders) participate in or sponsor programs
- the organization maintains a program to do charitable work in the community (such as job development or low-income housing rehabilitation), or
- the organization gets a significant portion of its funds from another public charity or a governmental agency to which it is, in some way, held accountable as a condition of the grant, contract, or contribution.

Factor 7. Additional Factors for Membership Groups Only

A membership organization is more likely to meet the attraction of public support requirement if:
- the solicitation for dues-paying members attempts to enroll a substantial number of people in the community or area, or in a particular profession or field of special interest

- membership dues are affordable to a broad cross section of the interested public, or
- the organization's activities are likely to appeal to people with some broad common interest or purpose—such as musical activities in the case of an orchestra or different forms of dance in the case of a dance studio.

Exempt Activities Support Test

Don't worry if your Section 501(c)(3) group does not qualify as a public charity either automatically or through the one-third or one-tenth public support test described above. There is another way to qualify as a public charity. The exempt activities support test is likely to meet your needs if your 501(c)(3) group intends to derive income from performing exempt-purpose activities and services (IRC § 509(a)(2)).

Although IRS publications sometimes include groups that meet the support test described in this section as publicly supported organizations, we do not in this chapter. For purposes of this chapter, publicly supported organizations are those that qualify under the public support test described above. We use the term "exempt activities support test" in this chapter to describe this test.

For more detailed information on this public charity category, see IRS Publication 557, *Tax-Exempt Status for Your Organization*, "509(a)(2) Organizations."

TIP

Let the IRS do the work for you. You can let the IRS do the hard part of deciding how each of the special rules described below applies to your group's anticipated sources of financial support. We show you how to check a box on the federal exemption application to do this. For now, just read through this material and you can come back to a particular section if you need to later when you fill in your IRS tax exemption application.

What Type of Support Qualifies and How Much Do You Need?

To qualify under the exempt activities public charity support test, a 501(c)(3) nonprofit organization must meet two requirements:

1. The organization must normally receive more than one-third of its total support in each tax year as qualified public support. Qualified public support is support from any of the following sources:
 - gifts, grants, contributions, or membership fees, and
 - gross receipts from admissions, selling merchandise, performing services, or providing facilities in an activity related to the exempt purposes of the nonprofit organization.

2. The organization also must normally not receive more than one-third of its annual support from unrelated trades or businesses or gross investment income. Gross investment income includes rent from unrelated sources, interest, dividends, and royalties—sources of support far removed from the activities of most small nonprofit organizations. However, it does not include any taxes you pay on income from unrelated businesses or activities—these amounts are deducted before the one-third figure is calculated.

Again, the most important aspect of this test, and the one that makes it appropriate for many 501(c)(3) groups, is that it allows the one-third qualified public support amount to include the group's receipts from performing its exempt purposes. Hence, this public charity classification is appropriate for many self-sustaining nonprofits that raise income from their tax-exempt activities, such as performing arts groups, schools, and other educational-purpose organizations, and nonprofit service organizations. School tuition, admissions to concerts or plays, or payments for classes at a pottery studio count as qualified public support under this public charity test.

Support Must Be From Permitted Sources

Qualified public support under this test must come from permitted sources including:

- individuals
- government agencies, and
- other 501(c)(3) public charities—generally, those that qualify as public charities under one of the tests described in "Automatic Public Charity Status" or "Public Support Test," above.

Permitted sources do not include disqualified persons (defined under IRC Section 4946)—people who would be considered disqualified if the organization were classified as a private foundation. These include substantial contributors, the organization's founders, and certain related persons.

Membership Fees and Dues Get Special Treatment

Dues paid to provide support for or to participate in the nonprofit organization, or in return for services or facilities provided only to members, are considered valid membership dues and can be counted in full as qualified public support. On the other hand, fees or dues paid in return for a discount on products or services provided to the public, or in return for some other monetary benefit, are not valid membership fees. However, these payments can still be counted as qualified public support if the fee entitles the member to special rates for exempt-purpose activities—in which case the payments would qualify as receipts related to the group's exempt purposes, but the payments may be subject to the 1% or $5,000 limitation discussed in the next section below.

> EXAMPLE: People pay $50 to become members of All Thumbs, a nonprofit group dedicated to rebuilding interest in the unitar, a near-extinct one-stringed guitar-like

musical instrument. All Thumbs' members are allowed $50 worth of reduced rate passes to all unitar concerts nationwide. Although these fees can't be counted as valid membership fees because they are paid in return for an equivalent monetary benefit (a $50 discount at unitar concerts), they still count as receipts related to the performance of the group's exempt purposes (putting on these concerts is an exempt purpose and activity of the group). Therefore, the fees can be counted by the organization as qualified public support (we assume the fees paid by each individual do not exceed the 1% or $5,000 limitation that applies to exempt-purpose receipts, as discussed in the next section below).

Are You Selling Services or Information That the Federal Government Offers for Free?

If your nonprofit plans to sell services or information, check to see if the same service or information is readily available free (or for a nominal fee) from the federal government. If so, you may need to tell potential clients and customers of this alternate source. This rule applies to all tax-exempt nonprofits (including any 501(c)(3) organization, whether classified as a public charity or private foundation). (IRC § 6711.) Failure to comply with this disclosure requirement can result in a substantial fine. For further information on these disclosure requirements, see IRS Publication 557.

The 1% or $5,000 Limit for Exempt-Purpose Income

There is one major limitation on the amount of income from exempt-purpose activities that

can be included in the one-third qualified public support figure. In any tax year, receipts from individuals or government units from the performance of exempt-purpose services that exceed $5,000 or 1% of the organization's total support for the year, whichever is greater, must be excluded from the organization's qualified public support figure. This limitation applies only to exempt-purpose receipts and not to gifts, grants, contributions, or membership fees received by the organization.

EXAMPLE: Van-Go is a visual arts group that makes art available to people around the nation by toting it around in specially marked vans. This year, Van-Go derives $30,000 total support from the sale of paintings. The funds are receipts related to the performance of the group's exempt purposes. Any amount over $5,000 paid by any one individual cannot be included in computing its qualified public support for the year, although the full amount is included in total support. Of course, if Van-Go's total support for any year is more than $500,000, then the limitation on individual contributions will be 1% of the year's total support, since this figure exceeds $5,000.

Some Gifts Are Gross Receipts

When someone gives money or property without getting anything of value in return, we think of it as a gift or contribution. But when people give a nonprofit money or property in return for admissions, merchandise, services performed, or facilities furnished to the contributor, these aren't gifts. They are considered gross receipts from exempt-purpose activities and are subject to the $5,000 or 1% limitation.

EXAMPLE: At its annual fundraising drive, the California Cormorant Preservation League rewards $100 contributors with a book containing color prints of cormorants. The book normally retails for $25. Only $75 of each contribution is considered a gift; the remaining $25 payments are classified as gross receipts from the performance of the group's exempt purposes and are subject to the $5,000 or 1% limitation.

Some Grants Are Gross Receipts

It is sometimes hard to distinguish money received as a grant from exempt-purpose gross receipts. The IRS rule is that when the granting agency gets some economic or physical benefit in return for its grant, such as a service, facility, or product, the grant is classified as gross receipts related to the exempt activities of the nonprofit organization. This means that the funds will be subject to the 1% or $5,000 limitation that applies to exempt-purpose receipts. Money contributed to benefit the public will be treated as bona fide grants by the IRS, not as exempt-purpose receipts. This type of bona fide grant is not subject to the 1% or $5,000 limitation.

EXAMPLE 1: A pharmaceutical company, Amalgamated Mortar & Pestle, provides a research grant to a nonprofit scientific and medical research organization, Safer Sciences, Inc. The company specifies that the nonprofit must use the grant to develop a more reliable childproof cap for prescription drug containers (the results of the nonprofit research will be shared with the commercial company). The money is treated as receipts received by Safer Sciences in carrying out its exempt purposes and is subject to the $5,000 or 1% limitation.

EXAMPLE 2: Safer Sciences gets a grant from the federal Centers for Disease Control and Prevention to build a better petri dish for epidemiological research. Since the money is used to benefit the public, the full amount will be included in the nonprofit organization's qualified public support figure.

Unusual Grants Drop Out of the Computation

To be included as qualified support (in the numerator of the support fraction), the support must be from permitted sources. Disqualified persons include founders, directors, or executive officers of the nonprofit. A large grant from one of these sources could undermine the ability of the nonprofit to qualify under this public charity test.

To avoid this result for nonprofits that would otherwise qualify under the exempt activities support test, unusual grants are ignored—that is, they drop out of both the numerator and denominator of the support calculation. (There is a similar exclusion for unusual grants under the public support test, discussed above.) A grant will be classified as unusual if the source of the grant is not regularly relied on or actively sought out by the nonprofit as part of its support outreach program and if certain other conditions are met. If you want to learn more about these unusual grant requirements for groups that qualify as a public charity under the exempt-activities support test, see IRS Publication 557, available on the Nolo website (see Appendix A for the link).

Rents Related to Exempt Purposes Are Not Gross Investment Income

Rents received from people or groups whose activities in the rented premises are related to the group's exempt purpose are generally not considered gross investment income. This is a good thing. Why? Remember: Under this public charity test, the organization must normally not receive more than one-third of its total support from unrelated trades or businesses or from gross investment income.

EXAMPLE: Good Crafts, Inc., a studio that provides facilities for public education in historic crafts, rents a portion of its premises to an instructor who teaches stained glass classes. This rent would probably not fall into the gross investment income category. However, if the tenant's activities in the leased premises were not related to the nonprofit's purposes, then the rent would be included as gross investment income and, if all the unrelated and investment income of the nonprofit exceeded one-third of its total support, the nonprofit could lose its public charity status under the exempt activities support test.

Keep this exception in mind if your group owns or rents premises with extra space. It may be important to rent (or sublease, if you are renting, too) to another person or group whose activities are directly related to your exempt purposes. (If you're renting, be sure the terms of your lease allow you to sublease; most of the time, you'll need your landlord's permission.)

SEE AN EXPERT

When to consult a tax expert. If you plan to supplement your support with income from activities unrelated to your exempt purposes (as more and more nonprofits must), check with your tax adviser. You'll want to make sure this additional income will not exceed one-third of your total support and jeopardize your ability to qualify under this public charity category.

There's That Word "Normally" Again

To qualify as a public charity under the support test, groups must "normally" meet the one-third qualified support requirements set forth in "Public Support Test," above. As with publicly supported organizations, this means that the IRS looks at the total amount of support over the current tax year and the previous four years to decide if the organization meets the support test for the current tax year. (See "What Does 'Normally' Mean?" above.)

Private Foundations

Initially, the IRS will classify your 501(c)(3) corporation as a private foundation. As we mentioned at the beginning of this chapter, almost all nonprofits will want to overcome this presumption and establish themselves as a public charity instead. Because you are probably interested in public charity status, you can skip this section or read through it quickly if you want learn about private foundations and the operating limitations and restrictions applicable to them. If you want to form a private foundation, you can use this book as an introduction to the subject, but you will probably also need the help of a nonprofit lawyer or tax specialist with experience setting up private foundations. The rules that apply to private foundations are very complicated and the penalties for not obeying the rules are stiff.

RESOURCE

Need more information on private foundations? See IRS Publication 4221-PF, *Compliance Guide for 501(c)(3) Private Foundations,* available at the IRS website, at www.irs.gov.

Background

Broadly speaking, the reason that private foundations are subject to strict operating limitations and special taxes, while public charities are not, is to counter tax abuse schemes by wealthy individuals and families. Before the existence of private foundation restrictions, a person with a lot of money could set up his own 501(c)(3) tax-exempt organization (such as The William Smith Foundation) with a high-sounding purpose (to wipe out the potato bug in Northern Louisiana). The potato bugs, though, were never in any danger, because the real purpose of the foundation was to hire all of William Smith's relatives and friends down to the third generation. Instead of leaving the money in a will and paying heavy estate taxes, William Smith neatly transferred money to the next generation tax free by use of a tax-exempt foundation that just happened to hire all of his relatives.

To prevent schemes such as this, Congress enacted the private foundation operating restrictions, special excise taxes, and other private foundation disincentives discussed in the next section.

Operating Restrictions

Private foundations must comply with operating restrictions and detailed rules, including:

- restrictions on self-dealing between private foundations and their substantial contributors and other disqualified persons
- requirements that the foundation annually distribute its net income for charitable purposes
- limitations on holdings in private businesses
- provisions that investments must not jeopardize the carrying out of the group's 501(c)(3) tax-exempt purposes, and
- provisions to assure that expenditures further the group's exempt purposes.

Violations of these provisions result in substantial excise taxes and penalties against the private foundation and, in some cases, against its managers, major contributors, and certain related persons. Keeping track of and meeting these restrictions is unworkable for the average 501(c)(3) group, which is the main reason why you'll want to avoid being classified by the IRS as a private foundation.

Limitation on Deductibility of Contributions

Generally, a donor can take personal income tax deductions for individual contributions to private foundations of up to only 30% of the donor's adjusted gross income. Donations to public charities, on the other hand, are generally deductible up to 50% of the donor's adjusted gross income.

Of course, the overwhelming number of individual contributors do not contribute an amount even close to the 30% limit, so this limitation is not very important. The real question of importance to contributors is whether you are a qualified 501(c)(3) organization so that charitable contributions to your group are tax deductible.

RESOURCE

For more on IRS rules about deduction limitations. IRS Publication 526, *Charitable Contributions*, discusses the rules limiting deductions to private foundations (called 30% limit organizations) and public charities (50% limit organizations), including special rules that apply to donations of real estate, securities, and certain types of tangible personal property. You can search for qualifying 501(c)(3) organizations (both public charities and private foundations) and other

qualified groups eligible to receive tax-deductible charitable contributions by using the IRS Exempt Organizations Select Check tool which can be found online at http://apps.irs.gov/app/eos/.

Special Types of Private Foundations

The IRS recognizes two special types of private foundations that have some of the advantages of public charities: private operating, and private nonoperating foundations. We mention them briefly below because they are included in IRS nonprofit tax publications and forms. Few readers will be interested in forming either of these special organizations.

Private Operating Foundations

To qualify as a private operating foundation, the organization generally must distribute most of its income to tax-exempt activities and must meet one of three special tests (an assets, support, or endowment test). This special type of 501(c)(3) private foundation enjoys a few benefits not granted to regular private foundations, including the following:

- **More generous deductions for donors.** As with public charities, individual donors can deduct up to 50% of adjusted gross income for contributions to the organization.
- **Extended time to distribute funds.** The organization can receive grants from a private foundation without having to distribute the funds received within one year (and these funds can be treated as qualifying distributions by the donating private foundation).
- **No excise tax.** The private foundation excise tax on net investment income does not apply.

All other private foundation restrictions and excise taxes apply to private operating foundations.

RESOURCE

For additional information on the rules that apply to private operating foundations, see *Public Charity or Private Foundation Status Issues under IRC §§ 509(a)(1)–(4), 4942(j)(3), and 507.* The section titled, "IRC 4942(j)(3)—Private Operating Foundations" has information on private operating foundations. You can download a copy of the document from the Nolo website (see Appendix A for the link).

Private Nonoperating Foundations

This special type of private foundation is one that either:

- distributes all the contributions it receives to public charities and private operating foundations (discussed just above) each year, or
- pools its contributions into a common trust fund and distributes the income and funds to public charities.

Individual contributors to private non-operating foundations can deduct 50% of their donations. However, the organization is subject to all excise taxes and operating restrictions applicable to regular private foundations.

Other Tax Benefits and Requirements

I n this chapter we discuss additional federal tax issues that affect nonprofits, such as the deductibility of contributions made to 501(c)(3) nonprofits and what happens if a 501(c)(3) makes money from activities not related to its tax-exempt purposes. We also cover nonprofit tax benefits and tax and nontax requirements that apply to 501(c)(3) nonprofits under California law.

Federal and State Tax Deductions for Contributions

A donor (corporate or individual) can claim a personal federal income tax deduction for contributions made to a 501(c)(3) tax-exempt organization. These contributions are called charitable contributions. Generally, California follows the federal tax deductibility rules for charitable contributions made to nonprofit corporations.

Corporations can make deductible charitable contributions of up to 10% of their annual taxable income. Individuals can deduct up to 50% of adjusted gross income in any year for contributions made to 501(c)(3) public charities and to some types of 501(c)(3) private foundations, as explained in Chapter 4. Donations to most types of private foundations are limited to 30% of an individual's adjusted gross income in each year.

What Can Be Deducted

A donor can deduct the following types of contributions:

- **Cash.**
- **Property.** Generally, donors can deduct the fair market (resale) value of donated property. Technical rules apply to gifts of appreciated property (property that has increased in value) that may require donors to decrease the

deduction they take for donating appreciated property—see IRS Publication 526, *Charitable Contributions*, "Giving Property That Has Increased In Value."

- **Unreimbursed car expenses.** These include the cost of gas and oil incurred by the donor while performing services for the nonprofit organization, and
- **Unreimbursed travel expenses.** These include expenses incurred by the donor while away from home and performing services for the nonprofit organization, such as the cost of transportation, meals, and lodging.

What Cannot Be Deducted

Certain types of gifts cannot be deducted as charitable contributions. Nondeductible gifts include:

- **The value of volunteer services.** For example, if you normally are paid $40 per hour for bookkeeping work, and you volunteer ten hours of your time to a nonprofit to help them prepare their annual financial statements, you cannot claim a charitable deduction for the value of your time donated to the nonprofit (you can't claim a charitable deduction of $400).
- **The right to use property.** If you rent out office space for $1,000 per month and allow a nonprofit to use one-tenth of the total space for a small office, you cannot claim a charitable deduction of $100 per month for letting the nonprofit use the space for free.
- **Contributions to political parties.** These contributions, however, can be taken as a tax credit, subject to dollar and percentage limitations.
- **Direct contributions to needy individuals.**
- **Tuition.** Even amounts designated as donations, which must be paid in addition to tuition as a condition of enrollment, are not deductible.

- Dues paid to labor unions.
- The cost of raffle, bingo, or lottery tickets, or other games of chance.
- Child care costs paid while performing services for a nonprofit organization.

Donations That Can Be Partially Deducted

Contributions that a nonprofit receives in return for a service, product, or other benefit (such as membership fees paid in return for special membership incentives or promotional products, or donations charged for attending a performance) are only partially deductible. Donors may deduct for these only to the extent that the value of the contribution exceeds the fair market value of the service, product, or benefit received by the donor.

> EXAMPLE: If a member of a 501(c)(3) organization pays a $30 membership fee and receives a record album that sells for $30, nothing is deductible. But if a $20 product is given in return for the $30 payment, $10 of the fee paid is a bona fide donation and may be deducted by the member as a charitable contribution.

501(c)(3) nonprofit groups should always clearly state the dollar amount that is deductible when receiving contributions, donations, or membership fees in return for providing a service, product, discount, or other benefit to the donor.

Reporting Requirements

Individuals can claim deductions for charitable contributions by itemizing the gifts on IRS Schedule A and filing this form with their annual 1040 income tax return. IRS rules require donors to obtain receipts for all charitable contributions claimed on their tax returns. Receipts must describe the contribution and show the value of any goods or services received from the nonprofit by the donor as part of the transaction. (See IRS publications mentioned below for more information on how to prepare donor receipts for your organization.)

RESOURCE

The IRS requirements for deducting and reporting charitable contributions change from year to year. For current information, see IRS Publication 526, *Charitable Contributions*. For information on valuing gifts, see IRS Publication 561, *Determining the Value of Donated Property*.

Federal Estate and Gift Tax Exemptions

Gifts made as part of an individual's estate plan (through a will or trust document) can be an important source of contributions for 501(c)(3) nonprofits. When the individual dies, the 501(c)(3) organization receives the money and the money is excluded from the taxable estate of the individual. This can provide significant tax savings for donors. Hence, many people are motivated to engage in estate planning, including making charitable gifts to nonprofit organizations.

Traditionally, colleges and universities and larger environmental and health organizations have actively solicited estate charitable giving by providing information to members and donors about estate planning and the benefits of charitable bequests. Increasingly, smaller nonprofits are starting to understand the game and are pursuing similar strategies in their fundraising efforts. If you understand how charitable giving affects the donor's taxes, you'll be better able to persuade potential donors to give to your cause.

Generally, an individual does not pay taxes on gifts made during his or her lifetime. However, gifts to an individual (who isn't the giver's spouse) or to a nonqualified organization will reduce the donor's unified estate and gift tax credit to the extent the gifts exceed a set amount each year (the current gift tax exclusion rules are posted on the IRS website). On the other hand, gifts made to a 501(c)(3) nonprofit that qualifies as a public charity (even if they exceed the exclusion amount) do not reduce this federal and estate gift tax credit. Hence, tax-wise you might be better off giving the money to a literary nonprofit that, in turn, gives grants to promising writers, rather than directly donating the money to a writer. (Unfortunately, your recipient could not earmark the money donated to a literary nonprofit for a particular writer, as explained in "Charitable Purposes," in Chapter 3.) There are many twists and turns to finding the best way to gift funds to deserving individuals and organizations. Consult a knowledgeable tax adviser or financial planner before deciding on a charitable or estate gifting plan.

> **CAUTION**
>
> **Estate and gift tax laws change frequently.** Check with your tax adviser for the latest rules.

> **RESOURCE**
>
> **For further information on federal and state estate and gift taxes and individual estate planning techniques,** see *Plan Your Estate*, by Denis Clifford (Nolo).

Federal Unrelated Business Income Tax

All tax-exempt nonprofit corporations, whether private foundations or public charities, may have to pay tax on income derived from activities unrelated to their exempt purposes. The first $1,000 of unrelated business income is not taxed. After that, the normal federal corporate tax rate applies: 15% on the first $50,000 of taxable corporate income; 25% on the next $25,000, and 34% on taxable income over $75,000 (with a 5% surtax on taxable income between $100,000 and $335,000). Higher corporate tax rates (35% and an interim 38% surtax) apply to corporate taxable incomes over $10 million.

> **CAUTION**
>
> **Be careful with unrelated income.** As explained in "Unrelated Business Activities," in Chapter 3, if unrelated income is substantial, it may jeopardize the organization's 501(c)(3) tax exemption. In addition, the federal income tax rates are likely to change. Check the IRS website for current rates.

> **RESOURCE**
>
> **For past history and current developments in the federal treatment of an exempt organization's unrelated business income tax,** see *UBIT: Current Developments*. You can download a copy of the document from the Nolo website (see Appendix A for the link).

Activities That Are Taxed

Unrelated business income comes from activities that are not directly related to a group's exempt purposes. An unrelated trade or business is one that is regularly carried on and not substantially related to a nonprofit group's exempt purposes. It is irrelevant that the organization uses the profits to conduct its exempt-purpose activities.

EXAMPLE 1: Enviro-Home Institute is a 501(c)(3) nonprofit organized to educate the public about environmentally sound home design and home construction techniques. Enviro-Home develops a model home kit that applies its ideas of appropriate environmental construction and is very successful in selling the kit. The IRS considers this unrelated business income because it is not directly related to the educational purposes of the organization.

EXAMPLE 2: A halfway house that offers room, board, therapy, and counseling to recently released prison inmates also operates a furniture shop to provide full-time employment for its residents. This is not an unrelated trade or business because the shop directly benefits the residents (even though it also produces income).

Activities That Are Not Taxed

A number of activities are specifically excluded from the definition of unrelated trades or businesses. These include activities in which nearly all work is done by volunteers, and those that:

- are carried on by 501(c)(3) tax-exempt organizations primarily for the benefit of members, students, patients, officers, or employees (such as a hospital gift shop for patients or employees)
- involve the sale of mostly donated merchandise, such as thrift shops
- consist of the exchange or rental of lists of donors or members
- involve the distribution of low-cost items, such as stamps or mailing labels worth less than $5, in the course of soliciting funds, and
- involve sponsoring trade shows by 501(c)(3) groups—this exclusion extends to the exempt organization's suppliers, who may educate trade show attendees on new developments or products related to the organization's exempt activities.

Some of these exceptions have been hotly contested by commercial business interests at congressional hearings. The primary objection is that nonprofits receive an unfair advantage by being allowed to engage, tax free, in activities that compete with their for-profit counterparts. Expect more hearings and future developments in this volatile area of nonprofit tax law.

Also excluded from this tax is income not derived from services (termed gross investment income in the Internal Revenue Code). Remember, this tax applies to unrelated activities, not necessarily to unrelated income. Examples of nontaxable income include:

- dividends, interest, and royalties
- rent from land, buildings, furniture, and equipment (some forms of rent are taxed if the rental property was purchased or improved subject to a mortgage, or if the rental income is based on the profits earned by the tenant), and
- gains or losses from the sale or exchange of property.

See Section 512(b) of the Internal Revenue Code for the complete list of these untaxed sources of income and the exceptions that exist for certain items.

SEE AN EXPERT

It is often difficult to predict whether the IRS will tax an activity or income as unrelated business. Furthermore, IRS regulations and rulings and U.S. Tax Court decisions contain a number of rules classifying specific activities as unrelated businesses that are subject to tax. In short, you should do more research or consult a tax specialist if you plan to engage in activities or derive income from sources not directly related to your exempt purposes. Please note, this isn't the

same thing as saying you shouldn't engage in an unrelated activity—many nonprofits must engage in commercial businesses unrelated to their exempt purposes to survive. But to avoid jeopardizing your 501(c)(3) tax-exempt status and to understand the tax effects of engaging in unrelated business, you simply need good tax advice.

California Unrelated Business Income Tax

California, like the federal government, taxes the unrelated business income of a tax-exempt nonprofit corporation. The state's definition of an unrelated trade or business is similar to that used by the IRS. Basically, any trade or business not substantially related to the organization's exempt purposes is considered an unrelated trade or business.

The tax rate for unrelated income is the standard California corporate franchise tax rate. (Franchise tax is the name of the tax in California that applies to the taxable income of most corporations.) This rate is currently set at 8.84%, and it applies to the net amount of unrelated business income (gross unrelated business income minus deductions for expenses directly connected with carrying on the unrelated business activity). Tax-exempt organizations are allowed a $1,000 deduction before computing their California taxable unrelated business income. The California franchise tax rate and the minimum annual franchise tax rates may change. Check the Franchise Tax Board website to confirm the current annual franchise tax rate and the current annual minimum franchise tax payment amount (www.ftb.ca.gov).

> **EXAMPLE:** A Section 501(c)(3) traveler's aid society earns $7,000 a year selling baked goods to passersby. Cost of the ingredients and all expenses related to this profit-making activity total $3,000. The society pays state unrelated business taxes on the $3,000 net amount ($7,000 – $1,000 deduction – $3,000 cost of goods sold).

The state does not tax certain activities as unrelated trade or business. The state exceptions are similar to the IRS exceptions and include any trade or business:

- where most of the work is performed by volunteers
- that exists mostly for the convenience of the members, students, patients, officers, or employees, or
- that sells merchandise, most of which was given to the organization as gifts or contributions.

Like the federal law, California also generally excludes specific kinds of passive income, such as rent and interest income, from unrelated business income tax.

California Nonprofit Tax Exemption

California corporations are subject to an annual corporate franchise tax of 8.84% on the net income of the corporation. A minimum franchise tax of $800 must be paid annually, starting in the corporation's second tax year. California nonprofit corporations that qualify for a federal 501(c)(3) tax exemption qualify for a parallel state corporate tax exemption under California Revenue and Taxation Code Section 23701(d).

Section 23701(d) of the California tax law exempts the same groups that are exempt under Section 501(c)(3) of the Internal Revenue Code. This means that religious, charitable, scientific, literary, and educational organizations—the most common types of nonprofit corporations and the ones this book is primarily concerned

with—can qualify for a state exemption from corporate franchise taxes. To do this, first obtain your federal 501(c)(3) tax exemption, then send the state a copy of your federal 501(c)(3) determination letter with a request form (see "Obtain Your State Tax Exemption," in Chapter 9).

California tax law, like the federal 501(c)(3) scheme, imposes restrictions on the political activity of 23701(d) tax-exempt groups. California rules are very similar to the federal rules in that California recognizes both the substantial activities test and the alternative political expenditures test. These tests limit the amount of political lobbying and expenditures that can be undertaken by tax-exempt nonprofits. (See "Other Requirements for 501(c)(3) Groups," in Chapter 3.)

California does not make a separate determination as to whether your tax-exempt nonprofit corporation is a private foundation or public charity. The state simply follows the determination made by the IRS. If your organization is classified by the IRS as a 501(c)(3) public charity, it will be considered a public charity in California once the state acknowledges your federal 501(c)(3) tax exemption.

California Attorney General Reporting Requirements

All charitable corporations and trustees holding property for charitable purposes must register with the California Attorney General's Office, Registry of Charitable Trusts. After registering with the attorney general, you will file annual financial disclosure returns showing how you operate your nonprofit and how your charitable funds are used. Most public benefit corporations (not just those formed for a specific charitable purpose) are considered charitable corporations for the purpose of these regis-

tration and annual reporting requirements. Religious corporations are not subject to these reporting requirements. The registration and annual reporting requirements are meant to ensure that the corporate funds are not misused in any way.

After you incorporate a California nonprofit public benefit corporation, you will receive a letter from the attorney general's office. The letter will include a pamphlet with information on the registration requirements, other statutes affecting charitable organizations, and a registration form and instructions. Don't be confused by the legal jargon in these documents—basically, the registration and annual reporting requirements apply to all 501(c)(3) nonprofit groups, except for religious corporations and certain schools and hospitals.

The attorney general registration and reporting requirements are a formality for most Section 501(c)(3) groups. However, if your public benefit corporation solicits funds for specific charitable purposes (such as to provide a free meal program), and the attorney general receives numerous complaints from the public claiming that your organization misrepresents itself when asking for donations or misapplies donated funds to nonprogram purposes, the attorney general will probably look over your annual reports closely. If the complaints sound credible and your reports look incomplete or inaccurate, you will probably receive an inquiry letter from the attorney general asking for more information. If the attorney general is not satisfied with your response, it can take your nonprofit to court and sue both the nonprofit corporation and its principals for the payback of funds fraudulently solicited from the public or misapplied to non-program purposes. (For further information on submitting these required forms, see "File an Initial Report With the Attorney General," in Chapter 9.)

California Welfare Exemption

Many California tax-exempt nonprofit corporations own or lease real property (or portions of property). Real property includes land, buildings, and fixtures attached to a building. For example, your group may own its building; or perhaps you are a tenant in someone else's structure. Your group may also own (or lease) movable property, known as personal property, such as equipment or vehicles.

For-profit businesses pay property taxes on the land and buildings they own and personal taxes on their business equipment and inventory. However, when a qualified 501(c)(3) uses real or personal property *exclusively* to carry out its exempt purposes, it gets a wonderful tax break—no taxes! This rule is known as the welfare exemption, contained in Section 214 of the California Revenue and Taxation Code. To apply for the welfare exemption, call your local county tax assessor and ask for a welfare exemption application and materials.

The welfare exemption can provide tremendous savings for your organization. For example, if you own property and pay relatively high taxes, your property tax bills will go down to zero after you incorporate and obtain a welfare exemption. Or, if you lease property from a nonprofit group that has itself qualified for the welfare exemption, the property tax attributed to your portion of the premises will be dropped from the property tax rolls once you obtain a welfare exemption.

TIP

If you're a tenant, remember the welfare exemption when negotiating your lease. Your landlord (assuming the landlord is a nonprofit that also qualifies for the exemption) will enjoy a tax break when you qualify for the welfare exemption.

Ask the landlord to pass some of his tax savings on to you, in the form of decreased rent, as soon as you qualify. (See "Leasing and the Welfare Exemption," below, for more information.)

RESOURCE

The material in this section is based on the *Assessors' Handbook,* **published by the California State Board of Equalization.** A copy of the "Welfare, Church and Religious Exemptions" section of the *Handbook* is included on the Nolo website (see Appendix A for the link). If you want to see if there's an updated version, go to the California State Board of Equalization website, at www.boe.ca.gov. Select the "Forms & Pubs" tab, then select *Assessors' Handbook,* then select Section AH 267. This contains the welfare exemption information, as well as information on the church and religious exemptions discussed later in this chapter.

Section 214 Exemption Requirements

Many nonprofit corporations qualify for the California welfare exemption. The general requirements for the exemption under Section 214 of the California Revenue and Taxation Code are:

- The property must be used exclusively for religious, hospital, scientific, or charitable purposes and be owned and operated by community chests, funds, foundations, or corporations organized and operated for religious, hospital, scientific, or charitable purposes.
- The owner must be a nonprofit corporation or other organization exempt from taxes under Section 501(c)(3) of the Internal Revenue Code or under Section 23701(d) of the California Revenue and Taxation Code.
- No part of the net earnings of the owner can inure to the benefit of any private

shareholder or individual (see "No Benefit to Individuals," below, for more information on this point).

- The property must be used for the actual operation of the exempt purposes of the group, and it must not exceed the amount of property reasonably necessary to accomplish the group's exempt purposes.

- The property cannot be used or operated by the owner or by any other person so as to benefit any officer, trustee, director, shareholder, member, employee, contributor, bondholder of the owner or operator, or any other person, through the distribution of profits, payments of excessive charges or compensation, or the more advantageous pursuit of their business or profession.

- The property cannot be used by the owner or members for fraternal or lodge purposes or for social club purposes, except where such use is clearly incidental to a primary religious, hospital, scientific, or charitable purpose.

- The property must be irrevocably dedicated to religious, charitable, scientific, or hospital purposes, and upon the liquidation, dissolution, or abandonment by the owner, will not inure to the benefit of any private person except a fund, foundation, or corporation organized and operated for religious, scientific, or charitable purposes. Irrevocable dedication is explained below, in "Irrevocable Dedication of Property."

Most 501(c)(3) nonprofit corporations meet the welfare exemption requirements because they are the same as, or similar to, those that must be met to obtain federal and state income tax exemptions. Although certain types of property owned and operated for religious purposes are covered by the welfare exemption, religious purpose groups generally seek property exemptions under the more flexible church and religious exemptions discussed below.

No Benefit to Individuals

The State Board of Equalization will deny the exemption if the use of the property benefits an individual. In making this determination, the Board takes into account:

- whether a capital investment made by the owner or operator for expansion of a physical plant is justified by the contemplated return on the investment and is required to serve the interests of the community

- whether the property for which the exemption is claimed is used for the actual operation of an exempt activity (under Section 214, the welfare exemption provision) and does not exceed the amount of property necessary to accomplish the exempt purpose

- whether the services and expenses of the owner or operator are excessive, based upon like services and salaries in comparable public institutions, and

- whether the operations of the owner or operator, either directly or indirectly, materially enhance the private gain of any individual or individuals.

Irrevocable Dedication of Property

To qualify for the welfare exemption, property must be dedicated to religious, charitable, scientific, or hospital purposes irrevocably, which means the dedication can't be rescinded. Since an irrevocable dedication clause of all of the nonprofit corporation's property is required by Section 501(c)(3) of the Internal Revenue Code and by Section 23701(d) of the California Revenue and Taxation Code to obtain the federal and state income tax exemptions, you can satisfy all three of these requirements with one irrevocable dedication clause in the articles of incorporation. You can make a specific dedication to a particular group or (as is more

common) the dedication can be for general purposes. The standard articles forms used with this book contain a general dedication clause that dedicates assets to charitable purposes, a category that falls under the requirements of federal and state tax exemption rules as well as the requirements of the welfare exemption.

Dedication Clause for Educational and Scientific Purposes

If property is dedicated to scientific or educational purposes, these purposes must fall within the specific meaning of scientific and educational for the welfare exemption. (We explain the requirements for scientific and educational purpose below.)

Special Statutory Categories

Under California law, certain nonprofit uses of property are specifically mentioned as eligible for the welfare exemption. In some cases, all of the welfare exemption requirements must be met; sometimes, specific requirements are waived. Here are a few examples.

Homeless Shelters

Property owned by a qualifying organization that is used wholly or partially to provide temporary shelter for homeless people qualifies for the welfare exemption. The exemption on the property is granted in proportion to the space used for this purpose.

Educational TV and FM Stations

Property used exclusively by a noncommercial educational FM broadcast station or an educational TV station that is owned and operated by a religious, hospital, scientific, or charitable fund, foundation, or corporation is within the meaning of the welfare exemption.

In addition, one or both of the following requirements must be satisfied:

- **TV.** The educational TV station must receive at least 25% of its operating expense revenues from contributions from the general public or dues from its members.
- **FM radio.** The station must be a noncommercial educational FM broadcast station licensed and operated under Federal Communications Commission rules (Section 73.501 and following of Title 47 of the Code of Federal Regulations).

Preservation of the Environment or Animals

Property used for the preservation of native plants or animals, preserved or protected for its geographical formations of scientific or educational interest, or open space land used solely for recreation and for the enjoyment of scientific beauty (nature trails, tidal pool exploration, and the like) can qualify as exempt from taxation. The property must be open to the general public, subject to reasonable restrictions concerning the uses of the land, and be owned and operated by a scientific or charitable fund, foundation, or corporation that meets the other requirements of Section 214.

Property Leased to the Government

Property that is leased to, and exclusively used by, a government entity for its interest and benefit is exempt if all the other requirements of Section 214 are met, except for the irrevocable dedication requirement. The dedication will be deemed to exist if the lease provides that the owner's entire interest in the property will pass completely to the government entity upon the liquidation, dissolution, or abandonment of the owner, or when the last rental payment is made under the lease, whichever occurs first, and if certain other formal requirements are met.

Property Under Construction or Demolition

Facilities under construction, together with the land where the facilities are located, fall under the welfare exemption, as long as the property and facilities will be used exclusively for religious, hospital, or charitable purposes. The same is true for property that is being demolished with the intent of replacing it with facilities to be used exclusively for religious, hospital, or charitable purposes.

Volunteer Fire Departments, Zoos, and Public Gardens

Property used by volunteer fire departments will fall within the welfare exemption, as long as it also meets certain other requirements. Property used exclusively for the operation of a zoo or for horticultural displays by a zoological society can also qualify for the welfare exemption.

Educational Purposes That Entitle Nonprofits to Use the Welfare Exemption

Educational purposes and activities that benefit the community as a whole (not just a select membership of the nonprofit organization) qualify as charitable purposes under the welfare exemption. Below are examples of the types of educational purposes and activities that meet the requirements of the welfare exemption.

Elementary and High Schools

Real and personal property used by elementary and high schools owned and operated by religious, hospital, or charitable funds, foundations, or corporations fall within the welfare exemption if all of the other requirements of Section 214 are met and the school is an institution of learning with one of the following characteristics:

- attendance at the school exempts a student from attendance at a public full-time elementary or secondary day school under Section 12154 of the Education Code, or
- a majority of its students have been excused from attending a full-time elementary or secondary day school under Section 12152 or 12156 of the Education Code.

Basically, this special provision exempts the property of an educational purpose group that sets up a private, institutionalized elementary or high school with state-approved curriculum and other state-approved institutionalized attributes (such as regular attendance and certified faculty). If you set up a private college in conjunction with a private elementary or high school, you can also seek to obtain the welfare exemption under this provision. If, however, your educational purpose is to set up a private college by itself, you will usually have to meet the requirements of the separate California college exemption to be exempt from personal and real property taxes (see "Other California Tax Exemptions," below).

Special rules extend the welfare exemption to certain property owned by colleges and certain property used for housing facilities for elderly or handicapped persons. Check with the tax assessor's office for further information on these special rules.

Other Educational Purpose Groups

Many general purpose educational groups qualify for the welfare exemption. For example, groups that give instruction in dance, music, or other art forms, or groups that publish instructional literature can qualify for the welfare exemption. The courts and the assessor's office have set up a number of general guidelines for determining whether a general educational purpose group is eligible for the welfare exemption. These include:

- The organization can't be a formal college, secondary, or elementary school (see the definition of elementary and secondary schools in "Elementary and High Schools," above).
- The organization can't receive support from public (governmental) agencies.
- The educational program should be available to the community at large and provide a social benefit to the general public—not just a select number of people. In other words, the educational program must have some charitable attributes that instruct or benefit those who attend as well as the general public. The fact that admission fees are charged for attendance at performances, or that tuition is charged for instruction, does not negate the charitable nature of the educational activities.

EXAMPLE 1: In a leading case, the court ruled that a theater group whose primary activities consisted of charging admissions to theatrical performances open to the general public was charitable in nature and its educational purpose was one within the meaning of the welfare exemption. In reaching this conclusion, the court took note of the fact that the only real estate owned by the group was a playhouse used for the production of popular plays and musical comedies. The real estate was not used to benefit any officer, trustee, director, shareholder, member, employee, contributor, or bondholder of the corporation. All productions were of amateur standing. Membership in the theater group was unrestricted and was obtained by anyone who purchased a season ticket. In addition, the theater obtained revenue from the sale of tickets to the general public for single performances and from gifts.

The court considered these facts favorably, as well as the fact that the theater group was dedicated to providing educational benefits both to those who took part in the productions and to members of the general public (members of the audience). These benefits were found to be beneficial to the community, and therefore charitable, so the group's educational purposes were found to be within the meaning of the welfare exemption. The group was granted the welfare exemption and the real and personal property owned by the group was held exempt. (*Stockton Civic Theatre*, 66 Cal.2d 13 (1967).)

EXAMPLE 2: In another important case, an educational-purpose group was denied the welfare exemption. This case involved an educational-purpose mortuary school that was an accredited junior college offering a one-year course in mortuary science leading toward an AA degree. The court found that because the school was a quasi–diploma mill, it did not qualify for the college exemption; and because it was of collegiate grade, it did not meet the welfare exemption's statutory requirements. The court went on to say that the organization was ineligible in any event, because its educational program (mortuary science) did not benefit the community at large or an ascertainable and indefinite portion of the community. All benefits went to a specific segment of the community (the funeral service industry) by providing it with competently trained personnel. (*California College of Mortuary Science*, 23 Cal.App.3d 702 (1972).)

Whether the tax assessor's office will consider your educational activities charitable in nature will depend on the particular activities of your group. If you show the assessor's office that your

educational purpose activities (seminars, lectures, publications, courses, and performances) benefit the community at large (which most do), you should qualify for the welfare exemption.

Scientific Purposes That Entitle Nonprofits to Use the Welfare Exemption

Scientific purposes are narrowly defined for purposes of the welfare exemption. Under Section 214, scientific purposes are limited to medical research whose objects are the encouragement or conduct of scientific investigation, research, and discovery for the benefit of the community at large, unless the research is carried on by an institution chartered by the U.S. government.

Religious Purposes That Entitle Nonprofits to Use the Welfare Exemption

Property owned by religious purpose groups and used for religious purposes is eligible for the welfare exemption. The courts have interpreted the terms religious and religion broadly under the welfare exemption. For example, property owned and operated for religious worship (such as a church building) and property used for general religious purposes (such as church schools, retreats, summer camps, reading rooms, and licensed church nursery schools) qualifies for the welfare exemption. Although the welfare exemption applies to this broad range of religious purposes, most religious groups use California's separate religious welfare exemption because it is easier to qualify for and use.

The religious exemption is a separate exemption under Section 207 of the California Revenue and Taxation Code. This exemption provides a streamlined and coordinated procedure that many nonprofit religious groups can now use to obtain their real and personal property tax exemptions. In the past, religious groups applied for both the church exemption (discussed below) and the welfare exemption. The church exemption was used for religious worship property, such as a church building; and the welfare exemption was used for other religious uses not involving religious worship.

The religious exemption exempts property owned and used by a nonprofit religious organization for religious purposes (not just religious worship) and involves a simplified application and renewal procedure. This consolidated exemption specifically lists church property used for preschool, nursery school, kindergarten, elementary, and secondary school purposes as exempt religious purposes. Like the welfare exemption, the religious exemption does not exempt college-level institutions. As a result, under this exemption a church need file only a single form to obtain an exemption on property owned by the church and used for religious worship as well as property used for school purposes.

All religious corporations, whether or not they own and operate church schools, should call their local county tax assessor's office (exemption division) and determine if they are eligible to use the religious exemption and its simplified application and reporting requirements.

The religious exemption does not apply to particular uses such as hospitals, educational FM radio or television stations, and certain housing owned by churches. In these cases, use the welfare exemption.

California law also provides certain religious groups with another property tax exemption: the church exemption. Although religious purpose groups usually use the religious exemption explained above, we briefly discuss this third exemption in case you don't qualify for the other exemptions and need to use this one instead.

The church exemption applies to personal and real property used exclusively by a church. This includes property owned or leased from another nonprofit or profit-making group. This is a broader exemption than the welfare exemption or religious exemption, because under this special religious exemption, it is strictly the use, and not the ownership of the property, that is determinative. As with the term religious, property used for church purposes has been liberally interpreted by the courts. Broadly speaking, the courts define property that qualifies for this separate exemption as "any property or facility that is reasonably necessary for the fulfillment of a generally recognized function of a complete, modern church" (see *Cedars of Lebanon Hospital v. County of Los Angeles*, 35 Cal.2d 729 (1950)). Consequently, church property includes not only property used directly for religious worship, but also property used for activities related to the function of churches, such as administrative and business meetings of the church governing body, religious instructional sessions, practice sessions of the choir, and most activities of auxiliary organizations accountable to the local church authority. For further information on the church exemption, call the local tax assessor's office or the main headquarters of the California State Board of Equalization in Sacramento.

Leasing and the Welfare Exemption

We have looked at some types of ownership, operation, and uses of property that will be considered religious, hospital, scientific, or charitable under the welfare exemption. The above discussion, for the most part, assumes that the group seeking the exemption both uses and owns the property. But what about leasing? How does a tax-exempt group that leases property benefit from the welfare exemption?

What problems are encountered when the tax-exempt group is the landlord?

Even groups that do not qualify for the welfare exemption can obtain a property tax exemption on leased premises rented to government or charitable organizations and used for public libraries, museums, public schools, colleges, or educational purposes by nonprofit colleges or universities. (See Revenue and Taxation Code §§ 251 and 442.)

Your Nonprofit Is the Renter

Let's first consider the situation in which your group, qualified as tax-exempt under the welfare exemption, leases property from another person or group.

Your group will be exempt from paying any personal property taxes on property located on the premises, regardless of the status (exempt or nonexempt) of your landlord. Although you don't own and operate the real property, as required by Section 214, your group does own and operate the *personal* property located on the premises. You will therefore be exempt from paying any personal property taxes that are levied on equipment, furniture, and other movable items located on the premises.

If your group is renting from another group that itself qualifies for and obtains the welfare exemption, then the exemption will apply to both the personal and real property taxes associated with the leased property. If you lease from a tax-exempt qualified lessor, you and the landlord should agree clearly in writing that the rent you pay will be lessened by an amount equal to the real property tax exemption for the leased premises for each year in which your group qualifies for the welfare exemption. This is a way of making sure that the benefits of the welfare exemption that apply to the leased premises will be passed on to you.

The only other way to obtain an exemption from payment of both personal and real property taxes on leased premises is for your group to fall within another exemption, other than the welfare exemption (see "Other California Tax Exemptions," below). Again, if this is true, the lease agreement should clearly state that a reduction or elimination of real property taxes on the owner's tax bill should be passed on to you for each year in which you qualify for the particular exemption.

Your Nonprofit Is the Landlord

Now let's look at the situation where your group qualifies for the welfare exemption and you lease property or portions of property to another organization. For example, if your group owns a building that is too large for your needs, it makes sense to lease out some of the extra space.

- If you lease the property to an organization that meets the welfare exemption requirements, the leased premises will continue to be exempt from real property taxes.
- If you lease to a group that meets the requirements of some other real property exemption provided under other provisions of California law, the leased premises will continue to be exempt from real property taxes.
- If you lease the property to a group that cannot meet any of the above three tests, you won't lose your entire exemption. However, your welfare exemption will apply to only the buildings or portions of buildings that you occupy or use. Your group will receive a real property tax bill for any portion of the facilities rented out to nonexempt tenants and, as the owner of the property, you'll have to pay these taxes. Of course, in this case, the owner organization will want to make sure that the lease agreement passes these taxes on to the nonexempt tenants in the form of rent.

Other California Tax Exemptions

Section 501(c)(3) nonprofits and other groups that do not qualify for the welfare exemption may be eligible for other tax exemptions under different provisions of California law. We've already touched on the separate college, religious, and church exemptions above. The following is a partial list of special property tax exemptions that can benefit nonprofit groups.

This is only a partial list and is subject to change—for current information on property tax exemptions that might apply to your nonprofit group, call your local county tax assessor's office or the main headquarters of the California State Board of Equalization in Sacramento.

Other Property Tax Exemptions

Type of Owner or Property	Personal Property Exemption	Real Property Exemption
Cemeteries	X	X
Churches	X	X
Colleges	X	X
Exhibitions	X	X
Free museums	X	X
Religious organizations	X	X
Veterans' organizations	X	X
Works of art	X	

State Solicitation Laws and Requirements

Fundraising is a way of life for most nonprofit organizations because these organizations depend on contributions solicited from the general public, and public and private grants.

for their operating funds. Most states, including California, regulate how a 501(c)(3) public charity can solicit contributions from the general public. State regulation of charitable solicitations is meant to serve two main purposes:

- to curb fundraising abuses by monitoring the people involved and their activities, and
- to give the public access to information on how much an organization spends to raise whatever ultimately goes into funding its charitable, educational, religious, or other nonprofit purpose.

The rules that apply to fundraising are beyond the scope of this book, but we recommend that you make learning about state charitable solicitation rules one of your top priorities after you incorporate. The U.S. Supreme Court has put the brakes on attempts by states to regulate what a nonprofit must disclose directly to potential contributors. However, California, like many other states, has enacted laws regulating disclosures by commercial fundraisers paid by a nonprofit. California also regulates the activities of consultants hired by nonprofits to help them raise funds. Both fundraisers and consultants are required to make periodic reports to the California Attorney General. California also imposes annual reporting requirements for any charity soliciting contributions or sales that collects more than 50% of its annual income and more than $1,000,000 in contributions from California donors during the calendar year, if the charity spent more than 25% of its annual income on nonprogram expenses. (See Business and Professions Code §§ 17510.9 and 17510.95 for the complete text.)

The best way to learn about the rules is to go to the California Attorney General's website and view or download the latest California Attorney General's Office *Guide to Charitable Solicitation*. It contains a thorough discussion of the various state operational and reporting requirements that apply to charitable solicitations by fundraisers in California. (The *Guide* is also available on the Nolo website; see Appendix A for the link.)

The California Nonprofit Integrity Act of 2004 imposes additional restrictions on the fundraising activities of charitable nonprofits. It primarily applies to nonprofit public benefit corporations (except schools and hospitals) and the commercial fundraisers (and lawyers) that they pay. Here is a partial summary of the Act:

- Commercial fundraisers hired by a charitable nonprofit must notify the attorney general before starting to work on a solicitation campaign, and they must have a written contract with the charitable organization. A charitable organization can cancel a contract with a fundraiser if the commercial fundraiser is not registered with the attorney general's Registry of Charitable Trusts.
- Fundraising contracts must contain other disclosures and provisions, including the charitable purpose of the solicitation campaign and the fees or percentages that will be paid to the fundraiser. The contract must require that all contributions the fundraiser receives either be deposited in a bank account controlled by the charitable organization or delivered in person to the charitable organization within five days. The charitable organization must have the right to cancel the contract without liability for ten days after the date it is signed. The organization must also have the right to cancel the contract for any reason at any time on 30 days' notice to the fundraiser.
- The Act imposes numerous other obligations and restrictions on charitable organizations and their commercial fundraisers. These rules were designed to ensure that donations solicited from the public are used for the stated

purposes of each fundraising campaign and to protect the public from misrepresentations and fraudulent fundraising practices. For example, the new rules say that a charity may accept contributions only for a charitable purpose that is expressed in the solicitation for contributions and that conforms to the charitable purpose expressed in the articles of incorporation or other governing instrument of the charitable organization, and the nonprofit must apply any contributions only in a manner consistent with that purpose. To help ensure accountability under the Act, fundraisers are required to keep records of fundraising drives for at least ten years.

RESOURCE

For more information on fundraising registration requirements, see *Nonprofit Fundraising Registration: Nolo's 50-State Digital Guide,* by Stephen Fishman (Nolo) and Nolo's website.

Here are some Internet resources you can use to learn more about the rules under the California Nonprofit Integrity Act of 2004:

- Go to the California Attorney General's website and under "Programs A–Z," "See All Programs" on the "Publications" page, select "Charities/Nonprofits" and you will find a link to the Nonprofit Integrity Act of 2004.

- To read the sections of California law amended or added by the Act, go to the Official California Legislation Information website at http://leginfo.legislature.ca.gov. Select and read under California Law, Government Code Sections 12581, 12582, 12583, 12584, 12585, 12586, 12599, 12599.1, 12599.3, 12599.6, and 12599.7, and Business and Professions Code Section 17510.5.

Regulation of charitable solicitation is an active and changing area of law. At the federal level, Congress has proposed putting multistate nonprofit fundraising activities under Federal Trade Commission (FTC) regulation, and thereby under federal court jurisdiction, while single-state fundraising would remain under state and local jurisdiction. You should do you best to keep your nonprofit network antennae tuned to developments in this area.

Choose a Name and File Your Articles of Incorporation

This chapter shows you how to form your California nonprofit corporation. To do this, you must first choose a name for your corporation; then you prepare and file articles of incorporation with the California Secretary of State. You'll see that it is a relatively simple and straightforward process and mostly involves filling in blanks on standard forms using information you already have at your fingertips. Take your time and relax; you'll be surprised at how easy it all is.

TIP

Forming your corporation will be the first step you take to obtain nonprofit status. Your corporation must be in existence when you apply for your state and federal tax exemptions. We recommend, however, that before you file your articles, you read through and prepare some of the other documents required later in the process, such as your bylaws and tax exemption applications. That way you'll know what is required to complete the process before you form your corporation. (See "Don't Rush to File," below.)

We go over all the forms you need to prepare and file your articles. These forms include the name availability and name reservation forms, articles of incorporation for a public benefit or religious corporation, and a cover letter for filing your articles of incorporation. Instructions for downloading forms from the Nolo website are in Appendix A.

The California Secretary of State's website has forms, such as the name availability and name reservation form, that you can complete online, print, and mail in. The secretary of state's website also has sample corporate documents, such as articles of incorporation and certificates of amendment to articles of incorporation. Go to the Business section and click on "Forms, Samples, and Fees." These sample corporate documents are intended for use as a guide

only—they can't be completed online or copied and mailed in.

TIP

Plan ahead. With the recent closures of secretary of state's offices, it can take two months or more to file your articles of incorporation by mail. If you need to create your corporation in a hurry, you can choose to file your articles in person, as explained in this chapter.

As you begin the process of forming your corporation, we suggest that you use the Incorporation Checklist to chart your way through the incorporation steps in Chapters 6 through 9. Look through the steps on the chart and check the box labeled "My Group" for each step that applies to you. When you complete each step, go back and mark the "Done" box. This will help you keep track of where you are and can greatly simplify the incorporation process for you.

CAUTION

Check the California Secretary of State's website (the Business section) for changes to the forms, fees, and filing address before you prepare or file your incorporation documents. We will also post updates on the Nolo website (see Appendix A for the link).

Choose a Corporate Name

The first step in forming your corporation is to choose a name that you like and one that also meets the requirements of state law. The California Secretary of State will approve your corporate name when you file your articles of incorporation. As explained more below, you can check name availability and reserve a corporate name before you file your articles.

Keeping or Changing Your Name

If you are incorporating an existing organization, you may want to use your current name as your corporate name, particularly if it has become associated with your group, its activities, fund-raising efforts, products, or services. Many new corporations do this by simply adding "Inc." to their old name (for example, The World Betterment Fund decides to incorporate as The World Betterment Fund, Inc.). Using your old name is not required, however. If you have been thinking about a new name for your organization, this is your chance to change it.

As a practical matter, your corporate name is one of your most important assets. It represents the goodwill of your organization. We don't use the term goodwill here in any legal, accounting, or tax sense; rather, your name is significant because people in the community, grant agencies, other nonprofits, and those with whom you do business will identify your nonprofit primarily by its name. For this reason, as well as to avoid having to print new stationery, change promotional literature, or create new logos, you should pick a name you'll be happy with for a long time.

There are certain legal requirements for corporate names in California. If you don't meet these requirements, the secretary of state will reject your corporate name (and will also reject your articles of incorporation).

Your Name Must Be Unique

Your proposed corporate name must not be the same as, or confusingly similar to, a corporate name already on file with the secretary of state. The list of corporate names maintained by the secretary of state includes:

- existing California corporations
- out-of-state corporations qualified to do business in California
- names registered with the secretary of state by out-of-state corporations, and
- names reserved for use by other corporations.

In deciding whether a corporate name is too similar to one already on file, the secretary of state's office will usually look only at similarities between the corporate names themselves, not at similarities in the types and locations of the corporations using the names. If you attempt to form a corporation with a name that is similar in sound or wording to the name of another corporation on the corporate name list, the secretary of state's office may reject your name and return your articles of incorporation to you. For example, suppose your proposed name is "Open Spaces." If another corporation is on file with the secretary of state with the name "Open Spaces International, Inc.," your name will probably be rejected as too similar.

The secretary of state does not compare proposed corporate names against the names of other types of legal entities on file with its office. For example, it does not check proposed corporate names against the names of limited liability companies (LLCs), limited partnerships, or registered limited liability partnerships (RLLPs). However, you should do your best to avoid names used by all other types of organizations and businesses, not just corporations. If your name is likely to mislead the public or create confusion because it is too similar to the name of an existing business, then you can be stopped from using that name, regardless of the types of business entities involved. (For information on trademark and trade name law, see "Perform Your Own Name Search," below. For information on how to

compare your proposed corporate name to corporate and LLC names already on file with the secretary of state, see "Check Existing Corporate Names Online," below.)

You Can't Use Certain Terms

A California nonprofit corporation cannot use the words "bank," "trust," or "trustee" in its name. These financial institutions are regulated by special California laws and there are special regulations that govern their formation.

No Need to Use "Inc."

Unlike many other states, California does not require a corporate designator in corporate names, such as "Corporation," "Incorporated," "Limited," or an abbreviation of one of these words ("Corp.," "Inc.," or "Ltd."). For example, The Actors' Workshop and The Actors' Workshop, Inc., are both valid corporate names in California. Most incorporators, however, want to use one of these corporate designators precisely because they want others to know that their organization is incorporated.

Using Two Names and Changing Your Name

If you want to adopt a formal corporate name in your articles that's different than the one you have used (or plan to use) to identify your nonprofit organization, you can do so. You'll need to file a fictitious business name statement (also known as a "dba statement") with the local county clerk.

You can also change your corporate name after you've filed your articles. After making sure that the new name is available for use (as explained further below), you can amend your articles and file the amendment with the secretary of state.

! CAUTION

Having your name approved by the secretary of state when you file your articles of incorporation does not guarantee that you will have the absolute legal right to use it. As explained in more detail in "Perform Your Own Name Search," below, another organization or business may already be using the name as its business name or may be using it as a trademark or service mark. If someone else is using the name, they may be able to prevent you from using it, depending on their location, type of business, and other circumstances. We show you how to do some checking on your own to be relatively sure that no one else has a prior claim to your proposed corporate name based on trademark or service mark.

Practical Suggestions for Selecting a Name

Now that we've looked at the basic legal requirements related to your choice of a corporate name, here are some practical suggestions to help you do it.

Use Common Nonprofit Terms in Your Name

There are a number of words that broadly suggest 501(c)(3) nonprofit purposes or activities. Choosing one of these names can simplify the task of finding the right name for your organization and will alert others to the nonprofit nature of your corporate activities. "Common Nonprofit Names," below, shows a few examples.

Names to Avoid

When selecting a corporate name, we suggest you avoid, or use with caution, the types of words described and listed below. Of course, there are exceptions. If one of these words relates to your particular nonprofit purposes or activities, it may make sense to use the word in your name.

Avoid words that, taken together, signify a profit-making business or venture, such as Booksellers Corporation, Jeff Baxter & Company, Commercial Products Inc., or Entrepreneurial Services Corp.

Common Nonprofit Names

Academy	House
Aid	Human
American	Humane
Appreciation	Institute
Assistance	International
Association	Learning
Benefit	Literary
Betterment	Mission
Care	Music
Center	Orchestra
Charitable	Organization
Coalition	Philanthropic
Community	Philharmonic
Congress	Program
Conservation	Project
Consortium	Protection
Council	Public
Cultural	Refuge
Education	Relief
Educational	Religious
Environmental	Research
Exchange	Resource
Fellowship	Scholarship
Foundation	Scientific
Friends	Service
Fund	Shelter
Health	Social
Help	Society
Heritage	Study
Home	Troupe
Hope	Voluntary
Hospice	Welfare
Hospital	

Avoid words that describe or are related to special types of nonprofit organizations (those that are tax exempt under provisions of the IRC other than Section 501(c)(3)), such as Business League, Chamber of Commerce, Civic League, Hobby, Recreational or Social Club, Labor, Agricultural or Horticultural Organization, Political Action Organization, Real Estate Board, and Trade Group.

 RELATED TOPIC

For a listing of these special tax-exempt nonprofit groups and a brief description of each group, see "Special Nonprofit Tax-Exempt Organizations," in Appendix B.

EXAMPLE: The name Westbrook Social Club, Inc., would clearly identify a social club, tax exempt under IRC Section 501(c)(7)—for this reason, you shouldn't use this type of name for your 501(c)(3) nonprofit. However, The Social Consciousness Society might be an appropriate name for a 501(c)(3) educational purpose organization. Also, although The Trade Betterment League of Pottersville would identify a 501(c)(6) business league and The Millbrae Civic Betterment League a 501(c)(4) civic league, The Philanthropic League of Castlemont might be a suitable name for a 501(c)(3) charitable giving group.

Avoid words or abbreviations associated with nationally known nonprofit causes, organizations, programs, or trademarks. You can bet that the well-known group has taken steps to protect its name as a trademark or service mark. Steer clear of the names in "These Names Are Already Taken," below.

Avoid words with special symbols or punctuation that might confuse the secretary of state's computer name-search software, such as: @ # $ % ^ & * () + ? and > or <.

These Names Are Already Taken

Here is a small sampling of some well-known —and off-limits—nonprofit names and abbreviations:

AAA

American Red Cross

American Ballet Theatre or ABT

American Conservatory Theatre or ACT

Audubon

Blue Cross

Blue Shield

Environmental Defense Fund

National Geographic

National Public Radio or NPR

Public Broadcasting System or PBS

Sierra Club

Pick a Descriptive Name

It's often a good idea to pick a name that clearly reflects your purposes or activities (for example, Downtown Ballet Theater, Inc.; Good Health Society, Ltd.; Endangered Fish Protection League, Inc.). Doing this allows potential members, donors, beneficiaries, and others to easily locate and identify you. More fanciful names (The Wave Project, Inc., Serendipity Unlimited Inc.) are usually less advisable because it might take a while for people to figure out what they stand for, although occasionally their uniqueness can provide better identification over the long term.

> **EXAMPLE:** Although the name Northern California Feline Shelter, Inc., will alert people at the start to the charitable purposes of the nonprofit group, Cats' Cradle, Inc., may stay with people longer once they are familiar with the activities of the organization.

Limit Your Name Geographically or Regionally

If you use general or descriptive terms in your name, you may need to further qualify it by geographic or regional descriptions to avoid conflicts or public confusion.

> **EXAMPLE 1:** Your proposed name is The Philharmonic Society, Inc. Your secretary of state rejects this name as too close to a number of philharmonic orchestras on file. You refile using the proposed name, The Philharmonic Society of East Creek, and your name is accepted.

> **EXAMPLE 2:** Suppose you are incorporating the AIDS Support Group, Inc. Even if this name does not conflict with the name of another corporation on file in your state, it is still a good idea to limit or qualify the name to avoid confusion by the public with other groups in other parts of the country that share the same purposes or goals. You could do this by changing the name to the AIDS Support Group of Middleville.

Choose a New Name Instead of Trying to Distinguish Yourself

Instead of trying to distinguish your proposed name from another established group by using a regional or other identifier, it's usually better to choose a new and different name if the public is still likely to confuse your group with the other group.

> **EXAMPLE:** Your proposed nonprofit name is The Park School, Inc. If another corporation (specializing in a nationwide network of apprentice training colleges) is already listed

with the name Park Training Schools, your secretary of state may reject your name as too similar.

You may be able to limit your name and make it acceptable (The Park Street School of Westmont, Inc.) but this may not be a good idea for two reasons: First, members of the public who have heard of the Park Training Schools might think that your school is simply a Westmont affiliate of the national training program. Second, you might still be infringing the trademark rights of the national group (they may have registered their name as a state or federal trademark).

Use a Corporate Designator in Your Name

Even though not legally required in California, you might want to include a corporate designator in your name to let others know that your organization is a corporation. Here are some examples: Hopi Archaeological Society, Inc., The Children's Museum Corporation, Mercy Hospital, Incorporated, and The Hadley School Corp.

Take Your Time

Finding an appropriate and available name for your corporation will take time and patience. It's usually best not to act on your first impulse—try a few names before making your final choice. Ask others both inside and outside the organization for feedback. And remember: Your proposed name might not be available for your use—have one or more alternate names in reserve in case your first choice isn't available.

Check Name Availability

The secretary of state will reject your articles of incorporation if the name you've chosen for your corporation is not available. Any name already being used by another corporation on file with the secretary of state's office is considered unavailable. To avoid having your articles rejected, it's often wise to check if the name you want is available before you try to file your articles.

Check Your Proposed Name by Mail

You can request a corporate name check by sending a Name Availability Inquiry Letter to the secretary of state's office in Sacramento. You can check up to three corporate names per request and there is no filing fee. The secretary will respond to your written request within one to two weeks.

The Name Availability Inquiry Letter form is included with this book as a downloadable form and it is available online at the secretary of state's business portal website. You must fill out the form, print it, and mail it to the secretary of state.

CAUTION

Checking the availability of a name doesn't reserve the name or give you any rights to the name. Even if the secretary of state indicates by return mail that a corporate name is available, it may not be available when you file your articles. To avoid this problem and to save time, you can check and reserve a name for a small fee, as explained in the next section.

Check Existing Corporate Names Online

You can check the names of existing corporations registered with the secretary of state online at the secretary of state's business portal website (see Appendix B for more information). Go to the Business Programs Section, then go to "Business Entities," then "Business Search." Enter your proposed name in the search box. Click the appropriate button and then check your proposed name against existing corporations,

LLCs, and limited partnerships. Even though the secretary of state may let you use a corporate name that conflicts with an LLC name, we advise against doing this. To avoid legal disputes, it's best to stay clear of any business name (whether a corporate, LLC, or unincorporated business name) that is the same as or similar to your proposed corporate name. The fact that an LLC name has a different ending than your corporate name (for example, "Racafrax, LLC" and you want to use "Racafrax" as your corporate name) does not mean you will be allowed to use your proposed name. If the names are substantially similar, a court may stop you from using your proposed name, even if you use it for a corporation and the competing business name is used by an LLC.

If your proposed corporate name is not the same as or similar to an existing name listed online, you may decide it's safe to go ahead and file your articles without formally checking name availability or reserving your name with the secretary of state. If you discover a match to your proposed name, and the corporation is still active (the name search tells you whether the corporation is active or not), you need to look for another name. If you discover a similar corporate name, the secretary of state may find that it is too similar to your proposed name to let you use it. The only way to tell whether the secretary of state will allow you to use a name that is similar to an existing corporate name is to do a formal name availability check or try to reserve the name. If the secretary of state reports that the name is not available or won't reserve it for your use, you know the name was too similar to the existing corporation's name.

What to Do When There's a Name Conflict

If using your proposed name is crucial to you and the secretary of state's office tells you that it is too similar to an existing corporate name already on file, there are a few things you can do.

Appeal the Decision

You can ask the secretary of state's legal counsel to review the staff's determination regarding your name's acceptability. This will involve filing a written request, and you may decide to seek the help of a lawyer. Here's why: The legal question of whether or not a name is so close to another name so as to cause confusion to the public is a difficult one, and involves looking at a number of criteria contained in court decisions. Factors such as the nature of each trade name user's business (the term "trade name" simply means a name used in conjunction with the operation of a trade or business), the geographical proximity of the two businesses, and other factors work together in ways that are difficult to predict. We cover trade name issues in more detail below but, for now, we simply note that if you do get into this sort of debate, you will probably want to see a lawyer who is versed in the complexities of trade name or trademark law or do some additional reading on your own.

Get Permission

An obvious resolution would be to obtain the written consent of the other corporation. Sometimes, profit corporations that have registered a name similar to the proposed name of a nonprofit corporation will be willing to allow the nonprofit corporation to use the similar name. We think this is too much trouble. Besides, most businesses jealously guard their name, and it is unlikely any business or organization will let you ride on the coattails of their existing name. If you are told your proposed corporate name is too similar to another name, we recommend you move on and choose another name that is available for your use.

Pick Another Name

You may decide that it's simpler (and less trouble all the way around) to pick another name for your nonprofit corporation. We usually recommend this approach.

> **CAUTION**
>
> **A name check gives you only a preliminary indication whether your proposed corporate name is available.** Don't order your stationery, business cards, or office signs until the secretary of state has formally accepted your name by approving your Name Reservation Request or filing your articles of incorporation.

Reserve Your Corporate Name

For a small fee, you can reserve an available corporate name with the secretary of state. It makes sense to reserve a name if you will not be filing your articles immediately—available corporate names are hard to find, and reserving a name allows you to hold on to the name while you complete your initial paperwork for incorporation.

To reserve a name, you can prepare and file a Name Reservation Request Form with the secretary of state. When filling in the form, you can list up to three names in order of preference. The first available name will be reserved for your use. If a name is accepted, only the person who filled in the Name Reservation form can file articles with the reserved name or a similar name during the 60-day reservation period.

The Name Reservation Request Form is available with this book (see Appendix A) and online at the California Secretary of State's website (go to the Business Entities section). You must fill out the form, print it, and mail it to the secretary of state. There is a $10 filing fee.

You can also reserve a corporate name in person at one of the secretary of state's regional offices:

Sacramento Main Office
1500 11th Street
Sacramento, CA 95814
(916) 657-5448

Los Angeles Regional Office
300 South Spring Street, Room 12513
Los Angeles, CA 90013
(213) 897-3062

The fee for reserving a name in person is $20. The clerk will ask for two $10 checks. If your proposed name is not available, the clerk will keep $10 and return one $10 check to you.

If your proposed name is accepted, the secretary of state will send you a certificate of reservation that is valid for 60 days from the date it is issued. If you cannot file your articles within that time, you can rereserve the name by preparing a new reservation letter. The secretary of state must receive the second reservation letter at least one day after the first certificate expires. You are not allowed two consecutive reservations of corporate name—therefore the requests must be separated by at least one day.

> **CAUTION**
>
> **The person whose name is on the reservation form must sign the articles of incorporation.** Make sure that the person submitting the reservation form (whose name is inserted in the top box of the form) will be available to sign articles of incorporation on behalf of your organization. The corporate name is reserved for this person's use only.

Perform Your Own Name Search

Approval by the secretary of state's office of your corporate name doesn't necessarily mean that you have the legal right to use this name. Acceptance of your corporate name by the secretary of state's office simply means that your name does

not conflict with that of another corporation already on file with the secretary of state. The secretary of state does not, however, check the state trademark/service mark registration lists maintained in the secretary of state's office, nor does it check your corporate name against the names of noncorporate entities on file with the office—such as LLCs, limited partnerships, and registered limited liability partnerships (RLLPs). Thus, another organization (corporate or noncorporate, profit, or nonprofit) may already have the right to use this same name (or one similar to it) as a federal or state trademark or service mark used to identify their goods or services. Also, another organization (corporate or noncorporate) may already be presumed to have the legal right to use the name in a particular county if they are using it as a trade name (as the name of their business or organization) and have filed a fictitious business name statement with their county clerk.

The secretary of state will send you a letter after you file your articles, repeating everything we've just said. The secretary puts it a bit more legalistically, warning you that filing articles of incorporation does not, in itself, authorize the use of a corporate name if that use would violate another person's right to use the name, including rights in a trade name, rights under state or federal trademark laws, or state fictitious business name laws, and rights that arise under principles of common law (the law expressed in court decisions). You're probably wondering—If someone is using my proposed name already, does that mean that I can't use the name either? And how can I discover whether someone is using the name in the first place? The sections below will give you some guidance.

Who Should Perform This Search?

In many circumstances, you will know that your name is unique and unlikely to infringe

on another organization's name. This would probably be the case, for example, if you called your group the Sumner County Crisis Hotline, or the Southern California Medieval Music Society. By qualifying your name this way, you know that you are the only nonprofit in your area using the name. However, in some circumstances you may be less sure of your right to use a name. For example, the names Legal Rights for All or The Society to Cure Lyme Disease may be in use by a group in any part of the country. Read on.

Who Gets to Use a Name?

The basic rule is that the ultimate right to use a particular name will usually be decided based on who was first in time to actually use the name in connection with a particular trade, business, activity, service, or product. In deciding who has the right to a name, the similarity of the types of businesses or organizations and their geographical proximity are usually taken into account.

Finding Users of Your Name

Below we list self-help name checking procedures you may want to use to be more certain that your proposed corporate name is unique. Do these name search procedures before you file your articles. Obviously, you can't be 100% certain—you can't possibly check all names in use by all other groups. However, you can check obvious sources likely to expose names similar to the one you wish to use. Here are some places to start.

Fictitious Business Name Files

Check the county clerk in the county or counties where you plan to operate to see if your name has already been registered by another person, organization, or business as a fictitious business name. Most county clerks will require you to

come in and check the fictitious business files yourself—it takes just a few minutes to do this.

State Trademarks and Service Marks

Call the California Secretary of State's trademark and service mark registration section (the phone number is 916-653-3984) and ask if your proposed corporate name is the same as or similar to trademarks and service marks registered with the state. They will check up to two names over the phone against their list of registered marks at no charge. You can also check the Business Programs/Trademarks and Service Marks section of the secretary of state's website.

Check Directories

Check major metropolitan phone book listings, nonprofit directories, business and trade directories, and so on to see if another company or group is using a name similar to your proposed corporate name. Large public libraries keep phone directories for many major cities throughout the country, as well as trade and nonprofit directories. A local nonprofit resource center or business branch of a public library may have a special collection of nonprofit research materials—check these first for listings of local and national nonprofits. One commonly consulted national directory of nonprofit names is the *Encyclopedia of Associations,* published by Gale Research Company.

Consult the Federal Trademark Register

If your name is the type that might be used to market a service or product or to identify a business activity of your nonprofit corporation, you should check federal trademarks and service marks. You can check the *Federal Trademark Register* for free at www.uspto. gov. You can also go to a large public library or special business and government library in your area that carries the *Federal Trademark Register*, which lists trademark and service mark names broken into categories of goods and services.

Use Other Internet Databases

Most of the business name listings mentioned above, including yellow page listings and business directory databases and the federal and state trademark registers, are available as part of several commercial computer databases. For example, the federal and state registers can be accessed through the TRADEMARKSCAN databases using SAEGIS, Dialog, or Westlaw online services. (Use your browser's search engine to find links to these services.) Subscription databases charge fees for your research time (unlike the www.uspto.gov site, which is free).

Further Searching

Of course, if you wish to go further in your name search, you can pay a private records search company to check various databases and name listings. Alternatively, or in conjunction with your own efforts or search procedures, you can pay a trademark lawyer to oversee or undertake these searches for you (or to render a legal opinion if your search turns up a similar name). Most organizers of smaller nonprofits, particularly those who believe that a specialized or locally based name is not likely to conflict with anyone else's name, will not feel the need to do this and will be content to undertake the more modest self-help search procedures mentioned above.

The Consequences of Using Another's Name

To avoid problems, we suggest using the name selection techniques discussed above, and performing the kind of commonsense checking described earlier. Disputes involving trade names, trademarks, and service marks

If You Use Another Company's Trade Name or Trademark

Legal remedies for violation of trade name or trademark rights vary under federal and state laws and court decisions. Most of the time, the business with the prior claim to the name can sue to enjoin (stop) you from using your name or can force you to change it. The court may also award the prior owner money damages for loss of sales or goodwill caused by your use of the name. If you violate a trademark or service mark registered with the U.S. Patent and Trademark Office, the court may award treble damages (three times the actual money damages suffered as a result of the infringement), any profits you make from using the name, and court costs; and may order the goods with the offending labels or marks to be confiscated and destroyed.

Here's an example of how this works. A company called Foul Weather Gearheads has been in business for ten years selling foul weather gear such as rain slickers and hip boots via catalogs and the Internet. For the first seven to eight years, Foul Weather averaged gross annual sales of approximately $2 million. Another company, calling itself Rainy Day Gearheads, starts selling competing products, and Foul Weather's gross revenues slip by about 25% over the next two years. If Foul Weather can prove that the Rainy Day Gearheads trademark likely caused customer confusion that resulted in Foul Weather's decrease in sales, Foul Weather can recover its lost profits. Or, if prior to the infringement, Foul Weather had registered its name on the Principal Trademark Register maintained by the U.S. Patent and Trademark Office, it could choose to go after Rainy Day's profits (instead of recovering its own losses), attorneys' fees, and treble damages.

For further information see *Patent, Copyright & Trademark: An Intellectual Property Desk Reference,* by Rich Stim (Nolo).

tend to arise in the private, commercial sector. It is unlikely that your nonprofit will wish to market products and services as aggressively as a regular commercial concern and thereby run afoul of another business's trademark or service mark (you'd also be jeopardizing your tax-exempt status by engaging in a substantial amount of commercial activity). Nonetheless, as a matter of common sense, and to avoid legal disputes later on, you should do your best to avoid names already in use by other profit and nonprofit organizations, or in use as trademarks or service marks.

Protect Your Name

Once you have filed your articles of incorporation, you may want to take some additional steps to protect your name against later users. For example, if your name is also used to identify your products or services, you may wish to register it with the California Secretary of State and the United States Patent and Trademark Office as a trademark or service mark. You may also want to register in other states if you plan to conduct operations there.

You can register your name if:

- you have actually used the name in interstate commerce (that is, in two or more states) in connection with the marketing of goods or services, or
- you intend to use the name in interstate commerce in connection with the marketing of goods or services.

If you specify the second ground in your trademark application, you must file an affidavit

(sworn statement) within six months stating that the name has been placed in actual use—and pay an additional fee. This six-month period may be extended for additional six-month periods (at a fee for each extension), up to a total extension of two and one-half years. To obtain these extensions, you have to convince the Patent and Trademark Office that you have good cause for delaying your use of the name. Because trademark application procedures are relatively simple and inexpensive, you may wish to tackle this task yourself—your local county law library should have practice guides available to help you handle state and federal trademark and service mark filing formalities.

Applying for a Federal Trademark

To apply for a federal trademark, go to the website of the Patent and Trademark Office (PTO) at www.uspto.gov and download a trademark application. Fill out the form following the instructions. A month or so after mailing the form, you should hear from the PTO. If there are any problems, you will receive a written list of questions together with the telephone number of a trademark examiner. The examiner should be able to address any questions and issues you can't handle yourself and should help you finalize your application without undue difficulty or delay.

Prepare Articles of Incorporation

The next step in organizing your corporation is to prepare articles of incorporation. This is your primary incorporation document—your corporation becomes a legal entity on the date you file your articles with the California Secretary of State. You must complete this step before you send in your federal tax exemption application because the IRS requires you to submit a filed copy of your articles with your tax exemption application.

TIP

Prepare your bylaws and look over the tax application early in the process. Even though you have to file your articles before you send in your federal tax exemption application, we recommend that you prepare bylaws and review or complete some of the work on the federal tax application before you file your articles. That way, you'll know what else is required to obtain nonprofit status and you won't be surprised late in the process (after you've already incorporated) about a condition or other requirement you can't or don't want to meet. (See the discussion in "Don't Rush to File," below.)

There are two types of articles used by readers of this book: one for California public benefit corporations (ARTS-PB-501(c)(3)) and one for California religious corporations (ARTS-RE). Both forms are provided as fillable PDF forms on the California Secretary of State website. To access the forms, go to the California Secretary of State's website and find the link in "Business Programs" to "Forms, Samples and Fees," or you can type "Cal Secretary of State forms" in the search box of your browser. You can also download the forms from the Nolo website (see Appendix A for the link).

If you are incorporating an existing nonprofit organization that was organized and operated as an unincorporated association (with formal articles of association, a charter, or association bylaws), you will need to add additional provisions to the state's standard articles form and may need to provide additional information about prior tax returns when you prepare your tax exemption application (Chapter 8). Please see a nonprofit lawyer for help in preparing

articles of incorporation and your nonprofit tax exemption application. Most preexisting nonprofit organizations are not unincorporated associations and will not need to concern themselves with these extra articles provisions and tax return disclosure requirements.

Preparing Articles for a Public Benefit Corporation

To prepare articles for a public benefit corporation, access the fillable Articles of Incorporation of a Nonprofit Public Benefit Corporation (ARTS-PB-501(c)(3)) from the California Secretary of State or Nolo website as explained above. Fill them in from your browser following the sample form and special instructions below. Then print and sign the form as explained below.

Special Instructions for Public Benefit Corporations

First, look at the "Filing Tips" for Articles of Incorporation—Domestic Nonprofit Corporations on the Secretary of State's website. These instructions provide useful information and guidance if you wish to prepare your own form instead of filling in and printing the online form.

Next, refer to the following instructions as you fill in the form. The numbers, below, correspond to circled numbers on the online ARTS-PB-501(c)(3) form.

Corporate Name

❶ Type the name of your corporation. If you have reserved a corporate name, make sure the name shown here is exactly the same as the name shown on your Certificate of Reservation.

Business Addresses

❷ (a) Insert the street address of the principal office of the corporation (not a P.O. box), which should be in California.

(b) If the mailing address of the corporation is different from the street address, insert the mailing address here. If the mailing address is the same as the street address, insert "Same as street address, above."

Service of Process

❸ (a) & (b) Type the name and residence or business address of the corporation's initial agent for service of process—this is the person to whom legal documents in any future lawsuit against the corporation must be sent. The agent must be a California resident, and the address must be a street address in California. Do not use a post office box address or abbreviate the city name, and don't use "in care of" or "c/o." Normally, you'll use the name of the incorporator (see Incorporator's Signature instruction below) and give the street address of the corporation. Don't designate a corporation as an agent unless you check the state's instructions first on how to do this.

Purpose Statement

❹ (a) Check "charitable" purposes. Public benefit corporations must be organized under state law for a charitable or public purpose, and the accepted practice for nonreligious 501(c)(3) public benefit groups—the type of group you are incorporating—is to indicate a charitable (as opposed to public) purpose in this sentence.

(b) Complete the statement of specific purposes. There is very little space here. The key is to specify one or more of the keywords associated with one or more of the nonreligious 501(c)(3) tax exemption categories (charitable, educational, scientific, or literary). For example, a nonprofit environmental group may complete this sentence by inserting "provide environmental education." A performance arts group might indicate "provide education in dance, music, theatre, and other performance arts." A group

that provides assistance to those in need, may state "to provide charitable assistance to …."

Remember: although you may qualify as tax exempt under one or more categories of Section 501(c)(3) (for example, a charitable and educational organization), you cannot also fall within another tax-exempt section of the Internal Revenue Code. For example, you can't be both a charitable group under 501(c)(3) and a social welfare group under Section 501(c)(4). Hence, be careful to avoid using key words associated with these other tax-exempt sections—such as social, fraternal, or recreational. For example, an educational and social welfare organization would not be eligible for a 501(c)(3) tax exemption because social welfare groups are exempt under the provisions of a different Internal Revenue Code section.

Additional Statements

This articles of incorporation form contains additional statements that meet the requirements for obtaining a 501(c)(3) tax exemption. They indicate that the organization is organized and operated for charitable purposes, will not provide private benefit to individuals, will not engage in substantial lobbying activities or intervene in political campaigns, and dedicates any assets remaining upon its dissolution to allowable 501(c)(3) purposes. Note that even though these are general statements, they do not conflict with your statement of specific purpose(s) in Article 2(b), which indicates the specific 501(c)(3) purpose(s) that your organization will carry out (charitable, educational, scientific, and/or literary).

Incorporator's Signature

You only need one person to sign your articles as incorporator. Your incorporator should be 18 years old or older. Typically, one of the corporation's founders signs as the incorporator. Insert the incorporator's name in the blank to the right of the signature. After printing the form, have the incorporator sign the form.

Adding Pages or Preparing Your Own Articles

Most nonprofits will find the official standard articles of incorporation form sufficient and won't need to alter or add provisions to the form. If you do prepare your own pages to add to or replace the official state form, print your page(s) on letter-sized paper, using one side of a page only.

Adding information. If the official form does not contain sufficient space for a response, you can add pages to the official form. If you do, make sure to indicate how the information fits on the official form (for example, "Continuation of (or "Response to") Item 5: …."

Preparing your own form. If you want to modify the articles and prepare your own form, do so only after making sure your changes conform to the California Nonprofit Corporation Law. (See Chapter 11 for suggestions on doing your own research or finding a lawyer to help you make modifications.) Also, to avoid problems, do not include the name of your corporation in the title of your self-prepared articles form. Instead, follow the format of the state form and only include the name of your corporation in a section on your form.

Delaying the Filing of Your Articles

You may be able to incorporate on a specific date (to establish a particular tax year). California law allows you to request a delayed filing date for your articles as long as this date is no more than 90 days from the date of receipt of your articles by the secretary of state (the delayed date may be a weekend day or a holiday, but your articles must be received by the secretary

Secretary of State

Articles of Incorporation of a Nonprofit Public Benefit Corporation

ARTS-PB-501(c)(3)

IMPORTANT — Read Instructions before completing this form.

Filing Fee – **$30.00**

Copy Fees – First page $1.00; each attachment page $0.50; Certification Fee - $5.00

Note: A separate California Franchise Tax Board application is required to obtain tax exempt status. For more information, go to *https://www.ftb.ca.gov.*

This Space For Office Use Only

1. Corporate Name (Go to www.sos.ca.gov/business/be/name-availability for general corporate name requirements and restrictions.)

The name of the corporation is _____

2. Business Addresses (Enter the **complete** business addresses. Item 2a cannot be a P.O.Box or "in care of" an individual or entity.)

a. Initial Street Address of Corporation - **Do not enter a P.O. Box**	City (no abbreviations)	State	Zip Code
b. Initial Mailing Address of Corporation, **if different than item 2a**	City (no abbreviations)	State	Zip Code

3. Service of Process (Must provide either Individual **OR** Corporation.)

INDIVIDUAL – Complete Items 3a and 3b only. Must include agent's full name and California street address.

a. California Agent's First Name (if agent is **not** a corporation)	Middle Name	Last Name	Suffix
b. Street Address (if agent is **not** a corporation) - **Do not enter a P.O. Box**	City (no abbreviations)	State **CA**	Zip Code

CORPORATION – Complete Item 3c. Only include the name of the registered agent Corporation.

c. California Registered Corporate Agent's Name (if agent is a corporation) – Do not complete Item 3a or 3b

4. Purpose Statement

Item 4a: One or both boxes **must** be checked.

Item 4b: If "public" purposes is checked in Item 4a, or if you intend to apply for tax-exempt status in California, you **must** enter the specific purpose in Item 4b.)

a. This corporation is a nonprofit **Public Benefit** Corporation and is not organized for private gain of any person. It is organized under the Nonprofit Public Benefit Corporation Law for: ☐ **public** purposes. ☐ **charitable** purposes.

b. The specific purpose of this corporation is to _____ .

5. Additional Statements (See Instructions and Filing Tips.)

a. This corporation is organized and operated exclusively for the purposes set forth in **Article 4** hereof within the meaning of Internal Revenue Code section 501(c)(3).

b. No substantial part of the activities of this corporation shall consist of carrying on propaganda, or otherwise attempting to influence legislation, and this corporation shall not participate or intervene in any political campaign (including the publishing or distribution of statements) on behalf of any candidate for public office.

c. The property of this corporation is irrevocably dedicated to the purposes in **Article 4** hereof and no part of the net income or assets of this corporation shall ever inure to the benefit of any director, officer or member thereof or to the benefit of any private person.

d. Upon the dissolution or winding up of this corporation, its assets remaining after payment, or provision for payment, of all debts and liabilities of this corporation shall be distributed to a nonprofit fund, foundation or corporation which is organized and operated exclusively for **charitable, educational and/or religious** purposes and which has established its tax-exempt status under Internal Revenue Code section 501(c)(3).

6. Read and Sign Below (This form must be signed by each incorporator. **See Instructions.** Do not include a title.)

_____ _____
Signature Type or Print Name

ARTS-PB-501(c)(3) (REV 03/2017)

2017 California Secretary of State
www.sos.ca.gov/business/be

of state at least one business day before the requested future filing date).

Here is an additional article you can add on an attachment page to the official articles of incorporation form to request a delayed filing date:

Delayed Effective Date. These Articles shall be withheld from filing until the following future date: ___**(insert future filing date here)**___ .

Preparing Articles for a Religious Corporation

To prepare articles for a religious corporation, access the fillable Articles of Incorporation of a Nonprofit Religious Corporation (ARTS-RE) from the California Secretary of State website as explained above. Fill them in from your browser following the sample form and special instructions below. Then print and sign the form as explained below.

Special Instructions for Religious Corporations

First, look at the "Filing Tips" for Articles of Incorporation—Domestic Nonprofit Corporations on the California Secretary of State's website. These instructions provide helpful information and guidance if you wish to prepare your own form instead of filling in and printing the online form.

Next, refer to the following instructions as you fill in the form. The numbers, below, correspond to circled numbers on the online ARTS-RE form.

Corporate Name

❶ Type the name of your corporation. If you have reserved a corporate name, make sure the name shown here is exactly the same as the name shown on your Certificate of Reservation.

Business Addresses

❷ (a) Insert the street address of the principal office of the corporation (not a P.O. box), which should be in California.

(b) If the mailing address of the corporation is different from the street address, insert the mailing address here. If the mailing address is the same as the street address, insert "Same as street address, above."

Service of Process

❸ (a) & (b) Type the name and residence or business address of the corporation's initial agent for service of process—this is the person to whom legal documents in any future lawsuit against the corporation must be sent. The agent must be a California resident, and the address must be a street address in California. Do not use a post office box address or abbreviate the city name, and don't use "in care of" or "c/o." Also, don't designate a corporation as an agent unless you check the state's instructions first on how to do this. Normally, you'll use the name of the incorporator and give the address of the corporation.

Purpose Statement

❹ There is nothing to fill in here—the official form indicates that you are forming your corporation for religious purposes. Remember, a religious corporation can be formed to establish a formal church or it may be formed for more general religious purposes (see Chapter 3, "Religious Purposes").

Additional Statements

❺ (a) Specific purpose. Insert a short statement that describes the specific purpose of your religious nonprofit; for example, to establish a church or perform other religious activities (see Chapter 3, "Religious Purposes").

Secretary of State

Articles of Incorporation of a Nonprofit Religious Corporation

ARTS-RE

IMPORTANT — Read Instructions **before completing this form.**

Filing Fee – **$30.00**

Copy Fees – First page $1.00; each attachment page $0.50; Certification Fee - $5.00

Note: A separate California Franchise Tax Board application is required to obtain tax exempt status. For more information, go to *https://www.ftb.ca.gov*.

This Space For Office Use Only

1. Corporate Name (Go to *www.sos.ca.gov/business/be/name-availability* for general corporate name requirements and restrictions.)

The name of the corporation is _____

2. Business Addresses (Enter the **complete** business addresses. Item 2a cannot be a P.O.Box or "in care of" an individual or entity.)

a. Initial Street Address of Corporation - **Do not enter a P.O. Box**	City (no abbreviations)	State	Zip Code
b. Initial Mailing Address of Corporation, **if different than item 2a**	City (no abbreviations)	State	Zip Code

3. Service of Process (Must provide either Individual **OR** Corporation.)

INDIVIDUAL – Complete Items 3a and 3b only. Must include agent's full name and California street address.

a. California Agent's First Name (if agent is **not** a corporation)	Middle Name	Last Name		Suffix
b. Street Address (if agent is **not** a corporation) - **Do not enter a P.O. Box**	City (no abbreviations)		State **CA**	Zip Code

CORPORATION – Complete Item 3c. Only include the name of the registered agent Corporation.

c. California Registered Corporate Agent's Name (if agent is a corporation) – Do not complete Item 3a or 3b

4. Purpose Statement

This corporation is a nonprofit **Religious** Corporation and is not organized for private gain of any person. It is organized under the Nonprofit Religious Corporation Law exclusively for religious purposes.

5. Additional Statements (The following statements are for tax-exempt status in California. **See Instructions and Filing Tips.**)

a. The specific purpose of this corporation is to _____.

b. This corporation is organized and operated exclusively for **religious** purposes within the meaning of Internal Revenue Code section 501(c)(3).

c. No substantial part of the activities of this corporation shall consist of carrying on propaganda, or otherwise attempting to influence legislation, and this corporation shall not participate or intervene in any political campaign (including the publishing or distribution of statements) on behalf of any candidate for public office.

d. The property of this corporation is irrevocably dedicated to the purposes in **Article 4** hereof and no part of the net income or assets of this corporation shall ever inure to the benefit of any director, officer or member thereof or to the benefit of any private person.

e. Upon the dissolution or winding up of this corporation, its assets remaining after payment, or provision for payment, of all debts and liabilities of this corporation shall be distributed to a nonprofit fund, foundation or corporation which is organized and operated exclusively for **charitable, educational and/or religious** purposes and which has established its tax-exempt status under Internal Revenue Code section 501(c)(3).

6. Read and Sign Below (This form must be signed by each incorporator. **See Instructions.** Do not include a title.)

_____ _____
Signature Type or Print Name

ARTS-RE (REV 03/2017)

2017 California Secretary of State
www.sos.ca.gov/business/be

5 (b) – (e) This form contains additional statements that meet the requirements for obtaining a 501(c)(3) tax exemption. They indicate that the organization is organized and operated for religious purposes, will not provide private benefit to individuals, will not engage in substantial lobbying activities or intervene in political campaigns, and will dedicate any assets remaining upon its dissolution to allowable 501(c)(3) purposes.

Incorporator's Signature

You only need one person to sign your articles as incorporator. Your incorporator should be 18 years old or older. Typically, one of the corporation's founders signs as the incorporator. Insert the incorporator's name in the blank to the right of the signature. After printing the form, have the incorporator sign the form.

Adding information. If the official form does not contain sufficient space for a response, you can add pages to the official form. If you do, make sure to indicate how the information fits on the official form (for example, "Continuation of (or "Response to") Item 5: …."

Preparing your own form. If you want to modify the articles and prepare your own form, do so only after making sure your changes conform to the California Nonprofit Corporation Law. (See Chapter 11 for suggestions on doing your own research or finding a lawyer to help you make modifications.) Also, to avoid problems, do not include the name of your corporation in the title of your self-prepared articles form. Instead, follow the format of the state form and only include the name of your corporation in a section on your form.

Delaying the Filing of Your Articles

You may be able to incorporate on a specific date (to establish a particular tax year). California law allows you to request a delayed filing date for your articles as long as this date is no more than 90 days from the date of receipt of your articles by the secretary of state (the delayed date may be a weekend day or a holiday, but your articles must be received by the secretary of state at least one business day before the requested future filing date).

Here is an additional article you can add on an attachment page to the official articles of incorporation form to request a delayed filing date:

Delayed Effective Date. These Articles shall be withheld from filing until the following future date: ___**(insert future filing date here)**___.

File Your Articles

When you file your articles of incorporation with the California Secretary of State, your corporation becomes a legal entity. Filing your articles is also the first step along the way to obtaining 501(c)(3) tax-exempt status, since you must include a file-stamped copy of your articles of incorporation with your federal tax exemption application. Thus, your corporation must already be in existence when you apply for tax-exempt status from the IRS.

Don't Rush to File

Even though filing your articles is the first step in the process, we recommend that you prepare bylaws and at least start your federal tax exemption application before you file your articles with the secretary of state. Taking these additional steps gives you the opportunity to think through your decision to incorporate more thoroughly. When you prepare bylaws, you must decide on basic organizational matters, such as the composition of your board of directors and whether you want to set up a membership or nonmembership structure for your nonprofit. Having to think through some

of these issues may lead you to rethink your decision to incorporate.

When preparing your federal exemption application, you might realize that your organization will have difficulty qualifying for the tax exemption. There may be questions on the application that you didn't anticipate or requirements that you realize you can't meet. You might decide that it's best to postpone your decision to form a nonprofit corporation until you get tax or legal advice. Or, if preparing the federal tax exemption application is just too much trouble, you might decide to put off your nonprofit plans for now. You might decide to form your tax-exempt nonprofit corporation later when you have more enthusiasm for the task (or at least a little more help).

If you change your mind at this point (before filing your articles), you won't incur any additional cost and there won't be additional work involved. On the other hand, if you rush to file your articles right away and then decide you really don't want to form a nonprofit corporation, it's too late. Your nonprofit legal entity will already be formed and you will either have to dissolve your corporation immediately (see "Dissolving a Nonprofit Corporation," in Chapter 10), or you will have to prepare and file regular state and federal corporate income tax returns each year and pay income taxes on any revenue remaining after the payment of deductible expenses.

CAUTION

There's always some uncertainty and risk. There is no guarantee that you will obtain your federal income tax exemption. Without this exemption, your nonprofit corporation will not obtain the benefits you undoubtedly wanted when you started this whole process (tax exemption, eligibility for grant funds, tax-deductible contributions). But there is no way around it. Filing articles to form a nonprofit corporation is

always a bit of a gamble. All you can do is reduce the risk by reading this book carefully and going through Chapter 8 ahead of time to get a sense of what the IRS expects from you to qualify for a nonprofit tax exemption. By reading our examples and sample responses in that chapter, you can learn how to best characterize and describe your organization's goals and programs to qualify for your tax exemption and to make your nonprofit corporation a viable, tax-exempt entity.

Your Filing Package

You will need your original articles of incorporation for the filing package you submit to the California Secretary of State. Make one copy of your articles, and place this copy in your corporate records book.

Send the original articles to the California Secretary of State. In your cover letter, you will ask to have a certified copy of your articles returned to you (and you will pay an additional $5 certification fee). The certification states that the certified copy conforms to the original articles filed with the secretary of state. When you get the certified copy back, you will keep a copy as proof that your corporation was formed and is a valid legal entity (some tax and other official forms may require you to submit a certified copy of your articles when you prepare the form). You only need one certified copy from the secretary of state—you can make additional copies of the certified copy once you receive it from the secretary of state.

Prepare Your Mail Submission Cover Sheet

Prepare the cover letter to the California Secretary of State that is included with the state's articles of incorporation form. You can prepare your mail submission cover sheet following the sample form and special instructions below.

- The parenthetical blanks, that is, "(_____)," in the sample form below indicate information that you must complete on the online form.
- Replace the blanks in the online form with the information indicated in the sample form below.

Each circled number in the sample form (such as, ❶) refers to a special instruction, which provides specific information to help you complete an item.

❶ Contact Person: Your incorporator who signed your articles should prepare and sign as the contact person. If you have reserved a corporate name, the person who reserved the corporate name should prepare and sign instead.

❷ Entity Information: In the line asking for a name, insert the name of your corporation. You should leave the entity number line blank. (Once your articles are filed, your corporation will be assigned an entity number.)

❸ Comments: Insert the following statement in the comments area: "My fee payment includes an additional $5 to receive one certified copy of the filed Articles."

If you have reserved the corporate name shown in your articles and are filing your articles within 60 days of the effective date of your Certificate of Reservation of Corporate Name, also include this statement in the Comments section: "The corporate name stated in the enclosed Articles was reserved: Reservation Certificate Number __(insert number shown on Certificate)__, issued __[date of issuance of Reservation Certificate]__."

If you decide to request additional (certified or uncertified) copies of your articles, change the above comment to state the total number and type of copies you are requesting. See the state filing office website to determine the additional fees to pay for these additional copies. We recommend that at a minimum you ask for one certified copy of your articles that you can place in your corporate records and copy as needed to send to the IRS or any other agencies or banks that may request a certified copy. If you don't ask for a certified copy, they will send you an uncertified file-stamped copy for free. Certification is a formal statement that the articles conform to those on file with the California Secretary of State. The secretary of state's office will not accept copies from you. You must ask the office to make the certified copy for you.

❹ Type the name and address information in the Return Address section of the Cover Sheet. Place a copy of the cover sheet in your corporate records book.

> **CAUTION**
>
> **Check that your fee amounts are current.** The fee for filing your articles (as well as other fees, such as the charge for comparing and certifying extra copies of the articles) changes from time to time. Find the latest fee information on the California Secretary of State's website.

> **CAUTION**
>
> **Check to see if online filing is available in California before mailing your articles to the secretary of state.** The California Secretary of State has been charged with implementing an online filing service called "California Business Connect Project." Go online to the California Secretary of State's website to check any progress on this initiative before you mail in your articles. If the service is available, you probably will wish to use it instead of preparing and mailing paper articles to the corporate filing office. You can also check Nolo's website (see Appendix A for the link) for updates and instructions on how to proceed if there are any significant changes for filing articles in California.

Secretary of State
Business Programs Division
Business Entities, P.O. Box 944260, Sacramento, CA 94244-2600

Mail Submission Cover Sheet

Instructions:

- Complete and include this form with your submission. **This information only will be used to communicate with you in writing about the submission**. This form will be treated as correspondence and will not be made part of the filed document.

- Make all **checks or money orders** payable to the Secretary of State.

- Do not include a $15 counter fee when submitting documents by mail.

- Standard processing time for **submissions** to this office is approximately 5 business days from receipt. All **submissions** are reviewed in the date order of receipt. For updated processing time information, visit *www.sos.ca.gov/business/be/processing-times.*

Optional Copy and Certification Fees:

- If applicable, include optional copy and certification fees with your submission.

- For applicable copy and certification fee information, refer to the instructions of the specific form you are submitting.

Contact Person: (Please type or print legibly) **❶**

First Name: _____ Last Name: _____

Phone (optional): _____

Entity Information: (Please type or print legibly) **❷**

Name: _____

Entity Number (if applicable): _____

Comments: **❸** _____

❹ Return Address: For written communication from the Secretary of State related to this document, or if purchasing a copy of the filed document enter the name of a person or company and the mailing address.

Name: ⌈ ⌉

Company:

Address:

Secretary of State Use Only	
T/TR:	
AMT REC'D:	$

City/State/Zip: ⌊ ⌋

Doc Submission Cover - Corp (Rev. 09/2016)

File Your Documents With the Secretary of State

Mail your filing package to the Document Filing Support Unit of the secretary of state's Sacramento office at the address indicated in the cover letter. Your filing package should include:

- one original articles of incorporation with the completed mail submission cover sheet
- a cover letter with a check made payable to the Secretary of State, and
- a stamped, self-addressed envelope.

Your next step is to wait. The secretary of state will make sure your corporate name is available for use and that your articles conform to law. If there are no problems, the secretary of state will file your articles and return the certified copies to you. You can check the secretary of state's website for current processing times for forming a nonprofit (it was ten days at the time this book was published).

When you receive your certified copy of your articles from the secretary of state, you will need to make copies for the following purposes:

- one copy to mail to the IRS with your federal tax exemption if you use the standard Form 1023 federal tax exemption (instead of Form 1023-EZ, which is prepared and submitted online)
- one copy to be filed with the post office to obtain a nonprofit mailing permit (see "Apply for a Mailing Permit," in Chapter 9)
- two copies to be filed with the local tax assessor's office if you wish to obtain an exemption from payment of local personal and real property taxes (see "Apply for Your Property Tax Exemption," in Chapter 9)
- additional copies to be filed in connection with any licenses or permits you wish to obtain (see "Licenses and Permits," in Chapter 10), and

- if you are incorporating an unincorporated association (with a lawyer's help), one copy to be filed with the county recorder of each county in which the unincorporated association owns property (see "File Your Articles With the County Recorder," in Chapter 9).

If You're in a Hurry, File in Person

Articles can be filed in person for $15 extra at the Sacramento or Los Angeles office of the secretary of state. (See Appendix B for contact information.) (Always check the California Secretary of State's website for changes to filing fees.) When you file in person at a secretary of state office other than the Sacramento office, you must submit an extra copy of your articles, which will be forwarded to the main Sacramento office. The processing time for dropped off articles is approximately one month (instead of the two-month period it takes to process mailed articles). You can also do an expedited filing, which is same or next day service, for substantially higher fees ($350–$750 and more). Expedited filing requests must be made in person at the Sacramento office. For more information, check the secretary of state's website.

If there are any problems, the secretary of state will usually return your articles, indicating the items that need correction. Often the problem is technical, not substantive, and easy to fix. If the problem is more complicated (such as an improper or insufficient corporate purpose clause), you may be able to solve the problem by rereading our examples and suggestions for completing the articles. If you get stuck, you will need to do a little research or obtain further help from a nonprofit lawyer with experience in drafting and filing nonprofit articles (see Chapter 11).

Sign Documents on Behalf of the Corporation

Congratulations! Once your articles are filed, your organization is a legally recognized nonprofit corporation. But before you rush out to pursue your nonprofit objectives, remember that your corporation is the one that is now doing business, not you as an individual. This means that signatures on any document, such as an agreement with a vendor, application for a grant, lease, or other financial or legal form, must clearly show that you're acting on behalf of the corporation (and not for yourself). Your signature should be a block of information (plus a signature), which looks like this:

> Parents for a Better Society, Inc.
> (the name of your nonprofit)
> By: ___(your signature)___
> Sarah Hovey, Director (your corporate title, such as director, president, secretary, and so on).

If you fail to sign documents on behalf of the corporation and in your capacity as a corporate director, officer, or employee, you are leaving yourself open to possible personal liability for corporate obligations. From now on, it is extremely important for you to maintain the distinction between the corporation that you've organized and yourself. As we've said, the corporation is a separate legal person and you want to make sure that other organizations, businesses, the IRS, and the courts respect this distinction.

Remember that until you obtain your federal and state tax exemptions, your corporation is liable for the payment of federal and state corporate taxes. Furthermore, until you obtain your federal 501(c)(3) tax exemption and public charity status, your corporation will be unable to receive most public and private grant funds, or assure donors that contributions made to the corporation will be tax deductible. You must follow through with the procedures contained in the succeeding chapters—doing so is vital to the success of your new corporation.

Appoint Initial Corporate Directors

Your next step after preparing and filing your articles of incorporation is to have your incorporator, who is the person who signed your articles, appoint initial corporate directors. This is an extremely simple step. The incorporator fills in an Incorporator's Statement to show the names and addresses of the initial directors who will serve on the board until the first meeting for the election of directors (which will be scheduled in your bylaws). The incorporator dates and signs the statement, types his or her name in the blank in the body of the form and under the incorporator's signature at the bottom of the statement, and places a copy in the corporate records book.

To complete this step, have your incorporator complete the "Incorporator's Statement," following the sample form and instructions below. (A copy of the form is available on the Nolo website; see Appendix A for the link.)

Instructions

❶ Indicate the full names and business or residence addresses of your initial director(s). You can organize a public benefit corporation with just one director, but will probably want to provide for more (see Chapter 7 on preparing bylaws for information on what the IRS likes to see). You can give the business address (usually the address of the corporation) or the residence address of each initial director. Remember, public benefit corporations must have at least two unpaid directors for each paid director, and the two

unpaid directors must be unrelated to the one paid director (see "Directors," in Chapter 2).

Your bylaws will show the full number of directors who will serve on your board—this full number is called the "authorized" number of directors of the corporation. Normally, the initial directors that you appoint here in your Incorporator's Statement will be the same as the anticipated authorized number that you will specify for your full board in your bylaws. However, if you must leave a seat open at this time because you have not yet found all the right people to serve on your board, that's okay. Just make sure that you appoint enough initial directors to meet your bylaws' quorum requirement. Article 3, Section 13, of nonprofit corporation bylaws and Article 3, Section 12, of religious

corporation bylaws define the corporation's director-quorum requirement—typically, a majority of the authorized number of directors is specified. Jump ahead at this point to Chapter 7 and skim the instructions to the directors' quorum section of the bylaws to get an idea of the number of initial directors you need to appoint to ensure that you appoint at least a quorum of initial directors in your Incorporator's Statement (public benefit corporations should refer to instruction 8 for public benefit corporation bylaws; religious corporations should refer to special instruction 8 for religious corporation bylaws).

❷ Have the incorporator date and sign the form, insert his or her typed name under the signature, then place a copy in the corporate records book. ●

Bylaws

Your next step is to prepare your bylaws. This document is, for all practical purposes, your corporation's internal affairs manual. It sets forth the rules and procedures for holding meetings, electing directors and officers, and taking care of other essential corporate formalities. Specifically, the bylaws:

- Contain information central to the organization and operation of your corporation (for example, dates of meetings, quorum requirements).
- Restate the most significant legal and tax provisions applicable to tax-exempt nonprofit corporations. This is useful for your own reference and necessary to assure the IRS that you are eligible for these tax exemptions.
- Provide a practical, yet formal, set of rules for the orderly operation of your corporation: to resolve disputes, provide certainty regarding procedures, and manage corporate operations.
- Contain provisions intended to help you get and keep your 501(c)(3) tax exemption. For example, we include conflict of interest

and compensation approval provisions that the IRS recommends as one way to comply with the IRS regulations. We also include a requirement that the nonprofit contemporaneously prepare its minutes of meetings. You'll see that the IRS asks you if you have these provisions in place when you complete your federal income tax exemption application and your annual federal 990 returns. Although these are optional provisions, including these and other IRS-recommended provisions in your bylaws can go a long way toward making your dealings with the IRS a lot easier, both now and in future years.

RESOURCE

For an excellent guide to the type of governance policies the IRS likes to see in an organization's bylaws, see the Panel on the Nonprofit Sector's *The Principles Workbook: Steering Your Board Toward Good Governance and Ethical Practice*, available at www.thenonprofitpartnership.org.

Preparing bylaws for a nonprofit corporation is not difficult. It simply involves filling in several blanks in the appropriate bylaws for your group. There are four sets of bylaws available on this book's companion webpage; you'll use the one that corresponds to your group's purpose and follow along with us as we show you how to complete the forms. Before you begin work on your bylaws, you'll need to decide whether your nonprofit will have members. We guide you through that issue below.

The bylaw sets you will choose from are:

- Bylaws for a Public Benefit Nonprofit Corporation
- Membership Bylaw Provisions for a Public Benefit Corporation
- Bylaws for a Religious Corporation, and
- Membership Bylaw Provisions for a Religious Corporation.

Customizing Your Bylaws

The bylaws in this book contain standard, workable provisions for running a corporation. Any changes to these standard provisions that affect only administrative matters can be made without researching the law. For example, matters related to the payment of salaries, duties of officers, and composition of advisory or standing committees are usually left to the discretion of the nonprofit corporation. However, if you want to change basic legal provisions in your bylaws (such as notice or call of meeting rules, or voting or quorum provisions), you should check the Nonprofit Corporation Law prior to making these changes or let an experienced nonprofit lawyer help you.

Form 990—See What the IRS Looks for in Bylaws

The IRS 990 annual nonprofit return and instructions reveal a lot about what the IRS likes to see in bylaws. By going through the form, you'll see what the IRS asks about (and likes to see) in bylaws. Namely, you'll see that the IRS is interested in:

- the avoidance of excess benefit and conflict of interest transactions
- the contemporaneous recording of nonprofit minutes of meetings and written consents
- independent (noncompensated) board members
- the ability of nonprofit insiders to report wrongdoing (documented by a written whistle-blowing policy)
- document retention and destruction (evidenced by a written document retention and destruction policy), and
- public disclosure of the organization's exemption application and annual tax returns on its website and/or on request by the public (through a written public disclosure policy).

Our bylaws help you meet the first two recommendations. We suggest you give thought to adding provisions to your bylaws that address one or more of the additional policies listed above. This will help you meet the other good governance policies and practices the IRS asks about.

What the IRS doesn't like to see authorized or allowed in bylaws is:

- a small board of directors composed of related people. (Even for a smaller nonprofit, four or five board members looks better than just two or three.)
- board members who are paid or related to paid people. If all or most of the board is paid or related to paid people in your nonprofit, expect questions from the IRS (which will be trying to determine whether your nonprofit is set up to benefit the paid directors instead of the public).

CAUTION

Don't think of your bylaws as meaningless fine print. On the contrary, bylaws are crucial to the functioning of your organization. Be sure to read them carefully, making sure you understand the purpose and effect of the different provisions included.

Choose a Membership or Nonmembership Structure

Your first step in preparing bylaws is to decide whether you want your nonprofit corporation to be a membership or nonmembership corporation. There are significant differences between the two structures and significant legal consequences that will result from your

decision. See "Membership Nonprofits," in Chapter 2, for a discussion of the two different types of structures and the legal consequences of setting up a membership versus a nonmembership structure.

Most groups want a nonmembership corporation because it is simpler to establish and operate. Nonmembership corporations are run by a board of directors, as opposed to membership corporations, where members have the right to vote on major corporate decisions (the election of directors, dissolution of the corporation, sale of substantially all of the corporation's assets, or changes to the articles or bylaws of the corporation). And you don't lose any significant advantages by not having members—most people who might want to

support your group aren't interested in having the technical legal rights given to members.

Some groups, however, will decide that the nature of their activities requires a membership structure. This is a reasonable decision in circumstances where membership participation in the affairs of the nonprofit corporation is essential or desirable (for example, to increase member involvement in the nonprofit's mission and program).

Bylaws for a Public Benefit Corporation

All public benefit corporations start by preparing the public benefit corporation bylaws included with this book. These bylaws are for any type of 501(c)(3) public benefit corporation: membership or nonmembership; and charitable, educational, scientific, or literary (for 501(c)(3) purposes). Groups with a formal membership structure need to add special provisions to these basic public benefit corporation bylaws. California religious corporations will use a different form to prepare their bylaws.

General Instructions

To prepare bylaws for a public benefit corporation, fill in the Bylaws for a Public Benefit Corporation. You can download the bylaws form from the Nolo website (see Appendix A for the link). Follow the sample form and special instructions below.

Here are some general instructions to help you prepare your bylaws:

- The parenthetical blanks, "(_____)," in the sample form indicate information that you must complete on the form that you download.

Don't Be Confused by References to Members in Bylaw Provisions

The basic public benefit corporation bylaws contain references to "the members, if any," of the corporation, and make certain provisions applicable to the corporation only if the corporation has members. These provisions have no effect on nonmembership corporations. As a practical matter, nonmembership corporations will simply approve, by normal board approval, matters that reference approval by the membership of a membership corporation. Leaving in the references to members simply allows membership corporations to use the same basic provisions as nonmembership corporations. It also allows nonmembership corporations to more easily amend their bylaws later if they ever decide to adopt a membership structure.

- Replace the blanks in the online form with the information indicated in the sample form below.
- Each circled number in the sample form (e.g., ❶) refers to a special instruction that provides specific information to help you complete an item.
- A vertical series of dots in the sample form below indicates a gap where we have skipped over language in the online form.

Sample Bylaws

The sample bylaws below are an abbreviated version of the online version that is available on the Nolo website (see Appendix A for the link). In the text below, we provide sample language and instructions for the few sections that contain blanks.

Instructions for Completing Your Bylaws

Download the Bylaws for a Public Benefit Corporation from the Nolo website (see Appendix A for the link) and follow these instructions. The numbers on the instructions correspond to the relevant place on the bylaw form.

❶ Type the name of your corporation in the heading of the bylaws.

❷ Type the name of the county where the corporation's principal office is located. The principal office is the legal address of the corporation. If your nonprofit is ever sued, most of the time the lawsuit will have to be filed in the county where your principal office is located.

❸ Don't fill in the blanks in this section at this time. Use these blanks later to change the principal office of the corporation to another location, within the same county, by showing the new address and date of the address change.

❹ This section allows you to state in more detail the primary objectives and purposes of your nonprofit corporation. (Remember, your statement of specific purposes in your articles of incorporation is brief.) Here you can go into as much detail as you want, describing the specific purposes and activities of your corporation. You can be concise, but we suggest you provide some detail about your organization. You should state your major objectives and describe the activities that you plan to engage in. Doing this will give insiders a sense of certainty regarding the specific goals you intend to achieve and the means by which you plan to achieve them. A more detailed statement here will also give the IRS additional information, which they will use to determine if the specific activities you plan to engage in entitle you to the necessary 501(c)(3) tax exemption.

In all cases, refer back to "Prepare Articles of Incorporation," in Chapter 6, and reread the sections on nonprofit purposes (which you studied when preparing a statement of purposes for your articles of incorporation). These considerations apply here too, except that you don't need (and probably don't want) to be as brief this time.

Below you'll see an example of an expanded list of objectives and purposes that an educational dance group could use. This is the same group we used when illustrating how to prepare a short statement of specific purposes (see "Prepare Articles of Incorporation," in Chapter 6).

Response for an Educational Group

ARTICLE 2
PURPOSES
SECTION 1. OBJECTIVES AND PURPOSES
The primary objectives and purposes of this corporation shall be:

(a) *to provide instruction in dance forms such as jazz, ballet, tap, and modern dance;*

(b) *to provide instruction in body movement and relaxation art forms, such as tumbling, tai-chi, and yoga;*

(c) *to give public performances in dance forms and creative dramatics;*

(d) *to sponsor special events involving the public performance of any or all of the above art forms as well as other performing arts by the corporation's performing troupe as well as by other community performing arts groups; and*

(e) *to directly engage in and to provide facilities for others to engage in the promotion of the arts, generally.*

<div align="center">

Bylaws

of

<u>**Name of Corporation**</u>

a California Public Benefit Corporation

ARTICLE 1

OFFICES

</div>

SECTION 1. PRINCIPAL OFFICE

The principal office of the corporation for the transaction of its business is located in <u>**(name of county)**</u> County, California. ❷

SECTION 2. CHANGE OF ADDRESS

The county of the corporation's principal office can be changed only by amendment of these bylaws and not otherwise. The board of directors may, however, change the principal office from one location to another within the named county by noting the changed address and effective date below, and such changes of address shall not be deemed an amendment of these bylaws:

(Fill lines in below later, if and when address changes) ❸

_____ Dated: _____

_____ Dated: _____

_____ Dated: _____

SECTION 3. OTHER OFFICES

The corporation may also have offices at such other places, within or without the State of California, where it is qualified to do business, as its business may require, and as the board of directors may, from time to time, designate.

<div align="center">

ARTICLE 2

PURPOSES

</div>

SECTION 1. OBJECTIVES AND PURPOSES

The primary objectives and purposes of this corporation shall be: ❹

<u>**(provide specific statement of your group's nonprofit purposes and activities)**</u>

ARTICLE 3
DIRECTORS

SECTION 1. NUMBER

The corporation shall have __(number of directors)__ ❺ directors and collectively they shall be known as the board of directors. The number may be changed by amendment of this bylaw, or by repeal of this bylaw and adoption of a new bylaw, as provided in these bylaws.

.
.
.

SECTION 5. COMPENSATION

Directors shall serve without compensation except that they shall be allowed and paid __("their actual and necessary expenses incurred in attending directors' meetings" or state other provisions allowing reasonable compensation for attending meetings)__ . ❻ In addition, they shall be allowed reasonable advancement or reimbursement of expenses incurred in the performance of their regular duties as specified in Section 3 of this Article. Directors may not be compensated for rendering services to the corporation in any capacity other than director unless such other compensation is reasonable and is allowable under the provisions of Section 6 of this Article. Any payments to directors shall be approved in advance in accordance with this corporation's conflict of interest policy as set forth in Article 9 of these bylaws.

.
.
.

SECTION 8. REGULAR AND ANNUAL MEETINGS

Regular meetings of directors shall be held on __(date)__ ❼ at __(time)__M, ❼ unless such day falls on a legal holiday, in which event the regular meeting shall be held at the same hour and place on the next business day.

 If this corporation makes no provision for members, then, at the annual meeting of directors held on __(date)__, ❼ directors shall be elected by the board of directors in accordance with this section. Cumulative voting by directors for the election of directors shall not be permitted. The candidates receiving the highest number of votes up to the number of directors to be elected shall be elected. Each director shall cast one vote, with voting being by ballot only.

.
.
.

SECTION 13. QUORUM FOR MEETINGS

A quorum shall consist of __(state number or percentage, e.g., "a majority of the board of")__ ❽ directors.

.
.
.

SECTION 15. CONDUCT OF MEETINGS

Meetings of the board of directors shall be presided over by the chairperson of the board, or, if no such person has been so designated or in his or her absence, the president of the corporation or, in his or her absence, by the vice president of the corporation or, in the absence of each of these persons, by a chairperson chosen by a majority of the directors present at the meeting. The secretary of the corporation shall act as secretary of all meetings of the board, provided that, in his or her absence, the presiding officer shall appoint another person to act as secretary of the meeting.

Meetings shall be governed by __("Robert's Rules of Order" or state other rules or procedures for conduct of directors' meeting)__ , ❾ as such rules may be revised from time to time, insofar as such rules are not inconsistent with or in conflict with these bylaws, with the articles of incorporation of this corporation, or with provisions of law.

.
.
.

ARTICLE 5
COMMITTEES

SECTION 1. EXECUTIVE COMMITTEE

The board of directors may, by a majority vote of directors, designate two (2) or more of its members (who may also be serving as officers of this corporation) to constitute an executive committee and delegate to such committee any of the powers and authority of the board in the management of the business and affairs of the corporation, except with respect to:

(a) The approval of any action which, under law or the provisions of these bylaws, requires the approval of the members or of a majority of all of the members.

(b) The filling of vacancies on the board or on any committee which has the authority of the board.

(c) The fixing of compensation of the directors for serving on the board or on any committee.

(d) The amendment or repeal of bylaws or the adoption of new bylaws.

(e) The amendment or repeal of any resolution of the board which by its express terms is not so amendable or repealable.

(f) The appointment of committees of the board or the members thereof.

(g) The expenditure of corporate funds to support a nominee for director after there are more people nominated for director than can be elected.

(h) The approval of any transaction to which this corporation is a party and in which one or more of the directors has a material financial interest, except as expressly provided in Section 5233(d)(3) of the California Nonprofit Public Benefit Corporation Law.

By a majority vote of its members then in office, the board may at any time revoke or modify any or all of the authority so delegated, increase or decrease but not below two (2) the number of its members, and fill vacancies therein from the members of the board. The committee shall keep regular minutes of its proceedings, cause them to be filed with the corporate records, and report the same to the board from time to time as the board may require. ❿

.
.
.

ARTICLE 8
FISCAL YEAR

SECTION 1. FISCAL YEAR OF THE CORPORATION

The fiscal year of the corporation shall begin on the ___**(day and month, e.g., "first day of January")**___ ⓫ and end on the ___**(day and month, e.g., "last day of December")**___ ⓫ in each year.

.
.
.

ARTICLE 9 ⓬
CONFLICT OF INTEREST AND COMPENSATION APPROVAL POLICIES

SECTION 1. PURPOSE OF CONFLICT OF INTEREST POLICY

.
.
.

ARTICLE 13 ⓭
MEMBERS

SECTION 1. DETERMINATION OF MEMBERS ⓮

If this corporation makes no provision for members, then, pursuant to Section 5310(b) of the Nonprofit Public Benefit Corporation Law of the State of California, any action which would otherwise, under law or the provisions of the articles of incorporation or bylaws of this corporation, require approval by a majority of all members or approval by the members, shall only require the approval of the board of directors.

WRITTEN CONSENT OF DIRECTORS ADOPTING BYLAWS ⓯

We, the undersigned, are all of the persons acting as the initial directors of ___**(name of corporation)**___, ⓯ a California nonprofit corporation, and, pursuant to the authority granted to the directors by these bylaws to take action by unanimous written consent without a meeting, consent to, and hereby do, adopt the foregoing bylaws, consisting of ___**(number of pages)**___ ⓯ pages, as the bylaws of this corporation.

Dated: ___**(date)**___ _____**(signature of director)**_____ ⓯

 (typed name) , Director

 (typed name) , Director

 (typed name) , Director

 (typed name) , Director

 (typed name) , Director

CERTIFICATE

This is to certify that the foregoing is a true and correct copy of the bylaws of the corporation named in the title thereto and that such bylaws were duly adopted by the board of directors of said corporation on the date set forth below.

(Fill in Certificate date and signature of secretary later, after first board meeting) ⓰

Dated: ___(date)___ ___(signature of secretary)___

 (typed name) , Secretary

❺ Indicate the total number of persons authorized to serve on your board. This number will usually be the same as the number of people you've already indicated as the initial directors of the corporation in your Incorporator's Statement (see Chapter 6). However, you may at this time state a greater number to allow for additional directors to be elected at a future meeting of the board. Don't forget to abide by the "51% Rule," which means that a majority of the board must not be paid by the corporation or related to another person who is paid by the corporation. (See "Directors," in Chapter 2, for more information on public benefit corporations and the 51% rule.)

A few groups might want to change this section to provide for a range of numbers of directors, with the exact number to be later fixed by resolution of the board of directors. For example, you might want to retype this section to provide as shown in the sample below.

Variation on Numbers of Directors

SECTION 1. NUMBER
The corporation shall have not fewer than five (5) nor more than eleven (11) directors, with the exact number to be fixed within these limits by approval of the board of directors or the members, if any, in the manner provided in these bylaws.

❻ Indicate in this blank any specific payments that will be allowed to board members for attending meetings of the board (note that reasonable advancement and reimbursement of expenses for performing other director duties are allowed by this section). You can enter a specific per-meeting amount (or you can use the sample language shown in the blank on the sample form above to authorize payment of "actual and necessary" expenses incurred by directors in attending board meetings). If, as is often the case, you do not wish to pay directors for attending meetings, simply type "no payments authorized" in this blank. Paying a director (a small amount) solely for attending board meetings does not make a director an "interested person" for purposes of the 51% rule (Corp. Code § 5227).

Payments to Directors

Directors shall serve without compensation except that they shall be allowed and paid **$50 for attending each meeting of the board of directors**.

Directors shall serve without compensation except that they shall be allowed and paid **no payment authorized**.

❼ In the blanks in the first paragraph, indicate the date and time when regular meetings of the board will be held. Many nonprofits hold regular board meetings, while others simply schedule regular meetings once each year and call special meetings during the year when required. In any case, make sure to indicate in the blanks that you will hold a regular board meeting at least annually.

Responses

> Regular meetings of directors shall be held on the first Friday of each month at 9 o'clock AM…
>
> Regular meetings of directors shall be held on the second Monday of December at 1 o'clock PM…
>
> Regular meetings of directors shall be held on July 1 and February 20 at 9 o'clock AM…

In the second paragraph of this section, fill in the blank to indicate which one of your regular board meetings will be specified as the annual regular meeting of the board to elect (or reelect) directors of your corporation. In a nonmembership corporation, the directors vote for their own reelection or replacements, with each director casting one written vote. Of course, if a corporation has provided for only one regular meeting each year in the first paragraph of this section, then the date of this regular meeting will be repeated in this blank as the date of the annual meeting of directors.

Responses for Annual Meeting Date

> If this corporation makes no provision for members, then, at the annual meeting of directors held on **January 1**, directors shall be elected

> If this corporation makes no provision for members, then, at the annual meeting of directors held on **the first Friday of July**, directors shall be elected…

The provisions in the second paragraph of this section apply only to nonmembership corporations. Membership corporations can leave this line blank, since they will add provisions to their bylaws specifying that the members, not the directors, elect directors of the corporation.

❽ A quorum (a minimum number of directors) must be present at a directors' meeting in order to conduct business. Indicate the number of directors who will constitute a quorum. Although the usual practice is to provide for a majority, you can choose a larger or smaller number. However, you cannot choose a quorum of less than one-fifth of the authorized number of directors (the number given in special instruction **❺**, above), or two, whichever is larger. Of course, one-director corporations can and will provide for a quorum of one director. For example, a seven-director corporation can't provide for a quorum of fewer than two directors, while a 15-director corporation must have at least a three-director quorum.

Whatever number or percentage you decide on, you should realize that this section of the bylaws concerns a quorum, not a vote requirement. A meeting can be held only if at least a quorum of directors is present, but a vote on any matter before the board must, generally, be passed by the vote of a majority of those present at the meeting.

EXAMPLE: If a public benefit corporation with seven directors provides for a minimum quorum of two, and just two directors hold a meeting, action can be taken by the unanimous vote of these two directors. However, if all seven directors attend the

meeting, action must be approved by at least four directors (a majority of those present at the meeting).

Many public benefit corporations will want a less-than-majority quorum rule. The reason is because these corporations must have a majority of "disinterested" directors on their board. Sometimes, corporations have difficulty getting nonsalaried directors to attend board meetings on a regular basis. A lower quorum requirement can help ensure that enough directors for a quorum will be present at meetings.

9 In this blank, indicate the rules of order that will be used at directors' meetings. Most nonprofits specify *Robert's Rules of Order* here, but you may choose any set of procedures for proposing, approving, and tabling motions. With a small board, you can leave this line blank if you see no need to specify formal procedures for introducing and discussing items of business at your board meetings.

10 This section follows a state law provision that allows the board of a public benefit corporation to set up an executive committee of the board consisting of board members only. The law allows the executive committee to have much of the management power of the full board (as specified in this section of the bylaws). Although at least two board members must serve on this committee, in practice, most nonprofit corporations establish an executive board committee of from three to five board members. Of course, you don't have to set up an executive committee of the board, and you can set up other types of committees with or without board members (see Section 2 of this Article in the bylaws).

11 The fiscal year of the corporation is the period for which the corporation keeps its books (its accounting period), and will determine the corporation's tax year for purposes of filing certain tax returns and reports. Indi-

cate the beginning and ending dates of the corporation's fiscal year in this space. You can choose the calendar year from January 1 to December 31, which most nonprofits do. Or, you can use what the IRS considers a true fiscal year, consisting of a 12-month period ending on the last day of any month other than December (for example, from July 1 to June 30).

12 Article 9 of the bylaws included in this book contains rules and procedures for approving or avoiding conflict of interest transactions, including compensation arrangements, between your nonprofit and its directors, officers, employees, contractors, and others. This bylaw provision contains the conflicts-of-interest language recommended by the IRS (included in the sample conflict-of-interest policy in Appendix A of the instructions to IRS Form 1023). It also contains language for the approval of compensation arrangements that attempts to comply with the safe harbor provisions of the excess benefit rules (see the discussion on the excess benefit rules in "Limitation on Profits and Benefits," in Chapter 3). You will need to become familiar with this provision, and make sure you are comfortable with its procedures for the approval and review of financial transactions with, and salary and other compensation paid to, your directors, officers, and others who are in a position to influence your nonprofit. If you decide to make changes to this provision, do so only after reading "Prepare Your Tax Exemption Application," instructions to Part V, in Chapter 8, where we refer to this bylaw provision when providing sample responses to question on the application. If you make any changes, you will need to create your own responses to some of the questions on the 501(c)(3) application.

13 The last portion of the basic bylaws (Article 13, Written Consent of Directors, and the Certificate section) is for nonmembership groups only. Membership public benefit

corporations do not need to fill in and use this last portion of the basic bylaws—we show you how to add membership provisions to complete your bylaws, below.

❶❹ Section 1 of Article 13 makes it clear that the directors of nonmembership corporations can take the place of members in taking any action that, under law, otherwise requires membership approval. In other words, the directors can act in place of the members in nonmembership corporations.

❶❺ Fill in the Written Consent of Directors paragraph, showing the name of the corporation and the number of pages in your final bylaws. Type your directors' names (the initial directors appointed by your incorporator (see Chapter 6)) below the signature lines. After printing and dating the form, have each initial director sign the form.

❶❻ Don't fill in the blanks following the Certificate at the bottom of the bylaws at this time. Your corporate secretary will complete these blanks after the first meeting of your board.

Bylaw Provisions for Schools and Federally Funded Groups

Some groups may need to add language or make other modifications to the bylaws we provide. Here are three examples: schools, federally funded groups, and larger public benefit groups (with annual gross revenues of $2 million or more).

Schools

If your nonprofit activities will consist of operating a formal school, you will need to add an article to the sample bylaws consisting of a "nondiscriminatory policy statement." For information on the applicability of this statement to your group and how to prepare it, see the discussion on Part III in "Prepare Your Tax Exemption Application," in Chapter 8.

Participants in Federal Programs

If your nonprofit corporation plans to receive federal or other public grants or money, some funding agencies may require that you include provisions in your bylaws stating that no board member, officer, or other person exercising supervisory power in the corporation, or any of their close relatives, can benefit from the receipt of grant funds. Generally, provisions of this sort are meant to prohibit board members, officers (president, vice president, secretary, treasurer), and their families from being paid from, or directly benefited by, grant monies given to the organization.

> **TIP**
>
> **If you plan to receive grant funds from government or other public sources, ask the funding agency for the exact language of any special provisions that you should include in your bylaws.** In many cases, you won't want to provide for payment of directors or officers and should delete or modify Article 3, Sections 5 and 6; Article 4, Section 10; and Article 11, Section 1, of the bylaws we provide.

State Audit Requirements for Nonprofits With Revenues of $2 Million or More

Public benefit nonprofits with annual gross revenues of $2 million or more may wish to add audit provisions to their bylaws to reflect special requirements under the California Nonprofit Integrity Act of 2004 that apply to them. These audit rules generally do not apply to schools or hospitals, and the $2 million threshold doesn't include grants received from government agencies if the nonprofit must provide an accounting of how it uses the governmental grant funds. However, if your nonprofit falls within the scope of these rules, you may want to include provisions in your bylaws that cover these requirements.

Here is a brief summary of the "larger non-profit" audit rules under the Act:

- The nonprofit must prepare audited annual financial statements, which it must submit to the attorney general and make available for public inspection.
- The nonprofit board must appoint an audit committee that (1) helps hire and set the compensation of the auditors (CPAs) that prepare the organization's financial statements, (2) reviews the organization's audited statements, and (3) reports to the board its finding as to whether the nonprofit's financial affairs and financial statements are in order.
- The audit committee cannot include staff members, the president or chief executive officer, the treasurer, or the chief financial officer of the nonprofit. If an organization has a finance committee, members of that committee may serve on the audit committee, but cannot make up 50% or more of the audit committee.

To learn more about the California Nonprofit Integrity Act of 2004:

- Go to the California Attorney General's website and in the search box type "Summary of New Law: Nonprofit Integrity Act of 2004."
- To read the sections of California law amended or added by the Act, go to http://leginfo.legislature.ca.gov. Select and read under California Law, Government Code Sections 12581, 12582, 12583, 12584, 12585, 12586, 12599, 12599.1, 12599.3, 12599.6, and 12599.7, and Business and Professions Code Section 17510.5.

Membership Bylaw Provisions for a Public Benefit Corporation

This section applies only to membership corporations and shows how to add special membership provisions to the basic public benefit corporation bylaws. If you have decided to form a nonmembership public benefit corporation, this section does not apply to you and you should skip ahead to the next chapter.

General Instructions

To add membership provisions to your public benefit corporation bylaws, fill in the blanks in the membership provisions file included with this book, following the sample form and instructions below. Once completed, copy these membership provisions to your basic bylaws as explained in special instruction ❶ below.

- The parenthetical blanks, "(_____)," in the sample form below indicate information you must complete on your form.
- Replace the blanks in the form you download with the information indicated in the sample form below.
- Each circled number in the sample form (for instance, ❶) refers to a special instruction that provides specific information to help you complete an item. The special instructions immediately follow the sample form.
- A vertical series of dots in the sample form indicates a gap where we have left out some of the language. This is an abbreviated version of the complete form.

Sample Membership Provisions

Below is an example of membership provisions that a nonprofit with members might use. Don't be alarmed by the short size of the sample—it's an abbreviated version of the form, with sample language and instructions only for the sections on the form that contain blanks.

Special Instructions

❶ After completing these membership provisions, add them to your basic bylaws—this material replaces Article 13, the Written Consent, and the Certificate sections and signature lines at the end of your basic bylaws that you prepared above.

❷ Use this blank to indicate any special qualifications required for members (for example, over the age of 18 or currently enrolled students in a school's curriculum). Be careful here. The IRS likes 501(c)(3) tax-exempt corporations to have an open-admissions policy for members, and for membership in the corporation to be open to the general public. As a result, most public benefit corporations don't specify any qualifications for membership (see the suggested wording in the blank on the sample form).

❸ Most public benefit corporations do not require formal application for membership in the corporation. However, some will indicate that members must pay an admission fee and/or annual dues prior to acceptance as a member in the corporation (see the suggested wording in the blank on the sample form).

❹ Indicate the manner of determining, or the amount of, admission fees and/or annual dues for members in the appropriate blanks (see the suggested wording in the blanks on the sample form).

❺ Indicate the date and time of the annual meeting of members. The members elect directors at this annual meeting. You may wish to coordinate this date with your annual directors' meeting (you might make it slightly before the annual directors' meeting).

❻ Type the date and time of any regular meetings of members. Many nonprofits will leave this line blank and decide to provide only for the annual meeting of members in their bylaws (in the previous paragraph). Those with a more active membership will indicate monthly or semiannual regular meetings of members here.

❼ You can set the quorum requirement for members' meetings at any number, whether greater or less than a majority. However, as indicated in the last paragraph of this section, if your public benefit corporation sets a quorum at less than one-third of the voting power and less than one-third of the members actually attend a meeting, then no action may be taken at the meeting unless the notice of the meeting stated the general nature of the proposals to be acted upon. Fixing a quorum at less than one-third of the voting power, therefore, can make matters more complicated. The normal rule is that any action may be taken at a regular members' meeting, whether or not it was stated in the notice of the meeting (see Subsection (c) of this article in the computer form). In any case, it's a good idea to have at least a one-third quorum to help make members' meetings more representative of the entire membership.

❽ Indicate whether the corporation will allow proxy voting by members. (A proxy is simply a written authorization by a member allowing another person to vote for the member.) Many small membership corporations decide that proxy voting will not be permitted, which avoids problems and complications that can arise in times of controversy or difficult decisions, such as proxy wars or solicitations of proxies by outside or competing interests.

If you decide to allow proxies, the restrictions relating to proxies contained in the next sections of this article will apply.

Membership Provisions

of

<u>(name of corporation)</u>

a California Public Benefit Corporation

ARTICLE 13 ❶
MEMBERS

SECTION 1. DETERMINATION AND RIGHTS OF MEMBERS

The corporation shall have only one class of members. No member shall hold more than one membership in the corporation. Except as expressly provided in or authorized by the articles of incorporation or bylaws of this corporation, all memberships shall have the same rights, privileges, restrictions, and conditions.

SECTION 2. QUALIFICATIONS OF MEMBERS

The qualifications for membership in this corporation are as follows: **(specify qualifications or, if none, type "Any person is qualified to become a member of this corporation")** . ❷

SECTION 3. ADMISSION OF MEMBERS

Applicants shall be admitted to membership **(state procedure, e.g., "on making application therefor in writing" and indicate if payment will be required, e.g., "and upon payment of the application fee and/or first annual dues, as specified in the following sections of this bylaw")** . ❸

SECTION 4. FEES, DUES, AND ASSESSMENTS

(a) The following fee shall be charged for making application for membership in the corporation: **(state specific admission fee or leave to discretion of board, e.g., "in such amount as may be specified from time to time by resolution of the board of directors charged for, and payable with, the application for membership," or, if no fee, type "None")** . ❹

(b) The annual dues payable to the corporation by members shall be **(state amount of annual dues, leave to discretion of board, e.g., "in such amount as may be determined from time to time by resolution of the board of directors," or type "None")** . ❹

(c) Memberships shall be nonassessable.

.
.
.

ARTICLE 14
MEETINGS OF MEMBERS

SECTION 1. PLACE OF MEETINGS

Meetings of members shall be held at the principal office of the corporation or at such other place or places within or without the State of California as may be designated from time to time by resolution of the board of directors.

SECTION 2. ANNUAL AND OTHER REGULAR MEETINGS

The members shall meet annually on **(date, e.g., "the first Monday of July, September 30")** ❺ in each year, at ___(time)___ M, ❺ for the purpose of electing directors and transacting other business as may come before the meeting. Cumulative voting for the election of directors shall not be permitted. The candidates receiving the highest number of votes up to the number of directors to be elected shall be elected. Each voting member shall cast one vote, with voting being by ballot only. The annual meeting of members for the purpose of electing directors shall be deemed a regular meeting and any reference in these bylaws to regular meetings of members refers to this annual meeting.

Other regular meetings of the members shall be held on ___(date)___ ❻ at ___(time)___ M.❻

If the day fixed for the annual meeting or other regular meetings falls on a legal holiday, such meeting shall be held at the same hour and place on the next business day.

.
.
.

SECTION 5. QUORUM FOR MEETINGS

A quorum shall consist of **(state percentage, which may be more or less than a majority)** ❼ of the voting members of the corporation.

The members present at a duly called and held meeting at which a quorum is initially present may continue to do business notwithstanding the loss of a quorum at the meeting due to a withdrawal of members from the meeting provided that any action taken after the loss of a quorum must be approved by at least a majority of the members required to constitute a quorum.

In the absence of a quorum, any meeting of the members may be adjourned from time to time by the vote of a majority of the votes represented in person or by proxy at the meeting, but no other business shall be transacted at such meeting.

When a meeting is adjourned for lack of a sufficient number of members at the meeting or otherwise, it shall not be necessary to give any notice of the time and place of the adjourned meeting or of the business to be transacted at such meeting other than by announcement at the meeting at which the adjournment is taken of the time and place of the adjourned meeting. However, if after the adjournment a new record date is fixed for notice or voting, a notice of the adjourned meeting shall be given to each member who, on the record date for notice of the meeting, is entitled to vote at the meeting. A meeting shall not be adjourned for more than forty-five (45) days.

Notwithstanding any other provision of this Article, if this corporation authorizes members to conduct a meeting with a quorum of less than one-third (⅓) of the voting power, then, if less than one-third (⅓) of the voting power actually attends a regular meeting, in person or by proxy, then no action may be taken on a matter unless the general nature of the matter was stated in the notice of the regular meeting.

⋮

SECTION 8. PROXY VOTING

Members entitled to vote __(type "shall" or "shall not")__ ❽ be permitted to vote or act by proxy. If membership voting by proxy is not allowed by the preceding sentence, no provision in this or other sections of these bylaws referring to proxy voting shall be construed to permit any member to vote or act by proxy.

If membership voting by proxy is allowed, members entitled to vote shall have the right to vote either in person or by a written proxy executed by such person or by his or her duly authorized agent and filed with the secretary of the corporation, provided, however, that no proxy shall be valid after eleven (11) months from the date of its execution unless otherwise provided in the proxy. In any case, however, the maximum term of any proxy shall be three (3) years from the date of its execution. No proxy shall be irrevocable and may be revoked following the procedures given in Section 5613 of the California Nonprofit Public Benefit Corporation Law.

If membership voting by proxy is allowed, all proxies shall state the general nature of the matter to be voted on and, in the case of a proxy given to vote for the election of directors, shall list those persons who were nominees at the time the notice of the vote for election of directors was given to the members. In any election of directors, any proxy which is marked by a member "withhold" or otherwise marked in a manner indicating that the authority to vote for the election of directors is withheld shall not be voted either for or against the election of a director.

If membership voting by proxy is allowed, proxies shall afford an opportunity for the member to specify a choice between approval and disapproval for each matter or group of related matters intended, at the time the proxy is distributed, to be acted upon at the meeting for which the proxy is solicited. The proxy shall also provide that when the person solicited specifies a choice with respect to any such matter, the vote shall be cast in accordance therewith.

SECTION 9. CONDUCT OF MEETINGS

Meetings of members shall be presided over by the chair of the board, or, if there is no chairperson, by the president of the corporation or, in his or her absence, by the vice president of the corporation or, in the absence of all of these persons, by a chair chosen by a majority of the voting members, present in person or by proxy. The secretary of the corporation shall act as secretary of all meetings of members, provided that, in his or her absence, the presiding officer shall appoint another person to act as secretary of the meeting.

Meetings shall be governed by __(type "Robert's Rules of Order" or indicate other rules or procedures)__, ❾ as such rules may be revised from time to time, insofar as such rules are not inconsistent with or in conflict with these bylaws, with the articles of incorporation of this corporation, or with any provision of law.

.
.
.

WRITTEN CONSENT OF DIRECTORS ADOPTING BYLAWS

We, the undersigned, are all of the persons acting as the initial directors of __(name of corporation)__, ❿ a California nonprofit corporation, and, pursuant to the authority granted to the directors by these bylaws to take action by unanimous written consent without a meeting, consent to, and hereby do, adopt the foregoing bylaws, consisting of __(number of pages)__ ❿ pages, as the bylaws of this corporation.

Date: _____

__(signatures of director(s))__ _____ ❿
(typed name) , Director

, Director

, Director

, Director

, Director

.
.
.

CERTIFICATE

This is to certify that the foregoing is a true and correct copy of the bylaws of the corporation named in the title thereto and that such bylaws were duly adopted by the board of directors of said corporation on the date set forth below.

(Fill in Certificate date and signature of secretary later, after first board meeting) ⓫

Dated: __(date)__ __(signature of secretary)__
(typed name) , Secretary

❾ Indicate, if you wish, the sets of rules that will govern for proposing and taking action at your membership meetings. Robert's Rules of Order is the standard, of course, but you may specify another set of procedures or "none" if you wish to run your membership meetings loosely and informally.

❿ Fill in the Written Consent of Directors paragraph, showing the name of the corporation and the number of pages in your final bylaws. Type your directors' names (the initial directors appointed by your incorporator—see Chapter 6) below the signature lines. After printing and dating the form, have each initial director sign the form.

⓫ Do not fill in the blanks following the Certificate at the bottom of the bylaws at this time. Your corporate secretary will complete these blanks after the first meeting of your board.

You're almost done! Replace the corresponding sections of your basic bylaws (Article 13 through the end of the bylaws) with these completed membership provisions. Now turn to Chapter 8 for the next step in your journey toward nonprofit status.

Bylaws for a Religious Corporation

To form a religious corporation, you need special religious corporation bylaws or some other similar document that sets forth the ground rules for your corporation. The reason we mention a "similar document" is that the law governing religious corporations (Section 9150 of the Nonprofit Religious Corporation Law) defines the bylaws of religious corporations as "the code or code of rules used, adopted, or recognized for the regulation or management of the affairs of the corporation

irrespective of the name or names by which such rules are designated." In essence, the state recognizes that religions are often governed by canons or other ecclesiastical documents instead of bylaws.

Special Rules for Religious Corporations

The law that applies to religious corporations is considerably more flexible and liberal than the law that applies to other nonprofit corporations. This is particularly true with respect to the form and content of a religious corporation's bylaws, which set forth the general operating rules for a corporation. The state is reluctant to get overly involved in this aspect of a religious corporation's affairs because of the constitutional protections afforded religions, the inappropriateness of state intrusion into most religious disputes, and the wide diversity of religious activities. (See the *California Attorney General's Guide for Charities*, which contains a statement regarding the attorney general's overall "hands-off" policy with respect to oversight of religious corporations.)

State Law Will Apply by Default

While the Nonprofit Religious Corporation Law provides certain fundamental rules regarding the operation of religious corporations, many of these rules apply only if the corporation's own canons or bylaws do not provide otherwise. In general, in areas most likely to involve doctrinal matters and First Amendment rights, such as membership meetings and member voting, religious corporations are given the most flexibility for establishing their own rules. (See "Religious Purposes," in Chapter 3, for more on the flexibility afforded religious corporations in general.)

Directors' Terms and Meetings

Religious corporations can set their own rules regarding the terms of office, election, selection, designation, removal, and resignation of directors. Subject to a few exceptions, religious corporations can also set their own rules about calling, noticing, and holding meetings of members or obtaining the approval of members. As mentioned above, if any of these subjects are not dealt with specifically in a religious corporation's bylaws, then the rules set forth in the Nonprofit Religious Corporation Law will apply.

You may remember from your reading of Chapter 2 that public benefit corporations are subject to the 51% rule, which requires at least 51% of the board to be "disinterested" (not paid for performing services other than as directors or related to any paid persons). Unlike public benefit corporations, all of the directors of a religious corporation can, if they wish, also serve as salaried officers, employees, or independent contractors of the corporation. (See Chapter 2 for a discussion of public benefit corporations and the 51% rule.)

Directors' Duty of Care

The general standard of conduct ("duty of care") for directors of religious corporations is similar to the standard that applies to public benefit corporation directors. Directors must act responsibly and in the best interests of the corporation. (See Chapter 2 for discussion about duty of care.) The duty of care for religious corporation directors is more lenient, however, because religious corporation directors can take into account the religious purposes of the corporation and its religious tenets, canons, laws, policies, and authority when making decisions.

In a public benefit corporation, directors can rely on business and financial reports prepared or presented by officers, employees, and experts, such as lawyers and accountants, when making business and financial decisions. Directors in religious corporations can also rely on information provided by religious authorities, ministers, priests, rabbis, or other people whose positions or duties in the religious organization the directors believe justify their reliance and confidence in them. This more lenient duty of care for religious corporations also applies to decisions relating to compensation for directors, loans to directors, guaranties of obligations of directors, and management of corporate investments. By contrast, for public benefit corporations, loans or guaranties to directors usually must be approved by the attorney general and there are stricter standards for managing corporate investments. (See Chapter 2 for more on directors' duty of care.)

The rules regarding the approval of self-dealing transactions for religious corporations (a transaction in which a director has a material financial interest, and that hasn't been properly approved by the board or a committee) are generally the same as those that apply to public benefit corporations, except for loans and guaranties to directors, as mentioned above. However, directors of religious corporations can take into account the religious purposes of the corporation when considering approval of a self-dealing transaction.

Membership Inspection Rights

In public benefit corporations, members have the right to inspect the corporation's membership list, financial books, and records of members' and board meetings. For religious nonprofits, these membership inspection rights may be limited or totally eliminated by the corporation's bylaws. This is an area where the state felt it was inappropriate—or perhaps, unconstitutional—to require broad inspection

rights or financial disclosure of corporate affairs to members. In the absence of any limitation on inspection rights, members of religious corporations have basically the same right to inspect as members of a public benefit corporation.

Attorney General Supervision

The Nonprofit Religious Corporation Law mandates a hands-off policy by the attorney general toward religious corporations, except to the extent the attorney general is empowered to act in the enforcement of the criminal laws. A few exceptions are also provided for the attorney general to step in based on the authority of the Religious Corporation Law. (See the *California Attorney General's Guide for Charities*, which contains a statement regarding the attorney general's overall hands-off policy with respect to oversight of religious corporations.)

The California Attorney General's traditional role of enforcing the charitable trust theory has, since 1980, been severely curtailed. A charitable trust, under Section 9142 of the Religious Corporation Law, is deemed to exist only under certain narrowly defined conditions. Moreover, the attorney general's office is, for the most part, prohibited from enforcing the terms of any implied or express trust (except with respect to certain property received by the corporation for a specific purpose from the general public, again subject to further restrictions; see Section 9230).

General Instructions

The bylaws for a religious corporation included with this book are basic, nonmembership religious corporation bylaws with standard provisions from the Nonprofit Religious Corporation Law. Nonmembership religious corporations can use these bylaws "as is." Religious corporations with a formal membership structure should start by preparing the basic religious corporation bylaws, then add the membership provisions as explained below.

To prepare bylaws for a religious corporation (member or nonmember), download and fill in the bylaws for a religious corporation following the sample form and special instructions below.

Here are some general instructions to help you prepare your bylaws:

- The parenthetical blanks, "(_____)," in the sample form below indicate information that you must complete on your form.
- Replace the blanks in the form with the information indicated in the sample form below.
- Each circled number in the sample form (for example, ❶) refers to a special instruction that provides specific information to help you complete an item. The special instructions follow the sample form.
- A vertical series of dots in the sample form below indicates a gap where we have skipped over parts of the form.

Sample Bylaws

The sample bylaws below are an abbreviated version of the complete form available on the Nolo website. In the sample bylaws, we provide sample language and instructions for the few sections that contain blanks.

Many of you will want to take advantage of the flexibility allowed under the Nonprofit Religious Corporation Law and add customized provisions to these basic bylaws, tailoring them to your organization's specific operating procedures. If you do this, make sure your changes conform to law. Review the legal provisions of the Nonprofit Religious Corporation Law (Sections 9110 through 9690 of the Nonprofit

Corporation Law). You can read these provisions online at the California Legislative Information website (http://leginfo.legislature.ca.gov). Under California Law, go to Corporations Code—CORP. Under Title 1. Corporations, you will find Nonprofit Religious Corporations in Division 2, Part 4 (Section 9110–9690). You can also examine the law at a local county law library. You can also ask a lawyer to make sure your variations are allowable (it shouldn't take the lawyer more than one or two hours to check the bylaws against the statutes).

Special Instructions

Here are the instructions to fill in the blanks in the standard religious corporation bylaws:

❶ Type the name of your corporation in the heading of the bylaws.

❷ Type the name of the county where the corporation's principal office is located. The principal office is the legal address of the corporation and, if your nonprofit is sued, will usually be the county where the lawsuit must be brought.

❸ Don't fill in the blanks in this section at this time. You may want to use these blanks later to change the principal office of the corporation to another location, within the same county, by showing the new address and date of the address change.

❹ This section allows you to state in more detail the primary objectives and purposes of your religious corporation (remember, your statement of specific purposes in your articles of incorporation should have been brief). Here you can go into as much detail as you want, describing the religious purposes and activities of your corporation. You can be brief here if you want, but a more detailed statement will give the IRS additional information it will use to determine if the specific activities you plan to engage in entitle you to the necessary 501(c)(3) tax exemption. (See "Prepare Articles of Incorporation," in Chapter 6, for examples of sample responses by nonreligious groups.)

❺ Indicate the total number of persons authorized to serve on your board. Most of the time, this number will be the same as the number of people you've already indicated as the initial directors of the corporation in your Incorporator's Statement (see Chapter 6). However, you may state a greater number to allow for additional directors who will be elected at a future meeting of the board.

For information on providing for a variable number of directors, see "Bylaws for a Public Benefit Nonprofit Corporation," above, special instruction ❺.

❻ Use this blank if you wish to pay your directors a per-meeting fee or other compensation arrangement (such as a yearly payment) for attending board meetings. If, as is often the case, you do not wish to pay directors for attending meetings, simply type "no payments authorized" in this blank. The last sentence allows the corporation to advance or reimburse directors for actual expenses they incur in attending meetings (gas, tolls, and the like) and for performing other director duties.

❼ In the blanks in the first paragraph, fill in the date when the board will hold its regular meetings. It's not uncommon to hold regular board meetings, while others simply schedule regular meetings once each year (and call special meetings during the year when required). In any case, make sure to indicate that you will hold a regular board meeting at least annually.

Bylaws

of

_____(Name of Corporation)_____ ❶

a California Religious Corporation

ARTICLE 1
OFFICES

SECTION 1. PRINCIPAL OFFICE

The principal office of the corporation for the transaction of its business is located in __(name of county)__ County, California.❷

SECTION 2. CHANGE OF ADDRESS

The county of the corporation's principal office can be changed only by amendment of these bylaws and not otherwise. The board of directors may, however, change the principal office from one location to another within the named county by noting the changed address and effective date below, and such changes of address shall not be deemed an amendment of these bylaws:

(Fill lines in below later, if and when address changes) ❸

_____ Dated: _____

_____ Dated: _____

_____ Dated: _____

SECTION 3. OTHER OFFICES

The corporation may also have offices at such other places, within or without the State of California, where it is qualified to do business, as its business may require and as the board of directors may, from time to time, designate.

ARTICLE 2
PURPOSES

SECTION 1. OBJECTIVES AND PURPOSES

The primary objectives and purposes of this corporation shall be: ❹

(provide specific statement of your group's nonprofit purposes and activities)

ARTICLE 3
DIRECTORS

SECTION 1. NUMBER

The corporation shall have ___(number of directors)___ ❺ directors and collectively they shall be known as the board of directors. The number may be changed by amendment of this bylaw, or by repeal of this bylaw and adoption of a new bylaw, as provided in these bylaws.

.
.
.

SECTION 5. COMPENSATION

Directors shall serve without compensation except that they shall be allowed and paid ___("their actual and necessary expenses incurred in attending directors' meetings" or state other provisions allowing reasonable compensation for attending meetings)___ . ❻ In addition, they shall be allowed reasonable advancement or reimbursement of expenses incurred in the performance of their regular duties as specified in Section 3 of this Article. Any payments to directors shall be approved in advance in accordance with this corporation's conflict of interest policy set forth in Article 9 of these bylaws.

.
.
.

SECTION 7. REGULAR AND ANNUAL MEETINGS

Regular meetings of directors shall be held on ___(date)___ ❼ at ___(time)___ M,❼ unless such day falls on a legal holiday, in which event the regular meeting shall be held at the same hour and place on the next business day.

If this corporation makes no provision for members, then, at the annual meeting of directors held on ___(date)___ , ❼ directors shall be elected by the board of directors in accordance with this section. Cumulative voting by directors for the election of directors shall not be permitted. The candidates receiving the highest number of votes up to the number of directors to be elected shall be elected. Each director shall cast one vote, with voting being by ballot only.

.
.
.

SECTION 12. QUORUM FOR MEETINGS

A quorum shall consist of ___(state number or percentage, e.g., "a majority of the Board of")___ ❽ directors.

.
.
.

SECTION 14. CONDUCT OF MEETINGS

Meetings of the board of directors shall be presided over by the chairperson of the board, or, if no such person has been so designated or in his or her absence, the president of the corporation or, in his or her absence, by the vice president of the corporation or, in the absence of each of these persons, by a chairperson chosen by a majority of the directors present at the meeting. The secretary of the corporation shall act as secretary of all meetings of the board, provided that, in his or her absence, the presiding officer shall appoint another person to act as secretary of the meeting.

Meetings shall be governed by ___**("Robert's Rules of Order" or state other rules or procedures for conduct of directors' meeting)**___ , ❾ as such rules may be revised from time to time, insofar as such rules are not inconsistent with or in conflict with these bylaws, with the articles of incorporation of this corporation, or with provisions of law.

.

.

.

ARTICLE 5
COMMITTEES

SECTION 1. EXECUTIVE COMMITTEE

The board of directors may, by a majority vote of directors, designate two (2) or more of its members (who may also be serving as officers of this corporation) to constitute an executive committee and delegate to such committee any of the powers and authority of the board in the management of the business and affairs of the corporation, except with respect to:

(a) The approval of any action which, under law or the provisions of these bylaws, requires the approval of the members or of a majority of all of the members.

(b) The filling of vacancies on the board or on any committee which has the authority of the board.

(c) The fixing of compensation of the directors for serving on the board or on any committee.

(d) The amendment or repeal of bylaws or the adoption of new bylaws.

(e) The amendment or repeal of any resolution of the board which by its express terms is not so amendable or repealable.

(f) The appointment of committees of the board or the members thereof.

By a majority vote of its members then in office, the board may at any time revoke or modify any or all of the authority so delegated, increase or decrease but not below two (2) the number of its members, and fill vacancies therein from the members of the board. The committee shall keep regular minutes of its proceedings, cause them to be filed with the corporate records, and report the same to the board from time to time as the board may require. ❿

.
.
.

ARTICLE 8
FISCAL YEAR

SECTION 1. FISCAL YEAR OF THE CORPORATION

The fiscal year of the corporation shall begin on the __(day and month, e.g., "first day of January")__
⑪ and end on the __(day and month, e.g., "last day of December")__ **⑪** in each year.

.
.
.

ARTICLE 9 ⑫
CONFLICT OF INTEREST AND COMPENSATION APPROVAL POLICIES

SECTION 1. PURPOSE OF CONFLICT OF INTEREST POLICY

.
.
.

ARTICLE 13 ⑬
MEMBERS

SECTION 1. DETERMINATION OF MEMBERS ⑭

If this corporation makes no provision for members, then, pursuant to Section 9310(b) of the Nonprofit Religious Corporation Law of the State of California, any action which would otherwise, under law or the provisions of the articles of incorporation or bylaws of this corporation, require approval by a majority of all members or approval by the members, shall only require the approval of the board of directors.

WRITTEN CONSENT OF DIRECTORS ADOPTING BYLAWS

We, the undersigned, are all of the persons acting as the initial directors of ___(name of corporation)___, **⑮** a California nonprofit corporation, and, pursuant to the authority granted to the directors by these bylaws to take action by unanimous written consent without a meeting, consent to, and hereby do, adopt the foregoing bylaws, consisting of ___(number of pages)___ **⑮** pages, as the bylaws of this corporation.

Date: _____

___(signatures of director(s))_____ **⑮**

(typed name) , Director

 , Director

 , Director

 , Director

 , Director

.

.

.

CERTIFICATE

This is to certify that the foregoing is a true and correct copy of the bylaws of the corporation named in the title thereto and that such bylaws were duly adopted by the board of directors of said corporation on the date set forth below.

(Fill in Certificate date and signature of secretary later, after first board meeting) ⑯

Dated: ___(date)_____ ___(signature of secretary)_____

 (typed name) , Secretary

Responses for Board Meeting Dates

Regular meetings of directors shall be held on **the first Friday of each month** at **9 o'clock A.M.**....

Regular meetings of directors shall be held on **the second Monday of December** at **1 o'clock P.M.**....

Regular meetings of directors shall be held on **July 1 and February 20** at **9 o'clock A.M.**....

In the second paragraph of this section, fill in the blank to indicate which of your regular board meetings will be the annual regular meeting of the board, when you'll elect (or re-elect) directors of your corporation. Note that in a nonmembership corporation, the directors vote for their own reelection or replacements, with each director casting one written vote. Of course, if a corporation has provided for only one regular meeting each year in the first paragraph of this section, then the date of this regular meeting will be repeated in this blank as the date of the annual meeting of directors.

Responses for Annual Meeting Dates

If this corporation makes no provision for members, then, at the annual meeting of directors held on **January 1**, directors shall be elected...

If this corporation makes no provision for members, then, at the annual meeting of directors held on **the first Friday of July**, directors shall be elected...

The provisions in the second paragraph of this section affect only nonmembership corporations. Membership corporations can leave this line blank. Membership religious corporations will add membership provisions to their bylaws indicating the procedure for the election of directors by the members, as explained below.

❽ Indicate the number of directors who must be present at a directors' meeting to constitute a quorum so that business can be conducted. Although the usual practice is to provide for a majority, a nonprofit religious corporation can provide for a larger or smaller number.

Whatever number or percentage you decide on, understand that this section of the bylaws concerns a quorum, not a vote requirement. A meeting can be held only if at least a quorum of directors is present, but a vote on any matter before the board must be passed by the vote of a majority of those present at the meeting. (There are some exceptions to the majority-of-those-present rules—see Section 13 of Article 3 of the religious corporation bylaws.)

EXAMPLE: If a religious corporation with five directors provides for a majority quorum, then a quorum of at least three directors must be present to hold a meeting of directors. If three directors actually attend, then action can be taken at the meeting by the vote of two of the directors present (the majority vote of those present at the meeting).

❾ In this blank, indicate the rules of order that directors will use at their meetings. Although many nonprofits specify *Robert's Rules of Order* here, religious groups may wish to refer to rules established by their organization for the conduct of business at directors' meetings. Alternatively, you may wish to leave this item blank if you see no need to specify formal procedures for introducing and discussing items of business at your board meetings.

❿ The Nonprofit Religious Corporation Law allows you to form an executive committee of the board, which must have at least two board members and can have much of the management power of the full board. This section of the bylaws provides for an executive committee of board members only. Although at least two board members must serve on this committee, in practice most nonprofit corporations establish an executive committee of from three to five board members. Of course, you can set up other types of committees with or without board members (see Section 2 of this article in the complete bylaws).

⓫ Indicate the beginning and ending dates of the fiscal year of the corporation. The fiscal year of the corporation is the period for which the corporation keeps its books (its accounting period) and will determine the corporation's tax year for purposes of filing certain tax returns and reports. It may be the calendar year, from January 1 to December 31 (this is the usual case for nonprofits); or it may be what the IRS considers a true fiscal year, consisting of a 12-month period ending on the last day of any month other than December (for example, from July 1 to June 30).

⓬ Article 9 of the bylaws included in this book contains rules and procedures for approving or avoiding conflict-of-interest transactions, including compensation arrangements, between your nonprofit and its directors, officers, employees, contractors, and others. This bylaw provision contains the conflicts-of-interest language recommended by the IRS (included in the sample conflict-of-interest policy, in Appendix A, of the instructions to IRS Form 1023). It also contains language for the approval of compensation arrangements that attempts to comply with the safe harbor provisions of the excess benefit rules (see the discussion on the excess benefit rules in "Limitation on Profits and Benefits," in Chapter 3). You will need to become familiar with this provision, and make sure you are comfortable with its procedures for the approval and review of financial transactions with, and salary and other compensation paid to, your directors, officers, and others who are in a position to influence your nonprofit. If you decide to make changes to this provision, do so only after reading "Prepare Your Tax Exemption Application," instructions to Part V, in Chapter 8, where we refer to this bylaw provision when providing sample responses to questions on the application. If you make any changes, you will need to create your own responses to some of the questions on the 501(c)(3) application.

⓭ Last portion of Basic Religious Corporation Bylaws: The last portion of the basic bylaws (consisting of Article 13, Written Consent of Directors, and Certificate sections) is intended only for nonmembership groups. Membership religious corporations do not need to fill in and use this last portion of the basic bylaws—we show you how to add membership provisions to complete your bylaws below.

⓮ Section 1 of Article 13 makes it clear that the directors of nonmembership corporations can take the place of members in taking any action which, under law, otherwise requires membership approval (in other words, the directors can act in place of the members in nonmembership corporations).

⓯ Fill in the Written Consent of Directors paragraph, showing the name of the corporation and the number of pages in your final bylaws. Type your initial directors' names (the initial directors appointed by your incorporator pursuant to your Incorporator's Statement (see Chapter 6)) below the signature lines. After printing and dating the form, have each initial director sign the form.

⓰ Do not fill in the blanks following the Certificate at bottom of the bylaws at this time. Your corporate secretary will complete these blanks after the first meeting of your board.

Membership Bylaw Provisions for a Religious Corporation

This section applies only to religious membership corporations. If you have decided to form a nonmembership religious corporation, this section does not apply to you and you can skip ahead to Chapter 8.

Before we show you how to fill in your bylaws, let's deal with one possible area of confusion. Your religious corporation will probably want to refer to its supporters as "members"—of the congregation or church, for example. This gives your participants a feeling of participation, which will be important for you. Calling supporters members is perfectly okay, and you can do so without thereby establishing a formal membership corporation in the eyes of the IRS. In fact, most religious groups will not want a formal membership structure because of the active role legal members assume in the affairs of a membership corporation. As long as you don't, in your bylaws, give your members the legal status of formal members, you will not have established a formal membership corporation. (See "Membership Nonprofits," in Chapter 2, for a complete discussion of member and nonmembership corporations.)

General Instructions

Here are general instructions for filling in membership provisions for bylaws of a religious nonprofit corporation:

- The parenthetical blanks, "(_____)," in the sample form below indicate information that you must complete.

- Replace the blanks in the form with the information indicated in the blanks in the sample form below.
- Each circled number in the sample form (for instance, **❶**) refers to a special instruction that provides specific information to help you complete an item.
- A vertical series of dots in the sample form below indicates a gap where we have skipped over language in the complete form.
- To add membership provisions to your basic religious corporation bylaws, fill in the blanks in the membership provisions file, following the sample form and instructions below. Once completed, copy these membership provisions to your basic bylaws as explained in special instruction **❶** below.

Customizing Your Membership Bylaw Provisions

The Nonprofit Religious Corporation Law gives religious groups considerable flexibility to fashion many of their bylaw provisions. Accordingly, we've borrowed several membership provisions from the public benefit corporation bylaws discussed earlier. We think they make sense for most small membership religious organizations.

You may want to take advantage of the flexibility allowed religious corporations and customize these provisions. If you make modifications, make sure that they comply with the Nonprofit Religious Corporation Law (or have an attorney check your work). Most of the statutory religious corporation membership provisions are contained in Sections 9310 through 9420 of the Corporations Code. (See "Sample Bylaws," above, for instructions on how to find the Religious Corporation Law online).

Sample Membership Provisions

The sample bylaws below are an abbreviated version of the complete form available on the Nolo website (see Appendix A for the link). We've provided sample language and instructions for the few sections that contain blanks.

Special Instructions

Here are the instructions for filling in the blanks in the religious corporation membership provisions:

❶ After completing these membership provisions, copy the full text of this file to your basic religious bylaws—this material replaces Article 13, the Written Consent and Certificate sections, and signature lines at the end of your basic bylaws.

❷ Use this blank to indicate any special qualifications required for members. Please realize, however, that the IRS likes 501(c)(3) tax-exempt corporations to have membership in the corporation open to the general public. Consequently, most religious corporations will not specify any qualifications for membership (see the suggested wording in the blank on the sample form).

❸ Most religious corporations do not require members to formally apply for membership in the corporation. However, a few may wish to require members to pay an admission fee and/or annual dues prior to acceptance as a member in the corporation (see the suggested wording in the blank on the sample form).

❹ If you're going to require admission fees and/or annual dues for members, enter the amount or explain how you'll determine what the amount will be (see the suggested wording in the blanks on the sample form). If you won't charge application or admission fees (most groups won't), type "None" in both blanks.

❺ A membership corporation will need a process for removing members. The member-ship termination provisions in Section 9 of this Article are taken from the Public Benefit Corporation Law. They give due process to members, allowing them notice and an opportunity to be heard before the board decides whether they will be expelled. Although we think these provisions reflect a sensible set of rules, religious corporations are free to fashion their own procedures (Calif. Corp. Code § 9340(d)). If you wish to do so, replace the language of Section 9 with your own termination of membership rules.

❻ Under Section 9410(a) of the Corporations Code, religious corporations can specify any reasonable method of calling, noticing, and holding regular or special meetings of members (though there are some limitations, as mentioned below). Therefore, you may wish to replace the default procedures for calling, noticing, and holding meetings contained in the various sections of this Article with your own rules. For example, you might want to allow directors to call special meetings of members upon two days' telephone notice.

There are notice rules that apply when members approve certain types of actions by less than unanimous consent. These rules cannot be waived. These rules are listed in Section 4(f) of Article 14 of the religious corporation membership provisions. We won't list all the special cases here. If you wish to change the notice rules and wish to check these special cases, see Section 9410(b) of the Corporations Code. If you have a lawyer review your changes, ask him or her to make sure your changes conform to this section of the Corporations Code.

❼ Indicate the date and time of the annual meeting of members. The members elect directors at this annual meeting. You may wish to coordinate this date with your annual directors' meeting (for example, slightly before the annual directors' meeting).

<div style="text-align: center">

Membership Provisions

of

_____**(name of corporation)**_____

a California Religious Corporation

.

.

.

ARTICLE 13 ❶

MEMBERS

</div>

SECTION 1. DETERMINATION AND RIGHTS OF MEMBERS

The corporation shall have only one class of members. No member shall hold more than one membership in the corporation. Except as expressly provided in or authorized by the articles of incorporation or bylaws of this corporation, all memberships shall have the same rights, privileges, restrictions, and conditions.

SECTION 2. QUALIFICATIONS OF MEMBERS

The qualifications for membership in this corporation are as follows ___**(specify**___ **qualifications or, if none, type "Any person is qualified to become a member of this corporation")** ___. ❷

SECTION 3. ADMISSION OF MEMBERS

Applicants shall be admitted to membership ___**(state procedure, e.g., "on making** **application therefor in writing" and indicate if payment will be required, e.g., "and upon** **payment of the application fee and/or first annual dues, as specified in the following sections** **of this bylaw")** ___. ❸

SECTION 4. FEES, DUES, AND ASSESSMENTS

(a) The following fee shall be charged for making application for membership in the corporation: ___**(state specific admission fee or leave to discretion of board, e.g., "in such** **amount as may be specified from time to time by resolution of the board of directors charged** **for, and payable with, the application for membership," or, if no fee, type "None")** ___.

(b) The annual dues payable to the corporation by members shall be ___**(state amount of** **annual dues, leave to discretion of board, e.g., "in such amount as may be determined from** **time to time by resolution of the board of directors," or type "None")** ___. ❹

(c) Memberships shall be nonassessable.

.

.

.

SECTION 9. TERMINATION OF MEMBERSHIP ❺

(a) Grounds for Termination. The membership of a member shall terminate upon the occurrence of any of the following events:

(1) Upon his or her notice of such termination delivered to the president or secretary of the corporation personally or by mail, such membership to terminate upon the date of delivery of the notice or date of deposit in the mail.

(2) Upon a determination by the board of directors that the member has engaged in conduct materially and seriously prejudicial to the interests or purposes of the corporation.

(3) If this corporation has provided for the payment of dues by members, upon a failure to renew his or her membership by paying dues on or before their due date, such termination to be effective thirty (30) days after a written notification of delinquency is given personally or mailed to such member by the secretary of the corporation. A member may avoid such termination by paying the amount of delinquent dues within a thirty- (30) day period following the member's receipt of the written notification of delinquency.

(b) Procedure for Expulsion. Following the determination that a member should be expelled under subparagraph (a)(2) of this section, the following procedure shall be implemented:

(1) A notice shall be sent by first-class or registered mail to the last address of the member as shown on the corporation's records, setting forth the expulsion and the reasons therefor. Such notice shall be sent at least fifteen (15) days before the proposed effective date of the expulsion.

(2) The member being expelled shall be given an opportunity to be heard, either orally or in writing, at a hearing to be held not less than five (5) days before the effective date of the proposed expulsion. The hearing will be held by the board of directors in accordance with the quorum and voting rules set forth in these bylaws applicable to the meetings of the Board. The notice to the member of his or her proposed expulsion shall state the date, time, and place of the hearing on his or her proposed expulsion.

(3) Following the hearing, the board of directors shall decide whether or not the member should, in fact, be expelled, suspended, or sanctioned in some other way. The decision of the board shall be final.

(4) If this corporation has provided for the payment of dues by members, any person expelled from the corporation shall receive a refund of dues already paid. The refund shall be prorated to return only the unaccrued balance remaining for the period of the dues payment.

SECTION 10. RIGHTS ON TERMINATION OF MEMBERSHIP

All rights of a member in the corporation shall cease on termination of membership as herein provided.

ARTICLE 14
MEETINGS OF MEMBERS ❻

SECTION 1. PLACE OF MEETINGS

Meetings of members shall be held at the principal office of the corporation or at such other place or places within or without the State of California as may be designated from time to time by resolution of the board of directors.

SECTION 2. ANNUAL AND OTHER REGULAR MEETINGS

The members shall meet annually on ___(date, e.g., " the first Monday of July, September 30)"___ ❼ in each year, at ___(time)___ M, ❼ for the purpose of electing directors and transacting other business as may come before the meeting. Cumulative voting for the election of directors shall not be permitted. The candidates receiving the highest number of votes up to the number of directors to be elected shall be elected. Each voting member shall cast one vote, with voting being by ballot only. The annual meeting of members for the purpose of electing directors shall be deemed a regular meeting and any reference in these bylaws to regular meetings of members refers to this annual meeting.

Other regular meetings of the members shall be held on ___(date)___, ❽ at ___(time)___.M. ❽

If the day fixed for the annual meeting or other regular meetings falls on a legal holiday, such meeting shall be held at the same hour and place on the next business day.

.
.
.
.

SECTION 8. PROXY VOTING

Members entitled to vote ___("shall" or "shall not")___ ❾ be permitted to vote or act by proxy. If membership voting by proxy is not allowed by the preceding sentence, no provision in this or other sections of these bylaws referring to proxy voting shall be construed to permit any member to vote or act by proxy.

If membership voting by proxy is allowed, members entitled to vote shall have the right to vote either in person or by a written proxy executed by such person or by his or her duly authorized agent and filed with the secretary of the corporation, provided, however, that no proxy shall be valid after eleven (11) months from the date of its execution unless otherwise provided in the proxy. In any case, however, the maximum term of any proxy shall be three (3) years from the date of its execution. No proxy shall be irrevocable and may be revoked following the procedures given in Section 9417 of the California Nonprofit Religious Corporation Law.

If membership voting by proxy is allowed, all proxies shall state the general nature of the matter to be voted on and, in the case of a proxy given to vote for the election of directors, shall list those persons who were nominees at the time the notice of the vote for election of directors was given to the members. In any election of directors, any proxy which is marked by a member "withhold" or otherwise marked in a manner indicating that the authority to vote for the election of directors is withheld shall not be voted either for or against the election of a director.

If membership voting by proxy is allowed, proxies shall afford an opportunity for the member to specify a choice between approval and disapproval for each matter or group of related matters intended, at the time the proxy is distributed, to be acted upon at the meeting for which the proxy is solicited. The proxy shall also provide that when the person solicited specifies a choice with respect to any such matter, the vote shall be cast in accordance therewith.

SECTION 9. CONDUCT OF MEETINGS

Meetings of members shall be presided over by the chairperson of the board, or, if there is no chairperson, by the president of the corporation or, in his or her absence, by the vice president of the corporation or, in the absence of all of these persons, by a chairperson chosen by a majority of the voting members, present in person or by proxy. The secretary of the corporation shall act as secretary of all meetings of members, provided that, in his or her absence, the presiding officer shall appoint another person to act as secretary of the meeting.

Meetings shall be governed by __**("Robert's Rules of Order" or indicate other rules or procedures)**__ , ❿ as such rules may be revised from time to time, insofar as such rules are not inconsistent with or in conflict with these bylaws, with the articles of incorporation of this corporation, or with any provision of law.

.
.
.

WRITTEN CONSENT OF DIRECTORS ADOPTING BYLAWS

We, the undersigned, are all of the persons acting as the initial directors of __**(name of corporation)**__ , ⓫ a California nonprofit corporation, and, pursuant to the authority granted to the directors by these bylaws to take action by unanimous written consent without a meeting, consent to, and hereby do, adopt the foregoing bylaws, consisting of __**(number of pages)**__ ⓫ pages, as the bylaws of this corporation.

Date: _____

(signatures of director(s)) _____ ⓫
(typed name) _____ , Director

_____ , Director

_____ , Director

_____ , Director

_____ , Director

CERTIFICATE

This is to certify that the foregoing is a true and correct copy of the bylaws of the corporation named in the title thereto and that such bylaws were duly adopted by the board of directors of said corporation on the date set forth below.

(Fill in Certificate date and signature of secretary later, after first board meeting) ⓬

Dated: ___(date)___ ___(signature of secretary)___

 (typed name) , Secretary

❽ Type the date and time of any regular meetings of members. Many nonprofits will leave this line blank and decide to provide for only the annual meeting of members in their bylaws (you did this in the previous paragraph). Those with a more active membership will indicate monthly or semiannual regular meetings of members here.

❾ Indicate whether the corporation will allow proxy voting by members. (A proxy is simply a written authorization by a member allowing another person to vote for the member.) Many small membership corporations decide against proxy voting, to avoid problems and complications that can arise in times of controversy or difficult decisions (such as proxy wars or solicitations of proxies by outside or competing interests).

If you decide to allow proxies, the restrictions relating to proxies contained in the next sections of this Article will apply.

❿ Indicate, if you wish, the sets of rules that will govern the proposing and taking of action at your membership meetings. Robert's Rules of Order is the standard, but you may specify another set of procedures.

⓫ Fill in the Written Consent of Directors paragraph, showing the name of the corporation and the number of pages in your final bylaws. Type your initial directors' names (the directors appointed pursuant to your Incorporator's Statement (see Chapter 6)) below the signature lines. After printing and dating the form, have each initial director sign the form.

⓬ Don't fill in the blanks following the Certificate at the bottom of the bylaws at this time. Your corporate secretary will complete these blanks after your board's first meeting.

Replace the corresponding sections of your basic bylaws (Article 13 through the end of the bylaws) with these completed membership provisions. ●

Apply for Your Federal 501(c)(3) Tax Exemption

Now that you've filed your articles and prepared your bylaws, it's time to prepare your federal exemption application (IRS Form 1023). Obtaining your federal exemption is a critical step in forming your nonprofit organization because most of the real benefits of being a nonprofit flow from 501(c)(3) tax-exempt status. Most groups complete and submit their federal tax exemption applications before obtaining their state tax exemptions because state exemptions often are contingent on nonprofits obtaining their federal tax exemption first (see "Obtain State Corporate Income Tax Exemption" in Chapter 9). To make your tax exemption retroactive to the date of your incorporation, your 1023 application must be postmarked within 27 months from the end of the month in which you filed your articles of incorporation.

The standard Form 1023 tax exemption application is long and complicated; completing it can be a daunting task. Fortunately, the IRS now has a streamlined Form 1023-EZ tax exemption application that is much easier to prepare. The 1023-EZ application is only three pages long (as opposed to the 26-page standard 1023 form) and it is completed and filed online. If you qualify for the 1023-EZ form, you will want to use it because it is so much shorter and easier than the standard 1023 form. Most smaller nonprofits (those with gross receipts of $50,000 or less and assets of $250,000 or less) will be eligible to use the Form 1023-EZ.

If you don't qualify for the 1023-EZ application, you will have to prepare the standard Form 1023. There are two different PDF versions of the standard 1023 form available on the IRS website—an interactive and an accessible. Both of these PDF versions allow you to fill the application out on your computer, but with both of them you must print out and mail the form in to the IRS; it cannot be filed online. Nevertheless, filling the form out on your computer or other device should be easier and less time consuming than filling out a hard copy by hand. The most time consuming and difficult way to do the application is by hand. If you decide to do a hard copy by hand, remember that you will need to add attachment pages if the paper form does not have sufficient space for your responses (which is likely to occur).

Whichever form you use for your IRS tax exemption application (the online Form 1023-EZ, or the interactive, accessible, or hard-copy Form 1023), reading and following our line-by-line instructions should help you accomplish the task in substantially less time than it would otherwise take. We provide a lot of handholding and suggestions for responses to make the task of filling in your tax exemption application easier and less time consuming. And keep the following suggestion in mind: If you get stuck on a difficult question or run low on energy (as many do), take a break and return to it when you feel better able to follow and absorb the material. You will be well rewarded in the end for the time and effort you devote to this task.

> CAUTION
>
> **Special purpose nonprofits may use a different IRS form.** If yours is a special purpose nonprofit group (formed for other than religious, educational, charitable, scientific, or literary purposes), you're likely to be exempt under subsections of Section 501(c) other than Subsection (3). To apply for your federal tax exemption, you may need to use IRS Form 1024 instead of IRS Form 1023. Certain cooperative hospital service organizations and cooperative educational service organizations can use Form 1023. (See the Instructions to Form 1023 and Form 1023-EZ for more information on the application process for special purpose groups.)

Getting Started

Before diving into the task at hand, take a moment to read this section, which sets out the various tax forms and other IRS publications you'll encounter. We'll also give you tips on how to fill out the forms and deal with the additional information you may need to supply. Think of this portion of the chapter as your orientation.

Forms and Publications

You'll encounter several IRS forms as you make your way toward federal tax-exempt status. We go over these forms and provide information on how to complete them:

- IRS Form 1023-EZ, *Streamlined Application for Recognition of Exemption Under Section 501(c)(3) of the Internal Revenue Code*. This is a simple form that many small organizations can use to easily apply for their federal income tax exemption.
- IRS Form 1023, Package 1023: *Application for Recognition of Exemption Under Section 501(c)(3) of the Internal Revenue Code*. This is the "long form" application that organizations that do not qualify for the streamlined 1023-EZ form must use instead. There are a few versions that you can use. Best is the downloadable "interactive" PDF version of Form 1023. It provides help text and automatically provides extra space for long responses so you don't have to prepare attachment pages. Next best is the online "accessible" PDF version. It allows you to fill in the form within your browser, but you still need to manually create attachment pages for responses that don't fit in the pre-allocated space on the form. And if all else fails, you can download and fill in a printed

1023 form manually (with a pen). Follow the instructions provided on the IRS website to open and use each version of the 1023 form.
- Form SS-4, *Application for Employer Identification Number*. You can use this form to apply for an EIN for your organization (but it's easier to get your EIN online).
- Form 5768, *Election/Revocation of Election by an Eligible Section 501(c)(3) Organization To Make Expenditures To Influence Legislation*. This is a special form that only applies to certain politically active nonprofits.

We have made available on the Nolo website some federal IRS tax publications (see Appendix A for the link to access these forms). These publications are surprisingly readable and give a lot of practical information. You can get copies or updated versions by going online to www.irs.gov or by calling the IRS forms and publications request number, 800-TAX-FORM.

- Publication 557, *Tax-Exempt Status for Your Organization*
- Publication 4220, *Applying for 501(c)(3) Tax-Exempt Status*
- Publication 4221-PC, *Compliance Guide for 501(c)(3) Public Charities*
- Publication 4221-PF, *Compliance Guide for 501(c)(3) Private Foundations*, and
- Publication 1828, *Tax Guide for Churches and Religious Organizations*.

RESOURCE

You can find additional helpful information, including articles on special exempt organization issues, from the IRS website at www.irs.gov. Check the "Charities & Non-Profits" page under the "Help & Resources" tab. Also, see the IRS online workshops and minicourses at IRS Stay Exempt—Tax Basics for Exempt Organizations (www.stayexempt.org).

Ways to Complete the Tax Exemption Application

Most incorporators will fill in one of the computer-enabled versions of the 1023 application: the online Form 1023-EZ or one of the Form 1023 PDF (interactive or accessible) versions. The 1023-EZ form, which is the easiest form to prepare, can be filled in, paid for, and submitted online; no printing or mailing is necessary. The official instructions to the 1023-EZ, available on the IRS website, contain an Eligibility Worksheet that you use to determine if your group qualifies to use the easier streamlined 1023-EZ form. If you use Form 1023-EZ, you will be charged the lower $400 application fee and will not need to provide financial data or complete extra schedules.

TIP

A downside to using the 1023-EZ form. The 1023-EZ form asks you to select the public charity status that applies to you, while the standard 1023 form lets you hand off this decision to the IRS by checking a special box on the form. No worries, though—by referring to Chapter 4, you can make an informed decision as to the most appropriate public charity classification to select for your nonprofit on the 1023-EZ form.

If you use the standard 1023 form, you will have more paperwork to complete, including providing financial data and possibly preparing additional schedules. There are several versions of the standard 1023 form. We recommend using the downloadable "interactive" PDF version of the standard 1023 form, which provides help text and eliminates the need for manually creating attachment pages. Next best is the accessible PDF version of Form 1023, which you can open and fill in from your browser. Both the interactive and accessible PDF Form 1023s must be printed and mailed to the IRS along with a check for the user fee. You will be charged the higher $850 application fee if you expect to have annual gross receipts (total receipts before subtracting expenses) over $10,000. Otherwise you pay the lower $400 fee.

Technical law changes that affect how you fill in the Form 1023. If you use the printed Form 1023, you'll see that it starts with a notice that instructs you to ignore certain portions of the form and to include additional financial information. (Our instructions, below, also include this updated information.) The reason for including the notice is that the IRS has not updated the 1023 form to reflect changes in the law. More specifically, the IRS adopted regulations that eliminated the advance ruling process for 501(c)(3) organizations. This was a technical process that some new organizations had to use when applying for their income tax exemption. The good news is that new organizations no longer have to be concerned with advance rulings and the technical rules that apply to them. The bad news is that the 1023 form still includes questions that apply to advance rulings as well as an incomplete financial data section to fill in. Hence, the notice at the beginning of the standard 1023 form tells you to ignore the advance ruling questions on the form and tells you how to provide additional financial data.

Note that the 1023 PDF forms that you fill in on your computer—the downloadable interactive 1023 form and the browser-friendly accessible 1023 form—do not include the updated notice with a summary of the new rules for completing your 1023 application. However, the interactive form helps a little in that it blocks out the old information that you do not need to fill in, and provides an

extra column in the financial data section for you to provide the required additional financial information under the new rules. The accessible form, though, follows the old format, and is not updated to reflect the new rules. So please do the following when filling in either the downloadable interactive 1023 PDF or the accessible PDF on your computer: *Read the notice (Notice 1382) that is printed at the beginning of the latest standard 1023 form (included at the top of the 1023 form in Appendix B) and/or refer to our instructions below before filling in the 1023 form.* By reading the notice, you'll get a good idea of what to do and not to do when filling in PDF versions of the form on your computer. By following our instructions as you work your way through the form, you'll be sure to include and exclude the appropriate information.

All versions of the 1023 form are available online from the IRS website. Go to the IRS website (www.irs.gov) and type "1023" in the search box to see links to each of the 1023 forms. If you use the standard printed 1023 form in Appendix B, make sure it is the current version by going to the IRS website to check the revision date of the latest 1023 form posted there. You also can obtain the latest IRS forms by calling 800-TAX-FORM.

There may be one more way to prepare and submit your exemption application. On the IRS website, check to see if the IRS has launched the "Cyber Assistant" program, an online program that will allow users to prepare and file the Form 1023 application online for a reduced filing fee. This program has been delayed several times and there is no new launch date. Our guess is that this program has been put on hold indefinitely since the IRS now provides an online 1023-EZ form that can be filled in and submitted online. In any case, it doesn't hurt to check to see if this additional service is available.

Preliminary Reading

Before starting your federal tax exemption application, read the Instructions to Form 1023-EZ, available from the IRS website, and go through the included Eligibility Worksheet to see if you qualify to use the EZ form. Most smaller new groups with modest expectations as to gross receipts ($50,000 in receipts annually before deducting expenses) and assets ($250,000 or less) that are not setting up an institutional nonprofit (such as a school, hospital, or church) should qualify. If you do not qualify, you will need to use one of the standard 1023 forms, in which event you will want to read the instructions to Form 1023, available on the IRS website.

All groups should also skim through Chapters 1, 2, and 3 of IRS Publication 557 and Publications 4220 and 4221-PC—the information there covers the basic requirements for obtaining a 501(c)(3) tax exemption.

Also, take a look at the IRS Form 990 Annual Return and Instructions. This form, called *Return of Organization Exempt From Income Tax*, must be filed each year with the IRS by 501(c)(3) organizations. It is an information return that the IRS uses to monitor the structure, activities, and finances of 501(c)(3) nonprofits. The annual disclosure requirements of the Form 990 are substantial, so look at the form and its schedules before you leap into applying for your tax exemption. You'll see that you will need to monitor and account for many of your nonprofit's financial and operational details throughout its life.

There are some exceptions to the Form 990 filing requirements. Churches and certain other types of nonprofits are not required to file Form 990. Also, if your nonprofit normally has receipts of $50,000 or less, it can file Form 990-N (an e-Postcard) instead of Form 990.

Smaller nonprofits that don't qualify to file the 990-N postcard may qualify to file a simplified 990-EZ form instead of the standard 990 form. (See the Form 990, 990-EZ, and 990-N instructions on the IRS website for more information on Form 990 filing requirements.)

If you find this reading a bit technical, don't let it bog you down. The information in this book, together with our line-by-line instructions for the forms, should be enough to get you through the process. If necessary, you can always refer back to the IRS publications and instructions when answering questions or filling out schedules.

Adding Attachment Pages

If you complete the online 1023-EZ or the interactive downloadable 1023 PDF form, you won't need to manually add pages to your application (the interactive PDF form expands to provide added space or if you need to add additional information in your responses). However, if you prepare the accessible 1023 PDF form or manually fill in the printed Form 1023, you may need to continue some of your longer responses on an attachment page or pages. If so, use letter-sized paper (8½" x 11") and include the following information:

- the name and EIN (Employer Identification Number) of your corporation, at the top of each attachment page
- for each response, state the part and line number to which the response relates. Also provide a description, if appropriate (see the sample attachment page below).
- the page number in the header or footer of each page if you include more than one attachment page to your application. (Many groups will have multiple attachment pages.)

You do not need to have a separate attachment page for each attachment response—just list your responses one after the other on your attachment pages (as shown on the sample below).

Attachments can also be used to indicate you are including additional information as exhibits to your application. For example, with all 1023 forms (except 1023-EZ), you will need to attach documents, such as articles and bylaws, and other materials, such as copies of solicitations for financial support, to your application. Mark each document as an exhibit and label them in alphabetical order. You can write the exhibit letter at the top of the document, or you can staple a page or note to the first page of the document and write the exhibit reference (for example "Exhibit A") on the cover page or note. We recommend that you use a separate cover page or note for your certified copy of your articles of incorporation, since the articles you include as an exhibit should exactly match the articles you filed with the secretary of state. Make sure each document has a heading that identifies its content and the name and EIN of your nonprofit. The copies of your legal documents should have headings printed on the first page already, such as "Articles of [name of your corporation]" or "Bylaws of [name of your corporation]." Put similar identifying headings on all financial statements and other exhibits you prepare yourself and number each page if the document has multiple pages.

Public Inspection Rights

As you begin entering information on the federal form (whether online or manually), keep in mind that members of the public, not just some anonymous IRS application examiner, can obtain access to the information you provide in your exemption application. So, don't include Social Security numbers, bank account information, home addresses, or other personal information that you do not wish to disclose to

the public in your tax exemption application or the attachments. Your federal 1023 tax exemption application, any papers submitted with the application, and your tax exemption determination letter from the IRS must be made available by your organization for public inspection during regular business hours at your organization's principal office. However, any information that has been submitted to the IRS and approved by it as confidential is not required to be publicly disclosed (see "How to Keep Form 1023 Information Confidential," below), and you do not have to disclose the names and addresses of contributors if you qualify as a public charity—which we assume you will.

How to Keep Form 1023 Information Confidential

Any information submitted with your 1023 is open to public inspection. However, if an attachment or response to your application contains information regarding trade secrets, patents, or other information that would adversely affect your organization if released to the public, you can clearly state "NOT SUBJECT TO PUBLIC INSPECTION" next to the material and include your reasons for requesting secrecy. If the IRS agrees, the information will not be open to public inspection.

IRS Regulation 301.6104(a)-5 says that the IRS will agree if you convince it that "the disclosure of such information would adversely affect the organization."

If your organization regularly maintains one or more regional or district offices having three or more employees (defined as offices that have a payroll consisting of at least 120 paid hours per week), you must make copies of the documents available for public inspection at each of these offices. Copies of your organization's three most recent annual information returns must also be available for public inspection at your principal office (and, if applicable, your regional or district office).

Members of the public can also make a written request for copies of your organization's tax exemption application and its tax returns for the last three years. You must comply within 30 days and are allowed to charge only reasonable copying and postage costs. The public also can request copies or public inspection of your organization's exemption application or its annual returns by calling IRS Exempt Organizations Customer Account Services at 877-829-5500. These public inspection requirements apply to 501(c)(3) public charities, not to 501(c)(3) private foundations—again, we expect most incorporators to qualify as public charities.

It's important to comply with inspection requests. If you don't permit public inspection, you could face a $20-per-day penalty. The IRS will impose an automatic $5,000 additional penalty if your failure to comply is willful. These penalties are not imposed on the organization—they are applied against "the person failing to meet (these) requirements." (See IRS Publication 557 and IRC §§ 6104(e), 5562(c)(1)(C) and (D), and 6685 for further information on these rules.)

FORMS AND RESOURCES

For additional information about IRS regulations on required disclosures by 501(c)(3) nonprofits, see Update: The Final Regulations on the Disclosure Requirements for Annual Information Returns and Applications for Exemption, available on Nolo's website (see Appendix A for the link). Also see *Every Nonprofit's Tax Guide*, by Stephen Fishman (Nolo), for information about the Form 990 and other key nonprofit tax issues.

FORMS AND RESOURCES

See Disclosure, FOIA, and the Privacy Act, for additional information on the restrictions applicable to the IRS and its employees regarding disclosures of information submitted to the IRS. The document is available on the Nolo website; see Appendix A for the link.

The Consequences of Filing Late

You should file your 1023 within 27 months after the end of the month in which you filed your articles of incorporation. In our experience, the most common problem faced by nonprofits is failing to file their Form 1023 on time. What happens if you file late?

First, if you file on time (within 27 months of incorporating) and the IRS grants your exemption, the exemption takes effect on the date on which you filed your articles. The same is true if you can show "reasonable cause" for your delay (this means you have convinced the IRS that your tardiness was understandable and excusable). If you file late and don't have reasonable cause (or the IRS doesn't buy your story), your tax-exempt status will begin as of the postmark date on your form. (For more information, see "Prepare Your Tax Exemption Application," Part VII, below and the instructions to Schedule E in "Filling Out the Schedules," below.)

If your nonprofit has been organized for several years and you're just now getting around to filing your Form 1023, don't despair—you've got plenty of good company. The important point here is to persevere, complete your application, and mail it to the IRS as soon as possible.

Do You Need to File Form 1023?

Almost all nonprofit groups that want 501(c)(3) tax-exempt status will file an application for a federal tax exemption (Form 1023 or Form 1023-EZ). Your application for recognition of exemption serves two important purposes:

- It is used by nonprofit organizations to apply for 501(c)(3) tax-exempt status.
- It serves as your notice to the IRS that your organization is a public charity, not a private foundation. Remember, as discussed earlier, the IRS will presume that your 501(c)(3) nonprofit group is a private foundation unless you notify the IRS that you qualify for public charity status.

There's an additional reason that California nonprofits should apply for their federal tax exemption. Namely, once a California nonprofit gets its federal exemption, all it needs to obtain a California tax exemption is to file Form FTB 3500A, *Submission of Exemption Request*, with a copy of the federal determination letter. This FTB 3500A form is a whole lot simpler than separately applying for a California tax exemption (by filling out the full FTB 3500 form). Further, the information required to fill out the California application is the same or similar to that required to complete the federal form, so why do this (arduous) work twice—once to apply for the state exemption, and possibly later when you are required or wish to apply for the federal tax exemption? This book assumes that all organizations will seek to obtain a California income tax exemption after successfully applying for and obtaining their federal 501(c)(3) income tax exemption (and will, therefore, be eligible to use Form FTB 3500A to request a California income tax exemption).

This said, there are a few groups that are not required to file an application for a 501(c)(3) tax exemption. You aren't required to file if you are:

- a group that qualifies for public charity status and normally has gross receipts of not more than $5,000 in each tax year. (The IRS uses a special formula to determine whether a group "normally" has annual gross receipts of not

more than $5,000—for specifics, see IRS Publication 557, "Organizations Not Required to File Form 1023," "Gross Receipts Test.")

TIP

Something to keep in mind. You need to file an application for a 501(c)(3) tax exemption within 90 days of the date your organization has annual gross receipts over $5,000. (See "Schedule E," Line 2(a)–2(b) instructions, below, for more information on how this works.) If you think it likely that your organization will exceed this gross receipts threshold sometime in the near future, it's probably best to go ahead and apply for your 501(c)(3) income tax exemption now.

- a church (a church includes synagogues, temples, and mosques), interchurch organization, local unit of a church, convention, or association of churches, or an integrated auxiliary of a church, or
- a subordinate organization covered by a group exemption letter (but only if the parent organization timely submits a notice to the IRS covering the subordinate organization—see the group exemption letter requirements in IRS Publication 557).

Even if one of the above exceptions applies to you, we recommend that you file a tax exemption application anyway. Why? First, it's risky to second-guess the IRS. If you're wrong and the IRS denies your claim to 501(c)(3) tax status several years from now, your organization may have to pay substantial back taxes and penalties. Second, the only way, on a practical and legal level, to assure others that you are a bona fide 501(c)(3) group is to apply for an exemption. If the IRS agrees and grants your tax exemption, then, and only then, can you assure contributors, grant agencies, and others that you are a qualified 501(c)(3) tax-exempt, tax-deductible organization listed with the IRS.

Prepare Your Tax Exemption Application

Now it's time to fill in your tax exemption application (either online, in your browser, or manually, according to the type of application form you use, as explained earlier). First, go through the Form 1023-EZ Eligibility Worksheet at the end of the official instructions to the 1023-EZ form to see if you qualify to use the 1023-EZ. If you qualify to use the 1023-EZ, answer the online questions as you follow our first set of instructions for Form 1023-EZ, below. If you don't qualify, you'll have to use one of the 1023 forms (the interactive, accessible, or printed version, as explained earlier), and should go on to our second set of instructions for Form 1023, below.

Instructions for Form 1023-EZ

Below are the instructions to help you answer the online Form 1023-EZ questions. Many are self-explanatory and easy to answer. We provide a few pointers to help you understand what the IRS is looking for. For some items, we point you to instructions that we provide for Form 1023. Also look at the official instructions to Form 1023-EZ for additional guidance as you fill in this form online from the IRS website.

Part I: Identification of Applicant

Line 1(a)–(e). Write the name of your corporation exactly as it appears in your articles of incorporation. Provide the mailing address of the corporation. If you do not have a street address, provide a post office box address. The IRS wants you to include the full nine-digit zip code in your address. Include it if you know it. (Zip code information can be obtained online at the U.S. Postal Service Zip Code lookup page.)

Line 2. You'll need an EIN for your nonprofit corporation. (See Form 1023 instructions, below, Part I, Item 4, for information on how to get one.)

Line 3. Insert the month your corporation's tax year ends. Use a two-digit month number for your response. (See Form 1023 Instructions, below, Part I, Line 5, for more information.)

Lines 4–6. State the name of a director or officer the IRS can contact regarding your application, the phone number where this person can be contacted during business hours, and a fax number. The fax number is optional—if you don't want to provide one, insert "N/A" or "not applicable."

Line 7. Insert "$275," which is the lower user fee that you pay if you qualify to use Form 1023-EZ.

Line 8. List the names, titles, and mailing addresses of your officers, directors, or trustees. Only list five. If you have more than five, select the ones to be listed as explained in the official instructions to Form 1023-EZ. Most smaller nonprofits have a president (or CEO), treasurer (or CFO), secretary, and perhaps a vice president and/or chairman of the board. If a person serves in more than one capacity, only list the person once and show the title of all positions held by that person. You can use the address of the corporation as the mailing address of your directors and officers.

Line 9. If applicable, list the website address of your nonprofit, and its email address. Any website content should be consistent with your nonprofit purposes and program as described in your 1023 application. Insert "N/A" if either item is not applicable.

Part II: Organizational Structure

Line 1. Check the corporation box.

Line 2. Check this box to indicate that you have the required organizing document; namely, articles of incorporation that have been certified as having been filed with the state.

Line 3. Insert the date your articles were filed by the California Secretary of State in mm/dd/yyyy format, such as 01/05/2017.

Line 4. Insert "California" as your state of incorporation.

Lines 5–7. When you use the standard California articles for public benefit or religious nonprofit corporations (see Chapter 6), you should be able to check each of these three boxes to indicate that your articles of incorporation contain the required provisions with respect to 501(c)(3) purposes, limitation of activities, and dedication of assets.

Part III: Your Specific Activities

In this section, the IRS wants to get an idea of how your nonprofit will actually operate. In some cases, your response may result in follow-up questions from the IRS (for example, if you indicate that you will pay officers or directors or engage in legislative activity, the IRS may want to make sure that the compensation is reasonable or the political activities insubstantial before granting your exemption). It's best to be as honest as you can at the start, and dispose of any issues the IRS raises early on, to avoid any potential problems later. Before filling in this section, read the official 1023-EZ instructions for each of the questions in this section; these instructions provide or point you to more information on some of the issues, activities, and purposes listed in this section.

Line 1. The list of 3-character NTEE Codes is included in the official 1023-EZ instructions. Select the one that best matches your 501(c)(3) purposes and/or activities.

Line 2. Check the box(es) that match(es) your 501(c)(3) purpose(s) contained in Article 5 of the California public benefit or religious corporation articles. Note that even though Article 5 of the standard public benefit articles refers only

to Article 2a, which mentions "charitable" purposes, this 2a statement is meant to help you comply with the California public benefit corporation law. You should check any box(es) that match the specific tax-exempt purposes mentioned in your short statement of specific purpose in Article 2b (Charitable, Educational, Scientific, Literary). Nonprofits filing California religious nonprofit articles will check the "Religious" box.

Line 3. You should be able to check this box to show that you will abide by these 501(c)(3) operational requirements (see Chapter 3, "Other Requirements for 501(c)(3) Groups," for more information on these requirements).

Line 4. If you will attempt to influence legislation, check this box. For the 501(c)(3) limits on this activity, and to consider whether you should make an election using Form 5768, see Chapter 3, "Limitation on Political Activities."

Line 5. If you will pay your officers or directors (or think you will), check the "Yes" box. We've already explained the basic 501(c)(3) prohibition against private inurement and the excess benefit rules that penalize nonprofits and their managers if they pay unreasonable compensation to insiders and outsiders (see the discussion on the excess benefit rules in "Limitation on Profits and Benefits," in Chapter 3).

Lines 6–11. If you check "Yes" to any responses, the IRS may ask for additional details in follow-up questions to ensure that your nonprofit is operating within allowable 501(c)(3) limits. These are: no private inurement or special benefits to individuals (including directors and officers); only incidental—not substantial—unrelated business income; no support to restricted foreign entities; and no bingo or gaming activities. Here are some pointers for more information on some special issues associated with these items:

- **Unrelated Business Income.** If you anticipate that your organization will earn $1,000 or more in annual unrelated business income, the IRS may send you additional questions to determine, based on the description you provide of your proposed operations, that such business income will not be a primary activity of your nonprofit (see Chapter 3, "Unrelated Business Activities"). Also be prepared to file annual 990-T forms as explained in "Federal Corporate Tax Returns" in Chapter 10.
- **Bingo and gaming.** See IRS Publication 3079, *Tax-Exempt Organizations and Gaming.*
- **Foreign operations.** Special tax exemption and deductibility of contribution rules apply to nonprofits created or operated abroad. If you plan to operate or provide assistance abroad, you may wish to seek guidance from a nonprofit adviser who has experience in advising nonprofits that operate in the foreign countries where you plan to operate. Also see "Foreign Organizations in General" in the official standard Form 1023 instructions for basic information on nonprofits formed abroad. Finally, realize that a big part of the IRS's energies is now devoted to scrutinizing the operations of foreign-based nonprofits as part of the service's participation in antiterrorism. Here is an excerpt from the IRS 2005 EO (Exempt Organization) report:

 In FY 2005, EO will examine a sample of foreign grant making organizations, the primary focus of the examinations is to ensure that funds are used for their intended charitable purpose and not diverted for terrorist activity. The project will gather information about current practices, that is, the existence and effectiveness of controls put in place to monitor the distribution of overseas grants and other assistance. This committee will also address the need for possible guidance or other modifications to the laws in this area.

- **Disaster Relief.** The IRS may prioritize the processing of your application if your organization provides disaster relief. (For more information, see IRS Publication 3833, *Disaster Relief: Providing Assistance Through Charitable Organizations.*)

Part IV: Foundation Classification

This is a technical section, which seeks to determine whether your 501(c)(3) will be a public charity or a private foundation. To help you answer the questions in this section, reread Chapter 4, where we explain the importance of qualifying your 501(c)(3) tax-exempt organization as a public charity and explain the three basic ways your organization can qualify as a public charity. Also read the official 1023-EZ instructions for this section.

The first thing to note is that certain nonprofits that may qualify for public charity status (we call this category "Automatic Public Charity Status" in Chapter 4), including churches, schools, and hospitals, do not qualify to use Form 1023-EZ (they have to check "Yes" to a question on the 1023-EZ Eligibility Worksheet, and hence do not qualify to use 1023-EZ). These "institutional" nonprofits have to use Form 1023 to apply for their tax exemption and public charity status. Therefore, this section of the 1023-EZ only applies to groups that can qualify as a public charity because of the types of public support or exempt purpose revenue they receive (they qualify as a public charity under either the "Public Support Test" or the "Exempt Activities Support Test" as described in Chapter 4).

Line 1. Check one of the boxes in this section to tell the IRS how you plan to qualify as a public charity:

- (a) Check this box if you anticipate qualifying as a public charity under the "Public Support Test" covered in Chapter 4.

- (b) Check this box if you anticipate qualifying as a public charity under the "Exempt Activities Support Test" covered in Chapter 4.

- (c) Certain organizations operated for the benefit of a governmental college or university (e.g., state school) qualify as public charities. We assume you are not forming this special type of nonprofit, but if you are, see a nonprofit specialist with experience with this sort of organization for guidance in forming your nonprofit and obtaining your tax-exemption and qualifying as a public charity.

Line 2. We assume readers will check box 1(a) or (b) to seek public charity status for their 501(c)(3) tax-exempt organization. If you do not think you qualify to check either the 1(a) or (b) box, and end up prepared to check box 2, you should get the help of a nonprofit adviser to form a private foundation and obtain its 501(c)(3) tax exemption (see Chapter 4, "Private Foundations" for more information).

Part V: Reinstatement After Automatic Revocation

You can ignore this section. It is used by nonprofits that have already obtained and lost their 501(c)(3) exemption due to a failure to file their annual IRS Form 990 informational tax returns. (Read the official 1023-EZ instructions to this section for more information). It's good to know that Form 1023-EZ can be used for this purpose, but by staying on top of your ongoing nonprofit tax filing responsibilities after you obtain your tax exemption (see Chapter 10), you will never need to do so.

Submit 1023-EZ Online

You fill in, submit, and pay the filing fee for Form 1023-EZ online. Follow the instructions on the IRS website to submit the form and pay the user fee.

Instructions for Form 1023

Below are the instructions to help you answer the questions on the Form 1023 tax exemption application. If you do not qualify to use the 1023-EZ online application as explained in the previous section, you will need to apply for your tax exemption by completing one of the 1023 forms (interactive, accessible, or printed version, which we describe at the beginning of this chapter). The official IRS instructions along with our instructions, below, should help you perform this task.

Part I: Identification of Applicant

Line 1: Write the name of your corporation exactly as it appears in your articles of incorporation.

Line 2: If you have designated one person in your organization to receive return mail from the IRS regarding your 1023 application, such as one of the founders, list this person's name as the "c/o name." Otherwise, insert "not applicable."

Line 3: Provide the mailing address of the corporation. If you do not have a street address, provide a post office box address. The IRS wants you to include the full nine-digit zip code in your address. Include it if you know it. (Zip code information can be obtained online at the U.S. Postal Service zip code lookup page.)

Line 4: All nonprofit corporations (whether or not they have employees) must obtain a federal Employer Identification Number (EIN) prior to applying for 501(c)(3) tax exemption. You will insert this number here on your 1023 form and use this identification number on all your future nonprofit federal information, income, and employee tax returns. Even if your organization held an EIN prior to incorporation, you must obtain a new one for the nonprofit corporate entity. If your nonprofit corporation has not yet obtained an EIN, it should do so now.

The easiest and quickest (and IRS-preferred) way to get an EIN is to apply online from the IRS website. Go to www.irs.gov and type "EIN" in the upper search box. Then click "Go" to open a page that lists links to EIN-related Web pages. You should see a link to the online EIN application. You can file this version of IRS Form SS-4, *Application for Employer Identification Number,* online. Fill in and submit the application to receive your EIN immediately.

Follow the instructions, below, when completing the SS-4 form:

- **Name and SSN of officer.** You will need to specify the name and Social Security number of one of your principal officers. Normally the chief financial officer or treasurer will provide a name and SSN here.

- **Type of entity.** Check "church or church-controlled organization" if you are forming one; if not, check "other nonprofit organization" and specify its 501(c)(3) purpose (educational, charitable, and so on).

- **GEN number.** Most groups will ignore this item—it applies only to a group exemption application request. Members of an affiliated group of nonprofits can specify a previously assigned Group Exemption Number.

- **Reason for applying.** Check "started new business," then specify "formed nonprofit corporation" in the blank. If (with the help of a lawyer) you are converting an existing unincorporated association (that has previously filed any appropriate tax returns for its association tax years with the IRS) to a nonprofit corporation, you can check "changed type of organization" instead, then insert "incorporation" in the blank.

- **Date Business Started.** The date you started your business is the date your articles were filed with the state filing office. Use the file-stamped date on the copy of your articles returned by the state office.

• **Employees.** You can enter zeros in the next item that asks the number of employees you expect to have in the next 12 months.

Make sure to write down your EIN immediately before changing webpages—you will not be able to back up and retrieve the EIN after you navigate away from the webpage. Print a copy of the online form (you can do this by clicking the "Print Form" button on the IRS webpage after receiving your EIN), write the assigned EIN in the upper-right space of the printed form, then date and sign it, and place the copy in your corporate records.

You also can apply for an EIN by phone. To do this, fill in the SS-4 form (available on the IRS website, or included on the Nolo website—see Appendix A for the link). Then call the IRS at 800-829-4933—be sure to complete the form before making the phone call. If you apply by phone, you will be assigned an EIN immediately. Write this number in the upper right-hand box of a printed SS-4 form, then date and sign it, and keep a copy for your records. The IRS telephone representative may ask you to mail or fax a copy of your signed SS-4 form to the IRS.

You also can apply for an EIN by fax and get your EIN faxed back to you within four business days. (See the instructions to Form SS-4 for more information on using the IRS Fax-TIN program.)

Finally, you can get an EIN the slow way by simply mailing your SS-4 form to the IRS. Have an officer—typically the CFO or treasurer—sign the form, stating his or her title. Expect to wait at least four weeks. Remember, you can't complete line 4 of your 1023 form until you have your EIN.

Line 5: Specify the month your accounting period will end. Use a two-digit number for your response. For example, if your accounting period will end December 31, insert "12." The accounting period must be the same as your corporation's tax year. Most nonprofits use a calendar year as their accounting period and tax year. If you choose to do the same, specify "12" here.

If you anticipate special seasonal cycles for your activities or noncalendar year record keeping or grant accountability procedures, you may wish to select a noncalendar accounting period for your corporation. For example, a federally funded school may wish to specify June ("06") in this blank, which reflects an accounting period of July 1 to June 30.

If you have any questions regarding the best accounting period and tax year for your group, check with your (probable) funding sources and consult your accountant or bookkeeper for further guidance.

Lines 6(a)–6(c): State the name of a director or an officer the IRS can contact regarding your application, the phone number where this person can be contacted during business hours, and a fax number. The fax number is optional—if you don't want to provide one, insert "not applicable." We suggest you list the name and telephone number of the director or officer who is preparing and will sign your tax exemption application (see Part XI, below). Nevertheless, don't expect the IRS to call to ask questions. If the IRS has questions about your application, it will usually contact you by mail.

Line 7: We assume you are filling in your 1023 form yourself, and will mark "no" to this item. However, if you are being helped by a lawyer, an accountant, or another professional representative, mark "yes" to allow the representative to talk on your behalf with the IRS about your 1023 application. If you mark "yes," you will need to complete and attach an IRS Form 2848, *Power of Attorney and Declaration of Representative* (available from the IRS website), to your 1023 application.

Line 8: We assume most readers will answer "no" here. However, if you have paid or plan to pay an outside lawyer, accountant, or other

professional or consultant to help you set up your nonprofit or advise you about its tax status, and the person is not acting as your formal representative (named in Form 2848, as explained in line 7, above) and the person is not a director, an officer, or an employee of your nonprofit, answer "yes" and provide the requested information. Traditionally, many nonprofits get professional guidance from unpaid lawyers and accountants who serve as volunteers to their board. If this is your situation, you can answer "no," since this item is asking about paid advice from an outsider. There is nothing wrong in paying an outsider for help. The purpose of this question is to require full disclosure of any paid relationships between your nonprofit and its advisers, to make sure the compensation arrangement is fair to the nonprofit, and to see that there is no obvious conflict of interest between the person's role and his or her paid status. An overriding concern of the IRS is to make sure that one person is not personally directing the organization and operation of your nonprofit to further personal financial interests and agendas.

Many professionals are being more careful these days and will shy away from providing professional advice on nonprofit boards unless they are indemnified and covered by directors' liability insurance. Some paid advisers will automatically say "no" when asked to sit on a nonprofit board because they do not want to confuse their role as adviser to the nonprofit entity (their real client to whom they owe a professional duty) with the separate task of acting as an adviser to the board and its individual members.

Lines 9(a) and 9(b): Insert the URL for your nonprofit's website, if you have one. Any website content should be consistent with your nonprofit purposes and program as described in your 1023 application. Also, provide an email address to receive educational information from the IRS in the future. The email address is optional. If you can't provide either of these items, insert "not applicable" in the blank.

Line 10: Some nonprofits using this box will be eligible for an exemption from filing IRS Form 990, the annual information return for nonprofits, or the shorter 990-EZ form for smaller groups (see "Federal Corporate Tax Returns" in Chapter 10). If you are reasonably sure you will be exempt—for example, if you are forming a church or know that you will have gross receipts of less than $25,000 per year—mark "yes" and state the reason why you are exempt on an attachment page. All other nonprofits using this book should mark "no" here. Remember, even if your nonprofit has $25,000 or less in gross receipts, it must file Form 990-N (e-Postcard) each year.

We think it is wise to file 990 returns each year, even if you and the IRS initially agree that your group should be exempt from filing the returns. Why? Because you may fail to continue to meet the requirements for the exemption from filing, and may get hit with late-filing penalties if you have to go back and file your returns for prior years that you missed. By filing a return, even if not required, you normally start the running of the time frame during which the IRS can go back and audit your nonprofit tax returns. And your filed 990 can come in handy in many states for meeting your state income tax and any state attorney general filing requirements. Groups exempt from the 990 filing requirements may still have to file a Form 990-N postcard or make the 990-N filing online from the IRS website. (See Chapter 10 for the federal tax filing requirements.)

Line 11: Insert the date your articles were filed by the secretary of state in mm/dd/yyyy format, such as 01/05/2014.

Line 12: We assume you will mark "no." If you are seeking an IRS 501(c)(3) tax exemption for a corporation formed abroad, mark "yes,"

insert the name of the country, and seek additional help from an adviser who can assist you through your more complicated tax exemption application process.

Part II: Organizational Structure

Line 1: Most tax-exempt nonprofits are formed as nonprofit corporate entities, and we expect you to follow the standard practice of forming a corporation too. Check "yes" to indicate that your group is a corporation and attach a copy of your articles to your application. The copy should be a certified copy you received from the state filing office. It should show a file-date stamp on the first page or include a certification statement or page that states it was filed with the state and is a correct copy of the original filed document.

Line 2: We assume you will check "no" to indicate that you are not seeking a tax exemption for an LLC. Very few nonprofits are formed as limited liability companies. If this is what you are attempting to do, you should consult with an experienced lawyer.

Line 3: We assume you will check "no" here because we expect readers to form a traditional nonprofit tax-exempt corporation, not an unincorporated association. An unincorporated association requires special paperwork (association charter or articles and association operating agreement), and it leaves the members potentially personally liable for the debts of and claims made against the association. If you are applying for a tax exemption for an unincorporated association, you should check with a lawyer before applying for your tax exemption.

Lines 4(a) and 4(b): Check "no" to show that you are not applying for a tax exemption for a nonprofit trust. If you are interested in establishing a tax-exempt trust, see an expert.

Line 5: Check "yes" and attach a copy of the bylaws you have prepared as part of Chapter 7.

Make sure you have filled in all the blanks in your printed bylaws and include a completed Adoption of Bylaws page at the end of your bylaws. The adoption page should show the date of adoption and include the signatures of your initial directors.

Part III: Required Provisions in Your Organizing Document

Line 1: Your articles must contain a 501(c)(3) tax-exempt purpose clause (see "Prepare Articles of Incorporation" in Chapter 6). Check the box, and on the line provided insert the page, article, and paragraph where the 501(c)(3) purpose clause appears. Public benefit nonprofits using the standard state form can refer to Article 5a which, in turn, refers to Article 2a. Since 2a only mentions "charitable" purposes (to help meet requirements of the California Nonprofit Public Benefit Corporation law), you may want to refer to Article 2b instead, which should briefly mention your nonprofit's specific 501(c)(3) nonprofit purpose(s) (charitable, educational, scientific, and/or literary). Religious nonprofits using the standard religious corporation articles can refer to Article 5b since it specifically refers to religious purposes under 501(c)(3).

Line 2: Check the 2(a) box to indicate that your articles contain a 501(c)(3) asset dedication, and fill in the blank in 2(b) to state the page, article, and paragraph where the dissolution clause appears in your articles. This clause is contained in Article 5d of the California public benefit corporation articles and Article 5e of the California religious corporation articles (see Chapter 6, "Prepare Articles of Incorporation"). Leave the box in 2(c) unchecked—it applies to groups whose articles do not contain a dissolution clause and are instead relying on specific state law provision as explained below.

To recap: A requirement for 501(c)(3) tax-exempt status is that any assets of a nonprofit

that remain after the entity dissolves be distributed to another 501(c)(3) tax-exempt nonprofit —or to a federal, state, or local government for a public purpose (see "Limitation on Profits and Benefits" in Chapter 3).

Part IV: Narrative Description of Your Activities

You should be familiar with the material in Chapter 3 concerning the basic requirements for obtaining a 501(c)(3) tax exemption before providing the information requested in this part of the form. We will refer to earlier explanations as we go along, but you may want to look over Chapter 3 now before you proceed.

TIP

Tell it like it is. When you describe your proposed activities, don't limit your narrative to only those activities that fit neatly within the 501(c)(3) framework if you're simply "gilding the lily" to gain IRS approval. Sure, you'll probably get your tax exemption, but you may not keep it. The IRS can always decide later, after examining your actual sources of support, that your activities go beyond the scope of the activities disclosed in your application. In short, it's a lot more painful and expensive to shut down your nonprofit if it loses its tax exemption than to decide at the outset not to apply for 501(c)(3) status because your proposed mission does not qualify for tax-exempt status.

On an attachment page, provide a detailed description of all of your organization's activities—past, present, and future—in their order of importance (that is, in order of the amount of time and resources devoted to each activity). For each activity, explain in detail:

- the activity itself, how it furthers an exempt purpose(s) of your organization, and the percentage of time your group will devote to it

- when it was begun (or, if it hasn't yet begun, when it will begin)
- where and by whom it will be conducted, and
- how it will be funded (the financial information or projections you provide later in your application should be consistent with the funding methods or mechanisms you mention here). For example, if your application shows you will be obtaining the bulk of your tax-exempt revenue from providing program-related services, such as tuition or admission fees, and/or from grant funds, you will want to mention these sources of support here (see additional instructions on describing your financial support below).

Many new groups will be describing proposed activities that are not yet operational, but you must still provide very thorough information.

If you plan to conduct any unrelated business (business that doesn't directly further your nonprofit goals), describe it here. Most nonprofits will not have planned unrelated business activities at this point. If you have, you will not want to stress the importance or scope of these incidental unrelated activities (for an explanation of the tricky issues surrounding unrelated business activities, see Chapter 3).

Tempting though it might be, resist copying the language that already appears in the purpose clause in your articles—the IRS wants a narrative, not an abbreviated, legal description of your proposed activities. You may include a reference to, or repeat the language of, the longer statement of specific objectives and purposes included in Article 2, Section 2, of your bylaws. However, unless your bylaw language includes a detailed narrative of both your activities and purposes, we suggest you use it only as a starting point for a fuller response here. Generally, we recommend starting over with a fresh, straightforward statement of your group's nonprofit activities.

EXAMPLE 1: A response by an environmental organization might read in part as follows:

> The organization's activities will consist primarily of educating the public on environmental issues with an emphasis on energy conservation. Since January 20__, the organization has published brochures promoting solar energy heating systems as an alternative to traditional energy sources. The price for the brochures is slightly above cost—see copies of educational material enclosed, Attachments A–D. The brochures are published in-house at [*address of principal office*]. Both paid and volunteer staff contribute to the research, writing, editing, and production process. This work constitutes approximately 80% of the group's activities. In addition to publishing, the organization's other activities include the following
>
> [*list in order of importance other current, past, or planned activities and percentage of time devoted to each, where performed, etc.*].

EXAMPLE 2: A nonprofit organization plans to sponsor activities for the purpose of supporting other nonprofit charities. It should describe both the activities in which it will engage to obtain revenue at special events and the manner in which this money will be spent to support other groups. Percentages of time and resources devoted to each should be given.

If you are forming an organization that automatically qualifies for public charity status (a church, school, hospital, or medical research organization) or has special tax exemption requirements, you will want to show that your organization meets the criteria that apply to your type of organization. (See "Automatic Public Charity Status," in Chapter 4, for a discussion of each of these special types of nonprofits.) In the 1023 form, you'll find schedules and instructions that apply to each type of special group (for example, Schedule A for churches, Schedule B for schools, and Schedule C for hospitals—see the table below). If you are forming one of these special types of nonprofits, skip ahead to "Filling Out the Schedules" and look over the instructions for the schedule you need to complete. That way, you'll have a better understanding of what the IRS is looking for in your statement about your nonprofit activities.

Schedules For Special Groups	
Type of Organization	**See Schedule**
Church	A
School, College, or University	B
Hospital and Medical Research Organization	C
Home for the Aged or Handicapped	F
Student Aid or Scholarship Benefit Organization	H

Your description should indicate your organization's anticipated sources of financial support—preferably in the order of magnitude (most money to least money). Here are a few tips to help you address this portion of your response:

- Your sources of support should be related to your exempt purposes—particularly if you plan to be classified as a public charity under the support test described in "Exempt Activities Support Test," in Chapter 4, where the group's primary support is derived from the performance of tax-exempt activities.

- If you plan to qualify as a publicly supported public charity (described in "Public Support Test," in Chapter 4), your responses here should show significant

support from various governmental grants, private agency funding, or individual contributions.

- If you expect your principal sources of support to fluctuate substantially, attach a statement describing and explaining anticipated changes (see the specific instructions to Part II, line 2, in the 1023 package).

Your description should show how you will fund your activities. For example, if you will give classes, state how you will recruit instructors and attract students. If you will rely on grants, state your likely sources of grant support—for example, the particular or general categories of grant agencies you plan to approach. If your nonprofit expects to obtain funds through grant solicitations or other fundraising efforts—that is, by soliciting contributions from donors either directly or through paid fundraising—make sure you provide a narrative description of these efforts here, and also refer to Part VIII, line 4, of your application, where you will provide additional information on your fundraising activities (see instructions to Part VIII, below).

Include as exhibits any literature you plan to distribute to solicit support and indicate that this material is attached to your application.

Fundraising activities include unrelated business activities that will bring cash into your nonprofit. If you have concrete plans to engage in unrelated activities (which, of course, you should be able to clearly describe as an insubstantial part of your overall activities), include the details if you have not done so already in your response.

If your organization has or plans to have a website, provide information on the existing site (including its URL) or the planned site. The existing or proposed website content and any revenue it generates should be related to and further the exempt purposes of the group. If

your website is used to solicit contributions or generate other revenue, explain how this is or will be done.

Finally, if your group intends to operate under a fictitious business name (an "aka"—also known as—or "dba"—doing business as—name) that differs from your formal corporate name as stated in your articles, make sure to mention the alternate name here, and state why you want to use an alternate name.

Part V: Compensation and Financial Arrangements With Your Officers, Directors, Trustees, Employees, and Independent Contractors

The IRS has expanded this part of the application to try and prevent people from creating and operating nonprofits simply to benefit one or more of the nonprofit's founders, insiders, or major contributors. We've already explained the basic 501(c)(3) prohibition against private inurement and the excess benefit rules that penalize nonprofits and their managers if they pay unreasonable compensation to insiders and outsiders (see "Limitation on Profits and Benefits" in Chapter 3). In this part of the application, the IRS tries to find out if your nonprofit runs the risk of violating any of these rules. So if you have compensation or other financial arrangements with any of your founders, directors, officers, employees, contractors, contributors, and others, now is the time to disclose this information. It's better to find out ahead of time that the IRS objects to your proposed financial arrangements rather than pay hefty excess benefit taxes later and run the risk of losing your tax exemption.

Line 1(a): Provide the names, titles, mailing addresses, and proposed compensation of the initial directors named in your articles and your initial officers. You can ignore the instructions concerning trustees—your directors are the

trustees of your nonprofit corporation. List your initial directors and your top-tier officer team, if you know who will fill these officer positions (such as president or chief executive officer, vice president, secretary, and treasurer or chief financial officer, or any other title used in your organization). For director or officer mailing addresses, you can state the mailing address of the corporation.

At this stage in the organization of your nonprofit, you may not be absolutely certain what you will pay your initial directors and officers. However, if you have a good ballpark estimate or a maximum amount in mind, it's better to state it in your response instead of "unknown" or "not yet decided." In the sample bylaws included in this book, we say that directors will not be paid a salary but may be paid a per-meeting fee and reimbursed expenses (see Article 3, Section 6). Therefore, you may wish to respond along the following lines:

"Pursuant to Article 3, Section 6, of the corporation's bylaws, directors will not be paid a salary. They may be paid a reasonable fee for attending meetings of the board [you may mention a specific amount or a range if you have decided on a per diem fee] and may be allowed reasonable reimbursement or advancement for expenses incurred in the performance of their duties." This response will not fit in the "Compensation amount" column, so you'll need to prepare your response as an attachment if you use this wording.

If you have decided on officers' salaries or a range or maximum compensation level for officers, you can state it in your response. If you are not sure who your board will appoint as initial officers and do not know the compensation level for your officers, you may wish to respond as follows: "The persons who will serve as officers and the compensation they will receive, if any, have not yet been determined by the board of directors. Any such compensation will be reasonable and will be paid in return for the performance of services related to the tax-exempt purposes of the corporation." This response will not easily fit in the space provided for your 1(a) response, so you'll probably need to prepare your response as an attachment if you use this wording.

If you have decided who will be elected to serve as officers, provide the details of these officer arrangements, including the amount of any salaries to be paid. Remember, though, that putting people on the payroll who are related to directors may cause you to run afoul of California's disinterested director (51%) rule (see "Directors," in Chapter 2).

Line 1(b): In this section, state the names, titles, mailing addresses, and compensation for your five top-paid employees who will earn more than $50,000 per year. You should include employer contributions made to employee benefit plans, 401(k)s, IRAs, expected bonus payments, and the like in computing the amount of compensation paid to your employees. You should list only employees who are not officers (all officer salaries should be reported in line 1(a) of this Part). It's best to anticipate who will be paid more than $50,000 by providing estimated compensation figures rather than leaving this information blank. However, if you really don't know yet which officers you will pay or how much you will pay them, you can respond as follows: "This corporation is newly formed and has not yet hired employees nor determined the amount of compensation to pay employees it may hire. However, all compensation will be reasonable and will be paid to employees in return for furthering the exempt purposes of this nonprofit corporation."

There is nothing special or suspect about paying an employee more than $50,000. In

fact, compensation paid to employees who make less than $80,000 (a figure that is adjusted for cost of living increases) normally is not subject to scrutiny under the excess benefit rules. (See "Limitation on Profits and Benefits," in Chapter 3, for more on the excess benefit rules.) If you are interested in the $80,000 category and how it fits within the excess benefit rules, see IRS Regulation 53.4985-3(d)(3)(i) and IRC § 414(q)(1)(B)(i). For this line item, the IRS wants to see exactly how much your top five highest-paid employees are getting paid if they make more than $50,000. Ignoring all the fine print of the excess benefit rules and regulations, just remember that the salary and other benefits you pay each employee should be no more than what a comparably paid person in a similar position in a similar organization would receive. With nonprofit symphony orchestra leaders getting paid millions in annual salaries, it is questionable that using a comparability standard always produces the best or even reasonable results. And we're sure that readers of this book, who work long, hard hours getting paid less than they should in pursuit of their public purposes, should have little to worry about when it comes to the question of receiving unreasonably large salaries or other excess benefits from their nonprofit.

Line 1(c): Indicate the names of individuals (or names of businesses), titles (if individual), mailing addresses, and compensation for your five highest-paid independent contractors who will earn more than $50,000 per year. Independent contractors are people and companies who provide nonemployee services to the nonprofit, such as a paid lawyer, accountant, outside bookkeeper, financial consultant, fundraiser, and other outside individuals and companies hired by the nonprofit who are not on the nonprofit's employee payroll. Typically, your nonprofit will have a separate contract for services with its independent contractors—particularly if it will

pay them more than $50,000 per year. If your newly formed nonprofit has plans to contract more than $50,000 with one or more outside individuals or companies, list them here and provide the expected amount of business you plan to do with each contractor annually. If, as is typical, your newly formed nonprofit does not have plans to contract for outside services, you can respond (in the blanks or on an attachment) as follows: "This newly formed nonprofit corporation has no current plans to contract for services with outside persons or companies. If and when it does, any such contracts will provide for payment in commercially reasonable amounts in return for services related to the exempt functions of this nonprofit."

Lines 2(a)–9(a): The remaining questions in this Part V seek to determine if your nonprofit may run afoul of the excess benefit restrictions that apply to 501(c)(3) public charities—the type of nonprofit you are trying to establish. The excess benefit rules apply to "disqualified persons," as defined under the Internal Revenue Code, Section 4958. For these purposes, a disqualified person means anyone who exercises substantial influence over the nonprofit, such as founders, directors, officers, and substantial contributors. People who fall within the definition of disqualified persons are not prohibited from being paid by your nonprofit. Instead, their salaries and benefits are subject to scrutiny under the excess benefit rules. If the IRS finds that a disqualified person was overpaid—that is, the person received a salary, bonus, or benefits that exceeded the fair market value of the services provided or was excessive compared to amounts paid to similar people in other nonprofits—the disqualified person and the nonprofit and its managers can be subject to sanctions. The sanctions include being required to pay back previously paid salaries and stiff penalty taxes. (For more

information on disqualified persons and the excess benefit rules, see "Limitation on Profits and Benefits" in Chapter 3.)

The IRS will review your answers in this section to see if there is any indication that an intentional or incidental purpose of your non-profit is to financially benefit the private interests of any board members, officers, employees, or contractors. If the IRS determines that you are using nonprofit funds to excessively compensate any of these people, it will deny your tax exemption.

If you answer "yes" to any of the remaining items in Part V, make sure to explain your response. Provide any additional information needed to show why you marked "yes" on an attachment page.

TIP

There are numerous definitions of "disqualified persons" in the Internal Revenue Code. Don't get confused or concerned if you run up against different definitions of "disqualified persons" that apply to nonprofits. For example, a different definition of disqualified person (under IRC § 4946) is used to determine permitted sources of public support for 501(c)(3) public charity support tests and when applying the excise tax restrictions that apply to private foundations (see Chapter 4 and "Who Are Disqualified Persons?" below in this chapter).

Line 2(a): Check "yes" if any of your directors or officers are related to each other or have a business relationship with one another. A family relationship includes an individual's spouse, ancestors, children, brothers, and sisters (see the instructions to Form 1023 for a description of family and business relationships that must be disclosed). If you check "yes," provide a list of names and a description of the family or business relationship between the individuals on an attachment page.

Line 2(b): Check "yes" if your organization ("you" means your nonprofit) has an outside business relationship with its directors or officers (see the Form 1023 instructions for the types of business relationships that must be disclosed). Again, these relationships will not be an absolute bar to your obtaining a tax exemption, but the IRS will scrutinize payments made to these "related" parties to make sure they are being fairly, not excessively, compensated by your nonprofit (either through salaries and benefits or through separate business contracts with your nonprofit). Of course, it looks best if your board and officers do not have an outside business relationship with your nonprofit—and we expect, even just for appearances' sake, that most smaller nonprofits will not appoint board members or officers with whom the nonprofit plans to do outside business. If you check "yes," disclose the names of the individuals and their business relationships with your nonprofit on an attachment page.

Line 2(c): This item asks if any of your directors or officers are related to the people listed in 1(b) or 1(c)—that is, related to your highest-paid employees or independent contractors who make more than $50,000. If you answer "yes," specify the names of the directors and officers and their relationship to the highest-paid people. Again, it looks best if your board and officers are not related to your more highly compensated employees or contractors. But in the real world of small nonprofits, it may be impossible to start your nonprofit without getting Uncle Bill or Aunt Sally to provide their expertise by volunteering as an unpaid board member. As long as you disclose these arrangements and make sure to fairly pay—and not overpay—anyone, the IRS should conclude that your nonprofit is on the up-and-up and is entitled to its exemption if it meets all the substantive requirements.

Line 3(a): This item requests very important information (on an attachment page), which the IRS uses to determine if your nonprofit will pay excessive benefits to any insider or outsider. Specifically, it asks you to list the qualifications, average hours worked (or to be worked), and duties of your directors and officers listed in 1(a) and highly compensated employees and contractors (listed in 1(b) and 1(c), respectively). Your responses here should justify any high salaries, benefits, or per diem amounts paid to your officers or directors. For example, if you plan to pay officers a significant salary that may raise IRS examiner eyebrows, make sure to list the extra qualifications and experience of the highly compensated officer. Don't hold back or be shy in touting the credentials (academic degrees, teaching positions, awards), experience (past associations as advisers or directors with other nonprofits), and other qualifications or community affiliations of your well-paid people. The IRS really wants to know why you pay people well (if, in fact, you are lucky enough to pay or plan to pay your officers and other employees a competitive wage, salary, or benefits). On the flip side, obviously, if you pay your part-time administrative aid, who just happens to be your cousin Joe, a lavish hourly wage plus full benefits, expect the IRS to balk. Unless Joe has special skills that are in high demand by other organizations and companies, the IRS will question this special arrangement.

Line 3(b): If any of the directors, officers, and highly paid people listed in 1(a) through 1(c) get paid by another organization or company that has "common control" with your nonprofit, you will need to mark "yes" on this item and provide an explanation on an attachment page. As the instructions to Form 1023 explain, organizations with common control include those that have their boards or officers appointed or elected by the same parent or overseeing organization. In addition, if a majority of your board and/or officers and a majority of the board and/or officers of another organization consist of the same individuals, then you share common control. If common control between your nonprofit and another organization exists, expect the IRS to attribute the total compensation paid by both commonly controlled organizations to your board and officers, and also expect the IRS to judge the purposes and activities of your nonprofit in light of the control exercised or shared by the other organization. For example, if a majority of your officers are officers of another nonprofit, the IRS will want to know whether your nonprofit exists to serve the purposes or foster the activities of the related nonprofit. This may be fine if the other nonprofit is, itself, a 501(c)(3) tax-exempt nonprofit. But if it isn't, the common control aspect probably will adversely affect your ability to obtain your tax exemption—your nonprofit can't be formed to promote nonexempt purposes.

Lines 4(a)–4(g): This item asks whether your group has established the procedures and practices recommended under the safe harbor rules of the excess benefit provisions and regulations (see "Limitation on Profits and Benefits," in Chapter 3, for a brief summary of the safe harbor rules). These procedures are meant to minimize the risk that nonprofits will pay out excess benefits. You don't have to adopt and follow them, but you should if you want the IRS to look kindly on your tax exemption.

If you adopt the standard bylaws contained in this book, you can mark "yes" to each question and provide the responses to each item shown below on an attachment page. The IRS instructions to this line do not ask for more information if you answer "yes" to an item, but we think you should offer more, stating in your response where the IRS can look in your bylaws to verify that you have adopted each practice (as explained for each item, below).

Line 4(a): Check "yes" and state on an attachment page: "This organization has adopted a conflict of interest policy that controls the approval of salaries to directors, officers, and other 'disqualified persons' as defined in Section 4958 of the Internal Revenue Code. See Article 9, as well as Article 3, Section 6, and Article 4, Section 10, of the bylaws attached to this application. Also, Article 9, Section 5, of this organization's bylaws applies additional conflict of interest requirements on the board and compensation committee when approving compensation arrangements."

Line 4(b): Check "yes" and state on an attachment page: "Article 9, Section 3, of this organization's bylaws requires the approval of compensation of directors, officers, and any 'disqualified person' as defined in Section 4958 of the Internal Revenue Code in advance after full disclosure of the surrounding facts and approval by disinterested members of the governing board or committee and prior to entering into the compensation agreement or arrangement. Further, Article 9, Section 5(a), of this organization's bylaws requires specific approval of compensation arrangements prior to the first payment of compensation under such arrangements."

Line 4(c): Check "yes" and state on an attachment page: "Article 9, Section 4, of the organization's bylaws, which are attached to this application, require the taking of written minutes of meetings at which compensation paid to any director, officer, or other 'disqualified person' as defined in Section 4958 of the Internal Revenue Code, are approved. The minutes must include the date and the terms of the approved compensation arrangements. Further, and specifically with respect to the approval by the board or compensation committee of compensation arrangements, Article 9, Section 5(d), of the organization's bylaws requires the recordation of the date

and terms of compensation arrangements as well as other specific information concerning the basis for the approval of compensation arrangements."

Line 4(d): Check "yes" and state on an attachment page: "Article 9, Section 4, of the organization's bylaws requires the written recordation of the approval of compensation and other financial arrangements between this organization and a director, officer, employee, contractor, and any other 'disqualified person' as defined in Section 4958 of the Internal Revenue Code, including the names of the persons who vote on the arrangement and their votes. Further, and specifically with respect to the approval by the board or compensation committee of compensation arrangements, Article 9, Section 5(d), of the organization's bylaws requires the recordation of the board or committee who were present during discussion of the approval of compensation arrangements, those who voted on it, and the votes cast by each board or committee member."

Line 4(e): Check "yes" and state on an attachment page: "Article 9, Section 5(c), of the organization's bylaws requires that the board or compensation committee considering the approval of a compensation arrangement obtain compensation levels paid by similarly situated organizations, both taxable and tax-exempt, for functionally comparable positions; the availability of similar services in the geographic area of this organization; current compensation surveys compiled by independent firms; and actual written offers from similar institutions competing for the services of the person who is the subject of the compensation arrangement. This article also provides that it is sufficient for these purposes to rely on compensation data obtained from three comparable organizations in the same or similar communities for similar services if this organization's three-years'

average gross receipts are less than $1 million (as allowed by IRS Regulation 53.4958-6)."

Line 4(f): Check "yes" and state on an attachment page: "Article 9, Section 5(d), of the organization's bylaws requires that the written minutes of the board or compensation committee meeting at which a compensation arrangement was discussed and approved include the terms of compensation and the basis for its approval. This bylaw provision includes a list of specific information that must be included in the required written minutes."

If you haven't adopted the bylaws included with this book or have deleted or changed the provisions in Article 9 of the bylaws, you may need to mark "no" to one or more of the items in line 4. And whether you mark "yes" or "no," you will need to provide responses on an attachment page that explains your particular conflicts of interest and compensation approval standards and procedures. Your responses should be sufficient to convince the IRS that your directors, officers, employees, and contractors will be paid fairly for work done to further your organization's exempt purposes and that disinterested directors or compensation committee members—for example, nonpaid directors or committee members who are not related to anyone paid by your organization— set the salaries and other compensation of your officers, employees, and contractors.

Lines 5(a)–5(c): Mark "yes" if you have adopted the bylaws included with this book. State on the attachment page for this item: "The board of directors of this organization has adopted bylaws that contain a conflicts of interest policy. The policy is set out in Article 9 of the attached bylaws. This policy is based on the sample conflict of interest policy contained in Appendix A of the official instructions to IRS Form 1023. The organization has added additional requirements in Article 9, Section 5, of its bylaws for the approval of compensation

arrangements that are based on the additional requirements contained in IRS Regulation 53.4958-6 to help ensure that all compensation arrangements are made by disinterested members of the organization's board or a duly constituted compensation committee of the board and are fair, reasonable, and in furtherance of the tax-exempt purposes of this organization."

If you mark "yes" to 5(a), you can skip 5(b) and 5(c). If you marked "no" to 5(a) because you did not adopt the bylaws included with this book or changed them to adopt a different conflict of interest policy, include responses to questions 5(a) and 5(b) on an attachment page. Your responses should show that you will follow your own practices to make sure that your directors, officers, employees, and others who exert significant influence over your nonprofit cannot feather their own nests by setting their own salary levels and making their own self-serving business deals with your nonprofit.

Lines 6(a)–6(b): The IRS instructions to Form 1023 explain what the terms "fixed payment" and "non-fixed payment" mean. Essentially, question 6(a) asks if your organization will pay its directors, officers, highly paid employees, or highly paid contractors (those listed in this part, lines 1(a) through 1(c)) any discretionary amounts (such as bonuses) or amounts based on your organization's revenues (such as a salary kicker or bonus computed as a percentage of annual contributions received by your nonprofit). Question 6(b) asks this same question with respect to all the other employees of your nonprofit who receive compensation of more than $50,000 per year. Obviously, it looks best if your nonprofit's principals and employees do not receive these types of revenue-driven incentives, which are more typical in a business, not a nonprofit, setting. We assume most small nonprofits will be able to answer "no" to this question. If, however, you have an overriding

need to pay directors, officers, and employees discretionary bonuses or provide them with revenue- or performance-based compensation or commissions, you need to provide the information requested on an attachment page. Your response should show that these nonfixed payments will be fairly and reasonably paid as incentives to promote the nonprofit purposes of your organization (this may not be easy to show), and that it won't be used simply to pay out revenues to your principals. Remember— private inurement is a nonprofit no-no—so siphoning over revenue to nonprofit principals is not allowed, even in the guise of bonus or performance-based employee incentives.

Lines 7(a)–7(b): Question 7(a) asks if your organization will purchase goods, services, or assets from its directors, officers, highly paid employees, or highly paid contractors (those listed in this Part V, lines 1(a)–1(c)). Question 7(b) asks if your organization will sell goods, services, or assets to these people.

Most nonprofits will be able to answer "no" to both these questions because they will want to stay clear of insider sales and purchase transactions, simply to avoid the appearance (if not the actuality) of self-dealing. That said, it's also a fact of life that some smaller nonprofits have to look to their directors, officers, and principal employees or contractors to buy or sell goods or services: These may be the only people willing to do business with the nonprofit at the start of its operations. Even more typically, a small nonprofit may want to buy goods at a special discount offered by a director or an officer. If you answer "yes" to one of these questions, provide the requested information in your response on an attachment page. Your response should make clear that any such purchases or sales will be at arm's length—that is, your nonprofit will pay no more and sell at no less than the commercially competitive, fair market value price for the goods, services,

or assets. If you plan to buy goods, services, or assets at a discount from a director, an officer, an employee, or a contractor, make sure to say so, since this sort of bargain purchase is better than an arm's-length deal from the perspective of the nonprofit.

The official instructions to Form 1023, lines 7(a) and 7(b), indicate that you can ignore purchases and sales of goods and services in the normal course of operations that are available to the general public under similar terms or conditions. In other words, if you buy normal inventory items from a contractor listed in Part V, line 1(c), at standard terms paid by the general public for these inventory items, you do not have to mark "yes" to 7(a). Frankly, if your organization plans to purchase any type of goods or services from a director, an officer, or an employee, we think it should be disclosed in your application, since a deal of this sort may have the appearance of a self-dealing transaction. In such a case, you can check "yes" to line 7(a), then make it clear in your response that your organization will pay the same price for the inventory or other standard items purchased from a director, an officer, or an employee as the price paid by the general public (the current commercially competitive fair market value price).

If you answer "yes" to either question and have adopted the bylaws included with this book, you can add in your response that "Article 9, Section 3, of the organization's bylaws requires the approval of conflict-of-interest transactions or arrangements, such as the purchase or sale of goods, services, or assets between the organization and one of its directors, officers, or any other 'disqualified person' as defined in Section 4958(f)(1) of the Internal Revenue Code and as amplified by Section 53.4958-3 of the IRS Regulations, by the vote of a majority of disinterested directors or members of a board committee, only after a

finding that a more advantageous transaction or arrangement is not available to the organization and that the proposed transaction or arrangement is in the organization's best interest, is for its own benefit, and is fair and reasonable."

Lines 8(a)–8(f): Question 8(a) asks if your organization will enter into leases, contracts, or other agreements with its directors, officers, highly paid employees, or highly paid contractors (those listed in this part, lines 1(a) through (c)). If you answer "yes," you must supply responses to items 8(b) through 8(f) on an attachment page.

To rephrase an observation made in the instructions to line 7, above, to avoid the appearance if not the actuality of self-dealing, it's best not to deal with nonprofit insiders when leasing property or contracting for goods, services, or making other business arrangements. Most nonprofits will shy away from doing this, and will answer "no" to 8(a).

However, newly formed nonprofits sometimes find it most practical (and economical) to lease or rent property owned by a founder, a director, or an officer, or may otherwise have to enter into a contract or an arrangement with one of these people. There is nothing absolutely forbidden about doing so, but you will want to make sure that any lease, contract, or agreement between your nonprofit and one of these people reflects fair market value terms or better. For example, it looks best if a director leases property owned by the director to the nonprofit at a lower-than-market-value rate (best of all, of course, is when the director lets the nonprofit use the lease premises rent free).

If you answer "yes" to 8(a), provide the information requested in 8(b) through 8(f) on an attachment page. If possible, attach a copy of any lease, rental, or other agreement as requested in 8(f). For a discussion of leases together with a sample assignment of lease, see "Prepare Assignments of Leases and Deeds" in

Chapter 9. Also, if you have adopted the bylaws included with this book, you can add in your response to item 8(d) or 8(e) that "Article 9, Section 3, of the organization's bylaws requires the approval of conflict-of-interest transactions or arrangements, such as a lease, a contract, or another agreement between this organization and any of its directors, officers, or any other 'disqualified person' as defined in Section 4958(f)(1) of the Internal Revenue Code and as amplified by Section 53.4958-3 of the IRS Regulations, by the vote of a majority of disinterested directors or members of a board committee, only after a finding that a more advantageous transaction or arrangement is not available to the organization and that the proposed transaction or arrangement is in the organization's best interest, is for its own benefit, and is fair and reasonable."

Lines 9(a)–9(f): These questions are similar to those in 8(a) through 8(f) above, except they apply to leases, contracts, and agreements between your nonprofit and another business or organization associated with or controlled by your directors or officers. Specifically, these questions apply to business deals between your nonprofit and another company or organization in which one or more of your directors or officers also serves as a director or an officer or one of your directors or officers owns a 35% or greater interest (for example, a 35% voting stock ownership interest in a profit-making corporation). You can ignore deals made between your corporation and another 501(c)(3) tax-exempt nonprofit organization, even if one or more of your directors or officers also serves on the board or as an officer of the other 501(c)(3) tax-exempt nonprofit organization.

EXAMPLE 1: If one of your directors also serves as a board member on a nonprofit cooperative that is not tax exempt under 501(c)(3) and your nonprofit enters into

leases, contracts, or other agreements with the other nonprofit, answer "yes" to 9(a) and provide the information requested in items 9(b) through 9(f).

EXAMPLE 2: If one of your officers owns a 35% or greater stock interest in a business corporation, and your nonprofit buys goods and services from the business corporation (either through a formal contract or a verbal agreement), answer "yes" to 9(a) and provide the information requested in items 9(b) through 9(f).

The discussion in line 8, above, about leases and agreements between your nonprofit and individuals applies here to leases and agreements between your nonprofit and affiliated or controlled companies and organizations. If you answer "yes," provide the information requested in items 9(b) through 9(f). Also, if you have adopted the bylaws included with this book, you can add in your response to item 9(d) or 9(e) that "Article 9, Section 3, of the organization's bylaws requires the approval of conflict-of-interest transactions or arrangements, such as a lease, a contract, or another agreement between this organization and any 'disqualified person' as defined in Section 4958(f)(1) of the Internal Revenue Code and as amplified by Section 53.4958-3 of the IRS Regulations, which includes 35% controlled entities, by the vote of a majority of disinterested directors or members of a board committee, only after a finding that a more advantageous transaction or arrangement is not available to the organization and that the proposed transaction or arrangement is in the organization's best interest, is for its own benefit, and is fair and reasonable."

Part VI: Your Members and Other Individuals and Organizations That Receive Benefits From You

Line 1(a): If you plan to implement programs that provide goods, services, or funds to individuals, check "yes" and describe these programs on an attachment page. Many smaller nonprofits will provide goods or services as part of their exempt-purpose activities, such as a nonprofit dance studio (dance lessons or admissions to dance performances), formal and informal nonprofit schools (tuition or fees for classes and instructional services), hospitals (health care costs), and other educational or charitable groups. Of course, charitable-purpose groups often provide goods or services free to the public or at lower than market-rate cost—such as free or low-cost meals, shelter, and clothing. But educational-purpose groups often charge standard or slightly reduced rates for admissions, tuition, and services. Doing the latter is permissible. What the IRS wants to see is that your nonprofit is set up to provide goods and services as part of a valid nonprofit tax-exempt program, and that all members of the public—or at least a segment of the public that is not limited to particular individuals—will have access to your goods or services. What you can't do is set up a tax-exempt nonprofit that intends to benefit a private class or specific group of individuals, as individuals (such as your Uncle Bob and Aunt Betty, or all your relatives and in-laws). The broader the class of people that your nonprofit benefits, the better. Making your nonprofit programs available to the public at large normally looks best to the IRS. And providing goods and services at rates below market rates also helps bolster your credibility as a nonprofit, as opposed to a revenue-driven organization.

At this point in the process, most groups have not fully determined what they will charge for goods and services. If this is the case, describe in your response the services and benefits that will be provided to the public (or a segment of the public) and explain generally how you will determine fees. For example, you may wish to indicate that "charges for the described benefits, products, and services are at present undetermined, but will be reasonable and related to the cost of the service to be provided." And again, if you plan to provide goods or services at a discount or free of charge, make sure you say so.

Line 1(b): If your nonprofit will provide goods or services to other organizations, check "yes" and describe your program plans on an attachment page. If you donate or sell goods and services to another 501(c)(3) tax-exempt nonprofit at fair or discounted rates for use in their tax-exempt programs, your program should pass muster with the IRS. But if you simply plan to obtain revenue by selling goods and services provided to profit-making businesses, expect to have to justify this sort of commercial-looking activity. For example, an educational group may provide seminars to the human resource managers of business corporations on how to comply with federal and state fair employment regulations. This sort of program that serves the needs of employees should be fine with the IRS. But simply trafficking in goods and services for a profit with other organizations and companies will look like (and probably is, in fact) a commercially driven, profit-making enterprise that won't qualify as a tax-exempt activity.

Line 2: Most groups will answer "no" to this question because the IRS frowns on groups that limit benefits, services, or funds to a specific individual or group of individuals. However, if the group of people benefited by the nonprofit

is broad (not limited to specific individuals) and related to the exempt purposes of the nonprofit group, the IRS should have no objection (see the discussion to line 1(a) of this part, above). If you answer "yes," provide an explanation on an attachment page. You may be able to refer to information already provided in your response to line 1(a) of this part.

> **EXAMPLE:** A nonprofit musical heritage organization plans to provide programs and benefits to needy musicians residing in the community. If the overall tax-exempt purpose of the organization is allowed, the IRS will permit this limitation of benefits to a segment of the community.

Line 3: In this question, the IRS is looking for prohibited self-inurement—in this case, whether your nonprofit is set up primarily or directly to provide goods, services, or funds to individuals who have a family or business relationship with your directors, officers, or highest-paid employees or contractors listed in Part V, lines 1(a) through 1(c). Most groups will answer "no" here. However, if you think someone who fits in one of these categories may receive goods, products, or services incidentally from your nonprofit as a member of the public, check "yes" and explain how these related people will have access to your nonprofit's benefits. If your response makes it clear that these related people are not the focus of your nonprofit programs, but as members of the general public only coincidentally qualify, you should be okay.

Part VII: Your History

Line 1: Most groups will answer "no" to this question. However, if you are a successor to an incorporated or a preexisting organization (such as an unincorporated association), mark "yes."

Successor has a special technical meaning, which is explained in the official IRS instructions to this item. Basically, you are most likely to be a successor organization if your nonprofit corporation has:

- taken over the activities of a prior organization—this is presumably the case if your nonprofit corporation has appointed initial directors or officers who are the same people who served as the directors or officers of the prior association, and your nonprofit has the same purposes as the prior association

- taken over 25% or more of the assets of a preexisting nonprofit, or

- been legally converted from the previous association to a nonprofit—typically by filing special articles of incorporation to state the name of the prior association and a declaration by the prior officers of the association that the conversion to a nonprofit corporation was properly approved by the association, or by filing articles of conversion to convert a profit-making entity to your new nonprofit corporation.

We assume most readers will be starting new nonprofits, not inheriting the assets, people, and activities of a preexisting formal nonprofit association. We also assume most readers have not adopted special articles to legally convert a prior association or profit-making entity to a nonprofit corporation. In the real world, this formal conversion of a prior association to a nonprofit corporation only occurs if the prior group was a highly organized and visible entity with a solid support base that it wants to leverage by formally converting the association to a nonprofit corporation. However, in most cases, a small nonprofit that existed previously as an informal nonprofit group with few assets, little support, and hardly any formal infrastructure normally starts out fresh with a newly formed corporation that is not a successor to the prior group. If you think your nonprofit corporation is a "successor" organization, we suggest you get help from a nonprofit expert to complete Schedule G and make sure all the paperwork for your new nonprofit as well as the prior group is in order.

If you are a successor to a prior organization, mark "yes," and complete Schedule G of the 1023 application. (See "Filling Out the Schedules," below, for instructions on filling out Schedule G.) The IRS will take the history, activities, and financial data of your prior organization as well as your responses to Schedule G into account when deciding whether your nonprofit corporation is entitled to its tax exemption. It may also ask you to file tax returns for the prior organization if it has not already done so for all preceding tax years during which the prior nonexempt organization was in operation.

Line 2: Most new groups will be able to answer "no" here because they will be submitting their exemption application within 27 months after the end of month when their nonprofit corporation was formed. The date of formation is the date the corporation's articles of incorporation were filed by the secretary of state and became effective. For example, if you filed your articles on January 12, 2015 you have until the end of April 2017 to submit (postmark) your exemption application.

If you are submitting your exemption application after this 27-month deadline, check "yes" and fill in and submit Schedule E with your 1023 exemption application. (See "Filling Out the Schedules," below, for instructions on completing Schedule E.)

Part VIII: Your Specific Activities

This part asks about certain types of activities, such as political activity and fundraising, that the IRS looks at more closely. These are activities

that a 501(c)(3) is prohibited from engaging in or can do only within certain strict limitations—namely, without benefiting or catering to the special interests of particular individuals or organizations. Please read the official instructions to this Part in the 1023 instructions before reading our instructions below.

Line 1: A 501(c)(3) nonprofit organization may not participate in political campaigns (although some voter education drives and political debate activities are permitted—see "Limitation on Political Activities" in Chapter 3). The IRS may deny or revoke your tax-exempt status if you participate in or donate to a campaign. Most groups should answer "no" here.

If you think you should answer "yes" to this question, check with a nonprofit lawyer or tax consultant—a "yes" response means you do not qualify for a 501(c)(3) tax exemption. However, you may qualify for a 501(c)(4) tax exemption.

Line 2(a): This question concerns your group's plans, if any, to affect legislation. Most groups will answer "no" to this question. If you answer "no," you can move on to line 3.

If you plan to engage in efforts to influence legislation, check "yes" and read the discussion in "Limitation on Political Activities," in Chapter 3. Then complete 2(b).

Line 2(b): Check "yes" if you plan to elect to fall under the alternate political expenditures test discussed in "Limitation on Political Activities," in Chapter 3, and attach a completed IRS Form 5768, *Election/Revocation of Election by an Eligible Section 501(c)(3) Organization To Make Expenditures To Influence Legislation.* We assume you have not already filed this form; if you have, attach a copy of the filed form. The political expenditures test is complicated, and you'll probably need the help of a seasoned nonprofit adviser to decide whether you will be able to meet the requirements and gain a benefit from electing this special test for political legislative activities. Before using Form 5768, go to the IRS website, at www.irs.gov, and make sure it is the latest version of the form. If the IRS site has a more current version, use that form.

If you checked "yes" to line 2(a) and do not plan to elect the political expenditures test, check "no" to line 2(b). On an attachment, you must describe the extent and percentage of time and money you expect to devote to your legislative activities compared to your total activities. Be as specific as you can about the political activities you expect to promote and how you will promote them. If possible (and accurate), make it clear that your legislative activities will make up an "insubstantial" part of your overall nonprofit programs and activities. If the IRS feels that your political program will be substantial, it will deny your 501(c)(3) tax exemption.

Lines 3(a)–3(c): Most 501(c)(3) nonprofits do not engage in bingo and gaming activities. If you plan to do so, read the IRS official instruction for this line as well as IRS Publication 3079, *Tax-Exempt Organizations and Gaming,* before checking "yes" to any of the questions in line 3 and providing the requested information.

Line 4(a): Read the official instructions to this line to learn the definition of fundraising and some of the different ways it may be conducted. Note that fundraising includes raising funds for your own organization, raising funds for other organizations, as well as having some other individual or organization raise funds for your group. If your nonprofit is one that will be obtaining revenue and operating funds only from the performance of its exempt functions—that is, by providing services or goods related to your exempt purpose—you can check "no" here. Make sure that none of the specific fundraising activity boxes listed in 4(a) apply to your group. However, if you expect your nonprofit to do any type of fundraising, such as soliciting government grants, attracting

private and public donations or contributions, or going whole hog and hiring a professional fundraiser, check "yes" and then check each box that describes a fundraising activity that you plan to or may pursue in your quest for program funds and revenue. On an attachment page, describe each activity whose box you have checked. If your nonprofit plans to engage in a type of fundraising not listed under 4(a), check the "other" box and describe it in your attachment response. Be as specific and as thorough as you can in your response about the people you will use, any compensation you will pay, the amount and type of support you hope to raise, and the use to which you will put raised funds for each fundraising activity. If you check "no" to 4(a), you can skip ahead to line 5.

Line 4(b): Mark "yes" if you plan to hire paid fundraisers, and provide the financial and contract information requested on an attachment page. Any financial information should be actual or projected figures that cover the same periods as the financial information you will provide in Part IX (see the official 1023 Part IX instructions and our Part IX instructions, below, to determine the period for which you should provide financial information). Many beginning nonprofits will not plan to use paid fundraisers right away and can state: "This newly formed nonprofit has not entered into oral or written contracts with individuals or organizations for the raising of funds, and has no specific plans to do so in the foreseeable future."

Line 4(c): If your nonprofit will do fundraising for other organizations, state "yes" and provide the information requested on an attachment page. Most nonprofit organizers using this book will not raise funds for other organizations even if they plan to raise funds for themselves and will mark "no" here.

Line 4(d): If you checked "yes" to 4(a), provide the information requested for this item. You should provide this information for states or localities where you will raise funds for your organization or for other organizations, or where an individual or another organization, including a paid fundraiser, will raise funds for your organization.

Line 4(e): See the official instructions for this item—it concerns the special practice of soliciting and using "donor-advised" or "donor-directed" funds. Most nonprofits will not have plans to use this practice, but if you do, provide the information requested on an attachment page. The IRS will want to make sure that your organization does not use funds to meet the private needs of donors, but instead will use donor-directed funds for purposes that are consistent with the tax-exempt purposes of the nonprofit.

Here is a statement from the 2005 IRS *Exempt Organization (EO) Report* that explains why the IRS is concerned about donor-advised funds, and indicates that it will be keeping an eye out for abuse in this area:

> Donor-advised funds allow private donors to provide input as to how their charitable contributions will be spent. A number of organizations have come to light through examinations, referrals from other parts of the IRS, and public scrutiny which appear to have abused the basic concepts underlying donor-advised funds. These organizations, while promoted as legitimate donor-advised funds, appear to be established for the purpose of generating questionable charitable deductions, providing impermissible economic benefits to the donors and their families (including tax-sheltered investment income for the donors), and providing management fees

for the promoters. EO Examinations will identify organizations with a high potential for abuse in this area and commence examinations during FY 2005.

Line 5: This item is for special government-affiliated groups (see the instructions to the 1023 form). If you check "yes," your nonprofit needs special assistance responding to this item and being able to meet the requirements for a 501(c)(3) tax exemption. If you check "yes," consult a nonprofit legal adviser.

Line 6: See the 1023 instructions. If you are an economic development nonprofit and mark "yes," you'll need expert help filling out your tax exemption to make sure your activities meet the 501(c)(3) requirements.

Below is a statement from the 2005 IRS *Exempt Organization (EO) Report* that explains why the IRS is applying special scrutiny to economic development nonprofits:

> In response to referrals from HUD concerning abuse by individuals setting up exempt organizations for the purpose of participating in a number of HUD programs, EO initiated a compliance project in this area in FY 2004. Potential abuses include lack of charitable activity, personal use of program property, and most often, private benefit provided to for-profit construction contractors hired to complete the repairs to program properties. In these cases, contractors were usually related to the organizations' officers or board members, and were often the same individuals. Costs were overstated and work was substandard or completely lacking. The project is currently focusing on abuses by exempt organizations in HUD's housing rehabilitation/resale and down payment assistance programs, and will expand to other HUD programs as staffing permits.

Line 7(a): Line 7 applies to a nonprofit that will own or develop real estate, such as land or a building, in pursuit of its nonprofit activities. (See the 1023 instructions for lines 7(a) through 7(c) for more information.) If you plan to develop or improve real estate, including land or buildings, mark "yes" to 7(a) and provide the information requested on an attachment page. Mostly the IRS wants to make sure that your nonprofit is not planning to make any "sweetheart" real estate development deals that benefit people associated with your nonprofit and its directors and officers through family or business ties.

Line 7(b): If your nonprofit will maintain facilities, such as a building or an office space or another physical address, and plans to use anyone other than employees or volunteers to manage the facilities—for example, if it plans to hire a management company to manage property—check "yes" and provide the information requested on an attachment page. Again, the IRS wants you to show that the managers are not getting special breaks or excess payments because they are family members or business associates of the nonprofit's directors or officers.

Line 7(c): This line wants you to provide information on all developers and managers of real estate or facilities owned or used by your nonprofit if any of these developers or managers have a business or family relationship with your nonprofit directors or officers. If this question applies to your nonprofit, provide the information requested on an attachment page. If you have already provided the information in response to 7(a) and/or 7(b), you can refer to your previous response. The IRS will scrutinize any contracts you provide and negotiation processes you describe to make sure your nonprofit is not paying more than fair market value for real property development and management services.

Line 8: First read the 1023 instructions for this line. If your nonprofit plans to enter into joint ventures (business deals) with individuals or other nonprofits or commercial business entities, see a legal adviser before providing the information requested and completing your 1023 tax exemption application. Nonprofit organization joint ventures raise complex issues that require expert help to make sure they are structured properly to meet the requirements of the 501(c)(3) tax exemption.

Lines 9(a)–9(d): If you are forming a child care organization, you may qualify for your tax exemption either under 501(k) of the Internal Revenue Code or 501(c)(3) as a school. Read the instructions before answering these questions. If you check "yes" to 9(a), answer 9(b) through 9(d). If you answer "no," go on to line 10.

Line 10: This question asks if your nonprofit plans to publish, own, or have rights in intellectual property, such as art, books, patents, trademarks, and the like (see the 1023 instructions for definitions). If you answer "yes," provide the information requested on an attachment page about ownership of the intellectual property, if and how you will derive revenue from the property, and generally how the property will be used as part of your nonprofit activities. In essence, the IRS wants to know whether your nonprofit plans to acquire and exploit copyrights, patents, and other forms of intellectual property and, if so, how. Examples of groups that would answer "yes" include a visual arts exhibit studio, an educational book publisher, a scientific research center that engages in original (patentable) research, and any group that plans to market its trade name (a name used by the nonprofit and associated with its activities), trademark, or service mark (logos, words, and images used by the nonprofit to market its goods and services).

501(c)(3) nonprofits that conduct scientific research in the public interest are expected to make their patents, copyrights, processes, or formulae available to the public, not simply develop and exploit results of their research for their own use (see "Scientific Purposes" in Chapter 3). There is nothing wrong or underhanded, however, about a nonprofit owning and exploiting intellectual property related to its exempt purpose—for example, a qualified literary or education nonprofit's owning and obtaining royalty revenue from the sale of its published educational works, or a nonprofit's selling donated art to raise funds for its exempt purpose. Be careful though: If a nonprofit deals in intellectual property as a routine method of raising operating revenue— for example, if a nonprofit licenses its trade name to obtain revenue—the IRS is likely to consider this income unrelated business income. If this unrelated income is clearly more than a small portion of the group's overall revenue, the IRS will likely question or deny the group's 501(c)(3) tax exemption.

The issue of copyright ownership sometimes is key to this issue. Remember: If copyrights in published works are owned by a 501(c)(3) nonprofit, this means that the copyrights, like all other assets owned by the nonprofit, are irrevocably dedicated to tax-exempt purposes and must be distributed (transferred) to another tax-exempt nonprofit when the organization dissolves. Hence, the IRS is apt to look more favorably on an educational nonprofit that holds copyrights in its published works. Conversely, if a nonprofit education group does not own the copyright to its published works, but instead publishes the works owned by others under the terms of standard commercial royalty contracts, the IRS may feel that the group is simply a commercial publisher that is not entitled to a 501(c)(3) educational tax exemption. However, if the group publishes education material written by volunteers or its employees or under "work for hire" contracts with outside

authors, copyrights in the works are owned by the nonprofit, not by the authors. Publication of this material is clearly in the public interest and contains content related to the educational purpose of the nonprofit. Thus, the IRS is more likely to agree that the group is entitled to a tax exemption.

The sale of art by nonprofits often piques the interest of IRS examiners. For example, if an educational nonprofit exhibits artwork owned by artists and collects a commission on each sale, the IRS may conclude that the organization runs a commercial art gallery that is not entitled to a tax exemption. There is no bright-line test for groups that deal in art or sell goods and services. The IRS looks at all the facts and circumstances related to a group's activities and operations to determine if the group's primary purpose is a charitable, educational, or another 501(c)(3) purpose or, instead, represents a commercial enterprise. For examples of when the IRS has reached different conclusions after examining the activities of groups that sell art as part of their activities, see the summaries of selected IRS revenue rulings below:

> **TIP**
>
> **How to read IRS revenue rulings.** Each IRS revenue ruling is referenced with a two- or four-digit year prefix followed by a number—for example, revenue ruling 2004-90 is a 2004 ruling and revenue ruling 80-106 is a 1980 ruling. The rulings are distinguished from other rulings during the year by the second number.

- Rev. Rul. 80-106. Thrift shop; consignment sales. An organization operated a thrift shop that sold items that were either donated or received on consignment. Substantially all of the work in operating the thrift shop was performed without compensation, all transactions were at arm's length, and all profits were distributed to Section 501(c)(3)

organizations. The organization qualified for exemption as an organization operated for charitable purposes.

- Rev. Rul. 76-152. Art gallery. A nonprofit educational organization, formed by art patrons to promote community under-standing of modern art trends by selecting for exhibit, exhibiting, and selling artworks of local artists, and which retained a commission on sales that was less than customary commercial charges and was not sufficient to cover the cost of operating the gallery, did not qualify for exemption under Section 501(c)(3). The following statement in the ruling provides perhaps the best clue as to why the IRS rejected the group's application: "Since ninety percent of all sales proceeds are turned over to the individual artists, such direct benefits are substantial by any measure and the organization's provision of them cannot be dismissed as being merely incidental to its other purposes and activities."

- Rev. Rul. 71-395. Art selling. A cooperative art gallery, which was formed and operated by a group of artists for the purpose of exhibiting and selling their works, did not charge admission but received a commission from sales and rental of art sufficient to cover the cost of operating the gallery. It did not qualify for exemption under Section 501(c)(3) as an educational organization.

- Rev. Rul. 66-178. Art exhibits. A nonprofit organization was created to foster and develop the arts by sponsoring a public art exhibit at which the works of unknown but promising artists were selected by a panel of qualified judges for display. Artists eligible to have their works displayed were those who were not affiliated with art galleries and who had no medium for exhibiting their creations. The organization did not charge the artists any fees, nor

did the organization sell or offer the displayed works for sale. For the exhibit, the organization prepared a catalog that listed each work displayed, the name of its creator, and the artist's home or studio address. The catalog was sold for a small fee to the public. The organization also received income from nominal admission fees to the exhibit and from contributions. Funds were paid out for renting the exhibition hall, printing the catalogs, and administrative expenses. The organization qualified for a 501(c)(3) tax exemption.

If nothing else, the above rulings reinforce one fundamental fact about seeking and obtaining a tax exemption: The IRS looks at the full context of a nonprofit's operations—including its sources and uses of revenue—when deciding whether a group qualifies for 501(c)(3) tax exemption. Normally, no one fact is fatal or determinative. The more a group demonstrates that its operations are public rather than private or commercial, the better its chances of obtaining a tax exemption. And on a more subjective note, the above rulings also hint at the importance of couching your nonprofit activities in the most acceptable (least commercial) terms—for example, it may sound and look better to the IRS if your group collects admission or consignment fees rather than commissions, since the latter term typically connotes overt commercial activity.

Below are two revenue rulings related to educational nonprofits that involve the publication of books and music. The first repeats the theme that the more a group looks and acts like a regular commercial venture, the less its chances of qualifying for 501(c)(3) tax-exempt status. The second shows that nonprofits that cater to a small, traditionally noncommercial segment of public education stand a better chance of obtaining a tax exemption, at least

partially because the nonprofit activity is, in fact, less likely to reap significant profits.

The two rulings provide as follows:

- Rev. Rul. 66-104. Educational publishing. An education organization was created to meet the need for more satisfactory teaching materials and textbooks in economics and related fields. The organization contracted with commercial publishing firms for the publication of these materials, which were used primarily by colleges and universities. The organization did not hold the copyright in its published material. The contracts between the organization and the publishers provided that the publishers pay all publication costs and a royalty to the organization on sales of the publication. In return, the publisher received the copy-right, publishing, and selling rights. The agreement between the organization and the editors and authors provided that the royalty income would first be applied to pay for the costs of preparing the materials for publication, including funds to authors and editors. The remaining royalty was divided into specific percentages between the organization and the editors and authors. The IRS concluded that: "Although educational interests are served by the publication of better teaching materials, the facts in this case show only an enterprise conducted in an essentially commercial manner, in which all the participants expect to receive a monetary return." The IRS denied the organization's 501(c)(3) tax exemption.

- Rev. Rul. 79-369. Musical recording. The organization was created to stimulate, promote, encourage, and sustain interest in and appreciation of contemporary symphonic and chamber music. The organization recorded the new works of unrecognized composers as well as

the neglected works of more established composers. The music selected for recording had a limited commercial market and was not generally produced by the commercial music publishing and recording industry for sale to the public. The organization sold its recordings primarily to libraries and educational institutions. Some records were provided free to radio stations operated by educational institutions. The organization also made sales to individuals. The records were not made available for sale through commercial record dealers except in a few specialty shops, but were sold through mail orders. The organization did not engage in any advertising, but relied upon those who were interested in this type of music to communicate the availability of the records. All sales were facilitated by the use of a catalog published by the organization. The catalog contents included information about the compositions and the composers. This information was retained in the catalog so that the catalog served as an archive with respect to these compositions and recordings. Copies of all recordings were maintained for availability in the future. The liner notes on the album covers contained a biography of the composer and a description of the composition by its composer. Composers received royalties from the sale of recordings as required by federal law. Due to the limited commercial market for this type of music, the royalties received by the composers were not significant. The group qualified for a 501(c)(3) tax exemption.

Line 11: This question asks if your nonprofit will accept contributions of various types of property, including works of art and automobiles. If you answer "yes," provide the information requested. If you receive contributions of art, you may be able to refer to portions of your response to line 10, if you used that line to provide information on how you sell contributed art works. The IRS mostly wants to make sure your nonprofit is not simply setting up a contribution-conduit organization formed and operated primarily to generate income tax contributions for wealthy individuals associated with your group. See IRS Publication 526, *Charitable Contributions,* for the latest rules on the deductibility of contributions to qualified 501(c)(3) charities, available on the IRS website at www.irs.gov.

Lines 12(a)–12(d): If your nonprofit plans to operate in one or more foreign countries, answer "yes" to 12(a) and provide the information requested in 12(b) through 12(d) on an attachment page. Special tax-exemption and deductibility of contribution rules apply to nonprofits created or operated abroad. If you answer "yes," see a nonprofit adviser who has experience in advising nonprofits that operate in the foreign countries where you plan to operate for help in completing your 1023 application. (Also see "Foreign Organizations in General," in the official 1023 instructions for basic information on nonprofits formed abroad.) Finally, realize that a big part of the IRS's energy is now devoted to scrutinizing the operations of foreign-based nonprofits as part of the Service's participation in antiterrorism. Here is an excerpt from the IRS 2005 *EO (Exempt Organization) Report*:

> In FY 2005, EO will examine a sample of foreign grant making organizations; the primary focus of the examinations is to ensure that funds are used for their intended charitable purpose and not diverted for terrorist activity. The project will gather information about current practices, that is, the existence and effectiveness of controls

put in place to monitor the distribution of overseas grants and other assistance. This committee will also address the need for possible guidance or other modifications to the laws in this area.

Lines 13(a)–13(g): If your nonprofit will make grants or loans to other organizations or receive and disburse funds (for example, as a fiscal agent) for other organizations, answer "yes" to line 13(a), then answer 13(b) through 13(g). Most smaller nonprofits do not make grants or loans to other nonprofits, but may receive grant money as fiscal agents for other nonprofits. If your group plans to do this, your responses should show that the groups you sponsor promote activities that are related to your tax-exempt purposes and that you exercise oversight in making sure the funds are accounted for and used properly by the groups you sponsor. If your responses demonstrate or imply that you disburse funds as a "feeder" group to promote regular commercial or nonexempt activities, the IRS will deny your exemption. The questions listed here should give you an indication of what the IRS is looking for—formal applications, grant proposals, fiscal reporting controls, and other procedures that you will use to select, monitor, and assess the groups that you sponsor.

Lines 14(a)–14(f): This question is similar to line 13, except it applies only to foreign groups that you assist or sponsor. If you answer "yes" to 14(a), it asks additional questions (14(b) through 14(f)) to make sure you apply extra scrutiny to any foreign groups you sponsor (see the antiterrorism note in the line 12 instructions, above—it is one of the drivers for this extra IRS scrutiny of groups that sponsor or assist foreign organizations).

Line 15: First read the instructions to this line in the official 1023 instructions. They provide a definition of what "close connection" means, and the definitions cover a lot of helpful material. If you answer "yes," provide a thorough explanation on an attachment page of how your structure and/or operations are connected to those of another group. Obviously, if you do share space, people, programs, or other attributes or activities with another group, the IRS will want to see that you are not diverting your tax-exempt purposes or revenue to nontax-exempt ends or purposes promoted by the group with which you are connected.

Line 16: See the instructions before answering this question. A cooperative hospital service organization is a very special type of organization that is tax exempt under Section 501(e) of the Internal Revenue Code, which like a 501(c)(3) group, uses the 1023 application to apply for its tax exemption. You will need expert help completing your tax exemption application if you answer "yes" here.

Line 17: See the instructions before answering this question. A cooperative service organization of operating educational organizations is another special type of organization that is tax exempt under Section 501(f) of the Internal Revenue Code. Like a 501(c)(3) group, it also uses the 1023 application to apply for its tax exemption. You will need expert help completing your tax exemption application if you answer "yes" here.

Line 18: We assume readers of this book are not setting up a charitable risk pool under Section 501(n) of the Internal Revenue Code (see the instructions to the 1023 form). If you are, get help from an expert in this special field of nonprofit activity before completing your tax exemption application.

Line 19: As explained in the 1023 instructions to this line, a school is defined as an educational organization that has the primary function of presenting formal instruction, normally maintains a regular faculty and curriculum, normally has a regularly enrolled body of students, and has a place where its educational

activities are carried on (for example, private primary or secondary schools and colleges). Check the "yes" box and fill in Schedule B if one of your purposes, whether primary or otherwise, is operating a nonprofit school. (See "Filling Out the Schedules," below, for instructions on completing Schedule B.)

Line 20: If your nonprofit is setting up a hospital or medical care facility, including a medical research facility (see the definitions in the 1023 instructions), answer "yes" and complete Schedule C. (See "Filling Out the Schedules," below, for instructions on completing Schedule C.)

Line 21: If you are forming a low-income housing facility or housing for the elderly or handicapped (see the 1023 instructions for definitions of these terms), check "yes" and complete Schedule F. (See "Filling Out the Schedules," below, for instructions on completing Schedule F.)

Line 22: Refer to the 1023 instructions for definitions of terms before answering this question. If your nonprofit, whether it is a school or otherwise, will provide scholarships or other education or education-related financial aid or assistance to individuals, check "yes" and fill in Schedule H. (See "Filling Out the Schedules," below, for instructions on completing Schedule H.)

Part IX: Financial Data

All groups should complete the financial data tables in Section A (Statement of Revenues and Expenses) and Section B (Balance Sheet) of this Part IX. Start by reading the 1023 instructions for this part.

We have replaced the official instructions to the 1023 form with updated instructions that reflect new rules adopted by the IRS (and summarized at the beginning of the 1023 form in Notice 1382). Remember to check the IRS

website to see whether an updated Form 1023 is available.

Under the latest regulations, there is no advance ruling period. If a new nonprofit shows in the financial information provided in its 1023 application that it can reasonably expect to receive qualifying public support during its first five years, it will be granted a definitive ruling as a public charity for the first five years. If it can't do this, it will be classified as a private foundation. The initial five-year definitive public charity status, if granted, is uncontestable—the nonprofit will retain this status during those five years regardless of its actual sources of support during this period. In other words, even if it guessed wrong in its 1023 exemption application projections, it will keep its public charity status. After the five-year period, however, the IRS will look at current and past year annual Form 990 or 990-EZ returns to see if the group continues to qualify as a public charity. (See Chapter 10 for more on Form 990s.)

EXAMPLE: The Free Food Program gets its 501(c)(3) tax exemption and public charity tax status starting in 2010. FFP will be treated as a public charity for the five-year period from 2010 to and through 2014. At the end of 2015, the IRS will look at the group's 2011 through 2015 Form 990 returns to see if it qualifies as a public charity for the year 2015.

For more information, go to the IRS website (www.irs.gov) and type "Elimination of the Advance Ruling Process" in the search box. This will display links to IRS information on the new rules.

Statement of Revenues and Expenses

The financial data listed here includes your group's past and current receipts and expenses (many groups will need to show proposed

receipts and expenses, as explained below). The IRS will use this financial data to make sure that:

- your group's actual and/or proposed receipts and expenses correspond to the exempt-purpose activities and operational information you describe in your application
- you do not plan to engage substantially in unrelated business activities, and
- you do or most likely will meet the appro-priate 501(c)(3) public charity support test (see our instructions to Part X, below).

The number of columns you use in Section A will depend on the number of full and partial tax years your group has been in existence. Most nonprofits will have a tax year that goes from January 1 to December 31, but some will have a tax year that ends on the last day of another month—see your response to Part 1, line 5, above.

New groups without prior tax years. If your nonprofit is newly formed, it probably has not been in existence for a full tax year. Put projected numbers for the current year in column (a), and projections for the next two years in columns (b) and (c) for a total of three years.

> **EXAMPLE:** You are a new nonprofit formed on February 15 of the current year, with a tax year that goes from January 1 to December 31, and you are applying for your tax exemption in June of the corporation's first tax year. The beginning "from" date of the period shown at the top of column (a) is the date you filed your articles—February 15 of the current year. The "to" date for this period should be December 31, the end of the current tax year. Use columns (b) and (c) to show projected figures for your next two tax years, going from January 1 to December 31 of each of the next two years. Many new groups will repeat much of the information from their first tax year for the next two

proposed tax years, unless they anticipate a major change in operations or sources of support. Use column (e) to show the total for columns (a) through (f).

Don't expect to fill in all the items. The IRS knows you've just commenced operations and that you are estimating possible sources of revenue and items of expense, and it expects to see a few blank lines. Also realize that some of your projected revenues and expenses may not neatly fit the categories shown in the printed revenue and expense table. You can use revenue item 7 (other income) and expense item 23 (other expenses) to list totals for these items, and attach a list that itemizes these additional items of revenue and expense on an attachment page. The IRS does not like to see large lump sum amounts, so break down these additional items of revenue and expense as much as possible.

Groups with prior tax years. If your nonprofit has been in existence for five or more prior tax years, show actual revenue and expense amounts for your last five completed tax years in columns (a) through (d). Note that you will have to add a column between (d) and (e) for your fifth year—column (e) is for totals for all five years. You can provide this extra column of information on an attachment page (or you can split column (e) in half and use the left side of (e) for your fifth-year data). Note that the current year, column (a), will be your last completed tax year, not the partially completed current tax year. You will be supplying figures for five completed tax years, and no projected information.

Alternatively, if your nonprofit has been in existence more than one full tax year, but less than five tax years, you must show projected financial information for your current tax year in column (a), then show figures for your prior completed tax year(s) in the other column or columns. You also may need to show projected

revenue and expense information in one of the columns for a future tax year depending on how many years you have been in existence. Here is how it works:

If your group has been existence one full prior tax year, show projected figures for the full current tax year in column (a), and your prior completed tax year in column (b). Then show projected figures for the next two years' revenues and expenses (the two tax years after the current tax year) in columns (c) and (d). This information represents four full tax years' worth of information—one completed tax year and three projected tax years.

If your group has been existence two full prior tax years, show projected figures for the full current tax year in column (a), your most recent completed tax year in column (b), and your first completed tax year in column (c). Then show projected figures for the next year's (the year after the current year) revenues and expenses in column (d). This information represents four full tax years' worth of information—two completed tax years and two projected tax years. Use column (e) for totals of the other columns.

Line 12 of the revenue and expense statement asks you to list any "unusual grant" revenue. This term is explained in the instructions for this line in the 1023 instructions, and we explain it in more detail in "Public Support Test" and "Exempt Activities Support Test," in Chapter 4, as it applies to the different public charity support tests. (Also see the specific rules on unusual grants contained in IRS Publication 557.)

Basically, unusual grants are permitted grants that can throw a kink in your public charity support computations because they come from one source, as opposed to several smaller grants from different sources. Remember, 501(c)(3) public support revenue is supposed to be spread out and come from a number of public sources, not just one or two. It is unlikely that you expect to receive an unusual grant this early in your nonprofit life—unusual grants normally happen only as a result of a sustained and successful outreach program that attracts one or two large grants that surprise the modest expectations of a small nonprofit. In effect, an unusual grant represents both good and bad news. The good news is the unusually large amount of the grant; the bad news is its potential damage to the group's ability to meet the technical public support requirements that apply to 501(c)(3) public charities. If you have received or expect to receive one or more unusual grants, insert the total number here on line 12 in the appropriate column (past, present, or future tax year), and list on an attachment page a description of each grant (what the grant was for, whether it was restricted to a specific use, and other terms of the grant), together with the donor's name, date, and amount of each unusual grant. If a large grant qualifies as an unusual grant, it will be disregarded by the IRS when it computes whether your support qualifies under the technical public charity support test rules (see Part X, below).

Balance Sheet

Prepare the balance sheet to show assets and liabilities of your corporation as of your last completed tax year, if any, or the current tax year if you have not yet completed one full tax year.

EXAMPLE: You have organized a new nonprofit corporation, formed on April 1. You are preparing your 1023 application in November of the same year. Your tax year goes from January 1 to December 31. The current tax year period covered by column (a) of your Statement of Revenue and Expenses is from April 1 to December 31. Your balance sheet ending date will be the same ending date, December 31, the eventual ending date of your first tax year. This date should appear as the "year-end" date in the blank at

the top right of the balance sheet page. Even though this is a future end date, you should base your statement of assets and liabilities on current information—that is on your organization's current assets and liabilities at the time of the preparation of your exemption application.

It's not uncommon for a small starting nonprofit without liabilities and accounts receivable to simply show a little cash as its only reportable balance sheet item. Other common items reported are line 8 depreciable assets—equipment owned by the corporation and used to conduct its exempt activities.

Line 17 of the balance sheet asks for fund balance or net asset information. Typically, this is the amount by which your assets exceed your liabilities—in other words, the net value of your assets. If you have difficulty preparing the financial information under this part, get the help of a tax or legal adviser.

Line 19 asks if there have been substantial changes in your assets and liabilities since the year-end date for your balance sheet. This question should be answered "no" by most groups. However, if your nonprofit is submitting a balance sheet for a prior completed period and your assets and liabilities have undergone significant change—as a result, perhaps of a sale or purchase of assets, a refinancing of debt, or other major structural change—answer "yes" and provide an explanation on an attachment page.

Part X: Public Charity Status

You should be familiar with the material in Chapter 4 in order to answer the questions in this part of the form. This is where terms such as "public charity" and "private foundation" become important. We will refer to earlier explanations as we go along, but you may want to look over Chapter 4 now before you proceed.

The questions in this part relate to whether you are seeking to be classified as a 501(c)(3) public charity or as a 501(c)(3) private foundation. As you know by now, we assume you want your nonprofit to qualify as a 501(c)(3) public charity, not as a 501(c)(3) private foundation.

Lines 1(a)–(b): In Chapter 4, we discussed the distinction between the public charity and private foundation classifications and the reasons that you should try to meet one of the three primary tests for being classified as a public charity. The 1023 instructions provide a list of groups that qualify for public charity status, which lumps all publicly supported groups together ("groups that have broad financial support"). We use a different classification scheme in Chapter 4, which puts public charities into one of three categories:

(1) Automatic Public Charity Status: groups that are set up for a specific purpose or special function, such as churches, schools, hospitals, and public safety organizations, qualify as public charities (we say they "automatically" qualify because these groups, unlike the other two types of public charities listed below, do not have to meet public support tests).

(2) Public Support Test Groups: these are groups that are supported by contributions and grants and that meet the one-third or one-tenth public support tests described in "Public Support Test" in Chapter 4.

(3) Exempt Activities Support Test Groups: these are groups that obtain support through the performance of their exempt purposes, such as admissions, tuition, seminar fees, and receipts from goods and services related to the group's exempt purposes.

We assume your nonprofit will either be setting up one of the special public charities that automatically qualify under (1), above, or a nonprofit

that has or can reasonably expect to receive the type of support listed in (2) or (3), above.

Line 1(a): Check "yes" or "no" on line 1(a) to indicate whether or not you are a private foundation. Again, we assume you expect to qualify as a public charity and will mark "no" to this question. If your response is "no," go on to line 5. If you are forming a 501(c)(3) private foundation, check "yes" and go on to line 1(b).

Line 1(b): This line only applies if you answered "yes" to line 1(a). Line 1(b) asks you to check the box as a reminder that your private foundation requires special provisions in your articles or reliance on special provisions of state law. This book and its forms do not address these extra requirements, and you will need the help of a nonprofit adviser to form your 501(c)(3) private foundation and prepare your articles properly.

Lines 2–4: As with line 1(b) above, these lines only apply if you answered "yes" to line 1(a) indicating that you are applying for a tax exemption for a 501(c)(3) private foundation. These questions ask even more specific questions to help pigeonhole the private foundation into special subcategories—private operating and private nonoperating foundation categories. We assume you will get the help of an experienced legal or tax person who works with private foundations before answering these questions. After answering these questions, a group that is preparing its 1023 application for a private foundation should skip the remaining lines in this part of the form and go on to Part XI.

Line 5: Check the box (letters (a)–(i)) that corresponds to the basis of your claim to public charity status. First, absorb what you can of the technical material given in the 1023 line 5 instructions. Then reread "How to Qualify for Public Charity Status," in Chapter 4—this section provides the names of these public charity organizations, the requirements they must meet, and the Internal Revenue Code sections that apply to them. Note that letter (i) is a special case that

allows certain groups to have the IRS determine which public charity support test best suits their activities and sources of revenue. We cover this special choice in more detail in line (i), below.

The following chart shows how the different types of groups listed in this part of the application fit within the three different categories of public charity status discussed in "How to Qualify for Public Charity Status," in Chapter 4. If you concentrate on our basic division of these different groups into the three public charity categories, rather than focusing on the individual Internal Revenue Code sections, this part will go more smoothly.

Let's look a little more closely at each of the lettered boxes in line 5:

Line 5(a): If you seek to qualify automatically for public charity status as a church, see the 1023 instructions to this item. You will need to complete Schedule A and include it with your 1023 application. (See "Filling Out the Schedules," below, for instructions on completing Schedule A.)

Line 5(b): Check this box if your primary purpose is to set up and operate a formal school. If you check this box, make sure you have completed Schedule B. (See the separate 1023 instructions to Schedule B, in "Automatic Public Charity Status," in Chapter 4 (see the section "Schools"), and our instructions for filling out Schedule B in "Filling Out the Schedules," below.)

If you will set up and operate a school, but operating the school is not your primary purpose, do not check this box—you will need to qualify as a public charity by checking one of the other line 5 boxes. However, you must complete Schedule B and attach it to your exemption application if you plan to operate a school, even if operating the school is not your primary purpose and the basis for your claim to public charity status—see the instruction to line 5(b) in the 1023 instructions.

Lines 5(c)–5(f): Read the instructions for these lines in the 1023 instructions. Few groups will choose one of these boxes—each applies to a special type of organization such as a hospital, supporting organization, public safety organization, or government agency.

Line 5(c) hospitals and medical research groups will need to complete Schedule C—you should refer to the 1023 instructions for this schedule, the section "Hospitals and Medical Research Organizations" in "Automatic Public Charity Status," in Chapter 4, and our instructions for filling out Schedule C in "Filling Out the Schedules," below.

Line 5(d) supporting organizations are a special type of nonprofit set up to support other public charities. They are operated solely for the benefit of, or in connection with, any of the other public charity organizations (except one testing for public safety). A supporting organization must complete Schedule D. This information helps the IRS determine whether this type of organization supports other qualified public charities.

TIP

Get help when applying for an exemption for a special type of nonprofit. If you check one of the 5(c) through 5(f) boxes, the lawyer, accountant, or other adviser who is helping you organize one of these special corporations should help you with your application and any additional schedules you have to prepare and include with your application.

Line 5(g): First read the 1023 instructions for this line. This box is for organizations that receive a substantial part of their support from government agencies or from the general public. These are the public support test groups discussed in Chapter 4. If you believe this is the public charity best suited to your organization's sources of support, check the box on this line. If you are unsure whether this is the best support test to use for your group (that is, if you think

that the exempt activities support test in line 5(h) also may apply to your organization), you may wish to let the IRS make this decision for you as explained in the line 5(i) instructions, below.

As discussed in "Public Support Test," in Chapter 4, many groups will not want to fall under this public charity test because it does not allow your receipts from the performance of services related to the corporation's exempt purposes to be included as "qualified public support."

Groups checking line 5(g), go on to Part X, line 6.

Line 5(h): Start by reading the 1023 instructions for this line. This box is for organizations that normally receive one-third of their support from contributions, membership fees, and gross receipts from activities related to the exempt functions of the organization (subject to certain exceptions) but not more than one-third from unrelated trades and businesses or gross investment income. This exempt activities support test is discussed in Chapter 4. This is the most common and often the easiest way to qualify a new nonprofit organization as a public charity. So reread the requirements of this test and the definition of terms associated with it in Chapter 4. If you believe this public charity test best suits your expected sources of support, check this box. If you are unsure, see the instructions to line 5(i), just below.

Groups checking line 5(h), go on to Part X, line 6.

Line 5(i): If you feel that your group may qualify as a public charity either under line 5(g) or 5(h) but aren't sure which to choose, you can check this box. The IRS will decide which of these two public charity classifications best suits your organization based upon the financial data and other financial support information included in your 1023 application. For many new groups, line 5(i) is the best way to go. Rather than working through the math and the

technical definitions necessary to approximate whether you will qualify as a public charity under line 5(g) or 5(h), by checking this box you let the IRS do the hard work for you.

Groups checking line 5(i), go on to Part X, line 6.

Here are some sample responses to line 5 by some typical, hypothetical nonprofit groups:

The First Fellowship Church, a religious organization that plans to maintain a space to provide weekly religious services to its congregation, checks line 5(a) to request automatic public charity status as a church.

The Workshop for Social Change, an educational group that plans to receive support from public and private grant funds and from individual and corporate contributions, checks line 5(g) to request public charity status as a publicly supported organization.

Everybody's Dance Studio and Dinner Theater, a group that expects to derive most of its operating revenue from student tuitions, special workshops, and ticket sales (as well as from other exempt-purpose activities), selects line 5(h) to be classified as a group that meets the exempt activities support test, discussed in Chapter 4.

The School for Alternative Social Studies, an accredited private postgraduate school with a formal curriculum, full-time faculty, and regularly enrolled student body, checks line 5(b) to request automatic public charity status as a formal private school.

The Elder Citizens' Collective and Information Exchange, which plans to derive support from contributions and grants as well as subscriptions to its weekly newsletter (and other exempt-purpose services and products made available to members and the public at large), checks line 5(i) to have the IRS decide whether line 5(g) or 5(h) is the appropriate public charity classification.

Line 6: Only groups that have checked line 5(g), 5(h), or 5(i)—groups that are seeking to be classified as a publicly supported public charity—should look at line 6. To start with, all of these groups should ignore line 6(a) and the following blank lines that appear under the Consent portion of this part of the form. Line 6(a) and the Consent portion used to apply if a publicly supported group wanted to or was required to seek an advance ruling as to its public charity status. Since the federal tax regulations have eliminated the advance ruling period for all groups, line 6(a) no longer applies. *Ignore it!*

If you checked line 5(g), 5(h), or 5(i), but your nonprofit has not been in existence for five or more completed tax years, you also should ignore lines 6(b) and 7, and you should go on to Part XI.

If you checked 5(g), 5(h), or 5(i) and your nonprofit has been in existence for five or more completed tax years, you should complete line 6(b) and line 7 of Part X. The IRS will use this additional information to determine if your nonprofit qualifies as a publicly supported public charity.

Line 6(b): If you checked line 5(g), 5(h), or 5(i) and your nonprofit has completed five or more tax years (ignore the requirements for completing line 6(b) on the 1023 form—these requirements are based on the old law), check the line 6(b) box and answer the remaining line 6(b) questions, as explained in the next several paragraphs. First read the official 1023 instructions to these additional line 6(b) items before following our instructions below.

Line 6(b)(i)(a): Enter 2% (0.02) of the amount shown in Part IX-A (Revenues and Expenses), line 8, column (e)—this is 2% of your organization's total public support received over the tax years shown in Part IX-A. The IRS will use this number in computing whether your group meets the appropriate public charity support test.

Who Are Disqualified Persons?

People who are disqualified in the eyes of the IRS are not necessarily prohibited from participating in the operation of the 501(c)(3) nonprofit corporation. Instead, their contributions to the nonprofit may not count when figuring the public support received by public charities. (Note that the definitions of disqualified persons discussed here are different from the definitions of disqualified persons under IRC § 4958—see the instructions to Part V, above, for information on this separate set of definitions.) If the corporation is classified as a 501(c)(3) private foundation, the corporation and the disqualified individual can be held liable for certain private foundation excise taxes. Disqualified persons for purposes of meeting the public charity support tests include:

1. Substantial contributors. These are donors who give more than $5,000, if the amount they contributed is more than 2% of the total contributions and bequests received by the organization. For example, suppose Ms. X makes a gift of $20,000 to your nonprofit corporation. If this gift exceeds 2% of all contributions and bequests made to your organization from the time it was created until the end of the corporate tax year in which Ms. X made the contribution, Ms. X is a substantial contributor.

For purposes of determining whether a substantial donor is a disqualified person, gifts and bequests made by that individual include all contributions and bequests made by the individual's spouse. Once a person is classified as a substantial contributor, he or she generally remains classified as one (regardless of future contributions made, or not made, by the individual or future support received by the organization). However, if other conditions are met, a person will lose his or her status as a substantial contributor if he or she makes no contribution to the organization for ten years.

2. All foundation managers. Directors, trustees, and officers (or people with similar powers or responsibilities), or any employee with final authority to act on a matter, are disqualified as foundation managers—this means the bigwigs in a nonprofit who exercise executive control. Officers include persons specifically designated as "officers" in the articles, bylaws, or minutes, and persons who regularly make administrative and policy decisions. Officers do not include independent contractors, such as accountants, lawyers, financial and investment advisers, and managers. Generally, any person who simply makes recommendations for action but cannot implement these recommendations will not qualify as an officer.

3. Owners and substantial players in entities that contribute. An owner of more than 20% of the total combined voting power of a corporation, the profits of a partnership, or the beneficial interest of a trust or an unincorporated enterprise are all disqualified, if any of these entities is a substantial contributor.

4. Family members. A member of the family—including ancestors, spouse, and lineal descendants, such as children and grandchildren, but not brothers and sisters—of any of the individuals described in 1, 2, or 3 above, is disqualified.

5. Other business entities. Corporations, partnerships, trusts, and so on in which the persons described in 1 through 4 above have at least a 35% ownership interest.

For more information on disqualified persons, type "private foundations and disqualified person" in the search box of the IRS website at www.irs.gov.

Line 6(b)(i)(b): If any individual, organization, or company has contributed more than the 2% amount shown in 6(b)(i)(a) during the prior tax years covered in Part IX-A (Revenues and Expenses) of your application, supply the name(s) of the contributor(s) and the amount(s) contributed on an attachment page. Conversely, if no individual, organization, or company contributes more than this 2% amount, check the box at the right. Why does the IRS want this information? For line 5(g) public support test charities, the IRS generally does not count amounts that exceed 2% of the group's total support as qualified public support (for more on the 2% rule and its exceptions, see "Public Support Test" in Chapter 4 and IRS Publication 557, "Support From the General Public").

Lines 6(b)(ii)(a)–6(b)(ii)(b): These questions require you to disclose sources of support that the IRS does not consider qualified public support for groups that are seeking public charity status under the exempt activities support test (the groups covered in "Exempt Activities Support Test," in Chapter 4, that rely on support received primarily from their exempt-purpose activities). We're talking here about contributions from disqualified persons or gross receipts from other individuals that exceed the larger of 1% of the organization's total support or $5,000 in any tax year.

Line 6(b)(ii)(a): For a definition of disqualified persons, including a "substantial contributor," see the official instructions to the form. We provide a somewhat friendlier set of definitions of these terms in "Who Are Disqualified Persons?" above. If a disqualified person provided gifts, grants, or contributions, membership fees, or payments for admissions, or other exempt-purpose services or products (these are the categories listed in lines 1, 2, and 9 of Part IX-A, Revenues and Expenses) during any tax year shown in Part IX-A, list the disqualified persons and amounts contributed or paid on an attachment page. If no disqualified person paid or contributed any of these amounts, check the box to the right.

Line 6(b)(ii)(b): If any person (other than a disqualified person) has paid more than the larger of either $5,000 or 1% of the amount shown in line 9 of Part IX, Revenues and Expenses (admissions or other exempt-purpose services or products), during any completed tax year shown in Part IX-A, provide the name of the person or organization who made the payment and the amount of each payment on an attachment page. The list should be broken down year by year. If no individual (other than a disqualified person) made such a payment for any of the completed tax years shown in Part IX-A, check the box to the right of this item.

Line 7: As with line 6(b), line 7 only applies to groups that checked line 5(g), 5(h), or 5(i), and have completed five or more tax years. To answer this question, first refer to our instructions to Part IX-A above (Statement of Revenue and Expenses). If you have listed any unusual grants on line 12 of the Statement of Revenue and Expenses in any of the columns, check "yes" and list them on an attachment page along with the donor's name, date, and amount and the nature of the grant (what the grant was for, whether it was restricted to a specific use, and other terms of the grant). If you provided this information in an attachment to Part IX-A, you can refer to your earlier response. (For further explanation of what constitutes unusual grants, see "Unusual Grants," below.) If you have not listed any unusual grants in the Part IX-A Revenue and Expense statement, check the "no" box.

Unusual Grants

Unusual grants are contributions, bequests, or grants that your organization receives because it is publicly supported but that are so large that they could jeopardize your ability to meet your public support test. The benefit of having a large grant qualify as an unusual grant is that it does not jeopardize the group's public charity status (as do other large sums received from a single source). It is unlikely that your beginning nonprofit has received sums that should be classified as unusual grants. For further information on this technical area, see the 1023 instructions to line 7 of Part X, the discussion and examples of unusual grants in "What Is Public Support?" in Chapter 4 (see "Money From Unusual Grants" and "Unusual Grants Drop Out of the Support Computation"), and the specific rules on unusual grants contained in IRS Publication 557.

Part XI: User Fee Information

You must pay a user fee when you submit your 1023 tax exemption application. The fee is determined according to the amount of gross receipts your group has or expects to receive annually (averaged over a four-year period). See the 1023 instructions to this part first before reading our instructions below.

CAUTION

Always check that the fee amount is current. Your user fee check should be made payable to the "United States Treasury" and show "User fee Form 1023 [name of your group]" on the check memo line. Before writing your check, go to the IRS website at www.irs.gov to make sure you have the current fee amounts. Type "Exempt Organizations User Fee" in the keyword box to find fee amounts. Alternatively, call the IRS Exempt Organization Customer Service telephone number at 877-829-5500 to ask for current 1023 user fee amounts.

Ignore the amounts listed in Part XI of the 1023 form. Here are the latest amounts (which are noted in the instructions at the top of the 1023 form).

Line 1: Groups that qualify for a reduced user fee of $400 check "yes." Your organization qualifies for this reduced fee if it is submitting its initial exemption application and it:

- is a new organization (in operation for less than four years) that anticipates annual gross receipts averaging not more than $10,000 during its first four tax years, or
- has been in operation for four tax years or more and has had annual gross receipts averaging not more than $10,000 during the preceding four years.

Line 2: If you check "yes" in line 1, also check the line 2 box. If you did not check "yes" to line 1, do not check box 2.

Line 3: If you did not check "yes" to line 1, check the line 3 box and include a user fee check for $850. If you checked the line 1 box, do not check this box.

Check the IRS website to see if the "Cyber Assistant" online program with reduced filing fees is available. The IRS has planned to launch this program for several years but it has been delayed.

TIP

What happens if you guess incorrectly? You may be concerned about what will happen if you estimate that your gross receipts will average no more than $10,000 during your first four tax years, but your actual gross receipts exceed this amount in one or more years. We don't know for sure, but if you make more than this threshold amount, it seems reasonable to assume that the IRS would monitor your annual information returns and ask you to pay the remaining balance later. Of course, if the financial information you submit with your 1023 exemption application shows that your group has, or expects to have, average gross receipts exceeding $10,000 for its first four years and you check the wrong box here,

expect the IRS to return your exemption application due to insufficient payment or to send out a request for an additional payment before it continues processing your application.

Signature, Name, Title, and Date Lines: Have one of your initial directors or officers sign, type his or her name and title (director, president, chief operations officer, or the like), and insert the date on the lines provided at the bottom of Part XI.

Write a check payable to the United States Treasury for the amount of the user fee. *Do not staple* or otherwise attach your check to your application. Simply place your check at the top of your assembled exemption application package, as explained in the next section. The check does not have to be an organizational check. The person preparing the application or any other incorporator may write a personal check. The user fee is kept by the IRS in almost all circumstances, even if your application is denied. The only time it is refunded is if the IRS decides that it cannot issue a determination as to your exempt status one way or the other— because it has insufficient information or cannot resolve some of the issues associated with your tax exemption request. By the way, this rarely happens. For example, if you don't respond to any follow-up questions that the IRS may ask in response to your application, it normally denies your exemption (and keeps the check).

Whew! You're just about done. Follow the instructions below for assembling your entire federal exemption package.

Filling Out the Schedules

Certain groups must complete and submit schedules with their Form 1023 application. In the line-by-line instructions to the 1023 form, above, we let you know when you are required to complete a schedule. For example, in Part VII, line 1, of the application, we tell you that

if you answered "yes" to that item, you must complete Schedule G. If you do not need to submit any schedules with your Form 1023, you can skip this section.

Schedule A. Churches

See the separate instructions to Schedule A, included in the last portion of the official 1023 instructions, for help in filling out this schedule. We've discussed the requirements for churches in "Automatic Public Charity Status," in Chapter 4. The questions here seek to determine whether your organization possesses conventional institutional church attributes —the more the better as far as the IRS is concerned. Some also relate to whether your organization unduly benefits, or was created to serve the personal needs of, your pastor or the pastor's family and relatives. Obviously, doing so is an IRS no-no.

Schedule B. Schools, Colleges, and Universities

See the official 1023 instructions to Schedule B for help in completing this schedule. Your responses to this schedule should show that your operations are nondiscriminatory and in accordance with a nondiscrimination statement included in your bylaws and published in the community in which you serve (you must attach this bylaw resolution to Schedule B). For information on drafting and publishing this statement of nondiscrimination, see "Educational Purposes" in Chapter 3. Also see IRS Publication 557, "Private Schools" (available on the Nolo website; see Appendix A for the link).

Schedule C. Hospitals and Medical Research Organizations

Make sure to check the appropriate boxes at the top of the schedule and fill out the appropriate

section of the form. Generally this schedule seeks to determine two things:

- whether the hospital is charitable in nature and qualifies for 501(c)(3) tax-exempt status, and
- whether the hospital or medical research organization qualifies for automatic public charity status (see the Schedule C instructions in the official 1023 instructions and IRS Publication 557, "Hospitals and Medical Research Organizations").

A 501(c)(3) charitable hospital normally has many of the following characteristics:

- staff doctors selected from the community at large
- a community-oriented board of directors (directors come from the community served by the hospital)
- emergency room facilities open to the public
- a policy of allowing at least some patients to be treated without charge (on a charity basis)
- a nondiscrimination policy with respect to patient admissions (it doesn't pick and choose its patient population) and particularly does not discriminate against Medicare or Medicaid patients, and
- a medical training and research program that benefits the community.

Hospitals need to be careful when it comes to renting space to physicians who are members of the board—and carrying out a private practice that's unrelated to the community service programs of the hospital. The IRS will be particularly suspicious if such physicians are prior tenants and their rent is below fair market value. Section 1, question 7, of Schedule C addresses this issue.

Hospitals should adopt a suitable conflict of interest policy in their bylaws (see Schedule C, Section 1, line 14). Article 9 of the bylaws included with this book contains most of the provisions in the sample conflict of interest policy provided in Appendix A of the official

1023 instructions. However, it does not include the special bracketed provisions that apply specifically to hospitals. There are two, which are clearly marked in Appendix A of the 1023 instructions with the words "*[Hospital Insert— for hospitals that complete Schedule C...].*" Make sure you insert these additional bracketed provisions to the provisions in Article 9 of the bylaws included with this book.

The Affordable Care Act added new requirements for charitable hospitals. (See Notice 2010-39 and Notice 2011-52 and ask your tax adviser for more information.)

Schedule D. Section 509(a)(3) Supporting Organizations

Refer to the 1023 instructions for this schedule, Chapter 4, "Automatic Public Charity Status" (see "Supporting Organizations") and Publication 557, "Section 509(a)(3) Organizations." This is a complicated schedule—you must meet a number of technical tests. Your nonprofit legal or tax adviser can help you qualify for this special type of public charity classification.

Schedule E. Organizations Not Filing Form 1023 Within 27 Months of Formation

Before filling in Schedule E, read the official IRS 1023 instructions to Schedule E, which are contained in the instructions for separate schedules at the end of the 1023 instructions. This material will give you some basic definitions and information that will help you work your way through the schedule.

Lines 1–3: Three groups are not required to file Form 1023: churches; public charities that normally have gross receipts of not more than $5,000 in each year (see the extra instructions for line 2(b) below); and subordinate organizations exempt under a group exemption letter (see Section B, above). If you decide that you

fall within one of these exceptions (after reading any additional instructions for the line below), check the "yes" box or boxes on the appropriate line (either line 1, 2, or 3) and go on to Part VIII of the 1023 form. You do not need to complete the rest of Schedule E. If the IRS agrees that you qualify as one of these three special groups, your federal exemption will be effective retroactively from the date of your incorporation, even though you filed your exemption application late (after more than 27 months from the end of the month when you filed your articles).

If you fall within one of the three groups, you are filing an exemption application even though you believe you are not required to do so and even though you are filing more than 27 months after your nonprofit corporation was formed. As we said in Section B, above, we agree that this is the best way to go because by submitting your exemption application you are making sure the IRS agrees that your group is entitled to a tax exemption in one of these three special 501(c)(3) categories.

Lines 2(a)–2(b): The 2(a) exception is often applicable to new nonprofits. Your group qualifies if it:

- is a public charity rather than a private foundation (because one of the purposes of completing your 1023 application is to establish that you are eligible for public charity status, we assume that you meet this requirement), and
- "normally" has gross receipts of not more than $5,000 in each tax year.

Groups that have been in existence for two tax years qualify if they had total gross receipts of $12,000 or less during the first two years. We assume your group has been in existence for at least two years because it is filing more than 27 months after it was formed. If you have been in existence for three or more tax years, your gross receipts over the three years must be $15,000 or less to qualify for the "normally $5,000" exception. Many new groups without outside sources of support can meet this gross receipts test during their beginning tax years. And, if you can't check "yes" to line 2(a), there's a technical loophole in line 2(b): It says that groups that are filing their 1023 application within 90 days after the end of the tax year when they qualified for the "normally $5,000 gross receipts" test also can file their application late.

EXAMPLE: You form a new nonprofit corporation in January of 2011 and file your tax exemption application more than four years later—in February 2015. Your group had gross receipts of less than $5,000 for 2011 through 2013, but 2014 was a really good year so the total gross receipts for your organization over the three-tax-year period from January 2012 through December 2014 was $25,000. This is well over the three-year $15,000 cumulative total maximum amount. If you submit your 1023 application in February of 2015, which is within 90 days of the end of 2014, you can check box 2(b) and have the tax exemption extend all the way back to the date of incorporation because it meets this special line 2(b) exception. Obviously, this 2(b) exception is intended for groups that file quickly after determining that their past three-year cumulative gross receipts put them over the $15,000 mark. Once they go over this mark, they become a group that is required to file a 1023 application—the IRS will let them have their tax exemption for all prior years, even though the last three-year cumulative total exceeded the $15,000 threshold, as long as the group files the Form 1023 within 90 days of the end of the high-receipts tax year.

Line 4: Here is where you end up if your group is filing the 1023 application more than 27 months from the date of your incorporation and you don't meet one of the three exceptions listed

in lines 1 through 3 of this part. Groups formed on or before October 9, 1969 get a special break. Of course, we assume you were formed recently, and will check "no" and move on to line 5.

Line 5: Since your group is not one of the special groups listed in the previous lines on Schedule E, your group can only qualify for an exemption that extends back to its date of formation if it asks the IRS to qualify for late filing. To do this, check "yes" and attach a statement giving the reasons why you failed to complete the 1023 application process within the 27-month period after your incorporation. Federal rules, contained in Treasury Regulations 301.9100-1 and 301.9100-3, also include a list of the acceptable reasons for late filing, as well as those that aren't. For example, acceptable reasons include the following: you relied on the advice of a lawyer, accountant, or an IRS employee, and received inaccurate information or were not informed of the deadline. These acceptable reasons are summarized in the 1023 instructions for this line. After attaching your statement, perhaps with the help of your tax adviser, go on to Part VIII of the 1023 application—you should not complete the rest of Schedule E.

If you don't think you can qualify for an extension (or if you decide not to bother—see "If You End Up on Schedule E, Line 5, Should You Ask for an Extension?" below), check "no" and go on to line 6.

Line 6 (a): If you checked "no" on line 5 (you don't want to qualify for an extension of time to file), you should check "yes" to 6(a). This means that you agree that your 501(c)(3) exemption can be recognized only from its postmark date, not retroactively to the date of your incorporation. By the way, if you check "no" to 6(a), you are saying that you are applying for a tax exemption as a 501(c)(3) private foundation, not a public charity—this is something you definitely will not want to do. We assume all readers will want to form a 501(c)(3) public charity, as mentioned

earlier in this chapter and explained in more detail in Chapter 4. So check "yes" to 6(a) and move on to 6(b).

If You End Up on Schedule E, Line 5, Should You Ask for an Extension?

Most groups will not end up on Schedule E, line 5—they will submit their 1023 application within 27 months from the date of their incorporation. If your group does end up here, you may decide not to bother seeking an extension and simply check "no" on line 5. This means that your 501(c)(3) exemption, if granted, will be effective only from the application's postmark date, not from the date of your incorporation. Is this so terrible? Often, it isn't. Here's why. Many nonprofits will not have any taxable income or contributions from donors during these early start-up months (the 27-plus months of operation prior to filing their 1023 application). Consequently, obtaining a tax exemption for these early months will not provide a tax benefit. However, if your group is facing tax liability for early operations, the need to provide donors with tax deductions for gifts contributed during the first 27-plus months, or the need to obtain 501(c)(3) tax-exempt status from the date of its creation for some other pressing reason, then it makes sense to prepare a special statement under line 5 as explained in the text. If you are unsure, check with your tax adviser.

Even though the 1023 instructions say that checking "yes" to 6(a) means that you will have to request an advance ruling period for your public charity status (by completing Part X, 6(a)), this is no longer true. As mentioned earlier, advance rulings have been eliminated and you should ignore Part X, line 6(a)—see our instructions to Part X, earlier in this chapter.

Line 6(b): Most groups that are applying late for their tax exemption are not planning to substantially change how they get financial support, so they will check "no" to 6(b) and ignore the table in line 7—they will move on to line 8 of Schedule E. However, some groups that are applying late realize that their past operations and sources of financial support may or may not qualify them to meet one of the public charity support tests (as more fully explained in our instructions to Part X), and will want to change their plans for financial support now. If this is the case for your late-filing nonprofit, mark "yes" to 6(b), then fill in the projected revenue table in line 7 to show your expected sources of future financial support.

Line 7: If you marked "yes" to line 6(b), fill in projected sources of financial support for the next two full years following the current tax year. For example, if you are applying for your tax exemption late in July of 2015, and your nonprofit's tax year goes from January to December (the typical case), supply financial figures for the period from January 2016 to December 2017 in the table. You don't have to fill in items for all rows, but you should be able to supply figures that show that you expect your nonprofit to obtain support from sources that qualify it for public charity status under one of the two basic financial support categories discussed in Part X.

Line 8: If you are filing your 1023 application late and checked "yes" to line 6(a) on Schedule E, you should complete line 8 of the Schedule, regardless of how you responded to 6(b). If you end up here, your application for 501(c)(3) status will be considered only from the date of its postmark. If you check "yes" to line 8, you are asking the IRS to grant your group tax-exempt status as a 501(c)(4) organization—a social welfare group or a civic league—during your late filing period (the 27-month-plus period from the date your articles

were filed up to the date your 1023 application postmark). What does this do for you? If your request for 501(c)(4) status is approved, your organization will be exempt from paying federal corporate income taxes as a 501(c)(4) organization from the date of its formation until the date of approval of your 501(c)(3) tax-exempt status (the 1023 postmark date). For most newly formed groups without taxable income during this initial period, obtaining this extra tax exemption will not be necessary and you can ignore this box.

501(c)(4) Organizations

Internal Revenue Code Section 501(c)(4) provides a federal corporate income tax exemption for nonprofit social welfare groups and civic leagues (see Special Nonprofit Tax-Exempt Organizations, in Appendix B). Since the promotion of public welfare is defined as "promoting the common good and general welfare of the people of the community," many 501(c)(3) nonprofits also qualify as 501(c)(4) social welfare organizations. Although 501(c)(4) nonprofits are exempt from federal corporate income taxation, they are not eligible to receive tax-deductible contributions from donors. They also do not enjoy many of the other advantages associated with 501(c)(3) tax-exempt status, such as eligibility to receive public and private grant funds, participate in local, state, and federal nonprofit programs, obtain county real and personal property tax exemptions, and other benefits.

But 501(c)(4) organizations do enjoy one advantage not available to 501(c)(3) groups: They may engage in substantial legislative activities and may support or oppose candidates to public office. (For further information on 501(c)(4) tax-exempt status, see IRS Publication 557.)

However, if you or your tax adviser determines that your organization is subject to tax liability for this initial period, check this box and call 800-TAX-FORM to order IRS Publication 1024 (or go to www.irs.gov). Fill in page 1 of Form 1024 and submit it with your exemption application. If you qualify as a 501(c)(4) social welfare group (as many 501(c)(3)s do—see "501(c)(4) Organizations," above)—your 501(c)(3) tax determination letter will indicate that you qualify as a 501(c)(4) organization during your initial late filing (your pre-501(c)(3)) period.

Schedule F. Homes for the Elderly or Handicapped and Low-Income Housing

See the 1023 instructions for help in filling out this schedule. In part, this schedule attempts to determine whether elderly or handicapped housing facilities are made available to members of the public or the particular community at reasonable rates, whether provision is made for indigent residents, whether health care arrangements are adequate, and whether facilities are adequate to house a sufficient number of residents.

Schedule G. Successors to Other Organizations

Line 1(a): We assume your nonprofit is not a successor to a prior profit-making company, which is one such as a sole proprietorship, partnership, limited liability company, or a business corporation that allows its owners to have a proprietary (financial) interest in its assets. In the unlikely case that you check "yes" to line 1(a) because you are a successor to a profit organization, we think you will need help from a nonprofit expert when filling out

Schedule G and the rest of your tax exemption application to explain to the IRS why you decided to convert a prior profit-making activity to nonprofit corporate status, and why the new nonprofit is entitled to its tax exemption.

Successor groups that check "no" to line 1(a) will have to check "yes" to line 2(a) to indicate that they are successors to a nonprofit group (remember, a successor group is one that meets one of the successor tests listed above—if you are not a successor group, you shouldn't be filling in Schedule G). Even these groups may need help responding to Schedule G. For example, it asks for the prior tax status and EIN of your predecessor group, and whether it has previously applied for a tax exemption. If the predecessor group was required to file tax returns and/or pay taxes but did not, expect the IRS to ask for these returns (and late filing and late payment penalties too). If the prior group was denied a tax exemption, you will need to clearly explain what has changed that makes you believe you qualify for an exemption now. The schedule also attempts to determine if the new nonprofit has been set up to benefit or serve the private interests of the people associated with the predecessor organization. If assets were transferred from the prior nonprofit association to the new nonprofit corporation, you are asked to provide a sales or transfer agreement (Schedule G, line 6(c)). If you have prepared this formal paperwork, attach a copy to your application. If you haven't (this is normally the case for small nonprofits that are formally converting a prior nonprofit association to a nonprofit corporation), you should prepare (perhaps with help from someone with financial savvy associated with your nonprofit) and put together a simple term sheet that lists the assets and liabilities transferred to the new nonprofit and the terms

of the transfer. This simple agreement should be signed by officers of the prior association and directors or officers of your new nonprofit and attached to Schedule G.

If your nonprofit corporation will lease property or equipment previously owned or used by the predecessor organization or will lease property from people associated with the prior group, include an explanation and copies of any leases as requested in line 8. The IRS will scrutinize a lease to make sure that it does not provide for excessive rent payments to the people associated with the former organization. If a nonprofit corporation is a successor to a prior nonprofit association, it's usually best, if possible, for the prior association simply to assign any leases to the nonprofit corporation without payment (or for a $1 consideration to keep things legal) or have the corporation renegotiate the leases with the landlord. That way, the successor nonprofit corporation can deal with the landlord directly rather than have people from the former organization retain the lease and require rent payments from the successor nonprofit corporation. (For an example of an assignment of lease form, see "Prepare Assignments of Leases and Deeds" in Chapter 9.) If your successor nonprofit will lease property back to the people associated with the prior group, line 9 also asks for a copy of the lease agreement. Obviously, a leaseback of property will be strictly scrutinized by the IRS to see if the payments are reasonable—the IRS also will wonder why the new nonprofit transferred the assets in the first place, since after the transfer it decided to lease them back to the people associated with the prior group. Leaseback deals like this look fine in the normal business world, but raise IRS examiner eyebrows when they are disclosed on tax-exemption applications.

Schedule H. Organizations Providing Scholarships, Educational Loans, or Other Educational Grants

Schedule H is used by the IRS to determine whether your nonprofit will provide financial aid on a nondiscriminatory basis. The IRS wants to know that financial aid funds will not be set aside specifically to help put family and friends of people associated with your nonprofit through school and that the providing of funds in general will promote your group's tax-exempt public purposes, which typically will be charitable and/or educational. (For further information on IRS guidelines, see IRS Publication 557, "Charitable Organization Supporting Education" and "Organization Providing Loans.") Section II of this schedule can be used to get IRS approval of your organization's grant-making procedures if your organization is classified as a private foundation (in the event your request for public charity classification under Part X is denied). If you wish to plan for this contingency, consult your tax adviser to help you select the appropriate IRC section on line 1(b) of Section II.

Assemble and Mail Your Application to the IRS

You've accomplished the most difficult part of your paperwork. The only task left is to gather up your application forms and papers and send them off to the IRS. Follow these steps:

Complete the checklist. The IRS wants you to complete and include the checklist with your mailed materials. The checklist is included as the last two pages of the 1023 application form. To complete the checklist, check each box to show you completed all the checklist tasks. If you followed the previous steps in this chapter,

you should be able to check each box and complete each checklist task as follows:

- **Assemble your application materials.** Put your materials together in the order shown in the checklist. Note that Forms 2848 and 8821, as well as amendments to articles of incorporation, nondiscriminatory school statement, and Form 5768, will not apply to most groups.

- **User fee.** Place your user fee check at the top of your materials. Do not staple it to your application papers.

- **EIN.** Make sure you have obtained an Employer Identification Number (it should be stated in Part I, line 4, of your application).

- **Completed Parts I through XI of your application.** We assume you can check this checklist box to show you have completed all parts of the 1023 form.

- **Schedules.** Check "yes" or "no" to show which, if any, schedules you have completed and included with your application. Many groups will mark "no" to all schedules. Only submit schedules with your application that you have completed—do not include blank schedules.

- **Articles.** We assume you have included a file-stamped or certified copy of your articles in response to Part II, line 1, of the application. Fill in the two blanks here to show (1) your purpose clause (repeat the reference to your articles you inserted in response to Part III, line 1) and (2) your dissolution clause (repeat the reference to your articles you inserted in response to Part III, line 2(b)—we assume you did not refer to a state law provision in line 2(c)— see our instructions to Part II above).

- **Signature.** Make sure a director or officer has signed, filled in the name and title lines, and dated the form at the bottom of Part XI (and, if applicable, completed and signed the Consent lines in Part X, line 6(a)—see our instructions to this line, above).

- **Name of organization.** The name you insert in Part I, line 1, of the 1023 application must be the same as the name of your corporation in your articles of incorporation.

Make copies. After completing the checklist and including it as the first page of your exemption materials, make at least one photocopy of all pages and attachments to your application and file them in your corporate records book.

Mail your application. Mail your package to the IRS address listed in the checklist. You may want to send it certified mail, return receipt requested, to obtain proof of mailing and/or of receipt by the IRS. You can check for the current mailing address on the IRS website, at www.irs.gov. At this writing, the address is:

Internal Revenue Service
P.O. Box 12192
Covington, KY 41012-0192

As an alternative to regular mail, you may want to send your application papers to the IRS via an express mail service (see the approved list of private delivery services in the Form 1023 instructions, "Private Delivery Services"). The express mail address currently shown on the 1023 checklist is:

Internal Revenue Service
201 West Rivercenter Blvd.
Attn: Extracting Stop 312
Covington, KY 41011

Your next step is to wait. Although the IRS turnaround time to respond to your application is usually about three months, you may have to wait three to six months or more for a response to your exemption application. To see the timetables for the review process, go to the IRS website at www.irs.gov and type in the search box "Where is my exemption application?"

You can request expedited filing of your 1023 application by submitting a written request along with your exemption application. The IRS may approve the request and speed up the processing of your application if your reason for the request is an impending grant deadline, if your nonprofit provides disaster relief, or if the IRS has already delayed a prior application or response to a previous application by the group. (See "Expedite request," in the 1023 instructions, for more information.)

> ! CAUTION
>
> **You must file annual federal and state information returns for your organization while your federal tax exemption application is pending (see "Annual Filing Requirements" in the 1023 instructions and in Chapter 10).** Indicate on your annual returns that your federal 1023 application is pending approval by the IRS.

What to Expect From the IRS

After reviewing your application, the IRS will do one of three things:

- grant your federal tax exemption
- request further information, or
- issue a proposed adverse determination (a denial of tax exemption that becomes effective 30 days from the date of issuance).

If the IRS asks for more information and you are not sure what they want from you—or you just feel that you are in over your head—consult a nonprofit attorney or tax adviser. If you receive a proposed denial and you wish to appeal, see a lawyer immediately. For further information on appeal procedures, see IRS Publication 557, *Tax-Exempt Status for Your Organization,* and type "Appeal Procedures" in the Search box on the IRS website at www.irs.gov for links to other appeals procedure information.

The Federal Determination Letter

The fortunate among you—and we trust it will be most of you—will get good news from the IRS. It will come in the form of a favorable determination letter, telling you that you are exempt from federal corporate income taxes under Section 501(c)(3) of the Internal Revenue Code, as a public charity. Unless you filed your application late and were not entitled to an extension, your tax exemption and public charity status will be effective retroactively to the date when your articles were filed with the secretary of state.

> ! CAUTION
>
> **If your determination letter tells you that you are exempt as a private foundation,** see a tax or legal adviser immediately. Most nonprofits will not want to maintain a nonprofit private foundation, and often either contest the determination or decide to dissolve their nonprofit corporation immediately.

Resist the natural temptation to file the letter without reading past the first sentences. In fact, the letter contains important information regarding the basis for your exemption and the requirements for maintaining it. Here's what to look for:

- **Are you properly classified?** Check to make sure that the public charity section listed by the IRS corresponds to the kind of public charity status you asked for. (You will find the various public charity code sections listed in Part X, line 5, of your copy of the 1023 form.) Some groups that use the 1023 form will have checked Part X, line 5(i), to let the IRS determine the proper public charity support test category support test for the organization.

- **Must you file a federal tax return?** The determination letter will tell you whether you must file a federal annual information return, IRS Form 990 or Form 990-EZ. Most 501(c)(3) groups must file a 990 return (as explained in Chapter 10).

- **Are you liable for excise taxes?** The determination letter also should state that you are not liable for excise taxes under Chapter 42 of the Internal Revenue Code. These are the taxes applicable to private foundations. The letter will also refer to other excise taxes for which you may be liable. These are the regular excise taxes applicable to all businesses that engage in certain activities, such as the sale of liquor, the manufacturing of certain products, and so on. (For further information, see IRS Publication 510, *Excise Taxes.*)

- **Information on deductions for donors.** Your letter will include information on the deductibility of charitable contributions made to your organization and will refer to Internal Revenue Code sections that cover the deductibility of such donations.

- **Must you pay FUTA taxes?** Most groups will be told in their letter that they are exempt from federal unemployment (FUTA) taxes. You are, however, subject to filing nonprofit unrelated business income tax returns (Form 990-T). Nonprofits and their employees, however, are subject to Social Security (FICA) taxes (see "Federal and State Corporate Employment Taxes" in Chapter 10.)

Congratulations! You've just finished the most complicated, and indeed most crucial, part of your nonprofit incorporation process. The remaining formal incorporation steps are explained in the next chapter.

Final Steps in Organizing Your Nonprofit

Most of the hard work is over, but there are still a few important details to attend to. Don't be overwhelmed by the number of steps that follow—many will not apply to your nonprofit corporation and others are very simple.

To chart your way through the tasks that follow, we recommend you use the Incorporation Checklist included with this book.

Obtain Your State Tax Exemption

The California Franchise Tax Board grants a state tax exemption from corporate franchise taxes to 501(c)(3) groups that have received their federal exemption determination letter from the IRS. The state tax exemption for religious, charitable, scientific, literary, and educational nonprofits parallels the federal 501(c)(3) tax exemption. Once you obtain your state tax exemption, your nonprofit corporation is exempt from paying the annual California franchise tax, including the minimum annual franchise tax payment of $800.

To obtain your California corporate tax exemption, mail a copy of your IRS determination letter with a completed FTB 3500A, *Submission of Exemption Request*, to the California Franchise Tax Board. You can fill in the form online at the Franchise Tax Board website (www.ftb.ca.gov); then print and mail it to the Franchise Tax Board at the address provided on the application.

The FTB 3500A form asks for basic information about the nonprofit organization's identity and purpose. The instructions to the form explain how to fill it out, attach your federal determination letter to it, and mail the packet to the Franchise Tax Board.

The FTB will send your nonprofit an acknowledgment letter, which indicates the effective date of your organization's California corporate tax exemption under Section 23701(d) of the California Revenue and Taxation Code—the section of state law that parallels the federal 501(c)(3) tax exemption. The effective date of your state exemption should be the same as the effective date of your federal 501(c)(3) corporate income tax exemption. If you have any questions about the California exemption acknowledgment process, see the Franchise Tax Board website.

This new California acknowledgment procedure for obtaining state tax exemption can only be used by nonprofits that the IRS has determined are exempt under Section 501(c)(3) of the Internal Revenue Code. All other entities seeking a California state tax exemption should file form FTB 3500, *Exemption Application*, with the California Franchise Tax Board. Much of the information you prepared for your federal tax exemption form (discussed in Chapter 8) can be used to fill in the FTB 3500 form.

Set Up a Corporate Records Book

Now take a few minutes to set up or order a corporate records book—this is an important part of your incorporation process.

Corporate Records Book

You will need a corporate records book to keep all your papers in an orderly fashion. These documents include articles of incorporation, bylaws, minutes of your first board meeting and ongoing director and shareholder meetings, tax exemption application and determination letter, membership certificates (for those nonprofits with formal members), and any other related documents. You

should keep your corporate records book at the principal office of your corporation at all times to make sure you always know where to find it.

To set up a corporate records book, you can simply place all your incorporation documents in a three-ring binder. If you prefer, you can order a custom-designed corporate records book through a legal stationery store.

Corporate Kits

You order a nonprofit corporate kit through a legal stationery store. These nonprofit corporate kits typically include:

- a corporate records book with minute paper and index dividers for charter (articles of incorporation), bylaws, minutes, and membership certificates
- a metal corporate seal (a circular stamp with the name of your corporation, the state's name, and year of incorporation), which you can use on important corporate documents, and
- membership certificates, printed with the name of your corporation.

Corporate Seals

Placing a corporate seal on a document is a formal way of showing that the document is the authorized act of the corporation. Nonprofits don't normally use a seal on everyday business papers (such as invoices and purchase orders), but they do use them for more formal documents, such as leases, membership certificates, deeds of trust, and certifications of board resolutions. A corporation is not legally required to have or use a corporate seal, but many find it convenient to do so.

A metal seal is usually included in the corporate kits or you can get a customized seal from a legal stationer for about $25 to $50.

Corporate Membership Certificates

If you have decided to adopt a formal membership structure with members entitled to vote for the board of directors, you may want to use membership certificates. Ten tear-out certificates are included in Appendix B. Unlike stock certificates used in profit corporations, membership certificates in nonprofit 501(c)(3) corporations do not represent an ownership interest in the assets of the corporation. They serve only as a formal reminder of membership status.

Each certificate that you issue should be numbered sequentially. Type the certificate number at the top of the form. Type the name of the corporation in the heading and the name of the member in the blank in the first paragraph. Have the certificate signed by your president and secretary, then place an impression of the seal of the corporation at the bottom. You should also record the name and address of the member and the number of the issued membership certificate in the membership list in your corporate records.

Prepare Offer to Transfer Assets From an Existing Business or Organization to Your Nonprofit

If you are incorporating an existing organization, you may want to prepare an offer to transfer assets—this document provides a formal record of the transfer and its terms. Your offer to transfer assets is a preliminary agreement. It will be accepted by the board of directors at the first meeting of the board and then formalized by a bill of sale. There are two basic types of offers, as we describe below.

Transfers From a For-Profit Business

If you are incorporating a preexisting for-profit business, you may want to prepare an offer to transfer the assets and liabilities of the predecessor organization to your nonprofit (to take effect after the corporation has obtained its federal tax exemption). An offer to transfer formalizes the transfer of assets and liabilities of the prior business to your nonprofit and provides documentation of the transfer.

! CAUTION

There can be significant federal and state income tax consequences when the assets and liabilities of a prior business or organization are transferred to a new nonprofit corporation. For an overview, see the author's blog article, "Converting an LLC to a Corporation—It's Not as Simple as It Seems," at the *LLC & Corporation Small Talk* blog, at www.llccorporationblog.com. Although it discusses issues relating to converting a co-owned profit-making business to a corporation, the tax issues can have applicability to nonprofit corporations as well. Make sure to check with a knowledgeable tax adviser before transferring the assets and liabilities of a business or organization to your new nonprofit corporation or using the offer and bill of sale in this book.

When the people connected with the preexisting business and the newly formed nonprofit corporation are one and the same, the assets are usually transferred without payment. However, when the nonprofit acquires assets from a preexisting profit-making business run by people different from those starting up the nonprofit, the nonprofit may agree to buy the assets. In either case, the offer will record the terms of the transfer (donation or sale of assets). You can prepare this offer (as we've explained in Chapter 9) when completing Schedule G, which you included with your federal tax exemption application. Refer to

Lots to Consider When Transferring Assets

Many practical and legal issues arise in a transfer of assets and liabilities from a prior business to a nonprofit. We suggest you consult an accountant to make sure you have considered:

- the best transfer method to assure the best treatment
- whether the preexisting business has retained sufficient assets to pay liabilities not assumed by the nonprofit
- whether real property should be kept by the prior business owners and leased to the nonprofit
- that payment by the prior business owners of liabilities not assumed by the nonprofit allows them a current, and sometimes necessary, tax deduction for the prior business, and
- that the transfer should be made on the date (the closing date referred to below) most advantageous for the prior owners of the profit business.

The new nonprofit corporation is not usually liable for the debts or liabilities of the prior business unless it assumes the debt or the transaction was fraudulent (with intent to frustrate and deceive the prior business creditors). In rare cases, the transfer must also comply with the Bulk Sales Law (the Bulk Sales Law is explained below, in "Complying With the Bulk Sales Law").

The former business owners remain personally liable for debts or liabilities of the prior business incurred prior to the transfer of assets to the corporation (even if they are assumed by the corporation). They may also be held personally liable for debts incurred after the transfer, if credit is extended to the corporation by a creditor who believes and relies on the fact that she is still dealing with the prior profit business and hasn't been notified of the incorporation (see "Notify Others of Your Incorporation," below, for notification procedures).

special instruction ❽, in "Prepare Your Offer to Transfer Form," below.

Transfers From an Informal Nonprofit Group

If you are incorporating a preexisting nonprofit association or another less formal type of nonprofit group, you might want to prepare a transfer form to document the details of the transfer of any assets and liabilities. Documentation of this type (who is transferring or contributing what to the new nonprofit) can avoid disputes or misunderstandings later on. In this case, you will need to modify the form to show that it is prepared by the trustees, officers, members, or organizers of the preexisting nonprofit organization or group.

Prepare Your Offer to Transfer Form

To transfer assets from a prior profit-making business or a nonprofit association to your nonprofit corporation, you can use the *Offer to Transfer Assets* form. Refer to the sample form as you follow the instructions below. The sample form below is written to apply to the transfer of a profit-making business to a nonprofit. We have included options in brackets for you to select either the word "business" or "organization" when preparing the form. Simply delete the inapplicable word as you prepare the offer with your word processor.

- The parenthetical blanks, "(_____)," in the sample form indicate information that you must supply.
- Optional information is enclosed in brackets, like this: "[**optional information**]."
- Replace the blanks in the online form (each series of underlined characters) with the information indicated in the blanks in the sample form below.

Each circled number in the sample form (they look like this: ❶) refers to an instruction that helps you complete an item.

❶ Attach a copy of an assets and liabilities statement (Balance Sheet) that is current as of the date that is one business day before the date of sale. Insert this Balance Sheet date in the blank—it represents the "closing date of the offer," a date that is referred to throughout the remainder of the offer. As explained earlier, this date should be as advantageous as possible, tax-wise, to the prior business owners or organization (consult with your accountant). If you prepare this offer at the same time that you prepare your federal exemption application, keep in mind the three- to six-month time lag that usually occurs before the IRS approves your exemption. This means that you may want to hold off making the offer until you hear from the IRS that your federal tax exemption has been approved. This offer states that it is contingent upon your nonprofit corporation obtaining its federal and state tax exemption (see instruction ❼, below). Also, in the unlikely event that the Bulk Sales Law applies to you, make sure this date allows you enough time to comply with the appropriate presale notice requirements.

For an example, see the general format of the Balance Sheet provided in Part IX(b) of your federal exemption application. The bookkeeper or accountant of the prior business or organization can help you prepare this statement.

❷ If the nonprofit corporation will not assume any debts or liabilities of the preexisting business or organization, include these bracketed provisions in paragraph 3(b) and omit the bracketed provisions of paragraph 4(a).

❸ If the corporation is going to assume the debts and liabilities of the business or organization, include the bracketed provisions

Offer to Transfer Assets

TO: __(name of corporation)__ , a California nonprofit __(public benefit [or] religious)__ corporation.

1. The undersigned is [are] the sole proprietor [partners] known as __"(name of prior business)"__ , located at __(street address)__ , __(city)__ , __(county)__ , California.

2. A true and correct statement of the assets and liabilities of this business as of the close of business on __(date of statement)__ , _____, is attached to this offer.❶

3. On the terms and conditions herein set forth, I [we] offer to sell and transfer to you at the close of business on __(closing date)__ , _____,❶ subject to such changes as may occur therein in the ordinary course of business between the date of this offer and the close of business on __(closing date)__ , _____:❶

 (a) All stock in trade, merchandise, fixtures, equipment, and other tangible assets of the business as shown on the financial statement attached to this offer __[except ... (indicate here any exceptions, e.g., real property to be leased to the corporation, retained cash, etc.) ;]__

 (b) The trade, business, name, goodwill, and other intangible assets of the business __[free and clear of all debts and liabilities of the business as shown on the financial statement attached to this offer, and all such additional liabilities as may be incurred by me (us) between the date of the financial statement and the close of business on the (closing date) ,]__.❷

4. As consideration for the sale and transfer, you agree:

 __[(a) To assume and pay all debts and liabilities of the business as shown on the financial statement attached to this offer, and all such additional liabilities as may be reasonably incurred by me (us) between the date of the financial statement and the close of business on (closing date) , , except ... (indicate any unassumed debts or liabilities).]__❸

 (b) To pay an amount of $_____ [which represents the fair market value of the business as transferred to the above Corporation per the terms prescribed above], to be paid as follows: __(state terms of payment)__ .❹

 [or]

(b) To execute a note in the amount of $_____, **[which amount represents the fair market value of the business as transferred to the above Corporation]**, incorporating the following provisions regarding payment under the note: **(state terms of loan)** . ❺

5. If this offer is accepted by you and upon payment of $_____, per the terms of paragraph 4(b), above **[or "upon execution of a note per the terms of paragraph 4(b), above"]**, ❻ I **[we]** shall:

(a) Deliver possession of the business and assets described in paragraph 3 of this offer to you at the close of business on **(closing date)** , _____.

(b) Execute and deliver to you such instruments of transfer and other documents as may be required to fully perform my **[our]** obligations hereunder or as may be required for the convenient operation of said business thereafter by you.

[NOTE: It is clearly understood that this offer is contingent upon the above nonprofit corporation obtaining tax-exempt status with the IRS under Section 501(c)(3) of the Internal Revenue Code and with the State of California under Section 23701(d) of the California Revenue and Taxation Code, and that failure to obtain either or both of these exemptions within (number) months shall allow me (us) to rescind this offer at any time thereafter, notwithstanding any of the other provisions of this offer contained above.] ❼

Dated: _____, _____ ❽

 (signature of prior business owner[s])

[The blanks below are to be filled in later, after the first board meeting:].

The above Offer was accepted by the board of directors on **(date of board meeting)** , _____, on behalf of **(name of corporation)** , a California nonprofit **(public benefit [or] religious)** corporation.

By: _____

_____, President

_____, Secretary

[When you have completed the form, you will wish to make several attachments as indicated in special instruction ❾.]

of paragraph 4(a) and omit the bracketed provisions in paragraph 3(b), as explained above. If the corporation is to assume some, but not all, debts and liabilities, indicate any exceptions in paragraph 4(a). If you are preparing the offer at the time of applying for your federal tax exemption, you should return to this section of your offer in your response to Schedule 6, question 7.

❹ Use paragraph 4(b) if you are transferring the business for a lump sum of cash to be paid by the corporation. If the assets will be donated, state $1 as the amount. This silly amount satisfies an age-old legal rule, namely, that there must be some consideration (money) for a contract to be valid, although the actual amount usually doesn't matter.

If you are transferring the business for its fair market value, write the dollar amount and include the language in brackets. If you are transferring the assets of a profit-making business, and you had an appraisal done (see Schedule G, question 6(a), of the federal exemption application), you can use the appraisal figure determined by the qualified expert in response to question 4(b) of Schedule I of your federal tax exemption application, unless this figure has changed. State the terms of the cash payment at the end of this paragraph (such as the date of payment).

❺ Use this paragraph 4(b) instead of the preceding paragraph 4(b) if the corporation will not immediately pay cash for the assets, but will instead sign a loan note and pay the amount in specified installments. The discussion above concerning fair market value applies here as well. Specify the terms of the loan—the amount and date of installment payments, the rate of interest, and maturity date, whether it's an interest-only loan with the principal amount paid at some future date, a noninterest note for the principal amount only, or payable on demand.

The terms of the loan should be commercially reasonable—a definite payback period and schedule, and a commercially reasonable rate of interest. This will help avoid a determination by the IRS that the prior business owners (who perhaps now are directors or officers of the nonprofit corporation) or organization are receiving some monetary advantage from the corporation, such as an above-market value payment or an excessive rate of interest paid by the nonprofit. Conversely, the more generous the terms to the nonprofit corporation, the less likely are your chances of having your exemption application denied or having problems with the IRS later upon an audit of your organization.

❻ Use the unbracketed sentence of paragraph 5 if the corporation will pay the full sum of money when the business is transferred to the corporation. Use the bracketed phrase if the amount will be paid off over time per the terms of a loan note.

❼ Include this bracketed NOTE paragraph if you are drafting the offer while preparing your federal exemption application. State how much time the corporation has to obtain its exemption before the prior business owner(s) can cancel the offer.

❽ Print the form and have the prior business owner(s) or one or more authorized managers or officers of the unincorporated organization sign and date the offer. If the offer is prepared for the transfer of assets of a prior nonprofit organization, we assume the transfer was properly approved by the prior nonprofit organization according to its charter or bylaws. Don't fill in the blanks at the bottom of the offer yet—do so after the first meeting of your board of directors. If you are preparing the offer for submission with your federal exemption application in response to Schedule G, question 6(b), your response to this item on an attachment page can state: "The offer is

contingent upon the nonprofit corporation obtaining its federal tax exemption, at which time the offer will be submitted to the board of directors and, upon approval by the board, will be signed by the appropriate officers of the corporation."

❾ Attach a copy of the prepared financial statement to the offer and a copy of an appraisal, if applicable.

If you are submitting this offer with your federal exemption application, make a copy of the form and all attachments, and submit these copies with your federal application (see Schedule G, question 6(c)). Place the originals of these papers in your corporate records book.

Prepare Minutes of Your First Board of Directors' Meeting

Now that you've prepared your articles and bylaws, filed your articles with the secretary of state, and obtained your federal and state tax exemption (and possibly prepared an offer to transfer assets of a prior business or organization to your nonprofit corporation), your next step is to prepare minutes of your first board of directors' meeting. The purpose of this meeting is to transact the initial business of the corporation (elect officers, fix the legal address of the corporation, and so on) and to authorize the newly elected officers to take actions necessary to get your nonprofit corporation going (such as setting up bank accounts and admitting members, if appropriate). Although this meeting sometimes is a "paper meeting" (where the directors informally agree to the decisions reflected in the minutes without actually sitting down together and talking business), we suggest that you take this opportunity to meet in person and discuss any other steps you'll need to take to get your

nonprofit corporation off the ground. Our minutes form assumes that your directors really did meet and approved the decisions reflected in the minutes.

Instructions for Preparing Minutes

Preparing minutes for your first meeting is not hard. Use the form included with this book (*Minutes of First Meeting of Board of Directors*) and consult the sample form below as you follow our instructions. We have flagged optional resolutions on the sample form and in the instructions. If an optional resolution does not apply to you, do not include it in your final minutes.

- The parenthetical blanks, "(_____)," in the sample form indicate information that you must complete on the form.
- Replace the blanks in the online form with the information shown in the blanks in the sample form.
- Each circled number in the online form (❶) refers to an instruction to help you complete an item.

❶ Normally, you must follow formal notice rules when holding special meetings (the first meeting of the board is a special meeting). This Waiver of Notice form allows you to dispense with that notice. Fill in this form as indicated, giving the time, date, and place of the meeting. Have all the directors sign the form and type the directors' names under their signature lines. It may be signed and dated before the actual meeting of the board.

❷ This is the first page of your minutes form. Fill in the blanks as indicated, entering the names of directors present and listing those, if any, who are absent (a quorum of the board, as specified in the bylaws, must be shown in attendance). Name one of the directors chairperson, and another as secretary of the meeting.

Minutes of First Meeting of Board of Directors
of

_____(name of corporation)_____

WAIVER OF NOTICE AND CONSENT TO HOLDING ❶
OF FIRST MEETING OF BOARD OF DIRECTORS

OF

_____(NAME OF CORPORATION)_____

A CALIFORNIA NONPROFIT (PUBLIC BENEFIT [OR] RELIGIOUS) CORPORATION

We, the undersigned, being all the directors of _ **(name of corporation)** _, a California nonprofit **(public benefit [or] religious)** corporation, hereby waive notice of the first meeting of the board of directors of the corporation and consent to the holding of said meeting at **(principal place of business)**, California, on **(date)**, ____, at **(time)** M., and consent to the transaction of any and all business by the directors at the meeting, including, without limitation, the adoption of bylaws, the election of officers, and the selection of the place where the corporation's bank account will be maintained.

Date: _____

_____**(signatures of director(s) listed in Article FIVE)**_____
(typed name) , Director

_____ , Director

_____ , Director

_____ , Director

_____ , Director

<div align="center">

MINUTES OF FIRST MEETING OF BOARD OF DIRECTORS ❷

OF

(NAME OF CORPORATION)

</div>

A CALIFORNIA NONPROFIT (PUBLIC BENEFIT [OR] RELIGIOUS) CORPORATION

The board of directors of **(name of corporation)** held its first meeting on **(date)** ,
_____ at **(principal office address)** , California. Written waiver of notice was signed
by all of the directors.

The following directors, constituting a quorum of the full board, were present at the
meeting:

<div align="center">

(names of directors present at meeting)

</div>

There were absent:

<div align="center">

(names of absent directors, if any)

</div>

On motion and by unanimous vote, **(name of director)** was elected temporary
chairperson and then presided over the meeting. **(name of director)** was elected
temporary secretary of the meeting.

The chairperson announced that the meeting was held pursuant to written waiver
of notice signed by each of the directors. Upon a motion duly made, seconded, and
unanimously carried, the waiver was made a part of the records of the meeting; it
now precedes the minutes of this meeting in the corporate records book.

<div align="center">

BYLAWS ❸

</div>

There was then presented to the meeting for adoption a proposed set of bylaws of
the corporation. The bylaws were considered and discussed and, on motion duly
made and seconded, it was unanimously:

RESOLVED, that the bylaws presented to this meeting be and hereby are adopted as
the bylaws of the corporation;

RESOLVED FURTHER, that the secretary insert a copy of the bylaws in the corporate
records book, and see that a copy of the bylaws is kept at the corporation's principal
office, as required by law.

FEDERAL AND CALIFORNIA TAX EXEMPTIONS ❹

The chairperson announced that, upon application previously submitted to the Internal Revenue Service, the corporation was determined to be exempt from payment of federal corporate income taxes as a/n **(501(c)(3) tax-exempt classification, e.g., "educational," "charitable," "religious," etc.)** organization under Section 501(c)(3) of the Internal Revenue Code per Internal Revenue Service determination letter dated **(date of federal determination letter)** and, further, that the corporation has been classified as a public charity under Section **(IRC section or sections under which the corporation qualifies as a public charity)** of the Internal Revenue Code. The effective date of the organization's 501(c)(3) tax exemption is **(effective date of federal tax exemption)**.

The chairperson also announced that the California Franchise Tax Board acknowledged the corporation's federal tax exemption and its classification as exempt from payment of state corporate franchise taxes under Section 23701(d) of the California Revenue and Taxation Code per Franchise Tax Board acknowledgment letter dated **(date of state acknowledgment letter)**. The effective date of the corporation's 23701(d) tax exemption is **(effective date of state tax exemption)**.

The chairperson then presented copies of the IRS tax-exemption determination letter and the California Franchise Tax Board acknowledgment letter, and the secretary was instructed to insert these letters in the corporate records book.

ELECTION OF OFFICERS ❺

The chairperson then announced that the next item of business was the election of officers. Upon motion, the following persons were unanimously elected to the offices shown after their names:

(names of officers)	
_____	President
_____	Vice President
_____	Secretary
_____	Treasurer

COMPENSATION OF OFFICERS ❻

There followed a discussion concerning the compensation to be paid by the corporation to its officers. Upon motion duly made and seconded, it was unanimously:

RESOLVED, that the following annual salaries be paid to the officers of this corporation:

President	$_____
Vice President	$_____
Secretary	$_____
Treasurer	$_____

CORPORATE SEAL ❼

The secretary presented to the meeting for adoption a proposed form of seal of the corporation. Upon motion duly made and seconded, it was:

RESOLVED, that the form of corporate seal presented to this meeting be and hereby is adopted as the seal of this corporation, and the secretary of the corporation is directed to place an impression thereof in the space next to this resolution.

(Impress seal here)

PRINCIPAL OFFICE ❽

After discussion as to the exact location of the corporation's principal office for the transaction of business in the county named in the bylaws, upon motion duly made and seconded, it was:

RESOLVED, that the principal office for the transaction of business of the corporation shall be at __(street address)__, in __(city)__, California.

BANK ACCOUNT ❾

Upon motion duly made and seconded, it was:

RESOLVED, that the funds of this corporation shall be deposited with __(name of bank)__.

RESOLVED FURTHER, that the treasurer of this corporation be and hereby is authorized and directed to establish an account with said bank and to deposit the funds of this corporation therein.

RESOLVED FURTHER, that any officer, employee, or agent of this corporation be and is authorized to endorse checks, drafts, or other evidences of indebtedness made payable to this corporation, but only for the purpose of deposit.

RESOLVED FURTHER, that all checks, drafts, and other instruments obligating this corporation to pay money shall be signed on behalf of this corporation by any __(number)__ of the following:

__(names of directors, officers, and/or staff)__

RESOLVED FURTHER, that said bank be and hereby is authorized to honor and pay all checks and drafts of this corporation signed as provided herein.

RESOLVED FURTHER, that the authority hereby conferred shall remain in force until revoked by the board of directors of this corporation and until written notice of such revocation shall have been received by said bank.

RESOLVED FURTHER, that the secretary of this corporation be and hereby is authorized to certify as to the continuing authority of these resolutions, the persons authorized to sign on behalf of this corporation, and the adoption of said bank's standard form of resolution, provided that said form does not vary materially from the terms of the foregoing resolutions.

· ·

CORPORATE CERTIFICATES (Optional) ❿

The secretary then presented to the meeting proposed director, sponsor, membership, or other forms of corporate certificates for approval by the board. Upon motion duly made and seconded, it was:

RESOLVED, that the form of certificates presented to this meeting are hereby adopted for use by this corporation and the secretary is directed to attach a copy of each form of certificate to the minutes of this meeting.

· ·

ISSUANCE OF MEMBERSHIPS (Optional) ⓫

The board next took up the matter of issuance of memberships in the corporation.

Upon motion duly made and seconded, it was unanimously:

RESOLVED, that upon __["making application therefor in writing" (or state other procedure as specified in the membership provisions in your bylaws)]__ __["and upon payment of an application fee" (and/or) "first annual dues in the amount(s) of $,"]__ members shall be admitted to the corporation and shall be entitled to all rights and privileges and subject to all the obligations, restrictions, and limitations applicable to such membership in the corporation as set forth in the articles of incorporation and by-laws of the corporation and subsequent amendments and changes thereto, and subject to any further limitations as resolved from time to time by the board of directors.

RESOLVED FURTHER, that the secretary of the corporation shall record the name and address of each member in the membership book of the corporation and, upon the termination of any membership in accordance with the termination procedures specified in the bylaws of the corporation, the secretary shall record the date of termination of such membership in the membership book.

[RESOLVED FURTHER, that each person admitted to membership in the corporation shall be given a membership certificate, signed by the president and secretary of the corporation, and the secretary shall record the date of issuance of said certificate in the corporate membership book.]

• •

ACCEPTANCE OF OFFER TO TRANSFER ASSETS AND ⓬ LIABILITIES OF PREDECESSOR ORGANIZATION (Optional)

Upon motion duly made and seconded, it was unanimously:

RESOLVED, that the corporation accept the written offer dated _____, _____, to transfer the assets and liabilities of the predecessor organization, __(name of predecessor organization)__, in accordance with the terms of said offer, a copy of which precedes the minutes of this meeting in the corporate records book.

RESOLVED FURTHER, that the appropriate officers of this corporation are authorized and directed to take such actions and execute such documents as they deem necessary or appropriate to effect the transfer of said business to this corporation.

Since there was no further business to come before the meeting, on motion duly made and seconded, the meeting was adjourned.

Dated:_____

_____ ⓭

, Secretary

❸ This resolution shows acceptance of the contents of the bylaws by your directors.

❹ This resolution recites the particulars of your federal and state tax exemptions. Fill in the blanks as indicated, using information contained in your federal tax exemption determination letter and Franchise Tax Board tax exemption acknowledgment letter. Indicate your tax-exempt classification with the IRS— for example, educational, religious, charitable— and the date of your federal determination letter. Then show the code section or sections under which you have obtained federal public charity status, as shown in your IRS exemption letter (for example, "a publicly supported organization of the type described in Section 509(a)(2)"). Next, insert the effective date of your federal tax exemption.

Fill in the remaining blanks to show the date of your letter from the Franchise Tax Board acknowledging your federal tax exemption and recognizing your state tax exemption under Section 23701(d) of the California Revenue and Taxation Code. Finally, show the effective date of your state tax exemption, which should be the same as the effective date of your federal tax exemption.

❺ Type the names of the persons you elect as officers of your corporation. Remember, directors may be officers and any one person may hold more than one officer position with the exception that the person(s) who serve(s) as the secretary and/or treasurer cannot also serve as the president (or chairperson of the board).

❻ If you decide to provide for officers' salaries, indicate each officer's salary in the blanks in this resolution. Of course, you may decide to omit one or more officer salaries here—if so, simply type a zero in the appropriate blank.

CAUTION

A majority of the directors of a California public benefit corporation cannot be paid (other than as directors of the corporation). See "Directors," in Chapter 2, for further information on this disinterested director rule for public benefit corporations.

Article 9, Section 5, of the bylaws included with this book contains compensation approval procedures that help your nonprofit meet the excess benefit avoidance rules under federal tax law (see "Limitation on Profits and Benefits," in Chapter 3, for more on these rules). These bylaw provisions require disinterested members of your board or a committee of the board (such as a compensation committee) to approve officer salaries, after obtaining comparable figures for compensation paid to similar officers in similar organizations. A safe harbor rule at the end of Article 9, Section 5c, allows smaller nonprofits to approve officer salaries if they have comparability data from three similar organizations showing that their officer salary levels are comparable to those organizations. Complying with this bylaw provision also should help you meet the special requirements under the California Nonprofit Integrity Act of 2004 for approving salaries paid to your chief executive officer (president) and chief financial officer (treasurer). (See "Compensation of Officers," in Chapter 2.)

If you fill in any of the officer salaries in this resolution, we suggest you add a paragraph to the resolution stating that you approved the salaries in compliance with Article 9, Section 5, of your bylaws, and that you document each of the applicable facts or items listed in Article 9, Section 5d, of the bylaws. For example, your additional language should include the following information:

- the name of the board committee that approved the salary and the members of the committee. This listing should show that only disinterested (unpaid) members voted for officer compensation
- the names and votes of each board or committee member
- the comparability data that justified the approval of the salary. Attach any written data to the minutes. The data should show specific salary levels paid by other organizations in your geographical and program area for similar officer positions, and
- the skills, experience, education, and other qualifications of all the officers that help justify each salary as reasonable.

❼ If you've ordered a corporate seal, impress your corporate seal in the space indicated on the printed form.

❽ So far, your formal documents have indicated only the county of the principal place of business of your corporation. Here you should provide the street address and city of this office. Do not use a post office box.

❾ It is important to keep corporate funds separate from any personal funds by depositing corporate funds into, and writing corporate checks out of, at least one corporate checking account. List the bank and branch office where you will maintain corporate accounts. In the fifth paragraph, say how many people must cosign corporate checks, giving the names of individuals allowed to cosign checks on the lines below this paragraph. As a minimal measure of fiscal control, specify the signature of two persons here. Many nonprofits list the president and treasurer, or the names of other supervisory officers who can be trusted with check-writing authority.

❿ This is an optional resolution for membership nonprofits. If you plan to use the tear-out membership certificates included with this book (or if you will order membership, director, or sponsor certificates from a legal stationer), include this page in your minutes. Attach to your printed minutes a sample of any certificates you plan to issue.

⓫ This resolution is for membership corporations, that must include it. State your procedure for admitting members in the first bracketed phrase, according to the membership provisions in your bylaws. If you have provided for application fees and/or annual dues in your bylaws, use the second bracketed phrase to describe the amount of such fees and/or dues provided for in your bylaws. If your membership corporation has no qualification requirements, annual fees, or dues, you can simply cross out the word "upon" just before the blank and leave the blank empty without filling in the blanks, or retype this paragraph to read: "RESOLVED that members shall be admitted to the corporation and shall be entitled to all rights and privileges and subject to all the obligations…" If you plan to issue membership certificates, add the bracketed paragraph shown on the sample form at the end of the resolution.

⓬ This is an optional resolution. If you have incorporated a preexisting profit-making business or other organization and have prepared an Offer to Transfer Assets, include this resolution in your final minutes, indicating the date of the offer and the name of the predecessor business or organization.

⓭ After printing your minutes, your secretary should date and sign the form at the bottom of the last page.

Place Your Minutes and Attachments in a Corporate Records Book

You are now through preparing your minutes. Place your minutes and all attachments in your corporate records book. Your attachments may include the following forms or documents:

- waiver of notice and consent to holding of the first meeting
- written offer (fill in the blanks at the end of the form and have your nonprofit corporation president and secretary sign the offer)
- certified copy of your articles
- copy of your bylaws, certified by the secretary of the corporation
- federal tax exemption determination letter and state exemption acknowledgment letter, and
- copy of any membership, director, and/or sponsor certificate that you plan to issue, certificate marked as a "Sample."

To certify your bylaws, have the corporate secretary date and sign the certificate section at the end of all copies of your bylaws.

Remember, you should continue to place an original or copy of all formal corporate documents in your corporate records book and keep this book at your principal office. For example, if you have prepared or ordered membership certificates, place any unissued certificates in the membership certificate section of your records book.

Complying With the Bulk Sales Law

A few nonprofits that have incorporated existing businesses may have to comply with California's Bulk Sales Law (Division 6 of the California Commercial Code, starting with Section 6101). You might have to comply, for example, if you have taken a preexisting retail or wholesale business, such as a charitable thrift shop, and incorporated it to obtain nonprofit corporate status. But compliance is required only if all of the following are true:

- The business being incorporated is a restaurant or one whose principal business is selling inventory from stock (such as a retail or wholesale business, including a business that manufactures what it sells).
- You are transferring more than half the value of the old business's inventory and equipment to your new corporation.
- The value of the business assets being transferred is $10,000 or more (an exemption from the provisions of the bulk sales law also applies if the value of the assets being transferred is more than $5 million).

If, as is true for most nonprofits, these three conditions do not apply to your incorporation, you can skip the rest of this section. For those of you who do, however, meet the test, take heart. Even if you are incorporating the type of business covered by this law, you may still be eligible for an exemption from most of the provisions of this law if your corporation:

- assumes the debts of the unincorporated business
- is not insolvent after the assumption of these debts, and
- publishes and files a notice to creditors within 30 days of the transfer of assets.

To comply with this exemption, call a local legal newspaper. The paper should be able to send you the proper form (see "Notify Others of Your Incorporation," below) to prepare and will publish and file this form with the county recorder's and tax collector's offices for a small fee.

There are various notice forms that fit specific provisions of the bulk sales law. To rely on the exemption above, prepare and have the newspaper publish and file a Notice to Creditors under Section 6013(c)(10) of the California Commercial Code. This notice will usually include a heading indicating that it is a Bulk Sale and Assumption form. In any case, it must include a clause stating that the buyer has assumed or will assume in full the debts that were incurred in the seller's business

before the date of the bulk sale (you may see slightly different wording, but the sense should be the same).

For other exemptions from the Bulk Sales Law, see Division 6 of the California Commercial Code.

Prepare a Bill of Sale for Assets

If you have incorporated a preexisting business or organization, you may want to prepare a bill of sale to formally transfer the assets for the organization to the nonprofit corporation. This should be done according to the terms of the written offer, if you prepared one in "Prepare Offer to Transfer Assets From an Existing Business or Organization to Your Nonprofit." It should have been accepted by the board at the first meeting and signed by the officers on behalf of the corporation after the meeting.

Before using this bill of sale, see the caution relating to tax consequences in "Transfers From a For-Profit Business," earlier in this chapter. Prepare the bill of sale by completing the form that is included with this book, following the sample form and special instructions below.

- The parenthetical blanks, "(_____)," in the sample form below indicate information that you must complete on the online form.
- Optional information is enclosed in brackets, for example, "[**optional information**]."
- Replace the blanks in the online form with the information indicated in the blanks in the sample form below.
- Each circled number in the sample form refers to a special instruction that will help you complete an item.

❶ Include this first bracketed phrase if your written offer specified an amount of money to be paid upon the transfer of the business. If

appropriate, include the language that states that this amount represents the fair market value of the business or organization (if the assets were donated, you will just show $1 as the amount of payment without the statement concerning fair market value).

❷ Include this second bracketed phrase (instead of the first bracketed phrase referred to above) if the business or organization will be transferred in return for a promissory note. A sample promissory note is shown below. You may need to modify its terms to conform to the terms contained in your offer. In all cases, your note should state the date and place of its execution, the due date, amount to be paid, and rate of interest, if any.

❸ Attach an inventory to the offer, showing all tangible assets of the business—this can be copied from the schedule of assets and liabilities you've attached to your written offer. Add, in the blank provided, any nontransferred assets according to the terms of your offer.

❹ Include this paragraph if the corporation will assume liabilities of the prior business or organization, noting any exceptions.

❺ Include this paragraph if the business's or organization's accounts receivable will be transferred to the corporation, indicating any exceptions.

❻ Fill in the bottom portion of the bill of sale and print the form. Have the form signed by the prior business owners or the authorized manager(s) or officer(s) of the prior organization (the "transferors") and the president and secretary of the corporation. Place the completed form, together with the attachments (inventory and promissory note), in your corporate records book. Give copies to the prior business owners or representatives of the prior nonprofit organization. The business or organization is now officially transferred.

Bill of Sale

This is an agreement by __(names of prior business owners)__, herein called "transferor(s)," and __(name of corporation)__, herein called "the corporation."

1. In return for __["payment of $_____ which represents the fair market value of the business transferred" (or state other amount to be paid per the terms of the written offer)]__ ❶ (or) __["execution of a promissory note in the principal amount of $_____, with the terms as contained in said note, a copy of which is attached to this agreement"]__ ❷ by __(name of corporation)__, a California nonprofit corporation, I [**we**] hereby sell, assign, and transfer to the corporation all my [**our**] right, title, and interest in the following property:

 All the tangible assets listed on the inventory attached to this bill of sale, and all stock in trade, trade, goodwill, leasehold interests, trade names, and other intangible assets __["except ... (show nontransferred assets) of (name of prior business), located at (street address), (city), (county), California"]__. ❸

2. __[In return for the transfer of the above property to it, the corporation hereby agrees to assume, pay, and discharge all debts, duties, and obligations that appear on the date of this agreement, on the books and owed on account of said business ["except ... (list any unassumed debts or liabilities) "]. The corporation agrees to indemnify and hold the transferor(s) of said business and their property free from any liability for any such debt, duty, or obligation and from any suits, actions, or legal proceedings brought to enforce or collect any such debt, duty, or obligation.]__ ❹

3. __[The transferor(s) hereby appoint(s) the corporation as his (her, their) representative to demand, receive, and collect for itself, all debts and obligations now owing to said business ["except (list any exceptions) "]. The transferor(s) further authorize(s) the corporation to do all things allowed by law to recover and collect such debts and obligations and to use the transferor's(s') name(s) in such manner as it considers necessary for the collection and recovery of such debts and obligations, provided, however, without cost, expense, or damage to the transferor(s).]__ ❺

Dated:_____, ____

_____ ❻
, Transferor

, Transferor

_____(name of corporation)_____
By:

, President

, Secretary

Promissory Note

For value received, the undersigned California nonprofit corporation promises to pay to __(names of prior business owners or name of prior unincorporated nonprofit association)__ the principal amount of $_____, together with interest at the rate of __% per annum with a total amount due under this note of $__(principal + interest)__, to be paid in full by __(due date)__, with payment to be made in __(number)__ equal monthly installments of $_____ each payable on the _____ day of each month, with the first installment being due on __(date)__ [or state other provisions per the terms of the written Offer regarding rate of interest, if any, due date, and manner of payment].

Executed this _____ day of _____, ____, at _____,

_____, County of _____, California.

_____(name of corporation)_____

By:

, President

, Secretary

Prepare Assignments of Leases and Deeds

If you have transferred a prior business or organization to your corporation, the prior owners or nonprofit organization may want to prepare assignments of leases or deeds if they are transferring real property interests to the corporation. Under an assignment, you step into the shoes of the old tenant—the terms and conditions of the lease don't change.

TIP

To avoid going through a reassignment, ask the landlord to terminate the old lease and renegotiate a new lease between the landlord and your new corporation. Use this approach if you think you can hammer out a better deal than the old lease gave the old tenants.

If you prepare an assignment, the terms of the lease itself will normally require you to get the landlord's consent. It is particularly important to communicate with the landlord if the nonprofit corporation expects to obtain an exemption from local real property taxes on the leased premises from the county tax assessor (see "Apply for Your Property Tax Exemption," below). Nonprofit groups that obtain the exemption will want a clause in their new lease that gives them a credit against rent payments for the amount of any decrease in the landlord's property tax bill.

A real estate broker can help you obtain and prepare forms to transfer property in which the prior owners have an ownership interest. If a mortgage or deed of trust is involved, you may well need the permission of the lender, too.

File Final Papers for the Prior Organization

If you have incorporated a prior business or other organization, you may need to file final sales tax and other returns for the preexisting organization. You will also want to cancel any permits or licenses issued to the prior business or its principals. If you need new licenses, get them in the name of the new nonprofit corporation.

Notify Others of Your Incorporation

If a preexisting group has been incorporated, notify creditors and other interested parties, in writing, of the termination and dissolution of the prior organization and its transfer to the new corporation. This is advisable as a legal precaution and as a courtesy to those who have dealt with the prior organization.

To notify past creditors, suppliers, organizations, and businesses of your incorporation, send a friendly letter that shows the date of your incorporation, your corporate name, and its principal office address. Make a copy of each letter and put it in your corporate records book.

If the prior group was organized as a partnership, have a local legal newspaper publish a Notice of Dissolution of Partnership in the county where the partnership office or property was located. Then file the form with the local county clerk's office according to the instructions on the form, or pay the newspaper to file it for you.

Apply for a Mailing Permit

Most 501(c)(3) tax-exempt nonprofit corporations will qualify for and want to obtain a third-class nonprofit mailing permit from the U.S. Post Office. This permit entitles you to lower rates on mailings, an important advantage for many groups since the nonprofit rate is considerably lower than the regular third-class rate.

To obtain your permit, bring to your local or main post office branch:

- a file-stamped or certified copy of your articles
- a copy of your bylaws
- a copy of your federal and state tax-exemption determination letters, and
- copies of program literature, newsletters, bulletins, and any other promotional materials.

The post office clerk will ask you to fill out a short application and take your papers. If your local post office branch doesn't handle this, the clerk will send you to a classifications office at the main post office. You'll pay a one-time fee and an annual permit fee. The clerk will forward your papers to the classification office at the regional post office for a determination. In a week or so, you will receive notice of the post office's determination.

You can download the application, Form 3624, online from www.usps.com. Fill it in and prepare the supporting documentation before you go to the post office (district offices that handle the mailing permit applications are listed online at the USPS website).

Once you have your permit, you can mail letters and parcels at the reduced rate by affixing stamps to your mail; by taking the mail to your post office and filling out a special mailing form; or by using the simpler methods of either stamping your mail with an imprint stamp (made by a stampmaker) or leasing a mail-stamping machine that shows your imprint information. Ask the classifications clerk for further information.

Apply for Your Property Tax Exemption

As a nonprofit corporation, you can obtain an exemption from local (county) property taxes on the corporation's personal and real property, whether it's owned or leased. Reread "California Welfare Exemption," in Chapter 5, which explains the welfare exemption, before deciding whether to apply for it. Most groups that meet the requirements will want it.

If you lease from an organization that, itself, is exempt under the welfare exemption, you should prepare and submit the application to be exempt from personal property taxes and to reduce your rent payments to your landlord once you qualify for a real property tax exemption on the portion of the premises that you rent (you should agree with your landlord to reduce your rent once you qualify for the welfare exemption on the leased premises). Both the nonprofit tenant and the nonprofit owner of the property must apply for and obtain the welfare exemption to qualify for a real property welfare tax exemption on the leased premises.

Timing Your Application

You need not have your federal and state tax exemption to apply for the welfare exemption. Even if you have not yet filed your articles with the secretary of state (but are sure that you will do so), go ahead and file if the February 15 property tax assessment deadline is approaching.

It's a good idea to file for this exemption early, before you've even obtained your state and federal tax exemptions. When you do become a tax-exempt nonprofit corporation, you will be able to obtain a complete, partial, or prorated refund on any applicable real or personal property taxes associated with real property you buy or rent or personal property you

acquire during the fiscal year after you submit the copies of your state and federal exemption letters to complete your welfare exemption application information.

In your application, explain how far along you are in your incorporation process. For example, you might write, "nonprofit corporation, preparing to apply for federal and state corporate tax exemptions"; or "proposed nonprofit corporation to be exempt from corporate taxation under Section 23701(d) of the California Revenue and Taxation Code and Section 501(c)(3) of the Internal Revenue Code" in the appropriate blanks. Answer the questions on the application and provide attachments as best you can (for instance, you can attach filed or unfiled articles or proposed financial statements). Note on the form that you will supply additional appropriate documents (such as filed articles, exemption letters, financial data, and descriptions of real and/or personal property) during the fiscal year, when available.

If you are seeking an exemption for real property owned by the nonprofit corporation, the grant deed for the property should be filed in the county recorder's office before March 1 (15 days before you file your claim). If you are seeking an exemption on leased property, your lease or assignment of lease should be dated before March 1.

Applying for an Exemption

Applying for the welfare exemption isn't difficult. Follow these steps:

- Go online to the Board of Equalization website at www.boe.ca.gov or call the local county assessor's office and request a welfare exemption claim form. If you go online, type "boe-267" in the site search box to locate the downloadable form. A list of county assessors with contact information is provided on the State Board

of Equalization's website at www.boe.ca.gov/ proptaxes/assessors.htm. When you contact the county assessor, ask for the welfare exemption form for first-time filers, Form BOE-267, *Welfare Exemption (First Filing)*. Complete the claim form, using the accompanying instruction sheet. Fill in all of the blanks on the form. If a particular item doesn't apply, mark it as "Not Applicable."

- Assemble copies of your certified articles, federal and state exemption letters (if you have obtained them), and the requested financial statements. These statements are your operating statement and balance sheet—you should be able to use the financial information submitted with your federal exemption application. Include any other appropriate attachments (such as a copy of a lease).

- Assemble all the papers together—the completed claim form and all documents. They do not need to be stapled or fastened together. Make two copies of all the papers.

- File two (duplicate) sets of your claim form and attachments with the county assessor. Keep one copy to place in your corporate records book. File your papers before February 15 of the fiscal year for which you are seeking the exemption (the property tax fiscal year goes from July 1 to June 30). If you submit it after this date and before January 1 of the following year, you will only be allowed a 90% exemption if your claim is approved. If you file even later than this during the fiscal year, you will be allowed an 85% exemption, except that the maximum amount in taxes you will have to pay is $250.

The assessor will go out and inspect your property, to determine if the uses to which it is being put meet the requirements of the welfare exemption. The inspector will prepare a field inspection report and send it, together with one copy of your claim and attachments, to the State Board of Equalization in Sacramento. The Board will review the documents and make a decision, sending a copy of the decision to you and one copy to the local assessor. If you've been granted the exemption, the local assessment roll will be updated and a tax "bill" showing your exemption will be sent to you. If you are renting, the updated tax bill will go to your landlord.

TIP

Religious corporations may be able to avail themselves of the streamlined application and renewal procedures of the religious exemption under Section 207 of the Revenue and Taxation Code—call your local county tax assessor's office (Exemption Division) or go online to the Board of Equalization website for more information.

RESOURCE

For more information on the welfare exemption and how to apply for it, consult the *Assessors' Handbook*—Welfare Exemption, publication number AH-267, a pamphlet for local tax assessors written by the Board of Equalization. The handbook is included on Nolo's website (see Appendix A for the link). If you want to check if a newer edition has come out since the publication of this book, go to the California State Board of Equalization website at www.boe.ca.gov and search for the "Assessors' Handbook," then select "AH-267-Welfare, Church and Religious Exemptions."

File a Domestic Corporation Statement

Shortly after you file your articles of incorporation, you will receive a *Statement of Information for a Domestic Nonprofit Corporation* (Form SI-100) from the secretary of state's office. This form requests basic organizational information (which will be a matter of public record and can be obtained by anyone for a small fee), including the address of your principal office, the names and addresses of your officers, and your agent for service of process. (Your initial agent is designated in your articles of incorporation and is the person authorized to receive legal documents on behalf of your corporation.) This form must be filled out and sent back to the secretary of state within 90 days of the date your articles are filed. You may want to retain some anonymity for your officers by listing the principal office of the corporation as their business address.

Every two years, the secretary of state will send you a new statement to prepare and file. Failure to file this statement when required can result in penalties and can, eventually, lead to suspension of corporate powers by the secretary of state.

The California Secretary of State's website allows you to fill in and file the domestic corporation statement online from your browser—if you use this online form preparation and filing method, you do not need to mail in your initial or biennial statements. Go to the state site to prepare and file this form online.

File an Initial Report With the Attorney General

Most California public benefit corporations must register by filing an initial report and thereafter file annual reports with the California Attorney General, Charitable Trusts Section. Some California nonprofit corporations, however, are exempt from registration and reporting requirements—these include California religious nonprofit corporations and California public benefit nonprofits organized as hospitals or schools. All other 501(c)(3) California nonprofit corporations must file an initial and annual reports with the Attorney General's Charitable Trusts Section. When a public benefit corporation files its articles, the secretary of state forwards a copy of the articles to the attorney general. The attorney general will send nonexempt groups an initial report form (Form CT-1) to complete and file, and an annual reporting form (RRF-1) to complete and file for the second and subsequent years of the corporation. (For more information on filing initial and annual reports, see "Attorney General Annual Periodic Report," in Chapter 10.)

As noted above, in addition to religious groups, the following types of 501(c)(3) nonprofits should be exempt from initial and annual reporting with the attorney general. If you think you fit in one of these categories but have received a CT-1 form, call the attorney general's office in Sacramento to see if you can establish your attorney general exemption.

- **Schools.** Educational organizations set up as formal schools with the institutional attributes (such as a regular faculty and curriculum, enrolled body of students, and established place of instruction) don't have to file form CT-1 with the attorney general. Notice that this definition is more restrictive than the one used for qualifying for your federal tax exemption, and is basically the same as that which applies to schools for purposes of obtaining public charity status.

- **Hospitals.** The attorney general has a restrictive definition of hospitals. In addition to being the kind of charitable hospital that made it eligible for the federal tax exemption and public charity status, the hospital must be operated on a 24-hour-a-day basis and have a round-the-clock medical staff. Day or outpatient clinics or those that don't have licensed practitioners regularly working at the clinic will not, in most cases, qualify for the exemption.

RESOURCE

The *California Attorney General's Guide for Charities* is a helpful guide for California nonprofits, as well as a source of information on the attorney general's reporting and filing requirements. It also contains excellent summaries of the legal responsibilities and liabilities of nonprofit directors under California law, as well as practical information on fundraising, fiscal management, and other important nonprofit issues. We recommend all California nonprofits obtain a copy of this valuable sourcebook. This guide is available for viewing and downloading from the Attorney General's Division of Charitable Trusts website, located at https://oag.ca.gov/charities/publications. The site also contains other informative publications of the Attorney General's Office, including the *Attorney General's Guide to Charitable Solicitations* plus the initial (CT-1) and ongoing (RRF-1) registration and reporting forms required to be filed with the Attorney General's office. The guide is also available on the Nolo website.

Issue Membership Certificates

If you have set up a membership corporation and have membership certificates, you will want to issue them to members after they have applied for membership in the corporation and paid any fees required by the membership provisions in your bylaws. The corporate president and secretary should sign each certificate before giving it to the member.

If you have ordered membership materials as part of a corporate kit, record each member's name and address, together with the number of the certificate, in the membership roll in your corporate records book.

If you are using the tear-out membership certificate included in Appendix B, complete each certificate by typing the number of the certificate, the name of the corporation, and the name of the member on the certificate. Then execute the certificate by filling in the date and having the president and secretary sign at the bottom (if you have a seal, impress it at the bottom of each certificate). Give the certificate to the member, then record the member's name, address, certificate number, and date of issuance on a separate page in your corporate records book. The information on these pages, kept in the corporate records book, constitutes the membership book of the corporation.

File Your Articles With the County Recorder

Unincorporated associations that have just incorporated (with the help of a lawyer) and that owned real property prior to incorporating should file a certified copy of their articles of incorporation with the county recorder of the county or counties in which the previous unincorporated association owned property. This will show legal ownership by the new nonprofit corporation of the preexisting unincorporated association's real property.

When filing these copies of your articles, send the county recorder two copies, together with the required fee. Request that one copy be file-stamped by the county recorder and returned to you. Place this copy in the articles section of your corporate records book.

Register With the Fair Political Practices Commission

If your nonprofit corporation plans to lobby for legislation, hire a lobbyist, or otherwise be politically active (for example, by supporting or opposing state, county, or city measures to be voted on by the public), you must comply with registration and reporting requirements for lobbying activity administered by the California Fair Political Practices Commission. Go online to www.fppc.ca.gov or call the office in Sacramento for further information if you think these registration and reporting requirements apply to the activities of your nonprofit corporation. (Read *Lobbying Disclosure Information Manual* online or call the California Fair Political Pratices Commission to request a copy.)

Check State and Local Solicitation Requirements

If you plan to solicit contributions directly (by mail, the Internet, or door-to-door) or through paid fundraisers or consultants, make sure your organization and the people it hires comply with state and local solicitation laws, regulations, and ordinances. For tips on how to learn about state laws that may apply to your organization and its fundraisers and consultants, see "State Solicitation Laws and Requirements," in Chapter 5.

After Your Corporation Is Organized

You have now incorporated your nonprofit and have handled many initial organizational details. But before you close this book, read just a little more. After incorporating, you need to become familiar with the formalities of corporate life, such as filing tax returns, paying employment taxes, and preparing minutes of formal corporate meetings. In this chapter, we look at some tax and other routine filings required by federal, state, and local governmental agencies. At the end, we give you an overview of what's involved in dissolving a nonprofit corporation.

The information presented here won't tell you everything you will need to know about these subjects, but will provide some of the basics and indicate some of the major areas that you (or your tax adviser) will need to go over in more detail.

Piercing the Corporate Veil—If You Want to Be Treated Like a Corporation, It's Best to Act Like One

After you've set up a corporation of any kind, your organization should act like one. Although filing your articles of incorporation with the secretary of state brings the corporation into existence as a legal entity, this is not enough to ensure that a court or the IRS will treat your organization as a corporation. What we are referring to here is not simply maintaining your various tax exemptions or even your nonprofit status with the state—we are talking about being treated as a valid corporate entity in court and for tax purposes. Remember, it is your legal corporate status that allows your organization to be treated as an entity apart from its directors, officers, and employees and allows it to be taxed (or not taxed), sue, or be sued, on its own. It is the corporate entity that insulates the people behind the corporation from taxes and lawsuits.

Courts and the IRS do, on occasion, scrutinize the organization and operation of a corporation, particularly if it is directed and operated by a small number of people who wear more than one hat (such as those who fill both director and officer positions). If you don't take care to treat your corporation as a separate legal entity, a court may decide to disregard the corporation and hold the principals (directors and officers) personally liable for corporate debts. This might happen if the corporation doesn't have adequate money to start with, making it likely that creditors or people who have claims against the corporation won't be able to be paid; if corporate and personal funds are commingled; if the corporation doesn't keep adequate corporate records (such as minutes of meetings); or generally doesn't pay much attention to the theory and practice of corporate life. Also, the IRS may assess taxes and penalties personally against those connected with managing the affairs of the corporation if it concludes that the corporation is not a valid legal or tax entity. In legal jargon, holding individuals responsible for corporate deeds or misdeeds is called "piercing the corporate veil."

To avoid problems of this type, be careful to operate your corporation as a separate legal entity. Hold regular and special meetings of your board and membership as required by your bylaws and as necessary to take formal corporate action. It is critical that you document formal corporate meetings with neat and thorough minutes. Also, it is wise to have enough money in your corporate account to pay foreseeable debts and liabilities that may arise in the course of carrying out your activities—even nonprofits should start with a small cash reserve. Above all, keep corporate funds separate from the personal funds of the individuals who manage or work for the corporation.

Federal Corporate Tax Returns

In this section, we list and briefly discuss the main IRS tax paperwork you can expect to face as a 501(c)(3) nonprofit corporation.

Your 990 and 990-T (unrelated business income return) forms must be made available for public inspection (see the IRS website at www.irs.gov for more information).

> **CAUTION**
>
> **IRS forms, instructions, fees, and penalties are subject to constant change.** Make sure to get the most current information (on return deadlines, tax rates, penalties, and so on) when you file. You can download the federal tax forms discussed in this section from the IRS website, at www.irs.gov. Go to "Forms & Pubs" on the IRS website, then "Current Forms & Pubs," and type in the form number.

Public Charities: Annual Exempt Organization Return

Nonprofit corporations exempt from federal corporate income tax under Section 501(c)(3) and treated or classified as public charities must file IRS Form 990, *Return of Organization Exempt From Income Tax* (together with Form 990, Schedule A). The filing deadline is on or before the 15th day of the fifth month (within four and a half months) following the close of their accounting period (tax year). You should file this even if your 1023 federal application for exemption is still pending.

Depending on their annual gross receipts and total assets, some groups may be eligible to file a simplified IRS Form 990-EZ or a 990-N (postcard) instead of Form 990. Also, some types of nonprofits, such as churches, are exempt from annual 990 filing requirements. (See the instructions to these 990 forms on the IRS website, www.irs.gov, for more information.) Section 501(c)(3) public charities that file Form 990 or 990-EZ must also complete and submit Form 990, Schedule A (with additional schedules if required), to their return. This form is used to test whether the publicly supported charity meets the applicable support test for the year (see Chapter 4).

> **CAUTION**
>
> **Watch out for short deadlines.** Your first 990 return deadline may come up on you sooner than you expect if your first tax year is a short year—a tax year of less than 12 months.

EXAMPLE: If your accounting period as specified in your bylaws runs from January 1 to December 31 and your articles were filed on December 1, your first tax year consists of one month, from December 1 to December 31. In this situation, your first Form 990 would have to be filed within four and a half months of December 31 (by May 15 of the following year), only five and a half months after your articles were filed. It is likely that your federal tax exemption application would still be pending at this time.

Your federal exemption determination letter should state whether you must file Form 990.

If your nonprofit corporation makes the political expenditures election by filing Federal Election Form 5768 (discussed in "Limitation on Political Activities," in Chapter 3), indicate on Form 990, Schedule A, that you made this election and fill in the appropriate part of the schedule showing your actual lobbying expenditures during the year.

TIP

990 returns as financial disclosure. Most California public benefit corporations must report annually to the California Attorney General. A copy of the nonprofit's federal Form 990 must be included with the attorney general annual report form.

CAUTION

IRS e-Postcard, Form 990-N, annual filing requirement for small nonprofits. Small tax-exempt organizations that are not required to file 990 returns with the IRS are required to file an annual electronic notice with the IRS—Form 990-N, *Electronic Notice (e-Postcard) for Tax-Exempt Organizations not Required To File Form 990 or 990-EZ*. Organizations that do not file the e-Postcard or an information return Form 990 or 990-EZ for three consecutive years will have their tax-exempt status revoked.

For more information and to file a 990-N online, go to the IRS website (type "990-N" in the search box).

Private Foundations: Annual Exempt Organization Return

Very few 501(c)(3) nonprofits will be classified as private foundations. If you are one, however, you must file a *Return of Private Foundation*, Form 990-PF, within four and one-half months of the close of your tax year. You file this Form 990-PF instead of Form 990, discussed above. You'll provide information on receipts and expenditures, assets and liabilities, and other information that will help the IRS determine whether you are liable for private foundation excise taxes. You should receive the form and separate instructions for completing it close to the end of your accounting period. Again,

watch out for a short first year and an early deadline for filing your Form 990-PF.

The foundation manager(s) must publish a notice telling the public that they may see the annual report. Do so in a local county newspaper before the filing deadline for the 990-PF. The notice must state that the annual report is available for public inspection, at the principal office of the corporation, within 180 days after the publication of the inspection notice. A copy of the published notice must be attached to the 990-PF.

File Your Returns on Time

The IRS and the state are notoriously efficient in assessing and collecting late filing and other penalties. So, while it's generally true that your nonprofit corporation does not have to worry about paying taxes, you should worry a bit about filing your annual information returns on time (including your employment tax returns and payments). Too many nonprofit corporations have had to liquidate when forced to pay late filing penalties for a few years' worth of simple informational returns that they inadvertently forgot to file.

Another important aspect of late filing penalties and delinquent employment taxes is that the IRS (and state) can, and often do, try to collect these often substantial amounts from individuals associated with the corporation if the corporation doesn't have sufficient cash to pay them. Remember, one of the exceptions to the concept of limited liability is liability for unpaid taxes and tax penalties. The IRS and state can go after the person (or persons) associated with the corporation who are determined to be responsible for reporting and/or paying taxes.

More Information on Taxes

We suggest all nonprofits obtain IRS Publication 509, *Tax Calendars,* prior to the beginning of each year. This pamphlet contains tax calendars showing the dates for corporate and employer filings during the year.

Information on withholding, depositing, reporting, and paying federal employment taxes can be found in IRS Publication 15, *Circular E, Employer's Tax Guide,* and the Publication 15-A and 15-B Supplements.

Other helpful IRS publications are Publication 542, *Corporations,* and Publication 334, *Tax Guide for Small Business.*

Helpful information on accounting methods and bookkeeping procedures is contained in IRS Publication 538, *Accounting Periods and Methods,* and Publication 583, *Starting a Business and Keeping Records.*

You can get IRS publications online at www .irs.gov. You can also pick them up at your local IRS office (or order them by phone—call your local IRS office or try the toll-free IRS forms and publications request telephone number, 800-TAX-FORM). California tax forms and information are available at www.ftb.ca.gov. California employment tax information can be downloaded from www.edd.ca.gov.

For information on withholding, contributing, paying, and reporting California employment, unemployment, and disability taxes, get the *California Employer's Guide* (Publication DE 44), available online at www.edd.ca.gov.

Unrelated Business Income: Annual Exempt Organization Tax Return

With a few minor exceptions, Section 501(c)(3) federal tax-exempt corporations that have gross incomes of $1,000 or more during the year from an unrelated trade or business must file an *Exempt Organization Business Income Tax Return* (Form 990-T). The form is due within two and a half months after the close of their tax year. For a definition and discussion of unrelated trades and businesses, see "Federal Unrelated Business Income Tax," in Chapter 5, and obtain Federal Publication 598, *Tax on Unrelated Business Income of Exempt Organizations.* Use booklet 598 and the separate instructions to Form 990-T to prepare this form.

The taxes imposed on unrelated business income are the same rates applied to normal federal corporate income. Remember that too much unrelated business income may indicate to the IRS that you are engaging in nonexempt activities to a substantial degree and may jeopardize your tax exemption.

California Corporate Tax Returns and Reports

In this section, we list some of the California tax reporting forms and paperwork you will need to tackle as a tax-exempt nonprofit corporation. Tax forms, instructions, and rates frequently change. Go to the Franchise Tax Board website at www.ftb.ca.gov for the latest information and forms.

Public Charities: Annual Exempt Organization Return

Nonprofit corporations exempt from tax under 23701(d) of the California Revenue and Taxation Code (the state parallel exemption to the federal 501(c)(3) exemption) and classified by the IRS as public charities must file a *California Exempt Organization Annual Information Return,* Form 199. The form is due within

five-and-a-half months of the close of their tax year. Depending on their annual gross receipts, some groups may be eligible to file a 199N (e-postcard) instead of Form 199. The state exemptions from the 199 filing requirements are similar to the IRS exemptions from filing Form 990. A failure to make timely 199 filings can result in a suspension of corporate rights, powers, and privileges; or a revocation of the corporation's state tax exemption.

If you've made a political expenditures election with the state (by submitting a copy of your federal 5768 election form to the Franchise Tax Board within the year), attach Form FTB3509, *Political or Legislative Activities by Section 23701(d) Organizations*, to your annual 199 filing.

Private Foundations: Annual Exempt Organization Return

California corporations exempt under Section 23701(d) of the Revenue and Taxation Code and classified as private foundations must file Form 199. Private foundations must provide some additional information not required of public charities that file the same form. Instead of filling out Part II of this form, you can (and should, to avoid extra paperwork) provide a copy of your annual report to the attorney general (Form RRF-1—see "Attorney General Annual Periodic Report," below), or furnish a copy of IRS Form 990-PF and its schedules instead.

Unrelated Business Income Tax Return and Quarterly Estimated Tax Payments

All corporations that are exempt from state corporate franchise taxes under Section 23701(d) (except those formed to carry out a state function) must file an annual *California Exempt Organization Business Income Tax Return*, Form 109, if their gross income during the year from an unrelated trade or business is $1,000 or more. They'll pay an 8.84% state tax (the normal corporate tax rate) on their taxable unrelated business income.

This return must be filed within four-and-a-half months of the end of the tax year. Paying the tax, unlike paying the federal unrelated business income tax, is done periodically during the year for which the tax is due, by estimating your expected income from unrelated trade or business activities during the current year. Twenty-five percent of the estimated tax must be paid within three-and-a-half months of the beginning of the tax year. The balance of the tax is payable in three equal installments on or before the 15th day of the sixth, ninth, and twelfth months of the tax year. If you've underestimated, at the end of the year you'll pay any additional amount with your annual return.

The state doesn't usually send you forms and instructions for paying this tax during your first year. You won't receive it for later years, either, unless a prior annual information return shows that the corporation is likely to have unrelated business income. If the state does send you a form, it will be Form 100-ES.

Form 100-ES is the same form that regular profit corporations use. The normal minimum franchise tax that profit corporations must pay with their first annual estimated tax payment does not apply to tax-exempt nonprofits. Nonprofits pay a simple 8.84% rate on their estimated taxable unrelated business income. Because you must make estimated unrelated business tax payments if this tax applies to you (whether or not the Franchise Tax Board sends you the forms), make sure you pay attention to this often overlooked aspect of nonprofit corporate taxation. Penalties apply to underpayment of this estimated tax and to late filing of the return referred to above.

Attorney General Annual Periodic Report

Subject to a few exceptions, 501(c)(3) and 23701(d) tax-exempt public benefit nonprofit corporations must file an annual report with the California Attorney General (Form RRF-1). However, religious organizations, nonprofit schools, and hospitals are exempt from the annual RRF-1 filing requirement (see the instructions to the RRF-1 form). The attorney general should mail the Form RRF-1 to you, along with a Form 990. Groups with total assets or gross receipts over $25,000 must also file a federal 990 or 990-PF annually with the attorney general (with the required schedules and attachments). Failure to make these required annual filings on time can result in late filing penalties. Groups with total assets or gross receipts of $100,000 or more must pay a Form RRF-1 filing fee.

Public Benefit Corporations' Annual Corporate Report

Nonmembership public benefit corporations must furnish all directors with an annual report containing financial information, including a statement of assets, liabilities, receipts, and expenditures. The report is due within 120 days after the close of the fiscal year. (See Article 7, Section 6, of the public benefit corporation bylaws.) Membership public benefit corporations must also submit this annual report within the same time period to any member who requests it. The annual report (or a separate statement sent to all directors and members) must also disclose the details of certain indemnification or self-dealing transactions (see "Directors," in Chapter 2, and Article 7, Section 7, of the public benefit corporation bylaws).

It should not be very difficult to compile the financial information required for this annual report. The corporation will have already prepared most of the information needed in order to comply with the state and federal annual tax return requirements discussed above. Keep in mind that this annual report to insiders must be furnished within approximately four months—120 days—after the close of the fiscal year. This is a little sooner than most of the annual state and federal tax returns, which must be submitted within four-and-one-half months of the close of the tax year.

Federal and State Corporate Employment Taxes

You must pay employment taxes on behalf of the people who work for your nonprofit corporation. Directors, with certain exceptions, are not considered employees if they are paid only for attending board meetings. However, if they are paid for other services or are salaried employees of the corporation, they will be considered employees whose wages are subject to the employment taxes. Nonprofit tax-exempt corporations are often exempt from having to pay certain employment taxes for their employees (for example, federal unemployment insurance).

Independent contractors (such as consultants) who are not subject to the full control of the corporation (for example, how the work is to be performed) are generally not considered employees. Wages paid to these outsiders are not subject to the employment taxes discussed below.

Of course, it goes without saying that corporate directors, officers, and other compensated corporate personnel must report employment compensation on their individual annual federal and state income tax returns (IRS Form 1040; California Form 540).

In addition to reading this material, we recommend you get the publications listed in "More Information on Taxes," above. This will give you more detailed and the most current information to help you compute your withholding and employer contribution payments. Also, check with the IRS and your local state employment tax district office if you need more information.

> ⚠ CAUTION
>
> **Be careful when classifying people as independent contractors.** The law in this area is fuzzy, and the IRS (as well as the California Employment Development Department, which oversees state unemployment taxes) is obstinate about trying to prove that outsiders really work for the corporation (and must be covered by payroll taxes). For more information, see IRS Publication 937. An excellent legal guide to the ins and outs of independent contractor status is *Working for Yourself: Law & Taxes for Independent Contractors, Freelancers & Consultants*, by Stephen Fishman (Nolo).

Federal Employment Taxes and Forms

This section summarizes the federal payroll tax paperwork and payment obligations that will apply to your 501(c)(3) nonprofit. It's not meant to give you all the details, just a heads-up so you can go online and figure out more for yourself. (See the online payroll tax resources listed above, in "More Information on Taxes.")

Employee's Withholding Certificate

Each employee of the corporation must fill out and give the corporation an *Employee's Withholding Allowance Certificate* (IRS Form W-4), on or before commencing employment. This form indicates the marital status and number of allowances claimed by the employee,

and is used in determining the amount of income taxes withheld from the employee's wages.

Income Tax Withholding

The corporation must withhold federal income tax from wages paid to employees based upon the wage level, marital status, and number of allowances claimed on the employee's W-4. These, as well as other employment taxes, are withheld and reported on a calendar year basis (January 1 to December 30), regardless of the tax year of the corporation. You'll submit returns on a quarterly basis and deposit withheld tax in an authorized bank on a quarterly (or more frequent) basis; or you can pay with the quarterly return (see IRS Publication 15).

Social Security Tax Withholding

Employees who work in a 501(c)(3) nonprofit corporation are subject to Social Security (FICA) tax withholding. Employers withhold FICA taxes from the employee's wages, and must match the tax, too. The combined amount is reported quarterly and paid either with the quarterly return or deposited in an authorized bank. See the next section below and IRS Publication 15 for specifics.

Quarterly Withholding Returns and Deposits

On or before the last day of the month immediately following the end of each calendar quarter, the corporation must file an *Employer's Quarterly Federal Tax Return*, Form 941. This is a consolidated return, including both withheld income taxes and Social Security taxes, and has specific payment and deposit rules.

Deposits of income and Social Security taxes must be made on a quarterly, monthly, or more frequent basis. You will want to pay careful attention to withholding, depositing, paying, and

reporting these taxes to avoid costly penalties. Again, consult IRS Publication 15 for details.

Federal Unemployment Tax

Your 501(c)(3) tax-exempt nonprofit corporation should be exempt from federal unemployment (FUTA) taxes. Your federal exemption letter should tell you that you are exempt from these taxes.

Annual Wage and Tax Statement

Your nonprofit corporation must furnish two copies of the *Wage and Tax Statement* (IRS Form W-2) to each employee from whom income tax has been withheld (or would have been withheld if the employee had claimed no more than one withholding allowance on his W-4). This form must show total wages paid and amounts deducted for income and Social Security taxes. A special six-part W-2 should be used in California to show state income tax and disability insurance contributions, in addition to the required federal withholding information. Give W-2s to employees no later than January 21.

The corporation must submit each employee's previous year's W-2 form and an annual *Transmittal of Wage and Tax Statements* (Form W-3) to the Social Security Administration on or before the last day of February.

State Employment Taxes and Forms

This section summarizes the state payroll tax requirements that will apply to your 501(c)(3) nonprofit. Again, see "More Information on Taxes," above, to obtain more information online and forms.

Employer Registration Form

Nonprofit corporations with employees must register with the California Employment Development Department (EDD) within 15 days of becoming subject to either the California Unemployment Insurance Code or to California personal income tax withholding provisions. Because this usually happens once wages in excess of $100 in a calendar quarter are paid, you should register right away if you plan to have any employees. Do this by preparing and submitting *Commercial Employer Account Registration and Update Form*, DE-1, available online at the EDD website (www. edd.ca.gov) or from a local Employment Tax District office. If you plan to apply for a sales tax permit, your permit application can also serve as your employer registration form. Employers will be required to file the DE-1 form online (see the EDD website for information).

Personal Income Tax Withholding

The corporation must withhold California personal income taxes from employees' wages according to the tax tables in the *California Employer's Guide*, Publication DE-44 (available online at the EDD website). The tables take into account the marital status, claimed allowances, and wage level of the employee. These tables automatically allow for applicable exemptions and the state's standard deduction.

California Unemployment and Disability Insurance

Most nonprofit 501(c)(3) tax-exempt corporations are subject to California unemployment and disability insurance tax contributions and withholding. Certain churches or religious nonprofit corporations and schools that are a part of a church or religious nonprofit corporation are not subject to unemployment and disability insurance taxes. Rates change constantly. For further information, consult the *California Employer's Guide* (DE-44), available online at

the EDD website. If you have any questions, call your local employment tax office.

Also, certain types of services performed for 501(c)(3) tax-exempt nonprofit groups are not subject to state unemployment and disability coverage unless elected (the criterion here is the type of services, not the type of nonprofit). The California Employment Development Department should mail Form DE-1-NP, which lists these excluded services and allows you to elect coverage for any that apply to you.

California unemployment insurance can be paid by 501(c)(3) groups in one of two ways: (1) the regular contribution rate method, or (2) a prorated cost of benefits paid. Form DE-1-NP, referred to above, allows you to select which payment method you want to use.

Under the regular contribution rate method, unemployment insurance contributions are paid by the corporation at its "employer contribution rate" shown on the *Quarterly Contribution Return and Report of Wages* (DE-9).

Under the prorated cost of benefits method, the corporation pays the actual amount of unemployment benefits received by ex-employees who receive such benefits, to the extent that such benefits are attributable to base period wages paid by the corporation to the ex-employee. Ask the local employment tax office for Form DE-1378-F, which contains examples of your potential liability under this method.

Disability insurance contributions are paid by the employee and withheld, reported, and submitted to the state by the corporation. Again, rates change—check your *California Employer's Guide* (DE-44).

Employer Returns

All California employers must report all their new or rehired employees who work in California to the New Employee Registry within 20 days of their start-of-work date (EDD Form DE-34).

The corporation must file a quarterly return (DE-9 annd DE-9C), reporting the employment taxes mentioned above for the previous quarter and pay any balance not already deposited and paid during the quarter. For specifics, consult the *California Employer's Guide* (DE-44).

> ⚠ **CAUTION**
>
> **Officers can be personally liable.** Under Section 1735 of the California Unemployment Insurance Code, officers and other persons in charge of corporate affairs are personally liable for taxes, interest, and penalties owed by the corporation.

Annual Wage and Tax Statement

The corporation should prepare a six-part combined federal/state *Wage and Tax Statement*, IRS Form W-2. This form indicates total annual state personal income tax and state disability insurance withholding. Copies of this form should be provided to the employee.

Sales Tax Forms and Exemption From Sales Tax

Many nonprofits sell goods to the public and therefore are subject to collecting, depositing, and reporting sales tax. We cover some of the basic rules and exceptions in this section. For more information on the sales tax and forms, go online to the main sales tax page on the State Board of Equalization's website.

Sales Tax

Subject to a few exceptions, as noted in "Exempt Transactions" below, every nonprofit corporation that has gross receipts from the sale of tangible personal property in California (for example, merchandise sold to customers) must apply for a sales tax seller's permit. You can file the application (Form BOE-400-SPA)

with the nearest office of the California Board of Equalization. The form is available online, at www.boe.ca.gov. The BOE should soon allow online applications and return filings—check the website for more information. Even groups exempt from collecting sales tax, as described below, must obtain a seller's permit. This application can also serve as an employer registration form with the Employment Development Department.

There's no fee for applying for or obtaining a sales tax (seller's) permit. Some applicants, however, may be required to post a bond or other security for payment of future sales taxes. A separate permit is required for each place of business at which transactions relating to sales tax are customarily entered into with customers. Sales tax is added to the price of certain goods and is collected from the purchaser.

Wholesalers, as well as retailers, must obtain a permit. A wholesaler, however, is not required to collect sales tax from a retailer who holds a valid seller's permit and who buys items for resale to customers, provided a resale certificate is completed in connection with the transaction.

> **EXAMPLE:** If your nonprofit sells supplies to another nonprofit with its own seller's permit, you are exempt from collecting sales tax on the transaction—the nonprofit buyer will collect the sales tax on the supplies when it sells them to the public.

Sellers must file periodic sales and use tax returns, reporting and paying sales tax collected from customers. A seller must keep complete records of all business transactions, including sales, purchases, and other expenditures; and have them available for inspection by the Board of Equalization at any time.

Exempt Transactions

Certain transactions entered into by any kind of organization (profit or nonprofit) are not subject to the collection of sales tax. Examples are sales of personal property shipped out of state, certain sales incidental to the performance of services, and purchases of art that will be loaned by certain nonprofits. Call a Board of Equalization office for further information.

Groups Exempt From Collecting and Submitting Sales Tax

A few tax-exempt nonprofit corporations are exempt from collecting sales tax and preparing the quarterly report. To be eligible for the exemption, a nonprofit corporation must meet all of the following stringent requirements:

- The organization must be formed and operated for charitable purposes, and must qualify for the welfare exemption from property taxation provided by Section 214 of the California Revenue and Taxation Code. If the corporation owns the retail location, it must have obtained the welfare exemption for the real property at this location. If it leases the premises, it must have obtained the welfare exemption on the personal property (such as inventory and furnishings) at this location.
- The organization must be engaged in the relief of poverty and distress and the sales must be made principally as a matter of assistance to purchasers in a distressed financial condition. These conditions are fulfilled if the corporation sells its goods at reduced prices so as "to be of real assistance to purchasers." Incidental sales to persons

other than low-income consumers will not prevent the organization from obtaining the sales tax exemption.

- The property sold must have been made, prepared, assembled, or manufactured by the organization. This condition will be satisfied when the property is picked up at various locations and assembled at one or more locations for purposes of sale, even though nothing other than assembling needs to be done to place it in salable condition. Property is considered prepared when it is made ready for sale by such processes as cleaning, repairing, or reconditioning.

A nonprofit corporation seeking to obtain this exemption from sales tax collection and reporting must, as we've said, still apply for a seller's permit by filing Form BOE-400-SPA, attaching to it a *Certificate of Exemption— Charitable Organizations*, Form BT-719, available at the nearest board of equalization office. Applicants should also request an information sheet relating to the exemption, Form BT-719-A.

Other sales tax exemptions exist for special nonprofit groups (for example, certain nonprofit cooperative nursery schools are exempt).

Licenses and Permits

Many businesses, whether operating as profit or nonprofit corporations, partnerships, limited liability companies, or sole proprietorships, must obtain state licenses and permits before commencing business. While you may not be subject to the usual kind of red tape applicable to strictly profit-making enterprises (for example, contractors and real estate brokers), you should check with your local department of consumer affairs office for information concerning any state licensing requirements for your activities or type of organization. If one of the boards does not regulate your activities,

they may be able to refer you to the particular state agency that oversees your operations.

Many nonprofit institutions (for example, schools or hospitals) will, of course, need to comply with a number of registration and reporting requirements administered by the state and, possibly, the federal government. A local business license or permit may also be required for your activities. Check with your city business license department.

Newly incorporated groups that have held licenses or permits for previous activities or operations should check to see if special corporate licensing requirements apply to their activities. In some cases, a separate corporate license must be taken out in the corporate name; in others a corporate license must be obtained in the name of supervisory corporate personnel.

You should also check to see if the city and county where your principal place of business is located (and other places where you plan to conduct activities) require you to obtain a permit for soliciting funds for charitable purposes. Many cities and counties have enacted permit (or other) requirements of this type.

Workers' Compensation

With some exceptions, employees of a nonprofit corporation, whether officers or otherwise, must be covered by workers' compensation insurance. Rates vary depending on the salary level and risk associated with an employee's job. If directors are paid only for travel expenses for attending meetings, they may be exempt from coverage (although flat per-meeting payments will generally make them subject to coverage). This is a blurry area, so check with your insurance agent or broker (or your local State Compensation Insurance Commission) for names of carriers, rates, and the extent of required coverage.

For online information, go to the California Department of Insurance website at www .insurance.ca.gov and enter "Workers' Compensation" in the search box.

Private Insurance Coverage

Nonprofit corporations, like other organizations, should carry the usual kinds of commercial insurance to help protect against losses in the event of an accident, fire, theft, and so on. Remember, although being incorporated can help insulate directors, officers, and others from personal liability and loss, it won't protect against losses to corporate assets. Look into coverage for general liability, product liability, and fire and theft. You should also consider liability insurance for directors and officers, particularly if your nonprofit corporation wants to reassure any passive directors that they will be protected from personal liability in the event of a lawsuit (see "Directors," in Chapter 2). To take advantage of California's volunteer director and officer immunity provisions, adequate director and officer liability insurance must be obtained (or be proven to be unobtainable)—see "Directors," in Chapter 2.

Dissolving a Nonprofit Corporation

We'll end our discussion of the housekeeping details affecting California nonprofit corporations with a short summary of the Nonprofit Corporation Law provisions related to dissolving (ending) the corporation. The primary point to keep in mind here is that a California nonprofit corporation may be dissolved by mutual consent (in a voluntary dissolution) with a minimum of formality. The forms and instructions you'll need to dissolve a nonprofit voluntarily are available online from the Secretary of State's Business Programs Division website. (See Appendix B for more information.) You can download *Certificate of Election to Wind Up and Dissolve* and *Certificate of Dissolution* forms for nonprofit corporations from the website.

Don't let our discussion of dissolution, court filings, and attorney general supervision scare you into thinking that this will be your fate. In fact, the great majority of small, sensibly run nonprofit corporations will never face any major problems. Of course, you should use good judgment as to when and why to pay a financial or legal adviser to answer important questions related to your individual problems. The fact that you can competently do many things on your own doesn't mean that you will never need to see an accountant or lawyer.

Voluntary Dissolution

Any nonprofit corporation may, on its own and out of court, decide to voluntarily wind up and dissolve, for any reason. In a nonmembership corporation, you'll need the board's approval; in a membership corporation, the approval of a majority of the members is needed.

The board of directors of a public benefit corporation may elect to dissolve the corporation, without membership approval, if any of the following conditions apply (the rules are essentially the same for religious corporations):

- the corporation has no members
- the corporation has not commenced business and has not issued any memberships
- the corporation has been adjudged bankrupt
- the corporation has disposed of all its assets and hasn't conducted any activity for the past five years, or
- a subsidiary corporation must dissolve because its charter from a head organization has been revoked.

Occasionally, the court will supervise a corporation's voluntary dissolution. This can happen upon the request of the corporation itself, or by request of 5% or more of the members or three or more creditors.

Involuntary Dissolution

An involuntary dissolution is one that happens in court against the wishes of the nonprofit board. One-third of the membership votes of a nonprofit corporation, one-half of the directors, or the attorney general can force a dissolution as explained below. The attorney general can also trigger a dissolution for the separate reasons discussed below. The petition for dissolution must be filed in the superior court of the county of the corporation's principal office.

Dissolution Triggered by Directors, Members, or Attorney General

One-third of the members, one-half of the directors, or the attorney general can force an involuntary dissolution by filing a court petition based on one or more of the following grounds:

- The nonprofit corporation has abandoned its activities for more than one year.
- The nonprofit corporation has an even number of directors who are equally divided and cannot agree to the management of its affairs, so that the corporation's business cannot be conducted to advantage, or so that there is danger that its property and business (exempt-purpose activities) will be impaired and lost, and the members are so divided into factions that they cannot elect an odd-numbered board.
- The members have been unable, at two consecutive meetings (or in two written ballots), where full voting power has been exercised, or during a four-year period, whichever period is shorter, to elect succes-

sors to directors whose term has expired or would have expired upon election of their successors.
- There is internal dissension and two or more factions of members are so deadlocked that the corporation's activities can no longer be conducted to advantage.
- Those in control of the nonprofit corporation (the directors) have been guilty of or knowingly allowed persistent and pervasive fraud, mismanagement, or abuse of authority, or the corporation's property is being misapplied or wasted by its directors or officers.
- Liquidation is reasonably necessary because the corporation is failing and has continuously failed to carry out its purposes.
- The limited period (if this applies) for which the corporation was formed has terminated without extension of such period (one member alone can file a court petition for involuntary dissolution on this basis).
- In the case of a subordinate corporation created under the authority of a head organization, the articles of incorporation of the subordinate corporation require it to dissolve because its charter has been surrendered to, taken away, or revoked by the head organization.

Additional Grounds for Dissolution in Actions Brought by Attorney General

In addition to the grounds mentioned above, the attorney general can bring an action for involuntary dissolution of the corporation based on its own information or upon another party's complaint, for any of the following reasons:

- The corporation has seriously violated any provision of the statutes regulating corporations or charitable organizations.
- The corporation has fraudulently abused or usurped corporate privileges or powers.

- The corporation has, by action or default, violated any provision of law that authorizes the forfeiture of corporate existence for noncompliance.
- The corporation has failed for five years to pay to the California Franchise Tax Board any tax for which it is liable.

In certain situations, the corporation may take corrective action to avoid a dissolution initiated by the attorney general.

Religious Corporations

The California Nonprofit Corporation Law doesn't directly provide for the involuntary winding up of a religious corporation. However, the attorney general may go to court and, following Section 9230 of the Religious Corporation Law and the procedures of Section 803 of the Code of Civil Procedure, ask a judge to rule on whether the corporation is properly qualified or classified as a religious corporation. If the judge decides that the corporation is improperly qualified, the attorney general can ask the Franchise Tax Board and IRS to revoke the corporation's religious tax exemptions.

Winding Up Corporate Business and Distribution of Assets

Once a voluntary or involuntary dissolution process begins (by vote of the board and/or members to start a voluntary winding up or upon the filing of an involuntary dissolution court petition), the corporation must stop doing business, except to the extent necessary to wind up its affairs pending a distribution of its assets. All corporate debts and liabilities must be paid or provided for (to the extent that corporate assets can do so). If any corporate assets remain after paying corporate debts, a 501(c)(3) tax-exempt nonprofit corporation must distribute them to another 501(c)(3) group as required by the "irrevocable dedication" clause in the corporation's articles.

If your involuntary or voluntary dissolution is subject to superior court supervision, you'll have to publish a notice to creditors of the corporation (a standard formality handled by newspapers that publish legal notices). Creditors who don't file claims within a specified period of time after you've published your notice will be barred from participating in any distribution of the corporation's assets.

Lawyers, Legal Research, and Accountants

While we believe you can take care of the bulk of the work required to organize and operate your nonprofit corporation, you may need to consult a lawyer or accountant on complicated or special issues. It also makes sense to have a lawyer or accountant experienced in forming nonprofits and preparing tax exemption applications look over your papers. Reviewing your incorporation papers with an attorney or accountant is a sensible way to ensure that all of your papers are up to date and meet your needs. Besides, making contact with a legal and tax person early in your corporate life is often a sensible step. As your group grows and its programs expand, you'll be able to consult these professionals for help with ongoing legal and tax questions.

The professionals you contact should have experience in nonprofit incorporations and tax exemption applications. They should also be prepared to help you help yourself—to answer your questions and review, not rewrite, the forms you have prepared.

The next sections provide a few general suggestions on how to find the right lawyer or tax adviser and, if you wish to do your own legal research, how to find the law.

Lawyers

Finding the right lawyer is not always easy. Obviously, the best lawyer to choose is someone you personally know and trust, who has lots of experience advising smaller nonprofits. Of course, this may be a tall order. The next best is a nonprofit adviser whom a friend, another nonprofit incorporator, or someone in your nonprofit network recommends. A local nonprofit resource center, for example, may be able to steer you to one or more lawyers who maintain active nonprofit practices. With patience and persistence (and enough phone calls), this second word-of-mouth approach almost always brings positive results.

Another approach is to locate a local nonprofit legal referral panel. Local bar associations or another nonprofit organization typically run panels of this sort. A referral panel in your area may be able to give you the names of lawyers who are experienced in nonprofit law and practice and who offer a discount or free consultation as part of the referral panel program. Ask about (and try to avoid) referral services that are operated on a strict rotating basis. With this system, you'll get the name of the next lawyer on the list, not necessarily one with nonprofit experience.

You can check Nolo's Lawyer Directory at www.nolo.com/lawyers for nonprofit lawyers in your area. The Nolo Directory offers comprehensive profiles of the lawyers who advertise, including each attorney's education, background, areas of expertise, fees, and practice philosophy. It also states whether the lawyer is willing to review documents or coach clients who are doing their own legal work.

When you call a prospective lawyer, speak with the lawyer personally, not just the reception desk. You can probably get a good idea of how the person operates by paying close attention to the way your call is handled. Is the lawyer available, or is your call returned promptly? Is the lawyer willing to spend at least a few minutes talking to you to determine if she is really the best person for the job? Does the lawyer seem sympathetic to, and compatible with, the nonprofit goals of your group? Do you get a good personal feeling from your conversation? Oh, and one more thing: Be sure to get the hourly rate the lawyer will charge set in advance. If you are using this book, you will

probably want to eliminate lawyers who charge top-dollar rates per hour to support an office on top of the tallest building in town.

What About Low-Cost Law Clinics?

Law clinics advertise their services regularly on TV and radio. Can they help you form a nonprofit organization? Perhaps, but usually at a rate well above their initial low consultation rate. Because the lawyer turnover rate at these clinics is high and the degree of familiarity with nonprofit legal and tax issues is usually low, we recommend you spend your money more wisely by finding a reasonably priced nonprofit lawyer elsewhere.

Legal Research

Many incorporators may want to research legal information on their own. You can browse the nonprofit laws online (go to http://leginfo. legislature.ca.gov; click on "California Law," then the Corporations Code—CORP and scroll down to Division 2, Nonprofit Corporation Law). Most county law libraries are open to the public (you need not be a lawyer to use them) and are not difficult to use once you understand how the information is categorized and stored. They are an invaluable source of corporate and general business forms, federal and state corporate tax procedures, and information. Research librarians will usually go out of their way to help you find the right statute, form, or background reading on any corporate or tax issue.

Finding the Law You Need

Whether you are leafing through your own copy of the nonprofit corporation law or browsing corporate statutes online or at your local county law library, finding a particular corporate provision is usually a straightforward process. First define and, if necessary, narrow down the subject matter of your search to essential key words associated with your area of interest. For example, if one of the directors on your board resigns and you want to determine whether there are any statutory rules for filling vacancies on the board, you will define and restrict your search to the key areas of "directors" and "resignation" or "vacancies."

The laws governing nonprofits in California (the Nonprofit Corporation Law) are contained in Division 2 of the California Corporations Code. If you want information on filling a director vacancy in your nonprofit (a public benefit corporation), you would start with the Nonprofit Corporation Law. There is a section in the Nonprofit Corporation Law (Part 2) that covers nonprofit public benefit corporations. One of the topics in the public benefit corporations section is "Directors and Management." Within that section, there is a subsection for "Selection, Removal and Resignation of Directors," followed by a range of code sections devoted to this subject area. If you read through those code sections, you would find the information you were looking for.

Another search strategy is to simply start at the beginning of the Nonprofit Corporation Law and leaf through all the major and minor headings. Eventually—usually after just a few minutes or so—you will hit upon your area of interest or will satisfy yourself that the area in question is not covered by the corporate statutes. By the way, after going through the nonprofit law this way once or twice, you should become acquainted with most of its major headings. This will help you locate specific nonprofit subject areas and statutes quickly when searching this material in the future.

> ### Legal Shorthand and Definitions
>
> Many rules in the corporate statutes are given in legal shorthand—short catchwords and phrases that are defined elsewhere in the code. For example, a common requirement in corporate statutes is that a matter or transaction be "approved by the board" or "approved by a majority of the board." But what do these phrases mean—how much approval is enough? An alphabetical listing of definitions that apply to California nonprofit corporations is contained in California Corporations Code §§ 5030–5080. Read this definition section before you go on to search for a particular rule, so that you'll understand any legal shorthand you might encounter. (By the way, the first phrase usually means approval by a majority of directors present at a meeting at which a quorum of directors is present; the second usually means approval by a majority of the full board.)

Annotated Codes

When you look up a nonprofit statute, whether online or in a book, you might want to use an annotated version of the codes. Annotated codes include not only the text of the statutes themselves, but also brief summaries of court cases that mention and interpret each statute. After you find a relevant statute, you may want to scan these case summaries—and perhaps even read some of the cases—to get an idea of how courts have interpreted the language of the statute.

RESOURCE

If you are interested in doing your own legal research, an excellent source of information is *Legal Research: How to Find & Understand the Law*, by Stephen Elias and the Editors of Nolo (Nolo).

Accountants and Tax Advice

As you already know, organizing and operating a nonprofit corporation involves a significant amount of financial and tax work. While much of it is easy, some of it requires a nit-picking attention to definitions, cross-references, formulas, and other elusive or downright boring details, particularly when preparing the long-form federal 1023 tax exemption application. As we often suggest in the book, you may find it sensible to seek advice or help from an accountant or other tax adviser when organizing your nonprofit corporation.

For example, you may need help preparing the income statements, balance sheets, and other financial and tax information submitted with your IRS tax exemption application. Also, if your organization will handle any significant amount of money, you will need an accountant or bookkeeper to set up your double-entry accounting books (cash receipts and disbursement journals, general ledger, and so on). Double-entry accounting techniques are particularly important to nonprofits that receive federal or private grant or program funds—accounting for these "restricted funds" usually requires setting up a separate set of books for each fund (and the assistance of a professional).

Nonprofit corporation account books should be designed to allow for easy transfer of financial data to state and federal nonprofit corporate tax returns and disclosure statements. It should be easy to use the books to determine, at any time, whether receipts and expenditures fall into the categories proper for maintaining your 501(c)(3) tax exemption, public charity status, and grant or program eligibility. You will also want to know whether your operations are likely to subject you to an unrelated business income tax under federal and state rules.

Once your corporation is organized and your books are set up, corporate personnel with experience in bookkeeping and nonprofit tax matters can do the ongoing work of keeping the books and filing tax forms. Whatever your arrangement, make sure to at least obtain the tax publications listed in "More Information on Taxes," in Chapter 10. These pamphlets contain essential information on preparing and filing IRS corporation and employment tax returns.

When you select an accountant or bookkeeper, the same considerations apply as when selecting a lawyer. Choose someone you know or whom a friend or nonprofit contact recommends. Be as specific as you can regarding the services you want performed. Make sure the adviser has had experience with nonprofit taxation and tax exemption applications, as well as regular payroll, tax, and accounting procedures. Many nonprofit bookkeepers work part time for several nonprofit organizations. Again, calling people in your nonprofit network is often the best way to find this type of person. ●

Using the Downloadable Forms and Other Online Material

This book comes with downloadable files that you can access online at **www.nolo.com/back-of-book/NON.html** To use the files, your computer must have specific software programs installed. Here is a list of types of files provided by this book, as well as the software programs you'll need to access them:

- **RTF.** You can open, edit, print, and save these form files with most word processing programs such as Microsoft *Word*, Windows *WordPad*, and recent versions of *WordPerfect*.

- **PDF.** You can view these files with Adobe Reader, free software from www.adobe.com. Some of the government PDFs (like the articles of incorporation) are fillable using your computer. Other PDFs are designed to be printed out and completed by hand.

Editing RTFs

Here are some general instructions about editing RTF forms in your word processing program. Refer to the book's instructions and sample agreements for help about what should go in each blank.

- **Underlines.** Underlines indicate where to enter information. After filling in the needed text, delete the underline. In most word processing programs you can do this by highlighting the underlined portion and typing CTRL-U.

- **Bracketed and italicized text.** Bracketed and italicized text indicates instructions. Be sure to remove all instructional text before you finalize your document.

- **Signature lines.** Signature lines should appear on a page with at least some text from the document itself.

Every word processing program uses different commands to open, format, save, and print documents, so refer to your software's help documents for help using your program. Nolo cannot provide technical support for questions about how to use your computer or your software.

CAUTION

In accordance with U.S. copyright laws, the forms provided by this book are for your personal use only.

List of Corporate, IRS, and other Forms and Publications on the Nolo website

The following files are available for download at **www.nolo.com/back-of-book/NON.html**
Before you file any form with California Secretary of State, the IRS, or any other governmental agency, make sure the form you are using is the current version by checking the applicable government agency's website.

Form/Document Title	File Name
Bill of Sale for Assets	BILLSALE.rtf
Incorporation Checklist	CHECKLST.rtf
Membership Certificate	MEMCERT.rtf
Incorporator's Statement	INCORPST.rtf
Minutes of First Meeting of Board of Directors	MINUTES.rtf
Offer to Transfer Assets	OFFER.rtf
Bylaws for Public Benefit Corporation	PUBBYLAW.rtf
Membership Bylaw Provisions for Public Benefit Corporation	PUBMEM.rtf
Bylaws for Religious Corporation	RELBYLAW.rtf
Membership Bylaw Provisions for Religious Corporation	RELMEM.rtf
IRS Revenue Procedure 75-50	IRS7550.rtf
IRC Section 4958, Taxes on Excess Benefit Transactions	IRS4958.rtf
IRS Regulations Section 53.4958-0, Table of Contents	IRS4958R.rtf
Member Register	MEMBERREG.rtf

The following files are in Adobe Acrobat PDF Format, and are available for download at:
www.nolo.com/back-of-book/NON.html

Form/Document Title	File Name
Pub 557: *Tax-Exempt Status for Your Organization*	p557.pdf
Publication 4220: *Applying for 501(c)(3) Tax-Exempt Status*	p4220.pdf
Publication 4221-PC: *Compliance Guide for 501(c)(3) Public Charities*	p4221pc.pdf
Publication 4221-PF: *Compliance Guide for 501(c)(3) Private Foundation*	p4221pf.pdf
Publication 1828: *Tax Guide for Churches and Religious Organizations*	p1828.pdf
Attorney General's Guide for Charities	guide_for_charities.pdf
Guide to Charitable Solicitation	99char.pdf
Public Charity or Private Foundation Status Issues under IRC §§ 509(a)(1)-(4), 4942(j)(3), and 507	eotopicb03.pdf
Disclosure, FOIA, and the Privacy Act	eotopicc03.pdf

Form/Document Title	File Name
Update: The Final Regulations on the Disclosure Requirements for Annual Information Returns and Applications for Exemption	topico00.pdf
Education, Propaganda, and the Methodology Test	cpe.pdf
Election Year Issues	eotopici02.pdf
Lobbying Issues	topic-p.pdf
Private School Update	topicn00.pdf
UBIT: Current Developments	topic-o.pdf
Intermediate Sanctions (IRC 4958) Update	eotopice03.pdf
IRS Revenue Ruling 2007-41: *Political Campaign Prohibition Guidance*	rr-07-41.pdf
Internal Revenue Bulletin (IRB 2008-18) with T.D. 9390 Final Regulation changes to Section 4958 regulations	irb08-18.pdf
Assessors' Handbook Section 267, Welfare, Church, and Religious Exemptions	ah267.pdf
Articles of Incorporation of a Nonprofit Public Benefit Corporation with Mail Submission Cover Sheet	arts-pb.pdf
Articles of Incorporation of a Nonprofit Religious Corporation with Mail Submission Cover Sheet	arts-re.pdf
Name Availability Inquiry Letter	naavinquiryform.pdf
Name Reservation Request	name-res.pdf

Forms

Incorporation Checklist

Special Nonprofit Tax-Exempt Organizations

Articles of Incorporation of a Nonprofit Public Benefit Corporation
with Mail Submission Cover Sheet

Articles of Incorporation of a Nonprofit Religious Corporation
with Mail Submission Cover Sheet

Name Availability Inquiry Letter

Name Reservation Request Form

California Form 3500A, *Submission of Exemption Request*

IRS Form 1023-EZ: *Streamlined Application for Recognition of Exemption Under
Section 501(c)(3) of the Internal Revenue Code*

IRS Package 1023: *Application for Recognition of Exemption* (With *Notice 1382*)

Member Register

Membership Certificates

Note: Government forms and filing fees are subject to change. Make sure the form has not
changed and the filing fee is still correct by checking the IRS, California Secretary of State, or
other governmental agency website.

| | | How to Form a Nonprofit Corporation in California | | | | | |
| | | **Incorporation Checklist** | | | | | |
Chapter	Page	New* Groups	Existing** Groups	Optional***	Step Name	My Group	Done
6	105	✓	✓		Choose a Corporate Name		
6	116	✓	✓		Prepare Articles of Incorporation		
6	123		✓	✓	Prepare Articles for an Unincorporated Association		
6	124	✓	✓		File Your Articles		
6	129	✓	✓		Appoint Initial Corporate Directors		
7		✓	✓		Prepare Bylaws		
8		✓	✓		Prepare and File Your Federal Tax Exemption Application		
9	230	✓	✓		Mail IRS Letter and Form 3500A to Franchise Tax Board		
9	230	✓	✓		Set Up a Corporate Records Book		
9	231		✓	✓	Prepare Offer to Transfer Assets		
9	237		✓		Prepare Minutes of First Board Meeting		
9	245	✓	✓		Place Minutes and Attachments in Corporate Records Book		
9	246		✓	✓	Comply With Bulk Sales Law		
9	247		✓	✓	Prepare Bill of Sale for Assets		
9	249		✓	✓	Prepare Assignments of Leases and Deeds		
9	250		✓	✓	File Final Papers for Prior Organization		
9	250		✓	✓	Notify Others of Your Incorporation		
9	250	✓	✓	✓	Apply for Nonprofit Mailing Permit		
9	251	✓	✓	✓	Apply for Property Tax Exemption		
9	252	✓	✓		File Domestic Corporation Statement		
9	253	✓	✓	✓	Register with Attorney General (Public Benefit Corps.)		
9	254	✓	✓	✓	Issue Membership Certificates		
9	254		✓	✓	File Articles With County Recorder		
9	255	✓	✓	✓	Register With Fair Political Practices Commission		

* New = Groups starting operations as newly formed corporations.

** Existing = Groups in operation prior to incorporation.

*** Optional = (1) Optional step may be elected by new or existing groups; or

 (2) Step must be followed by some (but not all) new or existing groups to which step applies.

Special Nonprofit Tax-Exempt Organizations

IRC §	Organization and Description	Application Form	Annual Return	Deductibility of Contributions[1]
501(c)(1)	**Federal Corporations:** corporations organized under an Act of Congress as federal corporations specifically declared to be exempt from payment of federal income taxes.	No Form	None	Yes, if made for public purposes
501(c)(2)	**Corporations Holding Title to Property for Exempt Organizations:** corporations organized for the exclusive purpose of holding title to property, collecting income from property, and turning over this income, less expenses, to an organization that, itself, is exempt from payment of federal income taxes.	1024	990	No
501(c)(4)	**Civic Leagues, Social Welfare Organizations, or Local Employee Associations:** civic leagues or organizations operated exclusively for the promotion of social welfare, or local associations of employees, the membership of which is limited to the employees of a particular employer within a particular municipality, and whose net earnings are devoted exclusively to charitable, educational, or recreational purposes. Typical examples of groups that fall under this category are volunteer fire companies, homeowners' or real estate development associations, or employee associations formed to further charitable community service.	1024	990	Generally, No[2]
501(c)(5)	**Labor, Agricultural, or Horticultural Organizations:** organizations of workers organized to protect their interests in connection with their employment (e.g., labor unions) or groups organized to promote more efficient techniques in production or the betterment of conditions for workers engaged in agricultural or horticultural employment.	1024	990	No
501(c)(6)	**Business Leagues, Chambers of Commerce, Etc.:** business leagues, chambers of commerce, real estate boards, or boards-of-trade organized for the purpose of improving business conditions in one or more lines of business.	1024	990	No
501(c)(7)	**Social and Recreational Clubs:** clubs organized for pleasure, recreation, and other nonprofit purposes, no part of the net earnings of which inure to the benefit of any member. Examples of such organizations are hobby clubs and other special interest social or recreational membership groups.	1024	990	No
501(c)(8)	**Fraternal Beneficiary Societies:** groups that operate under the lodge system for the exclusive benefit of their members, which provide benefits such as the payment of life, sick, or accident insurance to members.	1024	990	Yes, if for certain 501(c)(3) purposes
501(c)(9)	**Volunteer Employee Beneficiary Associations:** associations of employees that provide benefits to their members, enrollment in which is strictly voluntary and none of the earnings of which inure to the benefit of any individual members except in accordance with the association's group benefit plan.	1024	990	No
501(c)(10)	**Domestic Fraternal Societies:** domestic fraternal organizations operating under the lodge system that devote their net earnings to religious, charitable, scientific, literary, educational, or fraternal purposes and that do not provide for the payment of insurance or other benefits to members.	1024	990	Yes, if for certain 510(c)(3) purposes

	Special Nonprofit Tax-Exempt Organizations (continued)			
IRC §	**Organization and Description**	**Application Form**	**Annual Return**	**Deductibility of Contributions[1]**
501(c)(11)	**Local Teacher Retirement Fund Associations:** associations organized to receive amounts received from public taxation, from assessments on the teaching salaries of members, or from income from investments, to devote solely to providing retirement benefits to its members.	No Form[3]	990	No
501(c)(12)	**Benevolent Life Insurance Associations, Mutual Water and Telephone Companies, Etc.:** organizations organized on a mutual or cooperative basis to provide the above and similar services to members, 85% of whose income is collected from members, and whose income is used solely to cover the expenses and losses of the organization.	1024	990	No
501(c)(13)	**Cemetery Companies:** companies owned and operated exclusively for the benefit of members solely to provide cemetery services to their members.	1024	990	Generally, Yes
501(c)(14)	**Credit Unions:** credit unions and other mutual financial organizations organized without capital stock for nonprofit purposes.	1024	990	No
501(c)(15)	**Mutual Insurance Companies:** certain mutual insurance companies whose gross receipts are from specific sources and are within certain statutory limits.	1024	990	No
501(c)(16)	**Farmers' Cooperatives:** associations organized and operated on a cooperative basis for the purpose of marketing the products of members or other products.	1024	990	No
501(c)(19)	**War Veteran Organizations:** posts or organizations whose members are war veterans and that are formed to provide benefits to their members.	1024	990	Generally, No
501(c)(20)	**Group Legal Service Organizations:** organizations created for the exclusive function of forming a qualified group legal service plan.	1024	990	No
510(d)	**Religious and Apostolic Organizations:** religious associations or corporations with a common treasury that engage in business for the common benefit of members. Each member's share of the net income of the corporation is reported on his individual tax return. This is a rarely used section of the Code used by religious groups that are ineligible for 501(c)(3) status because they engage in a communal trade or business.	No Form	1065	No
521(a)	**Farmers' Cooperative Associations:** farmers, fruit growers, and like associations organized and operated on a cooperative basis for the purpose of marketing the products of members or other producers, or for the purchase of supplies and equipment for members at cost.	1028	990-C	No

For specific information on the requirements of several of these special-purpose tax exemption categories, see IRS Publication 557, *Tax-Exempt Status for Your Organization.*

[1]An organization exempt under a subsection of IRC Section 501 other than (c)(3)—the types listed in this table—may establish a fund exclusively for 501(c)(3) purposes, contributions to which are deductible. Section 501(c)(3) tax-exempt status should be obtained for this separate fund of a non-501(c)(3) group. See IRS Publication 557 for further details.

[2]Contributions to volunteer fire companies and similar organizations are deductible, but only if made for exclusively public purposes.

[3]Application is made by letter to the key District Director.

Secretary of State
Articles of Incorporation of a
Nonprofit Public Benefit Corporation

ARTS-PB-501(c)(3)

IMPORTANT — Read Instructions **before completing this form.**

Filing Fee — **$30.00**

Copy Fees — First page $1.00; each attachment page $0.50;
Certification Fee - $5.00

Note: A separate California Franchise Tax Board application is required to obtain tax exempt status. For more information, go to *https://www.ftb.ca.gov.*

This Space For Office Use Only

1. Corporate Name (Go to *www.sos.ca.gov/business/be/name-availability* for general corporate name requirements and restrictions.)

The name of the corporation is _____

2. Business Addresses (Enter the **complete** business addresses. Item 2a cannot be a P.O.Box or "in care of" an individual or entity.)

	City (no abbreviations)	State	Zip Code
a. Initial Street Address of Corporation - **Do not enter a P.O. Box**			
b. Initial Mailing Address of Corporation, **if different than item 2a**			

3. Service of Process (Must provide either Individual **OR** Corporation.)

INDIVIDUAL – Complete Items 3a and 3b only. Must include agent's full name and California street address.

a. California Agent's First Name (if agent is **not** a corporation)	Middle Name	Last Name	Suffix
b. Street Address (if agent is **not** a corporation) - **Do not enter a P.O. Box**	City (no abbreviations)	State **CA**	Zip Code

CORPORATION – Complete Item 3c. Only include the name of the registered agent Corporation.

c. California Registered Corporate Agent's Name (if agent is a corporation) – Do not complete Item 3a or 3b

4. Purpose Statement

Item 4a: One or both boxes **must** be checked.
Item 4b: If "public" purposes is checked in Item 4a, or if you intend to apply for tax-exempt status in California, you **must** enter the specific purpose in Item 4b.)

a. This corporation is a nonprofit **Public Benefit** Corporation and is not organized for private gain of any person. It is organized under the Nonprofit Public Benefit Corporation Law for: ☐ **public** purposes. ☐ **charitable** purposes.

b. The specific purpose of this corporation is to _____

5. Additional Statements (See Instructions and Filing Tips.)

a. This corporation is organized and operated exclusively for the purposes set forth in **Article 4** hereof within the meaning of Internal Revenue Code section 501(c)(3).

b. No substantial part of the activities of this corporation shall consist of carrying on propaganda, or otherwise attempting to influence legislation, and this corporation shall not participate or intervene in any political campaign (including the publishing or distribution of statements) on behalf of any candidate for public office.

c. The property of this corporation is irrevocably dedicated to the purposes in **Article 4** hereof and no part of the net income or assets of this corporation shall ever inure to the benefit of any director, officer or member thereof or to the benefit of any private person.

d. Upon the dissolution or winding up of this corporation, its assets remaining after payment, or provision for payment, of all debts and liabilities of this corporation shall be distributed to a nonprofit fund, foundation or corporation which is organized and operated exclusively for **charitable, educational and/or religious** purposes and which has established its tax-exempt status under Internal Revenue Code section 501(c)(3).

6. Read and Sign Below (This form must be signed by each incorporator. See Instructions. Do not include a title.)

_____ _____
Signature Type or Print Name

Mail Submission Cover Sheet

Instructions:

- Complete and include this form with your submission. **This information only will be used to communicate with you in writing about the submission.** This form will be treated as correspondence and will not be made part of the filed document.

- Make all **checks or money orders** payable to the Secretary of State.

- Do not include a $15 counter fee when submitting documents by mail.

- Standard processing time for **submissions** to this office is approximately 5 business days from receipt. All **submissions** are reviewed in the date order of receipt. For updated processing time information, visit *www.sos.ca.gov/business/be/processing-times.*

Optional Copy and Certification Fees:

- If applicable, include optional copy and certification fees with your submission.

- For applicable copy and certification fee information, refer to the instructions of the specific form you are submitting.

Contact Person: (Please type or print legibly)

First Name: _____ Last Name: _____

Phone (optional): _____

Entity Information: (Please type or print legibly)

Name: _____

Entity Number (if applicable): _____

Comments: _____

Return Address: For written communication from the Secretary of State related to this document, or if purchasing a copy of the filed document enter the name of a person or company and the mailing address.

Name: ⌈ ⌉

Company:

Address:

City/State/Zip: ⌊ ⌋

Secretary of State Use Only	
T/TR:	
AMT REC'D:	$

Doc Submission Cover - Corp (Rev. 09/2016)

Special Nonprofit Tax-Exempt Organizations

IRC §	Organization and Description	Application Form	Annual Return	Deductibility of Contributions[1]
501(c)(1)	**Federal Corporations:** corporations organized under an Act of Congress as federal corporations specifically declared to be exempt from payment of federal income taxes.	No Form	None	Yes, if made for public purposes
501(c)(2)	**Corporations Holding Title to Property for Exempt Organizations:** corporations organized for the exclusive purpose of holding title to property, collecting income from property, and turning over this income, less expenses, to an organization that, itself, is exempt from payment of federal income taxes.	1024	990	No
501(c)(4)	**Civic Leagues, Social Welfare Organizations, or Local Employee Associations:** civic leagues or organizations operated exclusively for the promotion of social welfare, or local associations of employees, the membership of which is limited to the employees of a particular employer within a particular municipality, and whose net earnings are devoted exclusively to charitable, educational, or recreational purposes. Typical examples of groups that fall under this category are volunteer fire companies, homeowners' or real estate development associations, or employee associations formed to further charitable community service.	1024	990	Generally, No[2]
501(c)(5)	**Labor, Agricultural, or Horticultural Organizations:** organizations of workers organized to protect their interests in connection with their employment (e.g., labor unions) or groups organized to promote more efficient techniques in production or the betterment of conditions for workers engaged in agricultural or horticultural employment.	1024	990	No
501(c)(6)	**Business Leagues, Chambers of Commerce, Etc.:** business leagues, chambers of commerce, real estate boards, or boards-of-trade organized for the purpose of improving business conditions in one or more lines of business.	1024	990	No
501(c)(7)	**Social and Recreational Clubs:** clubs organized for pleasure, recreation, and other nonprofit purposes, no part of the net earnings of which inure to the benefit of any member. Examples of such organizations are hobby clubs and other special interest social or recreational membership groups.	1024	990	No
501(c)(8)	**Fraternal Beneficiary Societies:** groups that operate under the lodge system for the exclusive benefit of their members, which provide benefits such as the payment of life, sick, or accident insurance to members.	1024	990	Yes, if for certain 501(c)(3) purposes
501(c)(9)	**Volunteer Employee Beneficiary Associations:** associations of employees that provide benefits to their members, enrollment in which is strictly voluntary and none of the earnings of which inure to the benefit of any individual members except in accordance with the association's group benefit plan.	1024	990	No
501(c)(10)	**Domestic Fraternal Societies:** domestic fraternal organizations operating under the lodge system that devote their net earnings to religious, charitable, scientific, literary, educational, or fraternal purposes and that do not provide for the payment of insurance or other benefits to members.	1024	990	Yes, if for certain 510(c)(3) purposes

	Special Nonprofit Tax-Exempt Organizations (continued)			
IRC §	**Organization and Description**	**Application Form**	**Annual Return**	**Deductibility of Contributions[1]**
501(c)(11)	**Local Teacher Retirement Fund Associations:** associations organized to receive amounts received from public taxation, from assessments on the teaching salaries of members, or from income from investments, to devote solely to providing retirement benefits to its members.	No Form[3]	990	No
501(c)(12)	**Benevolent Life Insurance Associations, Mutual Water and Telephone Companies, Etc.:** organizations organized on a mutual or cooperative basis to provide the above and similar services to members, 85% of whose income is collected from members, and whose income is used solely to cover the expenses and losses of the organization.	1024	990	No
501(c)(13)	**Cemetery Companies:** companies owned and operated exclusively for the benefit of members solely to provide cemetery services to their members.	1024	990	Generally, Yes
501(c)(14)	**Credit Unions:** credit unions and other mutual financial organizations organized without capital stock for nonprofit purposes.	1024	990	No
501(c)(15)	**Mutual Insurance Companies:** certain mutual insurance companies whose gross receipts are from specific sources and are within certain statutory limits.	1024	990	No
501(c)(16)	**Farmers' Cooperatives:** associations organized and operated on a cooperative basis for the purpose of marketing the products of members or other products.	1024	990	No
501(c)(19)	**War Veteran Organizations:** posts or organizations whose members are war veterans and that are formed to provide benefits to their members.	1024	990	Generally, No
501(c)(20)	**Group Legal Service Organizations:** organizations created for the exclusive function of forming a qualified group legal service plan.	1024	990	No
510(d)	**Religious and Apostolic Organizations:** religious associations or corporations with a common treasury that engage in business for the common benefit of members. Each member's share of the net income of the corporation is reported on his individual tax return. This is a rarely used section of the Code used by religious groups that are ineligible for 501(c)(3) status because they engage in a communal trade or business.	No Form	1065	No
521(a)	**Farmers' Cooperative Associations:** farmers, fruit growers, and like associations organized and operated on a cooperative basis for the purpose of marketing the products of members or other producers, or for the purchase of supplies and equipment for members at cost.	1028	990-C	No

For specific information on the requirements of several of these special-purpose tax exemption categories, see IRS Publication 557, *Tax-Exempt Status for Your Organization.*

[1]An organization exempt under a subsection of IRC Section 501 other than (c)(3)—the types listed in this table—may establish a fund exclusively for 501(c)(3) purposes, contributions to which are deductible. Section 501(c)(3) tax-exempt status should be obtained for this separate fund of a non-501(c)(3) group. See IRS Publication 557 for further details.

[2]Contributions to volunteer fire companies and similar organizations are deductible, but only if made for exclusively public purposes.

[3]Application is made by letter to the key District Director.

Secretary of State
Articles of Incorporation of a Nonprofit Public Benefit Corporation

ARTS-PB-501(c)(3)

IMPORTANT — **Read Instructions** before completing this form.

Filing Fee – **$30.00**

Copy Fees – First page $1.00; each attachment page $0.50;
Certification Fee - $5.00

Note: A separate California Franchise Tax Board application is required to obtain tax exempt status. For more information, go to *https://www.ftb.ca.gov*.

This Space For Office Use Only

1. Corporate Name (Go to *www.sos.ca.gov/business/be/name-availability* for general corporate name requirements and restrictions.)

The name of the corporation is _____

2. Business Addresses (Enter the **complete** business addresses. Item 2a cannot be a P.O.Box or "in care of" an individual or entity.)

a. Initial Street Address of Corporation - **Do not enter a P.O. Box**	City (no abbreviations)	State	Zip Code
b. Initial Mailing Address of Corporation, **if different than item 2a**	City (no abbreviations)	State	Zip Code

3. Service of Process (Must provide either Individual **OR** Corporation.)

INDIVIDUAL – Complete Items 3a and 3b only. Must include agent's full name and California street address.

a. California Agent's First Name (if agent is **not** a corporation)	Middle Name	Last Name	Suffix
b. Street Address (if agent is **not** a corporation) - **Do not enter a P.O. Box**	City (no abbreviations)	State **CA**	Zip Code

CORPORATION – Complete Item 3c. Only include the name of the registered agent Corporation.

c. California Registered Corporate Agent's Name (if agent is a corporation) – Do not complete Item 3a or 3b

4. Purpose Statement

Item 4a: One or both boxes **must** be checked.
Item 4b: If "public" purposes is checked in Item 4a, or if you intend to apply for tax-exempt status in California, you **must** enter the specific purpose in Item 4b.)

a. This corporation is a nonprofit **Public Benefit** Corporation and is not organized for private gain of any person. It is organized under the Nonprofit Public Benefit Corporation Law for: ☐ **public** purposes. ☐ **charitable** purposes.

b. The specific purpose of this corporation is to _____

5. Additional Statements (See Instructions and Filing Tips.)

a. This corporation is organized and operated exclusively for the purposes set forth in **Article 4** hereof within the meaning of Internal Revenue Code section 501(c)(3).

b. No substantial part of the activities of this corporation shall consist of carrying on propaganda, or otherwise attempting to influence legislation, and this corporation shall not participate or intervene in any political campaign (including the publishing or distribution of statements) on behalf of any candidate for public office.

c. The property of this corporation is irrevocably dedicated to the purposes in **Article 4** hereof and no part of the net income or assets of this corporation shall ever inure to the benefit of any director, officer or member thereof or to the benefit of any private person.

d. Upon the dissolution or winding up of this corporation, its assets remaining after payment, or provision for payment, of all debts and liabilities of this corporation shall be distributed to a nonprofit fund, foundation or corporation which is organized and operated exclusively for **charitable, educational and/or religious** purposes and which has established its tax-exempt status under Internal Revenue Code section 501(c)(3).

6. Read and Sign Below (This form must be signed by each incorporator. **See Instructions.** Do not include a title.)

_____ _____
Signature Type or Print Name

Mail Submission Cover Sheet

Instructions:

- Complete and include this form with your submission. **This information only will be used to communicate with you in writing about the submission.** This form will be treated as correspondence and will not be made part of the filed document.

- Make all **checks or money orders** payable to the Secretary of State.

- Do not include a $15 counter fee when submitting documents by mail.

- Standard processing time for **submissions** to this office is approximately 5 business days from receipt. All **submissions** are reviewed in the date order of receipt. For updated processing time information, visit *www.sos.ca.gov/business/be/processing-times.*

Optional Copy and Certification Fees:

- If applicable, include optional copy and certification fees with your submission.

- For applicable copy and certification fee information, refer to the instructions of the specific form you are submitting.

Contact Person: (Please type or print legibly)

First Name: _____ Last Name: _____

Phone (optional): _____

Entity Information: (Please type or print legibly)

Name: _____

Entity Number (if applicable): _____

Comments: _____

Return Address: For written communication from the Secretary of State related to this document, or if purchasing a copy of the filed document enter the name of a person or company and the mailing address.

Name: ⌈ ⌉

Company:

Address:

City/State/Zip: ⌊ ⌋

Secretary of State Use Only	
T/TR:	
AMT REC'D:	$

Doc Submission Cover - Corp (Rev. 09/2016)

⚖ NOLO *Online Legal Forms*

Nolo offers a large library of legal solutions and forms, created by Nolo's in-house legal staff. These reliable documents can be prepared in minutes.

Create a Document

- **Incorporation.** Incorporate your business in any state.
- **LLC Formations.** Gain asset protection and pass-through tax status in any state.
- **Wills.** Nolo has helped people make over 2 million wills. Is it time to make or revise yours?
- **Living Trust (avoid probate).** Plan now to save your family the cost, delays, and hassle of probate.
- **Trademark.** Protect the name of your business or product.
- **Provisional Patent.** Preserve your rights under patent law and claim "patent pending" status.

Download a Legal Form

Nolo.com has hundreds of top quality legal forms available for download—bills of sale, promissory notes, nondisclosure agreements, LLC operating agreements, corporate minutes, commercial lease and sublease, motor vehicle bill of sale, consignment agreements and many, many more.

Review Your Documents

Many lawyers in Nolo's consumer-friendly lawyer directory will review Nolo documents for a very reasonable fee. Check their detailed profiles at **Nolo.com/lawyers**.

**MEMBERSHIPS IN THIS
NONPROFIT CORPORATION
ARE NONTRANSFERABLE**

Certificate Number _____

A CALIFORNIA NONPROFIT CORPORATION

MEMBERSHIP CERTIFICATE

THIS IS TO CERTIFY THAT _____

is a member of the above Corporation incorporated under the laws of this state and is entitled to the full rights and privileges of such membership, subject to the duties and restrictions, as more fully set forth in the Corporation's Articles of Incorporation and Bylaws.

IN WITNESS WHEREOF, the Corporation has caused this Certificate to be executed by its duly authorized officers, and its corporate seal to be hereunto affixed.

Dated _____

_____, *President*

_____, *Secretary*

Index

A CALIFORNIA NONPROFIT CORPORATION

Membership Certificate

Certificate Number _____

THIS IS TO CERTIFY THAT _____

is a member of the above Corporation incorporated under the laws of this state and is entitled to the full rights and privileges of such membership, subject to the duties and restrictions, as more fully set forth in the Corporation's Articles of Incorporation and Bylaws.

IN WITNESS WHEREOF, the Corporation has caused this Certificate to be executed by its duly authorized officers, and its corporate seal to be hereunto affixed.

Dated _____

_____ , *President*

_____ , *Secretary*

MEMBERSHIPS IN THIS
NONPROFIT CORPORATION
ARE NONTRANSFERABLE

Received Certificate Number _____

For one membership

This _____ day of _____, _____

SIGNATURE OF MEMBER

Certificate Number _____

A CALIFORNIA NONPROFIT CORPORATION

MEMBERSHIP CERTIFICATE

THIS IS TO CERTIFY THAT _____

is a member of the above Corporation incorporated under the laws of this state and is entitled to the full rights and privileges of such membership, subject to the duties and restrictions, as more fully set forth in the Corporation's Articles of Incorporation and Bylaws.

IN WITNESS WHEREOF, the Corporation has caused this Certificate to be executed by its duly authorized officers, and its corporate seal to be hereunto affixed.

Dated _____

_____, *President*

_____, *Secretary*

Membership Certificate

A CALIFORNIA NONPROFIT CORPORATION

Certificate Number _____

THIS IS TO CERTIFY THAT _____
is a member of the above Corporation incorporated under the laws of this state and is entitled to the full rights and privileges of such membership, subject to the duties and restrictions, as more fully set forth in the Corporation's Articles of Incorporation and Bylaws.

IN WITNESS WHEREOF, the Corporation has caused this Certificate to be executed by its duly authorized officers, and its corporate seal to be hereunto affixed.

Dated _____

_____ , President

_____ , Secretary

Certificate Number _____

For one membership

Issued To: _____

Date _____ , _____

MEMBERSHIPS IN THIS
NONPROFIT CORPORATION
ARE NONTRANSFERABLE

Received Certificate Number _____

For one membership

This _____ day of _____ , _____

SIGNATURE OF MEMBER

**MEMBERSHIPS IN THIS
NONPROFIT CORPORATION
ARE NONTRANSFERABLE**

Certificate Number _____

A CALIFORNIA NONPROFIT CORPORATION

MEMBERSHIP CERTIFICATE

THIS IS TO CERTIFY THAT _____
*is a member of the above Corporation incorporated under the laws of this state and is
entitled to the full rights and privileges of such membership, subject to the duties and
restrictions, as more fully set forth in the Corporation's Articles of Incorporation and Bylaws.*

*IN WITNESS WHEREOF, the Corporation has caused this Certificate to be executed by its
duly authorized officers, and its corporate seal to be hereunto affixed.*

Dated _____

_____ , *President*

_____ , *Secretary*

Left Stub

Center Stub

Certificate

Certificate Number _____

A CALIFORNIA NONPROFIT CORPORATION

Membership Certificate

THIS IS TO CERTIFY THAT _____
is a member of the above Corporation incorporated under the laws of this state and is
entitled to the full rights and privileges of such membership, subject to the duties and
restrictions, as more fully set forth in the Corporation's Articles of Incorporation and Bylaws.

IN WITNESS WHEREOF, the Corporation has caused this Certificate to be executed by its
duly authorized officers, and its corporate seal to be hereunto affixed.

Dated _____ , President

_____ , Secretary

Certificate Number _____

▲ CALIFORNIA NONPROFIT CORPORATION

MEMBERSHIP CERTIFICATE

THIS IS TO CERTIFY THAT _____
*is a member of the above Corporation incorporated under the laws of this state and is
entitled to the full rights and privileges of such membership, subject to the duties and
restrictions, as more fully set forth in the Corporation's Articles of Incorporation and Bylaws.*

*IN WITNESS WHEREOF, the Corporation has caused this Certificate to be executed by its
duly authorized officers, and its corporate seal to be hereunto affixed.*

Dated _____

_____ , President

_____ , Secretary

▲ CALIFORNIA NONPROFIT CORPORATION

MEMBERSHIP CERTIFICATE

Certificate Number _____

THIS IS TO CERTIFY THAT _____
*is a member of the above Corporation incorporated under the laws of this state and is
entitled to the full rights and privileges of such membership, subject to the duties and
restrictions, as more fully set forth in the Corporation's Articles of Incorporation and Bylaws.*

*IN WITNESS WHEREOF, the Corporation has caused this Certificate to be executed by its
duly authorized officers, and its corporate seal to be hereunto affixed.*

Dated _____

_____ , President

_____ , Secretary

Certificate Number _____

For one membership

Issued To: _____

Date _____ , _____

MEMBERSHIPS IN THIS
NONPROFIT CORPORATION
ARE NONTRANSFERABLE

Received Certificate Number _____

For one membership

This _____ day of _____ , _____

SIGNATURE OF MEMBER

Certificate Number _____

A CALIFORNIA NONPROFIT CORPORATION

Membership Certificate

THIS IS TO CERTIFY THAT _____
*is a member of the above Corporation incorporated under the laws of this state and is
entitled to the full rights and privileges of such membership, subject to the duties and
restrictions, as more fully set forth in the Corporation's Articles of Incorporation and Bylaws.*

*IN WITNESS WHEREOF, the Corporation has caused this Certificate to be executed by its
duly authorized officers, and its corporate seal to be hereunto affixed.*

Dated _____

_____ , *President*

_____ , *Secretary*

Member Register

Certificate Number	Date of Issuance			Member's Name and Address
	Month	Day	Year	

Member Register

Certificate Number	Date of Issuance			Member's Name and Address
	Month	Day	Year	

☐ An exact copy of your complete articles of organization (creating document). Absence of the proper purpose and dissolution clauses is the number one reason for delays in the issuance of determination letters.

 • Location of Purpose Clause from Part III, line 1 (Page, Article and Paragraph Number) _____
 • Location of Dissolution Clause from Part III, line 2b or 2c (Page, Article and Paragraph Number) or by operation of state law _____

☐ Signature of an officer, director, trustee, or other official who is authorized to sign the application.
 • Signature at Part XI of Form 1023.

☐ Your name on the application must be the same as your legal name as it appears in your articles of organization.

Send completed Form 1023, user fee payment, and all other required information, to:

Internal Revenue Service
P.O. Box 192
Covington, KY 41012-0192

If you are using express mail or a delivery service, send Form 1023, user fee payment, and attachments to:

Internal Revenue Service
201 West Rivercenter Blvd.
Attn: Extracting Stop 312
Covington, KY 41011

Form 1023 Checklist

(Revised December 2013)

Application for Recognition of Exemption under Section 501(c)(3) of the Internal Revenue Code

Note. *Retain a copy of the completed Form 1023 in your permanent records. Refer to the* General Instructions *regarding Public Inspection of approved applications.*

<u>**Check each box to finish your application (Form 1023). Send this completed Checklist with your filled-in application. If you have not answered all the items below, your application may be returned to you as incomplete.**</u>

☐ Assemble the application and materials in this order:
- Form 1023 Checklist
- Form 2848, *Power of Attorney and Declaration of Representative* (if filing)
- Form 8821, *Tax Information Authorization* (if filing)
- Expedite request (if requesting)
- Application (Form 1023 and Schedules A through H, as required)
- Articles of organization
- Amendments to articles of organization in chronological order
- Bylaws or other rules of operation and amendments
- Documentation of nondiscriminatory policy for schools, as required by Schedule B
- Form 5768, Election/Revocation of Election by an Eligible Section 501(c)(3) Organization To Make Expenditures To Influence Legislation (if filing)
- All other attachments, including explanations, financial data, and printed materials or publications. Label each page with name and EIN.

☐ User fee payment placed in envelope on top of checklist. DO NOT STAPLE or otherwise attach your check or money order to your application. Instead, just place it in the envelope.

☐ Employer Identification Number (EIN)

☐ Completed Parts I through XI of the application, including any requested information and any required Schedules A through H.
- You must provide specific details about your past, present, and planned activities.
- Generalizations or failure to answer questions in the Form 1023 application will prevent us from recognizing you as tax exempt.
- Describe your purposes and proposed activities in specific easily understood terms.
- Financial information should correspond with proposed activities.

☐ Schedules. Submit only those schedules that apply to you and check either "Yes" or "No" below.

Schedule A Yes ___ No ___		Schedule E Yes ___ No ___
Schedule B Yes ___ No ___		Schedule F Yes ___ No ___
Schedule C Yes ___ No ___		Schedule G Yes ___ No ___
Schedule D Yes ___ No ___		Schedule H Yes ___ No ___

Schedule H. Organizations Providing Scholarships, Fellowships, Educational Loans, or Other Educational Grants to Individuals and Private Foundations Requesting Advance Approval of Individual Grant Procedures *(Continued)*

Section II	**Private foundations complete lines 1a through 4f of this section. Public charities do not complete this section.** *(Continued)*

4a Do you or will you award scholarships, fellowships, and educational loans to attend an educational institution based on the status of an individual being an *employee of a particular employer?* If "Yes," complete lines 4b through 4f. ☐ **Yes** ☐ **No**

b Will you comply with the seven conditions and either the percentage tests or facts and circumstances test for scholarships, fellowships, and educational loans to attend an educational institution as set forth in Revenue Procedures 76-47, 1976-2 C.B. 670, and 80-39, 1980-2 C.B. 772, which apply to inducement, selection committee, eligibility requirements, objective basis of selection, employment, course of study, and other objectives? (See lines 4c, 4d, and 4e, regarding the percentage tests.) ☐ **Yes** ☐ **No**

c Do you or will you provide scholarships, fellowships, or educational loans to attend an educational institution to employees of a particular employer? ☐ **Yes** ☐ **No** ☐ **N/A**

If "Yes," will you award grants to 10% or fewer of the eligible applicants who were actually considered by the selection committee in selecting recipients of grants in that year as provided by Revenue Procedures 76-47 and 80-39? ☐ **Yes** ☐ **No**

d Do you provide scholarships, fellowships, or educational loans to attend an educational institution to children of employees of a particular employer? ☐ **Yes** ☐ **No** ☐ **N/A**

If "Yes," will you award grants to 25% or fewer of the eligible applicants who were actually considered by the selection committee in selecting recipients of grants in that year as provided by Revenue Procedures 76-47 and 80-39? If "No," go to line 4e. ☐ **Yes** ☐ **No**

e If you provide scholarships, fellowships, or educational loans to attend an educational institution to children of employees of a particular employer, will you award grants to 10% or fewer of the number of employees' children who can be shown to be eligible for grants (whether or not they submitted an application) in that year, as provided by Revenue Procedures 76-47 and 80-39? ☐ **Yes** ☐ **No** ☐ **N/A**

If "Yes," describe how you will determine who can be shown to be eligible for grants without submitting an application, such as by obtaining written statements or other information about the expectations of employees' children to attend an educational institution. If "No," go to line 4f.

Note. Statistical or sampling techniques are not acceptable. See Revenue Procedure 85-51, 1985-2 C.B. 717, for additional information.

f If you provide scholarships, fellowships, or educational loans to attend an educational institution to *children of employees of a particular employer* without regard to either the 25% limitation described in line 4d, or the 10% limitation described in line 4e, will you award grants based on facts and circumstances that demonstrate that the grants will not be considered compensation for past, present, or future services or otherwise provide a significant benefit to the particular employer? If "Yes," describe the facts and circumstances that you believe will demonstrate that the grants are neither compensatory nor a significant benefit to the particular employer. In your explanation, describe why you cannot satisfy either the 25% test described in line 4d or the 10% test described in line 4e. ☐ **Yes** ☐ **No**

Schedule H. Organizations Providing Scholarships, Fellowships, Educational Loans, or Other Educational Grants to Individuals and Private Foundations Requesting Advance Approval of Individual Grant Procedures

Section I	*Names of individual recipients are not required to be listed in Schedule H.* Public charities and private foundations complete lines 1a through 7 of this section. See the instructions to Part X if you are not sure whether you are a public charity or a private foundation.

1a Describe the types of educational grants you provide to individuals, such as scholarships, fellowships, loans, etc.

b Describe the purpose and amount of your scholarships, fellowships, and other educational grants and loans that you award.

c If you award educational loans, explain the terms of the loans (interest rate, length, forgiveness, etc.).

d Specify how your program is publicized.

e Provide copies of any solicitation or announcement materials.

f Provide a sample copy of the application used.

2 Do you maintain case histories showing recipients of your scholarships, fellowships, educational loans, or other educational grants, including names, addresses, purposes of awards, amount of each grant, manner of selection, and relationship (if any) to officers, trustees, or donors of funds to you? If "No," refer to the instructions. ☐ Yes ☐ No

3 Describe the specific criteria you use to determine who is eligible for your program. (For example, eligibility selection criteria could consist of graduating high school students from a particular high school who will attend college, writers of scholarly works about American history, etc.)

4a Describe the specific criteria you use to select recipients. (For example, specific selection criteria could consist of prior academic performance, financial need, etc.)

b Describe how you determine the number of grants that will be made annually.

c Describe how you determine the amount of each of your grants.

d Describe any requirement or condition that you impose on recipients to obtain, maintain, or qualify for renewal of a grant. (For example, specific requirements or conditions could consist of attendance at a four-year college, maintaining a certain grade point average, teaching in public school after graduation from college, etc.)

5 Describe your procedures for supervising the scholarships, fellowships, educational loans, or other educational grants. Describe whether you obtain reports and grade transcripts from recipients, or you pay grants directly to a school under an arrangement whereby the school will apply the grant funds only for enrolled students who are in good standing. Also, describe your procedures for taking action if the terms of the award are violated.

6 Who is on the selection committee for the awards made under your program, including names of current committee members, criteria for committee membership, and the method of replacing committee members?

7 Are relatives of members of the selection committee, or of your officers, directors, or **substantial contributors** eligible for awards made under your program? If "Yes," what measures are taken to ensure unbiased selections? ☐ Yes ☐ No

Note. If you are a private foundation, you are not permitted to provide educational grants to **disqualified persons**. Disqualified persons include your substantial contributors and foundation managers and certain family members of disqualified persons.

Section II	Private foundations complete lines 1a through 4f of this section. Public charities do not complete this section.

1a If we determine that you are a private foundation, do you want this application to be considered as a request for advance approval of grant making procedures? ☐ Yes ☐ No ☐ N/A

b For which section(s) do you wish to be considered?

- 4945(g)(1)—Scholarship or fellowship grant to an individual for study at an educational institution ☐
- 4945(g)(3)—Other grants, including loans, to an individual for travel, study, or other similar purposes, to enhance a particular skill of the grantee or to produce a specific product ☐

2 Do you represent that you will (1) arrange to receive and review grantee reports annually and upon completion of the purpose for which the grant was awarded, (2) investigate diversions of funds from their intended purposes, and (3) take all reasonable and appropriate steps to recover diverted funds, ensure other grant funds held by a grantee are used for their intended purposes, and withhold further payments to grantees until you obtain grantees' assurances that future diversions will not occur and that grantees will take extraordinary precautions to prevent future diversions from occurring? ☐ Yes ☐ No

3 Do you represent that you will maintain all records relating to individual grants, including information obtained to evaluate grantees, identify whether a grantee is a disqualified person, establish the amount and purpose of each grant, and establish that you undertook the supervision and investigation of grants described in line 2? ☐ Yes ☐ No

Schedule G. Successors to Other Organizations

1a Are you a **successor** to a **for-profit organization**? If "Yes," explain the relationship with the predecessor organization that resulted in your creation and complete line 1b. ☐ **Yes** ☐ **No**

 b Explain why you took over the activities or assets of a for-profit organization or converted from for-profit to nonprofit status.

2a Are you a successor to an organization other than a for-profit organization? Answer "Yes" if you have taken or will take over the activities of another organization; or you have taken or will take over 25% or more of the fair market value of the net assets of another organization. If "Yes," explain the relationship with the other organzation that resulted in your creation. ☐ **Yes** ☐ **No**

 b Provide the tax status of the predecessor organization.

 c Did you or did an organization to which you are a successor previously apply for tax exemption under section 501(c)(3) or any other section of the Code? If "Yes," explain how the application was resolved. ☐ **Yes** ☐ **No**

 d Was your prior tax exemption or the tax exemption of an organization to which you are a successor revoked or suspended? If "Yes," explain. Include a description of the corrections you made to re-establish tax exemption. ☐ **Yes** ☐ **No**

 e Explain why you took over the activities or assets of another organization.

3 Provide the name, last address, and EIN of the predecessor organization and describe its activities.

 Name: _____ **EIN:** _____ —_____

 Address: _____

4 List the owners, partners, principal stockholders, officers, and governing board members of the predecessor organization. Attach a separate sheet if additional space is needed.

Name	Address	Share/Interest (If a for-profit)

5 Do or will any of the persons listed in line 4, maintain a working relationship with you? If "Yes," describe the relationship in detail and include copies of any agreements with any of these persons or with any for-profit organizations in which these persons own more than a 35% interest. ☐ **Yes** ☐ **No**

6a Were any assets transferred, whether by gift or sale, from the predecessor organization to you? ☐ **Yes** ☐ **No**

 If "Yes," provide a list of assets, indicate the value of each asset, explain how the value was determined, and attach an appraisal, if available. For each asset listed, also explain if the transfer was by gift, sale, or combination thereof.

 b Were any restrictions placed on the use or sale of the assets? If "Yes," explain the restrictions. ☐ **Yes** ☐ **No**

 c Provide a copy of the agreement(s) of sale or transfer.

7 Were any debts or liabilities transferred from the predecessor for-profit organization to you? ☐ **Yes** ☐ **No**

 If "Yes," provide a list of the debts or liabilities that were transferred to you, indicating the amount of each, how the amount was determined, and the name of the person to whom the debt or liability is owed.

8 Will you lease or rent any property or equipment previously owned or used by the predecessor for-profit organization, or from persons listed in line 4, or from for-profit organizations in which these persons own more than a 35% interest? If "Yes," submit a copy of the lease or rental agreement(s). Indicate how the lease or rental value of the property or equipment was determined. ☐ **Yes** ☐ **No**

9 Will you lease or rent property or equipment to persons listed in line 4, or to for-profit organizations in which these persons own more than a 35% interest? If "Yes," attach a list of the property or equipment, provide a copy of the lease or rental agreement(s), and indicate how the lease or rental value of the property or equipment was determined. ☐ **Yes** ☐ **No**

Schedule F. Homes for the Elderly or Handicapped and Low-Income Housing *(Continued)*

Section II	Homes for the Elderly or Handicapped

1a Do you provide housing for the elderly? If "Yes," describe who qualifies for your housing in terms of age, infirmity, or other criteria and explain how you select persons for your housing. ☐ **Yes** ☐ **No**

b Do you provide housing for the handicapped? If "Yes," describe who qualifies for your housing in terms of disability, income levels, or other criteria and explain how you select persons for your housing. ☐ **Yes** ☐ **No**

2a Do you charge an entrance or founder's fee? If "Yes," describe what this charge covers, whether it is a one-time fee, how the fee is determined, whether it is payable in a lump sum or on an installment basis, whether it is refundable, and the circumstances, if any, under which it may be waived. ☐ **Yes** ☐ **No**

b Do you charge periodic fees or maintenance charges? If "Yes," describe what these charges cover and how they are determined. ☐ **Yes** ☐ **No**

c Is your housing affordable to a significant segment of the elderly or handicapped persons in the community? Identify your **community**. Also, if "Yes," explain how you determine your housing is affordable. ☐ **Yes** ☐ **No**

3a Do you have an established policy concerning residents who become unable to pay their regular charges? If "Yes," describe your established policy. ☐ **Yes** ☐ **No**

b Do you have any arrangements with government welfare agencies or others to absorb all or part of the cost of maintaining residents who become unable to pay their regular charges? If "Yes," describe these arrangements. ☐ **Yes** ☐ **No**

4 Do you have arrangements for the healthcare needs of your residents? If "Yes," describe these arrangements. ☐ **Yes** ☐ **No**

5 Are your facilities designed to meet the physical, emotional, recreational, social, religious, and/or other similar needs of the elderly or handicapped? If "Yes," describe these design features. ☐ **Yes** ☐ **No**

Section III	Low-Income Housing

1 Do you provide low-income housing? If "Yes," describe who qualifies for your housing in terms of income levels or other criteria, and describe how you select persons for your housing. ☐ **Yes** ☐ **No**

2 In addition to rent or mortgage payments, do residents pay periodic fees or maintenance charges? If "Yes," describe what these charges cover and how they are determined. ☐ **Yes** ☐ **No**

3a Is your housing affordable to low income residents? If "Yes," describe how your housing is made affordable to low-income residents. ☐ **Yes** ☐ **No**

Note. Revenue Procedure 96-32, 1996-1 C.B. 717, provides guidelines for providing low-income housing that will be treated as charitable. (At least 75% of the units are occupied by low-income tenants or 40% are occupied by tenants earning not more than 120% of the very low-income levels for the area.)

b Do you impose any restrictions to make sure that your housing remains affordable to low-income residents? If "Yes," describe these restrictions. ☐ **Yes** ☐ **No**

4 Do you provide social services to residents? If "Yes," describe these services. ☐ **Yes** ☐ **No**

Schedule F. Homes for the Elderly or Handicapped and Low-Income Housing

Section I	**General Information About Your Housing**

1 Describe the type of housing you provide.

2 Provide copies of any application forms you use for admission.

3 Explain how the public is made aware of your facility.

4a Provide a description of each facility.
 b What is the total number of residents each facility can accommodate?
 c What is your current number of residents in each facility?
 d Describe each facility in terms of whether residents rent or purchase housing from you.

5 Attach a sample copy of your residency or homeownership contract or agreement.

6 Do you participate in any joint ventures? If "Yes," state your ownership percentage in each joint venture, list your investment in each joint venture, describe the tax status of other participants in each joint venture (including whether they are section 501(c)(3) organizations), describe the activities of each joint venture, describe how you exercise control over the activities of each joint venture, and describe how each joint venture furthers your exempt purposes. Also, submit copies of all joint venture agreements. ☐ Yes ☐ No

Note. Make sure your answer is consistent with the information provided in Part VIII, line 8.

7 Do you or will you contract with another organization to develop, build, market, or finance your housing? If "Yes," explain how that entity is selected, explain how the terms of any contract(s) are negotiated at arm's length, and explain how you determine you will pay no more than fair market value for services. ☐ Yes ☐ No

Note. Make sure your answer is consistent with the information provided in Part VIII, line 7a.

8 Do you or will you manage your activities or facilities through your own employees or volunteers? If "No," attach a statement describing the activities that will be managed by others, the names of the persons or organizations that manage or will manage your activities or facilities, and how these managers were or will be selected. Also, submit copies of any contracts, proposed contracts, or other agreements regarding the provision of management services for your activities or facilities. Explain how the terms of any contracts or other agreements were or will be negotiated, and explain how you determine you will pay no more than fair market value for services. ☐ Yes ☐ No
Note. Answer "Yes" if you do manage or intend to manage your programs through your own employees or by using volunteers. Answer "No" if you engage or intend to engage a separate organization or independent contractor. Make sure your answer is consistent with the information provided in Part VIII, line 7b.

9 Do you participate in any government housing programs? If "Yes," describe these programs. ☐ Yes ☐ No

10a Do you own the facility? If "No," describe any enforceable rights you possess to purchase the facility in the future; go to line 10c. If "Yes," answer line 10b. ☐ Yes ☐ No

 b How did you acquire the facility? For example, did you develop it yourself, purchase a project, etc. Attach all contracts, transfer agreements, or other documents connected with the acquisition of the facility.

 c Do you lease the facility or the land on which it is located? If "Yes," describe the parties to the lease(s) and provide copies of all leases. ☐ Yes ☐ No

Schedule E. Organizations Not Filing Form 1023 Within 27 Months of Formation (Continued)

7 Complete this item only if you answered "Yes" to line 6b. Include projected revenue for the first two full years following the current tax year.

Type of Revenue	Projected revenue for 2 years following current tax year		
	(a) From ------------- To	**(b)** From ------------- To	**(c)** Total
1 Gifts, grants, and contributions received (do not include unusual grants)			
2 Membership fees received			
3 Gross investment income			
4 Net unrelated business income			
5 Taxes levied for your benefit			
6 Value of services or facilities furnished by a governmental unit without charge (not including the value of services generally furnished to the public without charge)			
7 Any revenue not otherwise listed above or in lines 9–12 below (attach an itemized list)			
8 Total of lines 1 through 7			
9 Gross receipts from admissions, merchandise sold, or services performed, or furnishing of facilities in any activity that is related to your exempt purposes (attach itemized list)			
10 Total of lines 8 and 9			
11 Net gain or loss on sale of capital assets (attach an itemized list)			
12 Unusual grants			
13 Total revenue. Add lines 10 through 12			

8 According to your answers, you are only eligible for tax exemption under section 501(c)(3) from the postmark date of your application. However, you may be eligible for tax exemption under section 501(c)(4) from your date of formation to the postmark date of the Form 1023. Tax exemption under section 501(c)(4) allows exemption from federal income tax, but generally not deductibility of contributions under Code section 170. Check the box at right if you want us to treat this as a request for exemption under 501(c)(4) from your date of formation to the postmark date. ▶ ☐

Attach a completed Page 1 of Form 1024, Application for Recognition of Exemption Under Section 501(a), to this application.

Schedule E. Organizations Not Filing Form 1023 Within 27 Months of Formation

Schedule E is intended to determine whether you are eligible for tax exemption under section 501(c)(3) from the postmark date of your application or from your date of incorporation or formation, whichever is earlier. If you are not eligible for tax exemption under section 501(c)(3) from your date of incorporation or formation, Schedule E is also intended to determine whether you are eligible for tax exemption under section 501(c)(4) for the period between your date of incorporation or formation and the postmark date of your application.

1	Are you a church, association of churches, or integrated auxiliary of a church? If "Yes," complete Schedule A and stop here. Do not complete the remainder of Schedule E.	☐ **Yes**	☐ **No**
2a	Are you a public charity with annual **gross receipts** that are normally $5,000 or less? If "Yes," stop here. Answer "No" if you are a private foundation, regardless of your gross receipts.	☐ **Yes**	☐ **No**
b	If your gross receipts were normally more than $5,000, are you filing this application within 90 days from the end of the tax year in which your gross receipts were normally more than $5,000? If "Yes," stop here.	☐ **Yes**	☐ **No**
3a	Were you included as a subordinate in a group exemption application or letter? If "No," go to line 4.	☐ **Yes**	☐ **No**
b	If you were included as a subordinate in a group exemption letter, are you filing this application within 27 months from the date you were notified by the organization holding the group exemption letter or the Internal Revenue Service that you cease to be covered by the group exemption letter? If "Yes," stop here.	☐ **Yes**	☐ **No**
c	If you were included as a subordinate in a timely filed group exemption request that was denied, are you filing this application within 27 months from the postmark date of the Internal Revenue Service final adverse ruling letter? If "Yes," stop here.	☐ **Yes**	☐ **No**
4	Were you created on or before October 9, 1969? If "Yes," stop here. Do not complete the remainder of this schedule.	☐ **Yes**	☐ **No**
5	If you answered "No" to lines 1 through 4, we cannot recognize you as tax exempt from your date of formation unless you qualify for an extension of time to apply for exemption. Do you wish to request an extension of time to apply to be recognized as exempt from the date you were formed? If "Yes," attach a statement explaining why you did not file this application within the 27-month period. Do not answer lines 6, 7, or 8. If "No," go to line 6a.	☐ **Yes**	☐ **No**
6a	If you answered "No" to line 5, you can only be exempt under section 501(c)(3) from the postmark date of this application. Therefore, do you want us to treat this application as a request for tax exemption from the postmark date? If "Yes," you are eligible for an advance ruling. Complete Part X, line 6a. If "No," you will be treated as a private foundation.	☐ **Yes**	☐ **No**
	Note. Be sure your ruling eligibility agrees with your answer to Part X, line 6.		
b	Do you anticipate significant changes in your sources of support in the future? If "Yes," complete line 7 below.	☐ **Yes**	☐ **No**

Schedule D. Section 509(a)(3) Supporting Organizations *(Continued)*

Section II	Relationship with Supported Organization(s)—Three Tests *(Continued)*

5 Information to establish the "operated in connection with" integral part test (Test 3)

Do you conduct activities that would otherwise be carried out by the supported organization(s)? If "Yes," explain and go to Section III. If "No," continue to line 6a. ☐ Yes ☐ No

6 Information to establish the alternative "operated in connection with" integral part test (Test 3)

a Do you distribute at least 85% of your annual **net income** to the supported organization(s)? If "Yes," go to line 6b. (See instructions.) ☐ Yes ☐ No

If "No," state the percentage of your income that you distribute to each supported organization. Also explain how you ensure that the supported organization(s) are attentive to your operations.

b How much do you contribute annually to each supported organization? Attach a schedule.

c What is the total annual revenue of each supported organization? If you need additional space, attach a list.

d Do you or the supported organization(s) **earmark** your funds for support of a particular program or activity? If "Yes," explain. ☐ Yes ☐ No

7a Does your organizing document specify the supported organization(s) by name? If "Yes," state the article and paragraph number and go to Section III. If "No," answer line 7b. ☐ Yes ☐ No

b Attach a statement describing whether there has been an historic and continuing relationship between you and the supported organization(s).

Section III	Organizational Test

1a If you met relationship Test 1 or Test 2 in Section II, your organizing document must specify the supported organization(s) by name, or by naming a similar purpose or charitable class of beneficiaries. If your organizing document complies with this requirement, answer "Yes." If your organizing document does not comply with this requirement, answer "No," and see the instructions. ☐ Yes ☐ No

b If you met relationship Test 3 in Section II, your organizing document must generally specify the supported organization(s) by name. If your organizing document complies with this requirement, answer "Yes," and go to Section IV. If your organizing document does not comply with this requirement, answer "No," and see the instructions. ☐ Yes ☐ No

Section IV	Disqualified Person Test

You do not qualify as a supporting organization if you are **controlled** directly or indirectly by one or more **disqualified persons** (as defined in section 4946) other than **foundation managers** or one or more organizations that you support. Foundation managers who are also disqualified persons for another reason are disqualified persons with respect to you.

1a Do any persons who are disqualified persons with respect to you, (except individuals who are disqualified persons only because they are foundation managers), appoint any of your foundation managers? If "Yes," (1) describe the process by which disqualified persons appoint any of your foundation managers, (2) provide the names of these disqualified persons and the foundation managers they appoint, and (3) explain how control is vested over your operations (including assets and activities) by persons other than disqualified persons. ☐ Yes ☐ No

b Do any persons who have a family or business relationship with any disqualified persons with respect to you, (except individuals who are disqualified persons only because they are foundation managers), appoint any of your foundation managers? If "Yes," (1) describe the process by which individuals with a family or business relationship with disqualified persons appoint any of your foundation managers, (2) provide the names of these disqualified persons, the individuals with a family or business relationship with disqualified persons, and the foundation managers appointed, and (3) explain how control is vested over your operations (including assets and activities) in individuals other than disqualified persons. ☐ Yes ☐ No

c Do any persons who are disqualified persons, (except individuals who are disqualified persons only because they are foundation managers), have any influence regarding your operations, including your assets or activities? If "Yes," (1) provide the names of these disqualified persons, (2) explain how influence is exerted over your operations (including assets and activities), and (3) explain how control is vested over your operations (including assets and activities) by individuals other than disqualified persons. ☐ Yes ☐ No

Schedule D. Section 509(a)(3) Supporting Organizations

Section I	Identifying Information About the Supported Organization(s)

1 State the names, addresses, and EINs of the supported organizations. If additional space is needed, attach a separate sheet.

Name	Address	EIN
		−
		−

2 Are all supported organizations listed in line 1 public charities under section 509(a)(1) or (2)? If "Yes," go to Section II. If "No," go to line 3. ☐ **Yes** ☐ **No**

3 Do the supported organizations have tax-exempt status under section 501(c)(4), 501(c)(5), or 501(c)(6)? ☐ **Yes** ☐ **No**

If "Yes," for each 501(c)(4), (5), or (6) organization supported, provide the following financial information:

● Part IX-A. Statement of Revenues and Expenses, lines 1–13 and
● Part X, lines 6b(ii)(a), 6b(ii)(b), and 7.

If "No," attach a statement describing how each organization you support is a public charity under section 509(a)(1) or (2).

Section II	Relationship with Supported Organization(s)—Three Tests

To be classified as a supporting organization, an organization must meet one of three relationship tests:

Test 1: "Operated, supervised, or controlled by" one or more publicly supported organizations, or
Test 2: "Supervised or controlled in connection with" one or more publicly supported organizations, or
Test 3: "Operated in connection with" one or more publicly supported organizations.

1 Information to establish the "operated, supervised, or controlled by" relationship (Test 1)
Is a majority of your governing board or officers elected or appointed by the supported organization(s)? If "Yes," describe the process by which your governing board is appointed and elected; go to Section III. If "No," continue to line 2. ☐ **Yes** ☐ **No**

2 Information to establish the "supervised or controlled in connection with" relationship (Test 2)
Does a majority of your governing board consist of individuals who also serve on the governing board of the supported organization(s)? If "Yes," describe the process by which your governing board is appointed and elected; go to Section III. If "No," go to line 3. ☐ **Yes** ☐ **No**

3 Information to establish the "operated in connection with" responsiveness test (Test 3)
Are you a trust from which the named supported organization(s) can enforce and compel an accounting under state law? If "Yes," explain whether you advised the supported organization(s) in writing of these rights and provide a copy of the written communication documenting this; go to Section II, line 5. If "No," go to line 4a. ☐ **Yes** ☐ **No**

4 Information to establish the alternative "operated in connection with" responsiveness test (Test 3)

a Do the officers, directors, trustees, or members of the supported organization(s) elect or appoint one or more of your officers, directors, or trustees? If "Yes," explain and provide documentation; go to line 4d, below. If "No," go to line 4b. ☐ **Yes** ☐ **No**

b Do one or more members of the governing body of the supported organization(s) also serve as your officers, directors, or trustees or hold other important offices with respect to you? If "Yes," explain and provide documentation; go to line 4d, below. If "No," go to line 4c. ☐ **Yes** ☐ **No**

c Do your officers, directors, or trustees maintain a close and continuous working relationship with the officers, directors, or trustees of the supported organization(s)? If "Yes," explain and provide documentation. ☐ **Yes** ☐ **No**

d Do the supported organization(s) have a significant voice in your investment policies, in the making and timing of grants, and in otherwise directing the use of your income or assets? If "Yes," explain and provide documentation. ☐ **Yes** ☐ **No**

e Describe and provide copies of written communications documenting how you made the supported organization(s) aware of your supporting activities.

Schedule C. Hospitals and Medical Research Organizations *(Continued)*

Section I	Hospitals *(Continued)*

10 Do you or will you manage your activities or facilities through your own employees or volunteers? If "No," attach a statement describing the activities that will be managed by others, the names of the persons or organizations that manage or will manage your activities or facilities, and how these managers were or will be selected. Also, submit copies of any contracts, proposed contracts, or other agreements regarding the provision of management services for your activities or facilities. Explain how the terms of any contracts or other agreements were or will be negotiated, and explain how you determine you will pay no more than fair market value for services. ☐ Yes ☐ No

Note. Answer "Yes" if you do manage or intend to manage your programs through your own employees or by using volunteers. Answer "No" if you engage or intend to engage a separate organization or independent contractor. Make sure your answer is consistent with the information provided in Part VIII, line 7b.

11 Do you or will you offer recruitment incentives to physicians? If "Yes," describe your recruitment incentives and attach copies of all written recruitment incentive policies. ☐ Yes ☐ No

12 Do you or will you lease equipment, assets, or office space from physicians who have a financial or professional relationship with you? If "Yes," explain how you establish a fair market value for the lease. ☐ Yes ☐ No

13 Have you purchased medical practices, ambulatory surgery centers, or other business assets from physicians or other persons with whom you have a business relationship, aside from the purchase? If "Yes," submit a copy of each purchase and sales contract and describe how you arrived at fair market value, including copies of appraisals. ☐ Yes ☐ No

14 Have you adopted a **conflict of interest policy** consistent with the sample health care organization conflict of interest policy in Appendix A of the instructions? If "Yes," submit a copy of the policy and explain how the policy has been adopted, such as by resolution of your governing board. If "No," explain how you will avoid any conflicts of interest in your business dealings. ☐ Yes ☐ No

Section II	Medical Research Organizations

1 Name the hospitals with which you have a relationship and describe the relationship. Attach copies of written agreements with each hospital that demonstrate continuing relationships between you and the hospital(s).

2 Attach a schedule describing your present and proposed activities for the direct conduct of medical research; describe the nature of the activities, and the amount of money that has been or will be spent in carrying them out.

3 Attach a schedule of assets showing their fair market value and the portion of your assets directly devoted to medical research.

Schedule A. Churches

1a	Do you have a written creed, statement of faith, or summary of beliefs? If "Yes," attach copies of relevant documents.	☐ Yes	☐ No
b	Do you have a form of worship? If "Yes," describe your form of worship.	☐ Yes	☐ No
2a	Do you have a formal code of doctrine and discipline? If "Yes," describe your code of doctrine and discipline.	☐ Yes	☐ No
b	Do you have a distinct religious history? If "Yes," describe your religious history.	☐ Yes	☐ No
c	Do you have a literature of your own? If "Yes," describe your literature.	☐ Yes	☐ No
3	Describe the organization's religious hierarchy or ecclesiastical government.		
4a	Do you have regularly scheduled religious services? If "Yes," describe the nature of the services and provide representative copies of relevant literature such as church bulletins.	☐ Yes	☐ No
b	What is the average attendance at your regularly scheduled religious services?	_____	
5a	Do you have an established place of worship? If "Yes," refer to the instructions for the information required.	☐ Yes	☐ No
b	Do you own the property where you have an established place of worship?	☐ Yes	☐ No
6	Do you have an established congregation or other regular membership group? If "No," refer to the instructions.	☐ Yes	☐ No
7	How many members do you have?	_____	
8a	Do you have a process by which an individual becomes a member? If "Yes," describe the process and complete lines 8b–8d, below.	☐ Yes	☐ No
b	If you have members, do your members have voting rights, rights to participate in religious functions, or other rights? If "Yes," describe the rights your members have.	☐ Yes	☐ No
c	May your members be associated with another denomination or church?	☐ Yes	☐ No
d	Are all of your members part of the same **family**?	☐ Yes	☐ No
9	Do you conduct baptisms, weddings, funerals, etc.?	☐ Yes	☐ No
10	Do you have a school for the religious instruction of the young?	☐ Yes	☐ No
11a	Do you have a minister or religious leader? If "Yes," describe this person's role and explain whether the minister or religious leader was ordained, commissioned, or licensed after a prescribed course of study.	☐ Yes	☐ No
b	Do you have schools for the preparation of your ordained ministers or religious leaders?	☐ Yes	☐ No
12	Is your minister or religious leader also one of your officers, directors, or trustees?	☐ Yes	☐ No
13	Do you ordain, commission, or license ministers or religious leaders? If "Yes," describe the requirements for ordination, commission, or licensure.	☐ Yes	☐ No
14	Are you part of a group of churches with similar beliefs and structures? If "Yes," explain. Include the name of the group of churches.	☐ Yes	☐ No
15	Do you issue church charters? If "Yes," describe the requirements for issuing a charter.	☐ Yes	☐ No
16	Did you pay a fee for a church charter? If "Yes," attach a copy of the charter.	☐ Yes	☐ No
17	Do you have other information you believe should be considered regarding your status as a church? If "Yes," explain.	☐ Yes	☐ No

Schedule B. Schools, Colleges, and Universities

If you operate a school as an activity, complete Schedule B

Section I	Operational Information

1a Do you normally have a regularly scheduled curriculum, a regular faculty of qualified teachers, a regularly enrolled student body, and facilities where your educational activities are regularly carried on? If "No," do not complete the remainder of Schedule B. ☐ Yes ☐ No

b Is the primary function of your school the presentation of formal instruction? If "Yes," describe your school in terms of whether it is an elementary, secondary, college, technical, or other type of school. If "No," do not complete the remainder of Schedule B. ☐ Yes ☐ No

2a Are you a public school because you are operated by a state or subdivision of a state? If "Yes," explain how you are operated by a state or subdivision of a state. Do not complete the remainder of Schedule B. ☐ Yes ☐ No

b Are you a public school because you are operated wholly or predominantly from government funds or property? If "Yes," explain how you are operated wholly or predominantly from government funds or property. Submit a copy of your funding agreement regarding government funding. Do not complete the remainder of Schedule B. ☐ Yes ☐ No

3 In what public school district, county, and state are you located?

4 Were you formed or substantially expanded at the time of public school desegregation in the above school district or county? ☐ Yes ☐ No

5 Has a state or federal administrative agency or judicial body ever determined that you are racially discriminatory? If "Yes," explain. ☐ Yes ☐ No

6 Has your right to receive financial aid or assistance from a governmental agency ever been revoked or suspended? If "Yes," explain. ☐ Yes ☐ No

7 Do you or will you contract with another organization to develop, build, market, or finance your facilities? If "Yes," explain how that entity is selected, explain how the terms of any contracts or other agreements are negotiated at arm's length, and explain how you determine that you will pay no more than fair market value for services. ☐ Yes ☐ No

Note. Make sure your answer is consistent with the information provided in Part VIII, line 7a.

8 Do you or will you manage your activities or facilities through your own employees or volunteers? If "No," attach a statement describing the activities that will be managed by others, the names of the persons or organizations that manage or will manage your activities or facilities, and how these managers were or will be selected. Also, submit copies of any contracts, proposed contracts, or other agreements regarding the provision of management services for your activities or facilities. Explain how the terms of any contracts or other agreements were or will be negotiated, and explain how you determine you will pay no more than fair market value for services. ☐ Yes ☐ No

Note. Answer "Yes" if you manage or intend to manage your programs through your own employees or by using volunteers. Answer "No" if you engage or intend to engage a separate organization or independent contractor. Make sure your answer is consistent with the information provided in Part VIII, line 7b.

Section II	Establishment of Racially Nondiscriminatory Policy

Information required by **Revenue Procedure 75-50.**

1 Have you adopted a racially nondiscriminatory policy as to students in your organizing document, bylaws, or by resolution of your governing body? If "Yes," state where the policy can be found or supply a copy of the policy. If "No," you must adopt a nondiscriminatory policy as to students before submitting this application. See Publication 557. ☐ Yes ☐ No

2 Do your brochures, application forms, advertisements, and catalogues dealing with student admissions, programs, and scholarships contain a statement of your racially nondiscriminatory policy? ☐ Yes ☐ No

a If "Yes," attach a representative sample of each document.

b If "No," by checking the box to the right you agree that all future printed materials, including website content, will contain the required nondiscriminatory policy statement. ▶ ☐

3 Have you published a notice of your nondiscriminatory policy in a newspaper of general circulation that serves all racial segments of the community? (See the instructions for specific requirements.) If "No," explain. ☐ Yes ☐ No

4 Does or will the organization (or any department or division within it) discriminate in any way on the basis of race with respect to admissions; use of facilities or exercise of student privileges; faculty or administrative staff; or scholarship or loan programs? If "Yes," for any of the above, explain fully. ☐ Yes ☐ No

Schedule B. Schools, Colleges, and Universities *(Continued)*

5 Complete the table below to show the racial composition for the current academic year and projected for the next academic year, of: (a) the student body, (b) the faculty, and (c) the administrative staff. Provide actual numbers rather than percentages for each racial category.

If you are not operational, submit an estimate based on the best information available (such as the racial composition of the community served).

Racial Category	(a) Student Body		(b) Faculty		(c) Administrative Staff	
	Current Year	Next Year	Current Year	Next Year	Current Year	Next Year
Total						

6 In the table below, provide the number and amount of loans and scholarships awarded to students enrolled by racial categories.

Racial Category	Number of Loans		Amount of Loans		Number of Scholarships		Amount of Scholarships	
	Current Year	Next Year	Current Year	Next Year	Current Year	Next Year	Current Year	Next Year
Total								

7a Attach a list of your incorporators, founders, board members, and donors of land or buildings, whether individuals or organizations.

b Do any of these individuals or organizations have an objective to maintain segregated public or private school education? If "Yes," explain. ☐ **Yes** ☐ **No**

8 Will you maintain records according to the non-discrimination provisions contained in Revenue Procedure 75-50? If "No," explain. (See instructions.) ☐ **Yes** ☐ **No**

Schedule C. Hospitals and Medical Research Organizations

Check the box if you are a **hospital**. See the instructions for a definition of the term "hospital," which includes an organization whose principal purpose or function is providing **hospital** or **medical care**. Complete Section I below. ☐

Check the box if you are a **medical research organization** operated in conjunction with a hospital. See the instructions for a definition of the term "medical research organization," which refers to an organization whose principal purpose or function is medical research and which is directly engaged in the continuous active conduct of medical research in conjunction with a hospital. Complete Section II. ☐

Section I Hospitals

1a	Are all the doctors in the community eligible for staff privileges? If "No," give the reasons why and explain how the medical staff is selected.	☐	**Yes**	☐	**No**
2a	Do you or will you provide medical services to all individuals in your community who can pay for themselves or have private health insurance? If "No," explain.	☐	**Yes**	☐	**No**
b	Do you or will you provide medical services to all individuals in your community who participate in Medicare? If "No," explain.	☐	**Yes**	☐	**No**
c	Do you or will you provide medical services to all individuals in your community who participate in Medicaid? If "No," explain.	☐	**Yes**	☐	**No**
3a	Do you or will you require persons covered by Medicare or Medicaid to pay a deposit before receiving services? If "Yes," explain.	☐	**Yes**	☐	**No**
b	Does the same deposit requirement, if any, apply to all other patients? If "No," explain.	☐	**Yes**	☐	**No**
4a	Do you or will you maintain a full-time emergency room? If "No," explain why you do not maintain a full-time emergency room. Also, describe any emergency services that you provide.	☐	**Yes**	☐	**No**
b	Do you have a policy on providing emergency services to persons without apparent means to pay? If "Yes," provide a copy of the policy.	☐	**Yes**	☐	**No**
c	Do you have any arrangements with police, fire, and voluntary ambulance services for the delivery or admission of emergency cases? If "Yes," describe the arrangements, including whether they are written or oral agreements. If written, submit copies of all such agreements.	☐	**Yes**	☐	**No**
5a	Do you provide for a portion of your services and facilities to be used for charity patients? If "Yes," answer 5b through 5e.	☐	**Yes**	☐	**No**
b	Explain your policy regarding charity cases, including how you distinguish between charity care and bad debts. Submit a copy of your written policy.				
c	Provide data on your past experience in admitting charity patients, including amounts you expend for treating charity care patients and types of services you provide to charity care patients.				
d	Describe any arrangements you have with federal, state, or local governments or government agencies for paying for the cost of treating charity care patients. Submit copies of any written agreements.				
e	Do you provide services on a sliding fee schedule depending on financial ability to pay? If "Yes," submit your sliding fee schedule.	☐	**Yes**	☐	**No**
6a	Do you or will you carry on a formal program of medical training or medical research? If "Yes," describe such programs, including the type of programs offered, the scope of such programs, and affiliations with other hospitals or medical care providers with which you carry on the medical training or research programs.	☐	**Yes**	☐	**No**
b	Do you or will you carry on a formal program of community education? If "Yes," describe such programs, including the type of programs offered, the scope of such programs, and affiliation with other hospitals or medical care providers with which you offer community education programs.	☐	**Yes**	☐	**No**
7	Do you or will you provide office space to physicians carrying on their own medical practices? If "Yes," describe the criteria for who may use the space, explain the means used to determine that you are paid at least fair market value, and submit representative lease agreements.	☐	**Yes**	☐	**No**
8	Is your board of directors comprised of a majority of individuals who are representative of the community you serve? Include a list of each board member's name and business, financial, or professional relationship with the hospital. Also, identify each board member who is representative of the community and describe how that individual is a community representative.	☐	**Yes**	☐	**No**
9	Do you participate in any joint ventures? If "Yes," state your ownership percentage in each joint venture, list your investment in each joint venture, describe the tax status of other participants in each joint venture (including whether they are section 501(c)(3) organizations), describe the activities of each joint venture, describe how you exercise control over the activities of each joint venture, and describe how each joint venture furthers your exempt purposes. Also, submit copies of all agreements. **Note.** Make sure your answer is consistent with the information provided in Part VIII, line 8.	☐	**Yes**	☐	**No**

Part XI	User Fee Information

You must include a user fee payment with this application. It will not be processed without your paid user fee. If your average annual gross receipts have exceeded or will exceed $10,000 annually over a 4-year period, you must submit payment of $850. If your gross receipts have not exceeded or will not exceed $10,000 annually over a 4-year period, the required user fee payment is $400. See instructions for Part XI, for a definition of **gross receipts** *over a 4-year period. Your check or money order must be made payable to the United States Treasury. User fees are subject to change. Check our website at www.irs.gov and type "User Fee" in the keyword box, or call Customer Account Services at 1-877-829-5500 for current information.*

1 Have your annual gross receipts averaged or are they expected to average not more than $10,000? ☐ **Yes** ☐ **No**
 If "Yes," check the box on line 2 and enclose a user fee payment of $400 (Subject to change—see above).
 If "No," check the box on line 3 and enclose a user fee payment of $850 (Subject to change—see above).

2 Check the box if you have enclosed the reduced user fee payment of $400 (Subject to change). ☐

3 Check the box if you have enclosed the user fee payment of $850 (Subject to change). ☐

I declare under the penalties of perjury that I am authorized to sign this application on behalf of the above organization and that I have examined this application, including the accompanying schedules and attachments, and to the best of my knowledge it is true, correct, and complete.

**Please
Sign
Here** ▶

-- -- --------------
(Signature of Officer, Director, Trustee, or other (Type or print name of signer) (Date)
authorized official)

 --
 (Type or print title or authority of signer)

Reminder: Send the completed Form 1023 Checklist with your filled-in-application. Form **1023** (Rev. 12-2013)

Part X Public Charity Status (Continued)

e 509(a)(4)—an organization organized and operated exclusively for testing for public safety. ☐

f 509(a)(1) and 170(b)(1)(A)(iv)—an organization operated for the benefit of a college or university that is owned or operated by a governmental unit. ☐

g 509(a)(1) and 170(b)(1)(A)(vi)—an organization that receives a substantial part of its financial support in the form of contributions from publicly supported organizations, from a governmental unit, or from the general public. ☐

h 509(a)(2)—an organization that normally receives not more than one-third of its financial support from gross **investment income** and receives more than one-third of its financial support from contributions, membership fees, and gross receipts from activities related to its exempt functions (subject to certain exceptions). ☐

i A publicly supported organization, but unsure if it is described in 5g or 5h. The organization would like the IRS to decide the correct status. ☐

6 If you checked box g, h, or i in question 5 above, you must request either an **advance** or a **definitive ruling** by selecting one of the boxes below. Refer to the instructions to determine which type of ruling you are eligible to receive.

a **Request for Advance Ruling:** By checking this box and signing the consent, pursuant to section 6501(c)(4) of the Code you request an advance ruling and agree to extend the statute of limitations on the assessment of excise tax under section 4940 of the Code. The tax will apply only if you do not establish public support status at the end of the 5-year advance ruling period. The assessment period will be extended for the 5 advance ruling years to 8 years, 4 months, and 15 days beyond the end of the first year. You have the right to refuse or limit the extension to a mutually agreed-upon period of time or issue(s). Publication 1035, *Extending the Tax Assessment Period,* provides a more detailed explanation of your rights and the consequences of the choices you make. You may obtain Publication 1035 free of charge from the IRS web site at *www.irs.gov* or by calling toll-free 1-800-829-3676. Signing this consent will not deprive you of any appeal rights to which you would otherwise be entitled. If you decide not to extend the statute of limitations, you are not eligible for an advance ruling.

Consent Fixing Period of Limitations Upon Assessment of Tax Under Section 4940 of the Internal Revenue Code

For Organization

--------------------------------------- -- ------------------------
(Signature of Officer, Director, Trustee, or other (Type or print name of signer) (Date)
authorized official)

--
(Type or print title or authority of signer)

For IRS Use Only

-- ------------------------
IRS Director, Exempt Organizations (Date)

b **Request for Definitive Ruling:** Check this box if you have completed one tax year of at least 8 full months and you are requesting a definitive ruling. To confirm your public support status, answer line 6b(i) if you checked box g in line 5 above. Answer line 6b(ii) if you checked box h in line 5 above. If you checked box i in line 5 above, answer both lines 6b(i) and (ii). ☐

(i) (a) Enter 2% of line 8, column (e) on Part IX-A. Statement of Revenues and Expenses. _____

 (b) Attach a list showing the name and amount contributed by each person, company, or organization whose gifts totaled more than the 2% amount. If the answer is "None," check this box. ☐

(ii) (a) For each year amounts are included on lines 1, 2, and 9 of Part IX-A. Statement of Revenues and Expenses, attach a list showing the name of and amount received from each **disqualified person.** If the answer is "None," check this box. ☐

 (b) For each year amounts are included on line 9 of Part IX-A. Statement of Revenues and Expenses, attach a list showing the name of and amount received from each payer, other than a disqualified person, whose payments were more than the larger of (1) 1% of line 10, Part IX-A. Statement of Revenues and Expenses, or (2) $5,000. If the answer is "None," check this box. ☐

7 Did you receive any unusual grants during any of the years shown on Part IX-A. Statement of Revenues and Expenses? If "Yes," attach a list including the name of the contributor, the date and amount of the grant, a brief description of the grant, and explain why it is unusual. ☐ **Yes** ☐ **No**

Part VIII Your Specific Activities *(Continued)*

11	Do you or will you accept contributions of: real property; conservation easements; closely held securities; intellectual property such as patents, trademarks, and copyrights; works of music or art; licenses; royalties; automobiles, boats, planes, or other vehicles; or collectibles of any type? If "Yes," describe each type of contribution, any conditions imposed by the donor on the contribution, and any agreements with the donor regarding the contribution.	☐ Yes	☐ No

12a	Do you or will you operate in a **foreign country** or **countries?** If "Yes," answer lines 12b through 12d. If "No," go to line 13a.	☐ Yes	☐ No
b	Name the foreign countries and regions within the countries in which you operate.		
c	Describe your operations in each country and region in which you operate.		
d	Describe how your operations in each country and region further your exempt purposes.		

13a	Do you or will you make grants, loans, or other distributions to organization(s)? If "Yes," answer lines 13b through 13g. If "No," go to line 14a.	☐ Yes	☐ No
b	Describe how your grants, loans, or other distributions to organizations further your exempt purposes.		
c	Do you have written contracts with each of these organizations? If "Yes," attach a copy of each contract.	☐ Yes	☐ No
d	Identify each recipient organization and any **relationship** between you and the recipient organization.		
e	Describe the records you keep with respect to the grants, loans, or other distributions you make.		
f	Describe your selection process, including whether you do any of the following:		
(i)	Do you require an application form? If "Yes," attach a copy of the form.	☐ Yes	☐ No
(ii)	Do you require a grant proposal? If "Yes," describe whether the grant proposal specifies your responsibilities and those of the grantee, obligates the grantee to use the grant funds only for the purposes for which the grant was made, provides for periodic written reports concerning the use of grant funds, requires a final written report and an accounting of how grant funds were used, and acknowledges your authority to withhold and/or recover grant funds in case such funds are, or appear to be, misused.	☐ Yes	☐ No
g	Describe your procedures for oversight of distributions that assure you the resources are used to further your exempt purposes, including whether you require periodic and final reports on the use of resources.		

14a	Do you or will you make grants, loans, or other distributions to foreign organizations? If "Yes," answer lines 14b through 14f. If "No," go to line 15.	☐ Yes	☐ No
b	Provide the name of each foreign organization, the country and regions within a country in which each foreign organization operates, and describe any relationship you have with each foreign organization.		
c	Does any foreign organization listed in line 14b accept contributions earmarked for a specific country or specific organization? If "Yes," list all earmarked organizations or countries.	☐ Yes	☐ No
d	Do your contributors know that you have ultimate authority to use contributions made to you at your discretion for purposes consistent with your exempt purposes? If "Yes," describe how you relay this information to contributors.	☐ Yes	☐ No
e	Do you or will you make pre-grant inquiries about the recipient organization? If "Yes," describe these inquiries, including whether you inquire about the recipient's financial status, its tax-exempt status under the Internal Revenue Code, its ability to accomplish the purpose for which the resources are provided, and other relevant information.	☐ Yes	☐ No
f	Do you or will you use any additional procedures to ensure that your distributions to foreign organizations are used in furtherance of your exempt purposes? If "Yes," describe these procedures, including site visits by your employees or compliance checks by impartial experts, to verify that grant funds are being used appropriately.	☐ Yes	☐ No

Part VIII	**Your Specific Activities** (*Continued*)		

15 Do you have a **close connection** with any organizations? If "Yes," explain. ☐ Yes ☐ No

16 Are you applying for exemption as a **cooperative hospital service organization** under section 501(e)? If "Yes," explain. ☐ Yes ☐ No

17 Are you applying for exemption as a **cooperative service organization of operating educational organizations** under section 501(f)? If "Yes," explain. ☐ Yes ☐ No

18 Are you applying for exemption as a **charitable risk pool** under section 501(n)? If "Yes," explain. ☐ Yes ☐ No

19 Do you or will you operate a **school**? If "Yes," complete Schedule B. Answer "Yes," whether you operate a school as your main function or as a secondary activity. ☐ Yes ☐ No

20 Is your main function to provide **hospital** or **medical care**? If "Yes," complete Schedule C. ☐ Yes ☐ No

21 Do you or will you provide **low-income housing** or housing for the **elderly** or **handicapped**? If "Yes," complete Schedule F. ☐ Yes ☐ No

22 Do you or will you provide scholarships, fellowships, educational loans, or other educational grants to individuals, including grants for travel, study, or other similar purposes? If "Yes," complete Schedule H. ☐ Yes ☐ No

Note: Private foundations may use Schedule H to request advance approval of individual grant procedures.

Part IX Financial Data

For purposes of this schedule, years in existence refer to completed tax years. If in existence 4 or more years, complete the schedule for the most recent 4 tax years. If in existence more than 1 year but less than 4 years, complete the statements for each year in existence and provide projections of your likely revenues and expenses based on a reasonable and good faith estimate of your future finances for a total of 3 years of financial information. If in existence less than 1 year, provide projections of your likely revenues and expenses for the current year and the 2 following years, based on a reasonable and good faith estimate of your future finances for a total of 3 years of financial information. (See instructions.)

A. Statement of Revenues and Expenses

	Type of revenue or expense	Current tax year	3 prior tax years or 2 succeeding tax years				(e) Provide Total for (a) through (d)
		(a) From _____ To _____	(b) From _____ To _____	(c) From _____ To _____	(d) From _____ To _____		
Revenues	1 Gifts, grants, and contributions received (do not include unusual grants)						
	2 Membership fees received						
	3 Gross investment income						
	4 Net unrelated business income						
	5 Taxes levied for your benefit						
	6 Value of services or facilities furnished by a governmental unit without charge (not including the value of services generally furnished to the public without charge)						
	7 Any revenue not otherwise listed above or in lines 9–12 below (attach an itemized list)						
	8 Total of lines 1 through 7						
	9 Gross receipts from admissions, merchandise sold or services performed, or furnishing of facilities in any activity that is related to your exempt purposes (attach itemized list)						
	10 Total of lines 8 and 9						
	11 Net gain or loss on sale of capital assets (attach schedule and see instructions)						
	12 **Unusual grants**						
	13 Total Revenue Add lines 10 through 12						
Expenses	14 Fundraising expenses						
	15 Contributions, gifts, grants, and similar amounts paid out (attach an itemized list)						
	16 Disbursements to or for the benefit of members (attach an itemized list)						
	17 Compensation of officers, directors, and trustees						
	18 Other salaries and wages						
	19 Interest expense						
	20 Occupancy (rent, utilities, etc.)						
	21 Depreciation and depletion						
	22 Professional fees						
	23 Any expense not otherwise classified, such as program services (attach itemized list)						
	24 Total Expenses Add lines 14 through 23						

Part IX	**Financial Data** *(Continued)*

B. Balance Sheet (for your most recently completed tax year)

Year End: _____

Assets — (Whole dollars)

1	Cash .	1
2	Accounts receivable, net .	2
3	Inventories .	3
4	Bonds and notes receivable (attach an itemized list)	4
5	Corporate stocks (attach an itemized list)	5
6	Loans receivable (attach an itemized list)	6
7	Other investments (attach an itemized list)	7
8	Depreciable and depletable assets (attach an itemized list)	8
9	Land .	9
10	Other assets (attach an itemized list)	10
11	Total Assets (add lines 1 through 10)	11

Liabilities

12	Accounts payable .	12
13	Contributions, gifts, grants, etc. payable	13
14	Mortgages and notes payable (attach an itemized list)	14
15	Other liabilities (attach an itemized list)	15
16	Total Liabilities (add lines 12 through 15)	16

Fund Balances or Net Assets

17	Total fund balances or net assets	17
18	Total Liabilities and Fund Balances or Net Assets (add lines 16 and 17)	18

19 Have there been any substantial changes in your assets or liabilities since the end of the period shown above? If "Yes," explain. ☐ **Yes** ☐ **No**

Part X	**Public Charity Status**

Part X is designed to classify you as an organization that is either a **private foundation** or a **public charity**. Public charity status is a more favorable tax status than private foundation status. If you are a private foundation, Part X is designed to further determine whether you are a **private operating foundation**. (See instructions.)

1a Are you a private foundation? If "Yes," go to line 1b. If "No," go to line 5 and proceed as instructed. If you are unsure, see the instructions. ☐ **Yes** ☐ **No**

b As a private foundation, section 508(e) requires special provisions in your organizing document in addition to those that apply to all organizations described in section 501(c)(3). Check the box to confirm that your organizing document meets this requirement, whether by express provision or by reliance on operation of state law. Attach a statement that describes specifically where your organizing document meets this requirement, such as a reference to a particular article or section in your organizing document or by operation of state law. See the instructions, including Appendix B, for information about the special provisions that need to be contained in your organizing document. Go to line 2. ☐

2 Are you a private operating foundation? To be a private operating foundation you must engage directly in the active conduct of charitable, religious, educational, and similar activities, as opposed to indirectly carrying out these activities by providing grants to individuals or other organizations. If "Yes," go to line 3. If "No," go to the signature section of Part XI. ☐ **Yes** ☐ **No**

3 Have you existed for one or more years? If "Yes," attach financial information showing that you are a private operating foundation; go to the signature section of Part XI. If "No," continue to line 4. ☐ **Yes** ☐ **No**

4 Have you attached either (1) an affidavit or opinion of counsel, (including a written affidavit or opinion from a certified public accountant or accounting firm with expertise regarding this tax law matter), that sets forth facts concerning your operations and support to demonstrate that you are likely to satisfy the requirements to be classified as a private operating foundation; or (2) a statement describing your proposed operations as a private operating foundation? ☐ **Yes** ☐ **No**

5 If you answered "No" to line 1a, indicate the type of public charity status you are requesting by checking one of the choices below. You may check only one box.

The organization is not a private foundation because it is:

a 509(a)(1) and 170(b)(1)(A)(i)—a church or a convention or association of churches. Complete and attach Schedule A. ☐

b 509(a)(1) and 170(b)(1)(A)(ii)—a **school**. Complete and attach Schedule B. ☐

c 509(a)(1) and 170(b)(1)(A)(iii)—a **hospital**, a cooperative hospital service organization, or a medical research organization operated in conjunction with a hospital. Complete and attach Schedule C. ☐

d 509(a)(3)—an organization supporting either one or more organizations described in line 5a through c, f, g, or h or a publicly supported section 501(c)(4), (5), or (6) organization. Complete and attach Schedule D. ☐

Part VIII Your Specific Activities *(Continued)*

4a Do you or will you undertake **fundraising**? If "Yes," check all the fundraising programs you do or will conduct. (See instructions.) ☐ **Yes** ☐ **No**

- ☐ mail solicitations
- ☐ email solicitations
- ☐ personal solicitations
- ☐ vehicle, boat, plane, or similar donations
- ☐ foundation grant solicitations
- ☐ phone solicitations
- ☐ accept donations on your website
- ☐ receive donations from another organization's website
- ☐ government grant solicitations
- ☐ Other

Attach a description of each fundraising program.

b Do you or will you have written or oral contracts with any individuals or organizations to raise funds for you? If "Yes," describe these activities. Include all revenue and expenses from these activities and state who conducts them. Revenue and expenses should be provided for the time periods specified in Part IX, Financial Data. Also, attach a copy of any contracts or agreements. ☐ **Yes** ☐ **No**

c Do you or will you engage in fundraising activities for other organizations? If "Yes," describe these arrangements. Include a description of the organizations for which you raise funds and attach copies of all contracts or agreements. ☐ **Yes** ☐ **No**

d List all states and local jurisdictions in which you conduct fundraising. For each state or local jurisdiction listed, specify whether you fundraise for your own organization, you fundraise for another organization, or another organization fundraises for you.

e Do you or will you maintain separate accounts for any contributor under which the contributor has the right to advise on the use or distribution of funds? Answer "Yes" if the donor may provide advice on the types of investments, distributions from the types of investments, or the distribution from the donor's contribution account. If "Yes," describe this program, including the type of advice that may be provided and submit copies of any written materials provided to donors. ☐ **Yes** ☐ **No**

5 Are you **affiliated** with a governmental unit? If "Yes," explain. ☐ **Yes** ☐ **No**

6a Do you or will you engage in **economic development**? If "Yes," describe your program. ☐ **Yes** ☐ **No**
b Describe in full who benefits from your economic development activities and how the activities promote exempt purposes.

7a Do or will persons other than your employees or volunteers **develop** your facilities? If "Yes," describe each facility, the role of the developer, and any business or family relationship(s) between the developer and your officers, directors, or trustees. ☐ **Yes** ☐ **No**

b Do or will persons other than your employees or volunteers **manage** your activities or facilities? If "Yes," describe each activity and facility, the role of the manager, and any business or family relationship(s) between the manager and your officers, directors, or trustees. ☐ **Yes** ☐ **No**

c If there is a business or family relationship between any manager or developer and your officers, directors, or trustees, identify the individuals, explain the relationship, describe how contracts are negotiated at arm's length so that you pay no more than fair market value, and submit a copy of any contracts or other agreements.

8 Do you or will you enter into **joint ventures**, including partnerships or **limited liability companies** treated as partnerships, in which you share profits and losses with partners other than section 501(c)(3) organizations? If "Yes," describe the activities of these joint ventures in which you participate. ☐ **Yes** ☐ **No**

9a Are you applying for exemption as a childcare organization under section 501(k)? If "Yes," answer lines 9b through 9d. If "No," go to line 10. ☐ **Yes** ☐ **No**

b Do you provide child care so that parents or caretakers of children you care for can be **gainfully employed** (see instructions)? If "No," explain how you qualify as a childcare organization described in section 501(k). ☐ **Yes** ☐ **No**

c Of the children for whom you provide child care, are 85% or more of them cared for by you to enable their parents or caretakers to be gainfully employed (see instructions)? If "No," explain how you qualify as a childcare organization described in section 501(k). ☐ **Yes** ☐ **No**

d Are your services available to the general public? If "No," describe the specific group of people for whom your activities are available. Also, see the instructions and explain how you qualify as a childcare organization described in section 501(k). ☐ **Yes** ☐ **No**

10 Do you or will you publish, own, or have rights in music, literature, tapes, artworks, choreography, scientific discoveries, or other **intellectual property**? If "Yes," explain. Describe who owns or will own any copyrights, patents, or trademarks, whether fees are or will be charged, how the fees are determined, and how any items are or will be produced, distributed, and marketed. ☐ **Yes** ☐ **No**

Part V	**Compensation and Other Financial Arrangements With Your Officers, Directors, Trustees, Employees, and Independent Contractors** *(Continued)*

 b Describe any written or oral arrangements you made or intend to make.

 c Identify with whom you have or will have such arrangements.

 d Explain how the terms are or will be negotiated at arm's length.

 e Explain how you determine or will determine you pay no more than fair market value or that you are paid at least fair market value.

 f Attach a copy of any signed leases, contracts, loans, or other agreements relating to such arrangements.

Part VI	**Your Members and Other Individuals and Organizations That Receive Benefits From You**

The following "Yes" or "No" questions relate to goods, services, and funds you provide to individuals and organizations as part of your activities. Your answers should pertain to *past, present,* and *planned* activities. (See instructions.)

1a In carrying out your exempt purposes, do you provide goods, services, or funds to individuals? If "Yes," describe each program that provides goods, services, or funds to individuals. ☐ **Yes** ☐ **No**

 b In carrying out your exempt purposes, do you provide goods, services, or funds to organizations? If "Yes," describe each program that provides goods, services, or funds to organizations. ☐ **Yes** ☐ **No**

2 Do any of your programs limit the provision of goods, services, or funds to a specific individual or group of specific individuals? For example, answer "Yes," if goods, services, or funds are provided only for a particular individual, your members, individuals who work for a particular employer, or graduates of a particular school. If "Yes," explain the limitation and how recipients are selected for each program. ☐ **Yes** ☐ **No**

3 Do any individuals who receive goods, services, or funds through your programs have a family or business relationship with any officer, director, trustee, or with any of your highest compensated employees or highest compensated independent contractors listed in Part V, lines 1a, 1b, and 1c? If "Yes," explain how these related individuals are eligible for goods, services, or funds. ☐ **Yes** ☐ **No**

Part VII	**Your History**

The following "Yes" or "No" questions relate to your history. (See instructions.)

1 Are you a **successor** to another organization? Answer "Yes," if you have taken or will take over the activities of another organization; you took over 25% or more of the fair market value of the net assets of another organization; or you were established upon the conversion of an organization from for-profit to non-profit status. If "Yes," complete Schedule G. ☐ **Yes** ☐ **No**

2 Are you submitting this application more than 27 months after the end of the month in which you were legally formed? If "Yes," complete Schedule E. ☐ **Yes** ☐ **No**

Part VIII	**Your Specific Activities**

The following "Yes" or "No" questions relate to specific activities that you may conduct. Check the appropriate box. Your answers should pertain to *past, present,* and *planned* activities. (See instructions.)

1 Do you support or oppose candidates in **political campaigns** in any way? If "Yes," explain. ☐ **Yes** ☐ **No**

2a Do you attempt to **influence legislation**? If "Yes," explain how you attempt to influence legislation and complete line 2b. If "No," go to line 3a. ☐ **Yes** ☐ **No**

 b Have you made or are you making an **election** to have your legislative activities measured by expenditures by filing Form 5768? If "Yes," attach a copy of the Form 5768 that was already filed or attach a completed Form 5768 that you are filing with this application. If "No," describe whether your attempts to influence legislation are a substantial part of your activities. Include the time and money spent on your attempts to influence legislation as compared to your total activities. ☐ **Yes** ☐ **No**

3a Do you or will you operate bingo or **gaming** activities? If "Yes," describe who conducts them, and list all revenue received or expected to be received and expenses paid or expected to be paid in operating these activities. **Revenue and expenses** should be provided for the time periods specified in Part IX, Financial Data. ☐ **Yes** ☐ **No**

 b Do you or will you enter into contracts or other agreements with individuals or organizations to conduct bingo or gaming for you? If "Yes," describe any written or oral arrangements that you made or intend to make, identify with whom you have or will have such arrangements, explain how the terms are or will be negotiated at arm's length, and explain how you determine or will determine you pay no more than fair market value or you will be paid at least fair market value. Attach copies or any written contracts or other agreements relating to such arrangements. ☐ **Yes** ☐ **No**

 c List the states and local jurisdictions, including Indian Reservations, in which you conduct or will conduct gaming or bingo.

Form **1023**
(Rev. December 2013)
Department of the Treasury
Internal Revenue Service

Application for Recognition of Exemption
Under Section 501(c)(3) of the Internal Revenue Code

▶ (Use with the June 2006 revision of the Instructions for Form 1023 and the current Notice 1382)

(00) | OMB No. 1545-0056

Note: *If exempt status is approved, this application will be open for public inspection.*

*Use the instructions to complete this application and for a definition of all **bold** items.* For additional help, call IRS Exempt Organizations Customer Account Services toll-free at 1-877-829-5500. Visit our website at **www.irs.gov** for forms and publications. If the required information and documents are not submitted with payment of the appropriate user fee, the application may be returned to you.

Attach additional sheets to this application if you need more space to answer fully. Put your name and EIN on each sheet and identify each answer by Part and line number. Complete Parts I - XI of Form 1023 and submit only those Schedules (A through H) that apply to you.

Part I Identification of Applicant

1 Full name of organization (exactly as it appears in your **organizing document**)

2 c/o Name (if applicable)

3 **Mailing address** (Number and street) (see instructions)

Room/Suite

4 Employer Identification Number (EIN)

City or town, state or country, and ZIP + 4

5 Month the annual accounting period ends (01 – 12)

6 Primary contact (officer, director, trustee, or **authorized representative**)

a Name:

b Phone:

c Fax: (optional)

7 Are you represented by an authorized representative, such as an attorney or accountant? If "Yes," provide the authorized representative's name, and the name and address of the authorized representative's firm. Include a completed Form 2848, *Power of Attorney and Declaration of Representative,* with your application if you would like us to communicate with your representative. ☐ **Yes** ☐ **No**

8 Was a person who is not one of your officers, directors, trustees, employees, or an authorized representative listed in line 7, paid, or promised payment, to help plan, manage, or advise you about the structure or activities of your organization, or about your financial or tax matters? If "Yes," provide the person's name, the name and address of the person's firm, the amounts paid or promised to be paid, and describe that person's role. ☐ **Yes** ☐ **No**

9a Organization's website:

b Organization's email: (optional)

10 Certain organizations are not required to file an information return (Form 990 or Form 990-EZ). If you are granted tax-exemption, are you claiming to be excused from filing Form 990 or Form 990-EZ? If "Yes," explain. See the instructions for a description of organizations not required to file Form 990 or Form 990-EZ. ☐ **Yes** ☐ **No**

11 Date incorporated if a corporation, or formed, if other than a corporation. (MM/DD/YYYY) / /

12 Were you formed under the laws of a **foreign country**? If "Yes," state the country. ☐ **Yes** ☐ **No**

For Paperwork Reduction Act Notice, see page 24 of the instructions. Cat. No. 17133K Form **1023** (Rev. 12-2013)

Part II　Organizational Structure

You must be a corporation (including a limited liability company), an unincorporated association, or a trust to be tax exempt. (See instructions.) **DO NOT file this form unless you can check "Yes" on lines 1, 2, 3, or 4.**

1 Are you a **corporation**? If "Yes," attach a copy of your articles of incorporation showing **certification of filing** with the appropriate state agency. Include copies of any amendments to your articles and be sure they also show state filing certification.　　☐ **Yes**　　☐ **No**

2 Are you a **limited liability company (LLC)**? If "Yes," attach a copy of your articles of organization showing certification of filing with the appropriate state agency. Also, if you adopted an operating agreement, attach a copy. Include copies of any amendments to your articles and be sure they show state filing certification. Refer to the instructions for circumstances when an LLC should not file its own exemption application.　　☐ **Yes**　　☐ **No**

3 Are you an **unincorporated association**? If "Yes," attach a copy of your articles of association, constitution, or other similar organizing document that is dated and includes at least two signatures. Include signed and dated copies of any amendments.　　☐ **Yes**　　☐ **No**

4a Are you a **trust**? If "Yes," attach a signed and dated copy of your trust agreement. Include signed and dated copies of any amendments.　　☐ **Yes**　　☐ **No**

b Have you been funded? If "No," explain how you are formed without anything of value placed in trust.　　☐ **Yes**　　☐ **No**

5 Have you adopted **bylaws**? If "Yes," attach a current copy showing date of adoption. If "No," explain how your officers, directors, or trustees are selected.　　☐ **Yes**　　☐ **No**

Part III　Required Provisions in Your Organizing Document

The following questions are designed to ensure that when you file this application, your organizing document contains the required provisions to meet the organizational test under section 501(c)(3). Unless you can check the boxes in both lines 1 and 2, your organizing document does not meet the organizational test. **DO NOT file this application until you have amended your organizing document.** Submit your original and amended organizing documents (showing state filing certification if you are a corporation or an LLC) with your application.

1 Section 501(c)(3) requires that your organizing document state your exempt purpose(s), such as charitable, religious, educational, and/or scientific purposes. Check the box to confirm that your organizing document meets this requirement. Describe specifically where your organizing document meets this requirement, such as a reference to a particular article or section in your organizing document. Refer to the instructions for exempt purpose language. Location of Purpose Clause (Page, Article, and Paragraph): _____　　☐

2a Section 501(c)(3) requires that upon dissolution of your organization, your remaining assets must be used exclusively for exempt purposes, such as charitable, religious, educational, and/or scientific purposes. Check the box on line 2a to confirm that your organizing document meets this requirement by express provision for the distribution of assets upon dissolution. If you rely on state law for your dissolution provision, do not check the box on line 2a and go to line 2c.　　☐

2b If you checked the box on line 2a, specify the location of your dissolution clause (Page, Article, and Paragraph). Do not complete line 2c if you checked box 2a. _____

2c See the instructions for information about the operation of state law in your particular state. Check this box if you rely on operation of state law for your dissolution provision and indicate the state: _____　　☐

Part IV　Narrative Description of Your Activities

Using an attachment, describe your *past, present,* and *planned* activities in a narrative. If you believe that you have already provided some of this information in response to other parts of this application, you may summarize that information here and refer to the specific parts of the application for supporting details. You may also attach representative copies of newsletters, brochures, or similar documents for supporting details to this narrative. Remember that if this application is approved, it will be open for public inspection. Therefore, your narrative description of activities should be thorough and accurate. Refer to the instructions for information that must be included in your description.

Part V　Compensation and Other Financial Arrangements With Your Officers, Directors, Trustees, Employees, and Independent Contractors

1a List the names, titles, and mailing addresses of all of your officers, directors, and trustees. For each person listed, state their total annual **compensation**, or proposed compensation, for all services to the organization, whether as an officer, employee, or other position. Use actual figures, if available. Enter "none" if no compensation is or will be paid. If additional space is needed, attach a separate sheet. Refer to the instructions for information on what to include as compensation.

Name	Title	Mailing address	Compensation amount (annual actual or estimated)

Part V	Compensation and Other Financial Arrangements With Your Officers, Directors, Trustees, Employees, and Independent Contractors *(Continued)*

b List the names, titles, and mailing addresses of each of your five highest compensated employees who receive or will receive compensation of more than $50,000 per year. Use the actual figure, if available. Refer to the instructions for information on what to include as compensation. Do not include officers, directors, or trustees listed in line 1a.

Name	Title	Mailing address	Compensation amount (annual actual or estimated)

c List the names, names of businesses, and mailing addresses of your five highest compensated **independent contractors** that receive or will receive compensation of more than $50,000 per year. Use the actual figure, if available. Refer to the instructions for information on what to include as compensation.

Name	Title	Mailing address	Compensation amount (annual actual or estimated)

The following "Yes" or "No" questions relate to *past, present, or planned* relationships, transactions, or agreements with your officers, directors, trustees, highest compensated employees, and highest compensated independent contractors listed in lines 1a, 1b, and 1c.

2a Are any of your officers, directors, or trustees **related** to each other through **family or business relationships**? If "Yes," identify the individuals and explain the relationship. ☐ Yes ☐ No

b Do you have a business relationship with any of your officers, directors, or trustees other than through their position as an officer, director, or trustee? If "Yes," identify the individuals and describe the business relationship with each of your officers, directors, or trustees. ☐ Yes ☐ No

c Are any of your officers, directors, or trustees related to your highest compensated employees or highest compensated independent contractors listed on lines 1b or 1c through family or business relationships? If "Yes," identify the individuals and explain the relationship. ☐ Yes ☐ No

3a For each of your officers, directors, trustees, highest compensated employees, and highest compensated independent contractors listed on lines 1a, 1b, or 1c, attach a list showing their name, qualifications, average hours worked, and duties.

b Do any of your officers, directors, trustees, highest compensated employees, and highest compensated independent contractors listed on lines 1a, 1b, or 1c receive compensation from any other organizations, whether tax exempt or taxable, that are related to you through **common control**? If "Yes," identify the individuals, explain the relationship between you and the other organization, and describe the compensation arrangement. ☐ Yes ☐ No

4 In establishing the compensation for your officers, directors, trustees, highest compensated employees, and highest compensated independent contractors listed on lines 1a, 1b, and 1c, the following practices are recommended, although they are not required to obtain exemption. Answer "Yes" to all the practices you use.

a Do you or will the individuals that approve compensation arrangements follow a conflict of interest policy? ☐ Yes ☐ No
b Do you or will you approve compensation arrangements in advance of paying compensation? ☐ Yes ☐ No
c Do you or will you document in writing the date and terms of approved compensation arrangements? ☐ Yes ☐ No

Part V Compensation and Other Financial Arrangements With Your Officers, Directors, Trustees, Employees, and Independent Contractors *(Continued)*

d Do you or will you record in writing the decision made by each individual who decided or voted on compensation arrangements? ☐ Yes ☐ No

e Do you or will you approve compensation arrangements based on information about compensation paid by **similarly situated** taxable or tax-exempt organizations for similar services, current compensation surveys compiled by independent firms, or actual written offers from similarly situated organizations? Refer to the instructions for Part V, lines 1a, 1b, and 1c, for information on what to include as compensation. ☐ Yes ☐ No

f Do you or will you record in writing both the information on which you relied to base your decision and its source? ☐ Yes ☐ No

g If you answered "No" to any item on lines 4a through 4f, describe how you set compensation that is **reasonable** for your officers, directors, trustees, highest compensated employees, and highest compensated independent contractors listed in Part V, lines 1a, 1b, and 1c.

5a Have you adopted a **conflict of interest policy** consistent with the sample conflict of interest policy in Appendix A to the instructions? If "Yes," provide a copy of the policy and explain how the policy has been adopted, such as by resolution of your governing board. If "No," answer lines 5b and 5c. ☐ Yes ☐ No

b What procedures will you follow to assure that persons who have a conflict of interest will not have influence over you for setting their own compensation?

c What procedures will you follow to assure that persons who have a conflict of interest will not have influence over you regarding business deals with themselves?

Note: A conflict of interest policy is recommended though it is not required to obtain exemption. Hospitals, see Schedule C, Section I, line 14.

6a Do you or will you compensate any of your officers, directors, trustees, highest compensated employees, and highest compensated independent contractors listed in lines 1a, 1b, or 1c through **non-fixed payments**, such as discretionary bonuses or revenue-based payments? If "Yes," describe all non-fixed compensation arrangements, including how the amounts are determined, who is eligible for such arrangements, whether you place a limitation on total compensation, and how you determine or will determine that you pay no more than reasonable compensation for services. Refer to the instructions for Part V, lines 1a, 1b, and 1c, for information on what to include as compensation. ☐ Yes ☐ No

b Do you or will you compensate any of your employees, other than your officers, directors, trustees, or your five highest compensated employees who receive or will receive compensation of more than $50,000 per year, through non-fixed payments, such as discretionary bonuses or revenue-based payments? If "Yes," describe all non-fixed compensation arrangements, including how the amounts are or will be determined, who is or will be eligible for such arrangements, whether you place or will place a limitation on total compensation, and how you determine or will determine that you pay no more than reasonable compensation for services. Refer to the instructions for Part V, lines 1a, 1b, and 1c, for information on what to include as compensation. ☐ Yes ☐ No

7a Do you or will you purchase any goods, services, or assets from any of your officers, directors, trustees, highest compensated employees, or highest compensated independent contractors listed in lines 1a, 1b, or 1c? If "Yes," describe any such purchase that you made or intend to make, from whom you make or will make such purchases, how the terms are or will be negotiated at **arm's length**, and explain how you determine or will determine that you pay no more than **fair market value**. Attach copies of any written contracts or other agreements relating to such purchases. ☐ Yes ☐ No

b Do you or will you sell any goods, services, or assets to any of your officers, directors, trustees, highest compensated employees, or highest compensated independent contractors listed in lines 1a, 1b, or 1c? If "Yes," describe any such sales that you made or intend to make, to whom you make or will make such sales, how the terms are or will be negotiated at arm's length, and explain how you determine or will determine you are or will be paid at least fair market value. Attach copies of any written contracts or other agreements relating to such sales. ☐ Yes ☐ No

8a Do you or will you have any leases, contracts, loans, or other agreements with your officers, directors, trustees, highest compensated employees, or highest compensated independent contractors listed in lines 1a, 1b, or 1c? If "Yes," provide the information requested in lines 8b through 8f. ☐ Yes ☐ No

b Describe any written or oral arrangements that you made or intend to make.

c Identify with whom you have or will have such arrangements.

d Explain how the terms are or will be negotiated at arm's length.

e Explain how you determine you pay no more than fair market value or you are paid at least fair market value.

f Attach copies of any signed leases, contracts, loans, or other agreements relating to such arrangements.

9a Do you or will you have any leases, contracts, loans, or other agreements with any organization in which any of your officers, directors, or trustees are also officers, directors, or trustees, or in which any individual officer, director, or trustee owns more than a 35% interest? If "Yes," provide the information requested in lines 9b through 9f. ☐ Yes ☐ No

IMPORTANT — Read Instructions **before completing this form.**

Filing Fee – **$30.00**

Copy Fees – First page $1.00; each attachment page $0.50;
Certification Fee - $5.00

Note: A separate California Franchise Tax Board application is required to obtain
tax exempt status. For more information, go to *https://www.ftb.ca.gov.*

This Space For Office Use Only

1. Corporate Name (Go to *www.sos.ca.gov/business/be/name-availability* for general corporate name requirements and restrictions.)

The name of the corporation is _____

2. Business Addresses (Enter the **complete** business addresses. Item 2a cannot be a P.O.Box or "in care of" an individual or entity.)

	City (no abbreviations)	State	Zip Code
a. Initial Street Address of Corporation - **Do not enter a P.O. Box**			
b. Initial Mailing Address of Corporation, **if different than item 2a**	City (no abbreviations)	State	Zip Code

3. Service of Process (Must provide either Individual **OR** Corporation.)

INDIVIDUAL – Complete Items 3a and 3b only. Must include agent's full name and California street address.

a. California Agent's First Name (if agent is **not** a corporation)	Middle Name	Last Name	Suffix
b. Street Address (if agent is **not** a corporation) - **Do not enter a P.O. Box**	City (no abbreviations)	State **CA**	Zip Code

CORPORATION – Complete Item 3c. Only include the name of the registered agent Corporation.

c. California Registered Corporate Agent's Name (if agent is a corporation) – Do not complete Item 3a or 3b

4. Purpose Statement

This corporation is a nonprofit **Religious** Corporation and is not organized for private gain of any person. It is organized under the Nonprofit Religious Corporation Law exclusively for religious purposes.

5. Additional Statements (The following statements are for tax-exempt status in California. **See Instructions and Filing Tips**.)

a. The specific purpose of this corporation is to _____ .
b. This corporation is organized and operated exclusively for **religious** purposes within the meaning of Internal Revenue Code section 501(c)(3).
c. No substantial part of the activities of this corporation shall consist of carrying on propaganda, or otherwise attempting to influence legislation, and this corporation shall not participate or intervene in any **political campaign** (including the publishing or distribution of statements) on behalf of any candidate for public office.
d. The property of this corporation is irrevocably dedicated to the purposes in **Article 4** hereof and no part of the net income or assets of this corporation shall ever inure to the benefit of any director, officer or member thereof or to the benefit of any private person.
e. Upon the dissolution or winding up of this corporation, its assets remaining after payment, or provision for payment, of all debts and liabilities of this corporation shall be distributed to a nonprofit fund, foundation or corporation which is organized and operated exclusively for **charitable, educational and/or religious** purposes and which has established its tax-exempt status under Internal Revenue Code section 501(c)(3).

6. Read and Sign Below (This form must be signed by each incorporator. **See Instructions**. Do not include a title.)

_____ _____
Signature Type or Print Name

ARTS-RE (REV 03/2017)

2017 California Secretary of State
www.sos.ca.gov/business/be

Mail Submission Cover Sheet

Instructions:

- Complete and include this form with your submission. **This information only will be used to communicate with you in writing about the submission.** This form will be treated as correspondence and will not be made part of the filed document.

- Make all **checks or money orders** payable to the Secretary of State.

- Do not include a $15 counter fee when submitting documents by mail.

- Standard processing time for **submissions** to this office is approximately 5 business days from receipt. All **submissions** are reviewed in the date order of receipt. For updated processing time information, visit *www.sos.ca.gov/business/be/processing-times.*

Optional Copy and Certification Fees:

- If applicable, include optional copy and certification fees with your submission.

- For applicable copy and certification fee information, refer to the instructions of the specific form you are submitting.

Contact Person: (Please type or print legibly)

First Name: _____ Last Name: _____

Phone (optional): _____

Entity Information: (Please type or print legibly)

Name: _____

Entity Number (if applicable): _____

Comments: _____

Return Address: For written communication from the Secretary of State related to this document, or if purchasing a copy of the filed document enter the name of a person or company and the mailing address.

Name: ⌈ ⌉

Company:

Address:

Secretary of State Use Only	
T/TR:	
AMT REC'D:	$

City/State/Zip: ⌊ ⌋

Doc Submission Cover - Corp (Rev. 09/2016)

Name Availability Inquiry Letter

(Corporation, Limited Liability Company and Limited Partnership Names)

To check on the availability of a corporation, limited liability company or limited partnership name in California, complete the form below, and submit the completed form by mail, along with a self-addressed envelope, to Secretary of State, Name Availability Unit, 1500 11th Street, 3rd Floor, Sacramento, CA 95814.

Note: Checking the availability of a corporation, limited liability company or limited partnership name does not reserve the name and has no binding effect on the Secretary of State, nor does it confer any rights to a name. Please refer to our Name Availability webpage at www.sos.ca.gov/business/be/name-availability.htm for information about reserving a name.

Email and/or online inquiries regarding name availability cannot be accepted at this time.

Requestor's Information

Your name: _____

Firm name, if any: _____

Address: _____

City / State / Zip: _____

Phone #: _____ FAX #: _____

Entity Type (Select the applicable entity type. **CHECK ONLY ONE BOX.**)

[] Corporation [] Limited Liability Company [] Limited Partnership

Name(s) To Be Checked (You may list up to three names to be checked.)

1st Choice: _____

() is available. () is not available. We have:

2nd Choice: _____

() is available. () is not available. We have:

3rd Choice: _____

() is available. () is not available. We have:

The space below is reserved for office use only.

Date:	I #	By:

Clear Form Print Form

Name Reservation Request

(Corporation, Limited Liability Company, or Limited Partnership Names)

To request the reservation of a corporation, limited liability company or limited partnership name, complete the enclosed Name Reservation Request Form, attach a check in the amount of $10 (made payable to the Secretary of State) and submit the request:

- **By mail**, along with a self-addressed envelope, to Secretary of State, Name Availability Unit, 1500 11th Street, 3rd Floor, Sacramento, CA 95814.

- **In person (drop off)** at the Secretary of State's office in Sacramento. A request to reserve a *corporation* name also can be dropped off in person at our Los Angeles regional office, 300 South Spring Street, Room 12513, Los Angeles, CA 90013. In addition to the $10 name reservation fee, each drop off request must include a separate, non-refundable special handling fee in the amount of $10. Note: The special handling fee is not applicable to requests submitted by mail.

 Go to www.sos.ca.gov/business-programs/business-entities/processing-times for the current processing times at our Sacramento office.

Only one reservation will be made per request form. You may list up to three names, in order of preference, and the first available name will be reserved for a period of 60 days. The remaining names will not be researched.

A name reservation is made for a period of 60 days. The name reservation can be renewed to the same applicant or for the benefit of the same party, but not for consecutive periods.

E-mail and/or online requests for name reservations cannot be accepted at this time. Please complete the Name Reservation Request Form on the following page.

Note: The reservation of a proposed corporation, limited liability company or limited partnership name does not guarantee that the reserved name complies with all federal and state laws. At the time of filing the document containing the reserved name, it is your responsibility to ensure that you have complied with all federal and state laws, including specific name requirements. In some circumstances, the reserved name may require additional approval/consent pursuant to applicable law at the time of filing. Name styles for particular types of business entities and the need for consent/approval required by law are not considered at the time of the name reservation. Therefore, no financial commitment relating to the proposed name should be made based on the reservation, since the business entity record is not created/qualified/amended until the appropriate documents have been submitted to and filed by the Secretary of State.

Name Reservation Request Info (Rev. 01/2015) Page 1 of 2 California Secretary of State
www.sos.ca.gov/business-programs
(916) 657-5448

Corporation Names:

A corporation name must not be a name that is "likely to mislead the public or the same as, or resembling so closely as to tend to deceive," the name of a California or foreign corporation that has registered with this office or a name that has been reserved by another party. Note: Names are considered deceptive if the only difference is a corporate ending. (California Corporations Code section 201(b) and 2106(b).) A Corporation name is reserved pursuant to California Corporations Code section 201(c).

Limited Liability Company (LLC) Names:

An LLC name: (1) must not be a name that is "likely to mislead the public" and must be distinguishable in the records of the Secretary of State from the name of an existing LLC or an LLC name that has been reserved by another party. Note: Names are not considered distinguishable if the only difference is a limited liability company ending; (2) must include the words Limited Liability Company, or the abbreviations LLC or L.L.C. The words Limited and Company may be abbreviated to Ltd. and Co., respectively; (3) may not contain the words bank, trust, trustee, incorporated, inc., corporation, or corp.; and (4) must not contain the words insurer or insurance company or any other words suggesting that it is in the business of issuing policies of insurance and assuming insurance risks. (California Corporations Code section 17701.08 and 17708.05.) An LLC name is reserved pursuant to California Corporations Code section 17701.09.

Limited Partnership (LP) Names:

An LP name: (1) must be distinguishable in the records of the Secretary of State from the name of an existing LP or an LP name that has been reserved by another party. Note: Names are not considered distinguishable if the only difference is a limited partnership ending; (2) must end with the phrase Limited Partnership or the abbreviation LP or L.P.; and (3) may not contain the words bank, insurance, trust, trustee, incorporated, inc., corporation, or corp. Note: If entity is a foreign LP that is a foreign limited liability LP, the name must contain the phrase Limited Liability Limited Partnership or the abbreviation LLLP or L.L.L.P, and may not contain the abbreviation LP or L.P. (California Corporations Code section 15901.08, 15909.05.) An LP name is reserved pursuant to California Corporations Code section 15901.09.

Name Reservation Request Info (Rev. 01/2015) Page 2 of 2 California Secretary of State
www.sos.ca.gov/business-programs
(916) 657-5448

Secretary of State
Business Programs Division
Business Entities, 1500 11th Street, 3rd Floor, Sacramento, CA 95814

Name Reservation Request Form
(Corporation, Limited Liability Company, or Limited Partnership Names)

The proposed name is being reserved for use by:

Your Name: _____ Phone #: _____

Firm Name (if any): _____ Fax #: _____

Address: _____

City/State/Zip: _____

Type of Entity (Select the applicable entity type. Only one type may be selected.)

☐ Corporation ☐ Limited Liability Company ☐ Limited Partnership

Name To Be Reserved (Enter the name to be reserved. Only one reservation will be made per Name Reservation Request Form. You may list up to three names, in order of preference, and the first available name will be reserved for a period of 60 days. The remaining names will not be researched.)

1st Choice: _____

_____ is available. _____ is available only with consent from: _____ is not available. We have:

2nd Choice: _____

_____ is available. _____ is available only with consent from: _____ is not available. We have:

3rd Choice: _____

_____ is available. _____ is available only with consent from: _____ is not available. We have:

Suspended/Forfeited Entity

☐ If the proposed name is being reserved for the purpose of reviving a suspended
or forfeited entity, check the box and include the entity number.

Entity Number

Mail Back Response

☐ If the Name Reservation Request Form is submitted in person **and** if you would like the reservation to be mailed back, check the box and include a self-addressed envelope.

Fees (Please make check(s) payable to the Secretary of State.)

Reservation Fee: The fee for reserving a corporation, limited liability company or limited partnership name is $10.00 (per reserved name).

Special Handling Fee:

• In addition to the reservation fee, a $10.00 special handling fee is applicable for processing each Name Reservation Request Form delivered in person (drop off) to the Secretary of State's office.

• The $10.00 special handling fee must be remitted by separate check and will be retained whether the proposed name is accepted or denied for reservation.

• The special handling fee does not apply to name reservation requests submitted by mail.

THE SPACE BELOW IS RESERVED FOR OFFICE USE ONLY

Date:	Amt Rec'd:	R #.	By:

Name Reservation Request Form (Rev. 01/2015)

Submission of Exemption Request

Exemption Based on Internal Revenue Code (IRC) Sections 501(c)(3), 501(c)(4), 501(c)(5), 501(c)(6), or 501(c)(7), Federal Determination Letter

Enclose a copy of the Federal Determination Letter.

California Corporation number/ California Secretary of State file number	FEIN

Name of organization as shown in the creating document

Street address (suite, room, or PMB no.)	Telephone ()

City	State	ZIP code

Name of representative to contact regarding additional requirements or information	Telephone ()

Representative's mailing address (suite, room, or PMB no.)

City	State	ZIP code

Part I — Entity Information

1 Entity type (check applicable box): ☐ Corporation ☐ Association ☐ Trust ☐ Foreign corporation (State of incorporation) _____

2 Does the IRS consider the organization a private foundation? . 2 ☐ Yes ☐ No

3 When did the organization establish, incorporate, organize, or conduct business in California? . 3 ___ / ___ / ___
 mm dd yyyy

4 Provide gross receipts for the current year and the three immediately preceding taxable years in existence. Gross receipts are defined as the total amounts the organization received from all sources during its annual account period without subtracting any costs or expenses. If the organization has been in existence for less than one year, provide the projected amount of gross receipts for the entire year. List the account period beginning to the account period ending. Example: mm/dd/yyyy

Current Year or Projected Gross Receipts	Gross Receipts for the three immediately preceding taxable years:		
From:	From:	From:	From:
To:	To:	To:	To:

5 Has the IRS ever suspended, revoked, or audited the organization? . 5 ☐ Yes ☐ No

 If "Yes," explain _____

Part II — Group Exemption See instructions

6 Is the organization applying for a group exemption? . 6 ☐ Yes ☐ No

 If "Yes," attach the federal group determination letter and a list of all California subordinates. Include each subordinate's name, corporation number, Federal employer identification number (FEIN), and address.

Mail form FTB 3500A and a copy of the federal determination letter to:
EXEMPT ORGANIZATIONS UNIT, MS F120, FRANCHISE TAX BOARD, PO BOX 1286, RANCHO CORDOVA CA 95741-1286.

Under penalties of perjury, I declare I have examined this submission for exemption based on the IRC Section 501(c)(3), 501(c)(4), 501(c)(5), 501(c)(6), or 501(c)(7), federal determination letter, and to the best of my knowledge and belief, it is true, correct, and complete.

DATE	SIGNATURE OF OFFICER OR REPRESENTATIVE	TITLE

Part III — Purpose and Activity

1 Exemption based on IRC 501(c)(3) Federal Determination Letter

Check the organization's primary purpose and activity:

☐ Charitable ☐ Educational ☐ Literary ☐ Prevent cruelty to animals ☐ Prevent cruelty to children
☐ Testing for public safety ☐ Religious ☐ Scientific ☐ Church ☐ School
☐ Hospital ☐ Health care center ☐ Qualified sports organization

2 Exemption based on IRC 501(c)(4) Federal Determination Letter

Check the organization's primary purpose and activity:

☐ Civic league ☐ Local association of ☐ Social welfare ☐ Service clubs ☐ Veterans
 employees

☐ Legislative activities ☐ Festival organizations ☐ Municipal building ☐ Police, sheriff, ☐ Quasi governmental
 corporation volunteer firemen
 association

3 Exemption based on IRC 501(c)(5) Federal Determination Letter

Check the organization's primary purpose and activity:

☐ Agriculture ☐ Horticulture ☐ Labor ☐ Agriculture or horticulture county fair ☐ Public employees union
☐ AFL-CIO ☐ Independent ☐ Transportation ☐ Teamsters
 workers

4 Exemption based on IRC 501(c)(6) Federal Determination Letter

Check the organization's primary purpose and activity:

☐ Board of trade ☐ Business league ☐ Chamber of commerce ☐ Real estate board ☐ Professional association or society

5 Exemption based on IRC 501(c)(7) Federal Determination Letter

Check the organization's primary purpose and activity:

☐ Social and recreational ☐ Golf club ☐ Camps ☐ Fraternity or sorority ☐ Dog or horse club
☐ Car, motorcycle, ☐ Hunting or ☐ Common recreational ☐ Flying or airplane club
 trailer club fishing club area

2015 Instructions for Form FTB 3500A

Submission of Exemption Request

Exemption Based on Internal Revenue Code (IRC) Sections 501(c)(3), 501(c)(4), 501(c)(5), 501(c)(6), or 501(c)(7), Federal Determination Letter

References in these Instructions are to the IRC as of **January 1, 2015**, and to the California Revenue and Taxation Code (R&TC).

General Information

All corporations and unincorporated organizations, even if organized on a nonprofit basis, are subject to California corporation franchise or income tax until the Franchise Tax Board (FTB) gives exempt status to the organization. Until the exemption is given, the organization remains taxable.

California acknowledges federally tax exempt Internal Revenue Code (IRC) Sections 501(c)(3), 501(c)(4), 501(c)(5), 501(c)(6), or 501(c)(7), organizations as tax-exempt from state income tax if the organization submits form FTB 3500A, Submission of Exemption Request, and a copy of its federal determination letter to the FTB.

Disclosure of Application Materials

Until the FTB acknowledges an organization's tax-exempt status, the application and all associated documentation is confidential. The FTB may not discuss the application with any unauthorized person. However, once the organization's exemption is acknowledged, the application, and supporting documents, shall be open to public inspection.

Upon the organization's request, public disclosure of documents relating to any trade secrets, patents, process, style of work, or apparatus may be withheld if the FTB determines that disclosure would adversely affect the organization. Additionally, public disclosure of documents may also be withheld if the disclosure would adversely affect national defense.

A Purpose

Use form FTB 3500A, to obtain California tax-exempt status, if the organization has a federal determination letter granting exemption under IRC Sections 501(c)(3), 501(c)(4), 501(c)(5), 501(c)(6), or 501(c)(7). An organization without a federal determination letter may **not** use form FTB 3500A. Organizations without a federal determination letter must use form FTB 3500, Exemption Application. For more information, go to **ftb.ca.gov** and search for **3500**.

B What and Where to File

Send form FTB 3500A, with an original signature of either:

- An elected officer
- A director
- An authorized representative
- A trustee (if the organization is a trust)

Mail completed form FTB 3500A, with a copy of the organization's IRC Sections 501(c)(3), 501(c)(4), 501(c)(5), 501(c)(6), or 501(c)(7), federal determination letter to:

EXEMPT ORGANIZATIONS UNIT MS F120
FRANCHISE TAX BOARD
PO BOX 1286
RANCHO CORDOVA CA 95741-1286

If additional information is required, we will contact the officer or representative designated on form FTB 3500A.

If you have questions about form FTB 3500A, call 916.845.4171.

C What Happens Next

Upon receipt of the completed documents, the FTB will send the organization a letter acknowledging the federal tax exemption under IRC Sections 501(c)(3), 501(c)(4), 501(c)(5), 501(c)(6), or 501(c)(7), and specify the effective date of the organization's exemption under California law.

The organization must notify the FTB when the Internal Revenue Service (IRS) revokes their federal tax-exempt status. The FTB will revoke the organization's tax-exempt status if the organization fails to meet certain Revenue and Taxation Code (R&TC) provisions governing exempt organizations. If an organization's tax-exempt status is revoked or denied, the organization will need to file form FTB 3500 to reinstate its tax-exempt status.

D Incorporating in California

If the organization is not incorporated in California and wishes to do so, the organization should first incorporate with the California Secretary of State (SOS), then file form FTB 3500A with the FTB to obtain tax-exempt status. For more information on incorporating, go to the SOS's website **sos.ca.gov**.

An unincorporated organization that has tax-exempt status, and then incorporates, must reapply for California tax-exempt status.

Foreign Corporations

If the organization is incorporated in another state or country, it is considered a "foreign corporation." The organization may qualify to do business in California if it complies with the California Corporations Code requirements. For more information on qualifying, go to the SOS's website **sos.ca.gov**.

Organizational Requirements

Get California Form 3500, Exemption Application Booklet, this booklet contains Guidelines for Organizing Documents, sample articles, and organizational requirements.

E Trusts

Trusts organized and operated for purposes described in R&TC Section 23701d are treated as nonprofit corporations for tax-exempt purposes.

F Retroactive Exempt Status

For California franchise and income tax purposes, organizations seeking exemption based on their federal determination letter will be tax-exempt for state purposes beginning on the federal exempt effective date on the federal determination letter. If the entity's incorporation date is prior to the federal effective determination date, consider filing form FTB 3500.

We may consider this form as a claim for refund if the organization is subsequently found to be tax-exempt during the same period it previously paid tax. Under Cal. Regs., tit.18, section 23701, in no event shall a claim for refund be allowed unless timely filed under R&TC Section 19306.

G Group Exemption

Parent organizations requesting group exemption for their subordinates complete PART II of this form.

If the parent organization does not want to obtain group exemption, but wants tax-exempt status for specific subordinates, have each subordinate send the following:

- Form FTB 3500A, with the subordinate's name on the form.
- A copy of the parent organization's group ruling letter from the IRS, or a letter from the IRS to the subordinate that indicates the subordinate is covered under the parent organization's IRS group exemption.
- A letter from the parent organization on their letterhead indicating the entity is a subordinate of their organization.

H Suspended/Forfeited Status

An organization must be active and in good standing to retain tax-exempt status. If the organization is not currently in good standing and all filing requirements have been satisfied and/or amounts due have been paid, this form may be considered a request to bring the organization relief from suspension or forfeiture under R&TC Section 23776.

I IRS Revocation

If the organization's IRS exemption is revoked and then reinstated. Send us a copy of the following with the Form 3500A:

- Original IRS exemption determination letter
- IRS revocation letter
- Current IRS exemption determination letter

J Filing Requirements

California tax-exempt organizations may have to file one or more of the following returns:

- Form 199, California Exempt Organization Annual Information Return.
- FTB 199N, Annual Electronic Filing Requirement for Small Exempt Organizations, (California e-Postcard).
- Form 109, California Exempt Organization Business Income Tax Return.

For more information about state filing requirements, fees, and penalties, get FTB Pub. 1068, Exempt Organizations – Filing Requirements and Filing Fees or go to **ftb.ca.gov** and search for **1068**.

Specific Line Instructions

Provide the following:

- California Corporation number (seven digits) or California SOS file number (12 digits)
- Federal Employer identification number (FEIN)
- Organization name as shown in the organization's creating document
- Address

Private Mail Box (PMB) – Include PMB number in the address field. Write "PMB" first, then the box number. Example: PMB 123.

PART I — Entity Information

Line 1 – Entity type
Check the box for the exempt organization's entity type.

Corporation: The entity has endorsed articles of incorporation from the California SOS, or is a foreign entity that has articles of incorporation on file in another state or country.

Association: The entity is not incorporated in California, another state, or country.

Trust: A trust may be created by language in a will or in a written trust instrument. The trust creates legal obligations for the person (trustee) who manages the assets of the trust.

Foreign Corporation: Incorporated in another state or country. Give the name of the state or foreign country in which the entity is incorporated.

Line 5 – IRS information
If the entity was suspended, revoked, or audited by the IRS, check the "Yes" box and explain the reason for the suspension, revocation, or audit by the IRS.

PART II — Group Exemption

The parent organization must have California tax-exempt status before it can apply for group exemption.

List of subordinates
Include a list of subordinates to be covered under the group exemption. The list must include:

- Name of subordinate
- California corporation number
- FEIN
- Address
- Date subordinate affiliated with parent.

PART III — Purpose and Activity

Mark the appropriate purpose and activity box under your specific exemption section based on your federal determination letter.

How to Get California Tax Information
(Keep this page for future use.)

Automated Phone Service

Use our automated phone service to get recorded answers to many of your questions about California taxes and to order California Business Entity tax forms and publications. This service is available in English and Spanish to callers with touch-tone telephones. Have paper and pencil ready to take notes.

Call from within the United States	800.338.0505
Call from outside the United States	916.845.6500

Where to Get General Tax Information

By Internet – You can get answers to Frequently Asked Questions at **ftb.ca.gov**.

By Phone – You can hear recorded answers to Frequently Asked Questions 24 hours a day, 7 days a week. Call our automated phone service at the number listed above. Select "Business Entity Information," then select "Frequently Asked Questions." Enter the 3-digit code, listed below, when prompted.

Code – Prefiling Assistance

715 – If my actual tax is less than the minimum franchise tax, what figure do I put on line 23 of Form 100 or Form 100W?
717 – What are the current tax rates for corporations?
718 – How do I get an extension of time to file?
722 – When does my corporation file a short period return?
734 – Is my corporation subject to a franchise tax or income tax?

S Corporations

704 – Is an S corporation subject to the minimum franchise tax?
705 – Are S corporations required to file estimated payments?
706 – What forms do S corporations file?
707 – The tax for my S corporation is less than the minimum franchise tax. What figure do I put on line 21 of Form 100S?

Exempt Organizations

709 – How do I get tax-exempt status?
710 – Does an exempt organization have to file Form 199?
735 – Does an exempt organization have to file FTB 199N, California e-Postcard?
736 – I have exempt status. Do I need to file Form 100 or Form 109 in addition to Form 199?

Minimum Tax and Estimate Tax

712 – What is the minimum franchise tax?
714 – My corporation is not doing business; does it have to pay the minimum franchise tax?

Billings and Miscellaneous Notices

723 – I received a bill for $250. What is this for?

Miscellaneous

701 – I need a state Employer ID number for my business. Who do I contact?
703 – How do I incorporate?
737 – Where do I send my payment?

Letters

If you write to us, be sure your letter includes the California corporation number, or FEIN, your daytime and evening telephone numbers, and a copy of the notice. Send your letter to:

EXEMPT ORGANIZATIONS UNIT MS F-120
FRANCHISE TAX BOARD
PO BOX 1286
RANCHO CORDOVA CA 95741-1286

We will respond to your letter within ten weeks. In some cases we may need to call you for additional information. **Do not** attach correspondence to your tax return unless it relates to an item on the return.

Your Rights As A Taxpayer

Our goal includes making certain that your rights are protected so that you have the highest confidence in the integrity, efficiency, and fairness of our state tax system. FTB 4058, California Taxpayers' Bill of Rights, includes information on your rights as a California taxpayer, the Taxpayers' Rights Advocate Program, and how you request written advice from the FTB on whether a particular transaction is taxable.

Where to Get Tax Forms and Publications

By Internet – You can download, view, and print California tax forms and publications at **ftb.ca.gov**.

By Phone – You can order California tax forms from 6 a.m. to 10 p.m. weekdays, 6 a.m. to 4:30 p.m. Saturdays, except holidays. Call our automated phone service at the number listed above. Select "Business Entity Information," then select "Forms and Publications." Follow the recorded instructions and enter the 3-digit code, listed below, when prompted. To order prior year forms, call the number listed under "General Phone Services."

Allow two weeks to receive your order. If your corporation's mailing address is outside California, allow three weeks.

Code

817 – California Corporation Tax Forms and Instructions. This booklet includes: Form 100, California Corporation Franchise or Income Tax Return
814 – Form 109, California Exempt Organization Business Income Tax Return
815 – Form 199, California Exempt Organization Annual Information Return
818 – Form 100-ES, Corporation Estimated Tax
802 – FTB 3500, Exemption Application
831 – FTB 3500A, Submission of Exemption Request
943 – FTB 4058, California Taxpayers' Bill of Rights

By Mail – Write to:

TAX FORMS REQUEST UNIT
FRANCHISE TAX BOARD
PO BOX 307
RANCHO CORDOVA CA 95741-0307

General Phone Service

Telephone assistance is available year-round from 7 a.m. until 5 p.m. Monday through Friday, except holidays. Hours are subject to change.

Telephone:	800.852.5711 from within the United States
	916.845.6500 from outside the United States
TTY/TDD:	800.822.6268 for persons with hearing or speech impairments
IRS:	800.829.4933 call the IRS for federal tax questions

Asistencia en español

Asistencia telefónica esta disponible durante todo el año desde las 7 a.m. hasta las 5 p.m. de lunes a viernes, excepto días feriados. Las horas están sujetas a cambios.

Teléfono:	800.852.5711 dentro de los Estados Unidos
	916.845.6500 fuera de los Estados Unidos
TTY/TDD:	800.822.6268 para personas con discapacidades auditivas o del habla
IRS:	800.829.4933 para preguntas sobre impuestos federales

You must complete the Form 1023-EZ Eligibility Worksheet in the Instructions for Form 1023-EZ to determine if you are eligible to file this form. Form 1023-EZ is filed electronically **only** on Pay.gov.
Go to *www.irs.gov/form1023ez* for additional filing information.

Form **1023-EZ**
(June 2014)

Department of the Treasury
Internal Revenue Service

Streamlined Application for Recognition of Exemption Under Section 501(c)(3) of the Internal Revenue Code

OMB No. 1545-0056

► **Do not enter social security numbers on this form as it may be made public.**
► **Information about Form 1023-EZ and its separate instructions is at *www.irs.gov/form1023*.**

Note: *If exempt status is approved, this application will be open for public inspection.*

☐ **Check this box** to attest that you have completed the Form 1023-EZ Eligibility Worksheet in the current instructions, are eligible to apply for exemption using Form 1023-EZ, and have read and understand the requirements to be exempt under section 501(c)(3).

Part I Identification of Applicant

1a Full Name of Organization

b Address (number, street, and room/suite). If a P.O. box, see instructions. **c** City **d** State **e** Zip Code + 4

2 Employer Identification Number **3** Month Tax Year Ends (MM) **4** Person to Contact if More Information is Needed

5 Contact Telephone Number **6** Fax Number (optional) **7** User Fee Submitted

8 List the names, titles, and mailing addresses of your officers, directors, and/or trustees. (If you have more than five, see instructions.)

First Name:	Last Name:	Title:	
Street Address:	City:	State:	Zip Code + 4:
First Name:	Last Name:	Title:	
Street Address:	City:	State:	Zip Code + 4:
First Name:	Last Name:	Title:	
Street Address:	City:	State:	Zip Code + 4:
First Name:	Last Name:	Title:	
Street Address:	City:	State:	Zip Code + 4:
First Name:	Last Name:	Title:	
Street Address:	City:	State:	Zip Code + 4:

9 a Organization's Website (if available):
b Organization's Email (optional):

Part II Organizational Structure

1 To file this form, you must be a corporation, an unincorporated association, or a trust. **Check the box** for the type of organization.
☐ Corporation ☑ Unincorporated association ☐ Trust

2 ☐ **Check this box** to attest that you have the organizing document necessary for the organizational structure indicated above. (See the instructions for an explanation of **necessary organizing documents**.)

3 Date incorporated if a corporation, or formed if other than a corporation (MMDDYYYY): _____

4 State of incorporation or other formation: _____

5 Section 501(c)(3) requires that your organizing document must limit your purposes to one or more exempt purposes within section 501(c)(3).
☐ **Check this box** to attest that your organizing document contains this limitation.

6 Section 501(c)(3) requires that your organizing document must not expressly empower you to engage, otherwise than as an insubstantial part of your activities, in activities that in themselves are not in furtherance of one or more exempt purposes.

☐ **Check this box** to attest that your organizing document does not expressly empower you to engage, otherwise than as an insubstantial part of your activities, in activities that in themselves are not in furtherance of one or more exempt purposes.

7 Section 501(c)(3) requires that your organizing document must provide that upon dissolution, your remaining assets be used exclusively for section 501(c)(3) exempt purposes. Depending on your entity type and the state in which you are formed, this requirement may be satisfied by operation of state law.

☐ **Check this box** to attest that your organizing document contains the dissolution provision required under section 501(c)(3) or that you do not need an express dissolution provision in your organizing document because you rely on the operation of state law in the state in which you are formed for your dissolution provision.

For Paperwork Reduction Act Notice, see the instructions. Catalog No. 66267N Form **1023-EZ** (6-2014)

Form 1023-EZ (6-2014) | Page **2**

Part III Your Specific Activities

1 Enter the appropriate 3-character NTEE Code that best describes your activities (See the instructions): _____

2 To qualify for exemption as a section 501(c)(3) organization, you must be organized and operated exclusively to further one or more of the following purposes. By checking the box or boxes below, you attest that you are organized and operated exclusively to further the purposes indicated. **Check all that apply.**

☐ Charitable ☐ Religious ☐ Educational

☐ Scientific ☐ Literary ☐ Testing for public safety

☐ To foster national or international amateur sports competition ☐ Prevention of cruelty to children or animals

3 To qualify for exemption as a section 501(c)(3) organization, you must:

- Refrain from supporting or opposing candidates in political campaigns in any way.
- Ensure that your net earnings do not inure in whole or in part to the benefit of private shareholders or individuals (that is, board members, officers, key management employees, or other insiders).
- Not further non-exempt purposes (such as purposes that benefit private interests) more than insubstantially.
- Not be organized or operated for the primary purpose of conducting a trade or business that is not related to your exempt purpose(s).
- Not devote more than an insubstantial part of your activities attempting to influence legislation or, if you made a section 501(h) election, not normally make expenditures in excess of expenditure limitations outlined in section 501(h).
- Not provide commercial-type insurance as a substantial part of your activities.

☐ **Check this box** to attest that you have not conducted and will not conduct activities that violate these prohibitions and restrictions.

4 Do you or will you attempt to influence legislation? ☐ Yes ☐ No

(If yes, consider filing Form 5768. See the instructions for more details.)

5 Do you or will you pay compensation to any of your officers, directors, or trustees? ☐ Yes ☐ No

(Refer to the instructions for a definition of **compensation**.)

6 Do you or will you donate funds to or pay expenses for individual(s)? ☐ Yes ☐ No

7 Do you or will you conduct activities or provide grants or other assistance to individual(s) or organization(s) outside the United States? . ☐ Yes ☐ No

8 Do you or will you engage in financial transactions (for example, loans, payments, rents, etc.) with any of your officers, directors, or trustees, or any entities they own or control? ☐ Yes ☐ No

9 Do you or will you have unrelated business gross income of $1,000 or more during a tax year? ☐ Yes ☐ No

10 Do you or will you operate bingo or other gaming activities? ☐ Yes ☐ No

11 Do you or will you provide disaster relief? . ☐ Yes ☐ No

Part IV Foundation Classification

Part IV is designed to classify you as an organization that is either a private foundation or a public charity. Public charity status is a more favorable tax status than private foundation status.

1 If you qualify for public charity status, check the appropriate box (**1a – 1c** below) and skip to **Part V** below.

a ☐ **Check this box** to attest that you normally receive at least one-third of your support from public sources or you normally receive at least 10 percent of your support from public sources and you have other characteristics of a publicly supported organization. **Sections 509(a)(1) and 170(b)(1)(A)(vi).**

b ☐ **Check this box** to attest that you normally receive more than one-third of your support from a combination of gifts, grants, contributions, membership fees, and gross receipts (from permitted sources) from activities related to your exempt functions and normally receive not more than one-third of your support from investment income and unrelated business taxable income. **Section 509(a)(2).**

c ☐ **Check this box** to attest that you are operated for the benefit of a college or university that is owned or operated by a governmental unit. **Sections 509(a)(1) and 170(b)(1)(A)(iv).**

2 If you are not described in items **1a – 1c** above, you are a private foundation. As a private foundation, you are required by section 508(e) to have specific provisions in your organizing document, unless you rely on the operation of state law in the state in which you were formed to meet these requirements. These specific provisions require that you operate to avoid liability for private foundation excise taxes under sections 4941-4945.

☐ **Check this box** to attest that your organizing document contains the provisions required by section 508(e) or that your organizing document does not need to include the provisions required by section 508(e) because you rely on the operation of state law in your particular state to meet the requirements of section 508(e). (See the instructions for explanation of the section 508(e) requirements.)

Form **1023-EZ** (6-2014)

2. If in existence 5 or more years, complete the schedule for the most recent 5 tax years. You will need to provide a separate statement that includes information about the most recent 5 tax years because the data table in Part IX has not been updated to provide for a 5th year.

Part X. Public Charity Status

Do not complete line 6a on page 11 of Form 1023, and do not sign the form under the heading "Consent Fixing Period of Limitations Upon Assessment of Tax Under Section 4940 of the Internal Revenue Code."

Only complete line 6b and line 7 on page 11 of Form 1023, if in existence 5 or more tax years.

Part XI. Increase in User Fees

User fee increases are effective for all applications postmarked after January 3, 2010.

1. $400 for organizations whose gross receipts do not exceed $10,000 or less annually over a 4-year period.

2. $850 for organizations whose gross receipts exceed $10,000 annually over a 4-year period.

For the current user fee amounts, go to IRS.gov and in the "Search" box at the top right of the page, enter "Exempt Organizations User Fees." You can also call 1-877-829-5500.

Application for reinstatement and retroactive reinstatement. An organization must apply to have its tax-exempt status reinstated if it was automatically revoked for failure to file a return or notice for three consecutive years. The organization must:

(1) Complete and file Form 1023 if applying under section 501(c)(3) or Form 1024 if applying under a different Code section;

(2) Pay the appropriate user fee and enclose it with the application;

(3) Write "Automatically Revoked" at the top of the application and mailing envelope; and

(4) Submit a written statement supporting its request if applying for retroactive reinstatement.

If the application is approved, the date of reinstatement generally will be the postmark date of the application, unless the organization qualifies for retroactive reinstatement. Alternate submissions and standards apply for retroactive reinstatement back to the date of automatic revocation. See Notice 2011-44, 2011-25 I.R.B. 883, at *http://www.irs.gov/irb/2011-25_IRB/ar10.html,* for details.

Changes for the Instructions for Form 1023

- Change to Part III. Required Provisions in Your Organizing Documents
- Clarification to Appendix A. Sample Conflict of Interest Policy

(Continued)

 Department of the Treasury
Internal Revenue Service

Notice 1382

(Rev. October 2013)

Changes for Form 1023
- Mailing address
- Parts IX, X, and XI

Reminder: Do Not Include Social Security Numbers on Publicly Disclosed Forms

Because the IRS is required to disclose approved exemption applications and information returns, exempt organizations should not include Social Security numbers on these forms. Documents subject to disclosure include supporting documents filed with the form, and correspondence with the IRS about the filing.

Changes for Form 1023, Application for Recognition of Exemption Under Section 501(c)(3) of the Internal Revenue Code

Change of Mailing Address

The mailing address shown on Form 1023 Checklist, page 28, the first address under the last checkbox; and in the Instructions for Form 1023, page 4 under *Where To File,* has been changed to:

Internal Revenue Service
P.O. Box 12192
Covington, KY 41012-0192

To file using a private delivery service, mail to:

201 West Rivercenter Blvd.
Attn: Extracting Stop 312
Covington, KY 41011

Changes for Parts IX and X

Changes to Parts IX and X are necessary to comply with new regulations that eliminated the advance ruling process. Until Form 1023 is revised to reflect this change, please follow the directions on this notice when completing Part IX and Part X of Form 1023. For more information about the elimination of the advance ruling process, visit us at IRS.gov. In the top right "Search" box, type "Elimination of the Advance Ruling Process" (exactly as written) and select "Search."

Part IX. Financial Data

The instructions at the top of Part IX on page 9 of Form 1023 are now as follows. For purposes of this schedule, years in existence refer to completed tax years.

1. If in existence less than 5 years, complete the statement for each year in existence and provide projections of your likely revenues and expenses based on a reasonable and good faith estimate of your future finances for a total of:

 a. Three years of financial information if you have not completed one tax year, or

 b. Four years of financial information if you have completed one tax year.

(Continued)

You must complete the Form 1023-EZ Eligibility Worksheet in the Instructions for Form 1023-EZ to determine if you are eligible to file this form. Form 1023-EZ is filed electronically **only** on Pay.gov. Go to www.irs.gov/form1023ez for additional filing information.

Form 1023-EZ (6-2014)

Page **3**

Part V	Reinstatement After Automatic Revocation

Complete this section only if you are applying for reinstatement of exemption after being automatically revoked for failure to file required annual returns or notices for three consecutive years, and you are applying for reinstatement under section 4 or 7 of Revenue Procedure 2014-11. (Check only one box.)

1 ☐ **Check this box** if you are seeking retroactive reinstatement under section 4 of Revenue Procedure 2014-11. By checking this box, you attest that you meet the specified requirements of section 4, that your failure to file was not intentional, and that you have put in place procedures to file required returns or notices in the future. (See the instructions for requirements.)

2 ☐ **Check this box** if you are seeking reinstatement under section 7 of Revenue Procedure 2014-11, effective the date you are filing this application.

Part VI	Signature

☐ **I declare under the penalties of perjury that I am authorized to sign this application on behalf of the above organization and that I have examined this application, and to the best of my knowledge it is true, correct, and complete.**

PLEASE SIGN HERE ▶

(Type name of signer)

(Signature of Officer, Director, Trustee, or other authorized official)

(Type title or authority of signer)

(Date)

Form **1023-EZ** (6-2014)

Form 1023-EZ is filed electronically only on Pay.gov

Changes to Instructions for Form 1023, Application for Recognition of Exemption Under Section 501(c)(3) of the Internal Revenue Code (Rev. June 2006)

Part III. Required Provisions in Your Organizing Document

Applicable to organizations in the state of New York. Changes are necessary to comply with Rev. Proc. 82-2, 1982-1 C.B. 367, to incorporate the state of New York as a jurisdiction that complies with the *cy pres* doctrine to keep a charitable testamentary trust from failing the requirement for a dissolution clause under Regulations section 1.501(c)(3)-1(b)(4), when the language of the trust instrument demonstrates a general intent to benefit charity. Therefore, the instructions on page 8, line 2c, after the third paragraph now include the state of New York in the state listing as an authorized state. Since the state of New York allows testamentary charitable trusts formed in that state and the language in the trust instruments provides for a general intent to benefit charity, you do not need a specific provision in your trust agreement or declaration of trust providing for the distribution of assets upon dissolution.

Appendix A. Sample Conflict of Interest Policy

Appendix A, Sample Conflict of Interest Policy, is only intended to provide an example of a conflict of interest policy for organizations. The sample conflict of interest policy does not prescribe any specific requirements. Therefore, organizations should use a conflict of interest policy that best fits their organization.